POPULAR PARANOIA

A Steamshovel Press Anthology

Popular Paranoia

A Steamshovel Press Anthology

edited by
Kenn Thomas

Popular Paranoia
A Steamshovel Press Anthology

© 2002 by Kenn Thomas

ISBN 1-931882-06-1

First Printing September 2002

All Rights Reserved

Printed in the United States of America

Published by
Adventures Unlimited Press
One Adventure Place
Kempton, Illinois 60946 USA

www.adventuresunlimitedpress.com
www.adventuresunlimited.nl
www.wexclub.com

10 9 8 7 6 5 4 3 2 1

Popular Paranoia

A Steamshovel Press Anthology

PARANOIA:

More Popular than Ever

Introduction by Kenn Thomas

In the first anthology of *Steamshovel Press* back issues (#1-13), a book called *Popular Alienation* published in 1996 by IllumiNet Press (1), I noted that Allen Ginsberg "predicted" the Kennedy assassination in 1959. (2) With this current volume, a collection of *Steamshovel* back issues picking up where *Popular Alienation* left off (issue # 14 through the present), I would like to bring to the reader's attention a prescient observation by parapolitical researcher and writer John Judge from an interview in *Steamshovel Press* published in 1995:

"When I heard that it was an Oklahoma City federal building, I immediately ruled out in my mind that it was an international bombing, by international terrorists, because the building is too obscure. It has no symbolic value. It has no political value. It's in-land. And the whole idea of get them in the heartland, that will scare them. Something going off in DC would have had much more of an impact. Not that I'm suggesting such a thing, I'm just saying that if you were going to pick a target you would expect an international terrorist group, wanting to get at the US, I mean, the Trade Towers are symbolic in that they are right there in the heart of the financial district there in New York. A federal office with a lot of field workers in Oklahoma did not make sense to me from the beginning." (3)

This, of course, is not prophesying on the order of Sean David Morton (4). In fact, the Trade Towers had been hit by a bomb in 1993. Perhaps because that had already happened, however, and all of the other monuments in New York and elsewhere that could be considered possible targets of international terror, as well as his mention also of a DC target, Judge's prognostication seem particularly noteworthy. Similar comments from others in this collection, about biowarfare, terror cells, mind control sleeper agents, religious fanaticism and so forth, show what a remarkable look at "conspiracy thinking" from the past half-decade that *Popular Paranoia* gives.

According to the corporate media and the government (are these different things?), the disasters of 9/11 changed everything about America but its foreign policy. *Popular Paranoia* shows just the opposite, that the conspiracy culture was upon us for everyone who cared to look, well before the onset of the global war currently being conducted by an administration that now consciously refers to at least a part of itself as a "shadow government". These *Steamshovel* back issues reflect the advance view that paranoia sometimes brings. The late Jim Keith (4), for instance, went over his suspicions about the international flavor of the OKC bomb in issue #14 (5). In that same issue, Jack Burden foreshadowed the rightist politics that led to the post-Bill Clinton presidency-by-conspiracy.

Issue #15 dealt with the direct connections between America's muslims, the Nation of Islam, and the American Nazi Party. Although articles about mind control assassins like the one that appeared in issue #16 were looked upon with derision outside the conspiracy-reading underground, few now even in the mainstream no longer believe that such things are impossible.

Paranoia had made it big in popular culture somewhere between the publication of the first issue of *Steamshovel* and the 9/11 disasters. TV shows like *X-Files* and *Dark Skies* (and *The Pretender*, and *Alias*, and *The Company*...) have come and gone in abundance (6); movies from *Conspiracy Theory* to *Men In Black*, *The Matrix* and *The Mothman Prophecies*

(7) now almost comprise a whole genre of film. Ordinarily a volume such as this, containing voluminous arcane and often trivial facts suggesting conspiratorial undercurrents in the popular culture, is produced with some regularity, mostly as some kind of humorous almanac for reading in the water closet.

Of course, *Popular Paranoia*--and every issue of *Steamshovel*--can serve that purpose. Not everything here, of course, has to do with political paranoia. Considerable sections of these issues were devoted to celebrating *Steamshovel*'s friends and heroes, most notably the late, great and now long gone remnants of the Beat generation, William Burroughs and Allen Ginsberg, and everyone's favorite neuronaut, Timothy Leary, all of whom kindly consented to *Steamshovel* interviews before moving to the higher plane of existence. (What was left of Burrough's physical presence took up residence in the neighborhood of *Steamshovel* headquarters, as noted in the letters section of issue #17.) *Steamshovel* also examined the sociological aspects of conspiracy, control and manipulation, within the comic book industry, with the creation of the "yuppie" phenomenon and within religious movements, including a critical look at Elizabeth Clare Prophet as well as a sympathetic look at the rascal Rajneesh.

But in the "new" America, some of this material seems more than just funny or odd. It seems vitally important in understanding what's going on. I am particularly gratified that *Steamshovel* has stayed around long enough -- 15 years in 2003! -- to continue making its contribution to the popular, and ever more paranoid, public discourse.

Kenn Thomas
March 21, 2002

NOTES:

1. IllumiNet closed its doors after the early and unusual death of its owner, Ron Bonds in April 2001.

2. *Popular Alienation*, IllumiNet Press, p. 1.

3. Another *Steamshovel* ally, who made remarkably accurate predictions about the Fall 2001 US presidential election on the Art Bell show, and whose comments about the early days of discovery at Area 51 appear in issue #14 Sean Morton's newsletter, *The Delphi Associates*, is available from 2207 Hermosa Avenue, Hermosa Beach, CA 90254.

4. Jim Keith, too, died an early and mysterious death, possibly by exposure to deadly bacteria. Details about the deaths of Ron Bonds and Jim Keith will appear in a new edition of the book *The Octopus*, planned for publication by Feral House in late 2002. Keith's last contributions to *Steamshovel* are contained here, as are some of the details of his death in a memorial by his friend, Wayne Henderson.

5. Adam Parfrey brought forth this interesting footnote to the current concerns about world terrorism: *"Timothy McVeigh and Terry Nichols had continual contacts with known terrorist entities up to the day of the Murrah Building blast. Nichols was married to a Filipina woman, and took trips to Cebu City, Philippines (without his wife) in late '92 and early '93 to meet with such friendly folk from the Abu Sayyaf terrorist org as Ramzi Yousef, Abdul Hakim Murad, Wali Khan Amin Shah and several others to discuss the bombing of the OKC building."*

6. A talk show, entitled *Conspiracy Zone*, surfaced on cable TV, and I even appeared in one episode. I tried to argue from documents that Marilyn Monroe's death may have been connected to her lips, which she loosened up recklessly with regard to "the things from

outer space" that JFK showed her at a desert base, presumably Area 51. But the show became dominated by the opinions of Lisa Ann Walters, a daffy actress from the TV show *Emeril* with a Marilyn-suicide theory. Erstwhile Jonathan Vankin, author of *The 70 Greatest Conspiracies*, did his best to present Norman Mailer's mafia theory, but the show was in the end turned over to an old queen who knew Marilyn in New York. I did get to mention the similarities between Marilyn's death and that of JFK's LSD lover, Mary Pinchot Meyer, however.

Saturday Night Live comedian Kevin Nealon hosted the program on the TNN network. At one time TNN stood for "The Nashville Network", but in a bid to change its demographic from the country-music oldsters in the double-wides, of which *Conspiracy Zone* was a part, it changed to "The National Network" and started programming *Star Trek* reruns heavily. Nealon's self-deprecating humor in *Conspiracy Zone*, was offset in each episode by the belligerent tone of one comedian on a three-member panel of experts, a "good comedian/bad comedian" routine.

While the program gave rare TV time to such conspiracy stalwarts as Alex Constantine, David Lifton, David Childress and Jon Rappoport, it short-shrifted others. For instance, although he auditioned, the show did not use Rob Sterling, of **Konformist.com**, hands down the most charismatic and TV friendly person in the conspiracy underground. He was no doubt slighted so because he would have upstaged the comedians, turning them into his own comedic foil. *Conspiracy Zone* wanted the conspiracy people to be serious and the butt of the jokes told by such "bad comedians" as *The Man's Show's* Adam Carolla and *Welcome Back Cotter's* Gabe Kaplan.

7. Ron Bonds was responsible for bringing John Keel's classic of paranormal experience, *The Mothman Prophecies*, back in print, but he did not live to see it turned into a Richard Gere movie. Considering the disparate characters of John Keel and Richard Gere, it was an irony that Ron would have no doubt enjoyed.

Subscriptions to *Steamshovel Press* cost $25 for four issue; $7 per individual issues. All checks should be made out to "Kenn Thomas" NOT "Steamshovel Press". POB 210553, St. Louis, MO 63121.

find the *Steamshovel Press* web site at:

www.steamshovelpress.com

features include:

**From the Editor
The Latest Word
Offline Illumination
Link Tank
...and *Things Are Gonna Slide*,
a free e-wire newsletter**

POPULAR PARANOIA, page 3

STEAMSHOVEL 14
Fall 1995

Paranoid/Paranoia:

Media Buzzwords To Silence The Politically Incorrect

by Alan Cantwell Jr., M.D.

Ever since the bombing of the Federal Building in Oklahoma City, there has been a media blitz blaming paranoid people and anti-government militia groups for the violent deaths.

Feeling the heat are ordinary citizens who believe in such things as the New World Order, or the plot to kill Kennedy, or the existence of UFOs, or the theory that AIDS is man-made and countless other conspiracies. The media have been quick to dismiss these conspiracies as paranoia, thereby stifling serious discussion of these issues.

According to *Webster's Dictionary*, paranoia is a serious psychiatric diagnosis: a psychosis characterized by systematized delusions of persecution or grandeur usually without hallucinations. Paranoia can also be defined as a tendency on the part of an individual or group toward excessive and irrational suspiciousness and distrustfulness of others. People who exhibit such psychological traits are paranoid.

A definite diagnosis of paranoia requires the expertise of a psychiatric health professional. A diagnosis is made after a careful history and physical examination of the patient, and must include a detailed drug history and psychiatric observation.

All this is ignored by journalists who indiscriminately label people as paranoid. Their purpose is to discredit a person's mind and reasoning ability. Unfairly labeling people as paranoid is malicious and evil; and the word can be as hateful as words like "nigger", "kike", and "faggot". When terms like paranoia and paranoid are tossed around in the media, rational communication is no longer possible.

A paranoid person is not normal because paranoia indicates a diseased mind.

In their quest for power, politicians often portray their perceived enemies as diseased. Hitler was a master at this. After securing the cooperation of German physicians, he rid the Third Reich of thousands of mental and physical defectives by murdering them. When this was accomplished, he turned on the Jews. He labeled the Jews as a cancer that needed to be cut out of a diseased Germany. Thus, the roots of the Holocaust were planted.

Labeling people as diseased is an effective way of discrediting and silencing them.

The media overkill of paranoia is evident in "The Road to Paranoia," a 13-page essay by Michael Kelly appearing in the *The New Yorker*, June 19, 1995. According to Kelly, "There have always been radical fringes on both the left and the right which believe that the government conspires against the people. But lately, the two have formed a strange alliance — fusion paranoia — that is reaching millions of disaffected Americans." He reviews the major conspiracy theories, and interviews conspiracist Bob Fletcher, a member of a political organization called the Militia of Montana.

Not surprisingly, Kelly makes Fletcher look like a friendly loony-bird. Kelly also savages Ross Perot and his "paranoid style as the first fusion-paranoia candidate for the Presidency." In the 1996 Presidential race, "paranoia already has its first truly out-of-the-closet candidate, in the pugnacious form of Pat Buchanan."

As I read "The Road to Paranoia" I suddenly realized I was part of Kelly's story. For almost a decade, I had been promoting the idea that AIDS had originated as a genetically engineered virus that was deliberately seeded into the black and gay community via vaccine programs and experiments. My publishing house, Aries Rising Press, had published two books on the subject of AIDS as a man-made epidemic, which were well received in the alternative press. Unfortunately, *AIDS & The Doctors of Death* so infuriated the World Health Organization that it was banned from sale at the International AIDS Conference in Montreal in 1989.

Despite all this I had not expected to find Aries Rising Press included in Kelly's list of several dozen "rapidly growing alternative media that traffic in conspiracism."

Kelly mentioned the conspiratorial belief that "AIDS is a government plot to kill off blacks and homosexuals," but no details were provided. Also mentioned was a 1990 poll of African-Americans concluding that "a third believe that HIV was produced by scientists and disseminated through black neighborhoods for the purpose of genocide."

A decade ago, the idea of AIDS as a man-made disease was considered nonsense. Now the theory is frequently mentioned in the major media, but the evidence for it is never discussed, and the idea is always dismissed as paranoid. However, a surprising number of people I have talked to in the past few years now think the theory makes more sense than the government's African green monkey story.

Ex- New York City Health Commissioner Stephen Joseph, in his AIDS book *Dragon Within the Gates,* also dismisses without explanation "the paranoid theories about AIDS being a deliberate invention of biological warfare." However, he does note "the scars left by the Tuskegee experiment" in the Black community. In this notorious government-sponsored syphilis experiment, public health doctors deliberately lied to black sharecroppers in Alabama for over 40 years. The men were never told they were infected with syphilis, and when a penicillin cure became available the doctors withheld treatment so that they could study the devastating effect of untreated syphilis. When the men died, the doctors rushed to get an autopsy, coaxing the family into giving permission by having the government pick up the tab for the funeral expenses. Under pressure from civil rights activists, this racist experiment was finally terminated in 1972.

Joseph writes that the memory of Tuskegee "fueled a conspiratorial theory among blacks that AIDS resulted from a biological experiment, gone awry, performed on Africans by the United States government."

Conspiratologists know that government doctors and scientists, and the military, have conducted covert experiments on unsuspecting civilians. Recently the nation was shocked to learn that physicians had performed dangerous radiation experiments on unsuspecting hospitalized patients from the 1950s up until the 1980s. The proof was contained in previously classified government documents released by the Department of Energy.

Charges of secret and unethical experiments against helpless American citizens are not the ravings of paranoid people. On the contrary, they are serious accusations of an informed and enlightened citizenry.

It is time to speak out against falsely labeling people as paranoid.

Paranoid and paranoia are acceptable terms when used in a medical setting. But they have no place in slandering and denigrating people who express alternative views in a democratic society.

Dr. Cantwell is the author of *Queer Blood* **and** *AIDS & The Doctors of Death*—**two books on the man-made origin of AIDS. Further information can be obtained from Aries Rising Press, PO Box 29532, Los Angeles, CA 90029, voice/FAX 213-462-6458.**

The Only Honest Judge?
An Interview With John Judge
by Kenn Thomas

Q: What did you think of E. Howard Hunt having dinner with Oliver Stone (1)?

A: I didn't hear about that.

Q: Omigod. That was one of the great social events of the season, along with Mark Fuhrman having dinner with Ed Meese. You heard about that, I take it (2)?

A: No. The last dinner engagement I remember is Hinckley's older brother with Neil Bush.

Q: Let's talk about the new COPA conference coming up and what can we can expect will be looked at there, the new material that has come out since the Assassination Materials Review Act (3).

A: Probably the most exhaustive look at the records that's turned itself now into a new book is John Newman's Oswald and the CIA. Although its hasn't got a smoking gun, it's got smoking files. Some very interesting stuff about how early on the CIA opened up files on Oswald and was looking at him. A lot of surveillance pertaining to him that they had not admitted in the past. Newman, because of his intelligence background and familiarity with looking at files and signing off on files, was able to track what you and I would see in a file from reading it, but also the initials on it, the re-routing, who saw it, and from that he was able to reconstruct a lot of the structure of the CIA at the time, especially the segments that would have been dealing with Oswald in Mexico or otherwise.

That's been interesting. A lot of us had heard of Z-Rifle or AMLASH, he found nearly fifty code operations like that that he was able to identify and see in some cases who they were connected with. He also clearly shows that there was some sort of a deception game going on that involved the agency and the embassy in Mexico City at the time that he was down there. There was an Oswald impersonator. There's evidence earlier that Oswald's name is being used in connection with intelligence operations and that also Oswald was clearly being tracked during the time he was with the Fair Play For Cuba Committee. There's a whole fair Play For Cuba Committee section of the documents there, including, interestingly enough, some documents that show that David Atlee Phillips was working with James McCord, later of Watergate fame, early on. We're thinking about trying to put that document out. We try to do a document a month in

Open Secrets. Each issue has at least one document that's sort of new or interesting.

Q: Now the conference that you're having in October, Newman's going to be a speaker, right? And you are going to have a number of different people that are specialized in various areas from the new files?

A: A little different than, maybe, a conference like the ASK conference in Dallas, where people are just invited to speak. We do our conferences in a semi-professional manner, like a scientific conference is held. And what

we require is that we put out a call for papers and we ask for people to send up to 500 words as an abstract of the paper that they want to present. And there is some peer review, and committee review. ASK tended to be a showcase for current or known authors. ASK was basically a podium down situation

and it also had a lot of frivolous presentation and really didn't have any standard as to what could be presented. It was basically a commercial venture and it was never putting any resources back into the hands of the research community. The Coalition is made up of and run by the research community and elements of it and it represents the interests of that research community and its long-time members. So we try to put on a conference that limited research community and the general public. We are also hoping to get some press. We'd like to get gavel-to-gavel CNN coverage.

Q: Is that possible?

A: I think so. They're people were interested last year, but they make priority decisions each day and there was some stuff going on in Congress at the time.

Q: But never seems like a priority to have this kind of thing in the media. Although Norman Mailer is getting on Larry King and all that.

A: Right. It was clear to me in interviews when Mailer was asked why he chose to do this book on Oswald, he based it on the fact that Lawrence Schiller had gotten private access to the Minsk KGB files on Oswald and was willing to share those with Mailer. It's hard for me to imagine that Schiller was able to get those kind of documents based on his access to the KGB there or some sort of salesmanship. I would think that in order to crack that nut you would have to have some links to current KGB and US intelligence interconnections.

Q: Now what do we know about Schiller?

A: Schiller goes back in the history of the critical community at least as far as 1967 as

the source to the very first character assassination attack on the critical community in a book called *Scavengers and Critics of the Warren Commission* by Warren Lewis. The subtitle of that book is "Based on an Investigation by Lawrence Schiller."

Q: That's the kind of credit line he has on Albert Goldman's book about Lenny Bruce.

A: "Based on the Journalism of Lawrence Schiller" is the subhead to both Goldman's book on Lenny Bruce...

Q: Which was a smear.

A: Right. Honey Bruce challenged Goldman to a debate and reportedly his response was, "I can't debate you, you know too much." Then Goldman did the later smear on John Lennon with that same by-line. So Schiller seems to be somebody who collects dirt on people and then has these sort of ghost writers do the hit job. It's what I call the second assassination. First you kill the body and then you kill the character of a person. There's quite a bit of this literature about Kennedy, regular media attacks on Kennedy and on Robert as well and sex scandals relating to Martin Luther King and that sort of thing. These are intermittent. We usually get a Chappaquiddick book just around election time in case Teddy's thinking of running.

Q: The only book on Kennedy that is for sale at the National Archives book was the one by Richard Reeves, totally trashing Kennedy.

A: So it's that sort of thing and Schiller seems to be an expert at it.

Q: You can see Norman Mailer hedging his bets on the TV shows. He says he's 75% sure that Oswald acted alone.

A: I think Mailer, who funded the original Assassination Information Bureau, the Carl Oglesby operation in the 1970s that led to the House Select Committee, is basically allowing himself an out.

Mailer was asked at a press conference at ASK how long he had known Lawrence Schiller, and he said, "We go way back. We worked together on that book about the critics." Which means that Mailer somehow even back then was attacking at least part of the critical community. But that book slams Sylvia Meaghre, Penn Jones, Harold Weisberg, a lot of the early critics are downplayed in that book and their personal quirks are pointed out.

Q: So Mailer has this love/hate relationship with the critical community.

A: Either with the whole community or some part of it. Maybe there is a separate agenda at work here. If you discredit parts of the community, but certainly that early book attacks almost the whole community, and yet at the same time he shows up later as one of the defenders of people looking into the truth. He talked in those years of forming a People's CIA, now he seems to be much more back in bed in a clear way with the intelligence community, or at least some segment of it. Maybe he feels disenfranchised, I don't know.

Harlot's Ghost is an interesting book in that it takes the other tack that Oswald may have been a lone assassin but he was at least connected enough to the intelligence community that he was upsetting all the apple carts. This is the last book in a four book contract. He's basically edged into a position where he won't come all the way out and say that Oswald did it because he knows it's not

true. He can't base it on the evidence. He says you can't get in to the miasma of the evidence, we have to get to the other questions, which is why did Oswald choose Kennedy as his victim? Well, if you can't prove that Oswald shot Kennedy, it's useless to discuss why he chose Kennedy.

Q: Let's talk a little bit about Oklahoma City. Comparisons have been made between Timothy McVeigh and Oswald. What do you think is going on there? Is McVeigh a patsy?

A: It's too early to tell. We've got a story here that took a while in the making for them to come out with anything resembling an official version. Actually, a number of patsies were picked up early on and then dropped like hot potatoes. Early on there were two middle eastern looking individuals that were in a brown pick up truck. And then there was an early report that the axle found two blocks from the explosion matched a brown pick up truck rented from the Dallas/Ft. Worth airport. Then there were two men seen in a car in identical matching blue jump suits, trying not to be noticed. And then there was a Jordanian who was arrested the Chicago airport.

Q: You actually talked to that guy.

A: He was an individual who lived in Oklahoma City, worked for a computer company, he was not computer builder or engineer. He worked in sales at a computer company in Oklahoma City. He said chemistry was his worst subject in high school and he was trying to tell the FBI that he wouldn't know how to build a bomb. He was picked up he told me solely on the basis of a physical profile. In other words, he was a middle eastern looking person and he was leaving Oklahoma City that day. It may have been the location or it may have been that they saw this guy in the Chicago airport and they decided to grab somebody. They detained him for almost seven hours in Chicago. The INS first challenged him for about three hours on the basis that his passport was fake, as if that was something you couldn't check by phone in a few minutes. The FBI grilled him about where he was at the time of the bombing, what did he know about the bombing, what did he know about the politics of the Muslim community there, which is fairly small. They did have a national conference there because the hotels were cheap, but it's hardly a hotbed of radical Muslim activity.

Of course it immediately created a backlash of anti-Arab sentiment here in the US. Even Arab child care centers were getting bomb threat calls from Americans. There was a lot of talk while they were holding this guy. He was the first lengthy suspect in the case.

Q: While they were holding him, his luggage was going to Rome.

A: That's what I asked him, because I saw on CNN that his luggage was being emptied in Rome and they were saying that he had a hammer in there and he had some tape in there. He had brought some tools and things of better quality in this country to take back to his family in Jordan. And he had some electrical wire, and these were wires and things off the back of a VCR and he had brought again to bring back to the family. They said he had silicon in there and I asked him about that and he said, "well, I had bought some caulking material for my uncle, which was better quality, and I bought it here and I had two tubes of caulking material. And they said all of this could be used to make a bomb."

Well, most of us would be in trouble if we went to our tool drawer and looked under

our kitchen sink. You could put together a terrorist bomb right there in the kitchen. But the question that I asked him was, "How was it that your bag was in Rome while you were at Heathrow in England?" He said, "Well, when they stopped me in Chicago, they didn't stop my bag." And I immediately said to him, "then they didn't think you were the terrorist. Because the bag would have been stopped quicker than the suspect. They would not have let the plane leave the ground with the bag in it."

I think they were buying time. They got a patsy. They got a certain public reaction that they wanted quickly. Maybe eventually they were going to build that in to a larger cover story and for some reason that didn't work out. Eventually, but after quite a bit of time -- days -- we get Timothy McVeigh.

My version of this, because I heard about it on that day coming in to DC, I had flown in from California, on my way to a demonstration planned at noon in front of the FBI headquarters here in DC against domestic terrorism by the FBI and BATF, because it was the Waco remembrance. It was the anniversary of Waco and I was coming to talk about the militarization of police, which I really think is the unifying principle of these different scenarios and events, from Waco on back, to Wounded Knee, the MOVE situation, the SLA burn out, and all these exhibit different aspects of a growing scenario that has to do with both the militarization of police and the use of military troops in police work, and the breaking down of the division between the military and the police and the old Posse Comitatus Act. In fact, one of the elements of the counter-terrorism bill that Clinton composed was to end the Posse Comitatus restriction on bringing the military into counter-terrorism activities. The Senate version, the one that just passed, does not have it as broad, but it did accept a provision for nuclear, chemical or biological warfare terrorism scenarios, to bring the military in. But I have said for years from my study of this counter-terrorism clique that's built up in this country, and Ollie North is part of it, the Delta Force and all these different things that figure into the contra-gate scandal were counter-terrorism units. And there's a whole counter-terrorism industry that popped back

up at the time of the Oklahoma bombing, again justifying its funding and its expansion and its over-riding of the rights of Americans.

Q: Almost as if "counter-terrorism" is the catch phrase that replaces "national security."

A: Yes. And that we now have a new enemy worse than we thought. That was one of the things that sort of struck me about the racist interpretation that this country makes. First there's the assumption that it must have been Arabs. When I heard that it was an Oklahoma City federal building, I immediately ruled out in my mind that it was an international

thing, I'm just saying that if you were going to pick a target you would expect an international terrorist group, wanting to get at the US, I mean, the Trade Towers are symbolic in that they are right there in the heart of the financial district there in New York. A federal office with a lot of field workers in Oklahoma did not make sense to me from the beginning.

It also didn't make sense to me later as something for the militia to do or something for even a disgruntled person upset about Waco to do, as we are told that Timothy McVeigh was. What it fits into to me is what is known in Europe as the strategy of tension. This is revealed through the works of Stefano Dellachaiae for one. He's an Italian terrorist and he's responsible for a number of bombings of trains and public places, airport or train station bombings that set a pattern there--and other terrorists are doing this in other parts of Europe, France and other places. Dellachaiae represents this liaison that was formed between these neo-Nazi and fascist elements and also police intelligence units and segments of the national security and intelligence state. These bombings were planned and done in such a way that original credit or blame would be given to the left wing. When that cover story would fall through, if it did, the intelligence agencies would still be removed enough that they could blame elements of the right wing, but they hope it would never come back to the original planners.

The purpose of these things is to create a strategy of tension in the country, of fear, and use that as the guise to build up the police intelligence state, to reduce the rights of the citizens to a democratic process and to put everybody in the position of basically having their civil rights abrogated and having these police structures well funded. It becomes an excuse then for an increase in fascist rule.

Q: This sounds very similar to what a lot of the militia groups are saying.

A: I think that the militia groups are saying it in the sense that they have a suspicion that the government was involved in this. But what I see with the militia groups is that most of them have done very little investigative work on the government, the national security state and how it functions. They have a fear of the government. They see the government as a monolith. To such an extent that some are thinking that Bill Clinton is sitting in the White House saying, "OK, let's murder those little babies there in Oklahoma City so that we can pass this bill and bring in the New World Order." When I say that the government may have been involved in a thing like the Oklahoma City bombing, what I am talking about is specific segments of military intelligence and police intelligence and the national security state. I'm not talking about a plan that reaches to the White House through all of Congress, because such a plan wouldn't wash. You have to assume that some of the federal agents working in that building had some friends in the government as well who might not have wanted to see them blown up. It's more likely that if there's government involvement in the situation it really has to do with a segment that's trying to maintain funding and presence, and expanding presence, for these militarized police within the context of the state.

The mood here in DC just prior to the Oklahoma City bombing had a lot to do with the fact the CIA was in trouble. It had the Ames scandal, but it also had just started to break the Jennifer Harbury story to Representative Robert Toricelli, who spilled the beans on the fact that a current client of the CIA, on CIA payroll in Guatemala, this colonel, was responsible for the murder of an American citizen and the husband of another

American citizen. That these were basically carries out as state terror assassinations for political purposes in that country. Harbury's husband was a member of the Guatemalan left, a guerilla, who was captured by this Colonel Alperez. This colonel has been dismissed but he was given a severance well beyond anything that people in his position in the military would get. So he's been given this big bonus check at the end an we're not sure if that hasn't come from U.S. funds. But this was a big embarrassment in DC for the CIA and involved the CIA again in foreign assassinations and assassinations of American citizens, and there was quite a fight. And Torricelli released this information to Harbury and to the press and gave it to the Congress and he was immediately under attack by Newt Gingrich. Gingrich wanted him removed from the intelligence committee. What's happened in the past is that when people have for ethical reasons revealed government wrongdoing, they've been kicked off those committees because they are not keeping their secrecy oaths.

In addition to that, the Republicans had demanded during this current term a new secrecy oath for everybody in Congress, including the intelligence committee. And they were saying that Toricelli was violating the House rules.

Q: Never mind what he was saying, just that he was saying anything.

A: That's right. I don't want to paint him as a saint because this is a person who openly calls for a US invasion of Cuba. This is a person who for years supported the funding of the military government in El Salvador and turned a blind eye to the death squads there. But for whatever sets of reasons, Toricelli took the correct position that his ethics and the ethics of the situation were in direct conflict with his secrecy oath. He said that his constitutional oath to uphold the law took precedence over any secrecy oath. So I actually worked to organize about fifty national groups in the DC area to a sign-on statement supporting the principle--not everything Torricelli does, but the principle that he had moved on and the other people who have moved on it in saying that principle ought to be established as part of any congressional agreement to secrecy. It has to have the imprimatur that unless the congress person is aware of things that violate the constitution and US law. It's their responsibility to reveal the wrongdoing and not to hold to the secrecy. Of course, the intelligence agencies don't want this. Gingrich not only wanted Torricelli removed, he didn't want an investigation into the Harbury incident and that this no time to be attacking the CIA. The CIA had to be expanded in this period.

Q: This is right before Oklahoma City.

A: This is in early April. On April 4th, the *Washington Post* editorialized against the counter-terrorism bill. In an editorial, it said, "Is this American Justice?", asking specifically about some of the provisions that had to do with these secret trials that were going to be held with immigrants into the country. This bill was basically taking us back into the situation of the 1920s and the Palmer raids when accusation alone would become the basis for a secret trial and a secret deportation and no right to challenge or appeal. Blatantly anti-constitutional stuff in there, the breakdown of Posse Comitatus, a lot of provisions on wiretapping authority expanding, basically making legal all of the COINTELPRO stuff that the FBI was held back from doing legally since the 1970s.

The *Post* came out against it, the military budget was under question because the welfare budget was under attack and people were saying "what about corporate and

military welfare?" All of that turned around after the Oklahoma bombing. The counter-terrorism bill was on a roll, not likely to be stopped. Right are going to be curtailed because of it. The CIA is back in a position of saying that we need them to protect us from terrorism. Now we have an enemy, we're at the end of the Cold War. The peace dividend was still waiting but finally maybe we could get a smaller military, well now we can't, it's not Communism, it's terrorism that's the enemy. And these are things that I have talked about in my lectures for the last ten years, that terrorism is going to be the new enemy, the new excuse for state repression, specifically nuclear terrorism but now perhaps also chemical and biological is being thrown in with the Sarin attack in Japan that's being thrown in at the same time. They're going to scare the American public bad enough with one of these scenarios that it will be willing to go into a suspension of the constitution and into martial law.

I'm not talking about this because I just read in the *Spotlight*. I'm talking about it because I did years of study on the laws and the things that make these possible and the historical background of the rise of American fascism and its concentration especially since the time of the Kennedy assassination. These are things that I don't see being hit except in the most peripheral way by most of commentary from these militia groups. I could trace most of it for you through the right-wing literature that I get in the mail, through *Spotlight* and *Cosmic Connection*, which is Jesus and Buddha telling you to read Lyndon LaRouche, through some of the Nazi literature. In fact, one of the most amusing things to me, for its perversity, sections in the neo-Nazi and American fascist literature was talking about concentrations camps in America and how they were going to be used to pick up all the blacks and all the Hispanics and then it was saying to this audience, "Why should that bother me? That's where those people belong anyway? But here's the ticker: you're going to have to be in there with them, in the same concentration camp with all those people you hate."

Q: At the militia meetings I attended it did not seem like anyone there had the first awareness that what was being done to them, Ruby Ridge and Waco...

A:...has been done to others. They have two martyrs and they have no other victims. They are people that in my estimation seem to have read the first amendment and don't quite understand it. Then they got to the second amendment and they liked it so well that that took care of the rest.

Q: You can't really connect McVeigh to any of these groups, though.

A: Only in the sense that he seems to have played the same role that Oswald did with the right wing Cubans in being someone who came into their midst and promised a little more violence than they were ready for and was tossed out. This is also the way the classic *provocateur* establishes a legend and a connection to groups they eventually want to hang with particular crime.

Q: You mentioned that you talked to Michael Fortier before his "confession."

A: Myself and researchers I know talked to Fortier. He was an army buddy of McVeigh's and he also helped McVeigh get the job out in Arizona at the TruValue hardware store. When he spoke with us, and he didn't have to speak with us, we're not press, and if he was part of this elaborate plot it would not be likely that he would talk to anybody. He was saying to us that he knew McVeigh and he didn't think McVeigh would do anything like

this. He had never seen indication that McVeigh would bomb a building or do this kind of violence. He basically expressed frustration with the way things were going. He said, what happened to innocent until proven guilty? Now he seems to be the main prosecution witness. They have him visiting the building, checking it out with McVeigh. There's a whole story that's implicated McVeigh.

Q: He seems to be plea-bargaining with that.

A: I guess. It seems like they put him over a barrel and they said it's either going to be you or McVeigh, so take your pick. That's the implication always when you have somebody that's cooperating and all of sudden they become a suspect, or vice versa, you have to wonder about what the prosecution is up to. And there have been a string of these: the brother out on the farm in Michigan, Terry Nichols, was first said to be a very cooperative person and eventually become suspects. These people become suspects but then we're told they are not suspects in the bombing. They are just suspects of other, sort of related, crimes. Blowing up cans in the back yard, I guess.

There are a lot of disinformation rumors flying around. Michael McLure said years ago that even paranoids have enemies. That's true, but that doesn't mean that the paranoids know who their enemies are.

Q: That's my feeling about people I have met in the militia movement. Some of them are real, sincere populist types, but they should have real suspicions about their leadership.

A: It's quite likely that these groups are either created whole cloth or heavily infiltrated. These kinds of groups would be of use to the government, both in terms of as they sued the Klan and the Hell's Angels in the past, as an arm of the government to be paid to do murders, assassinations, hits or attacks on people that the government wanted to go after and thereby camouflage, this one done through COINTELPRO and other programs--Hell's Angels were paid off by the US government to kill Cesar Chavez, there were different plots of this sort in the past. So they're a good scapegoat if they need one. There's also quite a bit of history of missing weapons being stolen from military bases and in a few cases where there are suspects, these suspects tie back in to either the Aryan Brotherhood, neo-Nazi, right-wing or these militia movements. It was very clear that there were active police department and active military and reserve military veterans in the militia, even three congressmen were named in the congressional roll call as members of the militia. So the militia have clearly a whole range of people.

The militia want to see themselves as victims. They would say that the government did the Oklahoma bombing and are scapegoating them because they want to destroy the militia and take their guns away. I think all anybody has to do to put that claim in perspective is look at how the Panthers were treated in the 1960s, when black people picked up guns and how different their experience was. There weren't Panthers getting on *Nightline*. There weren't people being allowed to just espouse their philosophy without any political comeback. The militia people are basically being given a forum. "Are you a racist organization?" "Oh, no" But these are predominantly white organizations and their response to the situation that they believe is going on, which is partially racism and xenophobia coming out, that United Nations is bringing foreign troops and foreign weapons--this isn't going to be done with a good old American tank, they're going to have

go import a Russian tank to do this to us. We're more than willing to be a conduit for foreign weapons and to ship them out as long as they are inferior to any other country on the dole.

We certainly do bring foreign troops into this country and train them, as assassins and death squads. We train other foreign troops to be surrogate forces for us around the world, and it's us that's taking over the UN, not the other way around. The UN has clearly been used as an extension of US foreign policy for many years.

It's not that there haven't been victims of these federal police attacks, but you're comparing a few, the one Randy Weaver, even the hundred people at Waco, the underlying theme is that the people that the government is really after are these good white Christians.

Q: This is exactly the kind of thing that's behind, say, Qubilah Shabazz and Louis Farrakhan. The FBI is going in and trying to manipulate Shabazz into taking a contract out on Farrakhan. The militias don't seem to care about that. They don't care about the Black Panthers. But when it happens to Randy Weaver or the strange Christians at Mt. Carmel, the whole movement is enflamed.

A: Or the children in Waco or the children in Oklahoma City. But foreign children, when they die, aren't somehow as innocent or deserving of our pity. There are stories about seeing foreign troops being trained to go house to house and disarm the people in the houses. That's classic counter-insurgency warfare strategy that they would use in a place like Somalia. Does it mean that they wouldn't use it here? No, but the communities where it's going to be used first are the communities where they are afraid of people having guns. They have been providing guns to people in this country, much more so than taking them away. Any kid in Los Angeles, on the streets in a black or Hispanic neighborhood, in the gangs, they know where to go to get the guns. They come in by the trainload literally. At certain locations you go down and you can buy the guns. It's like the drugs. They don't come from the moon, they don't come from a sixteen year old kind with a plane that goes to Bogota every week. They come through channels that involve government complicity or looking the other way.

Guns generally don't protect homes. It's more likely that it's going to end up with a gun fatality in the home. On the other hand, I'm not saying that therefore no one should own a gun. But what I am saying is that guns cannot be said to protect civil liberties. The fact that somebody armed themselves--as G. Gordon Liddy says, when BATF comes to break into the house, shoot for the head because of the vests they've got on--is not protecting the civil liberties of themselves and the broader rights of people. Most of the

Something going off in DC would have had much more of an impact. Not that I'm suggesting such a thing, I'm just saying that if you were going to pick a target you would expect an international terrorist group, wanting to get at the US, I mean, the Trade Towers are symbolic in that they are right there in the heart of the financial district there in New York.

people that focus on the second amendment rights are not people that I have ever seen focused on anybody else's rights in the United States. They aren't concerned about the violation of civil and human rights here and abroad by this government for many, many years. They are people who have a kind of

reactionary response, a selfish response of "I'm going to protect what I have."

Going out and practicing with a 350 Magnum in the woods is the response of the last guy in a prison riot. In the last cell, back in there saying, "Come on in, you dirty screws! You'll never take me alive and I'm going to take a couple of you with me. Pry the gun out of my cold, dead hand." Well, so what? This isn't about changing the United States. It really isn't about realizing constitutional rights. It's about individual protection. It's the response of the guy who goes down to his fallout shelter as a response to the bomb and not only that, won't let you in. He takes the shot gun down there to make sure you try and come in.

There is another view. Yes, the government has conspired to take away your rights. But the thing to do about it is to expose it and to work for a democratic and public solution to it, not a private or little militia vigilante solution to it, because it doesn't rest there. You are not going to win a pop-gun war against the current US military. If the only game you understand how to play is the gun game, you've lost at this point in human history.

NOTES:

1. *Steamshovel* Debris: According to the *Chicago Sun-Times*, May 28, 1995 veteran spook E. Howard Hunt--of Bay of Pigs, JFK assassination and Watergate fame--visited the set of Oliver Stone's new movie *Nixon* and had lunch with Stone and Anthony Hopkins, who plays the late, unlamented ex-president. Actor Ed Harris, who plays Hunt, was not present.

2. More Debris: On May 24, 1995, the *Atlanta Journal* noted that "Diners at the University Club [in Washington] reportedly were abuzz last week over a pair lunching together: former Attorney General Ed Meese and Los Angeles detective Mark Fuhrman, who came to fame in the O.J. Simpson case." In June, the *Chicago Sun-Times* reported that Fuhrman has written a book entitled *Letters to Mark Fuhrman*, "a sock at Simpson's book about letters he got in prison...So now we know at least part of the luncheon conversation in Washington recently between former U.S. Attorney Ed Meese and Fuhrman."

As it turned out, the two may have discussed more than the book deal. As the *Charleston Gazette* put it in its September 2 edition, "Edwin Meese - the shabby former U.S. attorney general who hid wrongdoing in the Reagan administration - is defending Fuhrman and raising defense money for him. Meese is a director of a Washington committee called the Law Enforcement Legal Defense Fund. We always wondered how Meese escaped going to jail with all the other high-ranking Reagan officials. It's fitting that he's now allied to a lying racist."

O. J. Simpson lawyer Alan Dershowitz reported to the United Features Syndicate that "former Reagan Attorney General Edwin Meese, and his Assistant Attorney General Bradford Reynolds...are two of the four directors of an organization called the Law Enforcement Legal Defense Fund, located in Arlington, Va. On Aug. 17, 1995 -- several days after it was disclosed that Los Angeles Police Officer Mark Fuhrman had bragged on tape about committing perjury and tampering with evidence -- the Law Enforcement Legal Defense Fund issued a statement of support for Mark Fuhrman. The names of Meese and Reynolds and the fact that they are, respectively, the former attorney general and the former assistant attorney general, are featured prominently on the statement."

"When I first saw the letter, I was so shocked that I called the office of the fund's director to confirm that it is authentic. It is! On Aug. 23, 1995, I called again and was told

that the fund is now soliciting money for Fuhrman's defense."

"The thrust of the Meese-Reynolds letter is that if Fuhrman lied or planted evidence, the jury should not learn of these facts. So much for the Fourth and Sixth Amendments. Instead, the Meese-Reynolds letter proposes that the defendant should testify that he is innocent. So much for the Fifth Amendment."

"Earlier, Meese had joined Fuhrman for lunch at the University Club in Washington. Now Meese is helping to solicit funds for Fuhrman. Consider the message this show of support sends to other officers. If you lie, tamper with evidence and express racist views, the former attorney general of the United States and his deputy will support you."

One brief mention of Meese's connection to Fuhrman was made on CNN.

3. The Second Annual National Conference of the Coalition On Political Assassinations, happens at the Omni Sheraton Hotel in Washington, DC, October 20-22, 1995. The conference's theme will be "JFK-RFK-MLK: New Information from the Released Files." Researchers, academics, forensic and medical experts and others will present current information and analysis of these political murders. The conference will feature "Assassinations 101" for local students and teachers, an Awards Dinner, and presentations by the Assassinations Records Review Board. Pre-registration and student discounts apply; additional discounts for those who stay two or more nights at the Omni Sheraton (1-800 THE OMNI). Train and air travel discounts have been arranged. Call COPA's conference hotline, 202-310-1858 for more information. Basic annual membership in COPA costs $35. Send inquiries to POB 772, Ben Franklin Station, Washington, DC 20044-0772 (202-785-5299).

A Prophet In Her Own Compound:

The Millennial Angst of Elizabeth Clare Prophet, Secretary To The Gods

by Chris Roth

"OM on the Range," reads a headline in a recent issue of *Royal Teton Ranch News*, the monthly bulletin of the Church Universal and Triumphant's bunkered compound in the Rockies near Yellowstone National Park. Those four words underline the surreal contrasts within a millennial sect of Theosophy that claims thousands of members in forty countries, led by the charismatic Elizabeth Clare Prophet. On the one hand, the ranch sells itself as a rustic ashram, a Zen wilderness retreat full of happy, organically-fed families. On the other, there is evidence of ties to the worst elements of the extremist right wing.

One former "Keeper of the Flame," as advanced members are called, described Royal Teton Ranch as an "incredibly wealthy" commune, bristling with firearms and rife with racist ideologies, where Prophet whipped her devoted followers into a millennial frenzy during an "end of the world" scare in 1990. There are fears that this isolated ranch could be the next Waco.

"OM on the Range" is right. A recent summer session in world religions at the church's "Summit University" interspersed 4th of July picnics, hiking and fishing tours, and courses in aerobics and survival-skills with events like the "Great Central Sun Ritual" and "Initiations at the High Altar." Highlights included Prophet's channeled messages (she prefers the term "dictations")

from "Ascended Masters" like Lord Shiva, St. Joseph, Zarathustra, St. Germain, the Buddha, and Prophet's late husband Mark L. Prophet, who in previous lives was Sir Lancelot and Hiawatha and now goes by the name Beloved Lanello.

To a large extent the Church Universal and Triumphant (or C.U.T.) is Elizabeth Clare Prophet. Prophet, who is in her fifties, is the author of more than fifty books (with over a million copies in print) and hosts cable-TV programs reaching 35 million people. On tour, she dresses in televangelically glittery robes and chants and channels her way through high-rolling stage-shows full of shiny, art-deco icons and dark warnings of nuclear doom. Her teachings are a mishmash--or a union, if you prefer--of world faiths, with a heavy overlay of Theosophy, that product of 19th-century British spiritualism which introduced Westerners to reincarnation, karma, and "the New Age."

True, many Americans feel comfortable with reincarnation and karma--partly because enough of them aren't devoutly Christian enough to reject those possibilities outright. But why did Prophet's followers build air-raid shelters in Montana in 1990 in preparation for a nuclear apocalypse, and why (after it failed to come about) do C.U.T. members across America still flock to spend large amounts of money to attend glitzy, high-energy "dictation" sessions whenever "the Messenger," or "Mother," or "Guru Ma"--as Prophet is variously known--comes through town?

The last time Mrs. Prophet came through Chicago was February 1993, and, in the midst of her four-day marathon of lectures, dictations, and rituals at the North Shore Hilton in Skokie, I spoke with her for an hour and a half. She struck me as a healthy, down-to-earth, and plain-speaking American woman whose only peculiarity, aside from a sharp intelligence and a subtle show-biz savvy, was that she claimed to be the one Messenger for the Ascended Masters on planet Earth. My willingness to perceive her as a charlatan was continually ambushed by her charm and apparent candor.

But I came away with more questions than answers about Prophet and about the appeal of her church. For answers, we need to look first at who Elizabeth Clare Prophet is and where the Church Universal and Triumphant came from. The truth may be surprising and may answer the question of whether the C.U.T. will be the next Waco, as many seem to think, or whether it's no more harmful than yoga or crystal necklaces.

From New Jersey to New Age

According to official Church publicity, Elizabeth Clare Wulf was born in Red Bank, New Jersey, in 1939 and attended school in Switzerland, at Antioch College, and at Boston University, where she earned a B.A. in political science. Reared in the spiritual-healing doctrines of Christian Science, the Ur-church of the American self-help movement, she claims she heard Jesus speak to her at an early age, warning her of the inadequacy of modern Judaeo-Christian faiths. She was buffeted by recollections of past lives (now said to include Jesus's disciple St. Martha and St. Catherine of Siena) and by a powerful attraction to a book in her family library on St. Germain, the legendary alchemist.

The young Elizabeth met her own shining saint in Boston in 1961 in the Rev. Mark L. Prophet, a Pentecostal-bred preacher from Wisconsin who, following a series of visions and communications with the spirit of a turbaned mystic named El Morya, had founded the Summit Lighthouse in 1958. Elizabeth recognized Mark as "the teacher she had been looking for all her life." El Morya (the reincarnation of King Arthur and Sir Thomas More, the C.U.T. now claims)

appeared before long to her also to instruct her to let Mark train her as a messenger in "the Great White Brotherhood" (a body which a recent C.U.T. pamphlet explains in a footnote "refers not to race, but to the white light of the Christ that emanates from the auras of all ascended beings"--a story the former Keeper of the Flame I interviewed finds unconvincing). Mark and Elizabeth were married in 1963 and moved to Colorado in 1966, where they attracted more and more followers, published books, held lectures and "dictations," and raised three daughters, Erin Lynn, Tatyana, and Moira.

Mark Prophet "ascended" (i.e., died) in 1973, and soon after Elizabeth Prophet told me in an aside that strays from the official biography, she was contacted telepathically by "aliens in spacecraft" with evil intentions, as well as by the sinister "Men in Black" often reported harassing witnesses in UFO lore. She regarded this as a "crossroads" in her life, but through faith she rejected the space beings and re-embraced God and the Ascended Masters, and the aliens fled.

Elizabeth Clare Prophet, the official story goes on, changed the name of the Summit Lighthouse to Church Universal and Triumphant and moved herself and her followers to a 218-acre estate near Malibu in 1978 which she named Camelot. In 1981 she married Edward Francis, who had been with the church since 1970. Since 1986 the C.U.T.'s international headquarters has been at a 13,000-acre ranch near Yellowstone, formerly part of Malcolm Forbes's estate and now called the Royal Teton Ranch, in the shadow of a mountain inside of which St. Germain reportedly keeps the records of all human history. Prophet tours the country regularly and her church runs Montessori schools and adult-literacy programs in communities across the U.S., in addition to spreading the teachings of the Ascended Masters through healings, prayer vigils, and the chanting of "decrees."

Though, like all religious groups, the C.U.T. claims that its set of teachings is the original truth, few doubt that its lineage is more immediately traceable to the Theosophical Society.

Theosophical Foundations

The Theosophical Society or T.S. (Theosophists love initials) was founded in 1875 by another charismatic woman, Helena Petrovna Blavatsky or H.P.B. A fiery-eyed Russian *emigre* who used to win converts by staging fake apparitions in her "occult room" with tricks like trap-doors and sleights of hand, Blavatsky rode the wave of interest in table-rapping and communication with spirits that was sweeping America and England in the late Victorian period. Although H.P.B. said officially that getting in touch with discarnate spirits could be a dangerous parlor-game, she nonetheless sacralized the metaphysical views behind spiritist seances through massive, convoluted (and, some assert, plagiarized) tomes like *Isis Unveiled* and *The Secret Doctrine*.

These teachings of the Ascended Masters were issued through an official hierarchy that stretched from Ascended (usually Tibetan or "Aryan") Masters to H.P.B. and her inner circle and eventually to T.S. members around the world. Much of what passes for "New Age" beliefs today-- from astral projection, karma, and the transmigration of souls to vibrational frequencies, the Age of Aquarius, auras, and spirit helpers--is from the language of Theosophy.

Despite involvement in progressive issues like Indian independence and women's suffrage (especially under the later leadership of Annie Besant), the Theosophical Society's tone was too authoritarian, Masonic, and--

frankly--Aryan for most spiritualists' tastes. Still, no one slighted H.P.B. her genius for creating elaborate cosmologies, worthy of the most imaginative science-fiction.

The Secret Doctrine included a reconstruction of Earth's history, drawing on some Hebrew and Hindu texts and on legends like that of Atlantis. Other information was said to be supplied through letters from discarnate Tibetan adepts, which would appear in hidden places in T.S. higher-ups' homes in psychic deliveries called "apports." The Ascended Masters Koot Hoomi (or Kuthumi) and El Morya supposedly revealed to the T.S. inner circle in the 1880s a sorting out of the existing human races which separated Aryan "white conquerors," with an ancestral homeland in Central Asia, from the variously Semitic, African, and Chinese "fallen, degraded" sub-races.

This kind of anthropology raised fewer eyebrows in the era of Kipling and empire than it does today. Nevertheless, it shows that Theosophy was closer to the strains of occult belief that gave rise to Nazi theology than, for example, to the more benign--even sappy--Spiritualism of drawing rooms and self-improvement pamphlets.

A virtual doctrinal carbon-copy of the old Theosophical Society--even more so than today's T.S., which now looks pretty mainstream, with its sedate headquarters in Wheaton, Illinois, was the Great I AM Movement, which once claimed three million members in the U.S., under the leadership of the charismatic Guy and Edna Ballard, known to their followers as "Daddy" and "Mama." ("I AM" doesn't stand for anything; it refers to "the Mighty I AM Presence," i.e., God.)

The Ballards added St. Germain to Theosophy's pantheon, gave Jesus a more prominent role in it, and threw in some original flourishes, some of which today can be found elsewhere only in the C.U.T., such as the ostentatious use of color and the chanting of decrees. (You really have to attend a C.U.T. service yourself--as I did most recently in February 1993 at a hotel on Lake Shore Drive in Hyde Park--to appreciate the hypnotic effect of a throng of the faithful harmonizing a decree like "I AM the Violet Flame" over and over again for half an hour straight.)

The I AM movement collapsed to its present insignificance after the death of Guy Ballard in 1939 and the financial and legal troubles that followed. The only I AM community of any size today is clustered around its sacred site, California's Mt. Shasta (they also have locations in downtown Los Angeles, in Chicago's Loop and near Washington University in St. Louis, MO), although Prophet sometimes takes dictation from the Ballards' now-ascended spirits under the names Beloved Godfre and Beloved Lotus.

The T.S. meets The S.S.

However beloved Daddy and Mama Ballard are nowadays, it has been shown that I AM's American membership overlapped heavily with that of the Silver Legion, which stirred up anti-Semitic activity during the Great Depression through racial violence, hate-literature, and a paramilitary wing whose name, the Silver Shirts, was meant to evoke the Brownshirts then terrorizing Europe.

The Silver Legion's founder, William Dudley Pelley, a well-known sentimental writer of novels and screenplays, had experienced a life-change after a solitary mystical experience in a California bungalow in 1927. This led him to immerse himself in occult and Theosophical teachings, where he found racial theories that buttressed the anti-Semitism he had cultivated working for Jewish producers in Hollywood.

Pelley's plan to establish a "Christian Commonwealth" in the U.S.--which would

mystical experience in a California bungalow in 1927. This led him to immerse himself in occult and Theosophical teachings, where he found racial theories that buttressed the anti-Semitism he had cultivated working for Jewish producers in Hollywood.

Pelley's plan to establish a "Christian Commonwealth" in the U.S.--which would "liberate" American Indians from the reservations so that Jews could be settled there--was tabled when he was indicted in 1942 for spreading pro-Axis propaganda. He

had also been plotting--telekinetically as well as ballistically--against the supposedly Jewish Franklin D. Roosevelt. When he was released eight years later he founded a less overtly militant organization called Soulcraft.

It is still a matter of interpretation to what extent Pelley's racism was a necessary component of his occult views. At least some of his followers had trouble reconciling the two. To be fair, Theosophical-type occultism and 19th-century-type racism have both long existed in the U.S. and overlap in only a limited number of movements. The I AM movement clearly was one such movement. (I AM literature from the 1930s and 1940s included prayers for the annihilation of strikers and criticism of Hitler for being too left-wing.) The question is to what extent the Summit Lighthouse simply revived the I AM movement in its doctrines and membership-rolls, and to what extent the modern Church Universal and Triumphant carries on the Silver Legion's fascist project, if at all.

From Montana to Afghanistan

On the one hand, there are undeniable right-wing components to Elizabeth Clare Prophet's teachings. The book-tables at her appearances often feature the pro-life videotape *Silent Scream* alongside *Autobiography of a Yogi* and *The Lost Teachings of Jesus*. Prophet's support for the Strategic Defense Initiative and the Afghan resistance has been well publicized; her daughter Erin Lynn has made an album of songs about Afghanistan's rebels, distributed by the Committee for a Free Afghanistan (C.F.A.), an organization connected with Pat Robertson's Heritage Foundation. C.U.T. literature is famous for continuing to emphasize what Prophet sees as the threat from the Soviet Union, which she continued to warn of even after that entity had ceased to exist. And there was more than a slight Red-baiting tone to her predictions of nuclear war three years ago.

An article in the Washington-based watchdog journal *Covert Action Information*

C.U.T.'s possible ties to the Ku Klux Klan, neo-Nazi organizations, and the C.I.A. C.A.N.'s investigations are ongoing. However, the political researcher John Judge claims that the C.U.T. has ties to the World Anti-Communist League, one of the C.F.A.'s sponsors which, according to one former branch leader, was extensively involved with "neo-Nazi, ex-Nazi, fascist, neo-fascist, and anti-Semitic groups."

Even more disturbingly--for me at least--the chairman of the C.U.T.'s Department of Theology, Gene Vosseler, who gave a charming C.U.T. sermon in Hyde Park last February on reincarnation and "soulmates," turns out to be a close associate of David Balsiger, a militant pro-apartheid activist. The two were active in the Ban the Soviets Coalition (as in the 1984 Olympics) and in something called the RAMBO Coalition. Vosseler is also senior advisor to the right-wing Americans for the High Frontier, a pro-Star Wars lobby-group.

Slavin, who is Jewish, recalls rampant anti-Semitism at Royal Teton Ranch. She says secret rituals routinely involved raising the right arm in a Nazi-style salute to a Nordic-looking icon of St. Germain. The church controlled all sexual and marital choices, Slavin says, and imposed special "purification rituals" to perform before and after sex. Slavin also thinks "that there's physical abuse that goes on" in the commune's Montessori schools.

Prophet says her followers do not worship her. Slavin says the worship was fanatical when she was at the ranch and that Prophet was regarded as infallible and almighty. Slavin also says members were conditioned to believe that their souls could leave their bodies at night, to visit the hollow Royal Teton Mountain nearby and to consult with Ascended Masters. Slavin now does not believe in astral projection but at the time she thought she was indulging in it regularly and she remembers "visitations" by Lord Lanto, El Morya, and others.

And then there's the matter of the guns. There are disputes as to how heavily armed Royal Teton Ranch is and why. Officially, the C.U.T. has only individually-owned arms in small numbers, for self-defense purposes only. But in 1989 Prophet's husband Edward Francis, a C.U.T. vice-president, was convicted and imprisoned for buying $100,000 in semiautomatic weapons under a false name. With him at the time of the purchase was a C.U.T. "security chief," Vernon Hamilton. This led federal agents to confiscate from the church $26,000 in cash and gold and ten World War II-vintage anti-aircraft rifles.

When Prophecy Failed

These P.R. troubles were in the months leading up to the kick-off of Prophet's prophesied karmic "danger period," during which the two superpowers were to engage in all-out nuclear war. Thousands of followers bought space in bomb-shelters, some coming from as far away as Europe and South America to prepare for the cataclysm. Some sold all their possessions or paid up to $10,000 for a space in a shelter. One former C.U.T. member was awarded $1.56 million after the U.S. Supreme Court decided that the church had pressured him into handing over his life's savings. Slavin, who paid $6,500 for her shelter space, describes vividly the situation at Royal Teton Ranch during the run-up to the apocalypse.

Slavin brushes aside Prophet's assertion that she wasn't quite exactly predicting the end of the world, saying there's no other phrase for what the four thousand or more Keepers of the Flame on the Ranch expected to happen. Crowded into underground shelters and heavily armed against the possible influx of less prepared

locals once the bombs start falling, Slavin says she and the other members were conditioned by "mind control" to expect a nuclear apocalypse. After seven months, the C.U.T. faithful were to emerge into a radiation-free Eden to repopulate the planet. In the twenty-four hours leading up to the April 24th doomsday, Keepers of the Flame held a nonstop vigil, praying for the world to end. When it didn't, Prophet announced that their prayers had saved the world and averted disaster. Slavin says the faithful were too brainwashed to notice the contradiction.

Penniless, but her faith still not shaken, Slavin was allowed to return to her native Los Angeles for a time. There, she regained perspective and began the process of trying to understand what had happened to her. In addition to her work with C.A.N., she is now Coordinator of the Maynard Bernstein Resource Center on Cults for the Jewish Federation Council of Los Angeles.

The Aliens of Zion

The end-of-the-world scare made national headlines in 1990. Another current in C.U.T. activity that is less talked about surfaces in Mark Prophet's 1965 book of channeled prehistory, *The Soulless One: Cloning a Counterfeit Creation*. This small paperback tells of the extraterrestrial breeding program that created the human race, in terms that predated by about a decade Erich von Daniken's popularization of the so-called "ancient astronaut" hypothesis with Chariots of the Gods? In The Soulless One an Ascended Master called Master R warns readers of the small cabal of evil beings that one early genetic experiment produced. These soulless, materialistic would-be world-conquerors live on Earth for the most part undetected. They literally have no souls.

But the whole metaphor is familiar to anyone who has read the anti-Semitic literature of the earlier decades--including that of William Dudley Pelley and including that of one of Pelley's associates, George Hunt Williamson (a.k.a. "His Royal Highness Michel d'brenovic-Obilic van Lazar, Duke of Sumadija"). Williamson, a self-styled archaeologist and active I AM and Soulcraft member is the real antecedent of Mark Prophet's scenario of extraterrestrial origins. One of Williamson's books, *UFOs Confidential*, was co-written with John McCoy, a vocal anti-Semite who believed Jewish bankers were keeping the UFO mystery from the public. Eventually, in the 1950s, Williamson took a small group of followers to Peru to start an I AM-style commune called the Brotherhood of the Seven Rays.

The Soulless One is unmistakably influenced by Williamson's 1953 work *Other Tongues--Other Flesh*, which describes in detail the various types of extraterrestrials disguised as humans in present-day society. In addition to the spiritually advanced "Wanderers," whose job it is to "purify" the planet, there are the "Intruders"--the "slop and waste" from Orion--who are described as "small in stature with strange, oriental type eyes," "stubborn," "talkative," "parasitic," "materialistic," and deceitful. "Soon," Williamson promises, "they will be eradicated."

Mark Prophet, likewise, writes in *The Soulless One* of the sinister "non-man" that lives among us. This "counterfeit race" killed Jesus and John the Baptist, he asserts, and "today, as always, they occupy positions of authority and financial power," "seek ever to thwart the pure purposes of God," exert "injudicious use of taxation," and "control [the] entertainment media and the trends of youth," etc. etc. etc. Gee, I wonder who they could be?

Elizabeth Prophet was coy with me about who the "soulless ones" among us are today, although she claims that the Earth is a

"crossroads" of visiting and intermarrying extraterrestrials. She turned the discussion to the robotic, slimy bedroom-abductors of the CBS mini-series *Intruders*, but when pressed said that some "soulless ones" live among us in daily life, although they can "earn a divine spark," a soul, in future incarnations through serving God. (This seems disingenuous in light of Slavin's revelation that the C.U.T. teaches that Jews can reincarnate only as Jews because they never learn from their persecutions.)

With talk of aliens and spaceships, we enter the realm of lunacy, some might say. But remember the young widow Elizabeth Prophet's telepathic harassment and her flirtation with Space Brother worship. Note also that a few years ago she hosted a day-long seminar at Royal Teton Ranch with the four most prominent figures in American UFO research: the Emmy-winning documentarist Linda Moulton Howe, the nuclear physicist Stanton T. Friedman, the photographic analyst and sometime C.I.A. consultant Dr. Bruce Maccabee, and the best-selling "alien abduction" investigator Budd Hopkins, author of the book *Intruders* on which the CBS series was based. She's also spoken with Zechariah Sitchin, a philologist, anthropologist, and best-selling author of ancient-astronaut books many of whose theories seem to be borrowed wholesale from Williamson. Slavin says Sitchin's books were practically required reading at the ranch.

Both Friedman and Maccabee have told me that Prophet was alert and no-nonsense in her interviews with them and that she surprised them by asking "all the right questions"--this despite Prophet's telling me in February that she was "not really interested" in UFOs and paid little attention to the subject nowadays beyond her admiration for Sitchin's and her husband's books.

The point is not anything to do with UFOs except that Prophet seems ambivalent about the subject, perhaps because it represents a current of C.U.T. theology which she prefers to keep out of the public eye--a current that is anti-Semitic in tone. The fact that Slavin reports a number of the church members at the ranch in 1990 claimed to have had encounters with UFO aliens at various times in their lives thickens the plot. The C.U.T. is informally connected to several "UFO abductee" support-groups. Jacques Vallee's 1979 book, *Messengers of Deception: UFO Contacts and Cults*, makes a fascinating argument that much of what passes for "alien visitation" may be the result of mind-control by the government or other secret organizations. His book has a section on the I AM movement and related "space brother" movements.

Whither the C.U.T.?

Things have clearly changed a lot for the Church Universal and Triumphant lately. The Cold War has ended, and there is little of the apocalypse about its teachings since the big no-show in 1990. Indeed, it sometimes looks on the face of it as if the talk of Great White Brotherhoods and greedy materialist races is no more than the residue of earlier, less tolerant periods of church history, the sort of history that other groups, like Mormons, also face in their public-relations ups and downs. It could be that the C.U.T. nowadays is all about love and harmony, just as its propaganda claims--although Slavin's accounts and the possible links to neo-fascist organizations, if true, suggest otherwise.

A bigger worry for the C.U.T. today is not nuclear fallout but the fallout from the massacre at the Branch Davidian compound in Waco, Texas. So-called "cults" have not been under such close scrutiny since the Jonestown massacre. The C.U.T. has been

churning out press-releases to convince the public that they are not even a "cult" at all.

Recent issues of the *Royal Teton Ranch News* display a desire to portray the C.U.T. as overwhelmingly normal. All of the photos and articles are of country-music shows, hiking trips, vegetarian cook-outs, and crafts-classes--instead of air-raid shelters, healing rituals, channeling sessions, and alien invasions.

Several comparative-religion scholars and cult-awareness groups have been invited to the Montana ranch to see how "mainstream" things are. And even the Ascended Masters themselves are less uniformly Tibeto-Euro-Aryan than in times past. In a kind of divine affirmative-action program, Prophet now takes dictations from a couple Latin American spirits and even a Black Ascended Master named Afra. In Hyde Park in February a surprising number of African-Americans showed up to hear Gene Vosseler give his "stump lecture," and more and more Black faces are appearing in their promotional literature--although the church has refused to give out figures of its ethnic make-up.

Another recent crisis has been the Internal Revenue Service's sudden revocation of the C.U.T.'s tax-exempt status, citing allegations of money-laundering and weapons offenses. On one level, the church's indignation is understandable: however unorthodox Prophet's teachings are, there is no doubt that the C.U.T. is technically a church--especially while trailer-housed Elvis religions and two-family Bible-clubs around the country get to call themselves churches and round-file their tax-forms.

But the C.U.T. has been silent on the obvious political implications of the I.R.S.'s action. Specifically, if indeed the church was, among other things, a front for anti-Soviet gun-running and a crossroads for rightist hate-groups of all stripes, then perhaps the new administration in the White House has decided to let such groups know that the "new order" is less tolerant of the international shenanigans of the Reagan-Bush era.

(Perhaps what happened in Waco was a more extreme example of such a "clean-up job," considering the flimsy charges and unnecessary force with which David Koresh's compound was first stormed--and considering evidence suggesting that the conflagration that ended the standoff was planned by the Feds. But those speculations are another story.)

The Church Universal and Triumphant may now be in a kind of limbo, eager to shed its fascist past while guarding its very status as a religion from the most left-leaning federal government in nearly half a century. Perhaps Bill Clinton and Janet Reno know more than we do about the clean-up job that needs to be done at the Royal Teton Ranch. Certainly no one has yet gone wrong overestimating the underhandedness and secrecy of the weird American marriage of right-wing politics and religious extremism.

Then again, maybe it's still business as usual at Royal Teton Ranch, with its secret rituals, racism, close social control, and shady political ties. Perhaps there will be another bout of millennialism, and perhaps this time all those guns will be turned on the various groups the C.U.T. has little patience for: leftists, Jews, Russians, pro-choice advocates. And if Prophet dies, her daughter Erin, it is widely believed, is being groomed to take over as Messenger. As the Cold War order crumbles and more former members come forth, we may be learning more about Elizabeth Clare Prophet and the Church Universal and Triumphant.

Saucer Section:

The Kecksberg UFO Mystery:

An Interview Excerpt with Stan Gordon

by G.J. Krupey

With the recent developments in the unraveling of the Roswell cover-up, now would seem to be the time to press for the solution to the many other UFO crash mystery cases, such as the December 1965 Kecksburg incident. While not one of the more high profile UFO cases, it nevertheless remains one of the most intriguing incidents, one which has proven durably controversial, and even divisive, to the community in which it occurred.

What is known of the Kecksburg incident is primarily the work of veteran UFO researcher Stan Gordon, who has been investigating the Kecksburg incident almost since the evening it occurred, not far from his hometown. The following is taken from my soon-to-be published Steamshovel Press Occasional Paper, in which I interviewed Stan and several witnesses. The paper's publication is intended to promote interest in the forthcoming 30th Anniversary of the incident, on December 9, 1995.--GJK

On Thursday, December 9, 1965, at about 4:45 PM EST, a bright, fiery object hurtled across the sky above the Great Lakes, leaving a smoky trail in its wake, until it finally came to ground at Kecksburg, Westmoreland County, in southwestern Pennsylvania, about forty miles southeast of Pittsburgh.

The passage of the fiery aerial object was witnessed by many ground observers in several states, as well as by pilots in flight over Lake Erie. As the object veered southeastward over Pittsburgh, calls reporting sightings of it jammed the phone lines of police, the news media, and the Allegheny County Observatory. Most witnesses thought they were observing a plane going down in flames.

But in Kecksburg, where the object arrived suddenly and made its spectacular landing, the earliest reported eyewitness, a seven year old boy playing outside with his sister, declared that it looked like "a star on fire." The children's mother later described "a column of blue smoke rising through the trees" from the woods about a mile away where the object landed, and another "brilliant object" hanging above the tree line and to the left of the smoke column. She described this second object as resembling a "four-pointed star."

Stan Gordon: There were other witnesses in different parts of the village who independently saw the object go down into the woods, and at that time, they heard no sound, but momentarily after it happened, they saw the dust rise and a blue column of smoke go up, and in a matter of minutes it dissipated.

When they saw this thing coming in, by their descriptions, they were not just seeing a fireball or bright meteor. Some of them had this thing pass very close over their heads: it was slow-moving, it was gliding in...it appears to have been a controlled reentry vehicle of some type....it appears that it was purposely trying not to hit the edge of the ridges, to guide itself around those ridges, and was trying to gain altitude. Apparently, it did not gain enough over the last ridge when it crashed.

Whatever it was that came down, the witnesses tell us this thing did not come in at high speed and crash. And if it came in very slow, almost controlled, almost gliding in, that would account probably for the lack of physical evidence at the site. But several

was slow-moving, it was gliding in...it appears to have been a controlled reentry vehicle of some type....it appears that it was purposely trying not to hit the edge of the ridges, to guide itself around those ridges, and was trying to gain altitude. Apparently, it did not gain enough over the last ridge when it crashed.

Whatever it was that came down, the witnesses tell us this thing did not come in at high speed and crash. And if it came in very slow, almost controlled, almost gliding in, that would account probably for the lack of physical evidence at the site. But several witnesses claim that a number of trees were knocked down at the impact site.

Not long after the crash, members from many local volunteer fire companies were combing the woods, searching for what was still assumed to be a downed airplane. The state police also arrived, to coordinate the search as well as keep order, as radio and TV news reports of the mysterious object, no longer assumed to be a mere airplane, had drawn crowds of curious onlookers to the site for a glimpse of whatever was nestled in the darkened woods. John Murphy, news director of Greensburg radio station WHJB, was probably one of the first people on the scene, arriving even before the authorities. He witnessed the state police fire marshal, accompanied by an unidentified man carrying a Geiger counter descend into the woods. Upon their return sixteen minutes later, the state police fire marshal ordered the woods sealed off.

Murphy knew the fire marshal well, but when he attempted to get information from him as to what he had seen in the woods, he received the reply, "I'm not sure. You better get your information from the army." It was the first indication that Murphy received that there was a military presence at the site.

Murphy phoned the state police barracks at Greensburg, and was informed by the commanding officer there that personnel from the 662nd Radar Squadron, out of the Oakdale Army Support Facility (near what was then the Greater Pittsburgh Airport), were expected to arrive and conduct a briefing. Surprisingly, he invited Murphy to attend.

At the barracks, Murphy found both Army and Air Force personnel present, and was issued an official denial: "The Pennsylvania State Police have made a

thorough investigation of the woods. We are convinced there is nothing whatsoever in the woods." Despite this, the military-state police contingent departed for those woods where "nothing whatsoever" occurred, taking Murphy with them.

Murphy was not the only person to make contact with the military that night. Firemen returning from the search found the Kecksburg fire hall had been commandeered by the military, who brought in radio equipment and set up their headquarters within it. The firemen were expelled, and armed guards posted at each entrance. Most of the firemen were delegated to blocking the roads, preventing spectators from entering the area. Others found themselves conveying "the brass" down to the crash site on their trucks.

Jim Romansky encountered the military presence, and something even more disturbing, that night. At the time a nineteen-year old volunteer fireman, he was among the search group who discovered the mystery object. They were standing about the object in amazement when the first representatives of authority arrived...

Jim Romansky: Two gentlemen came down through the woods; they had overcoats on so you couldn't tell whether they had uniforms on under them or not... One of them did carry a little square box, but at the time I never paid much attention to it.

When they got there, they took one look at the object and they told us that the area was now totally off limits, and was under quarantine, and we must get out of there immediately...So we all started to get out of there, and I know we hadn't gone no more than twenty-five, maybe fifty feet when down from the top of the hill came a whole bunch of military personnel...in uniform, carrying equipment. They passed within five to ten feet of us. Never said a word. They kept going down to the object, and we just kept going out of our area.

By the time we got back down to the fire hall, there was wall-to-wall military everywhere: cars, jeeps, trucks...there was armed guards at the fire hall doors, there was military personnel carrying things in, like radios. But these guys at the door, both of them had rifles...we had no idea whether those weapons were loaded or not, and we weren't about to find out.

Later that night, witnesses saw a military flatbed truck emerge from the woods; lashed on top of it was a large, tarp-shrouded object, its shape described variously as resembling an upside down acorn, a mushroom, or a bullet.

Emblazoned by flashing lights and escorted fore and aft by other military vehicles, the truck barreled away with its booty, impressing onlookers that it would have mown down anything that dared get in its path. Not long after, "word was passed on to the firemen, and circulated among the crowds, that the search operation was over." Then came the explanation: a fallen meteorite, the "nothing whatsoever" that didn't crash into the woods, and that apparently wasn't hauled away under wraps at high speed, either.

Stan Gordon: We know that once the object left Kecksburg, it arrived at Lockbourne Air Force Base in Columbus, Ohio, for a short stay-over. I know this from a former Air Force security officer who was there. It was backed into a hangar; it was under very, very heavy security. And it was there for a while, then it was taken over to Wright-Patterson [AFB].

We don't know what it really was, that's the biggest problem. We can't say it was extraterrestrial or it was man-made. It could still swing either way.

The solution to the Kecksburg mystery remains elusive. Was it a case of the military conducting damage control over some embarrassing snafu, or was it retrieving "foreign technology", possibly Soviet, possibly something even more "foreign", like an extraterrestrial craft? The Kecksburg UFO Mystery: An Interview with Stan Gordon delves into these questions as Stan Gordon shares the results of his decades-long investigation into the incident of December 9, 1965 and its aftermath, while Jim Romansky and other witnesses to the events of that night relate what they saw and experienced. Also explored in the paper is the case of John Murphy, the reporter who arrived early enough on the scene to have possibly discovered the object before the firemen or the authorities. The censorship of Murphy's radio news program "Object in the Woods", and Murphy's own mysterious death years later in California are among the most disturbing aspects of the Kecksburg mystery. The government's continuing cover-up of the incident, and its possible relationship to the bizarre feud that developed among Kecksburg

residents, even among relatives, that was provoked by a TV show on the Kecksburg incident are also examined. The Kecksburg UFO Mystery does not claim to be the definitive treatment on the subject, but hopefully will be an impetus to further revelations.

Virtually Reality:

Oklahoma City, Turn Right

by Jim Keith

James D. Ellison, the founder of the Covenant, the Sword and the Arm of the Lord, was speaking to the prosecuting attorney prior to a 1988 trial in which he testified against 14 other rightist militants accused of attempting to overthrow the government -- a trial which resulted in the acquittal of all the defendants. It was during this discussion that Ellison talked to Steven N. Snyder about a multiple-group meeting which took place at the Aryan Nations' Hayden Lake, Idaho headquarters in July of 1983.

According to Snyder's account of the conversation with Ellison, late night sessions were held at Hayden Lake in which discussions about the overthrow of the government -- or rather, what some term ZOG, the Zionist Occupation Government -- took place. *The Turner Diaries*, a futuristic, rascist, homophobic fiction by Andrew McDonald (nee William Pierce), was discussed as a blueprint by which this might be accomplished. According to Snyder, plans were hatched for the destruction of federal buildings nation-wide, and for the blowing up of the Dallas office of the Jewish Defense League.

According to the *New York Times*, *The Turner Diaries* was Timothy McVeigh's "favorite book," which he "pressed... on friends and acquaintances." (1) A look at the *Turner Diaries* makes one wonder if, in fact, the book was not used as an explicit design for the bombing of the Oklahoma City federal building, and if there is not a larger battle plan of which the Oklahoma City bombing was the first "shot fired":

Relevant quotes from the book follow:

"September 16, 1991. Today it finally began! After all these years of talking -- and nothing but talking -- we have finally taken our first action. We are at war with the System, and it is no longer a war of words..."

"As carefully as we could, we calculated that we should have at least 10,000 pounds of TNT or an equivalent explosive to destroy a substantial portion of the building... Instead, what we have is a little under 5,000 pounds, and nearly all of that is ammonium nitrate fertilizer, which is much less effective than TNT for our purpose..."

"We can wreak havoc in all the offices with windows opening on the courtyard, but we cannot hope to blow away the inner facade of the building or to punch through the sub-basement where the computers are. Several hundred people will be killed, but the machine will probably keep running..."

"October 13, 1991. At 9:15 yesterday morning our bomb went off in the FBI's national headquarters building. Our worries about the relatively small size of the bomb were unfounded; the damage was immense..."

"My day's work started a little before five o'clock yesterday, when I began helping Ed Sanders mix heating oil with the ammonium nitrate fertilizer..."

"Meanwhile, George and Henry were out stealing a truck. With only two-and-a-half tons of explosives, we didn't need a big tractor-trailer rig, so we had decided to grab a delivery truck belonging to an office-supply firm...

"We were still two blocks away when the pavement shuddered violently under our feet. An instant later the blast wave hit us -- a deafening *ka-whoomp*, followed by an enormous roaring, crashing sound, accentuated by the higher- pitched noise of shattering glass all around us...

"We ran the final two blocks and were dismayed to see what, at first glance, appeared to be an entirely intact FBI headquarters -- except, of course, that most of the windows were missing... Dense, choking smoke was pouring from the ramp leading to the basement...

"Dozens of people were scurrying around the freight entrance to the central courtyard, some going in and some coming out. Many were bleeding profusely from cuts, and all had expressions of shock or dazed disbelief on their faces..." [2]

Evidence linking Timothy McVeigh and the bombing that actually took place at Oklahoma City with the group that met at Hayden Lake, Idaho is extensive, factual, and discussed almost not at all in the mainstream media. Ellison's CSA had "built a relationship" with Reverend Robert Millar of Elohim City, an Adair, Okalahoma Christian Identity conclave with about 100 members, along with other rightist groups such as the Silent Brotherhood of Robert Matthews. [3] Reverend Millar visited the Aryan Nations community, knows James Ellison, and was in close touch with Richard Wayne Snell, who apparently had advance information that the Oklahoma City bombing was about to take place. [4] Ellison, released from parole on April 20, 1995, coincidentally or not the day after the bombing, was last seen that day in Jasper, Florida, in the company of two women, driving a car with Oklahoma license plates. [5]

According to Snyder, James Ellison stated, "on one of the trips when I was with Wayne [CSA member Richard Wayne Snell], he took me to some of the buildings and asked me to go in the building and check the building out. That kind of thing." Snyder says that Ellison had told him that at the request of Snell he had gone into the federal building in Oklahoma to see what it would take to destroy the building.

Snell bore a grudge against persons in the Oklahoma Federal Building, according to Snyder. "Ellison said that Snell was bitter toward the government because of the IRS, and I think these were agents from the Oklahoma City office, and they had taken him to court, and his property had been seized by the FBI and other agents in a raid." [6]

Snell allegedly took part in a number of illegal activities in tandem with other individuals in the Aryan Nations/CSA/Silent Brotherhood orbit. He and CSA elder William Thomas are said to have bombed a natural gas pipeline near Fulton, Arkansas on November 2, 1983. They mistakenly believed that the pipeline was a major conduit from Gulf of Mexico gas fields to Chicago. Later in the same month they attempted to bomb a major electrical transmission line.

On November 11, 1983 Snell, Thomas, and CSA member Steve Scott held up a pawnshop in Texarkana, Arkansas. It is alleged that Snell, believing the owner of the shop, William Stumpp, to be Jewish, murdered him by pistol shot. Snell, according to published reports, was mistaken.

On June 30, 1984, Snell was stopped -- apparently in a routine traffic stop -- by a

State Trooper outside De Queen, Arkansas. Snell emerged from the car -- in the manner that one might reasonably expect Timothy McVeigh to have done in Perry, Oklahoma -- and shot the trooper dead. Later that day Snell was captured in Broken Bow, Oklahoma, and a gun was found in his car which is alleged to have been the one used in the murder of William Stumpp. I find it quite curious that Snell would have held on to this incriminating weapon, a fact which lends credence to Snell's protestations of being framed by the police. After his capture, Snell is alleged to have maintained that, like McVeigh, he was a "prisoner of war." (7)

Snell's defense of the killing of the state trooper was that, "we were justified in doing so, as we feared for our life, and self-defense is an inalienable right. Right?... Needless to say, I failed to convince the jury and was convicted of Capital Murder. This successfully made this writer a victim, as you will see. Not dead -- yet. Just live in a Tomb.

"Never have we felt animosity toward those men and women who sat in judgment. They were un-informed and too naive to relate to the evil described. (Calling one "naïve" is not derogatory, as it is one of the traits of honest people.). Time does pass, people do learn, and in light of what has transpired the past decade, I would be happy to have these same people sit in judgment again. This time I feel they would relate to evidence presented and return a verdict of 'Not Guilty.'" (8)

More information substantiating the possible Hayden Lake/Snell connection to the Oklahoma bombing were statements such as the following, in Taking Aim, the Militia of Montana newsletter, pointing out the significance of the April 19th date:

"If this date does not ring a bell for you, then maybe this will jog your memory: 1. April 19, 1775: Lexington burned; 2. April 19, 1943: Warsaw burned; 3. April 19, 1992: The fed's attempted to raid Randy Weaver, but had their plans thwarted when concerned citizens arrived on the scene with supplies for the Weaver family totally unaware of what was to take place; 4. April 19, 1993: The Branch Davidians burned; 5. April 19, 1995: [convicted murderer] Richard Snell will be executed -- unless we act now!" (9)

Clinton crony Governor Jim Guy Tucker of Arkansas determined the date of Snell's execution on March 9, 1995, and Snell was put to death by lethal injection on April 19, 1995, the day of the Oklahoma City bombing. The patriarch of Elohim City, Reverend Robert Millar, was with Snell for the last three hours prior to his execution, observed the execution, and brought Snell's body back to Elohim City to be buried there.

Although Reverend Millar denies ever meeting Timothy McVeigh, the accused bomber knew of Elohim City and, according to sources in the government quoted by the *New York Times*, may have visited the compound. (10) Although no other record of a visit by McVeigh to Elohim City has been located, he was stopped for a traffic violation about 20 miles from the compound and, according to federal officials, telephone records show that McVeigh called Elohim City on April 16, as well as four minutes after reserving the Ryder truck allegedly employed in the bombing. It is not plain to me how officials know that it was McVeigh made the telephone call. Was the Ryder truck agency under surveillance at the time of the renting of the truck? Certainly, a convenient phone call to Elohim City would be perfect if someone was attempting to link McVeigh to the radical right, while phoning collaborators or even allies would seemingly be the last thing that one would do if intent on the commission of the crime. (11)

Based upon statements that Snell made to jailors and fellow prisoners, he apparently knew about the bombing planned for Oklahoma City prior to it happening. Alan Ables, a spokesman for the Arkansas Department of Corrections, says that Snell repeatedly told prison guards as well as Reverend Millar about a bombing that was going to take place. "He said there was going to be a huge bombing, and not much more than that," Ables has stated. "He didn't give any impression that it would be a domestic bombing or something overseas. Just that there would be some confusion as to who did it and the United States was going to blame someone in the Mideast." Ables also said that, "He commented at least once (in his last week) that he wished he wasn't leaving; he'd like to stick around a few more weeks because he wanted to watch what was going to happen" in regards the bombing. Guards observed that Snell was "smiling and chuckling" as he viewed news about the Oklahoma City bombing on the day of his execution. (12)

Snell's last words are said to have been, "Governor Tucker, look over your shoulder. Justice is on the way. I wouldn't trade places with you or any of your political cronies. Hell has victory. I am at peace." (13)

The Silent Brotherhood, a group closely connected with the CSA and some of whose members were present at Hayden Lake in 1983, was infiltrated by FBI informant Thomas Martinez, who later testified against members of the group.

There were rumors within the Aryan Nations and associated groups that Bob Matthews, the leader of the Silent Brotherhood, was an agent provocateur for the FBI. Those rumors have never been substantiated, although it is known that Matthews did have a cousin who worked for the FBI in Washington. (14)

It is suspicious that the "second in command" in the Covenant, the Sword and the Arm of the Lord, Terry Noble served only a two-year sentence. According to the Miami Herald, "After getting busted, he underwent profound changes in attitude, renouncing extremism and cooperating with his prosecutors." But the most remarkable thing is that after his release from prison, Noble was hired by the FBI -- reportedly as a negotiator with right wing groups. (15)

Members of the Silent Brotherhood are reported to be living in southern Missouri, on a 160-acre parcel purchased with funds stolen by armored car robberies. Although the physical location of the camp is suggestive, it is not known whether Terry Nichols or Timothy McVeigh were in contact with members of the group. (16)

Untangling intentions and plans whose effects spread out from the Hayden Lake, Idaho meeting is complicated and speculative, but the above facts show that Timothy McVeigh was moved by currents that originated there, and possibly collaborated with their creators -- through discussion or more -- in the commission of the bombing. So, the answer is perfectly apparent. It was a group of right-wing radicals who were responsible for the bombing of the federal building -- and they may have had controllers in the FBI.

If only the answer was so simple.

NOTES:

1. Kifner, John. "Prosecutors say Oklahoma bomb plot was limited to a few bitter ex-GIs," *New York Times* Service, August 7, 1995.

2. McDonald, Andrew (William Pierce). *The Turner Diaries*, National Vanguard Books, Hillsboro, West Virginia, 1993.

3. Flynn, Kevin, and Gerhardt, Gary. *The Silent Brotherhood*, The Free Press, New York, New York, 1989.

4. Potok, Mark. "Group denies any role in blast," *USA Today*, May 25, 1995 5: Thomas, Jo, and Smothers, Ronald. "Oklahoma City Building Was Target Of Plot as Early as '83, Official Says", *New York Times*, May 20, 1995.

6. "Oklahoma City had been target of previous bomb plot," *New York Times* News Service, May 21, 1995.

7. Flynn, Kevin, and Gerhardt, Gary. *The Silent Brotherhood*, The Free Press, New York, New York, 1989; Thomas, Jo, and Smothers, Ronald. "Oklahoma City Building Was Target Of Plot as Early as '83, Official Says", *New York Times*, May 20, 1995.

8. Snell, Richard Wayne. "The Seekers," undated reprint of newsletter in author's possession.

9. Thomas, Jo, and Smothers, Ronald. "Oklahoma City Building Was Target Of Plot as Early as '83, Official Says", *New York Times*, May 20, 1995.

10. Weinraub, Bernard. "Leader of sect denies having ties to McVeigh," *New York Times* News Service, May 25, 1995.

11. Potok, Mark. "Group denies any role in blast," *USA Today*, May 25, 1995.

12. "Prisoner predicted big blast," *Detroit News*, July 2, 1995.

13. "State Police On Alert," *Corrections Digest*, April 28, 1995.

14. Flynn, Kevin, and Gerhardt, Gary. *The Silent Brotherhood*, The Free Press, New York, New York, 1989.

15. "New guy in the FBI: an ex-extremist," *Miami Herald*, August 7, 1995.

16. Coates, James. *Armed and Dangerous, the Rise of the Survivalist Right*, Hill and Wang, New York, New York 1987.

The MADE Manifesto
by Roy Lisker

Although it has apparently received very little attention from any of the popular, grass-roots or establishment political organizations working in the civil rights arena, discrimination on the basis of education is one of the major civil rights issues of our time. It is a blatant form of discrimination lying at the root of much economic in justice in this society. Directly or indirectly, it constitutes an enormous social evil that affects us all.

Historically the strategies of the traditional civil rights organizations in this country have been directed to obtaining either: (i) Improving the schools of their political constituencies; (ii) Getting their constituencies into other schools: the bussing experiments, the Equal Opportunity programs, Affirmative Action, etc.

It is perhaps owing to the fact that so much energy is being concentrated in this direction that no one pays much attention to an issue of equal, and potentially even greater, importance:

The right of individuals without BAs, MAs, or PhDs, or even an official high school education, to compete on equal terms with persons who have these degrees, on the basis of their qualifications, experiences, knowledge, ability and job record alone.

Consider these items:

1. The laws permit any enterprise to place the demand for a BA, a Master's Degree or even a PhD at the top of the list of qualifications for many if not all of its jobs, before the consideration of any other qualification. This is an outrageous violation of civil rights, at about the same level as that of refusing work to persons because of their skin color, gender, nationality, age, etc. I am only amazed that this point is rarely raised in the public arena.

2. This is overwhelmingly the case for jobs within the school system or the academic world: schools are free to demand certificates at whatever levels they wish even before interviewing a teaching candidate. Mozart himself, who received all of his training from his father, would today be required to produce a PhD in music to teach composition in our colleges. One might raise the objection that this example is so elitist that it represents only a tiny fraction of the group of persons looking for jobs in education.

I therefore provide an example which has real significance to our own times: the art of jazz music was developed in the early part of this century by poor musicians working in night clubs and brothels in New Orleans. their creative energy and imagination gave us an indigenous artistic medium that, for the first time in history (even though music is in some sense a universal language) is listened to and appreciated by most of the human race. Yet persons who teach music in the schools, whether jazz or classical, must have degrees that the persons who created jazz could never have hoped to obtain. Most musicians would concur with my opinion that the "jazz studies" offered in most colleges and universities have very little to do with the living art form.

3. One finds people everywhere who possess an exceptional competence for many different kinds of work, including teaching, the arts, medical skills, scientific knowledge, indeed just about any kind of skilled profession. Without even a murmur of protest, many of these have given up the search for the positions for which they are qualified, merely because they don't have, can't get, or for reasons of pride refuse to stoop to the indignity of, getting a certificate from a certification system for which they rightly feel contempt.

4. At the same time there are many so called unskilled trades, such as house-painting, carpentry, fruit-picking, even lawn-mowing, that require knowledge, experience and intelligence, yet the people who work at them, and do a very good job, are disparaged because no college or university has told the world that their unique skill is a form of higher knowledge. Perhaps we ought to be grateful for this much: for if the day comes that even an "unskilled laborer" needs a degree to get a job, we will all be in trouble!

5. Anyone claiming to have these "higher" forms of knowledge, but doesn't have an appropriate degree from an accredited university to back up such claims, is generally assumed to be a fraud. Yet the truth is that a disturbingly large percentage of persons with the right degrees are incompetent within their professions. In certain occupations persons without the degrees may often be even more competent, because the time and energy they invested in the invention and development of their abilities gave them insights into dealing with problems that were not learned by persons hitting the textbooks in the schools.

This is a serious civil rights issue. It is manifestly illegitimate that the government uphold and protect the existence of a mandarinate in any democracy.

If a mass movement where to be organized around these issues, the following things would happen:

1. Thousands of people who have believed up to now that they had no hope of finding work compatible with their abilities, would start militating, organizing, participating in marches and demonstrations, setting up test cases in the courts, committing civil disobedience and going to jail.

2. The liberal academics, proud of themselves as "champions of civilization", would bare their fangs, showing themselves to the whole world as exactly what they are: benefactors of an obscene structure of privilege, status and caste. Many of these venerated teachers are nothing more than mediocre functionaries, and it is they who will stoop to any baseness to protect the lies that keep them respectable, secure and pensionable. However there are also many idealists among them, who will lend support, even going so far as to quit the system, although this might turn them into social pariahs until the movement achieves its goals.

And the movement must triumph.

There are at least four reasons for my saying this; others can no doubt add several more:

1. The pragmatic business world only really wants dependable performance, and has little time for rubbish about credentials. If enough persons without credentials are given the chance to show that they can perform better than those who have them, the corporations will throw their weight behind the movement against discrimination by education.

2. Once the minorities, of which the United States citizens descended from the victims of the African slave trade are the best organized, realize that they have been misdirecting their energies towards getting degrees, rather than developing their natural abilities and gifts based on their unique experience, they will re-structure their movements to incorporate these same demands. other ethnic groups, people without enough money, women, the elderly, all kinds of people who for a host of reasons could not afford or did not have the time to waste getting an "official" education, will militate to have their work qualifications recognized on their merits, on the basis of their resume and experience.

Indeed, the entire civil rights movement would incorporate these issues into the list of its basic demands.

3. At a certain point the Movement Against Discrimination in Education would attract the attention of the media. Experienced editors and reporters have always been annoyed by these green, self-satisfied college graduates who arrive at their doorsteps with their freshly minted PhDs in Journalism, or Communications Science, or Media Technology, but who don't know a thing about the problems involved in covering real news. the newspapers and media organs will start slanting their reporting - using the crude, obnoxious methods for which they are known (!) - in favor of the activities of M.A.D.E. and against the academies.

4. Even the schools would eventually see that it is to their benefit to develop a kind of education that can stand on its own merits, rather than pandering to the arrantly undemocratic, unconstitutional worship of an official scrap of parchment.

Roy Lisker, M.A.D.E., #8 Liberty Street #306, Middletown, CT 06457.

rlisker@yahoo.com

Caries, Cabals and Correspondence
Letters From Readers

Send all correspondence to: Steamshovel Press, POB 210553, St. Louis, MO 63121. Steamshovel *encourages writers to submit letters in electronic form, preferably in IBM ASCHII, but all formats are welcome.*

Allow me to quote you just a small sample of the sage-like wisdom of Mr. Glenn Campbell:

"I think that Las Vegas should be destroyed with nuclear weapons..." --*Groom Lake Desert Rat Newsletter*

"I apologize...for saying that Las Vegas should be destroyed with nuclear weapons...I now think that New York City should be nuked..."--*Groom Lake Desert Rat Newsletter*

Campbell: "I came out here [to Rachel, Nevada] because I saw the video of the base (Groom Lake) shot by Sean Morton, and he guaranteed people that we could see UFOs out here any day of the week..."

Morton: "Glenn, you just got out here a day late and a dollar short. Most of the UFO stuff got moved when the public attention heated up in late '93. I stopped coming out cause there was just nothing to see!"

Campbell: "Yeah...Well I've been in the same valley at the same time when Sean saw UFOs and I didn't."

Morton: "That's not true..."
--Exchange on the *Montel Williams Show*

"I don't see how UFOs could possibly fly when they don't even have wings."--Glenn Campbell on the *Larry King Show*

As a long time fan and subscriber to *Steamshovel Press*, I was disappointed to see an interview with this rather sad, lonely individual ("A Lineman For Lincoln County," *SP12*). I mean if you wanted the "Party Line" that nothing more was going on at Area 51 other than secret aircraft testing, or the burning of toxic materials, you should have just talked to the PR officer at Nellis AFB, or picked up the Establishment's technology tabloid, *Popular Science*.

Steamshovel is exciting for giving vent to the other side of the story, and as a leader in Conspiratorial Theory you should have asked questions like, "Why is this man here?", "Where does he come from?", "What purpose does he serve?", "What exactly is his message?", "Why, in a town used to eccentrics, does the entire population want him tarred and feathered?" "Does the agent provocateur premise apply here?"

I first met Glenn Campbell when he had just blown into town at Rachel, Nevada's "Little A'Le'Inn". He bought me lunch and I cordially answered his questions about what I felt was going on at the Area 51 facility. We got out maps and I patiently showed him the military boundaries, the viewing area of the base which I had discovered in May of 1992, and the mountain top which he now calls "Freedom Ridge", and has become the obsessive focal point of his life. I did what I could and would do for anyone, with a genuine curiosity about this mystery.

It's a fact that in the media of 999 people see something and one blind man doesn't, the blind man will get just as much coverage, and his word will carry as much weight as the 999. Maybe Campbell felt that this was the best strategy to leech onto his fleeting 15 minutes of fame. There has yet to be a camera out there that he hasn't thrown himself in front of! Feeling he could make a quick buck by knocking down people who had done research and taken the risks so he and his cronies could peer down the base from picnic tables and deck chairs, he went on to call me a "moron" in his self-published

Area 51 Viewers Guide. Everybody that went out to the sight with me he described as my "mindless minions", which I assume would include Kenn Thomas.

Joe and Pat Travis, the owners of the Rachel bar, also made the mistake of befriending this man who has never repaid money he has borrowed from them and who he has gone on to call "yokels", "hicks" and "fools."

If this was just about a difference of opinion, Hey! I love a good debate! But

Campbell's twisted psyche, or should I call him "The Glenn Campbell", as he always refers to himself in his newsletter, like some megalomaniac all star wrestler, or as "the PSYCHO spy", but Campbell says that I am "...his arch nemesis! The embodiment of evil" and I am always at the top of his "Death List". I ride in esteemed company.

Others he call "truly evil" are Bob Lazar, Gene Huff, George Knapp, John Lear, Gary Schultz, Norio Hawakawa, Anthony Hilder, Bill Cooper, Joe and Pat Travis including all who live in Rachel)...in fact,

everyone who believes that there might be some extraterrestrial origin to what was going on at the Groom test site he feels are "the evil spawn of Satan" and have made his "Hate List" of enemies. This is a well adjusted individual? He counts among his heroes and friends such debunking cranks as Philip Klass and Russ Estes.

There is an old Irish saying that goes: "To be cursed by the devils is a blessing indeed!" So I find myself truly sainted.

I laughed out loud when I read his quote: "...I'm looking for things that are alien that are probably beyond our current knowledge, that doesn't mean you can abandon the scientific method." Who-ha! That's a good one! He constantly ignores and conveniently avoids hundreds of eye-witness testimonies and video tapes that don't fit into his incessant "it's just the military" bleating.

He continues to call me a liar when my sightings have been backed up by video taped proof and similar eyewitness accounts. Maybe he forgets that on the self same tape he claims to have seen on the *Montel Williams Show* I showed that the much ballyhooed "Old Faithful", which appears every morning in the sky at 4:50 AM was merely some kind of landing plane...but on many other occasions it wasn't and jumped wildly back and forth, witnessed by myself and others and filmed by Norio Hayakawa.

It was also on this same show, thanks to my direction and urging of the producers, that they received a letter back from the military admitting for the first time that the Groom Lake facility did in fact exist. This should help Glenn in his upcoming court case. (You're welcome!)

Campbell says that I would "...charge $99 and point to the landing lights of commuter jets and call them saucers..." This is patently absurd! I thank you Kenn for defending me. You at least have been out there with me, whereas Campbell has not. I

live by the LA airport so I should know the difference between UFOs and landing lights! Everyone in my groups carry high-powered binoculars, and far from being my "mindless minions" I think they could judge for themselves what was what.

I started taking the tours because so many people insisted on going. The $99 paid for a van (at $160 a day and .39 cents a mile), gas, firewood, equipment and meals. I limited the groups to eight, and took them on a 14 mile hike up and back to the peak to look down on the base and then dealt with the sheriff when we got down. You can't even take a bus to Vegas from LA round trip for less than that. Suffice it to say I didn't break even, and I stopped going for one reason...by late 1993 we simply weren't seeing anything, and my excellent sources told me that everything had been moved to Tucson and Maryland.

It is also ironic to have Campbell accuse me of profiteering from Area 51 by taking tours there, while he has now based his entire livelihood and income on doing the same thing with his tours and catalog and newsletter and patches, ad nauseam! Somebody is paying for his smear spot on the Internet!

It was all very exciting while it lasted, but unlike the individual you cover in your piece...I have a life.

Please remember that until I let the cat out of the bag about the location of the peak that looked own on the facility, I was one of a handful of people who had actually seen the base without having worked there. So when I spoke with men who claimed to be scientists, or workers or guards, all of whom confirmed some kind of alien presence or backing of the technology going on there, all I had to do was ask them to tell me what the base looked like and how it was laid out to test their veracity, because I had the place on film.

So Glenn Campbell can go on calling me a liar and fake or "evil" if it suits his peculiar neurosis to knock down everybody who took the risks and did the work long before this person came along to base his life on and live in the shadow of the deeds of others, whom he gives no credit or due. He can even go on claiming that he "shooed me away" from going out to the test site, but I stopped going when there was nothing left to see...which is just about when Glenn showed up to trumpet, against all available evidence, that there had never been anything there at all. So next time you see him in print or grumbling on some TV show somewhere, just think about a crazy little man who shows up at the barn with the doors wide open and the cows all gone, squealing at the top of his lungs that he has been tricked...and that because he hasn't seen any, bovines must not exist.

Thanks for your time, and keep up the excellent work!

Peace!
Sean Morton
c/o 2629 Manhattan Avenue, Suite #210
Hermosa Beach, California Republic

There is nothing *new* about the "New World Order"! They are "The International Bar-Lawyers" of London, England, via the American Lawyer-Bar of Chicago, Illinois, via each of its fifty subordinate State Bar-Lawyer groups, via their local individual members holding "Title of Nobility", "Lawyer" and a "member number" which they lie and refer to as a "License" (which it is not). Not all "lawyers" belong to the "association", but they are "admitted".

They have "taken over" each and every government, and political party, local, state, Federal, and National (all branches of it) the world over. Throughout all human recorded history, throughout all Wars, regardless who Won or Lost, or which real

estate changed hands, or what "type" of government (Kingdom, Democracy, Republic, Socialist Soviet Communist, etc.), the People "think" they lived under, the Lawyers controlled the "courts" with their "code" language, under "presumption" that everyone in the world is a "subject" to their Code, and "Debtor" to their (behind the scenes) Master- -the "World Money Renters" (Morgan, Rothschild, Mellon, Rockefeller, Loeb, Warburg, Bilderberg, Krupp, etc.) [they meet every six months at a Castle in Switzerland, and decide where the next "War" will be so they can make profit while the Christians (and other non zionists) exterminate themselves].

They control all political groups (Parties) and candidates through these "Lawyers", so it matters not which candidate "Wins" the "rigged" elections. The World over.

David S. DeRiemer
Delaware, Not Lawyer-Feudalism possession
DE

Re: Prouty's identification of Edward Lansdale ("JFK Redux: Can Anyone Verify Fletcher Prouty's ID of Lansdale and Conein in Dealey Plaza?" by Jack White, *SP11*) and the picture of his ear: Alfred V. Iannarelli, *The Iannarelli System of Ear Identification* (New York: The Foundation Press, 1964).

Robin Ramsay
Lobster
UK

Steamshovel Debris: *Steamshovel Press* has been unable to locate this book and asks the readers for help.

A recent issue of your publication carried an article titled "A Newly Declassified Document on Wilhelm Reich."

Please be advised that in an article of mine, titled "Reich and the INS: A Specific Plague Reaction" published in the *Journal of Orgonomy* of November 1983 (Vol. 17, No. 2) this document is mentioned and extensively quoted from. Thus your introductory statement about recent "declassification procedure that led to this new look at a day in Reich's career" is erroneous and misinformed. I trust that in the interest of truth and accuracy you will acknowledge this error in a future issue of your publication.

I would greatly appreciate receiving a copy of any such acknowledgement and rectification that may appear in *Steamshovel Press*.

Maybe I managed to get the document in question while it was still classified because I actually went down to the INS building in New York City and spent hours going through the files on Reich, and perhaps they released this document to me without realizing that it hadn't been declassified.

A new, enlarged edition of my book on Reich's legal troubles (*Steamshovel* Debris: the classic, *Wilhelm Reich Vs. The USA*) won't - alas! - be coming out in the U.S., but it will be coming out in several European countries. It will be issued in Germany by Zweitausendeins Press (Postfach 1326 D-24319 Lutjenburg, Germany). This outfit is issuing a number of Reich's seminal books at the same time as mine will be coming out. It was supposed to have been in February, but they didn't like the translation, so they had to do it over and it should be coming out any day now. I have no idea what the price would be...Maybe by this time the books by Reich have already been issued.

Cordially,

Jerome Greenfield
Associate Professor of English

The College At New Paltz
New Paltz, NY

I recently picked up my first issue of *Steamshovel Press*, #12. Wow! I've always been attracted by fringe mags--mostly left, an occasional right, for balance. *SP* blew my mind! I read it cover-to-cover, including ads.

Perhaps the most profound thing I read in *SP12* was in the first article, "Conspiracy Phobia," by Michael Parenti: "Those who suffer from conspiracy phobia are fond of saying: 'Do you actually think there's a group of people sitting around in a room plotting things?'" How many times have I said those exact words, discussing history, current events and the future with my partner?!! Too many, I'm ashamed to admit. I'm also not proud of the fact that I had never heard of the Gemstone Files prior to reading *SP12*, and I'm still not sure I know what they are. I found the detailed scientific analysis of the Shroud of Turin somewhat confounding as well. Who cares? It was still fascinating, absorbing.

My mind is opening up but my brains remain intact--for now.

Kate Hickman
Indianapolis, IN

Being aware of the general flavor of *Steamshovel Press*, I was pleased that your review of my book, *Pictures of the Pain: Photography and the Assassination of President Kennedy*, was as generous as it was. I do, however, want to comment upon one of your criticisms which I do find wanting.

Your comment about my "...weird mix of brilliant technical detail and lousy assassination history..." as exemplified by the so-called "Wink" photo is stretching your point. It is true that I have heard of this frame from the Johnson swearing-in sequence as being referred to by some as a dastardly sign- what with Representative Albert Thomas winking in apparent dark conspiracy at the new President. I've wondered if these same people also interpret Mrs. Johnson's smile and Mrs. Kennedy's not sad look as seen in this frame to also include them in on the conspiracy.

The reviewer might see onerous implications in the content of this photo, but contrary to the review's statement, David Lifton did not directly or indirectly make anything of this particular picture in the text of his book, *Best Evidence*, Thomas is not even included in the index. A mention is made only within the caption to six of the swearing-in photos reproduced in the book. The caption neutrally states in part: "Then Johnson turns to his wife, looks up, and gets a wink and a smile from Congressman Thomas."

Sometimes a wink is just a wink! It can just as easily be interpreted as a making of contact with another as a gesture of good luck, or as a sign of empathy, or other such non-conspiracy possibility. I suspect, but can not prove, that someone saw in this negative what they thought might be construed by others as an inappropriate gesture given the morbid nature of the circumstances surrounding the swearing-in, and an attempt was made to get rid of the negative. Prints however obviously do exist of this negative as is readily seen on your most recent magazine cover. It should also be noted that another non-controversial negative from the swearing-in sequence, this made with the Hasselblad camera, is also missing.

To so prominently note this so-called controversial negative as a weakness in my text actually gives me satisfaction that my text is indeed strong on the more critical areas covered.

Also contrary to what was mentioned in the review, I do indeed cover Jim Murray as well as William Allen in the text as regards if

they saw any projectiles on the grass infield area. they both answered in the negative.

Thank you for your review of my book. I appreciate your efforts.

Richard Trask
Danvers, MA

I do take serious issue with your suggestion that "the book (*Final Judgement: The Missing Link in the JFK Assassination Conspiracy*, reviewed in *SP11*) cannot be read, however, without trying to identify the fine line between of an anti-Israel/anti-Zionist critique with old-fashioned anti-Semitism." I really don't know where you get off saying that.

I hasten to point out that of my three major sources on the conflict between JFK and Israel, two of them--Stephen Green and Seymour Hersh--happen to be Jewish. That fact doesn't matter to me, but it may mean something to those who are worried about "anti-Semitism." Both of these chaps are confirmed "liberals." Likewise with my third source, Andrew Cockburn. No raving "Nazi," I'm sure you'll agree.

Frankly, I was very careful not to cite any "anti-Semitic" sources (nor, for that matter, did I rely on any such sources) in writing the book. What's more, for the information of those who have not read the book, I have never suggested that is utter nonsense and I do believe that this was implied in your review. I will not waste my breath denying that I am anti-Semitic since no matter how much I deny it, it will only make me appear so.

For your information both Mark lane (yes, that Mark Lane) and Alfred Lilienthal, the noted critic of Israel (and yes, they're both Jewish) read the book prior to publication. Neither found it "anti-Semitic."

Which brings me to my other point: when will *SP* publish my critique of Dave Emory's "the Nazis killed JFK" nonsense in the context of my allegation that, quite the contrary, it was the Israeli Mossad which was responsible?

I hate to spoil the party, but Permindex (of which Clay Shaw was a board member) was not a "Nazi front" but an Israeli front with multiple links to the Mossad and the Meyer Lansky Crime Syndicate. And that ain't Nazi.

Is *SP* afraid of any conspiracy that smells of the Mossad? I thought you guys had some guts or is it simply a matter of keeping newsstand distribution (which I certainly understand)?

And, oh, by the way, did you know that Oliver Stone's chief financial backer for *JFK* was Arnon Milchan, described by Alexander Cockburn in *The Nation* as "Israel's biggest arms dealer." (Whoops!) That ought to give you conspiracy nuts something to chew on.

Michael Collins Piper
Washington, DC

My friend turned me onto *Steamshovel Press* a bit more than a year ago, and I was very impressed, and also filled up with bile from this country's murderous mischief and false tomfoolery, the kind that makes folks dead.

Untrustingly,

Chris Koestner
Levittown, NY

Steamshovel Debris: Check out Charles Koestner's zine *T.S.F. (This Space For) Rant*, 38 Peacock Lane, Levittown, NY 11756. Sample issue: $2.

Book Reviews

Bases Of Suspicion

The Dulce Papers by Christa Tilton, available from Crux Publications, 2163 S. 78th East Avenue, Tulsa, OK, 74129-2421. $22.

Does the tiny township of Dulce, New Mexico, harbor a secret underground base controlled by hostile extraterrestrials? And should grown-ups spend $22 on a compilation volume devoted to this topic?

My answers to those questions would be, in order, "probably not" and "yes." Note, though, that Christa Tilton's new book, *The Dulce Papers*, is not for all. It's not even a book, really. Tilton has produced a fairly thick piece of spiral-bound samizdat, a fittingly "underground" publication chock full of fascinating reprints, rare documents, and accounts of on-site investigations.

The author has herself garnered some notoriety as a UFO abductee with a twist: She asserts that her captors included both aliens and military personnel, who whisked her on a tour of an underground facility (possibly the one under discussion here) during a period of missing time. This claim, along with her two unwise marriages within the UFO community, have made her quite a controversial figure. An admission: I know Christa well, and thus can scarcely proclaim myself an objective analyst of either her assertions or her writings. (Then again, objectivity isn't everything. Was Boswell objective about Johnson?)

Despite this possible bias, I still feel that I can fairly recommend her latest volume to specialists -- specifically, to those ufologists intent on hunting down the "Dulce base" rumor, one of the most celebrated and eccentric tales ever heard within saucerdom. Even skeptics may want to peruse this file on what they would consider a fringe fable, if only because of the documentation provided. Tilton's scrapbook is your one-stop-shopping resource on northern New Mexican weirdness.

Be warned, though: No-one has ever described Christa as America's most masterful prose stylist, and her organization of materials may bewilder. She doesn't inform the reader that a number of these pages earlier saw print in her irregularly-published newsletter, "Crux." Certain texts would have been more easily comprehensible if we knew the original publication date. And you may need a second reading to re-arrange the narrative in a linear order.

That's too bad, because Christa performs her best service when she gives patient readers the data necessary to trace the growth of the Dulce tale over time. The story remains widely misunderstood because many don't know its history. Those who first heard the rumors back in the late 1980s must have felt as though they had walked into a complex film noir 45 minutes after the show started.

Most UFO aficionados learned of Dulce in 1987, when John Lear publicized his famous (some would say *infamous*) "John Lear Hypothesis." At that time, a number of wild-eyed, Lear-ing saucer buffs anxiously circulated photocopies of the Dulce sketches -- ten pages of simple line drawings depicting underground chambers, aliens, odd genetic experiments, incomprehensible devices, and so forth. These drawings allegedly were adapted from photographs and videotapes smuggled out of the hidden facility -- located beneath the Jicarilla Indian reservation -- where humans and aliens work together, conducting ghastly experiments. This sub-surface alliance is the real reason for the UFO sightings and cattle mutilations which have long plagued the area.

Or so we were told by Lear, and by the anonymous artist who compiled the Dulce

illustrations. Alas, no one has ever proven that these drawings represent anything more than ink on paper. The actual photos and videos have never come to light (except for one still photograph, which may in fact depict any laboratory anywhere). The putative smuggler of this photographic evidence was a former Dulce guard known only as "Thomas C." who has never gone public and may not exist. (More on the "C." sub-mystery later.) Just to make things even more complicated: The hyper-ballyhooed Dulce drawings are in fact "cleaned up" versions of the original (much rougher) sketches, which saw far more limited distribution. Christa publishes, for the first time, both sets.

In any variant, these unverified sketches – "notes from the underground," as it were -- provide slim evidence for such a wild tale. Yet these drawings, and Lear's confident pronouncements, inspired scores (perhaps hundreds) of ET-spotters to make the pilgrimage to Dulce, in search of hidden entrances to the wonders and horrors below. Naturally, these seekers have somewhat annoyed the local Jicarilla Apache police. Most base-buffs have zeroed in on Archuleta Mesa, to the north of town. Despite years of searches, nobody has ever found anything truly odd in this area. Christa avers that the Archuleta Mesa reports are misleading -- that to find the heart of Dulce darkness, you have to look elsewhere.

And earlier.

* * *

The story really began in 1967, when the U.S. Atomic Energy Commission set off nuclear blasts south of Dulce, in order to set free repositories of natural gas. Alas, the gas became too radioactive to be of any use, which is why Uncle Sam doesn't do that sort of thing anymore. (Lord knows how much of this natural resource was contaminated, or how much of the truth about this debacle remains untold.) More than a decade later, the U.S. Department of Energy continued to find tritium in the water table. The DOE insists that the presence of this radioactive substance in drinking water has never posed a health problem. Needless to say, everyone considers these assurances very comforting.

Much less comforting were the spate of bizarre cattle mutilations which plagued this area throughout the 1970s. A local rancher named Manuel Gomez was hit particularly hard. Of course, attacks also occurred (and still occur) in other states – "mutes" became the chic oddity of the '70s, achieving much the same status as crop circles in the '80s. But if this widespread phenomenon had a home, it was in northern NM; as Nashville was to twanging guitars, Dulce was to cored cattle carcasses.

Journalists Daniel Kagan and Ian Summers did much field work in the Dulce area while studying the mute phenomenon; in 1984, these studies culminated in a well-written debunking volume called *Mute Evidence*, which ascribes the lacerated bovines to coyotes and other scavengers. (For some reason, used copies of this book are now as rare as blue M&Ms.) Kagan and Summers end their opus by playing pop psychologist: The oil crisis and other unsettling news events caused folks to transform odd-looking, but perfectly natural, predations into the stuff of conspiratorial nightmares. That bottom line outraged "mutologists," who argue that the laser-precise incisions prove that the cows came to a far-from-natural end.

In the earlier pages of their work, Kagan and Summers toy with the interesting notion that the Dulce-area mutilators were government operatives, perhaps using silent, ultra-modern, helium aircraft. The goal: sampling livestock for nuclear contaminants

left over from the 1967 blast. In other words, the nukes created the mutes.

K&S outline this theory only to toss it away. Others might not wish to discard so hastily this scenario, which neatly explains both the mutilations and the UFO sightings in the Dulce area.

To examine the next permutations of the Dulce story, we must first travel south -- specifically, to Albuquerque, NM. Here we meet the sad Dr. Paul Bennewitz, a respected defense contractor who maintained Thunder Scientific Laboratories on the outskirts of Kirtland Air Force Base (located, in turn, on the outskirts of Albuquerque). Bennewitz had a longstanding interest in UFOs, and in 1979 began studying an abduction case; such cases, you will recall, were not nearly so fashionable then as they later became. The abductee in question remains anonymous in most accounts, although a few published reports divulge the name: Myrna Hansen. I've heard that she now works in northern California.

Hansen told Bennewitz her captors absconded her to an underground facility. Indeed, she was one of the first abductees to make such an assertion, although subterraniana became a motif in a few subsequent abductee accounts, including Christa Tilton's and Larry Warren's.

What happened next has generated much ink within the UFO-oriented press, although the full story probably remains untold. Here's the version I've pieced together:

Hansen claimed to have received an "alien" intracerebral implant, which Bennewitz assumed was a receiver for signals from her UFO-naut kidnappers. Using equipment from his lab, the scientist believed that he could trace the signal to its origin point: Kirtland AFB. Still convinced that ETs were the culprits, Bennewitz contacted AFOSI officers stationed at Kirtland -- specifically, Special Agent Richard Doty and Major Ernest Edwards. There is no evidence that they took Bennewitz' warning ("Space aliens are hiding on your base!") at face value. Yet they did not dismiss him as a mere nut. Indeed, they decided to pay special attention to Paul Bennewitz -- the sort of attention that would haunt him for the rest of his life.

Shortly after this initial meeting, Edwards and Doty somehow gained access to Paul Bennewitz' computer system -- or thus I have been informed by one believable source. Bennewitz soon began to receive on-screen computer messages from "the aliens." Having established contact with "them" (the dream of every ufologist), he initiated the grandly-named "Project Beta," in which he tried to learn as much as possible from the suddenly-chatty off-worlders.

He also allegedly photographed alien craft swooping over Kirtland AFB. These photos don't seem to have impressed anyone except Bennewitz, who dutifully reported this additional evidence of alien intrusion to Edwards and Doty. Interestingly, they invited the scientist on the base for a briefing session. Most self-proclaimed UFO-spotters never receive such attention.

The obvious inference is that Bennewitz was in contact not with aliens, but with psychological warfare specialists employed by Air Force intelligence, pursuing an agenda of their own. One might even speculate that the Air Force was responsible for the original Hansen implant, if said implant ever truly existed. Being a proud man, Bennewitz refused (and probably still refuses) to accept the possibility that he was hugger-muggered by human beings.

At this point Bill Moore -- an intelligent, Harley-riding former teacher who co-wrote the first book on the Roswell incident -- became involved in this sorry business. Doty, who knew Moore, tasked him

to check up on poor Dr. Bennewitz, in order to gauge the effectiveness of the disinformation campaign. In some circles this sort of thing is called spying. When Moore confessed to his role during a 1989 UFO conference in Las Vegas, he became a much-hated figure within the saucer-buff community. (Frankly, even before this confession, Moore's somewhat abrasive personality had won him few friends.)

At this point, I should interject an interesting side-story. I met Bill Moore over lunch (in the summer of 1991, if memory serves) to discuss the Bennewitz business and other matters. I told him I had heard that Edwards and Doty somehow gained access to Dr. Bennewitz' computer system -- a key point never before published (to my knowledge). I conjectured that E&D, or their AFOSI comrades, were the "aliens" sending computer messages to the naive, easily-bamboozled scientist. (Those who have read my monograph *The Controllers* can probably guess the line of inquiry I was pursuing.)

Upon hearing the name of Major Edwards, Moore momentarily seemed to lose his famed composure. At our next lunch, and after checking with his "inside sources," Bill gave me additional data: The computer virus which contaminated Bennewitz' system was actually the product of -- not the E&D team -- but Dr. J. Allen Hynek, the late, famed ufologist who originated the term "Close Encounters." Hynek, it seems, secretly worked for "them" (i.e., the intelligence community) all along, and played a key role in the effort to spike Bennewitz.

Or so I was meant to believe. Yet so I did not believe. If Bill Moore possessed Irish charm and twinkling eyes, he could babble such blarney without making so many folks enraged. At any rate, individuals who knew the late J. Allen Hynek well have assured me that Moore's "Hynek-did-it" story is a laughable libel, directed against someone who isn't around to defend himself.

Leg-pulls of this sort demonstrate why some people have a problem with Bill Moore -- and why some people get fed up with ufology in general.

At any rate: Whoever was playing Gaslight with Paul Bennewitz during the 1980s managed to do quite a number on that poor fellow's noggin. He eventually reported alien "bedroom visitations." Ultimately, he did a stint or two in a mental health facility. The following excerpt from a Bennewitz letter to a colleague, written after protracted "alien" communication, should demonstrate how far his thought processes had degenerated -- or expanded, depending on your point of view:

"So, in simplicity, Initiation is GOD, sacrifice and Law. Progression is Mentor created with special attributes. Mentor is terminated and then sacrifice is Mentor. History is kept. Reference established. Culture follows progeny and a new reference is established. Then teaching must occur, new keys must be made, and co-existent Star-Progeny established. History must now be shown as History! Isn't that great?! TRUE SPIRITUAL ENLIGHTENMENT FOR ALL!"

It must be emphasized that Bennewitz previously had been a respected scientist whose writings did not resemble the schizy scribblings printed on Dr. Bronner's soap packages. More than a few UFO buffs have wondered whether unknown bar-sinisters placed a foreign substance in Dr. Bennewtiz' coffee, or resorted to some even dirtier MKULTRA-style trick. At any rate, AFOSI safely decredibilized Bennewitz' work on the Hansen case.

Now, as Bill Cosby once said, I told you that story to tell you this one. "The aliens" (a.k.a. Air Force Intelligence) told Dr. Bennewitz many "tall tales" during this

period. And a number of those tall tales focused on Dulce.

Remember Dulce...?

Bennewitz learned -- and repeated to the world -- the awful truth about the underground alien base at Dulce, New Mexico. He learned about an atomic-powered alien space craft which had crashed on or near Archuleta Mesa. He heard of an alien-human shoot-out in 1979 which led to the deaths of some 44 scientists. And so forth. Thus was born a legend.

These bizarre tales probably would not have gone very far if the only man relating them was the same person responsible for such nuggets of wisdom as "Progression is Mentor with special attributes." But a few years later, others picked up the tune. One noteworthy advocate of the Dulce tale was, as we have mentioned, John Lear, the famed CIA-pilot turned ufologist. Another was Air Force Technical Sergeant John Grace (a.k.a. "Val Valerian"), who publishes anything he can swipe in his *Matrix* books and *Leading Edge* newsletter.

But Lear and company claimed that additional sources "confirmed" the Dulce rumors. Who were these post-Bennewitz informants? And where did the Dulce sketches come from?

Here's where the story becomes (to me) particularly interesting, and where Christa's volume becomes particularly helpful. The Paul Bennewitz revelations about Dulce were seconded and expanded by the mysterious Thomas C., who -- recall -- allegedly smuggled the photos which inspired the Dulce sketches. But, as far as I can determine, Lear never met this individual directly. So: how did Thomas C. make his material available to Lear, and to the world at large?

The intermediary, it turns out, was a para-weird character named Thomas A. Levesque, a.k.a. "Tal," a.k.a. "Jason Bishop."

Some years ago, I used to speak with Tal on a fairly regular basis; I even met him a couple of times. Talk about unforgettable characters! A devout believer in "hollow earth" theories, Tal worked (works?) as a security guard at Northrup -- yet he also has intimate knowledge of nearly every occultic group in California. His pet beliefs concern the presence of an evil "reptilian" alien race which had established covert control over Earth. (Perhaps coincidentally, "the serpent race" has become a key euphemism employed by certain anti-Semites.) Naturally, he'd once experienced an alien visitation -- from a reptilian, no less -- and even once mentioned something about receiving his very own alien implant. More ominously, Tal also claimed to have connections to a paramilitary group intent on "re-taking" the ET-infested Dulce base.

I never did figure Tal out; he seems to have constructed his life as an act of surrealism. Of course, he has also dabbled -- well, "dabbled" isn't quite the word -- in do-it-yourself LSD research, which may explain how he achieved expert knowledge of so many cosmic mysteries.

At any rate: Back when I was in communication with Tal, he described himself as a longtime friend to, and latter-day protector of, our old friend "Thomas C.," that elusive, fugitive Dulce whistleblower. Years ago, Tal and T.C. went through Army G2 training together. When T.C. bugged out of his Dulce duties, he called upon his old pal Tal, who helped him lie low while they planned how to alert the world to the terrors below.

Or so I was told; Tal -- almost needless to say -- never gave me any real proof of Thomas C.'s existence. However, a favored few in the UFO community have received copies of letters supposedly written by the secretive Mr. C. These letters address issues that go way beyond the Dulce mystery.

They contain speculations about metaphysical matters (religion, the origin of humanity, and whatnot) -- speculations in striking accordance with Tal's own oddball philosophy. Perhaps Tal and "Thomas C." are one and the same...?

Another "begettor" of the Dulce papers was a middle-aged woman named Cherry Hinckle, who lives (or lived) in Henderson, Nevada. Hinckle, who has trouble conjugating the verb "to be," apparently wrote the text which usually accompanies the Dulce sketches. While Christa's volume never names this woman directly, the book spends a few pages outlining Hinckle's connections to both "Thomas C." and the anti-Dulce paramilitary force -- which I sincerely hope has laid down its arms, if it ever truly existed.

And that's as far as I can trace the origins of the Dulce tale: Everything leads back to Bennewitz, Tal, and Hinckle. This is the trio who inspired Lear, Grace, and the rest. This is the trio who founded the "mystery" that will, in all likelihood, continue to set UFO buffs hiking through the wilds of northern NM for decades to come.

Nevertheless, I strongly suspect that the Dulce rumor has deeper origins. We know that Bennewitz did not create the tale out of whole cloth; he merely regurgitated what AFOSI fed him. Moore has stated that the same AFOSI people who disinformed Bennewitz also disinformed John Lear. If that's true, Levesque and Hinckle may have been early victims of (or participants in?) a deception operation, conceived and continued for purposes we can only guess at.

But then again: Is the Dulce rumor just a rumor?

Christa's volume convinces me that you probably won't find anything very unusual on Archuleta Peak (except, perhaps, some higher-than-normal tritium readings.) But you may spot oddities if you fly over the area south of Dulce, as did Christa and a team of Japanese videographers. This team captured images purporting to show air vents and hidden entrances dotting the rugged New Mexican landscape. Alas, this photographic evidence is indistinct and (to me) unpersuasive.

However: Christa once let me examine a very clear aerial photo (which, oddly, she refuses to reproduce) that I found genuinely spooky. This image showed a man-made circular hole in the ground, large enough to provide helicopter entrance and exit; the surrounding area was uninhabited New Mexico forest land. The entire set-up seemed strikingly reminiscent of the hidden facility depicted in the James Bond film *You Only Live Twice*.

Keep in mind: John Lear was proven partially right about Nevada's Area 51. There really is a secret base there, just as he claimed in his "Hypothesis" -- although it almost certainly does not have anything to do with extraterrestrials. So perhaps -- just perhaps -- the Dulce base rumors have a similar foundation in reality.

But if so, why did the Air Force leak the info in such a bizarre fashion? Why did they pick on the beleaguered Bennewitz? And why did they (if my suspicions are correct) continue the fun using Levesque and Lear -- not to mention the quasi-mythical Thomas C. -- as their vehicles?

Dulce, New Mexico, may not be the home-away-from-home of an alien race. But it is the abode of a continuing mystery. If you want to have a go at this conundrum, Christa Tilton's *The Dulce Papers* will prove invaluable.
--Martin Cannon

Taking Trask To Task (Again)

It may seem pointless, indeed, to question the merits of *Pictures of the Pain*, Richard Trask's recent tome discussing photography and its relation to the JFK

assassination. Indeed, in reviewer Kenn Thomas' words: "...[it] belongs in the collections of every JFK buff". This regarding a book that "...doesn't seem to get the main point about the assassination, almost willfully avoiding facts that lead to conclusions about the conspiracy." In fairness to Mr. Thomas, he does attempt to differentiate between the book's value as a photo album, as opposed to a work of research on the JFK assassination conspiracy. But presuming one can draw such a distinction, just how valuable is *Pictures of the Pain* as a photo album?

Like the "JFK researcher" mentioned by Mr. Thomas, I also purchased the book "for its obvious pictorial merits." I saw no problems in doing so--even if it were necessary to completely ignore the text. Unfortunately, that may be a nearly impossible task. Here are several examples demonstrating that, try as they might, Mr. Thomas and other readers may not be aware of just what it is that this photo collection is revealing...or hiding. For all the verbiage on focal length, F-stops, and chosen lenses, omits basic data germane to even a rudimentary understanding of the photographs in question. Check out "Willis #7" (*Pictures of the Pain*, p. 171) captioned, "the Willis slide taken moments before the president is hit." Here are a few such examples of what Trask feels comfortable omitting from his discussion of this photo, not the least of which concerns how the picture was extensively altered, while ostensibly in the protection of the U.S. Secret Service between November 25, 1963 and some time late in January 1964:

1. The railroad boxcars, clearly visible through the slats of the structures next to the grassy knoll (pp. 185; 190; 208; 210-213 of, believe it or not, *Pictures of the Pain*) are airbrushed completely out of existence in "Willis #7", leaving just pale sky. Relevance? Oh, minor, I guess: the three "tramps"--whose recent and sudden "identification" Trask is all too eager to believe, as pointed out by Mr. Thomas--were picked up from these occasionally invisible box cars.

2. Connally's head is partially airbrushed and Mrs. Kennedy's appearance has been altered to a degree which must be seen to be believed; and the results are downright eerie: her stylish pillbox hat and short jacket have suddenly become a "get-up" that would be considered conservative on, say, Ethel Merman: the hat is now, in Willis #7, a head-hugging "Flapper" style cap; the jacket's conservative collar is now an enormous fur boa-like affair so large that the forgers even have it appear that the breeze has lifted it up on the side facing her husband. Relevance? Again, trivial, I guess: utilizing, for example, the Z-film--Mr. Zapruder is visible in Willis #7--parallax can be carefully analyzed, and the limousine's precise location, in time and space, determined. Thus, if the photo reveals Mrs. Kennedy of Connally reacting to shots in an "improper" manner or even at an "inappropriate" moment, that data would have to "go". It went.

Check out the famous photograph by Associated Press photographer Ike Altgens (*Pictures of the Pain*, pp. 314, 320). A ton of intelligence has been gleaned from this once-suppressed picture. Trask discusses much of it, including of course the issue of whether the man in the doorway is Oswald or a co-worker of his. But am I the only individual who finds the gentleman on the left of "Oswald" at least as important? Is it within the purview of a work on photography to discuss the identity of someone about whom the forgers were so concerned that they've hidden his identity with a superimposed grey triangle?

On it goes. Space prevents the presentation of further examples of lousy photographic analysis, let alone "missing the main point of the assassination." Luckily,

most researchers who want these photographs for their collections already "get" the "main point". Luckily, that portion of the "lay" public that wants them will probably be protected to a degree by the book's expense and low availability. Chances are they've probably already shelled out thirty bucks for *The Killing of the President*, Robert Groden's colorful and incomprehensible 1993 coffee-table style book which is equally appalling, albeit for somewhat different reasons. As is his custom, Groden plays the "limited hang-out" game, playing lip service to the fact of conspiracy while providing absolutely nothing in the way of insight or intelligence. Again luckily, one needn't lose too much sleep over the specter of confused masses being forever influenced by incomplete or inaccurate photographic analysis. Try to match a photo to its corresponding text--both are haphazardly slapped onto each and every slick and glossy page. (Robert Groden, *The Killing of a President*, New York: Viking Studio Books, 1991)

It is of more than passing interest that Trask, at the end of *Pictures of the Pain*, mentions the growing perception among researchers that Groden, while photographic "expert" for the House Select Committee on Assassinations (HSCA), "liberated" more than mere copies of the photographic evidence he was analyzing. Although the jury may still be out on this issue, it may have a verdict on another issue, the relevance of which should be obvious: will Groden's name be expunged from future printings of *High Treason*, the 1989 book that co-author Harrison Livingstone has been claiming for years that he, himself, wrote alone? Stay tuned.

--Larry Lentol

The Biggest Scam in the World

The Creature From Jekyll Island by G. Edward Griffin, American Media, P.O. Box 4646, Westlake Village, California 91359, 800-282-2873, $24

Money. Money. Money. Everybody's interested in money. But where does it come from? And where does it go?

If you've ever wondered, you should read G. Edward Griffin's *The Creature from Jekyll Island*, the story of the Federal Reserve. Neither "federal", nor a "reserve", it turns out that the euphemistically named "Fed" is a cartel, established by private banks, which effectively controls the money supply in the United States.

As background for a true story of international intrigue, Mr. Griffin writes about a secret meeting in 1910 on Jekyll Island in Georgia. "The purpose of this meeting... was to come to an agreement on the structure and operation of a banking cartel."

"The goal of the cartel, as is true with all of them," he writes, "was to maximize profits by minimizing competition between members, to make it difficult for new competitors to enter the field, and to utilize the police power of government to enforce the cartel agreement... In more specific terms, the purpose and indeed the actual outcome of this meeting was to create the blueprint for the Federal Reserve System."

"...The purpose of a cartel is to reduce competition and thereby increase profitability. This is accomplished through a shared monopoly over their industry which forces the public to pay higher prices than would be otherwise required under free-enterprise competition."

As monopoly capitalist John D. Rockefeller once so-aptly put it, "Competition is a sin."

Mr. Griffin continues, referring to the members of the meeting. "They were often

competitors and there is little doubt that there was considerable distrust between them and skillful maneuvering for favored position in any agreement. But they were driven together by one overriding desire to fight their common enemy. The enemy was competition."

Sound like a conspiracy? Nope, just business as usual. With a couple of new twists. Imagine a business that owns a machine that creates money out of thin air. If the machine breaks, you have the taxpaying public pay for a new one. *Ad infinitum*. What a deal...

As historian Antony Sutton has written, "The Federal Reserve System is a legal private monopoly of the money supply operated for the benefit of the few under the guise of protecting and promoting the public interest."

In other words, the alchemists' ancient dream of creating gold out of lead had been surpassed by the Federal Reserve which makes money out of nothing.

Actually it's really not nothing; it's debt. And how does this remarkable process take place? In his book, Mr. Griffin patiently explains the arcane secrets of banking.

Here's an example:

"It is difficult for Americans to come to grips with the fact that their total money supply is backed by nothing but debt and it is even more mind-boggling to visualize that, if everyone paid back all that was borrowed, there would be no money left in existence."

A Federal Reserve bulletin, quoted in the book, states that, "modern monetary systems have a fiat base -- literally money by decree -- with depositary institutions, acting as fiduciaries, creating obligations against themselves with the fiat base acting in part as reserves."

Welcome to the strange world of international finance. But it gets even more interesting.

Paul Warburg, one of the masterminds behind the Federal Reserve, himself wrote that "while technically and legally the Federal Reserve note is an obligation of the United States Government, in reality it is an obligation, the sole actual responsibility for which rests on the reserve banks...The government could only be called upon to take them up after the reserve banks failed."

What does that mean? Mr. Griffin writes that "Warburg is telling us that Federal Reserve notes constitute privately issued money with the taxpayers standing by to cover the potential losses of those banks which issue it. One of the more controversial assertions of this book is that the objectives set forth at the Jekyll Island meeting included the shifting of the cartel's losses from the owners of the banks to the taxpayers. Warburg himself has confirmed it."

Mr. Griffin should be applauded for his heavily footnoted and meticulous research in *The Creature from Jekyll Island*, a clear, concise analysis of the Federal Reserve System.

It's fascinating reading, a short course in history, economics, and banking that explores the reasons behind the Civil War, the Bolshevik Revolution, World War I and II, and the global consolidation of wealth and power in the so-called New World Order.

And it's a thought-provoking look at the occult secrets of finance with a solid historical overview of the central bank system in England and the United States -- typically a scam run by bankers and politicians in cahoots with one another.

You'll find out how the Federal Reserve as well as the International Monetary Fund have been used to create wars, revolutions and mega-profits for bankers. And how the creation and manipulation of money relates to the establishment of the socialists' biggest wet dream -- totalitarian government on a global scale. High tech

feudalism coming right to your own neighborhood, if you give them a chance.

With that in mind, Mr. Griffin makes a strong and eloquent case for the abolition of the Federal Reserve System. Why? Mr. Griffin gives seven reasons: "1/ It is incapable of accomplishing its stated objectives, 2/ It is a cartel operating against the public interest, 3/ It is the supreme instrument of usury, 4/ It generates our most unfair tax (inflation), 5/ It encourages war, 6/ It destabilizes the economy, and 7/ It is an instrument of totalitarianism."

Mr. Griffin's version of the domino theory goes like this. "The chain of events begins with fiat money created by a central bank, which leads to government debt, which causes inflation, which destroys the economy, which impoverishes the people, which provides an excuse for increasing government power, which is an on-going process culminating in totalitarianism."

The Creature From Jekyll Island should be required reading in every high school (and home school) and college in the country. It's the most readable and easy to understand explanation of "economics" I've ever seen.

I wish I could get a copy of this book for everyone I know. It's that important!

--Uri Dowbenko

Planning for Dictatorship

Socialism: The Road To Slavery by Dr. John Coleman, Joseph Publishing Co., 2533 N. Carson St., Carson City, Nevada 89706, $20., 800-942-0821

Socialism doesn't work. Never has. Never will.

So despite a dismal track record of failure (witness the social and economic havoc in Great Britain, Sweden, and the former Soviet Union), why has this ideology remained a favorite of plutocrats around the world?

In his third book, *Socialism: The Road to Slavery*, Dr. John Coleman examines the totalitarian impulse of the Power Elite that drives them in their silent and invisible war to repress freedom and produce a Brave New World (Order).

The motto of the Fabian Society, founded by Socialists, was, after all, "Make Haste Slowly". Named after Quintas Fabian, a Roman general whose claim to fame derived from his tactics -- waiting patiently for the enemy then striking without mercy, the Socialists have done exactly that in America -- subverting the U.S. Constitution through illegal treaties like NAFTA and GATT as well as presidential "executive orders" which are *ipso facto* unconstitutional.

According to Dr. Coleman, "The Four Pillars of the House of Socialism, written by Sydney Webb shortly after WW I, became the blueprint for future Socialist action, not only in Britain, but also in the United States. The plan called for the destruction of the system of production of goods and services based on competition, unlimited taxation, massive state welfare, no property rights and a one world government."

"These objectives did not differ all that much from the principles laid down by Karl Marx in the Communist Manifesto of 1848. The differences lay in method of application and style rather than substance."

In other words, while the Communists called for bloody revolution, the Socialists wanted to slowly transform the American system into a neo-feudal dictatorship run by plutocrats using a welfare state federal government as a front.

Dr. Coleman continues: "In detail, state-financed welfare was to be the first principle... All land to be nationalized with no private property rights. All industries 'serving the people' (rail, power, light, phone, etc.) to be nationalized, 'private profit' to be eliminated from the insurance industry,

confiscation of wealth via taxation to be stepped up, and finally the concept of a One World Government was spelled out: international economic controls, international courts providing international legislation governing social affairs."

Sound vaguely familiar? It should. The Socialist agenda is ratified every day by all three branches of U.S. government.

Then what exactly is the difference between a Socialist and a Communist?

Ezra Taft Benson wrote in *A Race Against Time,* "Where the ends they seek are concerned, Socialism and Communism are virtually interchangeable terms. Indeed Lenin's party continued to call itself, 'Social Democrat' until the Seventh Party Congress of March, 1918, when it substituted the term, 'Bolshevik' as a protest against the non-revolutionary parties of the West."

In his book, Dr. Coleman writes that "the Fabian Socialists followed the Communist Manifesto of 1848, but in a more genteel, less abrasive manner. Their aims however were the same: a world revolution which would end in a One World Government -- a New World Order in which capitalism would be replaced by Socialism in a welfare state, in which every individual would be beholden to a dictatorial Socialist hierarchy for everything in life."

And how was this to be done? "The Fabian Socialists set out to achieve their goals in England and the United States by placing individuals in key positions from where they were able to exert undue influence in changing the direction of both countries. In the United States, the two prime agents in this regard undoubtedly were Professor Harold Laski and John Kenneth Galbraith. In the background, one of the 'old guard' of British Fabianism, Graham Wallas, was director of propaganda."

Wallas himself wrote a book called *The Great Society,* appropriated fifty years later by President Lyndon B. Johnson for his program of the same name. According to Coleman, "Wallas became a conduit into the United States for Fabian Socialist ideas, much of them going into Roosevelt's 'New Deal', written by Socialist Stuart Chase, Kennedy's 'New Frontier' written by Socialist Henry Wallace and Johnson's 'Great Society' written by Graham Wallas. From these facts alone, the tremendous impact of Fabian Socialism upon the American political scene can be gauged."

And how did they get in position to wreak such havoc? Coleman writes that "Fabian Socialists, both in the United States and Great Britain appeared in such a benign light and their highly-cultured background and great personable charm made it very hard to believe those who were warning that these affable social elite were a subversive group desirous of stripping the right to own property and threatening to carry off the United States Constitution piece by piece. It just didn't seem possible to think of this elite group as revolutionaries and anarchists -- which in essence is exactly what they were."

"Perhaps one of the more singular of its big lies is that Socialism strives to better the lot of the common people and unlike capitalism, Socialists are not interested in personal wealth. Socialists are always preaching about the evils of capitalism. But a quick look at some of the leading Socialists quickly reveals that the leadership is drawn from the most elite elements of our society, people using Socialist causes to feather their own nests."

Millionaire Socialist Ted Kennedy comes to mind for some reason.

The Socialists are basically a hypocritical tribe. " 'Do as I say, not as I do' seems to be their motto. Nothing was too base for Franklin D. Roosevelt and his family in pursuit of money," writes Dr. Coleman. "The Delanos (Roosevelt married Sara

Delano) made a fortune out of the opium trade...One of Roosevelt's closest advisors, Bernard Baruch and his partner had a monopoly on the copper industry that enabled Baruch to make millions upon millions of dollars out of World War I while the 'common man' was dying by the millions in the mud and blood of the trenches in France."

One of the greatest Socialist ploys is trying to make an end run around the Constitution. Dictatorial and unconstitutional so-called "executive orders" have been routinely used by Socialists from Ronald Reagan to Bill Clinton.

The latest wrinkle? "Line Item Veto power is another step toward the Socialist goal of making the United States Constitution of no effect. The Constitutional power of the president is found in Section II of the United States Constitution. He has no other power."

Ever wondered about Roosevelt's "New Deal"? Coleman writes that "the New Deal Socialist program was cleverly couched as a 'relief' program for workers who were stricken by the Depression. In fact the "New Deal" was the book *New Deal* written by Stuart Chase, a British Fabian Society member."

"... Chase proposed three major steps to be taken by Socialists in America: 1) To obviate accidental inflation and deflation, the dollar was to be 'managed', 2) The national income to be forcibly redistributed through increased income taxes and inheritance taxes, 3) A vast public works program was to be instituted, particularly in electrification works, based on the Soviet model and large-scale housing projects."

Number One is the establishment of the Federal Reserve System, a private banking cartel that creates "money" out of debt and charges the American taxpayer interest. Number Two is the Income Tax, and Number Three consists of so-called "entitlement programs", which create and perpetuate the Underclass, wards of the Welfare State. The pernicious legacy of these programs is very much with us today.

Socialists aren't too concerned about your property rights, but if something goes wrong with their "investments" you can count on the U.S. Government bailing them out through increased taxes. And you (or your sons and daughters) could even be called upon to fight their wars.

"Secret advisors were also responsible for getting Roosevelt to retrieve Standard Oil property taken over by the Japanese using American troops for this purpose, the so-called Stimson Doctrine. This doctrine was repeated by President George Bush in the Gulf War which was fought to retrieve British Petroleum Oil property seized by Iraq."

So how do they get away with this fraud?

Dr. Coleman says "that Socialists pick key government positions to this day, a pattern which was to become a part of the scenery whether a Republican or a Democrat sat in the Oval Office. For instance in the Reagan Administration, 3,000 key positions were filled by Heritage Foundation nominees. Ostensibly a 'conservative' think tank, the Heritage Foundation was run from behind the scenes by Peter Vickers Hall, a leading member of the Fabian Society and a committed Socialist."

Since the mainstream print and electronic media don't report these facts, you can draw your own conclusions.

In his book *Socialism: The Road to Slavery*, Dr. Coleman delivers profound insights into world events as well as recent history. Regarding Vietnam, he writes that "there has never been a war like the Vietnam War where our soldiers tried to fight with both hands manacled behind their backs, the keys held by Robert Strange McNamara, Walt Rostow and Dean Rusk."

"No nation's military had to fight according to the rules laid down by an out and out traitor -- Robert S. McNamara. This man should have long ago been tried for treason and hanged. According to McNamara's rules of engagement, our soldiers had to wait until they were surrounded and being shot at before they were allowed to respond."

Dr. Coleman devotes entire chapters to what he calls the Socialist policy of 'permeation' and 'penetration' in education and religion. This means targeting an area of life and saturating it with Socialist propaganda in an effort to subvert it to Socialist goals.

So-called "Outcome Based Education (OBE)" is a case in point. In this program, education is subverted into a means of conditioning and programming children to become good foot soldiers in the New World Order. So-called "liberation theology" takes Christian traditions and principles and perverts them with Socialist doctrine.

"How Socialist 'gradualism' works should be studied by all who are concerned about the future of the United States,' writes Coleman.

"... The success of these tactics can be seen in the Clinton presidency, where one major piece of Socialist legislation after another has been forced through on the basis of gradually converting opponents of Clinton into believers in his program. Clinton's Socialist NAFTA, the Crime Bill, and his bill imposing the biggest tax increase in the world on the American people are prime examples of how this creeping paralysis works and how important it is to have traitors in Republican ranks who are wholeheartedly for Socialism but who are labeled 'moderate' Republicans."

Whoah! Adolf Gingrich steps up to the plate.

Don't forget Gingrich's track record. He was the one who sponsored a so-called crime bill HR4079 in 1990 that would have placed the United States in a State of National Emergency, suspended the Bill of Rights and installed martial law because of the so-called "war on drugs". Incidentally a new bill, sponsored by Gingrich, called HR666 would rescind the 4th Amendment which protects Americans from unreasonable search and seizure.

Socialism: The Road to Slavery also explains why NAFTA, GATT and other so-called 'free trade' agreements are unconstitutional. "The first order of business of the Fabian Socialist Colonel Edward House who put President Woodrow Wilson in power was to break down the trade barriers and protective tariffs that had made the United States a great nation in a relatively short time...The NAFTA Agreement and GATT take up where Wilson and Roosevelt left off. Both agreements violate the Constitution of the United States and are the work of the Fabian Society and their American cousins."

"... Breaking down the trade barriers erected by Washington, Lincoln, Garfield and McKinley was long a cherished goal of the Fabian Society. NAFTA is their concoction, their big chance to open the markets of the United States to one way 'free trade' and through it deal a mortal blow to the American middle class..."

"The Socialist goal to reduce the standard of living of the middle class American to that of a Third World country is somewhere in the region of 87 percent complete, and if matters go as planned, the Clinton administration will soon put the finishing touches to the trade war at the cost of stabbing the American people in the back. As we have often said, President Clinton was selected to carry out a Fabian Socialist mandate and 'free trade' is only one of the treasonous policies he was ordered to carry out."

Socialists are also skilled in the use of semantics, cleverly manipulating words to disguise their real intent.

Watch for this word and hold on to your wallets: "reform", as in health-care reform, or labor reform, or tax reform. Code words like these have been used by Socialist politicians and media to convey an image that appears benign but is actually a "change agent" in itself.

Coleman writes that "Fabian Socialism developed the art of dissembling and lying without seeming to lie. Many were deceived in England and later in the United States where we are still being deceived on a grand scale. But there were occasions when Socialist leaders could not contain themselves, such as the occasion of the 1936 Eastern Spring Conference of Professional Schools for Teachers."

"Roger Baldwin explained the double meaning of words so often used by Fabian Socialists. *Progressive* meant 'the forces working for democraticizing of industry by extending public ownership and control' while *democracy* meant 'strong trade unions, government regulation of business, ownership by the people of industries that serve the public'."

Take note how many times you hear the U.S. government incorrectly referred to as a "democracy" on radio and television. It's not just an innocent mistake. The USA is in fact a republic, and by constantly using the misnomer "democracy" the Socialist view of the world is reinforced in everyone's mind.

Yes, the Power Elite are planning for dictatorship on a global scale. And Coleman's *Socialism: The Road to Slavery* is not only a well-documented account of this treachery, but it delivers a powerful antidote to this pernicious doctrine.

Coleman's book exposes the modus operandi of the archdeceivers of mankind, the manipulators of the Abundant Life, and the monopoly capitalists who use Socialism to move the United States step by step into a One-World Government.

"Socialism is far more dangerous than Communism," writes Coleman, "because of its inherent, evil slow approach to forcing drastic, unwanted changes upon the people of the United States. There is only one way to overcome this violently dangerous menace, and that is for the whole people to be educated to where they recognize what they are up against..."

If you had a sense of humor, you could even say: Freedom Fighters of the World Unite!

Steamshovel Debris: Dr. John Coleman's previous books include *Conspirators' Hierarchy: The Story of the Committee of 300* and *Diplomacy by Deception*.

--Uri Dowbenko

A Saucerful of Secrets

Space Aliens From the Pentagon by William R. Lyne, $24.95, Available from: Creatopia Productions, Lamy, New Mexico 87540.

William R. Lyne has written an astounding and controversial book called *Space Aliens From the Pentagon: Flying Saucers Are Man-Made Electrical Machines*.

Despite the ironic B-movie-like title, Lyne's book is fascinating. His theme is that flying saucers have been around at least since the early twentieth century when the anti-gravity theories of maverick scientist Nikola Tesla were hijacked and developed into secret flying machines by the Nazis.

Subsequently flying saucer technology was kept secret by the National Security Agency (NSA) and the Central Intelligence Agency (CIA) in the United States, when Nazi scientists were put to work in the American scientific establishment at the Atomic Energy Commission, NASA, and other federal agencies, refining and continuing their

experiments on this highly advanced technology.

Why? According to Lyne, the Tesla anti-gravity technology, as well as so-called free energy available through his discoveries, would destroy the petroleum cartel's ability to retain a monopolistic hold on the global economy. Thus, with the release of the secrets of flying saucer flight, the worldwide population control mechanisms of the global cryptocracy which Lyne calls the Illuminati would be shattered overnight.

"The modern Illuminati are a group of powerful and wealthy coercive monopolists," writes Lyne, "actually unfit and incompetent businessmen and industrialists who sustain their power and wealth as a group, through theft of advanced technology and concealment of it through mysticism. If known to the general public, this technology would break their coercive monopoly and reduce them to the normal realm of capitalist competition and survival of the fittest.

"For this reason this book is the greatest threat to Illuminati power ever seen because it discloses the technological secrets of the flying saucer, as their best kept secret, and makes the construction of the flying saucer a possibility for anyone having competent technological skills and wishing to build their own."

Yes, Chapter 9 of the book is entitled "How to Build a Flying Saucer". There are diagrams, drawings and plans, as well as a legal disclaimer.

Lyne believes that "the greatest threat to the corporate-state and the Trilateral Commission member corporations which control basic mineral resources, refineries, chemicals, pharmaceuticals, public utilities and other public service cartels fueled by these is the development of autonomous home-generated power systems, which can also be used to power cheap transportation."

"To make this threat more complete, such power systems should generate their energy from water (hydrogen and oxygen), from the air (combustion of nitrogen and oxygen by electrical spark discharge), from the earth atmosphere electrical potential, from magnetism, or from non-radioactive nuclear reactors, which the government cannot justify the regulation of because they are 'safe'. The development and use of such autonomous home-generated power systems is completely consistent to the achievement of a pollution-free environment."

Currently a New Mexico resident, Lyne saw his first flying saucer in 1953. He assumed that the saucer was a "secret government project."

Writing about the incident, he says, "What I saw in 1953 was a flying machine. The most irrational assumption would have been that it was 'extraterrestrial' in origin. The most rational assumption was that it was made by human beings and that was my first impression..."

"I knew by the way that the saucer could jump around in space that its gravity was being controlled. Otherwise it would have flown to pieces, and any pilot would have been slammed around so badly that he would have been injured and rendered unconscious by the 'G' forces. I knew from the electrical corona that the means for controlling gravity was by some sort of high voltage electricity."

His mother had seen one in 1950 on two subsequent days. In each case, Lyne writes "the description sounded as if the crews had experienced malfunctions which were responsible for the saucers being there in the first place [over Kermit, New Mexico City Hall] rather than over White Sands or Alamogordo. [He] later determined that these first saucers appeared to be of an older type of WW-II vintage German design which looked sort of like teapots or saucers with an overturned cup in the center."

With an ongoing interest in aerodynamics and engineering, Lyne found another piece of the flying saucer puzzle in 1979 -- an old wooden box labeled *Peiltochterkompass* ("Polar Slave Compass" in German) According to Lyne, "this presupposed that the master compass, a gyrocompass, was celestially calibrated before takeoff, since a magnetic compass would be disabled by the electric field around the saucer during operation. This was probably the earliest celestial navigational system ever developed."

And whatever happened to Tesla technology?

"Fascist-state revisionists decided, without our consent, that the scientific truth about gravity is a 'national security secret'," writes Lyne, "although Tesla published his Dynamic Theory of Gravity in 1897."

"In 1942, under orders from the secret government, the FBI deleted and removed from public access, not only Tesla's early theory, but also all other known information relating to a scientific understanding of gravity, electrical control of gravity, or 'free energy', as such information might pertain to flying saucer principles."

"The way to protect flying saucer secrets, they said, was to rewrite the theories of physics, and to conceal the great moments of scientific history. Then when our people are all reduced to ignorant scientifically-deprived yokels, we will have `national security' and only the N.S.A., the Trilateral Commission, and the Illuminati will possess true scientific knowledge."

"... After all, the rats said, since a 'healthy petroleum industry' is essential to 'national defense', it is in the 'national security interest' to protect Big Oil, at the expense of scientific, economic and social freedom and progress. With such inventions as the flying saucer at the public's disposal, the economy would be wrecked, they said (at least for the Trilateral Commission). Meanwhile our government helped the fascists take firmer control of the system, in the interest of 'national security'."

Sound too far-fetched?

According to Lyne, the media is regularly used to present elaborate government hoaxes like the "MJ-12" documents purporting to deal with the "alien threat", the so-called Roswell incident, the Travis Walton incident (popularized in the film *Fire in the Sky*) as well as popular entertainment like *ET*, *Hangar 18*, and so on.

In the classic Hegelian set-up of thesis (aliens and flying saucers are real), antithesis (there's no evidence for flying saucers) and synthesis (confusion about flying saucers), the classic disinformation scenario is played out in the media.

"The two hoax counterparts are complimentary," writes Lyne. "For example, the frantic, defensive, paranoid and mystical posture of the alien abduction huxters is designed to attract the nuts and invite the ridicule of the Klass psychophants, whose posture in turn is designed to attract sadistic bullies and residual skeptics, who taunt and incite the paranoia of the nuts even more. The overall effect is to exclude reason, and to entrap you in a labyrinth, a sort of purgatory for the disinformed public."

The Fire in the Sky story, in its present form, is a double hoax, a hoax within a hoax, like the Roswell incident. The 'alien' huxters and their newswriters, on one side of the hoax and, together with the protagonists of the pseudo-rational Klass class and their newswriters are counterparts to the same giant hoax...Both Roswell and the Fire Hoaxes were initially bungled, and both were much later revised, one as the MJ-12 hoax and the other as the Fire in the Sky hoax."

"A phony staged debate is presented in the media. The individual member of the public, who may have never seen a flying

saucer, is confronted with a dilemma, for which he is presented with no rational alternative. With such a display of reports, assertions and denials -- by the government, by seemingly unrelated private investigators, and by airline pilots and other witnesses and sometimes just plain 'nut cases', there is little room for the 'ordinary reasonable and prudent person'. The truth is lost between the Illuminati controlled propaganda orchestrating the positions of two irrational sides which are (1) Either extraterrestrials from outer space are visiting us and there is a 'government conspiracy' to hide it from us or (2) Flying saucers just don't exist!"

Lyne also presents several chapters of description on how the anti-gravity technology works as well as a discussion of other Tesla inventions.

And what about the global cryptocracy, the Illuminati?

"The mainstay of the Illuminati is its monopoly of energy, minerals, raw materials, and related technology. Of all its present investments, the flying saucers represent the single most important invention, the continued secrecy of which is indispensable to the maintenance of Illuminati world control, because of its incredible fuel efficiency, speed and electrical performance characteristics."

"...That is the reason the secrets have thus far remained concealed under the veil of confusion, deception, mysticism, superstition, hoax, lies and official denials while phony, fancy, well-financed books, movies, and TV productions brainwash us with lies that flying saucers are 'extraterrestrial'."

Lyne finishes his book by writing a bold declaration. "In the name of the people of the world, I hereby take back the flying saucer secrets the Illuminati stole from us, so that we may liberate ourselves from the Illuminati and create a prosperous new free world civilization, based on the creative process, individuality, peaceful lifestyles, free trade, free travel and little or no government." Just ranting? But it might be a radical agenda, *nicht wahr*?

Space Aliens from the Pentagon is a must read for anyone interested in mind control, flying saucers, Tesla technology, and alternative history.

--Uri Dowbenko

Adam Parfrey speaks with more clarity in *Cult Rapture* ($14.95; POB 3466; Portland, OR 97208;www.feralhouse.com), the new release from his Feral House Press, than his 1987 classic *Apocalypse Culture* (in its various revisions)--rightly described as having breathed new life into the alternative press-- because he speaks more frequently and on topics more relevant to the conspiracy circuit as it stands in 1995. Whereas in *Apocalypse Culture,* he expounded upon not much more than things like historical lycanthropy and self-castration, leaving more pertinent topics to other writers in the anthology, in *Cult Rapture* he frames and punctuates the anthology with more of his own writing.

As documented in the book, Parfrey has over the years turned his critical insights to some fairly bizarre scenes: the fag-hags of the late Ruth Norman's Unarius Cult; the nexus of rightist politics and Andrea Dworkin's anti- intercourse feminism; the good-ol' girls fan club of Ginger Alden, Elvis' last girlfriend, replete with some horrid fan fiction (oddly, Elvis' second-to-last girlfriend was Linda Thompson, who shares a name with the militia activist nearly agent-baited by Parfrey in a later chapter); the I CAN sex cult for the disabled; the bug-eyed cuty kitsch of Walter Keane.

Parfrey takes a long look at each of these with fairly bald commentary about the absurdities of the situations, not without compassion but with a practiced and almost

snobbish distance, something he actually apologizes for in the early chapters. (To avoid total identification with the subject, *70 Greatest Conspiracies* author Jonathan Vankin does a similar thing by posing as a commentator looking in on the conspiracy world from the perspective of a mainstream that, as a conspiracy observer, he must eschew.)

Cult Rapture also deals with personalities and issues immediately recognizable to readers with only a passing acquaintance with conspiracy issues, raising the serious questions about the *provocateur* implications of Linda Thompson's aborted march on Washington and her support of Bill Cooper; offering a possible insight into drug lord Khun Sa's fingering of Richard Armitage at Bo Gritz's behest; reproducing the *Soldier of Fortune* photo of a Tim McVeigh lookalike (it actually looks like a mop-top was airbrushed over his buzzcut.)

Here and as he chops through the "fusion paranoia" rhetoric recently offered by *New Yorker*, Parfrey moves from the sardonic postmodern observer to a player in the madness. "My political beliefs combine skepticism of authority tempered with libertarian-style economic self-reliance," he explains, "Unlike hardcore libertarians, I do not worship at the altar of a free market economy for the simple reason that unlimited economic growth along with unchecked procreation seems incompatible with long-term survival of the species." Such a scarcity model differs only in tone from the militia man Parfrey defends, and even though he dismisses the conspiracy theories of Debra Van Trapp, et. al., about Oklahoma City, he clearly has the macrocosmic view that real hard-ball questions remain about that bomb-- questions that say things about the overall political situation in the US and the world that make the funky, little social scenes documented in *Cult Rapture* pale in comparison. *Cult Rapture* is without doubt the best "conspiracy" book of the season

Also from Feral House comes *Psychic Dictatorship in the USA* by Alex Constantine, who trumpets his debt to Mae Brussell in the dedication and introduction to the book, and proves a worthy disciple; and reports up-front his own status as a victim of the "non- lethal" biotelemetric weapons technology, the main topic in this book. *Psychic Dictatorship* even includes an entire chapter on E. Howard Hunt and a section on the mysterious child-procurement group known as the Finders. It otherwise offers a tremendous compendium of reportage and sources on mind-control, brainwashing, involuntary human experimentation and intelligence community cults--a wealth of information that rivals previous classics in historical study on this topics as *Acid Dreams* and *Journey Into Madness*. One brief example: "Dr. Allan Frey, a biophysicist at General Electric's Advanced Electronics Center, Cornell University (and a contractor for the Office of Naval Research), published a 'technical note' in *Aerospace Medicine* reporting that the auditory system responds "to electromagnetic energy in at least a portion of the radio frequency (RF)

POPULAR PARANOIA, page 59

spectrum. Further, this response is instantaneous and occurs at low power densities...well below that necessary for biological damage." Frety's subjects "heard" buzzes and knocks when exposed to low frequency radio emissions. In one experiment a radio beam swept over a subject, and with each sweep he "heard the radio frequency (RF) sound for a few seconds and reported it...It seems that the brain is a powerful receiver." With the help of Operation Paperclip Nazi scientists, similar tests were done on unwitting subjects with microwave technology--as if the average unwitting citizen's daily exposure to television was not enough to turn normal human brains to sausage.

Even today, a scientist like Jose Delgado, whose electronic brain implants once stopped a charging bull and whose infamous 1969 book *Physical Control of the Mind: Toward a Psycho-Civilized Society* work is footnoted ruefully in *Psychic Dictatorship*, passes himself off as a humanist in the very latest issue of *Free Inquiry* with observations like "human beings are not born free but are products of their genes and modifiable by their culture." Constantine's book helps expose the historical nightmare wrought by that kind of thinking and is a highly recommended antidote.

Paul David Pursglove has put together an anthology of flying saucer testimonials entitled *Zen in the Art of Close Encounters, Crazy Wisdom and UFOS* ($14.50; The New Being Project, POB 3070, Berkeley, CA 94703) that perhaps sheds more humor than light on either the enigmas of Zen or alien abduction. The book collects essays and anecdotes from an impressive variety of crazy wise people, including Stanley Krippner, Terrence McKenna, Timothy Leary, Marilyn Ferguson, Whitley Strieber and R.A. Wilson. The sagacity of some of the pieces certainly is challengeable. Barry Taff, for instance, suggests that the government "might be doing the right thing for one of the few times in their existence by continuing the UFO cover-up." Michael Grosso takes an episode of saucer voyeurism, in which he claims to be in "a perfectly normal state of mind" despite having a half-dressed girlfriend "sprawled on the sofa" during the visitation by Coltrane-coordinated lights in the sky, as a work of alien art.

As editor Pursglove points out, though, these experiences are very much like Zen koans, enigmas that yield new meanings through study over years. Also like koans, contributions to *Zen and the Art of Close Encounters* are short, culled from UFO, psychedelic and zine literature from the past couple of years. It may on the surface seem to "New Agey" for some tastes, but the book actually concentrates Zen-ish wisdom from scattered sources and is an easy read for such a difficult topic.

In that Pursglove's book includes many psychedelic celebrities as contributors, readers might consider *Practical LSD Manufacture* by Uncle Fester ($15; Loompanics Unlimited, POB 1197; Port Townsend, WA 98368) as a good companion book. Uncle Fester notes that because of the "alarmingly low number of [LSD] labs the supply of LSD in this country at constant peril" and sets forth to de-mystify the drug's natural sources and processes of extraction. De-mystification is certainly what is needed in this area, not the demonization and dismissal of the culture at large. To this end, Fester also reports on harvesting the psychedelic TMA-2 from calamus plant roots.

Borderlands Sciences has released *Loom of the Future: The Weather Engineering Work of Trevor James Constable*, a fascinating interview-book with Constable, a loose cannon among cloudbusters, who developed interesting variations of Wilhelm Reich's orgone technology ($18.75 plus $2.75 p&h;

Borderland Sciences, POB 220, Bayside, CA 95524; 707-825-7733).

Unfortunately, Constable also introduced some variety of mystico-fascistic ideology to orgonomy, something that is not discussed in much detail here. As Constable points out, however, "Rain doesn't recognize political boundaries," and the book amply documents Constable's various Etheric Weather Engineering and Smog Reduction projects with good oral history and a generous number of radar maps and photographs, including four pages of color plates. One photo, of Constable at Disneyland with Cab Calloway, is absolutely priceless. Calloway actually beats out Reich as the only man Constable ever idolized. *Loom Of The Future* was put together over time from phone, faxes and mail with former Borderland Sciences director Thomas J. Brown, who has since fled to New Zealand.

Still, important questions go wanting: at the end of Curtis LeMay's life, for instance, the general helped Constable conduct weather-manipulation projects with miniature cloudbusting-like cannons called Spiders; Constable also worked for the 1968 George Wallace/Curtis LeMay political campaign. Loom of the Future discusses this briefly, but makes no mention that LeMay once yelled at Barry Goldwater--the only other person Constable ever voted for--for inquiring about the Roswell greys. This would have been an interesting line of questioning, considering Reich's UFO involvement.

Constable's politics are self-serving: he worked for Wallace because he was convinced Wallace would be assassinated (according to Mrs. LeMay, Wallace felt the same way), and his friend the general be made president. But Constable calls LeMay "the embodiment of integrity and honor" when, in fact, LeMay was the architect a saturation bombing in Japan before Hiroshima and became a nuclear hawk who almost destroyed the world. John Judge has also recently noted that witness Paul O'Connor reported LeMay's presence at JFK's autopsy. Sad that such a figure as LeMay has even a remote link to the work of Wilhelm Reich. *Loom of the Future* is recommended, though, to students of the ether, as long as it is taken with heavy does of original Reich.

The best place to go for that--and the most highly recommended item in this section, if not in all previous issues, is the new video release by Flatland: *Wilhelm Reich & The UFO Phenomena: In Conversation With Eva Reich, MD* ($35 from POB 2420, Fort Bragg, CA 95437). It is not an exaggeration to say that it's like watching an hour of Reich reincarnated as a woman. Put together from two interviews, one conducted in Hancock, Maine in 1990 and another conducted by Jim Martin in Philo, California in 1995, this tape is as close as it gets to seeing things as Reich saw them. Eva Reich was not only his daughter, but also a major player in the original cloudbusting work and in the time of Reich's persecution and imprisonment. At age 71, she comes off as extremely sharp and intelligent, someone who has absorbed healthy doses of the orgone and someone well aware of her legacy—even knowledgeable about Reich's flying saucer propulsion mathematics. Unlike others who claim affinity with her father's work, Eva Reich is quite comfortable discussing Reich's UFO work, providing more detail about his actual experiences looking up from under the cloudbusting tubes than anything since *Contact With Space*. Although like her father, she is a literalist when it comes to space ships and alien beings, she discusses with intelligence alternate theories about trans-dimensional visitation and how it fits into the Reichian perspective. Viewers might wonder why Eva Reich has not hit the lecture circuit or produced volumes of her own writing, but she explains by reviewing her father's difficult history--supplemented with

brief footage and stills of Reich and time lapse films from the Atmospheric Physics Weather Modification Study done in Tucson close to when Reich was there cloudbusting--and explains her own successes in the Human

EVA REICH, MD (1995)

Potential movement and as a medical practitioner. It is indeed a rare wonder that Martin--who adds his dismay to the talk at one point by stacking up copies of all the out-of-print Reich books available now more in the used book stores, if at all, than in the college classrooms where they belong--has been able to commit the thoughts of Reich's true heir, who seems to have no inclination for self-promotion, to videotape. If *Steamshovel* readers pick up nothing else in mentioned in this issue here, they should get this.

Short Shrift: IllumiNet Press has released John Keel's classic *Disneyland of the Gods* ($9.95; POB 2808; Lilburn, GA 30226), gathering Keel's Fortean investigations for *Saga* magazine and other writings around Ivan Sanderson's notion that Earth is a farm ad "we are the crop!"; It looked for a while like Dennis Stacy's UFO articles put *OMNI* magazine under, until the damn thing resurfaced after filling subscriptions with the even more banal *Discover* magazine. Never mind: Stacy now edits *The Anomalist*, well above the *OMNI* pablum in its exploration paranormal and Forteanic science. Issue 2 contained remarkable writing by Loren Coleman, Rupert Sheldrake, Robert Baker and others ($10 plus $2.50 postage, checks payable to Stacy, POB 12434, San Antonio, TX 78212; Alfred Vitale's *Rant* is always worth its $3.95 cover price, but the current issue (#5) includes Tuli Kupferberg's "Nixon's Big Regret," which is not to be missed, a contribution from Hakim Bey and a "blast from the past" by Aleister Crowley. POB 6872, New York, NY 10128; it came too late for this issue, but expect an extended treatment of Edward Haslam's *Mary, Ferrie and the Monkey Virus*, exploring the connections of David Ferrie's cancer researches ($12.95; Wordsworth, 7200 Montgomery #280; Albuquerque, NM 87109.)

THINGS ARE GONNA SLIDE

Timothy Leary's Structure Dissipates

Psychologist/author/philosopher Timothy Leary reported to the *Los Angeles Times* (8/28/1995) that he is dying of metastasized prostate cancer. With characteristic aplomb, he remarked, "When I found out I was terminally ill, and I know this can be misinterpreted, I was thrilled...It's the exit, the final scene of the glorious epic of your life. It's the third act, and you know, everything builds up to the third act...I've been waiting for this for years."

"I grew up in a culture where you never talked about how much money you made or anything about death. I love topics the Establishment says are taboo," he explained. He received the diagnosis in January after a long speaking tour that ended with a bout of pneumonia. According to Leary, "It was the first time in my life I was ill. I asked for a complete physical exam, and it

came back that I had prostate cancer." As of late summer he was not feeling pain or showing other symptoms.

Dr. Leary also made several additional observations about his newly discovered condition to the *LA Times* reporter, including that he might consciously expedite the process ("I use the term 'voluntary dying'...It's a nice way of saying 'killing yourself'") and would possibly use LSD to experience the event: "I like options...You're as young as the last time you changed your mind." Another option he keeps open is the cryonics firm that might make efforts to preserve his brain and/or body after death: the addresses of competing cryonics firms adorn different bracelets on his wrists. Leary remarked, "How you die is the most important thing you ever do." He has begun work on a quality of life document to help preserve threats to his dignity: "I have certain fears of losing my dignity," he says. "Having to be diapered, losing whatever is left of my mental agility. I'm tremendously frightened. The only thing I've ever been frightened of in my life is that stage of total, undignified, vegetable passivity." He also expressed discomfort with conventional burial: "I went past that veterans' cemetery in Westwood the other night, with all those stones in perfect rows, and it just gave me the creeps. It looked like they were all index cards."

The *LA Times* article included comments from two Leary comrades, Ram Dass and G. Gordon Liddy. Ram Dass noted that "Timothy moves fast through things, leaves them half-digested and goes on to something else. That's very much the way a visionary works. He moves on, but he leaves a lot of ideas behind. It's like science fiction. Someone writes about a world but they don't actually create it. They leave a map for others to follow." Liddy commented that Leary "called me when he was diagnosed and talked about how he was handling it. I promised myself I would get out there to see him, and I will, soon." Leary's third wife, Rosemary Woodruff Leary, who helped him break out of prison in 1970, said, "I think there is an added sweetness to Tim now. In the past you would say he was brilliant, bigger than life, all those things, but not so much a sweet person."

Leary divorced his fourth wife, Barbara, last year and currently has her son, Zach, age 21, temporarily residing with him.

Newsweek reported that Dr. Leary has two rooms prepared at his residence in Beverly Hills for the event of his passing, one for "deliverance" and one for "reanimation." He explained to *Steamshovel* that his personal papers and other archival materials will be given to Stanford University.

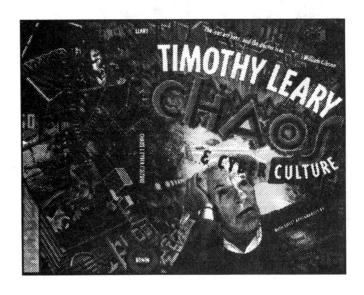

An anthology of recent interviews with and writings by Timothy Leary, entitled *Chaos and Cyberculture*, is available for $19.95 from Ronin Publishing, Inc., Box 1035, Berkeley, CA 95701. Although each of Tim Leary's books are entertaining and revelatory-- and a permanent, on-going contribution to the debate on the important issues of this and the next century--one good place to begin navigating through that large body of work is

the *Annotated Bibliography of Timothy Leary* by Michael Horowitz, Karen Walls and Billy Smith, published in 1988 by the Shoe String Press. *Steamshovel Press* joins the chorus of Tim Leary fans and supporters to express gratitude for his life and career and the certainty that if anyone can turn a terminal condition into one last great adventure, Tim Leary can.

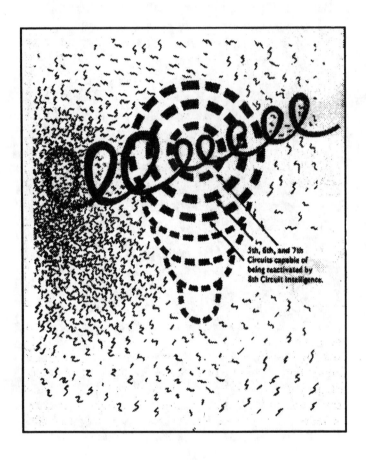

Above: One of a series of maps on brain circuits, from Tim Leary's 1977, *Exo-Psychology* (Starseed/Peace Press). Some editions had the arrows in red, and would animate into a spin as the reader flipped the pages. Leary revised the book as *Info-Psychology* in 1987 (Falcon Press), with nods to the emerging cyber-computer culture...and with instructions for scratching out and re-routing the arrows. Ram Dass told the *LA Times*: "That's very much the way a visionary works. He moves on, but he leaves a lot of ideas behind. It's like science fiction. Someone writes about a world but they don't actually create it. They leave a map for others to follow."

Where Is Thy Sting?

A 1994 Barricade Books, Inc.-published title called: *Psychedelics: A Collection of the Most Exciting New Material on Psychedelic Drugs*, compiled by Thomas Lyttle has an essay by Ray Clare on page 45 which makes reference to the rare honey of a "stingless domesticated honey bee" native to Mexico. This honey, he claims, contains natural psychoactive lysergic acid amides...LSD honey, which the Mesoamaerican shamans used in their entheogenic shamanic rites.

Ray Clare has succeeded in "rediscovering" this ancient honey during ethnobotanical research at UCLA in 1981. The essay has even more interesting info on the symbiosis of the "Toltec masked-clown cults" with their bees. Is this for real? Will Beavis and Butthead risk being stung to get at the psychocandy, Candyman? Will the DEA begin harassing beekeepers if they think they're running illegal "DRUG HIVES"??? Look what Law Enforcement has done lately trying to rid our Nation's youth of "TOAD LICKING MANIA"! Will Park Service personnel run into boobytrapped "Drug Hives" as they now do with fields of hemp? Where will the hysteria end?

--Cal Meacham

Philip Agee Sues Barbara Bush

WASHINGTON (Reuter) - Philip Agee, a former CIA operative who turned against the spy agency, announced Wednesday he had filed a $4 million libel suit against Barbara Bush, saying she had wrongly

linked him to the assassination of a senior CIA officer.

Agee, who led a worldwide campaign in the late 1970s to unmask Central Intelligence Agency officers, accused the former first lady of making false and defamatory statements about him in her 1994 autobiography, *A Memoir*.

Agee claims he has been unfairly tarred by the CIA and U.S. officials in connection with the December 23, 1975, assassination of Richard Welch, CIA station chief in Athens.

Mrs. Bush wrote in her book that Agee disclosed Welch's identity in a "traitorous, tell-all" book published shortly before Welsh's assassination by a Greek extremist group.

Agee asserts in his suit, however, that nowhere in his 1975 book, *Inside the Company: A CIA Diary*, did he mention Welch. Nor, he says, did he ever mention Welch in any publication or communication before Welch's death.

Agee said he was suing Mrs Bush because her claim that he exposed Welch was "particularly egregious" since her husband, former president George Bush, became CIA director 38 days after the killing.

"The man's name was not in my book," Agee said in a telephone interview from his home in Hamburg, Germany. "She's just repeating what her husband and others have been saying ... This just cannot stand."

Agee had his passport revoked in 1979 for allegedly having damaged U.S. national security.

Lynne Bernabei, Agee's Washington lawyer, told a press conference that Agee, 60, had suffered serious damage to his reputation "as a result of the CIA's concerted efforts -- this time through the baseless allegations in Mrs. Bush's autobiography -- to malign him and falsely ascribe blame to him for a death that was caused by its own ineptitude."

In addition to compensatory and punitive damages of at least $4 million, the suits seeks a full retraction by Barbara Bush and her publisher, Charles Scribner's Sons and Simon & Schuster, that Agee caused or contributed to Welch's killing.

A spokesman for the Bush family in Houston, Jim McGrath, declined comment on the suit.]

Philip Agee v. Barbara Bush: An Analysis of the Case

Richard Welch was killed in December 1975 in Athens. A Greek urban guerrilla group calling itself "November 17" took credit for the killing. Richard Welch's name was first published in *Who's Who in CIA* by Julius Mader (East Berlin, 1968), along with 2500 other names.

It was also published in early 1975 by *Counterspy Magazine* (Winter 1975 issue, page 26), along with about 100 other names. This issue of *Counterspy* listed Welch as residing in Lima, Peru -- which was his previous posting. In the next issue, Summer 1975, *Counterspy* again listed Welch as a CIA officer, under cover as an attache at the U.S. embassy in Lima.

Welch was listed in the 1969 *State Department Biographic Register* and the 1973 *State Department Biographic Register*, and no doubt others as well (these are the two I have handy). In both the 1969 and 1973 listings, the biographic details peg him as an obvious CIA officer for those who know how to read the Register.

Counterspy could have gotten its information from the *Biographic Register*. Beginning in 1975, the *Biographic Register* was given a "Limited Official Use" classification, but before 1975 it was available to the public. In the *Washington Monthly*, November 1974, an article by former State Department official John Marks, titled "How to Spot a Spook," described how to read the *Biographic Register*.

In fact, *Counterspy* told Agee that a Maryknoll priest who worked as a missionary in Peru had visited their office a year earlier, and brought with him a copy of a Peruvian

journal with Welch's name in it as the CIA chief in Lima. ("On the Run," p. 133)

In late November 1975 the *Athens News* named ten CIA people in Greece, and included Welch's name and address. It is said that even the local tour buses would point out the home of the CIA station chief as they drove by.

Agee's book came out in 1975, which blew the cover on dozens of CIA officers. By the Summer 1975 issue of *Counterspy*, Agee was listed on the advisory board of *Counterspy*, along with 15 other prominent activists.

By the time Agee's book came out, the CIA's Ted Shackley was running a major operation to control the damage to the CIA and discredit Agee (see David Corn's *Blond Ghost*, 1994). The Welch assassination was also seen as a convenient "hook" for stopping the Congressional investigations of the CIA, by changing the focus from "what is the CIA doing around the world," to the issue of "endangering the lives of officers by naming names." The media, which the CIA can manipulate by planting stories and calling in chits from friendly reporters, pretty much fell for this. The CIA had every reason to play up the Welch assassination, and nothing to lose.

The "November 17" group, according to Agee's autobiography *On the Run* (1987), had been stalking Welch's predecessor in Athens, Stacy Hulse, until Welch replaced him in mid-1975. They knew what Welch ate, what cars he drove, and the hours he came and left his residence. (*On the Run*, page 134).

It's apparent that "November 17" did not rely on anything Agee did in order to identify Richard Welch. Even William Colby admitted as much:

From the *Los Angeles Times*, 12/28/77, part I, page 8: ... "[William] Colby said 'bad cover' contributed to the assassination two years ago of Richard Welch, CIA station chief in Athens. This was partly a result of administrative practices that made it easy to identify CIA employees from embassy lists, he said.

"Besides, Colby said, Welch 'accepted the bad cover' by living in the same house as his predecessor and by making only minimal efforts to disguise his identity.

"Although an Athens newspaper published a story naming Welch as a CIA official shortly before his death, Colby said this had only the indirect effect of inflaming potential killers to strike at CIA employees. He said Welch's cover was not adequate to hide him, even without the newspaper account.

"Subcommittee Chairman Les Aspin (D-Wis.) reminded Colby that CIA spokesmen called a number of newspapers the morning after Welch's death to suggest that the assassination was a direct result of the newspaper's printing his name.

'I have pretty specifically avoided saying that,' Colby said. 'Maybe you are right about the first few telephone calls.'"

As Colby suggests in the above quotations, elements within the CIA seized on the Welch assassination as a convenient way to discredit Agee. But the details of what happened don't support their propaganda that Agee was responsible for Welch's death. The media, however, didn't worry about the details and tended to repeat the CIA's line. By 1982 the CIA's campaign was successful: the investigations had stopped and the Intelligence Identities Protection Act was signed by Ronald Reagan.

Barbara Bush and her fact-checkers were careless, and forgot to make allowances for the fact that George Bush has always been willing to believe the worst about Agee. George inherited the weak cover problems during his tenure as CIA director immediately following Welch's assassination.

Agee's lawsuit, if it goes to trial, hinges on whether the judge will limit the evidence to the facts of the Welch death specifically. If the

judge limits the testimony, Barbara had better reach for her pocketbook. However, if the judge allows the issue of "naming names" in general to be admitted into evidence, then Agee might not even get an apology. Barbara's defense will be that although she got the "letter" of the facts wrong, she had the "spirit" of the general situation correct.

Needless to say, if the judge is interested in his own career, he won't go against the CIA and Barbara and George. Nevertheless, Agee's lawsuit is a good idea, because it might stop some of the sloppy history, disinformation, and shoot-from-the-hip impressionism that has plagued the issue of Welch, Agee, and "naming names." If you are going to pump out disinformation, you should at least be held accountable for getting the facts right.

--Daniel Brandt

In All Directions

Santilli's Case: Can Americans purchase a copy of Ray Santilli's $70 footage of the alleged autopsy of the Roswell greys and sell dubs for cost? If it comes from the US military, the images are as much in the public domain as any in the National Archives. If he sues, he must confess a hoax...*Could You Be An Israelite And Not Know It?* A newspaper called *The Jubilee* in Midpines, CA sent a pamphlet with that title and reported that "over 90 percent of the people known as 'Jews' are not descendants of Abraham, Isaac and Jacob. History reveals they are actually descendants of the fierce Turkish, Mongolian Khazar tribes which roamed the steppes of southern Russia and who adopted the religion of Judaism between the 7th and 9th Centuries. Today, the Khazars are known as 'Jews' not because of race, but because of religion." The only thing that distinguishes this dubious predilection for pedigree from other to a non-anti-Semitic audience is it's footnoted reference, to Arthur Koestler, author of *Case of the Midwife Toad*, explicator of synchronicity and LaMarckian evolution...*Danny Casolaro Meets Ed Wood?* "B" filmmaker Al Adamson, whose masterworks included *Satan's Sadists, Five Bloody Graves, The Naughty Stewardesses* and *Dracula Vs. Frankenstein* (Lon Chaney Jr.'s last movie, was found murdered and interred beneath the Jacuzzi at his home in Indio, California, in August. Indio was the site of a series of murders that writer Danny Casolaro investigated before his own mysterious death in 1991. Those murders involved members of the local Cabazon Indian tribe that attempted to oust the tribes non-Cabazon, mob-and-weapons-industry connected leadership. Police have not connected those murders to this one, however. They arrested a man Adamson contracted to remodel his house...*Fate of the Dharma Combatants:* Nostalgic for Jim Keith's old zine *Dharma Combat*, a three page screed reported the prognostications of a gypsy psychic named Madame Natasha for sometimes *Steamshovel* contributors. Bob Black, for instance, will give up "irrelevant ideological brouhahas" to become the high-paid divorce lawyer; Ron Bonds will sell out to Rupert Murdoch; Len Bracken will flee to France (Bracken actually had plans for this at press time) and work on a drama, *Waiting for Debord* (or someone like him); Jim Keith himself will "move to take over the Christian Patriot movement (which he has already infiltrated)"; and G. J. Krupey will be exposed in *Crash Collusion* as Comte de Saint-Germain. According to the screed, Madame Natasha's crystal ball exploded just after reporting that the editors of *Paranoia* used mind-control to have X. Sharks DeSpot and Stephanie Caruana assassinate *Steamshovel* editor Kenn Thomas. The explosion killed Madame Natasha and blinded Thomas, described as a "stolid sentinel of liberty who..." and the document cuts off...*Sticking*

His Neck Out: In an unpublished manuscript entitled *Ostrich*, Joseph Headrick supports Howard Donahue's contention that JFK was accidentally shot by one of the Secret Service agents in the back seat of the follow-up car to the presidential limousine. According to Headrick, he shared a hospital room with the agent, George Hickey, in 1991, and Hickey verified the theory...*West Goes South: Steamshovel* reader Jack West lists a two page litany of legal problems, beginning with a separation from his wife in Kentucky in 1976 to exile in Indonesia in 1994. He seeks legal counsel at POB 2329, Jakarta Pusat, Indonesia...*Red Mercury Countdown:* The UK's *Sunday Times* reported in 1992 that a compound originating in Russian labs of mercury and antimony oxides necessary to the creation of miniature atomic bombs had been seized by customs all throughout Europe, but that none of it had nuclear-explosive potential. The inventor of the neutron bomb, Dr. Sam Cohen (awarded by Pope Paul VI for the neutron bomb's "potential to transform armed conflict to better reflect the Christian Just War principles"), warned about the Red Mercury mini-bomb in *Spin*, January 1995. The Associated Press reported in April 1995 that Yasser Arafat ordered the arrest of Hamas militants who accidentally blew up their own quarters, leaving behind among other things a plastic bomb with 65 pounds of mercuric oxide...*Blast Connections Wanted:* Just prior to the Oklahoma City bombing, April 19 (Waco day) an assistant secretary of the Air Force, Clark G. Fiester, his assistant Jack Clark both died along with six others after the explosion and crash of their C-21 military Learjet over the woods patch near Alexander City, Alabama. Two witnesses heard explosions while the jet was still in flight. Sherman Skolnick suggests that plane crash and the OKC bomb are connected and would like anyone with information to contact his Citizens Committee To Clean Up The Courts at 312-375-5741...*Cross The Border, Down The Line:* Two developments help in understanding the 1994 Mexican political assassinations: (1) Raul Salinas, guest scholar at the University of San Diego and elder brother of former Mexican President Carlos Salinas de Gortari, has been arrested and charged with conspiratorial complicity in the killing of his former brother-in-law, Jose Francisco Ruiz Massieu, secretary-general of Mexico's ruling, oxymoronic Institutional Revolutionary Party. The Mexican *federalis* charge that he worked on the plot while using his Visiting Scholar position as a cover; (2) Special prosecutors in Tijuana wrecked the government's lone nut theory in the assassination of Luis Donaldo Colosio, certain to have been the next president of Mexico if he had not been gunned down, by arresting Othon Cortez Vasquez, a 28 year old man employed by the current president's press office, as the second gunman. Mario Aburto Martinez, a factory worker in Tijuana, was convicted in November 1994 of Colosio's murder. Six people claiming to be relatives of Martinez illegally crossed the border and requested political asylum. Colosio's widow notes correctly, "It will be very difficult to know the truth any time soon about the death of my husband." (Special thanks to Tim Lauzon for the research.)...*Colin Trouble:* As General Colin Powell mulls overs the possibilities of a presidential bid, the conspiracy circuit will not long forget that his potential vice-presidential candidate Richard Armitage, former Assistant Secretary of Defense under Reagan, has been connected to the Golden Triangle heroin traffic by Bo Gritz and as having been compromised into corrupting the process of finding surviving Vietnam POWs and MIAs by Ross Perot. In the late 1980s, Daniel Sheehan's Christic Institute charged that Armitage belonged to a cabal dating back the Vietnam War which used profits from drug sales to finance arms

trading and secret commando operations, activity he repeated during the Iran-Contra scandal. While courting Powell as a possible vice-president for his own candidacy, Ross Perot reported these charges to the Defense Department, resulting in two FBI investigations that exonerated Armitage. Even so, it is a matter of public record that Powell, Armitage and Defense Secretary Caspar Weinberger were the only Pentagon officials with knowledge of the full details of Iran/contra arms transactions...*Dairy of A Mad Cow:* Dr. Harash Narang has received permission to conduct promising diagnostic tests on Jean Wake, a 38 year old woman who may be dying of Creutzfeldt Jakob, or "Mad Cow", Disease, a degenerative ailment of the central nervous system that once captivated the attention of investigator Danny Casolaro. Current medical technology can only diagnose the disease after the victim dies; Dr. Narang plans to develop testing procedures for Mad Cow Disease in living people as well as for its animal equivalent, Bovine Spongiform Encephalopathy, in living cattle. In the early 1990s, Bovine Spongiform Encephalopathy almost destroyed the British beef industry (Germany nearly outlawed importing beef from England) when a number of cases--1000 cases a week according to the Agriculture Ministry's chief epidemiologist--occurred among its cattle fodder. The disease has been connected to Bovine Growth Hormone, now injected into cows to improve milk production via a process developed by Monsanto Chemical. Cows injected with the hormone feed on meat and bone meal "rendered" from other animals, including other cows that have died from indeterminate cause. Cows contract Bovine Encephalopathy from eating infected meat. In humans, the disease can incubate for up to three decades. In January 1995, the *Scottish Daily Record & Sunday Mail* reported that nearly 7,000 cattle were slaughtered after Mad Cow Disease struck more than one in six farms in Scotland...Next issue out in short order: readers will not have to wait as long for the next issue of *Steamshovel Press*. The current issue was delayed by the production of two books, *The Octopus: Secret Government and the Death of Danny Casolaro*, to be released by Feral House next spring; and *Popular Alienation*, an anthology of *Steamshovel Press* back issues now available from IllumiNet Press ($19.95--address). *Popular Alienation* includes one chapter of new material, dubbed *Steamshovel Press #13*. To take advantage of the irresistable #13, all subscriptions have all been bumped up one number (all subscriptions that ended with issue #14, for instance, now end with issue #15). Individual back issues of *Steamshovel Press* are still available for $5 each plus $1 postage. An overworked editor/publisher expresses gratitude for readers' patience. *If the theory fits:* the events of the OJ trial fit the Casey Sucharski scenario more neatly than anything since the Reagan election and the October Surprise. specifically the in the OJ case. Sucharski, Michael Militello and OJ were under investigation in Florida in the 1970s for drugs--only Sucharski was ever prosecuted and he got off with $200 fine. Sucharski was found dead in Miramar, Florida, shortly after Nicole Brown's murder, and in the same time frame Militello reported back to OJ in his cell. The scenario goes like this: Sucharski arranged Nicole Brown's murder to send a message to OJ to pay off a drug debt (possibly owed to the owner of the San Francisco 49ers); OJ, through Michael Militello, arranged Sucharski's murder; the prosecution and the defense never even attempted to get near the truth--save for some thinly veiled threats sent to the court by Robert Shapiro. Add this up from the recent developments and revelations: 1. the *Vanity Fair* writer that CBS hired as the slack-jaw interpreter of the trial said one of the jury guards told him the jurors were packed on

Sunday; 2. News reports indicated that Ito ordered the jurors to pack their bags; 3. the incestuous relationships: Ito's wife was Fuhrman's boss; Nicole Brown's sister's boyfriend was defense witness Tony The Animal; 4. According to Sherman Skolnick, both OJ and Nicole both held interests in fried chicken franchises also co-owned by the Japanese Yakuza and known as drug-laundering outfits; 5. A man can't repay a drug debt from prison; Ito's juror dismissals ended with the right demographic for an acquittal. One pundit suggested on the Geraldo Rivera show that Fuhrman was the killer. Could Fuhrman also have been a mob patsy in helping put the right pressure on the court for get OJ off?

The Conspiracy Conspiracy
by Jack Burden

If you believe a growing chorus of voices in the media, Bill Clinton is the head of the Illuminati, or at least the Knights of Malta. For months now, the alternative ether has been full of rumors, allegations and innuendoes about Clinton and a growing list of supposed crimes. Clinton's alleged misdeeds range from the Whitewater scam to murdering Vince Foster to renting Mena, Arkansas to the Medellin drug cartel. Does anyone want to toss in the Simpson slayings while we're at it?

The chorus of accusers includes featured solists like Christian rightists Jerry Falwell and Pat Robertson, guns-and-God activist Linda Thompson, talk radio reactionaries Rush Limbaugh and G. Gordon Liddy as well as ostensibly countercultural publications like *Paranoia* magazine. In addition to these folks (who, after all, don't apologize for being wild or crazy), there is a phalanx of more traditional voices from what's called "the mainstream,"--i.e., the more "responsible" sectors of the ruling class. These include the editors of the *Wall Street Journal* editorial page, Lord William Rees-Mogg of the *London Times*, staffers at the Moonie-owned Washington Times and noted moral paragons like Republican Senator Alphonse D'Amato.

The claims, without substantiation, have also surfaced in the heart of the mainstream, in articles in the *Washington Post* and on TV shows like *Rivera Live*, where they are presented not as news items in themselves but as the bracketed claims of some newsworthy individual. Though the mainstream journalists present the rumors with disclaimers about their truth value, the net effect is that the rumors are reproduced. And that's all a sexy lie needs in our space age au gogo disinformation society--repetition. "Say it enough times and it becomes true" is the guiding principle of postmodern media manipulation.

Et voila: the now stock reading of Clinton as someone who, wherever he goes, is "dogged by questions," to quote the *Chicago Tribune*.

This is not to say that Clinton's record is without blemish or above reproach; far from it. But this isn't about Clinton's record, it's about smear tactics, propaganda campaigns and a double standard in the press.

Where were Clinton's accusers-- particularly pillars of the establishment like Robertson, the *Journal*, the *Post* and the *Times*-- when the Reaganites were committing shameless assaults on democracy throughout the 1980s? When real big-time conspiracies were being run from the oval office, these folks were nowhere to be found. Iran-Contra amounted to an attempted fascist takeover of the government, but the story of this conspiracy, and particularly Reagan-Bush involvement in it, was swept under the rug by

the same people who now want a special prosecutor to investigate every presidential bowel movement.

Though Clinton is dogged by questions, Reagan was never dogged by anything other than a sycophantic press corps. Mainstream journalists always shake their heads about this phenomenon, as if the Gipper just had some magic knack for avoiding incrimination. He was the Teflon president, they chuckle; nothing stuck to him. In fact though, this was due to the press acting as Reagan's Teflon shield. Now, for some mysterious reason, the shields are down and Clinton is continually blasted, not just for things he actually did, but for any comic book scenario his enemies can cook up. With Reagan, even verified assaults on the constitution like Iran-Contra were downplayed in the media. With Clinton, anything goes and it goes right to the top of the media agenda.

And consider George Bush. When the issue of his since proven Iran-Contra involvement was raised by Dan Rather during the '88 campaign, Bush simply pitched a how-dare-you-ask-such-a-question fit and the matter was dropped, never to be picked up again. (In fact, Bush scored points with mainstream pundits for "standing up to the press" and defusing the dreaded wimp factor.) When Iran-Contra Special Prosecutor Lawrence Walsh published his findings in 1993, he clearly implicated both Reagan and Bush in the scheme to trade arms for hostages, deceive Congress and illegally arm the Contras in their attempt to overthrow the government of Nicaragua. The Clinton conspiracy freaks mentioned above uttered nary a peep, though they scathingly criticized fellow Republican Walsh for wasting the taxpayers' money and conducting a witch hunt.

Clinton, on the other hand, is about to be subpoenaed by his second special prosecutor in the Whitewater matter. The first one, a Republican, cleared the White House of any wrongdoing, a finding that, in the view of Clinton's enemies, simply wouldn't do. A three man team of federal judges (all Reagan appointees) used an obscure legal loophole to declare the previous investigation invalid and appoint a new special prosecutor. The new prosecutor, Kenneth Starr, is a right-wing ideologue who, before being appointed, had offered free legal counsel to Clinton accuser Paula Jones. Is the legal system being used for political ends here? Is the special prosecutor function being abused in a blatant attempt to undermine Clinton politically? Not according to the Republicans. They deplored one special prosecutor for Iran-Contra, but for Whitewater, we apparently can't have enough.

And then there's Whitewater itself. All investigations thus far have, as I've said, cleared the Clintons of any wrongdoing. But let's assume, for the sake of argument, that all the allegations about the Clintons and Whitewater are true. Let's assume they scammed a lot of money in a shady real estate deal made possible by Reaganite policies that deregulated the savings and loan industry. That's certainly not cute, but methinks Sen. D'Amato, Rev. Robertson and company do protest too much. This is, after all, the kind of financial scam that the upper classes consider their birthright, the sort of thing for which Republicans and the Wall Street Journal ordinarily give out medals. Hell, in the Bush household you got spanked if you didn't bring home a scam like this every fiscal quarter.

Also, at its worst, Whitewater is a financial scam, pure and simple. It's not in the same solar system, let alone the same league, as Watergate or Iran Contra. One is a ripoff, and one is a *coup d'etat*. One is an 80s-style attempt to scam a quick buck and one is an assault on our system of government, on your right to have your voice heard in a representative democracy. There is a slight

difference of scale and of moral-political significance here.

But oh, you say, the death of Vince Foster looks mighty suspicious. Well, maybe, though so far several official investigations have ruled it a suicide. But suppose Foster was murdered. Does that mean the Clintons had him killed? Does President Bill look like the Godfather to you? Is he a figure of fear and terror? Clinton can't even get his version of things on TV. He can't even get fellow Democrats to stop badmouthing him for a few minutes. If this is a criminal mastermind, we're in real trouble.

As for the stories about the airfield at Mena, Arkansas allegedly used in Iran-Contra-related drug smuggling, they have the ring of credibility, given what else we know about Oliver's army. The claim that then-Governor Clinton knew about and approved the use of the airstrip by the North network is a bit flimsier, but let's assume it's true. Does this mean that Clinton is part of what the Christic Institute calls the "secret team"? Is he a national security neofascist of Ollie North proportions? And if he is, then why are North and his political cronies working so mightily to destroy Clinton?

Would that there were some truth in some of these scenarios; at least then it would mean that Clinton had some power. But there is no conspiracy being run by Clinton. Moreover, the claim that such is the case is itself part of the conspiracy against Clinton. The orchestrated pattern of rumors, allegations and conspiracy fears about the president has all the earmarks of what in the CIA they call "psy-ops," or psychological operations. Specifically, it smacks of the psy-ops subgenre called "black propaganda."

It is instructive, in this regard, to look at some of the classic CIA interventions in foreign countries. Take, for example, the agency's destabilization, in the early 70s, of the democratically elected (but, to American corporate interests, unacceptably leftist) government of Salvador Allende in Chile. The CIA ultimately armed and financed a military coup which overthrew the government and left Allende dead. But before it came to that, our boys spent a couple of years just setting up bogus media outlets and floating all sorts of crazy yet vaguely disturbing rumors about Allende. Overnight, wherever he turned, Allende was "dogged by questions."

Could it happen here? Veteran investigative reporter Robert Parry, writing in the Dec. 12 *In These Times*, thinks so:

"Today's conservative operatives have achieved striking political success by spreading wild rumors about President Clinton and other administration officials and appointees. The various Vince Foster conspiracy theories and stories about political violence in Arkansas continue to undermine Clinton's public standing and are reminiscent of the sophisticated disinformation campaigns that the CIA deployed overseas."

Parry goes on to describe the intricate apparatus of conservative institutions which have been used in recent years to promote the right-wing agenda. Such right-wing propaganda outlets are found at all levels of American culture, from popular to highbrow. They range from fringe group newsletters and radio ranters to periodicals and pundits to TV networks and think tanks. The same apparatus has been used to float and keep afloat the various Clinton conspiracy rumors. These right-wing institutions are peppered with players from the national security establishment and they employ the same dirty tricks strategies deployed by agencies like the CIA.

Take, for example, the case of one Floyd G. Brown. A huge amount of what you've read about Whitewater has not, contrary to what you may think, been dug up by the reporters whose bylines appear on the stories about the affair. The financial labyrinth

of it all is too boring and time-consuming for your average journalist (or, for that matter, your average reader). Most of the Whitewater press emanates from an organization called Citizens United, headed by a the 33 year old Brown, who looks like Rush Limbaugh's younger, more desperate brother.

Brown describes himself simply as a concerned conservative and claims no affiliation with the Republican party. He admits to having a financial base of some $3 million, supposedly raised by direct mail solicitations. His organization works round the clock to unmask what he sees as the Clinton Menace, devoting most of its expensive energy to Whitewater. Brown and company issue daily press releases and hourly fax updates on the topic. They have a Whitewater conspiracy press kit they send out to reporters that practically writes the story for them. If a reporter asks them to, they'll probably set the type and cook the coffee.

Of course, Brown and company are just doing this because they "want to see the truth come out." Mainstream Republicans are supposedly embarrassed and disgusted by Brown's sleazeball tactics and shameless taste for the smear.

But check it out: The last time Republicans were "embarrassed" by Floyd G. Brown was in the 1988 election, when they were embarrassed all the way to the White House. It was Brown who produced the racist Willie Horton TV ad which practically won the election for George Bush singlehanded. When Bush was confronted with complaints that the ad combined racist stereotypes with outright lies, he too condemned it. The ad continued to run, however, because it was the "independent" work of Brown and so, supposedly, out of Bush's control. Thus Bush was able to benefit from a race-baiting appeal while giving lip service to its condemnation. Of course Brown, Bush and the rest of the "conservatives" involved in this incident were completely unacquainted with each other and just wanted to see the truth come out. Just ask Michael Dukakis.

This is the way the game is played by the well-funded media manipulators of the right. Consequently, it's not surprising to see right-wingers like Limbaugh, Falwell and D'Amato promoting the Clinton conspiracy cartoon. What's disturbing is the way that people who should know better--members of the countercultural left--have been sucked into the scam.

Part of the psy ops strategy here is the exploitation of popular interest in conspiracy. Though mainstream rationalism would have it that American politics always proceeds in an open, orderly, democratic fashion--that conspiracy can't happen here--contemporary Americans know better. They've learned better. The Kennedy assassination seems to shriek conspiracy, but not everyone agrees on that, so let's leave it aside. Watergate was unquestionably a case of the C word, as was Iran-Contra. Conspiracies, at very high levels of the US establishment, do occur. This history has, understandably, made Americans profoundly suspicious of the words and deeds of the high and mighty.

It has also contributed to the emergence of a new genre of popular culture, one we might call *conspiracy noir*. This genre is large and growing, and includes everything from the fiction of Robert Anton Wilson and Umberto Eco to TV shows like the *X Files*, Hollywood movies like *JFK* and comics like *The Invisibles*. Combining existential dread, political cynicism, fascinating occult mumbo jumbo and the sense of significant things hovering just beyond the veil, this genre has immense appeal as both entertainment and cultural myth.

In Euro-American politics of the right, there is a tradition of conspiracy theory, an extremely checkered one. Far-rightists can always tell you the names and phone numbers

of the members of the Ruling Cabal. And though such analyses are shrill, naively personalistic and often racist, they do arise from political conditions, of oppression and corruption, that are actual, though typically misread by the rightists. This, to a large extent, is the history of what's called populism in American politics.

"Antisemitism is the socialism of fools," the saying goes. This is to say that genuine critical energy and political outrage are easily manipulated and often misdirected against racial scapegoats. Any good leftist will tell you that the ruling class isn't just a myth or an intellectual construct; that structures of power, domination and exploitation are real in a society built on principles of self interest, scarcity and competition. But by the same token, the ruling class isn't a set of personalities, let alone a racial group; it's a complex social formation that transcends individuals. If David Rockefeller or Ollie North weren't around, the forces of multinational capital and the national security state would find others eager to do the dirty work.

So beware of simplistic conspiracy theories: they're often scapegoating fantasies. But beware too of the mindset that says conspiracies never happen and that talk about them is nothing but fantasy. Both positions are irrational oversimplifications.

It's illogical to assume conspiracies happen everywhere, but equally absurd to claim, *a priori*, that they never do. Moreover, not all conspiracies are equal.

In Hitler's Germany, the myth of an international Jewish-communist conspiracy was used to scapegoat Jews and justify the holocaust. The international Jewish-communist conspiracy was a pernicious fantasy. But the Nazis' final solution, their plan to exterminate the Jews, was a conspiracy, an agreement to commit mass murder, and it was very much a genocidal reality. Moreover, in Nazi Germany, popular belief in the false conspiracy (of Jews) was essential to the working of the real conspiracy (to exterminate the Jews).

In the US today, there is, in addition to the traditional right-wing interest in conspiracy, a new element, the broad-based pop cult of conspiracy mentioned above. The *conspiracy noir* cult has evolved for reasons, both historical and sociological, that are understandable and important. Propaganda specialists like Floyd Brown are well aware of this newly expanded audience for conspiracy theory and mean to take advantage of it. Consequently, they work to generate sexy conspiracy material for the consumption of both the standard right-wing audience and the mainstream, tabloidized *conspiracy noir* culture. Such propaganda campaigns play on fantasy but have very real effects; the "crimes of Clinton" scam, with its debilitating effect on Clinton's credibility, is a case in point. What we are seeing is the exploitation of popular conspiracy consciousness for the purpose of advancing a pernicious hidden agenda.

Now that's a conspiracy.

STEAMSHOVEL 15
Fall 1996

The American Nazis and the Nation of Islam
by Saab Lofton

One might try to claim that the Black Panthers bearing arms in public is what ultimately caused their demise. Yet the Black Panthers armed themselves strictly for self-defense against cops guilty of Rodney-King-esque beatings which took place on a daily basis during their era. The Panthers never arbitrarily killed anyone. However, if the FBI

really wanted to shut down a clearly violent organization that had a long history of performing assassinations, it should have gone after the group who ordered the public execution of Malcolm X.

The Nation of Islam has since been implicated in the deaths of Malcolm X loyalists, whether they happened to be civilians or ministers of their own mosques. And if it decided not to kill a Malcolm X loyalist, or any other critic for that matter, the NOI would resort to harassment or terrorism. In 1970, Philadelphia's Uhuru Kitabu bookstore was firebombed because its employees would not take a Malcolm X poster from their store window after being threatened by local Black Muslims.

But if the following doesn't prove that the Nation of Islam is capable of being more of a threat to the community than the Black Panthers ever dreamed of being on their worst day, nothing will. This was taken from an article in *The Nation* magazine (1/21/91) written by Adolph Reed Jr., a professor of political science at Yale University:

"Most chilling, in January 1973 a simmering theological dispute with members of the Hanafi Islamic sect in Washington ignited into an attack of which only zealots or hardened killers are capable. Seven Hanafis were murdered in their 16th Street residence, owned by Kareem Abdul Jabbar; five of the victims were children, including babies who drowned in the bathtub. (The Hanafis held the Nation [of Islam] responsible and four years later occupied a government building and B'nai B'rith center and took hostages to press their demands for retribution.)"

So obviously, the FBI wasn't too concerned with an all-Black group causing mayhem. Else they would have assassinated Farrakhan as they did fellow Chicago native, Fred Hampton. Clearly the reasons why the Black Muslims were left unscathed were primarily ideological. Or as Milton Kleg,

professor of social science education at the University of Colorado in Denver put it, "unlike the Black Panthers, the Black Muslims are right-wing racists as opposed to the leftist, Marxist-Leninist Panthers."

The Nation of Islam has always shared the same, exact platform as its White supremacist counterparts. Stance by stance, right down to their opposition to Jewish life, socialism, and equal rights for women and gays. But the one position more than any other that has brought them together was their common belief that all the races should be segregated. And yes, they have come together--on more than one occasion.

In the fall of 1992, Tom Metzger was the sole guest on an episode of *The Whoopi Goldberg Show*, said that he had spoken with Farrakhan at length, and declared, as rapper Ice Cube had in the album Death Certificate, that the best thing for any young Black man in America to do was to join the Nation of Islam. Metzger also attended a rally in Los Angeles that Farrakhan gave in early October, 1985 and donated $100.00 according to both *Time* magazine and *The New York Times*.

Wayne King, who wrote that particular piece for the *Times* also said that, "cooperation between Black and White separatists is not without precedent." And he wasn't just whistling Dixie. On June 25th, 1961, George Lincoln Rockwell, "fuhrer" of the American Nazi Party appeared at the Nation of Islam's National convention at the Uline Arena in Washington, DC, and contributed $20.00.

On February 25th 1962, Rockwell was invited again to the NOI's annual convention. This time, the "fuhrer" was dressed in full Nazi regalia and was accompanied by 10 of his storm troopers all of whom had front row seats. Rockwell was one of the first speakers of the convention and said to hundreds of Black Muslims, "Elijah Muhammad [the leader of the NOI before Farrakhan] has done some wonderful things for the so-called Negro. Elijah Muhammad is to the so-called Negro what Adolph Hitler was to the German people. He is the most powerful Black man in the country. Heil Hitler!"

In a letter to his followers, George Lincoln Rockwell said the following:

"I have just had a meeting with the most extraordinary Black man in America: The Honorable Elijah Muhammad, leader of the Nation of Islam. I was amazed to learn how much they and I agree on things; they think that Blacks should get out of this country and go back to Africa or to some other place and so do we. They want to get Black men to leave White women alone, and White men to leave Black women alone, and so do we. The Honorable Elijah Muhammad and I have worked out an agreement of mutual assistance in which they will help us on some things and we will help them on others."

And then of course there was the ever-popular Malcolm X, who while he had spent the last year of his political career (and his life) as a liberal, had also spent the previous 10 years of his public life as a minister and the national representative of the Nation of Islam. During this right-wing tenure, Malcolm himself was cutting a deal with the Ku Klux Klan according to a New York City FBI file dated 5/17/61, bureau file number: 100-399321. But Malcolm's own words, taken from a speech of his given on February 15th 1965 in Harlem's Audobon Ballroom, would do the events more justice:

"The way they threw that bomb in there [referring to the NOI's firebombing of Malcolm X's home] they could have it in a Ku Klux Klan house. Why do they want to bomb my house? Why don't they bomb the Klan? I'm going to tell you why. In 1960, in December, in December of 1960, I was in the home of Jeremiah, the [Black Muslim] minister in Atlanta, Georgia. I'm ashamed to

ON JUNE 25TH, 1961, GEORGE LINCOLN ROCKWELL, "FUHRER" OF THE AMERICAN NAZI PARTY APPEARED AT THE NATION OF ISLAM'S NATIONAL CONVENTION

say it, but I'm going to tell you the truth. I sat at the table myself with the head of the Ku Klux Klan. I sat there myself, with the heads of the Ku Klux Klan, who at that time were trying to negotiate with Elijah Muhammad so that they could make available to him a large area of land in Georgia or I think it was South Carolina. They had some very responsible persons in the government who were involved in it and who were willing to go along with it [Hence the FBI report?]. They wanted to make this land available to him so that his program of separation would sound feasible to Negroes and therefore lessen the pressure that the integrationists were putting upon the White man. I sat there. I negotiated it. I listened to their offer. And I was the one who went back to Chicago and told Elijah Muhammad what they had offered. Now, this was in December of 1960. The code name that Jeremiah gave the Klan leader was 666. Whenever they would refer to him they would refer to him as Old Six. What his name was right now escapes me. But they even sat there and told stories how--what they had done on different escapades that they had been involved in. Jeremiah was there and his wife was there and I was there and the Klan was there. From that day onward the Klan never interfered with the Black Muslim movement in the South. Jeremiah attended Klan rallies, as you read on the front page of the *New York Tribune*. They never bothered him, never touched a Muslim, and a Muslim never touched him...When the brothers in Monroe, Louisiana, were involved in trouble with the police, if you'll recall, Elijah Muhammad got old [James] Venable. Venable is a Ku Klux Klan lawyer. He's a Ku Klux Klan chieftain, according to *The Saturday Evening Post*, that was up on the witness stand. Go back and read the paper and you'll see that venable was the one who represented the Black Muslim movement in Louisiana.

Yet another sacred cow of the Black community was guilty of very much the same things. There is an actual photo, albeit rare, of none other than Marcus Garvey in an all-black, custom made Ku Klux Klan robe standing before a burning cross with half a dozen Klansmen around him. This move was similar to the one Martin Delany had made in the 1870s, according to Clayborne Carson, professor of history at Stanford University. Garvey's organization, the United Negro Improvement Association, shared the Klan's goal of the total deportation of Black

Americans to Africa and even expelled members who married Whites.

Marcus Garvey met with the KKK's Acting Imperial Wizard Edward Young Clarke in Atlanta (where Malcolm X met Old Six) on June 25th (the date Rockwell went to the NOI's 1961 convention--strange...), 1922, according to E. David Cronon's, *Black Moses: The Story of Marcus Garvey* and Robert A. Hill's, *Marcus Garvey: Life and Lessons*.

Garvey's second volume of his *Philosophy and Opinions* carried an advertisement for Major Earnest Sevier Cox's *White America*, a polemic calling for racial separation. Major Cox, in turn, wrote a pamphlet on maintaining racial purity dedicated to Garvey. Cox also spoke to UNIA audiences at New York's Liberty Hall during the mid-1920s as did John Powell, organizer of the Anglo-Saxon Clubs of America. Just as George Lincoln Rockwell would speak before the NOI 40 years later and as Tom Metzger would be teamed up with Louis Farrakhan some 40 years after that.

It must be remembered, however, that it was not the mere existence of extremism surrounding these figures which brought them together. The Black Panthers were extremists, but they were extreme leftists. Ergo they never would've had anything to do with these groups and never did. In the end, it was the fact that these Black and White reactionaries shared the same belief system, the same political platform, and the same world view, not much more. In the Nation of Islam's case at least, they had already joined forces with the CIA because they felt a shared need to kill Malcolm X. And what do they always say? "You never leave the agency, once CIA, always CIA..."

Saab Lofton authored *A.D.*, an expose that documents the Nation of Islam's dealings with both the KKK and the American Nazi Party. It is available from III Publishing, POB 170363, San Francisco, CA 94117-0363.

The Octopus:
Wild Rumors

by Kenn Thomas and Jim Keith

On August 19, 1991, investigator Danny Casolaro was found dead in a hotel room, ending his investigation of a secret intelligence community cabal he called the Octopus. His body was found with both wrists slashed and an unconvincing suicide note. His work and life have since passed into the conspiracy lore. The full story of Casolaro's research is told in The Octopus: Secret Government and the Death of Danny Casolaro, *published by Feral House.*

The facts that Casolaro investigated were astounding enough, but the rumors were out of this world. Rumor had it, for instance, that the Cabazons belonged to worldwide "Reservation Operations" run on Indian lands by the "Enterprise" and Wackenhut under the project name "Yellow Lodge." (1) Yellow

Lodge allegedly produced advanced warfare projects, including parthenogenic viruses co-engineered with Stormont Labs in Woodland, California. Stormont Labs later even acknowledged that it had discussions with Wackenhut concerning biological weapons.(2)

Again according to rumor, Yellow Lodge ran operations on Jicarilla Apache lands and other Indian reservations, including a center called "D6" located in Dulce, New Mexico. UFO enthusiasts identify this location as the site of a huge underground joint human/alien base. Others believe the "alien base" to be government disinformation intended to confuse the real nature of the Dulce operation.(3)

In his notes Casolaro mentions "MJ 12 – extraterrestrial", alleged by the more excitable end of the UFO research spectrum to be a super-secret US military group charged with signing a non-aggression pact with space aliens. (4) He also mentions "Area #51," and "Pine Gap". Area #51 (Area 51) is a military test site in Nevada for advanced aerial weaponry. Although only through a recent job-hazards lawsuit has the Air Force begun to admit to the existence of the base, Area 51 has long been known as the staging ground for the U2 spy plane, the SR17 Blackbird, and is much-rumored as the home of the post-Stealth marvel called the Aurora. In 1989, someone named Bob Lazar went public with claims that he had worked at Area 51, taking apart and reverse-engineering alien space craft. Although even UFO skeptics acknowledge consistencies in Lazar's stories, his efforts at documenting his credentials and work history have met with some doubt.(5)

Pine Gap is the top secret underground American base located near Alice Springs in Australia, officially known as the Joint Defense Space Research Facility. (6) Pine Gap allegedly serves as the central American base for the monitoring of spy satellites and interception and decoding of various forms of broadcast communications between foreign powers unfriendly to the US. Pine Gap was built in 1968, ostensibly as a means of sharing space program data with the Australians. Opposition to the base grew as it became clearer that it had a more prosaic purpose--espionage. In his 1987 book *Crimes of Patriots*, author Jonathan Kwitny demonstrates that CIA manipulation led to the early end in Australia of the administration of Labor Party PM Gough Whitlam, in part because of his opposition to Pine Gap. Indeed, Whitlam was rousted after his public complaints about intelligence agency deceptions over the tragic US policy in East Timor, and the CIA's funding of Australia's right-wing Country Party. By a quirk of Australia's constitution, Whitlam was not driven from office by an election, but was removed by a governor-general he had appointed, one who had strong ties to the CIA. (7) No doubt the paranoia about this destabilization of the US ally down under fueled other rumors among locals about the underground Pine Gap base involving alien/government collaboration (8), rumors privy to Danny Casolaro.

One early page of Casolaro's notes seemingly tied together Area 51, Pine Gap, a small Pennsylvania town called Tonoma, and possibly one of its citizens, someone named Fred Dick. Perhaps tracing one of many

CASOLARO'S BODY WAS FOUND HERE WITH AN UNCONVINCING SUICIDE NOTE

convoluted dead ends that Casolaro's traced, the authors of this book dispatched an investigator to the "Tonoma, PA" in the notes, but failed to find Dick, even after placing a classified in the local newspaper, or any indication of what may have linked him to the two mysterious military bases.(9) Buried in notes written much later, however, were references to Tonomopah, Nevada, near Area 51. Fred Dick, however, remains a mystery.

Casolaro's interest in the UFO world may have begun with Michael Riconosciuto. Riconosciuto had a proclivity for flights of flying saucer fancy going back at least a generation. After Casolaro's death, he told one computer magazine that Casolaro had learned nothing more than what one of two intelligence agency factions wanted him to know in order to embarrass the other faction. One faction was called Aquarius and had a leadership sub-group called MJ-12. (10) Riconosciuto even told one writer that he had witnessed the autopsy of an alien body. The writer concluded that Riconosciuto "would have told anyone anything to get out of prison." (11)

Rumors also had it that Riconosciuto had worked for Lear Aircraft in Reno, Nevada. This connected him to both John Lear, Sr., creator of the Lear jet, and often claimed by UFO buffs as having done research on anti-gravity for the government, as well as John Lear, Jr., a former CIA pilot who also hit the UFO circuit with tales of saucers and aliens in cahoots with the US government. Lear, Jr., and Bob Lazar comprise a faction within the ufological subculture that still maintains a regular presence at its gatherings. Other members of this nexus have included the redoubtable William Cooper, whose 1991 book, *Behold A Pale Horse*, shared the title of the first draft proposal of Casolaro's manuscript and became a cult classic for its examination of Area 51, its reprinting of the anti-Semitic *Protocols of the Elders of Zion*, and its claim that JFK was shot by the driver of his car in the presidential motorcade. To a lesser extent the nexus also included Gordon Novel, by rumor and confession a minor player in the Kennedy assassination and the Watergate scandal. Some have suggested that the bizarre tales of extraterrestrials coming from this nexus serve as disinformation to deflect attention away from serious issues such as gun-running and black project weapons development. (12)

Riconosciuto had his own intergenerational connection to the UFO lore, and his own link to the Kennedy assassination. His father Marshall had been a business associate of Fred Crisman, a man involved in one of the earliest UFO incidents to follow pilot Kenneth Arnold's famed flying discs over Mt. Ranier in 1947, something called the Maury Island incident. (13) Arnold, in fact,

investigated claims by Crisman and another man named Harold Dahl that Dahl, his son, his dog and two others witnessed six saucers as the crew boated around the harbor at Puget Sound, along the shore of Maury Island. This was near where Casolaro spent time years later looking for a tape that Danger Man Riconosciuto had tossed, supposedly documenting threats he had received from Peter Videnieks of the US Justice Department. Dahl's child was burned and the dog killed when one of the saucers spewed metallic debris on the boat. Crisman and Dahl mailed metal fragments of the debris to *Amazing Stories* editor Ray Palmer, who hired Kenneth Arnold himself to investigate. Confused by what he was hearing from Crisman and Dahl, Arnold called in two Air Force Intelligence officers. They conducted some interviews, collected some of the debris, and were headed back to home base on a B-25 when an explosion on their early morning flight killed them both. The Maury Island incident was written off for years as a hoax (14), but recent research suggests otherwise, bringing up the possibility that Crisman used his possession of the saucer debris as a means to a career among the spooks.(15)

Flying saucer crash retrieval rumors mounted in 1947 near the Riconosciuto stomping ground in Tacoma, Washington. *The Tacoma News Tribune* reported upon a retrieval by William Guy Bannister, the FBI Special Agent in Charge of the area at the time. (16) Bannister became famous much later in life when he shared office space with the Fair Play for Cuba Committee in New Orleans, possibly employing Lee Harvey Oswald as an agent provocateur. Crisman, too, had been connected to Oswald via a subpoena from the investigation of JFK's death by New Orleans District Attorney Jim Garrison. Some alleged that Crisman was one of the three hoboes photographed after their arrest in the railroad yard behind the infamous grassy knoll on November 22, 1963. Crisman was notably silent about both Maury Island and JFK in his 1970 memoir of life in Tacoma, entitled *Murder of a City*, written under the pseudonym of Jon Gold. (17) He did have warm comments about Marshall Riconosciuto, however, and recounted that the young Michael "had discovered several electronic bugs" at his father's office.

NOTES:

1. "The Com-12 Briefing," *Phoenix Liberator*, March 23, 1993, p. 16.

2. Cockburn, Alexander, "Meters and Mortars," *New Statesman*, March 27, 1992.

3. "Com-12," p. 23.

4. Blum, Howard, *Out There*, Simon and Schuster, New York, 1990. Sources for the history of MJ12 abound in the rumor mill. This book, written by a two-time Pulitzer Prize nominee and former *New York Times* investigative reporter, discusses without dismissing the prospect of secret US government investigations of extraterrestrials.

It also reproduces the infamous MJ12 documents, from which lore about this unholy alliance has arisen.

5. "A Lineman For Lincoln County: Area 51's Glenn Campbell Interviewed," *Steamshovel Press #12*, 1995.

6. Sauder, Richard, *Underground Bases and Tunnels,* Dracon Press, 1995. Although this book does not mention Pine Gap, it documents similar underground bases around the world and provides a credible view of the tunneling technology.

7. Kwitny, Jonathan, *The Crimes of Patriots*, Touchstone, New York, 1987. Casolaro took extensive notes from this book primarily for its main subject, the Nugan Hand bank scandal, which began to figure prominently in the Octopus theory.

8. "The Mysterious US Base of Pine Gap," *Notes From the Hangar*, 3rd Quarter, 1991.

9. Correspondence with investigator G. J. Krupey, September 8, 1993.

10. Brown, Colin, "CIA Computer Genius Alleges Massive Conspiracy," *Technical Consultant*, December-January 1991.

11. Ecker, Don, "Inslaw: Was Wackenhut A Player?," *UFO Magazine*, Vol. 8, No. 1, 1993.

12. Hansson, Lars, *UFOs, Aliens and "Ex"-Intelligence Agents: Who's Fooling Whom? The Inside Story of John Lear, Bill Cooper and the Greatest Cover Up in History*, Paragon Research, Orlando, Florida, 1991.

13. According to researcher Virginia McCullough, Marshall Riconosciuto also had associations to Nixon crony Pat Moriarty, and references to both appear in Casolaro's notes.

McCullough notes that Moriarty helped arranged Nixon's first trip to China and was later connected to another conspiracy potentate, Bo Gritz.

Michael Riconosciuto mentions his father in point 14 of his March 1991 affidavit for the House Judiciary Committee.

14. Ruppelt, Edward J., *The Report On Unidentified Flying Objects*, Doubleday, Garden City, NY, 1956, pp. 26-27; Menzel, Donald H. and Boyd, Lyle G., *The World of Flying Saucers*, Doubleday, Garden City, NY, 1963, pp. 21-23.

15. Flammonde, Paris, "The Age of Flying Saucers," Hawthorne Books, New York, 1971, p. 13-17; Halbritter, Ron, "The Hoax On You," *Steamshovel Press #12*, 1995, p. 23.

16. Halbritter, p. 24.

17. Gold, Jon, *Murder of A City*, Tacoma, WA, 1970, p. 78

Kenn Thomas publishes *Steamshovel Press,* the magazine you now hold in your hands. An anthology of *Steamshovel Press* back issues, entitled *Popular Alienation*, was published by IllumiNet Press. He is currently working on a new annotated edition of the Torbitt Document for Adventures Unlimited Press. Jim Keith's book *OKBomb!* also is available from IllumiNet. Keith also has authored *Black Helicopters Over America, Casebook on Alternative Three* and has edited the volumes *The Gemstone File* and *Secret and Suppressed.* He is still esteemed for his old zine *Dharma Combat.*

VIRUS WARS:
Does HIV Cause AIDS?

by Alan Cantwell Jr., M.D.

Imagine going to the doctor to get the results of our HIV AIDS blood test. For years you have been looking for love, sometimes indulging in risky things to please your partner. You are not promiscuous, but you're no angel either.

Finally the moment you dread has arrived. The doctor sits you down. He has impeccable credentials: A famous Berkeley professor of molecular and cell biology, he was one of the first virologists to map out the structure of AIDS-like retroviruses back in the early 1970s. At age 59, he is a member of the prestigious National Academy of Sciences and was one a candidate for the Nobel Prize for his virus research. Supported by grants from the National Cancer Institute, the National Institutes of Health, and the U.S. Public Health Service, the professor's research has been published in leading scientific journals.

The doctor smiles, his face reassuring. You break out into a cold sweat as he opens your records and looks you straight in the eye. Your test is positive.

Your life is over. Tears are welling in your eyes and he you can hardly listen to what the professor is saying, but he seems to be telling you that there is nothing to worry about. Please listen carefully, he says. "Your positive AIDS test doesn't mean anything except you have encountered the virus called HIV. Your body has recognized the virus and now it has produced protective antibodies to the HIV virus, and that's a good sign. Don't worry. HIV is harmless. It doesn't cause and you didn't get it from sex. AIDS is not a contagious or sexually-transmitted disease. Everything will be fine. And you can have sex without fear. And don't let anyone give you AZT. That drug will make AIDS."

You can hardly believe what you are hearing. You thought a positive test meant AIDS. "Nonsense," he says. "AIDS is caused by drugs, the kind people take for recreation and sex. That is the real cause of AIDS. You don't take drugs, do you?" No, not really, you respond. "Good, then you won't get AIDS."

OK. Now let's get back to reality.

By insisting that HIV doesn't cause AIDS, Peter Duesberg, Ph.D. and his followers have evoked the wrath of the AIDS establishment. With no good treatment or vaccine in sight, Duesberg's ideas appeal to people who think the AIDS experts don't know what the hell they are doing. Predictions of one billion people infected with AIDS by the year 2025 hardly fosters confidence in AIDS scientists.

If HIV doesn't cause AIDS, why have so many gays died of the disease? According to Duesberg, HIV is picked up by sexual promiscuity combined with intravenous drug use. When interviewed in *Spin* magazine, Duesberg claimed: "Virtually all heterosexual Americans and Europeans who had AIDS are intravenous drug users. And the homosexuals who get AIDS had hundreds if not thousands of sexual contacts. This is not achieved with your conventional testosterone. It is achieved with chemicals. Those are the risk groups. They inhale poppers, they use amphetamines, they take Quaaludes, they take amyl nitrite, they take cocoaine and aphrodisiacs." He thinks the high incidence of Kaposi's sarcoma (the so-called "gay cancer") is caused by the widespread use of "poppers" and nitrites by homosexual men.

Duesberg's appraisal of HIV as a harmless virus offers solace to some gay men who are HIV-positive. His pronouncements

also appeal to people who don't want to practice safer sex.

Duesberg thinks AIDS is Africa is not due to HIV at all, but caused by malnutrition, parasites, and poor sanitation. Half the hemophiliacs in the U.S. are HIV-positive, but the professor says they are dying from the same diseases they always had, only now doctors are calling it AIDS. What about other people who get AIDS from blood transfusions? Blood normally contains many microbes, not just HIV, he declares. Why are there so few lesbians with AIDS? He says lesbian drug habits are the same as heterosexuals, and they don't use nitrites and amphetamines, as do gay men.

Duesberg asserts there is no proof that HIV causes AIDS because "Koch's Postulates" (the definitive method to prove that a microbe causes a specific disease) have never been demonstrated with the HIV virus. Furthermore, Duesberg says HIV doesn't kill cells. Virus infections traditionally act quickly and don't take 10 or 20 years to develop like AIDS. And no virus could cause the 25 or more diseases that are now included in the definition of AIDS.

Although most virologists believe HIV and other retroviruses are implicated in cancer, Duesberg dismisses such ideas as dead wrong. After studying retroviruses for over a quarter century, he insists retroviruses could never cause cancer, AIDS, or any other disease!

To prove his point, Peter Duesberg tells reporters he wouldn't be afraid to be injected with HIV. In a *New York Native* interview (July 6, 1987), Duesberg claims he would allow himself to be injected with HIV, but he told Robert Gallo, M.D. (the co-discoverer) of the AIDS virus) that "The virus couldn't come from your laboratory, it would have to be cleaner than that." With Gallo's HIV virus, "something else could be transmitted, something that could be the real cause of AIDS."

At that time (1987), Duesberg acknowledged that he did not know what caused AIDS. "I doubt that it could be a known virus or bacterium, because viruses are simply not seen, and most of the bacteria respond to antibiotics, which I'm sure have been tried and have not been effective. So I really wonder what it could be."

Nine years later, Duesberg has still not injected himself with HIV. In a letter to the *Los Angeles Times* (August 7, 1994) he wrote: "If prominent AIDS officials can be pinned down to declare which strain of the virus supposedly causes AIDS, and under which conditions, we will gladly do so."

The AIDS and cancer establishments have retaliated against Duesberg's heresies by cutting off his research grants and by disavowing any professional association with him.

When asked about Deusberg, Gallo told William Booth of the journal *Science*, "I cannot respond without shrieking."

Ignoring Duesberg is difficult. As a media gadfly he has attained a certain notoriety. A *Los Angeles Times* reporter refers to his ego as "planet- sized" and recites a story where Duesberg is asked in court who is the most respected molecular biologist. Without heistation, Duseberg proclaims, "I am." When the judge admonishes him to be more humble, Duesberg quickly snaps back: "But your honor, I am under oath!"

In an attempt to set the record straight, Robert Gallo in his book *Virus Hunting* devotes ten pages to discrediting Duesberg. Gallo writes that the method of proof required by Koch's Postulates was set up a century ago when viruses were not even known. Physicians recognize that these postulates don't wok well for many virus diseases, and frequently don't work for bacterial diseases either. In truth, the

postulates fail totally in syphilis and leprosy, two infectious diseases caused by bacteria. It is well-known, but never mentioned by Duesberg, that the bacteria causing these diseases have never been cultured in a laboratory, thus precluding the proof required by Koch.

Praising Duesberg's outstanding contributions to molecular virology, Gallo nonetheless notes that "Duesberg is not an epidemiologist, a physician, or a public health official; nor has he ever worked on any naturally occurring disease of animals or on any disease of humans, including AIDS. Nor, I believe, has he ever worked with HIV."

Gallo claims that HIV can be demonstrated in almost every AIDS case with newer techniques of viral identification and isolation. He chides Duesberg's assertion that the AIDS HIV antibody blood test is meaningless, as well as his idea that HIV antibodies are "protective." On the contrary, Gallo adds that decades of clinical experience in infectious disease indicate that most antibodies are not protective at all.

Duesberg's heresies enrage virologists who have worked feverishly to prove that viruses, especially retroviruses, are at the root of human cancer and new diseases like AIDS. Animal cancer viruses are now routinely used in human genetic experiments to "taxi in" replacement molecular material into the patient's cells. By constantly insisting that HIV can't cause AIDS, Duesberg ignores principals of virology based on decades of animal research. Not surprisingly, the National Cancer Institute has retaliated by discontinuing his research funding.

More importantly, Duesberg ignores what has been learned from accidental human exposure to HIV. For example, on July 25, 1987, at Sacramento's Mercy Hospital in California, a 38 year-old nurse accidentally sat down on a syringe filled with several milliliters of blood drawn from an AIDS patient. Fearing the worst, JoAnn Ruiz consulted an infectious disease specialist who ran blood tests and warned her about a flu-like illness that might occur within a month if she was exposed to HIV.

Six days after the accident, she came down with "the flu." Her physician reassured her this was probably just "regular flu." To her relief, her HIV test was reported as negative. However, in late August, JoAnn was still feeling poorly, and new blood tests showed severe blood abnormalities indicating immune depression. On September 15th, less than two months after the needle stick, her HIV test turned positive. She also showed signs of a yeast infection of the mouth, which can be an early sign of AIDS.

JoAnn Ruiz died of AIDS in June 1991. She was one of the first health-care workers to become infected with HIV in the workplace. Since that time, the CDC has documented several dozen similar cases. Duesberg might argue that JoAnn's death was

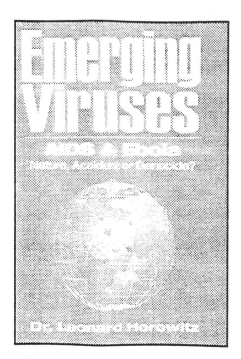

not caused by HIV because blood contains all sorts of infectious microbes. But to physicians, the evidence linking HIV to her death is clear from the history, laboratory, and clinical findings in this case. At any rate, Duesberg has never agreed to be injected with blood from an AIDS patient.

The ongoing feud between Robert Gallo and Luc Montagnier of the Pasteur Institute in Paris, concerning which scientist was the original discoverer of HIV, hasn't helped the AIDS establishment's image. Unlike Gallo, Montagnier now says that co-factors, particularly "mycoplasma" microbes, are necessary for HIV to initiate full-blown AIDS. Gallo rejects this finding and thinks the mycoplasma idea has no merit. And Gallo believes HIV comes from Africa, but Montagnier says no proof exists for this. Gallo thinks HIV originated from African green monkeys, but some molecular biologists say this is impossible.

AIDS science is filled with peculiarities which have not been adequately explained. Why did AIDS affect only white young gay men initially? In Virus Hunting Gallo writes that viruses "do select by sex, for many obvious and logical reasons," and adds that "the least risk of sexual transmission is to a man by a woman." But, before the strange and mysterious outbreak of AIDS, viruses never selected by sex. And if what Gallo says is true, why do men comprise half the AIDS cases in Africa and Asia?

Why is Kaposi's sarcoma the leading form of cancer in gay men with AIDS? Drugs can play a role, as Duesberg insists. Back in the early 1970s and before AIDS, physicians learned that deliberate immunodepression of the immune system by prescribed drugs could increase the incidence of KS tremendously. This occurred in kidney transplant cases when immunosuppressive drugs caused the incidence of KS to skyrocket 400 to 500 times normal.

KS has been studied for a century. Before the epidemic this tumor was occasionally diagnosed in older men of Jewish and Italian heritage, but it was exceedingly rare in women and was never seen in African-Americans. However, in blacks in Central Africa, KS is a common form of cancer. Before AIDS, KS was never thought to be a sexually-transmitted disease because this cancer never spread sexually from one person to another, and husbands never transmitted it to their wives. Except for transplant cases, KS was never connected to immunodeficiency.

The introduction of HIV into the gay community in the late 1970s transformed KS from a rarely seen disease into the scarlet letter of AIDS. By 1985, the incidence of KS in "never-married men" in Manhatten increased 1850 times; in San Francisco the rate of KS increased over 2000 times!

My own published KS research shows that bacteria can be found in KS tumors, as well as in the swollen lymph nodes of AIDS, and in damaged organs at autopsy. These microbes are similar to "cancer-associated bacteria" which have been demonstrated in various forms of cancer by scientists for over a century. Unlike regular bacteria, cancer microbes cannot be eradicated by antibiotics.

Ignoring the published findings of bacteria in KS, Duesberg still blames drugs for KS in gay men; and Gallo still maintains "we have looked for 7 years, and we haven't found any other virus or microbe in KS. That dosen't mean it is not there, it means neither we nor anyone else has yet found the missing link."

Also ignored by Duesberg and his followers are continuing studies that prove HIV is intimately involved with AIDS. A recently published study of a large group of gay men in Vancouver, Canada, is only one example. Professor Martin Schecter and a team of epidemiologists monitored the HIV

blood test and the sex and drug activity of 715 healthy gays for over 8 years. As time went by, 136 men came down with AIDS, and every single one of them belonged to the group of 365 individuals that were HIV-positive. Most of the men who remained HIV-negative admitted to high-risk sex without a condom, and their drug use was similar to the men who were HIV-positive. However, all the men who were HIV-negative had normal blood tests, including normal numbers of immune cells. In essence, the study showed that despite unsafe sex and recreational drugs, the immune system was not affected unless the men were infected with HIV.

Of course, like most laboratory tests in medicine, the accuracy of the HIV blood test is not 100%. But additional confirmatory tests can determine whether a person has AIDS or not. There are reports of a few AIDS cases that are HIV-negative, perhaps due to infection with certain strains of HIV that escape lab detection. Nevertheless, these facts do not negate the conclusion that HIV causes AIDS.

Why is Duesberg destroying his career, his reputation, and his livelihood, by promoting the view that HIV is harmless? Does he know something we don't?

Interviewed in *Praxis*, he states: "It's like I've gone out of the convoy. If I succeed in my mission, then I'm threatening them very seriously. I'm treated a bit like the enemy from within because I know all of their trade secrets, their tricks, and their jargon and why the claims were made and how they came together."

As a physician and AIDS researcher who doesn't believe Gallo's official theory that AIDS comes from African green monkeys and the rain forest, I tend to read between the lines. I don't totally trust a government and its scientists who have a terrible history of secretly experimenting on unsuspecting people. I am suspicious when a new virus pops up exclusively in homosexuals, especially when they have just come out of the closet and volunteered as guinea pigs for virus experiments. The U.S. government has an awful reputation of secretly experimenting on old people, poor people, sick people, Blacks, indigenous people, pregnant women, retarded and mentally ill people, and babies. So why not gay people?

When Duesberg trashes Gallo and reminds us that "Since there were no deadly viruses in the Western World since the '50s, at least some were invented in the laboratories," is he referring to the AIDS virus? And when Gallo writes in *Virus Hunting*, "Sometimes we (virologists) have a virus in search of a disease," is he talking about some laboratory biological weapon the government wants to test on gay people or other "undesirables"?

And what about "slow viruses" purported to cause "Mad Cow Disease" and incurable nerve diseases like "kuru" and so-called Creutzfeldt-Jacob disease that is now

rotting the brains of Englishmen who eat contaminated British beef?

In their book *Why We Will Never Win the War on AIDS* (1994), Duesberg and Bryan Ellison also believe "slow viruses" are a myth. They are critical of Carleton Gajdusek, who received a Nobel Prize in 1976 for his discovery of an "unconventional virus" in kuru and C-J disease. Gajdusek, a virologist at the National Institutes of Health for decades, began studying cases of kuru in New Guinea in 1957. He claimed the disease was transmitted through the cannibalistic practice of eating human brains.

Ellison and Duesberg debunk Gajdusek's kuru research and his cannibal theory, explaining that he received a Nobel Prize "for the kuru and C-J viruses he has still never found" and that cannibalism could not be verified by other scientists and sociologists. They describe Gajdusek as an unmarried and emotionally insecure man with no interest in women, "who has adopted thirty-four children, almost all boys, from obscure villages of New Guinea."

One week after Britain's mad cow disease made international headlines, Gajdusek was arrested and charged with child abuse and perverted sex practices. According to *The New York Times* (April 6, 1996), "Gajdusek, 72, has been accused of molesting a teen-ager he brought home from Micronesia in 1987. And investigators are now taking a closer look at all the children he has brought into the United States." Authorities also found no evidence that any of these children were legally adopted. Gajdusek was previously accused of child abuse in 1989, but charges were dropped because victims would not cooperate.

While virologists air their dirty linen and scientific disagreements in print, the HIV debate continues. Obviously Professor Duesberg and Doctor Gallo can't both be right about HIV and the cause of AIDS. But

could they both be hiding the truth about HIV and its introduction into the gay and Black African populations? Could their dispute be diverting us from asking crucial questions about AIDS and its origin? Questions that Duesberg and Gallo never address.

* If AIDS in Africa is a Black heterosexual epidemic, how could it have started in the U.S. exclusively in young white homosexuals?

* Was the introduction of HIV into the homosexual community an accident of nature, or a deliberate seeding of a laboratory cancer virus into the environment?

* What is the role of mycoplasma and cancer microbes in AIDS, and why is this research suppressed?

* Are cancer viruses, which form the basis of new genetic experiments, the cause of cancer? Or are they laboratory creations, as Duesberg suggests?

* Can these laboratory cancer viruses now used experimentally to make us well, also be used to make us sick?

It is unlikely that Duesberg and Gallo will ever provide satisfactory answers to these

questions. In the meantime, people are urged to use common sense to avoid catching AIDS. And people should be relieved to know that Peter Duesberg, Ph.D., can't practice medicine without a license.

Dr. Cantwell writes frequently about cancer and AIDS conspiracies. He is the author of *The Cancer Microbe;* **and** *AIDS & The Doctors of Death***, both published by Aries Rising Press, PO Box 29532, Los Angles, CA 90029.**

New
Neal Cassady
Document

by Tom Christopher

Steamshovel Debris: Neal Cassady, known as Dean Moriarity in Kerouac's *On The Road* and by other names in other Beat writings, was too hip a hipster to put much of it down on paper. His only book, autobiographical notes entitled *The First Third*, told a bit of his history, but much of the rest comes from tapes, transcripts and third party accounts that

celebrate Cassady as the Dionysian Beat party animal and say little about "a man so balled up," as Cassady described himself on the jacket of *First Third*. An important new volume, *Neal Cassady Volume One: 1926-1940*, has just been produced that begins to correct that shortcoming in history's understanding of this remarkable character. It includes four pages of previously unpublished Neal Cassady writing, photos, school records and other documents that reflect more about pre-*First Third* Cassady than any other source. The following excerpt from Volume One, a Catholic Charities report on the young Cassady and his childhood environment, illuminates that pre-history.

APPLICATION FOR ADMISSION
J. K. Mullen Home For Boys
Ft. Logan, Colorado

Boy's History:

Neal Cassady was born, 2-8-26 in Salt Lake City, Utah. He was baptized in 1938 at Camp Santa Maria and made his First Communion at Camp Santa Maria in 1938. He was Confirmed at the Church of the Holy Ghost in Denver during 1939. He is at the present attending Cole Junior High School and will enter 9-A in the fall of 1940.

He is the son of Neal and Jean Daly Cassady. Mrs. Cassady died in Denver in May 1936.

After the death of his mother, Neal lived with a half-brother, Jack Daly. However in October, 1939, Neal returned to his father as his half-brother had been remarried and the second wife did care for the boy.

Father:

Neal Cassady, Sr., was born 9-7-93 in Unionville, Missouri. He is a member of the

United Brethren Church. He has worked as a barber but in the last few years has been employed on the WPA project at Fitzsimons General Hospital.

Mother; Cassady Children:

Jean Daly Cassady was born in Minnesota and was 44 years of age at the time of her death in 1936 in Denver. She had married Neal Cassady, Sr. in 1925. Judge Lindsay performed the ceremony. Previous to her marriage to Mr. Cassady, Mrs. Cassady was the wife of James Daly, deceased. She had five children by her first marriage. All the children of her second marriage are Neal Cassady, born 2-8-26, and Shirley Jean, born 5-22-30.

Catholic Charities Contact:

The case first became known to Catholic Charities shortly after the death of Mrs. Cassady. Plans were being asked by the relatives for her son, James Daly, then 15 years old. The boy was the only minor child of the first marriage. In a short contact with this office a job was secured for James and the relatives accepted responsibility of his care. The Cassady case came to the attention of the Catholic Charities in the Fall of 1939, when Mr. Cassady asked plans for Shirley Jean. It was found that Mr. Cassady was living in the home of a XXXXXX at XXXXXX. Mrs. XXXXXX was working on WPA and was the mother of two boys, the eldest of whom was employed at Hendrie & Boltoff, and the younger boy attending high school. The XXXXXX family is non-Catholic. Some years ago Mr. XXXXXX had deserted his wife and their children. The wife has not heard from him since.

During the course of our investigation, Mr. Cassady changed his mind and did not wish to place his daughter. A little later, however, Mr. Cassady was found to be caring for the child in a cheap rooming house and to have been in a drunken state for some time. The case was taken into the Court and the custody of Shirley Jean given to Catholic Charities. She was placed in St. Clara's on 10-17-39. The girl has never been baptized.

Mr. Cassady has been known to the Denver Police Department for some years and has been frequently picked up on drunken charges. There is no possible opportunity for a child to be raised Catholic as long as they remain with him. Furthermore, his living with Mrs. XXXXXX brings about a very questionable situation since there is no proof of Mr. XXXXXX's death. Since Neal has been in the XXXXXX home, he has missed Mass frequently and has been subjected to a non-Catholic atmosphere. It was not until 1938 that Neal was afforded the opportunity of going to Camp Santa Maria that he was able to be baptized in the faith of his mother.

School Adjustment:

The school reports and adjustment of Neal in Cole Jr. High School since grade 7B through 9B show a significant correlation with home conditions. On entry to Cole Jr. High Neal was found to have an IQ of 120. He was placed in what was termed a "core" class, that is a group of advanced pupils. He passed 7B satisfactorily and in 7A achieved a rating of Honors which classed him as one of the outstanding pupils in the school. In grade 8B he received a rating of satisfactory, a standing lower than the previous honor rating. In grade 8A he was taken out of "core" class and placed in a regular 8A class, an indication that he was not doing the work that justified his placement in the higher group.

In grade 8A he received 4 C's and 3 B's; his work of the last semester in grade 9B is as follows:

Spanish D; Latin C; Earth Science D; Social Science B; Jr. Business Training C; Music C; Health Program C.

It was during the past semester that the first instance of the boy's being truant occurred. It is significant to note that the gradual downhill indication in the boy's school work coincides with the home situation he was experiencing. Near the time that he was taken out of the "core" group, the boy was rejected from Daly home. The low grades of the last semester indicate the boy's residence with his father and the XXXXXX family. It is felt that the boy has lost none of his ability, but his unhealthy environment contributed to his poorer school adjustment.

Recommendation:

It is recommended very strongly by the Catholic Charities that Neal Cassady be considered for the J. K. Mullen Home for Boys. The boy is most anxious to enter and will most likely make a fine adjustment in the institution. Furthermore, his faith will be safeguarded; otherwise, it is felt that from the family situation there is some danger of his not being raised in the Church as a practical Catholic.

Edward F. Owens

Situation:

Mr. Cassidy in CO on 9-25-39 asking placement for his daughter, Shirley Jean, age 9 years. he stated that at present Mrs. XXXXXX, a friend of Mr. Cassady's is caring for the child; she is unable to do so further.

9-26-39

Visited at XXXXXX. This is the home of Mrs. XXXXXX and her two sons, XXXXXX and XXXXXX. Mrs. XXXXXX is divorced and is working on a WPA Art Project at City Park Museum. Her oldest son, XXXXXX, is a clerk at the Hendrie Bolthoff Company. Her younger son, XXXXXX, goes to high school.

Mr. Cassidy and his daughter were present at the time. The principle reason for placement, he pointed out, was the fact that two complaints had already been registered against

Mrs. XXXXXX. These were to the affect that Shirley Jean was living at the XXXXXX home and that Mr. Cassady was paying for her care. Therefore, the complainants felt that Mrs. XXXXXX was receiving extra income and should therefore not be employed on WPA. Mrs. XXXXXX showed extreme anxiety in the prospect of losing her job and stated that she had already received two notices from WPA that the girl must not be in the home any longer.

In talking over the problem of placement, worker pointed out that since Mr. Cassidy himself was working on a steady WPA job at Fitzsimmons Hospital earning $55.00, it was possible that he may be interested in boarding home placement. He retorted that he had tried this form of care several times in the past bit with little success and that institutionalization would probably be much more satisfactory.

Worker pointed out that he would submit the request to the Placement Committee and that he would get in touch with WPA, pointing out that DCC was on the case and that plans would soon be made. Mrs. XXXXXX was extremely fearful of any contact with WPA, attempting to formulate the conversation and information he should have the WPA. this was to the effect that the girl had only been a short time with her and that she was receiving no compensation for her care. Mr. Cassidy further added that he made no cash monthly payment but rather bought clothes and food intermittently.

9-27-39

XXXXXX telephoned stating that his mother did not wish worker to call WPA and that Mr. Cassidy was going to rent an apartment and care for Shirley himself.

9-28-39

Case presented to Placement Committee and placement approved.

Later

Mr. Cassidy in CO. He stated very definitely that he did not want to place the girl. Said he had located an apartment but that he did not know the lady's name in charge. He stated that he would paid 9-30-39 and asked that rent be guaranteed by CO to that time. This was granted.

9-29-39

Mr. Cassidy in CO. He said that he had rented one room at XXX and that he would guarantee the rent personally to Mrs. Klarenback and gave a $1.50 grocery order to Mr. Cassidy at Chris' Food Store. Mr. Cassidy said that he would reimburse DCC on his next pay day.

9-30-39

Worker visited Mrs. Klarenbeck and guaranteed rent.

10-3-39

Mrs. Klarenbeck telephoned asking worker to come to her address immediately as it was most urgent.

Later

Visited: Mr. Cassidy, extremely drunk, met worker on front porch and attempted to steer him into his own room. Worker talked with Mrs. Klarenbeck who was very indignant over the entire situation. She said that she had been up all night with the racket which Mr. Cassady

had been causing. She threatened to call the police if immediate action was not taken.

Worker took Mr. Cassidy to his room. Owing to his ddrunk condition a little could be discussed intelligently. Mr. Cassidy said that his daughter was at Mrs. XXXXXX's and that Mrs. XXXXXX had received notice of her discharge from WPA. Worker attempted to get Mr. Cassidy to remain in his room all day to sober up. He was unable to tell the day of the week and was not sure to the status of his own job owing to his two or three day "spree".

10-5-39

Called at Rendrie & Bolthoff and saw XXXXXX. He is a nice appearing young man of about 20 years of age. Worker explained briefly his contact with the case and pointed out that it was rumored his mother had been discharged or was in danger of discharge from her job. In addition there was some feeling that DCC was the cause of this situation. Worker pointed out that on the contrary DCC is attempting to help Mr. Cassidy and that no contact had been made whatsoever regarding his mother. XXXXXX said that he did not know as to the status of his mother's job. He was very appreciative of the worker's visit and seemed to understand the function of DCC in this case.

10-7-39

Miss Ford, neighbor of XXXXXX, telephoned saying that she had been keeping Shirley for the past few days and that she could do so no longer. Worker explained that Mr. Cassidy was unwilling to place the girl and that DCC could do little in the situation. When it was pointed out that DCC could take the case on a court basis, Mrs. Ford said she would call the court in.

Later

Mr. Carlson, Juvenile Court, telephoned that Mrs. Smith had recommended the case to him and he would put the case on the calendar as soon as possible.

10-11-39

Custody

Case heard by Judge Madden. Present were: Mr. Cassidy, Miss Ford, Mr. Carlson, police officer and worker. the testimony of Mr. Carlson and the police officer was to the affect that at the death of Shirley's mother, the girl was placed with her aunt, Mrs. Betty Cooper on their request to the court. This arrangement held till the first of this year when Shirley was given to her father. Over the period of the last few years, there has been many complaints of drunkenness against Mr. Cassidy. Worker told the court that DCC would accept the girl if it were so decided. Judge Madden gave the custody of Shirley Jean to the DCC and ordered Mr. Cassidy to pay into the register of the court, the sum of $7.50 twice a month and in addition to provide such clothing as was necessary.

10-14-39

Visited Mrs. Jack Daly, wife of Shirley's mother's brother. The Daly's at XXXXXX have raised Shirley's brother, Neal Cassady, Jr., aged 14, since the death of his mother. It was verified thru Mrs. Jack Daly that Shirley had never been baptized. They stated that the mother was a Catholic and they were raising Neal, Jr., in the faith. They said they would be glad to stand for Shirley when she is baptized.

10-16-39

Stopped at Ebert School and secured Shirley's school report and transfer. Shirley was then taken to AMC for examination.

10-17-39

Miss Graef, AMC, called to report that Shirley's culture was negative.

Placed

Took Shirley to St. Clara's.

10-28-39

Mr. Cassidy in CO stating that Jack Daly had brought Neal Jr. back to Mr. Cassidy inasmuch as Mrs, Daly had been expecting confinement within a short time. He said that the present Mrs. Daly is a second wife and does not feel she can raise Neal from now on. Mr. Cassidy asked the advise of worker in securing a lower rate of payment through the Juvenile Court for Shirley. He was anxious that this be accomplished immediately. He said he was to be paid on November 1st, the sum of $27 and that $23 of this amount was already outstanding for the Court costs, cleaning bills, two weeks expenses for him and Neal, for barber tools and a suit in hock.

The total of these items left $4 for him and Neal to live on for the next two weeks.

Worker advised that it would be better for him to contact Mr. Carlson of the Juvenile Court direct, and discuss the situation with him. It was emphasized that the expenses that he enumerated should be definitely proved to the Court and strong reason shown whereby a reduction of Court costs would have to be permanent.

Mr. Cassidy was quite jubilant over the fact that Neal was coming to live with him and that he had resolved to give up drinking and move into a better neighborhood and support the boy in the best way possible. Stated he had told Mrs. XXXXXX that he has responsibilities which are greater now and that he could no longer afford to assist her in any manner. Moreover, he felt he could not allow himself any exclusive hold on her and informed her that it would be better for her to affiliate with whom she pleased.

He said he had not secured a room for Neal and himself yet and had asked XXXXXX to take care of the boy for the time being, which she has very "gladly" done. Mr. Cassidy intends his future housekeeping to be on a basis of batching. When the question of finances was again brought up, Mr. Cassidy said he and Mrs. XXXXXX could very well pool their resources and their families and perhaps achieve financial stability, but both feared that neighbors would again complain and that Mrs. XXXXXX would eventually lose her WPA position.

Worker told Mr. Cassidy that it had been proved definitely that Shirley was not baptized, and asked how he felt about the Sacrament being received in the institution. Mr. Cassidy stated he was heartily in favor of it.

7-19-40

See the attached summary of the case on Neal Cassidy, Junior and the contacts made by the DCC. On this date, application was made for the placement of the boy in the J. K. Mullen Home for Boys. The father was at first opposed and then in favor of the plan. From the reports received from the school, it appeared necessary to remove the boy from his present environment.

8-26-40

Neal was asked to report to the DCC for examination, pending admission to the J. K. Mullen Home for Boys on 8-28-40.

**8-28-40
Placed**

Neal came to the CO and was taken to the J. K. Mullen School for Boys, where he was given a complete examination. The admissions committee approved this boy and he remained at the institution from this date on.

**Summary to
4-12-41**

From the time that Shirley Jean was placed to the present, worker had talked with both Mr. Cassidy and Mrs. XXXXXX on occasions when they came to CO. On one occasion, Mr. Cassidy requested groceries as he had lost his WPA job and had not been able to get the household needs. Mrs. XXXXXX had come to the office several times asking for advice and always stating that Mr. Cassidy had been drinking and was not contributing the way he should. Mrs. XXXXXX has been on ADC receiving $18 per month for the one boy. Worker talked several times with Dr. Ford, the next door neighbor, who stated that the family situation has improved very little and that she feels that it is very bad for Neal and for his sister, Shirley Jean.

On 8-28-40, Neal Cassady was placed at the Mullen Home for Boys; however, on 12-31-40, Neal ran away from Mullen Home and could not be located. Worker finally found Neal at his home and was told by the boy that he did not like the discipline nor some of the boys in the home. Worker had checked with Brother previously and found that he had stolen some athletic equipment before he left.

Neal Cassady Volume One: 1926-1940 **is available for $5 (includes first class postage; international air-mail: $7) from Liam Christopher, 17101 135th Pl SW, Vashon, WA 98070, phone: 206-463-3443.**

JFK Redux
David Ferrie's Web of Intrigue

by John S. Craig

Of the vast array of characters surrounding the assassination of President Kennedy, few are more mysterious and enigmatic than David William Ferrie of New Orleans. Before and after the assassination, Ferrie's life is full of mystery, strange activity, and puzzling behavior. Cuban exiles christened him the "master of intrigue." Jim Garrison, New Orleans D.A. during the sixties, called him a key figure in the assassination of the president and "one of history's most important individuals." Robert Morrow, a CIA contract employee from 1959 to 1964, worked with Ferrie on many CIA covert operations and believes that Ferrie was the "mastermind" behind the assassination.

At the time of the assassination Ferrie was a forty-five year old New Orleans resident who was acquainted with some of the most notorious names linked to the assassination: Lee Oswald, Clay Shaw, Guy Banister, Jack Ruby, Sergio Arcacha Smith, and Carlos Marcello. He possessed assorted talents and eccentricities. He was a pilot, and at one time a senior pilot with Eastern Airlines until he was fired for homosexual activity on the job. He was also a hypnotist, a serious researcher of the origins of cancer, amateur psychologist, and a victim of a strange disease, alopecia, which made all of his body void of hair. He listed his name in the telephone list as Dr. Ferrie by right of a doctorate degree in psychology from an unaccredited school, Phoenix University of Bari Italy. Anti-Castro, anti-Kennedy, and anti-Communist, Ferrie was also a bishop of the Orthodox Old Catholic Church of North America. His odd lifestyle was embellished with an equally bizarre appearance featuring a red toupee and false eyebrows. He often made disparaging remarks concerning the intelligence of women. Investigator and author Harrison Livingstone met Ferrie and remembered him as "an intense and sinister, cynical, disgusting, disheveled individual who was excited at the prospect of preying upon the vulnerable, the helpless, and the innocent."

Ferrie wasn't always anti-Castro. In the fifties he flew guns to Castro's rebel forces as they fought Bastista's army in the Sierra Maestra. In August 1959 he was put under surveillance by Miami custom agents who believed he was involved in gun smuggling.(1) After a 26 hour surveillance and background investigation, Custom agents notified FAA officials that Ferrie was "not involved in any nefarious acts of wrongdoing." In 1961 he flew bombing missions over Cuba and sometimes made daring landings to retrieve anti-Castro resistance fighters. When Castro announced his intentions to become a Communist, and aligned his political philosophy with Kruschev's Soviet Union, Ferrie turned against him.

Communism in Cuba, and Kennedy's seemingly inability to do anything about it, drove Ferrie to become vociferous in his speech against the president. He turned against Kennedy during the Bay of Pigs debacle. In a July 1961 speech before the New Orleans chapter of the Military Order of World Wars the organization put a stop to Ferrie's remarks when he became too critical of Kennedy. (2) At this time Ferrie became a member of the anti-Castro Cuban Revolutionary Front (CRC), financed by New Orleans mafia boss, Carlos Marcello. His anti-Castro activities led him to Sergio Arcacha Smith, head of the Cuban Revolutionary Front delegation in New Orleans. An FBI report in April 1961 indicated Marcello contributed funds to

Smith's CRC in exchange for concessions in Cuba after Castro's overthrow.

Ferrie worked with Smith in counter revolutionary activities. He built two miniature submarines, which he planned to use in an attack on Havana Harbor. Ferrie became involved with Smith and Gordon Novel in a raid on a munitions dump in Houma, Louisiana. (3) Smith requested Eastern Airlines to give Ferrie a leave with pay for full-time work for the CRC. Though the request was denied, Ferrie's vacation in April 1961 coincided with the Bay of Pigs invasion.(4) The HSCA was unable to find whether Ferrie had any role in the invasion.

In March 1962 Ferrie began work as a private investigator for G. Wray Gill, Marcello's New Orleans attorney. This arrangement continued through 1963. Eventually Ferrie worked extensively for Marcello and a New Orleans private investigator, Guy Banister, an ex-FBI agent, anti-Communist, who kept an office at 544 Camp Street in New Orleans, a location known as a hot-bed of sinister activities surrounding right-wing and anti-Castro organizations. He worked with Banister the same time he was employed with Gill. It was at 544 Camp Street that Lee Oswald kept company with Banister and Ferrie.

During his public war on organized crime, documented in his book *The Enemy Within*, Robert Kennedy, as attorney general, deported crime boss Carlos Marcello. Kennedy branded Marcello as an undesirable character who had no positive use for American society. On April 6, 1961 Marcello was whisked away in a plane and dumped on a Guatamalan beach. Two months later Marcello found his way back into the country, possibly with the help of David Ferrie's pilot experience. Marcello privately vowed to get even.

In September of 1962, private investigator Ed Becker met with Ferrie's boss, Carlos "The Little Man" Marcello. He hoped to obtain funds from Marcello for an oil venture. During a whiskey-laced conversation at Marcello's country estate in Louisiana Becker mentioned Marcello's deportation. Marcello angrily announced that Robert Kennedy "would be taken care of." But he hinted that it would be done in a round-about manner. He declared that to kill a dog you don't cut off the tail but the head. The head would be the president, and the plan would include finding a nut to take the blame, "the way they do it in Sicily."

Marcello employed Oswald's uncle Charles Murret as a bookmaker in the New Orleans gambling world. In the 1970s the FBI wiretapped many of Marcello's phone conversations. However, the FBI has refused to release 161 reels of tape containing these

conversations. An FBI informant, Joe Hauser, who claimed he made several of these recordings, told author John H. Davis that Marcello spoke of involvement in the assassination and that he personally knew Oswald.

Though Ferrie officially denied knowing Oswald, it is widely believed that Ferrie met Oswald far before their alleged liaison at 544 Camp Street. In 1955 both Ferrie and Oswald were members of the Louisiana Civil Air Patrol. Ferrie was asked to leave the air patrol just before Oswald joined, but apparently still remained close to the members of the organization. Though Ferrie denied any relationship with Oswald, a former schoolmate claimed that he, Oswald, and Ferrie all worked in the Civil Air Patrol. Edward Voebel told the Secret Service that "when he joined the CAP Capt. Dave Ferrie, a former pilot or co-pilot for Delta or Eastern Airlines, was the commander." (5)

Several other members of the Civil Air Patrol said that Oswald and Ferrie were in the organization at the same time. A photo taken by John Ciravolo in the summer of 1955 at a Civil Air Patrol picnic shows Ferrie and Oswald together. (6) On the day Oswald handed out pro-Castro leaflets in New Orleans, Ferrie was leading an anti-Castro demonstration a few blocks away. Guy Banister's secretary Delphine Roberts told author Anthony Summers that at least once Oswald and Ferrie went together to a Cuban exile training camp near New Orleans for rifle practice.

In 1954 Oswald joined the Civil Air Patrol. In an interview with Look magazine in 1967 Oswald's brother Robert told a reporter, "According to Lee's own later statement, 1954 was the year when he first became interested in communism . . . I can't help wondering whether it might have been Ferrie who introduced Lee to Communist ideas. I realize that I have nothing solid on which to base such a speculation, except the timing."

The House Select Committee on Assassinations records released in 1993 revealed a flight plan (HSCA RG 233) dated April 8, 1963. The flight plan that details a pilot named Ferrie flying three passengers, Hidell, Lambert, and Diaz from New Orleans to Garland, Texas. A March 1967 FBI report cited Jim Garrison's investigation that "a group of Cuban refugees training near Lake Pontchartrain, Louisiana, presumably during the period Oswald resided in New Orleans . . . these Cubans reportedly had been 'left in the lurch' and had become angry at everyone . . . some of these Cubans attended a meeting in the apartment of David William Ferrie. One of the Cubans was named Diaz . . . also present at the meeting were Clay Bertrand, aka Clay Shaw . . ." (7)

It is well known that Oswald used the alias of A.J. Hidell and more recently there is evidence that Clay Shaw, the subject of Jim Garrison's New Orleans investigation into the assassination, used an alias of Clay Bertrand and Lambert. An affidavit accompanying the HSCA RG 233 document claims that Georgian Edward J. Girnus stated in 1967 that one of Clay Shaw's aliases was Lambert. Several witnesses have maintained that Shaw and Ferrie were seen together at the New Orlean's airport; speaking to each other in a limousine; together in Clinton, Louisiana; and at private parties and New Orlean's bars. Though Shaw and Ferrie denied knowing each other, two photos taken in 1949 show both men together at two different social gatherings. (8)

Jack Martin, Perry Russo, and Clay Shaw

Ferrie's difficulties with authorities concerning Kennedy's murder started with an FBI interview between agent Jerry P. Stein and private investigator Jack S. Martin,

November 25, 1963. Martin told the FBI that Ferrie had a relationship with accused assassin Oswald. This certainly must have been unwanted news to the FBI; just the day before the only suspect in the case was murdered and now there were others to investigate. For the FBI Martin's claims were equally disturbing and outrageous: Ferrie had instructed Oswald in the use of a rifle; he may have hypnotized Oswald to shoot the president; he had seen rifles like the one Oswald supposedly killed the president with in Ferrie's apartment, and Ferrie was in Texas on the day of the shooting acting as Oswald's getaway pilot. Martin's claim that Ferrie was in Texas was found to be false. Ferrie's Stinson Voyager airplane was found to be inoperable. An FAA document showed that Martin believed that Ferrie's airplane was airworthy as of July 1963, or that Ferrie had access to a Stinson. Martin retracted his allegations concerning Ferrie in a statement to the Secret Service.(9)

Why Martin didn't pursue these incredible claims has always been of question. He may have considered Ferrie's relationship with Marcello, a man known as a ruthless ruler of the New Orleans underworld. For Martin to pursue his strong claims might lead to a difficult situation for him.

In 1978 Martin told the HSCA that on the afternoon of November 22, 1963 he was having drinks with Guy Banister when their discussion began to revolve around long distance phone calls and politics. The two returned to Banister's infamous 544 Camp St. office where they came to blows over Martin's off-hand remark, "What are you going to do, kill me like you all did Kennedy?" Banister became furious and beat Martin with a pistol. Martin called the New Orleans police but eventually refused to press charges. This incident may have been the impetus for the interview with the FBI on November 25th. He stayed quiet about his relationship with Ferrie after December of 1963, but his allegation that Ferrie knew Oswald and may have had a sinister influence on him remains as possible today as it did in 1963.

In September 1963 Perry Russo, a New Orleans insurance agent, attended a party at Ferrie's apartment. According to Russo, after the party broke up a group of anti-Castro Cubans began talking of the possibilities of assassinating Fidel Castro. Ferrie introduced Russo to a tall, distinguished-looking, white-haired man named Clem Bertrand, whom Garrison believed was an alias of Clay Shaw. Whether Russo really encountered Shaw has been the subject of an acute controversy. Ferrie also introduced Russo to a bearded man named Leon Oswald. The conversation eventually drifted to the subject of Kennedy's inability to control the communists in Cuba. Ferrie dramatically took the floor and discussed the possibility of killing Castro and illustrated his points by showing his audience a map of Cuba, where the assassination team could land, and the routes to and from Havana.

Russo claimed he and Ferrie became friends and had several meetings. Russo said Ferrie at one time spoke of killing Kennedy and blaming it on Castro. This would give anti-Castro activists an excuse to invade Cuba - getting rid of two of Ferrie's enemies, Castro and Kennedy, and opening Cuba to free enterprise. He believed Kennedy could be killed by a triangulation of rifle fire. Ferrie elaborated on his plan of triangulation saying that two shooters would create diversionary shots and the third shooter would make the kill. There would be one shooter who would take the blame. Jim Garrison, in his 1967 interview with Playboy, discussed finding a book on firearms characteristics that was found in Ferrie's apartment after his death. The margins were filled with notations, and the most heavily annotated section was one

that described the direction and distance a cartridge travels from a rifle after ejection.

Questions about Russo's testimony were immediate. *Saturday Evening Post* author James Phelan reported that he had seen the original report written by Andrew Sciambra, a Garrison aide. Sciambra interviewed Russo February 25, 1967, three days after Ferrie died, but Phelan said the original report had no mention of any assassination plot, the party at Ferrie's apartment or any identification of Shaw or Oswald. It was two days later when Russo was put under the influence of sodium pentothal, the truth serum, that any indication of the plot, party or seeing Shaw or Oswald was given.(10)

November 1963

On Novembers 9, 10 and 16, 17, the two weekends prior to the assassination, Ferrie worked with Carlos Marcello at Marcello's remote farmhouse known as Churchill Farms. When asked about these meetings Ferrie told the F.B.I. that he had worked with Marcello to "map out strategy for Marcello's trial," The United States v. Carlos Marcello. It is curious that Marcello would spend so much crucial time together with a man who had no legal training, when he could have conferred with a variety of his legal aides like Gill or deportation expert Jack Wasserman, who played prominently in his cases.

On the day of the assassination Ferrie was in a courtroom with Carlos Marcello. Marcello was found innocent of all charges brought against him by Robert Kennedy. Only hours after the shooting, Marcello attorney C. Wray Gill, visited Ferrie's home with unwanted news. Gill was telephoned by an unknown source in Dallas saying that Oswald's wallet contained a library card with Ferrie's name on it. Oswald's former landlady in New Orleans was paid a visit by a visibly agitated Ferrie, who wondered if she knew anything about the card. Ferrie then rushed to an ex-neighbor of Oswald's and again asked for any information about the card that she might know, but was again frustrated from finding an answer. Mrs. Doris Eames, a neighbor of Oswald's, told New Orleans district attorney investigators in 1968 that Ferrie had also come by her house about the library card. Immediately after searching for information about his library card and finding none, Ferrie made a phone call to Houston to reserve a room at the Alamotel, a motel owned by Carlos Marcello.

When asked why he took the trip to Houston, Ferrie told federal authorities that he and two male companions drove all night on November 22, 1963, 350 miles, through a fierce thunderstorm to Houston to go goose hunting in Texas. He also claimed the trip was designed to gather information on how to run an ice skating rink, a business he wished to open in New Orleans. On the 23rd of November Ferrie visited the Winterland Skating Rink, managed by Chuck Rolland. Rolland told authorities he never spoke to

FERRIE'S BRAIN, PRESENT AND ACCOUNTED FOR

Ferrie about the skating rink business. All Ferrie did, said Rolland, was make and receive phone calls for hours at a pay phone.

On the afternoon of November 23rd Ferrie called his roommate, who told him that he was being accused of involvement in the assassination. Ferrie returned to New Orleans to find that the FBI and Secret Service had just learned about his library card being found in Oswald's wallet. An FBI teletype from the New Orlean's office to FBI headquarters notified Director Hoover that Carlos Marcello's attorney G. Wray Gill had notified Ferrie about the library card. Though someone at the Dallas P.D. had tipped off Gill about the card, and information about it was teletyped to Hoover, an inventory of Oswald's personal property by the Dallas P.D. shows no record of a library card. On the evening of November 23, 1963 Ferrie drove to Galveston, stayed the night and returned to New Orleans the next day. There is no record explaining why Ferrie went to Galveston.

Whether Oswald's wallet contained Ferrie's library card or not, some intriguing questions can be posed concerning the situation. If someone in Dallas safely removed the card from official evidence, why didn't they tell Gill? If Ferrie never knew Oswald, as he claimed, why did he show so much concern about the story? There is the possibility that the card never existed and was used to frame and provoke Ferrie. Framing Ferrie would implicate Marcello, an act that would only benefit the real assassins. 11 The F.B.I. questioned Gill about how he learned that Ferrie's card had been found with Oswald's affects, but Gill replied he could not recall who told him the "rumor." The F.B.I. dropped the matter. (12)

Garrison, a friend of C. Wray Gill, checked the records of office calls made from Gill's office during November 1963. He found that the records were missing, and that Ferrie had access to the records. Gill told Garrison that Ferrie had made numerous long distance phone calls from Gill's office in 1962 and '63. During questioning by New Orleans D.A. assistant Herman Kohlman and Secret Service Agent John Rice, Ferrie denied that he had been in Dallas recently. He claimed that he hadn't been in Dallas for eight to ten years. However, a close investigation of Gill's phone records show that Ferrie had made several visits to Dallas and had made numerous phones calls from the Dallas and Forth Worth area. (13) Though how many calls from and to Texas in November of 1963 may never be known, there are records that show Ferrie called Dallas from New Orleans as late as August 10, 1963; called New Orleans from Fort Worth on September 10, 1963; and called New Orleans from Houston November 17, 1963 (a call that appeared on a December billing). Clearly Ferrie lied about his visits to Dallas.

Minutes after the assassination an investigation of the Dal-Tex Building, situated at Elm and Houston Streets that overlooked Dealey Plaza, yielded a man named Eugene Brading. Brading had recently had his name changed to Jim Braden. When an elevator man had noticed a suspicious person using the freight elevator, he called the police. The police questioned Braden who said he had taken the elevator to the third floor to find a telephone. The police released him, not knowing his real identity-Eugene Brading, a convicted felon.

Braden had stayed at the now infamous Cabana Motel in Dallas the night before. The Cabana was owned by the Campisi brothers, Joe and Sam, who had close relationships with Jack Ruby and Carlos Marcello. Joe Campisi had played golf and visited the racetrack with the Marcello brothers on several occasions. In 1978 Campisi proudly told congressional investigators that he sent hundreds of pounds

of sausage to Marcello each Christmas. Ruby had visited the Cabana's Egyptian Lounge the night before the shooting, had met with a man named Lawrence Meyers, and made several phone calls, some as late as 2:30 a.m. on the day of the assassination. Early on the day of the assassination, Braden had checked in with parole officers at a Dallas federal courthouse. He gave his New Orleans address as the same building and floor where David Ferrie kept an office.

On November 26, 1963 a Georgian businessman, Gene Summer, told the FBI that he was sure he saw Oswald accept money from a man he believed was the owner of the Town and Country restaurant in Louisiana. Hoover eventually ordered an investigation of the matter. The Town and Country restaurant was owned by Carlos Marcello. This was a place where Ferrie and Marcello often did business. The FBI questioned a Marcello employee, and Marcello's brother Anthony, concerning Gene Summer's testimony, but nothing came of the investigation.

Other FBI investigations at this time focused on New Orleans. The more agents investigated Ferrie's life the more links they found between Oswald and Ferrie. The relationship surely caused some suspicion in the FBI since they knew Ferrie had a verifiable relationship with Carlos Marcello, the well-known New Orleans underworld figure and hater of Robert Kennedy. Just when the investigation was yielding clearer links between all of these individuals, Director Hoover abruptly closed the investigation of Ferrie December 6, 1963, only two weeks after the assassination. None of the information the FBI collected concerning Ferrie was ever presented to the Warren Commission. David Belin, a former Warren Commission counsel, wrote a book in 1988, *Final Disclosure*, in which he defended the Warren Commission's findings that Oswald was the sole gunman. In his book, Belin never mentions David Ferrie.

Horizon Room

On February 13, 1964, Canadian Richard Giesbrecht unwittingly overheard a conversation between two men in the Horizon Room of the Winnipeg International Airport. Giesbrecht noticed that one of the men had "the oddest hair and eyebrows I'd ever seen." He later told the FBI he was certain that the man was David Ferrie. Ferrie's companion was approximately the same age as Ferrie, late forties, wore a hearing aid and spoke with a Latin accent. Giesbrecht heard Ferrie tell his companion that he was concerned about how much Oswald had told his wife about the plot to kill Kennedy. They spoke of the Warren Commission investigation and discussed a man called "Isaacs," his relationship with Oswald, and wondered why he got involved with someone so "psycho" as Oswald. One of the men lamented the fact that Isaac's had been caught on television film sometime during the Dallas motorcade. Ferrie said that "they" had more

ON FEBRUARY 13, 1964, CANADIAN RICHARD GIESBRECHT UNWITTINGLY OVERHEARD A CONVERSATION BETWEEN TWO MEN IN THE HORIZON ROOM OF THE WINNIPEG INTERNATIONAL AIRPORT. GIESBRECHT NOTICED THAT ONE OF THE MEN HAD "THE ODDEST HAIR AND EYEBROWS I'D EVER SEEN."

money than ever. Then Giesbrecht caught a snippet of a conversation relating to a meeting that was to take place in March in Missouri, since there had been no meeting since November of 1963. Giesbrecht immediately contacted the FBI through his attorney. He gave details of the conversation and after seeing a picture of Ferrie asserted that he was the man he had seen and heard at the Winnipeg airport.

After questioning Giesbrecht and telling him that his information was important and "the break we've been waiting for," the FBI contacted him several months later and told him to forget about the matter since it was too serious and since he was a Canadian, there would be nothing the FBI could do for him if he needed protection. In a 1969 interview Giesbrecht told writer Paris Flammonde that he was 100 per cent certain the man he saw at the Winnipeg Airport was David Ferrie.

The F.B.I. interviewed two "Isaacs" that could possibly have a connection to the case. In March of 1964 Martin Isaacs, a social worker in New York City, was interviewed about his involvement with the Oswalds when they first arrived in the U.S. from Russia. Additionally, the F.B.I. interviewed Charles R. Isaacs in January of 1964, since his place of employment was listed in Jack Ruby's notebook. The F.B.I. reports claim that Martin Isaacs had no knowledge of anything that transpired at the Winnipeg Airport. The report on Charles Isaacs added little to the case, other than the fact that Mrs. Isaacs had worked for Ruby as a wardrobe designer. (14)

In November of 1993 a woman contacted author Peter Whitmey and told him that on November 18th or 19th of 1963 she went to the Winnipeg Airport to retrieve a package. While waiting in the Horizon Room she overheard a conversation between three men. One of the men said that someone was going to be killed in Dallas that coming Friday. She never told any authorities about what she heard and claims that she never knew about Giesbrecht's similar experience in February of 1964. (15)

In February of 1967, New Orleans D.A. Jim Garrison announced that he was reopening the investigation into the president's assassination. Garrison's announcement came the day after John Roselli, a mafia figure with ties to various mafioso bosses throughout the country, told Chief Earl Warren through his attorney that he had been involved in several CIA attempts to assassinate Fidel Castro. To retaliate, Roselli claimed that Castro's agents, in conjunction with mafia figures, planned the murder of the president.

Garrison spoke to Giesbrecht about testifying at the Shaw trial. Giesbrecht claimed that he was threatened with harm to his family, and notified Garrison that he would not come to New Orleans and testify. (16)

Ferrie the Suspect

In February of 1967 Garrison announced that one of his chief suspects was David Ferrie. He placed Ferrie in protective custody, accompanied by a bodyguard in a New Orleans hotel. Ferrie publicly scoffed at Garrison's allegations telling journalists that " . . . I have been pegged as the getaway pilot in an elaborate plot to kill Kennedy . . ." and that it was "fruitless to look for an accomplice of Oswald." On February 21, Ferrie was inexplicably released from protective custody before he had completely testified. He returned to his apartment.

Ferrie was found dead in his apartment on February 22, 1967. He had left two typed notes that suggested suicide. The first began "To leave this life, to me, is a sweet prospect." For several paragraphs he rambled on about crime in America and the

incompetence of the American government. The second note was brief and declared that "when you read this I will be quite dead and no answer will be possible." New Orleans Metro Crime Commission director, Aaron Kohn believed that Ferrie was murdered. The New Orleans coroner officially reported that the cause of death was natural: a cerebral hemorrhage. The day before Ferrie's death, Eladio del Valle was murdered in Miami with hatchet and bullet by unknown assailants. Del Valle was an ex-city councilman from Havana during the Batista regime. He was associated with Florida mafia boss Santos Trafficante. Del Valle and Ferrie were members of the Cuban Democratic Revolutionary Front, an organization devoted to overthrowing Castro. New Orleans D.A. Jim Garrison believed that del Valle paid Ferrie for bombing missions over Cuba. In 1961 del Valle boasted that he had assembled over 8,000 men in Cuba ready to overthrow Castro. In 1963 he was also a leader of the Committee to Free Cuba.

During his investigation, Garrison found that before the assassination Ferrie had deposited over seven thousand dollars in his bank account, and after the assassination someone purchased Ferrie a gasoline-station franchise. Ferrie also secured a job with Marcello-based United Air Taxi Corporation and later worked for Marcello associate Jacob Nastasi's air cargo service firm, a position Ferrie kept for several years. Marcello testified that he paid Ferrie seven thousand dollars for Ferrie's paralegal work in November of 1963. Though Ferrie had several interesting connections to the assassination, Garrison never linked any of Ferrie's activities to Marcello. Garrison never publicly recognized any mafia presence in New Orleans. Authors John H. Davis, Philip Melanson, attorney Frank Ragano, and Victor Marchetti and many investigators believe that Garrison's investigation was designed to protect Carlos Marcello from being linked to the assassination.

Though Ferrie's relationship with Marcello was obvious and a matter that Marcello publicly acknowledged, there is no mention of Marcello in Garrison's 1970 book on the assassination, *A Heritage of Stone*, nor is there any mention of Marcello in the Warren Commission Report.

Executive Assistant to the Deputy Director of the CIA Victor Marchetti was told by a CIA colleague that "Ferrie had been a contract agent to the Agency in the early sixties and had been involved in some of the Cuban activities." Marchetti was convinced that Ferrie was a CIA contract officer and involved in various criminal activities. Marchetti told author Anthony Summers that "he observed consternation on the part of then CIA Director Richard Helms and other senior officials when Ferrie's name was first publicly linked with the assassination in 1967."

Raymond Broshears, an ex-roommate of Ferrie, said that Ferrie had told him that he went to Houston the day after the assassination to await a call from a man, allegedly one of the gunmen. This person was to fly from Dallas to Houston in a twin-engine plane that would take them to Central America and eventually to South Africa where the U.S. government had no extradition treaty. South Africa, at the time, was the home of Permindex, an organization with a sinister and cloudy past that had been reportedly ousted from Europe for nefarious activities and had a history of connections with world-wide assassinations. Ferrie was to function as a co-pilot for the gunmen and supposedly another companion who was to be deeply involved in the assassination. The men had code names and the only codename Broshears could remember was Garcia. Ferrie said he never received the phone call. Ferrie told Broshears that the assassins panicked and

tried to fly non-stop to Mexico, but they crashed off the coast of Corpus Christi and perished.

Broshears believes Ferrie was murdered. Ferrie told him "no matter what happens to me I won't commit suicide." On the other hand, Ferrie had often boasted that he knew of ways of killing people that could be mistaken for suicide.

Broshears told author Dick Russell in 1975 that Ferrie believed Kennedy was a Communist. Ferrie had told him that he knew Oswald and that he felt Oswald did not shoot the president. Ferrie believed that Oswald thought he was working for Castro, but in reality he was a pawn in an anti-Castro conspiracy. The plotters wanted to make the assassination look like it was a communist conspiracy. In 1963 Ferrie told Broshears that four people would shoot from different angles. Later in 1964 he said one fired from a sewer opening, another from the grassy knoll, and one from behind the motorcade. Funding for the plot came from Marcello, Ferrie told Broshears, and Clay Shaw knew of many things involved with the plot but did not engineer it.

Ruby, Ferrie, and Oswald

On September 24, 1963 Ferrie made a phone call to an apartment building that housed Jean West (aka Jean Aase). Ms. West was the companion of Lawrence Meyers while they stayed at the Cabana Motel the night of the assassination. In 1993 Ms. West claimed that the fifteen minute phone call on September 24, 1963 was between Ferrie and Meyers. (17) Records of Jack Ruby's phone calls in November of 1963 showed that he had also called Jean West's number. Ferrie was known to use an alias of "Farris" on occasions. Though there is no known physical link between Ferrie and Ruby, Jim Garrison claimed that Jack Ruby's address book contained the name of "Farris."

Beverly Oliver, in her book *Nightmare in Dallas*, claimed that Ferrie was a visitor to the Carousel Club in 1963. She describes Ferrie as a shifty-eyed, creepy looking man who could speak several languages and engaged in boasting with Ruby. She also claims that Ferrie offered $50,000 to Larry Ronco, Oliver's friend and fellow employee at the Carousel, to kill Castro. Oliver, the infamous Babuska Lady, has additional fantastic stories, which include seeing Oswald at the Carousel, seeing Roscoe White on the grassy knoll immediately after the shooting, and having her film of the assassination confiscated by FBI agents never to be returned.

On December 2, 1963 Gene Barnes, an NBC cameraman, made the following statement to the FBI: "Barnes said Bob Mulholland, NBC News, Chicago, talked in Dallas to one Fairy, a narcotics addict now out of bail on a sodomy charge in Dallas. Fairy said that Oswald had been under hypnosis from a man doing a mind-reading act at Ruby's 'Carousel.' Fairy was said to be a private investigator and the owner of an airplane who took young boys on flights 'just for kicks.' " (18) Mulholland later said that he had been quoted incorrectly and that he had heard FBI agents mention Ferrie's name as a possible link to Oswald. (19) Either the FBI or Mulholland had an extraordinary amount of information about Ferrie just days after the assassination.

Ferrie had made phone calls from Dallas on January 21 and 29, 1963. (20) Raymond Cummings, in an interview with Jim Garrison's staff, said he gave a taxi ride to Ferrie, Oswald, and an unknown third man sometime between January 11, 1963 and March 15, 1963. He supposedly gave them a ride to Ruby's Carousel Club. (21) Cummings claimed he recognized Oswald as a man he

had driven a few weeks earlier from the bus station to a suburban Irving. Cummings was an ex-marine and remembered talking to Oswald about the service. Upon further investigation of Dallas taxi records, Cummings may not have had a cab during early 1963. (22)

In February of 1967 a New Orleans policeman claimed he saw Oswald and Ferrie in a car together near the mysterious training grounds of Lake Pontchartrain early one morning in the fall of 1963. He said one of the men identified himself as Oswald, but he was not clear on how the other man identified himself. Since then he has identified the other man as Ferrie. Though the officer took the men to headquarters, the men were released due to insufficient evidence of any wrongdoing.

Permindex

On March 4, 1967, three days after Clay Shaw was arrested for complicity in the assassination of JFK, an Italian newspaper with strong communist ties, *Il Paese Sera* reported that Clay Shaw was one of the directors of the Rome World Trade Centre, an organization that was run by the CIA to undermine communism. The CIA had admitted that Shaw was a contact for the agency's Domestic Contact Service during the 1950s. *Il Paese Sera* had strong links to Italian Fascists and Permindex (Permanent Industrial Exhibitions). The article also claimed that Permindex was expelled from Switzerland because of criminal activities, and that Permindex was a financial benefactor to the OAS of France and eventually was relocated in Johannesburg, South Africa. A few days later the same paper published the names of men involved in anti-communist activities through Permindex. Several other communist newspapers, the Italian *L'Unita* and Moscow's *Pravda*, began to add to the fantastic claims of the conspiracy theories of Permindex. Eventually many researchers began seeing the Permindex connection as a disinformation campaign orchestrated by the CIA or more likely communist organizations in Europe. The history of Permindex is complicated and mysterious. Though it was never ousted from Switzerland by the Swiss government, as *Il Paese Sera* reported, it did move to Rome and then South Africa. The Rome World Trade Centre and Permindex have a shadowy past, but that darkness maybe nothing more than shadows cast by communist political organizations intentionally clouding the conspiracy issue with disinformation. (23)

CIA contract agent Robert Morrow claimed that while working at Permindex in the early sixties he received a call from David Ferrie from Switzerland. Ferrie had been instructed by CIA contacts to tell Morrow to go to Paris and pick up a packet of papers from an American couple who had recently been traveling in the Soviet Union. They had been given the packet of papers by a CIA agent, a "Harvey of Minsk." Since Oswald was living in Minsk during this time, Morrow firmly believes it was Oswald who was providing information for the CIA. Morrow also recounts a story about Ferrie's associate Eladio del Valle. Del Valle had called Morrow in the early autumn of 1963 and requested four walkie-talkies, low-frequency transceivers that could not be traced. Morrow knew that del Valle had connections with the mafia and various anti-Castro groups. Morrow provided the equipment and believes that one of the radios he furnished can be seen in pictures taken of Dealey Plaza on November 22, 1963, hanging out of a man's back pocket.

Four 7.35 Mannlicher rifles

In Morrow's 1992 book *First Hand Knowledge*, he details several CIA missions in

which Ferrie acted as a pilot for several of Morrow's covert operations in Cuba. Ferrie also served as an assistant to Morrow when he was instructed by the CIA to purchase weapons in Europe. Morrow claims that his CIA case officer, Tracy Barnes, spoke of many of the Ferrie's New Orleans colleagues as early as June 1961. In 1961 Morrow was instructed to fly to Greece to facilitate the purchase of Schmeisser and Thompson machine guns stored in a Permindex warehouse. Barnes told Morrow that Clay Shaw, a contract consultant with the CIA, had helped the CIA organize the sale, and his right-hand man, Ferrie, had worked with del Valle and Jack Ruby in the arrangement.

In July of 1963, Morrow, upon instructions from case officer Barnes, purchased four 7.35 Mannlicher rifles from a surplus store in Baltimore. Before passing on the rifles Morrow was directed to alter the forepiece of each rifle so they could be easily dismantled and reassembled quickly. Morrow was then contacted by del Valle and told to deliver the rifles to Ferrie in Baltimore.

On August 1, 1963 Morrow delivered the rifles to Ferrie. Ferrie told Morrow that they were to be used in the assassination of Juan Bosh of the Dominican Republic. Morrow believes the guns were involved in the assassination in some manner and told the Church Intelligence Committee of the Senate and the House Assassination Committee the complete story. Morrow writes in *First Hand Knowledge* that Barnes had described Oswald in 1961 as being a CIA contact who had penetrated Banister's right-wing enclave in New Orleans. Morrow candidly declares that Ferrie was the "brains" behind Shaw and Marcello's various operations, and that Ferrie was the central planner of the assassination.

Conclusion

After the assassination, the Secret Service put Marina Oswald under protective custody-a state she remained in for over three months. According to researcher Harold Weisberg, in his book *Oswald in New Orleans*, on November 24, 1963, the day that Oswald was shot by Ruby, Secret Service agents asked Oswald's wife Marina whether she knew a Mr. David Ferrie. She said she did not.

In January of 1992, a former attorney for mob boss Santos Trafficante and Teamster leader Jimmy Hoffa, Frank Ragano, spoke of a meeting he had with Hoffa in early 1963. According to Ragano, Hoffa asked the attorney to tell Trafficante and Marcello that he wanted the president killed. Ragano didn't take the threat seriously but passed the word on anyway. He was shocked to see their reactions; it appeared to Ragano that they had already considered the thought.

On November 22, 1963 Ragano said Hoffa called him and asked him if he had heard the good news. Hoffa reportedly said that it looked like Bobby would be thrown out of his attorney general position by Johnson. That night Ragano had dinner with Trafficante. Trafficante made a toast to the actions of the day declaring that their problems were over and that access to Cuba would be a reality. Ragano said that Marcello

DAVID FERRIE AND LEE HARVEY OSWALD

told him that Hoffa owed him, and Hoffa recognized the fact that Marcello had done him a big favor.

Though the JFK Assassination Records Collection Act of 1992 has released a significant amount of key documents, in August of 1993 two documents concerning Ferrie were officially restricted from public record. Both records, according to the National Archives, were "withdrawn from this file" because the records contain "otherwise restricted information." One record, whose subjects were Arcacha Smith, Ernesto Betancourt, Ferrie, and Juan Doll, was withdrawn by the authority of the FBI, INS, and HSCA. (24) The other record, whose subjects were Ferrie, Broshears, Jim Garrison, and Lyndon Johnson, were withdrawn by the authority of the Secret Service.(25)

Transcripts of Ferrie's FBI interview have been buried in the National Archives. They were not turned over to the Warren Commission. Author John H. Davis, a Board of Advisors of the Assassination Archives and Research Center in Washington, D.C., has reported that a 30 page FBI report on Ferrie is missing from the National Archives.

NOTES:

1. HSCA, v. X, p. 109.

2. JFK document 014904.

3. HSCA v. X, p. 109.

4. HSCA v. X, p. 109.

5. CE 3119, p. 771, Secret Service report 00-2-34,030.

6. *The Search for Lee Harvey Oswald*, Robert Groden, Penguin Studio, 1995, p. 76.

7. FBI report 62-109060.

8. *The Search for Lee Harvey Oswald*, Robert Groden, Penguin Studio, 1995, p. 18.

9. HSCA v. X, p. 115.

10. James, Rosemary and Wardlaw, Jack. *Plot or Politics*, Pelican Publishing, 1967, p. 79.

11. "The Kennedy Contract: A Review," Mike Sylwester, *The Fourth Decade*, November 1993, v. 1 no. 1, p. 25.

12. *The Kennedy Contract*, John H. Davis, McGraw Hill, 1992, p. 113-114.

13. Peter R. Whitmey, "Did David Ferrie Lie to the Secret Service?" *The Fourth Decade*, January 1996, v. 3, no. 2, pp. 5-9.

14. Ibid. p. 22-23.

15. Ibid. p. 24-25.

16. Ibid. p.22.

17. Peter R. Whitmey, "The Winnipeg Airport Incidents," *The Fourth Decade*, November 1995, v.3 no. 1, p. 23.

18. CE 2038.

19. Peter Noyes, *Legacy of Doubt*, Pinnacle Books, NY, 1973, pp. 117-118.

20. Peter Whitmey, "Did Ferrie Lie to the F.B.I?," *The Fourth Decade*, v. 3, n. 2, p.8.

21. *The Kennedy Conspiracy*, Meredith Press, NY, Paris Flammonde, 1968, p. 182.

22. James, Rosemary and Wardlaw, Jack. *Plot or Politics*, Pelican Publishing, 1967, p. 145.

23. "Permindex: The International Trade in Disinformation," Steve Dorrill, *The Third Decade*, v.2 no. 1, November 1985, p. 11-15.

24. HSCA 1801007810412.

25. HSCA 1801007610172.

Timothy Leary:
The Unpublished *Steamshovel Press* Interview
by Kenn Thomas

When Timothy Leary accelerated off this plane of existence on May 31, 1996, *Steamshovel Press* lost a comrade with whom it had maintained contact on and off for a number of years. *Steamshovel* reported regularly on the various public spectacles involving Dr. Leary, like the failed attempt to connect his psychedelic research work to government radiation experiments and his arrest for smoking a cigarette at an Austin airport.

In *SP#7 Steamshovel* began a dialogue about the relative merits of personal computer technology with Dr. Leary at a lingerie party he was conducting at his Beverly Hills home. In September 1992, *Steamshovel* editor Kenn Thomas continued that dialogue at the studios of radio station KDHX. That interview is published here for the first time. *Steamshovel* offers it here as a send-off to its departed friend, whose ashes are expected to be launched into earth orbit even as this issue goes to press.

Q: Dr. Leary...

A: Yeah!

Q: Hello, welcome!

A: Who's this?

Q: This is Kenn Thomas.

A: Oh, hi, Kenn!

Q: I'd like to talk to you about your lectures. Do you use a VR lab?

A: No, not any lab. I bring audio tapes. I can't reproduce the 360 degree immersive environment of the right brain experience, but we get the idea...I'm getting feedback here (on the tape of this conversation)...

Q: We're getting rid of it...carry on.

A: It's enough I have to say these words, I don't want to have to hear myself.

I run through a series of, I call them left brain/right brain switches. I demonstrate how you can put yourself into a trance state with the audio-visual overload simulation, and then how your right brain can reprogram your mind so you can come out with new ideas, new realities. I demonstrate not with head mounts and not with the full technology, but at least you get the idea, and hopefully people will get a mild hallucinogenic trance state and mild experience.

Q: (still adjusting tape equipment) I'm pushing buttons and switches here and it sounds like everything you're saying is coming through with feedback, psychedelicized...

A: Sound, hypnotic hypnotic hypnotic trance trance trance...reimprint a new concept...

Q: Do you talk about historical topics at all? You're one of the most interesting historical figures, or do you just kind of concentrate on computers and trance states?

A: No, I mix. You can't talk about the present and future without talking about the past, and I review the past, where we came from, where we're going. And then there's the question and answer period, at least half of it will be questions and answers, so that people can ask any questions they want, you know, about

what it was like to be there in Athens with Socrates, growing marijuana with George Washington on Mt. Vernon. I try to bring up history if people ask me about it.

Q: I read *Flashbacks* and understand that much was left out and that you have several hundred pages that weren't included in the published version.

A: Well, that covered about 10% of my life.

Q: What could you tell us about Mary Pinchot Meyer?

A: That's an issue in my life that's kind of minor, as far as I'm concerned, although it's major as far as history is concerned. Mary Pinchot Meyer was well established, was a mistress to John Kennedy and a close confidant and he was even thinking of marrying her when he left the White House. And she was a member of a group of very intelligent women in New York City and Washington who were using psychedelic substances to work with men in power, to help them expand their consciousness and to get more vision and to get a broader picture of life. And Kennedy was one of those people, and the story about Mary Pinchot Meyer was that she was mysteriously

assassinated, and they never found out who did it, and the CIA came to her house and took all of her diaries. That's a matter of record and fact. So there's a lot of mystery there. And I'm not a great conspiracy buff, and we all know we don't know the truth about Jack Kennedy, but I don't spend a lot of time with it because there are more important things to worry about. But that's an intriguing little side issue in history. But the important thing is, you know, how it helps us in the future to think for yourself more effectively, communicate more clearly and question authority. So I'm interested in methods that can help people right now deal with a potent situation and hook up in better link-ups to make a better world.

Right now, why are we talking about the Kennedys? That's nice if it had something to do with something happening in the White House now. Two of the most monstrous, nitwit, psychotic, bungle-foot, people, Quayle and Bush, and we're basically talking about how the Kennedy's liked good music. That's great, but what are you going to do about Buchanan, and Pat Robertson? Good God, they're raving maniacs! Any born again Christian who believes that right-wing stuff of Pat Buchanan should not be allowed to operate heavy machinery. But the idea of speaking about the government--can you imagine the absolute horror of Pat Buchanan in the White House?

Q: I was just wondering if I could pick your brains for your memories of the Kennedy assassination.

A: I don't want to talk about that. You have hundreds of people working on it, we don't need another person. I'm just not interested.

Q: Okay, let's move on to another topic.

A: I saw Oliver Stone's movie. I liked it, but I don't know anything.

Q: Does the ability to shift from right brain to left brain employ ancient Hindu tradition?

A: The Hindus and most of the Eastern religions have said that the aim of your life is to get illuminated or to go within. That's also what Socrates said, the Greek tradition. The aim of your life is to "know thyself" and help yourself grow in wisdom and intelligence. Actually, though, the Catholic Church has developed the best methods of brainwashing, and the Catholic Church has incredibly wonderful things to get people into a trance situation by using overload: the bell. For hundreds and hundreds of years, for people, peasants living in villages, suddenly the church bell would come at certain times and they'd never heard a sound like that. It was the largest, loudest thing, except for lightning, and of course, lightning comes from God, so the bell is telling you that God is the Catholic Church. And then, of course, all of the multimedia effects, special effects of the Catholic Church, the candles, the incense, the Gregorian chant, the rose windows, the jewels, the Pope's costumes, these enormous cathedrals where you look up and it puts you immediately into a state of trance an hypnosis. Must be God. Only God could bring those diamonds and those jewels, because the brain loves to be stimulated. The way to get through to your brain and turn on your right brain is to over-stimulate, and particularly with sound and also with flashing diamonds and reflections and gold and candlelight. We all know that the eye loves that. The Catholic Church has been using that for a thousand years to program people's minds so that they actually believe such crazy, psychotic stuff, that someone named Jesus Christ died for your sins and will come back and be your

personal savior and on and on and on...or is that because of the power of the hypnotic, multi-media, audio-visual effects of those wizards of the Catholic Church?

Q: So you're saying that a little IBM PS/2 can compete with all that?

A: You get the CD-ROM, you got to have good graphics and good sound, but you can do it yourself, yeah. We have custom designed hallucinations, put yourself in a trance state and imprint yourself. And, of course, television does that. Television, all the commercials, they overload you, you know, where you are, is it water, is it desert, what's that flash flashing? The night belongs to Michelob. Well, you can do the same thing. The night belongs to you and your boyfriend or girlfriend. We're trying to make for this power, which has been in the hands of the big networks and the big media, mass media people, to the individuals, so that, number one, you'll know when you're being brainwashed, you'll know how the church or George Bush's campaign is trying to do it to you, and you can do it yourself.

Q: Some people have suggested that virtual reality is nothing more than expensive toys for rich people, and just another way to catch an expensive high. How can virtual reality assist social change as far as you see it?

A: A compact disc plays off a Nintendo or any C-Turbo Graphic 16, the Turbo Graphic 16 sells for $69, 16 bit. That's the equivalent of an IBM five years ago, with a CD-ROM attachment. One CD-ROM disc can have a hundred books, can have hundreds of color graphics, lots of sound, brilliant stereo sound, and a few minutes, right now, of slow motion video. And that's running on equipment that costs less, listen to me, it costs less for a CD-ROM player than the textbooks that kids do not read in school now. Now this is not...I'm totally opposed to this high-tech, high expensive stuff. We want to put the "high" back in high technology. We want it available to the Third World kid or any inner city kid. That's the aim of all of my work, is to empower individuals. I'm not the elite or the wealthy, so...and there's one law about electronic equipment: within in two years, everything that's selling now is gonna be half price. It's gonna be ten times more powerful in memory and the amount of images it"l give you, and about a third of the size. Electronics are basically almost free, and the textbooks are rich and cost a lot of money. It's the textbooks that require the wood pulp that's destroying the Amazon rain forests. Electrons don't use any material stuff except in instruments and players. Now believe me, anyone who's thinking this is toys of the rich,

just go down to the Nintendo store, see what's on those screens. These 12 year old kids are flashing stuff around. Right now it's Donkey Kong and the Mario Brothers, but we're gonna get great images up for the school room or the living room, and of course also to create your own right brain activating trance situation.

Q: Isn't that what you're up against, though? A lot of this is Donkey Kong and Teenage Mutant Turtles and its media that inundates people with images of violence and silliness.

A: Absolutely, but we're going to make you wrong. You can't sit around and tear your hair and not do it. We've got to take over that power, electronic power, and change it. Don't complain about it. Do it. Do it, and...it's happening very quickly. Nintendo kids from the 1980s with Donkey Kong and those horrible shoot-em-up games are getting older, getting into like girls and boys, and they like to dress up, they want more sophistication. yes, we all deplore the violence, but the thing to do about it is to not turn the whole electronic thing over to the bad guys. We've got to move in and take it over so the screens will flower with beautiful images and peaceful images and sexy images, not guns and bashing.

Q: Do you watch the Democratic and Republican national conventions?

A: Not very much. A little bit.

Q: What do you think?

A: The thing about politics in America, and I'm going to shock some people I hope by saying this, is that when you look at the evil men and the body count of great empires, and the distortion and betrayal of power, the American government under Republicans starting with Abraham Lincoln, through Teddy Roosevelt, right down to Grenada, and now, the Republican Party, with its CIA, and its big military and its oil, is the most evil of any empire in world history. It makes Stalin look like nothing. Stalin was killing a lot of people, but we all knew it, and Russia was a very primitive czarist country. Whereas America is the land of the free to the world, and so the Republicans come in and sabotage that. The body count--think of the guns circulated in the world in the last twenty years by the Republicans and the Pentagon. Think of the body count of the wars that America has indulged in. Think of the prison count right now, the number of people in America in prison is like three times more than in South Africa and China put together. We're the largest imprisoning country in the world right now! And Stalin wasn't going around making people pee in bottles.

I'm trying to make the point that the totalitarianism in America is even more evil because you don't notice it. Did Stalin ever make the people piss in bottles, you know, urine tests? Did he poke his nose into reproductive rights? And he was dealing with an agricultural, rather primitive, society that he took over, whereas the Republicans now are dealing with a very open-minded, sophisticated country, America, and is getting away with a lot of stuff that I would call totalitarianism.

Q: Think of the body count on the streets right now too.

A: There you go. It's like taking a country like America and having these ridiculous wars, meanwhile education is down, child mortality is up, the morale of young people today is absolutely destroyed. For the first time in history young people can't look forward to having better economic conditions and better

education than their parents and their grandparents. Thanks a lot, Nancy and Ronnie. The Democrats, of course, are not much better. The American system is through, just like the Soviet Union, the United Soviet States of America is through. We've got to decentralize, just like the Soviet Union.

This is a rant and I'll stop it. We've got to vote for any candidate that will loosen the power, loosen it. Right now, just like

WHY NOT? —1996

before Gorbachev we had Brezhnev, you have Yeltsin because he was looser than Gorbachev. We've got to go all out for Clinton and Gore knowing that they are not the answer but at least they'll loosen things up and we gotta keep that going.

So you gotta vote for Hillary and Clipper [sic], but then we want the next people. A Yeltsin will come along. I don't know who that is, but none of us like a central government in Washington.

Timothy Leary's last book, *Chaos and Cyberculture,* **is available for $19.95 from Ronin Publishing, Box 1035, Berkeley, CA 94701.**

There is no form of energy on this planet that is not recorded somewhere on your body. Built in every cell are molecular strands of memory and awareness. --1966

Higher Intelligence, located in interstellar nuclear-gravitational-quantum structures, has already sent a message to this planet. The UFO message is in the form of the DNA code and of electro-atomic signals which can be transceived by the nervous system.
Each life form on this planet is an alien immigrant from outer space. We are all Unidentified Flying Organisms. --1977

Why not? --1996

Caries, Cabals, Correspondence
Letters from Readers

Over the years I have come to regard John Judge as a suspect character and your interview with him in *SP #14* highlighted the reasons why.

My first exposure to Judge was a few years back via a two tape set of a lecture/Q&A session he conducted before an audience of true-red leftists at a church in (where else?) Berkeley, CA., about 1986. They all reacted appropriately: gasping in awe at John's revelations, snickering in derision at the one unenlightened fellow in the audience who

persisted in quizzing Judge about ideologically incorrect conspiracy theories, such as the alleged divisions of Russian troops massing along the US-Mexican border. The only thing that made me wince harder than that ridiculous question was Judge's ridiculous answer: as the true believer's in the audience tittered, Judge quipped something like, "Why would they be there? To come to tea?"

Now, even a leftist in the mid-80s would have had to admit, if only to himself, that a Soviet invasion of the US wasn't completely out of the question, even from Mexico. It was no more inherently ridiculous than many of the things Judge had to say. But Judge tipped his hand by declaring, with some dithering around, that he regarded the Soviet Union, even though an obvious military state, as basically a defensive power. Although I considered myself a leftist at the time, even I couldn't buy that. But I overlooked it in light of Judge's other information.

Since I no longer consider myself a leftist, I can no longer overlook Judge's half-truths and remain silent about them. While I won't deny much of his critique, it is a skewed, lopsided, half-assed thing, concerned with objective truth only when it advances his ideologically partisan agenda. Judge is the kind of character that mocks the McCarthyist tendency to see a communist under every bed, then goes ballistic seeing Nazis under the same mattresses.

Judge, of course, denies that he's a conspiracy theorist; and, indeed, he doesn't speculate: since he's got all the answers, he dispenses revelations with certainty. He knows where all the bodies are buried, and who all the villains are. (Rep. Torricelli isn't a "saint" because he "openly calls for a US invasion of Cuba"? Gracious, what will happen to that nice Senor Fidel?)

This is his legacy as a devotee of the late Mae Brussell, whose Jewish paranoid world view Judge shares, even though he's not (as far as I can tell) a Jew. And just like his Guru Ma and his arch rival to her throne, Dave Emory, there are two very conspicuous powers that escape the Brussellian critique: Israel and the former Soviet Union. I don't think that is coincidence.

For all his posturing as some sort of fringe prophet, Judge is heavily invested in the consensus view of the Nazis as the worst mass murderers in all history and the very metaphysical embodiment of evil. Never mind that the communists murdered millions more, in Russia alone, before the Third Reich and after it. And when the millions more slaughtered in other communist countries in the name of the dictatorship of the proletariat are added, the true size of the communist mountain of corpses compared to the Nazi molehill becomes hideously apparent to every honest student of history. But, as most of us know but dare not say, it's not a matter of how many were killed, but of who was killed that determines the identity of the officially sanctioned Beast.

Which brings me to ask why Judge hasn't been stumping for trials of former communists for "crimes against humanity" in Russia and eastern Europe? He also seems to be mute on the need for war crimes trials for the Israelis responsible for the mass executions of Egyptian prisoners of war unearthed a few months ago in the Sinai, but then, so does most of the world (That story sure got a lot of press, didn't it? One can only imagine how different the media reaction would have been had the boots been on the other cadaver.)

Of course, maybe Honest John has never been an actual KGB-Mossad

disinformation agent just because he's parlayed the right propaganda for the role, maybe he's just nostalgic for those glorious Popular Front days when naive democrats allied themselves with overt and covert communists to fight the fascist menace. John would have been in his element in the OWI under Herbert Marcuse, cranking out anti-Nazi propaganda preapproved in Moscow.

But when all is said and done, John's just another aging New Left yippie, and nothing proves this more than his idolatry of black militants. John has his nose so far up the Big Black Butt of Political Correctness, that he doesn't mind falsifying the facts of the Black Panthers relationship to the '60s media. Of course the Panthers didn't get on Nightline, there was no such show then. But they did get all the free, often fawning publicity from the media that could be gotten in that time period. The various Panthers had best-selling books published that were taught in high school and college course to gullible white students by radical teachers. They were acclaimed by avant-garde writers like Genet, and feted and funded by limousine liberals and radical chic fops like Leonard Bernstein, and balled by guilt-ridden white ingénues. Airhead white leftist students swooned over them like bobby-soxers and tacked posters of Huey Newton on his wicker throne on their walls next to other radical pop stars like Che Guevara. Wherever they showed up in their black leather, Afro-fascist drag, the TV cameras and microphones materialized, hanging on every cliched slogan and clenched-fist posture. And Brother Huey and several others, got away with murder-- literally--again and again, in Oakland, in New Haven, in San Francisco, thanks to the nexus of liberal media hacks, white radical student revolutionaries, and leftist "civil rights" shysters like Charles Garry.

Yet Judge Dread would have us believe that in comparison, the militias are getting kid glove treatment, and even being encouraged. Everything I have seen or heard regarding them coming from the mainstream media is no different in tone, or even actual phrasing, than what Judge says. While I will agree that many camo-clad Second Amendment absolutists are badly in need of a broader education in the concepts of freedom and tolerance, anybody who conjures up the nightmare scenario that Judge does, of an incipient Nazi resurgence with all the accompanying genocide, then says, "You are not going to win a pop-gun war with the current US military," and that "the thing to do about it is to expose it and to work for a democratic and public solution to it," either can't be serious about what he's preaching, or is actually up to something other than what he claims.

But of course to Judge, the militia's main crime is that they are overwhelmingly white, and even (the horror!) proud of it. They're not shedding tears over the dead children in Somalia or Bosnia or wherever like good, humane leftists do; instead they're mourning Randy Weaver's dead family members, or those Waco kids. One has only to peruse the left press' coverage of those incidents to see where the boundaries of humane "progressive" concern lay: as far away as possible, and preferably where skins are as dark as possible, but not here, among those that look like us but think differently. Among the left establishment, only Alexander Cockburn, to his credit (and he doesn't deserve much credit otherwise), dissented from this self-righteous *schadenfreude*. Here, once more, John Judge reveals himself to be more in

tune with the elite opinion-molders than with any true populist position. Which, considering that his work has always advanced a far left agenda, should come as no surprise.

G. J. Krupey
North Huntingdon, PA

John Judge has always had great potential as an author, but other than that article he wrote on Jonestown, which used to be reprinted in a different zine every few months, I could only get xeroxes of his stuff from *Prevailing Winds*. Has Judge ever had a book actually published? I'm not complaining--the man does incredible work organizing COPA and attending one of his lecture gives one more food for thought than most books. But thank you, *Steamshovel*, for a relevant, contemporary look at where Judge is coming from. I find many otherwise progressive people taking an armchair pro-militia view, but more because it nurtures their remnants white reaction than any understanding that what destroyed the MOVE headquarters in Phildadelphia also brought down David Koresh and is coming after you and me.

Ross Wells
Truth Or Consequences, NM

(*Steamshovel* Debris: COPA is the Committee On Political Assassinations is a non-profit group active in promoting the release of government files pertaining to the political assassinations of the 1960s. It will hold a conference, "The Killing Of A President," at the Paramount Hotel overlooking Dealey Plaza at Commerce and Houston Streets in Dallas. Membership in COPA, which costs $35, covers admission to all events there. In addition to working panels and research topic groups, featured speakers include Dr. Gary Aguilar, Walt Brown, Robert Groden, Jum Marrs, Jack White and John Judge. Hotel rates are $59 per night. Call 202-785-5299 for more details.)

Jack Burden's simplistic attack on the messengers places you all deeply and squarely in some real time damage control operation. To do "Clinton corruption" without reference to Larry Nichols of ADFA means cover-up. So do the Larry Nichols story...prove you're not part of the Masonic/Zionist alliance conspiracy. We'll be watching!

Anonymous
Eastern Maine

For the past five years, my hobby has been alternate views on history, current events and religion. I found the tone of *Steamshovel* #14 enlightening, especially the way many articles were presented with both sides of the story.

I especially enjoyed the interview with John Judge and your questioning on the naivety of many patriot and militia groups. I have been keeping track of the patriot groups through Dayton's public access channel, where interviews and commentary are featured on a regular basis. In fact, the writer of *Creature From Jekyll Island* (reviewed in *Steamshovel* #14) was featured on Dayton public access giving a speech.

There were many other facets of *Steamshovel* #14 that were impressive, including the article, "The Conspiracy Conspiracy." I'm not endorsing Clinton, but the Republican smear campaign towards him is hypocritical, compared to the antics of the Reagan-Bush years.

Looking forward to reading more!

Richard Wells
Dayton, OH

"Right wing" conspiracy theories are interesting to study, and make for amusing

reading, but one recognizes that they are usually flawed arguments predicated on a series of false assumptions and/or myths, and invariably the theory eventually contradicts even itself. So it was doubly amusing to read the review of a right-wing conspiracy book by Mr. Dowbenko, who did a good job of conveying the gist of the theory, but in doing so, gave the distinct impression that the "theory" was actually valid. Let's look at a few points:

1. The use of the word "socialism" to describe the machinations of "monopoly capitalists." If they are capitalists, then what they "do" is "capitalism." As has been explained many times, but most clearly by George Bernard (actual Fabian Socialist) Shaw, there exists in all societies institutions that in all candor must be called communistic. A pure *laissez-faire* "capitalist" society is "High-tech Feudalism," to use Mr. Dowbenko's phrase from the other review.

2. The seeming contradiction of pointing out that the "Federal Reserve System encourages war," and that monopoly capitalists want you (or your sons and daughters) to fight "their" wars, with the statement about Vietnam: where now "our" soldiers tried to fight with "both hands manacled behind their backs." (Translation: military could bomb three countries into basket cases, but was not allowed to kill every living thing in those countries in order to "save" them.)

3. "So-called Liberation theology takes Christian traditions and principles and perverts them with Socialist doctrine." Let's understand one thing: there never was more of a PINKO than Jesus Christ. It is "imperialists" and "fascists" who have "perverted" the message of Jesus Christ to further their own avaricious ends. Do people really believe that the incomprehensible God of light who created the endless universe gives a rat's ass about their sordid geopolitical interests? Evidently they do.

It is interesting to imagine that every time the word "socialism" appears in the review, substitute the word "capitalism" or perhaps "national socialism". For "Fabian Socialism", the word "liberalism" would be more accurate. But remember that the goals of "liberals" and "conservatives" (reactionaries) are exactly the same, as spelled out by noted Trotskyite Adam Smith in *The Wealth of Nations*. To protect the few and their booty from the many with itchy fingers. The "Welfare State," such that it is, is a tactical institution, subject to debate amongst the people who count. When streetcar drivers demanded that their workday be reduced from 16 hours to 12, Theodore Roosevelt denounced it as "communistic." Let these latter day populists like Dr. Coleman and Mr. Dowbenko go out amongst the "middle class" (who think that getting time and a half after 40 hours is what so enamors them to the "capitalist" system) and start telling them how they should dismantle the "socialist" institutions that make them the happy campers they are, despite their sickening whining about being "overtaxed."

So...keep on truckin'...I'm enlightened by the opinions and theories in *Steamshovel*, and I recommend you keep your format intact, right-wing and all.

D. S. Ward
Upper Marlboro
Former Republic of Maryland

There's been some talk lately that *PARANOIA* magazine is a toll of the far-right because it publishes articles from the "politically-incorrect" fringe. With the long awaited *Steamshovel Press* #14, it seems Kenn Thomas is trying to show that, unlike those *PARANOIA* folks, he's socially responsible. I've respected *Steamshovel Press* for its

alternative analysis, which is why I was a bit angered by the Elizabeth Clare Prophet smear by Chris Roth. To start, I have no belief in the religions of Ms. Prophet, but I am surprised that Kenn Thomas would publish an attack of this nature on a religious minority, given the history of federal government repression against non-conformist dissenters. Further, I am amazed that Thomas wasn't warned off by the author's use of Cult Awareness Network resources. CAN is additionally linked to forcibly removing adults from "cults" and then "de-programming" them. Roth's despicable linking of Theosophy and its spin-offs to Nazism and other nefarious ideas in an attempt to tie modern-day new-agers to genocide is typical of a classic smear job. Additionally, it is logically unsound. By the same token, modern Christians are directly responsible and fully believe and support all aspects of the historical Church involvement in such outrages as the Crusades and the Inquisition. Kenn Thomas might have wanted to look at the history Roth was citing, too. Roth attacks Pelley, the leader of a minute political sect in the 1930s and 1940s, the Silver Shirts. While FDR was setting the stage to undermine America's isolationist, anti-war public opinion, and push the USA into the war, he set up an infamous show-trial that sent Pelley to prison for eight years on the Smith Act charges. The Communist Party loved it while FDR pedaled a "Brown scare" and grabbed assorted rightists. They loved it even more when the feds shifted their sights leftward, and put Trotskyists in prison on the same charges. The CP helped prepare the government's case. Suddenly, though, things weren't so great; the federal government used precedent and public opinion to move on the Communists, transforming the "Brown Scare" into the "Red Scare" of the 1950s. Kenn Thomas might want to think about the implications of accepting CAN-style smears. Furthermore, I have to agree with Michael Collins Piper. If saying anything bad about Mossad is "anti-Semitic", then, by the same token, speaking ill of the CIA is an attack upon all American citizens, and, further, probably denotes an advocacy of genocide. I cannot believe that, in this day and age, people would still resort to demonology in a discussion of Middle East politics, a major issue in American foreign policy.

Best Wishes,
Fred Edwards

Just to add my comments on the flap over Michael Piper's egregious *Final Judgement* and his letter in *SP #14*: in the course of reviewing his book for another conspiracy publication, a colleague and I noticed that about a third of Piper's references came from *Executive Intelligence Review*, put out by convicted con-artist Lyndon LaRouche. In addition, much of Piper's book was obviously dictated by Hitler admirer Willis A. Carto, who edited the pro-Nazi *American Mercury* for many years, and who is thanked by Piper for his support and encouragement. In fact, a gratuitous comment in *Final Judgement* about an obscure court case during World War Two was a paraphrase of a "filler" item in *Mercury* which appeared in the mid-1950s. Among the contributors to the Mercury back then were George Lincoln Rockwell and convicted Nazi spy George Sylvester Viereck. Carto wrote most of the articles himself, under various aliases.

Piper makes numerous claims in *Final Judgement* for which he presents not a shred of evidence. Among these: 1. George Bush was poisoned by the Israelis on his trip to Japan; 2. Lyndon Johnson was part Jewish; 3. Marilyn Monroe spied on JFK for the Mob, pumping him for information on his Middle East policy. One would have to be pretty nutty to take any of this seriously.

As for Piper's implication that an Israeli arms dealer exerted control over Oliver Stone's *JFK*, readers of *SP* should be aware that colonel L. Fletcher Prouty, who appears as Mr. X in the film, and who advised Stone on the scenario, is no the executive board of Carto's Liberty Lobby, which published Piper's book.

I find it hard to understand why conspiracy researchers believe every theory they hear. The theories can't all be true, and some of them are obviously red herrings aimed at throwing investigators off the track. Track down the sources of these red herrings, and you'll learn who was involved in the Kennedy assassination. Common sense.

Richard Morrock
Bay Terrace, NY

I've recently obtained *Popular Alienation*--thank you. It's remarkable. One of the most crucial, incredible collections I've ever read. It almost makes up for the time I spent clawing at comics in high school, when I could've been reading *Steamshovel*. It's kind of daunting to be in the presence of such a powerful scribe, and the words may emerge gargled yet the thought will/must always endure: THANKS for being out there for us; for having the intelligence to rise above and enlighten, the courage to sustain that "loft," and the wit to ultimately laugh (I hope) since things are so utterly, goddamn hopeless.

Truly,
Chris Koestner
Levittown, NY

Address all letters to: *Steamshovel Press*, POB 210553, St. Louis, MO 63121. *Steamshovel* welcomes electronic submissions in all formats but prefers ASCII/IBM text files. Readers interested in contacting individual *Steamshovel* writers should address the correspondence to "Steamshovel Press" followed by the writer's name. Letters will not be forwarded unless accompanied by the necessary postage.

Book Reviews

Poolside reading

Iain Spence explains in his new book, *The Sekhmet Hypothesis* (Bast's Blend Publications, POB 9600, Oban, Argyll, PA34 4BP UK), that the title theory complements the Gaia hypothesis of James Lovelock, which views the Earth itself as an organism. Spence argues that the solar-sphere, through the mechanism of solar tides, has affected the smaller biosphere by creating new waves of

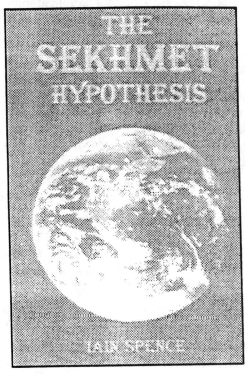

youth culture from 11-22 year solar cycles. The idea was first put forth by philosopher Peter Carroll in *Liber Null -*

Psychonaut. It holds that such subcultures--Hippies, "psycheterria", and punk rock--move from expansiveness (Hippies) to destruction (Punks) as the sun pulsates in these cycles. Rave culture and designer drugs represent the last, expansive cycle, and "social mind contraction and a celebration of pessimism" await 1999.

Spence takes the name "Sekhmet" from the female lion God of ancient Egypt, who represents positive and negative aspects of the sun, whose "untamed nature" best reflects the wild aspects of modern global-oriented youth. If this sounds a bit astrological for the average reader, bear in mind that the author asserts proudly that the geo-sociology of the Sekhmet hypothesis picks up where Timothy Leary "got swept off by the happenings of the mid-sixties." Spence claims that it is grounded in Leary's Transactional Analysis personality grid of the 1950s, viewed as a mandala.

Along the way, it also examines the notion of retroactive and directed synchronicity, claiming that "it is possible to 'nudge' future events to our benefit." *The Sekhmet Hypothesis* is every bit the heady mix it appears to be, but it is worth a read and comes cheap. Publishers explained to *Steamshovel* that they offer a few hundred slightly marked copies are available for $5 and the remainder "goes in the skip" in early 1997.
--Kenn Thomas

Control Freaks Rule!

It's a tough job to run the world, but somebody's got to do it.

This could be the motto of the characters named in *Who's Who of the Elite* by Robert Gaylon Ross, Sr., (RIE, 1700-AA Ranch Road 12, Suite 325, San Marcos, Texas, 78666, $23). If you were an anthropologist, you might call this tribe the "Global Control Freaks".

And who are the "Global Control Freaks"?

According to alternative historians, strong evidence exists of a group of self-appointed would-be rulers of Planet Earth. Typically they form themselves into International Ruling Cliques and consider themselves a Global Power Elite. They're composed of plutocrats (actually plutocracies, financial dynasties, families who maintain their wealth and power through interlocking corporate directorships, trusts and foundations) and their minions: front-men like politicians, academics, technocrats, corporate executives and others, the Global Managers of their international holdings.

Of course this group doesn't rule as a monolith of power-- yet. But a One World Government, or as British author H.G.Wells called it, "The Open Conspiracy," (the title of one of his books) has been their goal for over a century.

Yes, they have their rivalries as well as their alliances, which last until there's a better deal somewhere else. They know that in this ever-changing world, things obviously change and there's always another way to make a couple zillion dollars without working too hard.

But how can you identify them, recognize them despite their camouflage of seemingly left-wing, right-wing, conservative, liberal, capitalist or marxist ideologies? One way is to see if they belong to any of the Global Good Ole Boy Clubs. These are organizations like the Council on Foreign relations (CFR), the Trilateral Commission (TC), the Bilderbergers, The Order (Skull & Bones Society), and the Committee of 300.

The Council on Foreign Relations (CFR) is the sister organization of the Royal Institute of International Affairs (RIIA) and an outgrowth of Cecil Rhodes' secret society The Round Table Group. According to CFR Annual report, 1994, it's a "nonprofit and

nonpartisan membership organization dedicated to improving the understanding of US foreign policy and international affairs through the exchange of ideas." Is that innocuous or what? Hey, send me an app.

"Trilateralists are not three sided people," according to a January 1977 editorial by the *Washington Post*. "They are members of a private, though not secret internationalist organization put together by a wealthy banker, David Rockefeller, to stimulate the establishment of dialogue between Western Europe, Japan and the US.

The Bilderbergers, on the other hand, can be likened to a mafia of international politicians and financiers who meet secretly (no US press coverage) on a regular basis. From all accounts, these national and international power brokers coordinate socio-economic policies on a global scale. In other words, even though fiercely competitive on one level, they tend to act as a cartel when dealing with the "peasants" as Nelson Rockefeller used to call the "common people".

According to historian Dr. Anthony Sutton, author of *Americ's Secret Establishment* (Liberty House, 1517 14th Street, #216C, Billings, Montana 59102, $19.95) the Order or the Skull & Bones Society, has been known for more than 150 years as Chapter 322 of a German secret society. More formally, for legal purposes, the Order was incorporated as the Russell Trust in 1856. The old line American families and their descendants involved in the Skull & Bones are names such as Whitney, Perkins, Stimson, Taft, Wadsworth, Gilman, Payne, Davidson, Pillsbury, Sloane, Weyerhauser, Harriman, Rockefeller, Lord, Brown, Bundy, Bush and Phelps. In a supposedly classless society, these are the families that consider themselves the financial and political aristocracy of the USA. Past and current members include George Bush, McGeorge Bundy, William Sloane Coffin, and William F. Buckley, Jr.

According to Dr. John Coleman, who wrote *Conspirators' Hierarchy: The Committee of 300* (Joseph Publishing Co., 2533 N. Carson St. Carson City, Nevada 89706, $20) the Committee of 300 are another grouping of Global Power Mongers whose membership is made up of the so-called Black Nobility of Europe as well as politicians, international bankers, wealthy industrialists and their attendant plutocracies.

These Global Good Ole Boys Clubs and their memberships are the focus of Who's Who of the Elite, a researcher's guide to the global hierarchy of money and power. It's like a Social register for Power mongers and though it's just a listing of their names with their day job affiliation, you can get a lot of insights by matching these names with the names in the news.

The prime mover and shaker behind these organizations seems to be octogenarian David Rockefeller, Chairman of the Board of Chase Manhattan bank, Honorary Chairman of the Council on Foreign relations, as well as Chairman of the Trilateral Commission and frequent Bilderberger meeting attendee. Author Ross likes to call him "czar" of the New World Order.

Another fixture on the Power Monger scene is Henry Kissinger, also a Bilderberger, a member of the Trilateral Commission as well as the Council on Foreign Relations. Kissinger, who started out as a Rockefeller asset, soon moved up to being a Gofer for the Global Good Ole Boys as well as Secretary of State fro Presidents Nixon and Carter. Now he operates Kissinger and Associates, a high-priced ($250k per) introduction service to world-famous tyrants and arms dealers.

Watching the Oliver Stone film *Nixon*, for example, you can contemplate Kissinger's role as Global Fixer and Bagman and how he was able to manipulate events around the

hapless Tricky Dick. Nixon's Secretary of State Alexander "I'm In Charge" Haig is also a member of the Council on Foreign Relations.

Most recently, Kissinger has been meeting the Speaker of the House Newt Gingrich, according to the New York Times. In his role as Eminence Grise of Gofers for the New World Order, it's fun to think about his Masters' instructions to Newt, himself a member of the Council on Foreign Relations.

The Clinton Administration is replete with Global Good Ole Boys Club members. Bill Clinton himself is a member of the Council on Foreign Relations, the Trilateral Commission as well as a Bilderberger, having attended the Baden-Baden, Germany meeting in 1991.

Was that when Clinton was tapped to run for U.S. president?

Other CFR members in the Clinton Administration include Mike Espy, the Secretary of Agriculture; Ron Brown, the late Secretary of Commerce; Les Aspin, former Secretary of Defense; John Deutch, CIA director and former Under Secretary of Defense for Acquisitions; Donna Shalala, Secretary H.H.S. Department (also Trilateral Commission), Henry Cisneros, Secretary HUD (also Trilateral Commission); Bruce Babbit, Secretary Department of Interior (also Trilateral Commission); Warren Christopher, Secretary of State (also Trilateral Commission); Walter Mondale, US Ambassador to Japan (also Trilateral and Bilderberger); Richard Holbrooke, Ambassador to Germany; and Pamela Churchill Harriman, Ambassador to France. Robert Rubin, Secretary of Treasury, is not a member of the Trilaterals or CFR but is a Bilderberger.

Colin Powell, former Chairman Joints Chiefs of Staff, is also a CFR member.

The Media and Publishing World is also stacked with Global Good Old Boys Club members. For instance, by perusing Who's Who of the Elite, you would discover that the following big shots in magazine publishing are members of the Council on Foreign Relations: Norman Podhoretz, Editor in Chief, Commentary; R. Emmet Tyrrell, Editor In Chief, American Spectator; William F. Buckley, Jr., Editor Chief, National Review (also a Bilderberger); Mort Zuckerman, Editor in Chief, US News and World Report (also a Bilderberger); Lewis Lapham, Editor, Harper's Magazine; Ralph P. Davidson, Chairman, Time, Inc.; Richard M. Smith, Editor In Chief, Newsweek; and Michael J. Novack, columnist, Forbes Magazine, among others.

In TV broadcasting, CFR members include David Brinkley; ABC anchor, Diane Sawyer, ABC; Barbara Walters, ABC; Dan Rather, CBS anchor; Tom Brokaw, NBC anchor; John Chancellor, NBC commentator; and Rowland Evans, CNN.

Wonder when they'll do a show on the Global Good Ole Boys Clubs, huh?

With all due respect, you could think of people listed in Who's Who of the Elite as simply "Useful Idiots" for the New World Order. A "Useful Idiot" is old Soviet jargon for someone who can be manipulated through greed and/or ideology.

These people all fervently believe that a centralized One World Government is the logical conclusion of their efforts. They practice and preach corporate socialism (i.e., fascism, in which industry and government form a monopolistic and parasitic relationship) as well as state socialism (i.e., centralized marxist-style dictatorships). they really believe that national sovereignty is "obsolete" and that the US Constitution must be circumvented, bypassed or made irrelevant to accomplish their goals.

However, despite their hubris and Machiavellian schemes for world domination, time is running out for the Control freaks.

Why? Because the planet is rushing into global decentralization, completely counter to the wet dreams of the International power Elite.

If you don't know the players on a world-wide scale, *Who's Who of the Elite* is a fascinating introduction to the anthropology of International Ruling Cliques. if you want to know who thinks they're pulling your strings, this is a great place to start.
--Uri Dowbenko

Inside the CIA Cocaine Empire

Allegations that tiny Mena Airport in rural Arkansas has been used for gun-running, drug-smuggling and money-laundering have kept surfacing since the so- called Iran-Contra affair.

The missing link between the CIA and these illegal activities seems to be Terry Reed, a former FBI operative and CIA flight instructor, involved in training anti- Sandinista Nicaraguans to air-deliver arms, munitions and supplies to Contras in the field.

After moving his manufacturing company to Mexico, Reed discovered that his warehouse was being used as a storage depot for CIA cocaine smuggling. The drugs were shipped north into Mexico, then to Arkansas for distribution. The drug money was subsequently laundered by Arkansas brokerage companies and state agencies.

Why haven't you heard about this story? That's a good question that a video called *The Mena Connection* (REKO, P.O. Box K, White Springs, Florida 32096, Tel.: 800-MENA 850, $23.95 Postpaid) tries to answer.

After all, when he found out that the so-called "War on Drugs" was a complete hoax, Terry Reed decided to take Nancy Reagan's advice and "Just Say No" to CIA cocaine smuggling. And that's what got him in trouble.

Reed confronted his CIA handler Max Gomez (whose real name was Felix Rodriguez).

Rodriguez was allegedly the CIA hitman responsible for the assassination of Che Guevara, delivering the dead guerilla's fingers to CIA Headquarters at Langley as proof of his success.

While in Mexico, Reed, who decided he was in way over his head, then, abruptly took off with his wife and three children on a cross country trip through the United States. After six months of The Fugitive lifestyle, living in their camper and constantly on the move, Terry and Janis Reed went back to face the false charges filed against them.

After two years of court battles, the Reeds were completely exonerated. And now they've filed a lawsuit of their own -- against Buddy Young, who as Arkansas Governor Bill Clinton's security chief, was responsible, they claim, for instituting the false charges against them as well as placing false information about them on the Law Enforcement computer network.

The Mena Connection is a fascinating video showing all the background of the Reed case, through extensive news clips from CBS, CBN, and local Arkansas coverage of the shady dealings and shaky agents of Mena. The second half of this two-hour video includes interviews with both Terry and Janis Reed and how they dealt with their experiences.

Terry Reed's book *Compromised: Clinton, Bush and the CIA* is also a powerful indictment of the CIA, Democrat Bill Clinton who was Governor of Arkansas at the time and who, according to Reed, was well aware of the fact that the CIA was using Arkansas as its own "banana republic" for cocaine smuggling, as well as Republican President George Bush, a former CIA director whose Attorney General William Barr, then a CIA operative, met with Terry Reed to exert

damage control on the situation in Arkansas. In other words, folks, this is a bi-partisan scandal and coverup.

The money laundering part of this enterprise, estimated at $40 million per month, was allegedly done through ADFA (Arkansas Development and Finance Authority), a state agency started by Clinton to spur economic development in Arkansas. This money was evidently used for illegal loans paid to the reigning Good Old Boys in the state, as well as backing for bonds sold by so-called "Bond Daddies" or brokerage houses like Lasater & Company.

Another of Terry Reed's CIA handlers was John Cathey, a code name for Oliver North. Once you see The Mena Connection or read Compromised, several questions arise about the CIA Cocaine Empire.

* Was Oliver North rewarded for keeping quiet by getting a multi-million dollar armored vest company as well as a radio talk show?

* Was Bill Clinton rewarded with the US Presidency for doing his part and keeping quiet about CIA cocaine smuggling and money laundering in Arkansas?

* Why doesn't the US Department of Justice conduct a serious investigation based on these charges?

* Why don't State Propaganda Organs like *Time*, *Newsweek*, *New York Times* or the *Washington Post* dig deeper and confront former CIA Director and US President George Bush about CIA cocaine smuggling and money laundering?

* Is the story behind *The Mena Connection* a National Media coverup?

Yessireebob. You can bet your narco-dollars, gringo.
--Uri Dowbenko

Truth/Ferrie

Now that the American public has been made aware of secret government-sponsored radiation experiments conducted on unsuspecting citizens during the cold war, the idea that AIDS is a man-made disease no longer seems far-fetched. If you question the fairy tale that AIDS is caused by a natural virus that drifted in from a remote African village, *Mary, Ferrie & the Monkey Virus: The Story of an Underground Medical Laboratory* by Edward Haslam (Wordsworth Communications: Albuquerque, NM, 258 pp, $12.95) is for you.

Edward Haslam contends that a secret government animal cancer virus laboratory located in New Orleans in the 1960s may have served as the birthplace of the AIDS virus (HIV). Of interest to conspiracy buffs is that David Ferrie, one of the key players in the assassination of President Kennedy, had documented links to the lab. In fact, some of the cancerous animals were housed in his apartment. Fans of Oliver Stone's JFK will remember Joe Pesci's over-the-top portrayal of Ferrie, who met an untimely death in the film when he was force-fed a lethal dose of prescription drugs by government agents. the Coroner ruled that Ferrie died of natural causes, and there was no evidence of foul play. Ferrie's demise conveniently occurred the day before he was to be arrested on charges of conspiring to murder the President, thus helping to destroy prosecuting attorney Jim Garrison's conspiracy case against the government.

Sharing center stage with Ferrie and also linked to the underground lab is Mary Sherman MD, a noted cancer researcher who was found slashed, mutilated, radiated, and set

afire in a still unsolved murder of Grand Guignol proportions. Why was Sherman involved with a violent political extremist and a laboratory that specialized in inducing cancer in animals? Why was she murdered in her apartment and set on fire? Where are her medical records and writings today?

Forget Anne Rice and her vampire-infested Southern mansions, Haslam's true life New Orleans story has enough horrors and creepiness to satisfy the most jaded conspiracy reader.
--Alan Cantwell, Jr. MD

Ferreting Out David Ferrie on the Phone

Twelve pages of David Ferrie's telephone records from 1962 to 1963 remain a virtually untapped resource available for $10 from researcher Peter Whitmey, A-149 1909 Salton Road, Abbotsford BC Canada V25 5B6. Ferrie was a prolific telephone talker and the records contain only numbers and cities of the many places he called. *Steamshovel Press* challenges its readers to send for the list and find the names of individuals and businesses Ferrie called close to their homes. The research requires only that the researcher go to the local public library and find either City Directories for 1962 and 1963. Phone numbers can be looked up numerically in these directories and matched to names. Those interested in doing more can research the names with other research tools available at their library.

All information reported to *Steamshovel* will be printed in the next issue, and with luck the tapestry of Ferrie's phone connections will yield interesting new information. Following is a list of cities called by David Ferrie:

Ardmore, OK; *Atlanta, GA; *Augusta, GA; *Baltimore, MD; *Baton Rouge, LA;*Bay City 713; *Beaumont, TX; *Bethesda, MD; Birmingham, AL; Birmingham, MI; *Bisbee, AZ; *Breckenridge; Brownsville, TX; *Carson City, NV; *Chicago, IL; *Columbus, OH; Coral Gables, FL; Covington, LA; *Dallas, TX; Decatur, AL; *Denver, CO; *Des Plaines, IL; *Destin, FL; *Detroit, MI; Douglas, AZ; *Fort Smith, AR; *Fort Worth, TX; Fox Chapel, PA; *Gainesville, TX; *Galveston, TX; *Glenshaw, PA; Guatamala City, Guatemala; Helena, AZ; *Houston, TX; Huntington, WV; Irving, TX; *Jackson, MS; *Kansas City; Kenner, LA; Laurel. MS; La Jolla, CA; Lacombe, LA; Little Rock, AR; *Louisville, KY; *Lubbock, TX; Magnolia, MS; Matavaros, Mexico; *Memphis, TN; Mexico DF, Mexico; *Miami, FL; *Minneapolis, MN; *Mount Vernon, NY; *Nashville, TN; New Orleans, LA; *New Roads, LA; *New York City, NY; *Oklahoma City, OK; *Oakland, IL; Opa-Locka, FL ; *Orange, TX; *Paul's Valley, OK; Philadelphia, PA; *Pittsburgh, PA; *Port Arthur, TX; *Reno, NV; *River For., IL ; Roseville, MI; *Sacramento, CA; *St. Francisville; *St. Louis, MO; San Francisco, CA; *Shreveport, LA; *Springfield, MO; Stamford, CT; Stephens, AR; *Stockton, CA; *Texarkana, TX; *Toronto, Canada; Tulsa, OK; Tyler, TX; *Washington, DC; *Waukegan, IL; *Waynesville, NC; *West Columbia, TX; *Wichita, KS

Readers living in or close to these cities are especially encouraged to participate in this small group research project. Note: only cities with asterisks before their names have actual phone numbers; the others only list the city and may not lead to fruitful research. Researchers should send any names and additional information on Ferrie's contacts to Steamshovel Press, Project Truth/Ferrie, POB 210553, St. Louis, MO 63121.

Discernible patterns have already emerged from this research effort. Ed Haslam reports in *Mary, Ferrie and the Monkey Virus* that one of

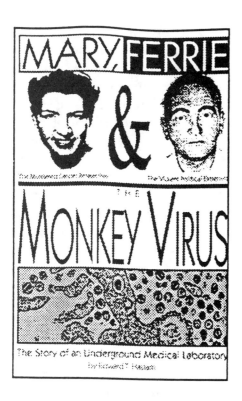

the earliest instances of AIDS-like disease appeared in the Steamshovel environs near St. Louis, MO. The City Hospital admitted a young black man with "extensive lymphadema of the genitals and lower extremities...Kaposi's sarcoma, chlamydia, cytomeglavirus, herpes simplex, Epstein-Barr virus, and prominent hemorrhoids" in July 1968, only three months from the congressional testimony suggesting that the Pentagon was interested in developing an AIDS-like biological weapon. Haslam suggests a link between this case and the rumor of an AIDS death in New Orleans at about the same time. He notes that three of nine doctors who wrote an article on the case for the *Journal of the American Medical Association* in October 1988 worked at Tulane University, site of the suspected underground AIDS lab. A search of David Ferrie's phone calls to St. Louis reflect that he called a Catholic bookstore, which may have related to his connection to weird religion, the City Police, a mysterious unlisted number and St. Louis Scale, which presumably sold scales, typically used in dope deals and medical research.

Cuba si, Clinton No

Professor Peter Dale Scott pointed out that Brothers To The Rescue, the Miami-based anti-Castro Cuban group that provoked Cuba's shootdown of two of its planes earlier this year, has connections going back to the heyday of Frank Sturgis, notorious JFK assassination figure. The group's leafletting of Havana, which preceded Cuba's deadly action, in fact, only replayed identical raids directed by Sturgis in 1959. The group's leader, Jose Basulto Leon, sprayed bullets at civilians in a Cuban hotel in April 1962 -- a incident recorded by Warren Hinckle and William Turner's book, *The Fish Is Red* (1981). Scott noted that Jose Basulto Leon "today proclaims himself a non-violent Gandhian no longer willing to use a cannon to strafe a hotel," but it's an attitude belied by his group's tragically successful attempts to draw fire from tin-horn Fidel. Resulting diplomatic fallout included rebuke to the US from the European economic community over its sanctions against Cuba in response to the shootdowns. It's Bill Clinton's trade-off for the still powerful anti-Castro Cuban vote in Florida, and one more example of the relevance of JFK assassination research to current political studies, if you don't mind Mr. Chomsky. No doubt saner diplomatic initiatives will follow the November elections. Scott reanimates the people and issues surrounding the JFK assassination perhaps better than any other scholar using material that has emerged from the collection efforts of the Assassinations Material Review Board in *Deep Politics II: Essays On Oswald, Mexico and Cuba*, (Green Archives Publications, 8614 N. Hamlin Avenue, Skokie, IL 60076-2210; 708-675-8610) a comb-bound addenda to his 1993 book, *Deep Politics*. In addition to fresh looks

at such old topics as the Kennedy-CIA split over Cuba and the multiple Oswalds (Scott analyzes the variety of Oswald pseudonyms – "Alek Hidell," etc.--as "barium meals," designed to trace disinformation as it was released under a given false name. Direct mail consumers will recognize the strategy as a variant of the "Departments" they often write to when responding to ads; advertisers use it track responses), the book looks at freshly uncovered documents such as the CIA's pre-assassination Oswald files and the full-text of the Inspector General's Report of 1967 on CIA Plots to Assassinate Fidel Castro. By the mid-1970s, the IG Report made the formerly unthinkable CIA-Mafia marriage common knowledge. Scott maintains that the report reflects the CIA's efforts to restore the Mafia in Cuba, its propensity to act in JFK's name without his authorization, its design of the AMLASH program to thwart JFK's developing dialogue with Castro, and that the attempts on Castro's life may have warped into the JFK assassination.

Ocean Press published the full text of the Inspector General's Report as a book entitled *CIA Targets Fidel* (11.95, Ocean Press, GPO 3279, Melbourne, Victoria 3001, Australia; available in the US from Talman Company, 131 Spring Street, New York, NY 10012), which also includes an interview with Fabian Escalante, former head of Cuban counterintelligence. Ocean also published Escalante's history of covert operations against Cuba, *The Secret War* ($15.95). It begins with Operation Mongoose, described by Escalante as a plan for a large-scale US invasion of Cuba before Soviet missiles arrived on the island. Escalante is a Havana native who spent his life first fighting Batista's mafia dons, then the CIA and various counter-revolutionary organizations as a member of post-Castro State Security Forces. He followed a career path within the Cuban bureaucracy to his present position as adviser to Cuba's Interior Minister. Like any military memoir, *The Secret War* can only be read with acknowledgement of the intense prejudice of the author. Despite the ignominious history of the US in the region, which is ugly and this book documents it well, Escalante is still a military autocrat working for the despot of a Soviet-styled socialist island-state. Ocean also offers a book with the Cuban perspective on the Missile Crisis, furthering the argument that JFK was pursuing back-channels to normalize relations with Fidel, entitled *Eye of the Storm* (15.95) by Cuba's ambassador at the time, Carlos Lechuga Hevia.

The US, with its lotteries, casinos, gambling riverboats, amusement parks, political corruption and organized crime, has remade itself in the image of Fulgencio Batista many times over since the Cuban revolution. It certainly doesn't need another Las Vegas on a small island south of Florida. The argument for this belongs to a small minority of former Cuban landowners with some residual political clout and their excitable proxy provocateurs. Thinking along these lines does not mean support for Fidel Castro as Cuban dictator for life. The Ocean books will start a reader on the way to counteracting the ignorance and prejudice many Americans are taught about the history of Cuba, and *Steamshovel* readers particularly will know when that stops and the propaganda begins.
--Kenn Thomas

Looking at Lockerbie

Similarly, it should be noted up front that Libyan money is behind the publication of *Foreign Agent 4221: The Lockerbie Cover-Up* (Bridger House Publishers, Inc., POB 2208, Carson City, NV 89702), or at least behind its author, William C. Chasey. Chasey was by his own description a hard-nosed Republican political lobbyist and former marine who took

up work as a foreign agent for Libya through a US company, International Communications Management (ICM). He figured he could accept the official US position of Libyan culpability in the December 1988 crash over Scotland of Pan Am Flight 103 and still pursue the valid need for diplomatic normalcy, and so registered for his book's title role. He was working to get exposure in Washington for Libyan denials of the US charges when OFAC, the Office of Foreign Assets Control, told him to cease work with the Libyans and froze what it determined was a bank account holding money from Libya. Chasey argues that his bankroll came from the American company ICM. Chasey also claims to have been harassed and spied upon. OFAC eventually fined him $50,000 and put him under investigation for fraud. All of this helped convince Chasey that the Libyans were right about their innocence in the downing of Pan Am 103.

Views of the Lockerbie disaster diverge over whether the bomb was placed by two Libyan agents, Abdel Bassett Ali Al-Megrahia and Lamen Khalifa Fhimah, or by a Lebanese-American killed in the explosion named Khalid Jafaar, working on behalf Ahmed Jibril, a Syrian terrorist with the somewhat signature trademark of planting bombs in Toshiba tape decks like the one that contained the Pan Am 103 bomb. US and UK governments come down on the former conspiracy theory, having indicted the two Libyans in November 1991. Adherents of the second theory say that Jibril conned Khalid Jafaar into taking the bomb aboard with a shipment of heroin he knew the CIA would never do anything to stop. According to the theory, Jafaar also worked as a CIA drug-trafficking asset.

Filmmaker John Ashton claims to have heard off-the-record statements from searchers who scoured the Pan Am 103 crash site that American plain-clothes operatives came the day after the crash in a huff to find something, presumably the incriminating heroin. Ashton readily admits that initial funding for his film documentary on Lockerbie, *The Maltese Double Cross*, came from a business with ties to Libya ("How The CIA Blew Up Pan Am Flight 103," *Night & Day*, June 9, 1996.). Jim Swire, whose daughter died on the flight, has supported the idea of having Ashton's film distributed and discussed, but relatives of other victims have condemned it as an exploitation of their tragedy.

Others who have countenanced the second theory, though, include Lester Coleman, whose 1993 book *Trail of the Octopus: From Beirut to Lockerbie* describes the "controlled delivery" tracking process allowed by the DEA for some heroin smuggling activity, an argument that actually exonerates US intelligence from deliberate trucking in heroin for profit. (In the book, Coleman also injected himself into the Casolaro/Inslaw story with the claim that he witnessed the unpacking of the surveillance software PROMIS from boxes marked "PROMIS Ltd, Toronto, Canada". Although it seemed unlikely that such secret dealings would be so trumpeted, the story supported Casolaro informant Michael Riconosciuto's allegations that the software had been sold to the Canadians.) An insurance investigator named Juval Aviv also verified the theory, but was accused of trying to clear Pan Am's security practices of blame for the Lockerbie disaster. Both Coleman and Juval Aviv claim to have since received the kind of harassment that Chasey says he suffered.

Lobbyists are not investigators. In fact, they are professional shmoozers. The most damning thing about the credibility of *Foreign Agent 4221* is its photo section, showing author Chasey gripping and grinning with such unsavory people as Ed Meese, Dan Quayle, Pete Wilson, even George Bush and Ronald Reagan--and, of course, Muammar

Qadhafi. So readers should be cautious that Chasey's book has an agenda, expressed explicitly in the introduction as trying to clear the Libyans of "sole" responsibility for the sabotage over Scotland. There is an attempt here to humanize Qadhafi and present the personal side of his losses in protracted struggle with the US (a 16 month old daughter died in a 1986 US bombing). It also includes discussions with the two Libyans indicted for the crime. In the course of all that, it shows also how the CIA "protected Qadhafi and sanctioned his acquisition of the accoutrements of modern terrorism" in a scheme involving three tentacles of Casolaro's Octopus: Edwin Wilson, Theodore Shackley and Thomas Clines. With the agenda antennae up, such tidbits of diplomatic/spook history make Foreign Agent 4221 compelling reading.

In the long run, maybe the paper trails of all the supporters of Pan Am 103 theory two will trace back to Qadhafi. Or maybe the CIA wants the public to believe that rumors of its involvement in heroin traffic are simply disinfo planted by the Libyans, despite how well they dovetail with a known history of CIA drug dealing stretching from the Golden Triangle of Southeast Asia to the American mafia. Interestingly, a new edition of Foreign Agent 4221, retitled Pan Am 103: The Lockerbie Cover-Up, is scheduled for publication in the UK and Chasey has had some contact with American publisher Warren Hinckle, who co-wrote The Fish Is Red book, which drew Peter Dale Scott's attention to Jose Basulto Leon's terrorist escapades, and who was unable to publish Lester Coleman's book in the US because its distributor, Publishers Group West, bowed to lawsuit pressure.
--Kenn Thomas

Pulling the Cosmic Trigger

Written before Timothy Leary died, but after suffering a non-death via rumors of his own demise on the Internet, Robert Anton Wilson's *Cosmic Trigger Volume III* ($14.95; New Falcon Publications, 1739 East Broadway Road, Suite 1-277, Tempe, AZ 85282) contains all the humor and erudition readers have come to expect from an author whose living presence has sustained many a conspiracy reader for more than two decades. Wilson explores the funny and not-so-funny dimensions of being declared dead on the information superhighway. His co-author *Illuminatus!* trilogy co-author, Robert Shea, recently died, making the irony of misguided eulogies received by Wilson a bit stinging, particularly those that emphasized the great satiric work the two men wrote together. Like a strand of DNA, however, the inanity of the Wilson-Is-Dead rumor replication and mutation in cyberspace ("The CIA killed Robert Anton Wilson...and had LSD advocate Timothy Leary neutralized with a neurotoxin which DESTROYS THE MIND") is interwoven with new research tributaries, for instance plugging the Solar Temple ritual deaths into synchronicity as Wilson has expounded upon it since the first volume of *Cosmic Trigger* in 1977. One such interwoven tributary explores the story of Elmyr de Hory, an art forger whose biography, *Fake!*, was written by Clifford Irving before Irving forged his infamous fraudulent biography of Howard Hughes. It gives the reader pause to check out Orson Welle's documentary, *F is for Fake*, explicated upon by Wilson, which includes the story of Elmyr De Hory as well as Welles' own meditation on art, forgery, life, death and the difference. Since Welles' career was built on the *War of the Worlds* fake/not fake (according to *Buckaroo Banzai*) Martian invasion, his and Wilson's thoughts in this regard have particular relevance in these days

of alien autopsies and black helicopter raids over Los Angeles used to promote the film Independence Day.

New Falcon offers a list of titles of varying degrees of merit: *The Mysteries Revealed* by Andrew Schneider; *Beyond Duality* by Laurence Galian; *Metaskills* by Amy Mindell; *Astrology and Consciousness* by Rio Olesky; *Soul Magic* by Katharine Torres; and *Carl Sagan & Immanuel Velikovksy* by Charles Ginenthial. The last is a thorough examination of the differences between famed catastrophist Velikovsky and *Parade Magazine's* spin doctor for *scientificus normalis*. Along with the alternative scientific views of Leary and James DeMeo, Wilson discusses this debate a bit in *Cosmic Trigger III*, noting with awe "the completeness of it!."

An interesting synchronicity that ties Wilson's book with *Amok Journal, Sensurround Edition*, edited by Stuart Swezey ($19.95, Amok Books, 1764 North Vermont Avenue, Los Angeles, CA 90027) is Ibiza, stomping ground of the art fakir Elmyr DeHory. It also happens to be the 1965 birthplace of trepanation, the technique of boring a hole in one's skull in order to stay permanently high. There, Joey Mellen--the author of *Bore Hole*, the central text of this medical procedure-- met its first proponent, Bart Hughes. Two members of Parliament have had this done to them and this book contains photos of one of them, Amanda Fielding, having it done, plus a 1992 interview with her from *Fortean Times*. It also includes some Joey Mellen poetry taken from a book by LSD spook Michael Hollingshead. Readers who squint at the idea of drilling a third eye into their skull are warned away from *Amok Journal*. Trepaning takes it place as the least bizarre human behavior documented therein on a list that includes scrotum self-repair, auto-erotic asphyxiation (with a Volkswagen in one instance, making it truly auto-erotic and amputee fetishism. Much of *Amok Journal* is taken from the medical literature and the presentation looks a bit like an annual report from a Fortune 500 company, making it all the more nerve-wracking to read.

Short Shrift

The opinion of the Arcturus Book Service notwithstanding, David Hatcher Childress' new offering, *Lost Cities of Atlantis, Ancient Europe and the Mediterranean* ($16.95, Adventures Unlimited Press, Stelle, IL 60919) provides an excellent launch point into the author's scholarship of the maybe-not-so mythical civilization of the ancient past. Like all of Childress' "Lost Cities" series, the text is picaresque, anecdotal and very accessible to the average reader. It starts as an adventure tale but ends as a waltz through a wealth of accumulated detail on the topic. Arcturus has carried so much of the related literature for so long, it's view is jaundiced...sometimes *Steamshovel Press* contributor Jenny Ledeen has produced *Prophecy In the Christian Era* ($18, Peaceberry Press of Webster Groves, 124 West Lockwood, Suite 116, St. Louis, MO 63119), which, despite the broad stroke of its title, is a particularized comparison of Bob Dylan's 20th century writing to Dante Alighieri's 13th century poetry. Ledeen also examines other poets and the use of "enigma" in the writing, but grounds it with historical notes on the peace movement. It's good to see Dylanology still pursued with a passion...*Angels Don't Play This HAARP* by Jeane Manning and Dr. Nick Begich ($14.95, Earthpulse Press, POB 201393, Anchorage, Alaska, 99520) remains the best early source on the Alaskan High Frequency Active Auroral Research Program . It's an antennae array for which the US military has many evil plans, notably global communication jams and the artificial augmentation of electromagnetic radiation...Under the auspices of *FATE Magazine, Strange Encounters* by Curt Sutherly

($5.99, Llewellyn Publications, St. Paul, MN 55164) collects over thirty years of paranormal observation and even includes the rightly lauded research efforts of people like Loren Coleman and John Keel. It's discussion of the Maury Island incident is actually informed by an FBI report issued through the Freedom of Information Act. The airport-newsstand type format of the book makes this seem remarkable. *Strange Encounters* seems like a book more fit for the specialized paranormal press...One very good place to find that specialized press is *The Anomalist*, edited and published by Dennis Stacy and Patrick Huyghe, although it's avowed purpose, "exploring the mysteries of science, history and nature", makes it sound like *National Geographic*. The latest issue, #3 has a remarkable collection of articles, including Huyghe's observation that so-called skeptics' calls for "extraordinary proof" often have ever-expanding re-definitions of what "extraordinary" means, and Doug Skinner on the little-known artwork of UFO-s/f- pulp-cult hero Richard Shaver. Writing in *The Anomalist* is well-sourced and clearly written, a scholarly effort intended to be absorbed over time. Only two issues come out annually, and they are available for $9.95 plus $2 postage ($5 overseas) from (checks payable to) Dennis Stacy, POB 12434, San Antonio, TX 78212.
--Kenn Thomas

Things Are Gonna Slide

Strategy of Tension I: Investigative authorities contend that they have not ruled out any possibilities for the cause of the crash of TWA Flight 800, but they have yet to examine the obvious possibility of UFO involvement. Air crash death caused by UFOs in the modern lore date to the January 7, 1948 death of Captain Thomas Mantell, who went down in his P51 Mustang training plane after chasing a bright disc-shaped object to 15,000 feet. TWA Flight 800 came down at the same altitude. The FBI acknowledges nine witnesses seeing a cylindrical object approach Flight 800 before the consequent fireball; reports on the Internet had 100 witnesses. One witness, NY Coast Guard Captain Fritz Meyer, noted that what he saw resembled a "shooting star" and came down to the plane from above. Researcher and author Loren Coleman passes on from *UFO Roundup* reports that UFOs were sighted in Johnston, Rhode Island, 70 air miles northeast and 45 minutes before the crash of the TWA plane and again in Toronto 15 minutes before the crash. [*Steamshovel* Debris: the passenger manifest of Flight 800 included the name "Lars Hansen," an Americanized version of Lars Hansson, a conspiracy researcher interviewed twice in *Steamshovel Press*. Various press versions of the TWA list did not include descriptions of passenger Lars Hansen's occupation and attempts to reach researcher Lars Hansson did not bear fruit. Still, *Steamshovel* regards this as a coincidence of names. The name of the captain of Flight 800 was Kevorkian.]...*Steamshovel Classics Illustrated*: Comics writer Doug Moench produced a large comic book for DC Comics illustrating well-known conspiracy theories, including many taken from the pages of *Steamshovel Press*. Entitled *The Big Book of Conspiracies*, it points comic book readers to real reading and gives long-time con watchers a reason to read a comic book. For those in-between, Ivan Stang notes in the intro that Moench "has saved you a lot of homework", which means a lot of footnotes to Jon Vankin, Tom Lyttle, *Flatland*, Jim Keith, Don Ecker, James Shelby

Downard, Robert Anton Wilson, and *Steamshovel*, but without the address or subscription rates. *Steamshovel* returns the favor by not including order information for the book here. A research trip to the comic book archives, however, revealed that Moench joined the Merry Marvel Marching Society--Marvel Comics' in-house fan club--in November 1968, the same month as "Bruce Roberts," the name of the researcher responsible for surfacing the Gemstone Files...*What about when the superheroine sucks blood?* Another comics writer, T. Casey Brennan, author of *Vampirella of Drakulon* comic, wants to learn if he and his father are related to Warren Commission witness H. L. Brennan since they were beaten and robbed of more than $1400 then bound and gagged and set on fire in 1975. Brennan has since led a crusade to get comics characters to forsake smoking because of "the subtle message given to young people when their heroes are smokers." Information about any link between T. Casey and H. L. should be directed to 317 S. Division St., #181, Ann Arbor, Michigan 48104...*Strategy of Tension II*: If the FBI ever makes a case for the culpability of security guard Richard Jewell in the bombing of the Olympics' Centennial Park in Atlanta, one point that will not be made to federal lawmakers contemplating draconian "anti-terrorism" legislation: Jewell was hired as part of already excessive security measures that can never guarantee protection from committed terrorists. Jewell's psychological profile--a little too eager to exert his authority to harass innocent citizens fits the bureaucratic profile of the national insecurity apparatus...*Fictionalized History/Historicized Fiction*: is the title of a novel by Todd Brendan Fahey that uses Kerouac, Cassady, Al Hubbard, Aldous Huxley, even Hunter S. Thompson and many other familiars to tell the fictionalized tale of "paid government agents seeking to subvert

the American consciousness." It may not sound like fiction to some readers as Fahey trots these counter-culture figures through an espionage story involving MKULTRA that is all too familiar. The book should expect to draw fire for using actual names in very thinly veiled actual historic situations, especially without the burden of documentation that fiction affords. Fahey's recounting of the Mary Pinchot Meyer story, for instance, has the African American man acquitted of her murder hanging "himself with a bedsheet in his jail cell awaiting arraignment." In fact, the man, whose name--not used by Fahey--was Raymond Crump, reportedly fled as far from Washington, DC as he could after the incident. Someone named Raymond Crump, an African American involved with theft of janitorial equipment from a high school, was living in Oakland, CA as late as 1989. Fahey's book is available for $16.95 plus $2 postage from Far Gone Books, POB 43745, Lafayette, LA 70504-3745. *More Meyer fiction:* author John H. Davis, the Jackie O. cousin who wrote *Mafia Kingfish* pinning JFK's death on the mob, has assumed the research on Mary Pinchot Meyer's biography gathered by Leo Damore before his suicide last December. He thinks RFK did Meyer in...*Jimmy Carter's UFO briefing:* Researcher Josh Goldstein

tracked the story of Jack McGeorge, the Jimmy Carter security guard who--according to a report once given by a journalist named Harry Levelson--was debriefed about the UFO situation. The story went that McGeorge and Carter were shown films of meetings with the aliens. McGeorge is currently consulted regularly in the media for his security expertise. Goldstein contacted McGeorge and reports: "Yes, McGeorge was in the Secret Service from 1974-1980, as a technical security specialist on chemical and biological warfare and bombs within the Technical Security Division. He briefed Carter on two occasions about security matters but he says none of that had anything to do with UFOs and that he honestly had no exposure to such material. He knows no one in the Secret Service who did. He believes the story started when he was a consultant to the Green berets in New York. Someone there was kind of a nut case who later made up the story and told it to Harry Levelson. So he says he would like to strangle Levelson."...*At least they didn't call it The Files Files*: Another "first and only" jailhouse confession to the JFK assassination has been making the rounds of mainstream video outlets like Blockbuster. Researcher Joe West had almost goaded the confession out of James E. Files until West died in 1993. West's associates taped the confession a year later and are now trumpeting it as "The Most Important Video To Ever Be Released In The History of The Industry." Presumably this means the JFK assassination cottage industry. Files is currently serving a term in Joliet State Penitentiary for murder. *Mad Milk Cow Blues*: Somerset farmer Mark Purdey argues that Bovine Spongiform Encephalopathy, Mad Cow Disease, was produced by organophosphorous pesticides...*Tim Leary's Bitchy Obituaries*: Jonah Raskin complained in the *Santa Rosa Democrat* that he "refused to grow up or to become a responsible adult though he was married four times and had two children and published more than a dozen books." PBS' *Newshour* had Robert Coles, a pundit in a fright wig who remarked that Leary appealed to "self-indulgent people who have wherewithal and political and economic power, the ordinary working people of this country, black, white, whatever, never got involved with this" and offered a conspiracy theory: "Richard Nixon and Timothy Leary tied together beautifully for the purposes of the 1968 election and Nixon knew it." Jack Boulware in *SF Weekly* summed up his sentiment about Tim Leary succinctly: "Fucking Hippy." He also noted that "Fucking hippies always told us young punks what to do. They knew better, because their eyes were opened to the bullshit, man. Fucking hippies always preached the power of the individual--and gathered in mass groups to prove their point. Fucking hippies thought if you scarf-danced to a guitar solo long enough, the bombing of Cambodia would cease.

Fucking hippies are responsible for America's archetypal conspiracy-nut cliche, the Army jacket guy standing at a microphone waving documents, yelling, "In 1962, man, the CIA was running tests on me, and they were running them on you too, man. They still won't admit it! Release the files!" Boulware did admit, however, that Leary "had some juice." Jim Mosely in *Saucer Smear* noted of Leary, "We met him once in New York City, long after the golden age of the 1960s was over. He mentioned something about having become interested in UFOs during his time in prison." *Steamshovel*, of course, has already filed its Freedom of Information request for Leary's files. A video-clip tribute to Leary is now available from *Steamshovel* for $16...*Hey, you, get offa my Shroud:* The Shroud of Turin, believed by many to be the actual burial cloth of Jesus and seen by others as a clever medieval forgery, will be exhibited by the Vatican in both 1998 and 2000. 1998 marks the 100th anniversary of the first photographs taken of the Shroud, revealing from the indistinct human form on the Shroud became a life-like portrait of a crucified with all the wounds described in the Gospels as inflicted upon Jesus Christ. The year 2000 will a be a "Holy Year" in Rome. It's not clear if the Shroud will actually be brought to Rome or will just be shown in Turin for that occasion. These exhibitions indicate that the Vatican does not accept the C-14 results of 1988 that claimed that the Shroud only dated back to AD 1260-1390. In the meantime, scientific research on the cloth remains unabated. Research in the United States is seeking to confirm the claim of Russian scientists that the fire suffered by the Shroud in 1532 added extra carbon to the cloth, thus yielding an incorrect C-14 result in 1988. Several scientists are working on theories that the image was formed by some sort of radiation that emanated from the body of the man in the Shroud. Two researchers in San Antonio have claimed that a microscopic layer of bacteria and fungi may have thrown off C-14 dating of the Shroud and all other ancient fabrics by hundreds, even thousands of years. Two Italian scientists studying the Shroud say that they have discovered, using computerized instruments, the image of a Roman coin minted by Pontius Pilate. One of the most famous critics of the Shroud, Dr. Walter McCrone, who had become renowned by his study in the early 1970s of a well-known object called "The Vinland Map," has had his Shroud work called into question. McCrone, who believes the Shroud is a medieval painting, had asserted that the Vinland Map, believed to have been from around AD 1440 and to show the first cartographic evidence of North America, was a twentieth century forgery. Tests in 1985 and more recent testing show that the map is indeed authentic. Several symposia on the Shroud are being held in the near future: one in Esopus, New York on August 23-25 will honor Fr. Adam Otterbein, president of the Holy Shroud Guild, celebrating his 60th year in the Redemptorist order; in Nice, France, a symposium is planned for May 1997; and in August 1997, a symposium will be held in Colorado Springs. During the 1998 Turin exhibition, the 3rd World Congress on the Shroud will be held in Turin. (Thanks to John Hayward for this report.) *Ron Brown Nose Dive (Strategy of Tension III)*: The most thorough discussion of political wrangling that might have led to the possible sabotage of Commerce Secretary Ron Brown's plane came in the form of historicized fiction/fictionalized history by investment advisor Nick Guarino in *Wall Street Underground*, who blames the crash on "a standing network of high-level killers sometimes called the Octopus," but Ace Hayes of *Portland Free Press* had the most chilling conclusion regarding the lack of radio contact for the last five minutes on Brown's doomed plane: "No radio for the last five

minutes means the crew was popped with a cockpit cyanide bomb, per the Dorothy Hunt flight 399 into Chicago O'Hare Airport, 1973." *Mensapause:* Trying to deal with the Moongate research that brings up some interesting and disturbing questions about the lunar landings and the possibility that they were faked, *Parade* columnist Marilyn Vos Savant came up with this crystal clear analysis: "you chose to believe that the scientists were honest when they said the Moon was covered with dust, and you used that choice to prove the scientists were dishonest when they said that astronauts landed there. This is logically weak. You could just as easily say that because the astronauts left footprints there, the Moon must not be covered with dust." So trust those scientists, damn it! They told you the moon was there in the first place..*Digging Roswell:* At about the same time the Air Force was trying to produce its new version of what happened at Roswell, NM in 1947, the U. S. Geological Survey, under Bruce Babbitt's Interior Department, produced a CD-ROM illustrating the geology and mineral and energy resources of the area--perhaps reflecting also the level of intelligence work going on there at the time. If the survey measured the Deadly Orgone Radiation that Reich found there in the 1950s, it probably didn't include that information here (for the Roswell completist, it's *U. S. Geological Survey Digital Data Series DDS-17*, by Ronald R. Tidball and Susan Bartsch-Winkler)...*Arising from William Colby's ashes (It's all a Strategy of Tension):* newspapers noted that the late former CIA director--late, that is, if he is not just in hiding until after the impact of the new book on *The Octopus* by Jim Keith and Kenn Thomas (Colby was a tentacle)--directed the infamous Operation Phoenix, a program aimed at neutralizing communist infrastructure in Viet Nam that led, in Colby's understated terms, to "some illegal killing" in that country. As noted in the new Keith/Thomas book, Operation Phoenix used an early version of the PROMIS computer software. Colby justified the abuses and defended Operation Phoenix--which was actually a program of political assassination on a massive scale--as part of a political war. That would make Danny Casolaro one of its latest casualties.
--Kenn Thomas

The University and the Ghetto Mind

by Dr. Roy Lisker

I. Prejudice, Politics and the Enclave

Much of what we call prejudice arises from a simple lack of familiarity. Whenever one community has, owing to barriers of custom, clan, religion or economics, infrequent and guarded contact with another, both come to regard each other as being different in essence. With enough time this mutual suspicion becomes a habit, ingrained and automatic.

Like the streets of one's neighborhood or the contours of the horizon, the misconceptions engendered through artificial, even enforced, isolation, come to appear self-evident, the unquestioned givens of social reality. In times of stress or economic hardship these latent assumptions, of which people by and large are not even aware, will rise to the surface, determining collective behavior, degenerating, in the worst case, into ignorant hatred, so that what reposited formerly in the form of a vague uneasiness or disinclination to associate with the other is now overcast with the blinding glimmerings of fact: anecdotal proofs of inferiority, or immorality, or predispositions to violence.

We can see this process at work in two widely distanced social milieu. Indeed, it is only because the gulf between them is so vast that it does not occur to us to draw comparisons between them: ethnic ghettos and academic departments of fields of knowledge. Most descriptions of the closed, alienated or ghettoed mind focus upon the former. Let it not however be forgotten that the perpetuation of narrow-minded enclaves called "Mathematics", "English", "Business Administration", "Art History", etc., though apparently benign, has extensive consequences in terms of the propulsion of a destructive fragmentation of all intellectual activity throughout the culture. This has, in our own time, lead to a society that, with each succeeding generation, is becoming progressively more innumerate, functionally illiterate, manually inept, politically passive, xenophobic: in the fullest sense of the word, backward.

For our purposes a 'ghetto' will be defined as any self-contained community whose identity depends upon the maintenance of arbitrary or artificial social barriers. Although these barriers are externally imposed, they quickly internalize. No correlation with poverty is intended: an affluent all-white suburb is as much a ghetto as New York's Bedford-Stuveysant, Philadelphia's Columbia Avenue, or Boston's South End.

This model certainly fits Education as much as it does the economic, religious or ethnic enclaves to which it is usually applied.

I am interested in examining the intellectual consequences of the creation of "mental ghettoes" out of the various branches of knowledge. One finds this phenomenon at every institution of higher learning. The pathology seems to intensify with the size or importance of the institution. For example, Harvard, Stanford, Columbia, Princeton, etc., the large, prestigious research universities, although under the delusion that they are giving a better sort of education, are merely the most thorough in staining the souls of their enrollment with ignorant prejudices about how English majors can never understand mathematics, or how sociology is inferior to physics, or how it is a waste of time for an anthropologist ever to go to a seminar in French poetry.

I sense that the value of my insight lies in the way I have highlighted the mental liability emerging from this insidious academic politics: because the mathematician comes to believe that his mind has a structure that is different in essence from that of an English scholar, he actually shuts down a region within thought: in some sense the entire portion of his brain from which literary and linguistic thought are generated. The academic community, including faculty, undergraduates, graduate students and even administration, becomes a collection of 'ethnic' ghettoes, ('ethnicity' of math, 'ethnicity' of linguistics, etc...) its barriers maintained, just as they are in any immigrant district in the big cities, by ignorant prejudice and fear.

The professors of each discipline then transmit this largely unconscious bias to generations of students, who may then go through life believing that certain kinds of ability are, owing to some intrinsic defect in their makeup, either forever beyond their grasp, or beneath their consideration.

I have been a direct witness of the consequences of prejudices existing between different disciplines, reinforced as they are by so many factors: by the fatuousness of academic politics; by the over-specialization that derives from the need to stay on top of one's field; by the avoidance of all contact with departments other than one's own or, very occasionally that of some closely related field, (physicists may show up at times at mathematics seminars); by the stagnation of the sources of intellectual life down the long,

dreary corridors of university departments, where legions of scholars, functionally handicapped by excessive co-habitation with a single mode of thought, rot through the long decades.

The poverty of imagination which is a characteristic of most scholarly discourse in the modern world results in large part from the hostility felt and shown towards other disciplines and the consequent inability to grasp their intellectual tools: universities have become the Third World of the mind

An eloquent example: one might think that, with the introduction of the New Math into public education in the late 50's and 60's, it could be taken for granted that scholars in letters, history, biology, economics, (even in so-called 'criminal justice'!), are able to use basic notions from modern algebra such assets, unions and intersections, Boolean algebra, isomorphisms, commutative and transitive laws, modular arithmetic, etc.

I suppose that I am being facetious, because we all know that the educational experiment of the New Math collapsed at the same time, in societies as different as Russia and the U.S., all over the world. This squares with my basic thesis: the root of the failure of the New Math lay in the enclave mentality endemic to the trans-continental university.

II. The Chauvinism of Mental Faculties

The impenetrability of the fiefdoms will generally differ from one university to the next. The relative isolation of specific fields may change from place to place, yet there are certain branches of higher learning in which fear, even hostility, towards the surrounding world comes with the territory: Mathematics and Music for example. Both of these require strong commitment and specialization. The concentrated withdrawal required for mathematical research provides an understandable attraction for congenital introverts; while Music has an equally strong appeal to a certain kind of extrovert/ introvert: someone who presents an aura of excessive friendliness yet is totally self-preoccupied, without much real friendliness underneath.

These types can set the style in university faculties. I well recall walking down the corridors of the Music Department at the University of Colorado at Boulder, with almost every door slamming in my face as I approached it. (1) More or less the same thing happened to me when I visited the San Francisco Conservatory: music conservatories are historically notorious for their inculcation of the manacled mind: the feat of trying to visit Julliard, for example, is akin to gaining access to the Potala.

Departments of languages, philology, area studies, anthropology, etc.- the 'Artifact' sciences - are often so stuffy that they don't have to eject foreigners. It is assumed that most visitors from the outside world will either suffocate or flee. To convince you of this, I advise you to invest one hour wandering the labyrinths of Dwinelle Hall at U.C. Berkeley. Dwinelle Hall is the name given a conglomerate of 3 or 4 buildings grafted onto one another more crudely than the body parts of the creatures in H.G. Wells' *Island of Dr. Moreau*. All of the artifact sciences have roosted in the rafters of these damp condominiums: languages, comparative literature, linguistics, rhetoric, communications, geography.

To walk through this building is to have a foretaste of entombment. Coughing and gasping, teachers and their students labor in this pea-soup fog from decade to decade, never ever save on the rarest of occasions attending any seminar or lecture or coffee hour or informal discussion in math, physics, chemistry, fine arts, law, business, computer science, economics, geology, optometry...The conviction, supported by reliable data, that

they would be treated as intruders from reviled contiguous clans, is equaled only by their own determination to repel the rest of the intellectual community through the generation of a poison cloud of unrelieved tedium.

Star Trek and the Science Section of the *NY Times* have taught T.C. Mits (2) that the 'hard sciences' are the most glamorous. These disciplines thus find themselves forced to react much more aggressively towards turf-violators: somebody from Engineering with a novel opinion concerning the extinction of the dinosaurs may decide to drop in at the Geology coffee hour; a professor of German who was told in a dream that the sun is alive may visit Astronomy; a biologist may try to prevail upon an astrophysicist to search for platyhelminthes in the Microwave Radiation; a cleaning woman may have discoverred an amazing, short proof of Fermat's Last Theorem.

Mathematicians ,of course, find cranks everywhere. I estimate the chances as about 60% in, say 80% of all mathematics departments, that anyone walking into their common rooms who is not immediately identifiable as a mathematician, will be assumed to be a crank. There is some logic to this: what sane person would voluntarily submit to such tribal xenophobia?

At the same time, the reception given to a bonafide crank may not be as chilly as that given to a science writer. There are situations in which it actually helps to pretend that you are interested in the mathematics of flying saucer pilotry, rather than state that you are researching an article on, say, Non-Standard Arithmetic.

Even as street gangs, armed with baseball bats, switch blade knives and guns will invade the territory of another, one finds equivalent behavior in the academic world. The classic well-documented example of this is the scurvy treatment that the Humanities Division at the Institute for Advanced Study has always received from the dominant class of mathematicians and physicists who, through the use of their transcendental intelligence, have concluded that human scientists are neither human nor scientists.

I do not want to leave the impression that Mathematics departments are necessarily the most unfriendly to intruders. In fact, all science departments function essentially like racially homogeneous enclaves, warrens of dark minds steeped in suspicion, superstition, ignorance and fear. (3) Psychology departments are, by and large, so frightening that I almost never go into them. When I walked into the Geology department at U.C. Berkeley in 1986, a senior researcher, waving his arms like a maddened bully, came running out of his office shouting : "What are you doing around here!!?" The same thing happened in the Chemistry department at Wesleyan University in 1992. A similar reception greeted me in 1985 from the Stanford Mathematics department. (4) In 1987, an architecture professor at U.C. Berkeley called out the campus police on me when I tried to sell him a subscription to my newsletter *Ferment*. When the cops caught up with me they laughed louder than I did. These may be considered isolated incidents, more indicative perhaps of the paranoia of specific individuals than of the character of institutional life.

I've been waiting for years for the right moment to recount the Smith College story; its time has come at last. In the summer of 1986 I was canvassing Smith for customers for Ferment Press books and potential Ferment subscribers. Bruce Hawkins of the Physics department, a very fine and hospitable man, had been a subscriber for a few years. I first visited him, then fanned out around the campus.

In every department that I visited there was at least one person who

immediately got on the phone to campus security to complain that "Someone's going around selling books!" A pudgy, middle-aged lumbering cop caught up with me towards evening. What I was doing, he explained, with a peculiar look in his eye, was against campus regulations. I promised to stop. He continued to regard me strangely. Then he bent over, (no mean task given the size of his paunch), placed his mouth close to my ear and whispered: "What kinda books you got in that bag?"(5)

Finally I want to relate an anecdote to illustrate how racial barriers may arise even within the precincts of a single department. I was on the campus of Washington University in the summer of 1984. I visited various places before alighting on its English department. Here I uncovered a small lounge with four faculty members sitting about. I walked in, described myself as a writer, and explained that I was in St. Louis for the first time and wanted to meet other writers.

I must give them this much credit: they weren't offended by my question and they did seriously consider it. The man nearest the door replied: "We aren't writers. We're scholars." After a moment or so, a woman at the back of the room added: "All of the writers are at the Breadloaf Writers' Conference."

III. Higher Education as the Formation of Intellectual Handicaps

All forms of prejudice handicap thought: this inquiry has touched on prejudice emerging within the sub-divisions of thought itself. The roots of this form of prejudice are surprisingly similar to those that give rise to all other forms of intolerance. Persons working in a certain field see themselves almost as a different race because they cultivate a unique mental aptitude. And there are those who go so far as to find a genetic basis for this uniqueness. It seems scarcely credible today, but I actually know of a mathematician at U.C. Berkeley who , during the Jenny Harrison tenure crisis, asserted that women can't do mathematics because their brain capacity is smaller.

There exist, in the structure of university life, physical barriers between disparate talents and modes of thought, almost as if there were barriers inside the brain itself between the right and left hemispheres. These are products of politics; resentment; fear; competitiveness; a continually reinforced inertia that fixes one's time and energy within the narrow obsessional circle of a single subject, or a small number of related subjects; finally, a blithe unawareness (6) of the fact that one's cultural horizons have been shaped by prejudices as blatant as those that handicap Afrikaners, anti-Semites, Serbs, Croats, or Islamic fundamentalists.

Because educators do not seem to have realized that the invention of mental categories is a form of prejudice, they pass this world picture on to their students, who upon graduation will inject them into the mainstream of culture. So that a John Allen Paulos must write a series of books to prove to us that almost all Americans are innumerate. Or a Rudolf Flesch, in his still relevant, "Why Johnny Can't Read?" can report that almost all of us are functionally illiterate.

Or a Suzuki, by means of the famous dictum: "All Japanese children speak Japanese", must remind us that we all have musical talent. Or a Stephen Jay Gould, who is obliged to devote many hours to fighting Creationism, wonders aloud where this peculiar ideological virus has its breeding grounds. Or the news media can continue to get away with deluging us with oceans of specious, misleading or worthless statistics. The mental racism of the academy has a considerable role in the promotion of this

state of affairs, though there are obviously many factors at work. It may just be that the educational establishment is becoming more reactionary as its role in society becomes increasingly irrelevant.

In a world in which destabilizing chance is so dependable, much of our education becomes useless even before we graduate. Each field rushes to the defence of its superior virtues because of the fear that nothing in our civilization may be able to outlast the power of our technological imagination. Already the Internet has undermined copyright law; synthesizers are making composers, and even musicians, obsolete; children who use pocket calculators don't feel they need to learn how to add or multiply; television has abolished literacy; political participation is reduced to a manipulated toggle switch between clones; art and philosophy are all but totally submerged in the fight for the buck; much of our science has been diverted into the invention and production of weapons of mass destruction.

It would be futile to speculate further on the direction in which these phenomena are leading us. It may be that many of them will work themselves out in the long run. My intention has been achieved if I have succeeded in identifying a particular species of ideological disease, a form of racism within the intellect, deeply embedded in academic life and leading ultimately to a handicapped society.

NOTES:

1. I've since been assured by a number of people that this department is thoroughly second rate.

2. The Celebrated Man In The Street.

3. How's that for rhetoric!

4. Then again, Ivan Streletsky was just then being released from prison.

5. To quote Allen Ginsberg, "This really happened".

6. Universities are traditionally hotbeds of blithe unawareness.

This communication comes from to Dr. Roy Lisker, author/ editor, since 1983, of the private newsletter *Ferment*, PO Box 243 Middletown, CT, 06457; e-mail: aberensh @lynx.neu.edu; web page: http://rendezvous.com/ferment. *Ferment* subscriptions cost $25/year, for a minimum of 15 issues, (whichever takes longer).

Letter from the UK
by Robin Ramsay

"What's been did and what's been hid."

Order! Order! Betty Boothroyd, the KGB and MI5

It can be hard to understand another political culture. The British and American assemblies, your Senate/Congress, our Parliament, both have "Speakers". It looks similar but it isn't. Your Speaker has real power; ours is essentially someone who chairs the meeting, makes decisions on procedure. And our "Speakers" take pride in being neutral, unbiased. (Which why they are chosen.) Even so, there have been odd rumblings in the last year from the Conservative Party that the current British Speaker of the House of Commons, Betty Boothroyd was prejudiced against them. For Betty Boothroyd is - was - a Labour MP. The charge had no foundation as far as I am

aware. It was simply an attempt to put pressure on the Speaker. We are entering General Election year; there are lots of stinky scandals in the Conservative political closet; they don't want a Speaker too keen on airing them in the House of Commons.

So no shock - surprise, yes - when the (London) *Sunday Times*, 18 February 1996 ran a long story about KGB - and MI5 - attempts to recruit Betty Boothroyd, the Speaker of the House of Commons, thirty years ago. In 1965 the young and rather glamorous Betty Bothroyd, former show-girl Betty Boothroyd (a Tiller girl), worked as the personal secretary to one of the junior Ministers at the Foreign Office of the then Labour government, Lord Walston. (Equivalent of, say, an Under Secretary at the State Department.) She had been an unsuccessful candidate for MP. A KGB officer in London tried to recruit her. Standard KGB tactics of the period; good-looking man goes romancing among the political lower orders; secretaries are favourite. He bought her lunch; he bought her lunch again and asked her to get some documents for him - nothing secret, just Labour Party policy documents. Absurd: the Labour Party would have sent them to the Soviet Embassy on request.

Betty Bothroyd, loyal citizen, would-be Member of Parliament, knew where her duty lay. She told her boss; her boss called in MI5, the Security Service, our version of the spy-hunting wing of the FBI. But the MI5 officer didn't say "Well done." He mis-read her, mistaking turning in Strelnikov, the KGB officer, for the act of a serious anti-communist. He treated her like a walk-in, someone MI5 could recruit. He tried to recruit her to spy on some Labour Members of Parliament - her party. She refused. MI5 did what they do so well. They bad-mouthed her at the Foreign Office where she was working for Lord Walston and she was banned. The head of MI5 told Prime Minister Wilson that she had been having an affair with this KGB officer.

Betty Boothroyd is quoted now as saying "I don't care a monkey's what they think of me." But back then, like all the other Labour Party people who were smeared by MI5, she took her fucking in silence.

There are two interesting features to this story. The first is that this episode did not arise during the 1986-90 period when ex MI5 officer, Peter Wright -Spycatcher - and others blew the whistle on MI5, and in particular the attempts by some MI5 personnel to discredit the Labour Government of Harold Wilson. In the resulting we fall-out we learned of several Labour MPs who had run-ins with MI5 in that period. But nothing, from either Prime Harold Wilson or Boothroyd, on her experience.

The second point of note is really an extension of the first. Why now? Betty Bothroyd, the august Speaker of the House of Commons, is perhaps the most respected woman in Britain, the majority choice in a recent poll for the imaginary post of President, were we ever to get off our knees and get rid of the Royal Family. (Can you imagine living in a country which has a Queen, in 1996? And a country which has no republican movement? Weird.) Why would she chose to bring this up now? (For the story came from her.)

My immediate reading was that MI5 - an instinctive supporter of the Conservative Party - has leaked the story of her lunches with the man from the Soviet Embassy. This KGB story will be behind the rumblings in the Conservative ranks. The threat of the smear to try and keep her in line. But, intelligent lady, she knew - or was advised to - get her version of the story into the media first. A pre-emptive strike by Boothroyd.

The call of duty

The thing that's hard to grasp about the defenders of the Warren Commission version of events is just how important it is to some of them. Serious, intelligent, people are willing to make themselves look utterly ridiculous in the pursuit of that goal. (Presumably they tell themselves they are doing it in the interests of a higher goal, the US national interest.) The latest is Peter Grose in his routine *Gentleman Spy: the Life of Allen Dulles* (Andre Deutsch, London, 1995). On the jacket we learn that Grose was a long-time foreign and diplomatic correspondent for the *New York Times*, executive editor of Foreign Affairs (CFR), and worked in the State Department under Jimmy Carter. Because his subject, Dulles, was one of the lynch-pins of the Warren Commission, Grose has to deal with Oswald. This is in a footnote on p. 550:

"Critics have seized on the rumour from Minsk about Oswald's poor marksmanship. Other information acquired by the Commission and subsequent investigators is convincing that whatever he showed in Minsk, he was certainly good enough with a rifle to have made the three shots from the Texas Book Depository on November 22."

But there was no such "other information"; nor, indeed, could the FBI's best marksmen replicate Oswald's alleged feat.

Matrix, Matrixes, Matrices?

A couple of people have offered me copies of the various *Matrix* books which are now a standard feature on the crankier end of the UFO literature. Author - compiler - of these massive photocopy collections, Mr Valerian, exhibits in extreme form the basic methodology of many of the so-called New Age theorisers: chuck every conspiracy theory, bit of new knowledge, pseudo-knowledge and rumour into a big pan and stew it up. Like Britain's leading global conspiracy theorist, David Icke, Valerian believes that if it is in print it must be true. *Flatland*'s Jim Martin commented: "Valerian holds out the hope that we will move away from the alien 'control paradigm' and question 'all paradigms' and maybe even adopt a 'scientific holism' and the whole planet will change overnight in a polar shift in the global consciousness. Gee whizz, I sure hope so. First I need to don my foil helmet and finish reading *Matrix 3:2.....*let's see..."

The PELT dossier

One Michael Todd (24 Fairfax Avenue, Selby, Yorkshire, UK) is offering copies of this dossier which, it is alleged, contains information – "irrefutable information" - of a world-wide conspiracy; 30 offices world-wide and a network of 25,000 highly trained and motivated "Intelligence Officers". The aim of PELT? To discredit, destabilise and destroy the alternative movement in Europe. (By which he means animal rights, organic food, eco-groups, peace groups etc.) Intriguing, if implausible, stuff; but the dossier costs L95 (about $140). I asked Mr Todd for a sample of his evidence received no reply.

Beams and Motes

There was a really comic piece in the (London) *Sunday Telegraph* (4 February 1996) bemoaning a reported closing down of foreign scholars 'access to the archives of the former Soviet Union and its Communist Party. Historian of the Soviet Union, Robert Conquest, is quoted as saying that, "If they shut the archives that would remind me of the burning of the library of Alexandria or the emperor who had all the books circulating in

China destroyed." Somewhat over the top, perhaps? And do we hear Conquest clamouring for access to, say, the British Conservative Party's files, or for a Freedom of Information Act over here? Or even for the release of the files on the now defunct Foreign Office/MI6 psy-war outfit, the Information Research Department, his erstwhile employer? No sir, we do not.

Uncle Sam's a generous man

In the entertaining memoir of the Conservative Party MP Julian Critchley, *A Bag of Boiled Sweets* (Faber and Faber, London, 1995), there is a glimpse of how the US government provides freebies for sympathetic British MPs.

"What was most coveted among the up-and-coming in the House was a Smith-Mundt scholarship to visit America. I let it be known that I had yet to visit the Land of the Free and, lo and behold, I received a summons to attend the US cultural attache in Grosvenor Square....Six weeks in America, going where one wished, a handsome per diem in dollars and the gift of twelve books of my choice." (p. 77)

Books, even!

The Professionals

Perhaps the single most striking piece in the British mass media in the last year was "Gulf of Despair" by Peter Beaumont in the (London) *Observer*, 14 January 1996, reporting that when the Gulf War broke out the British Army top brass discovered they had virtually no Army;

"The mustering of the armed forces for the Gulf revealed the unthinkable. The four British divisions on the Rhine...proved so ill-maintained that the best Britain could muster was a single armoured division - and only after cannabilising its remaining Challenger tanks for spares....the Challengers broke down so often that the RAF had to organise a 'Red Star' service to supply a stream of spares...some British tank crews...had not fired their tank's main gun for two years...the Tories, the party of strong defence, had allowed the armed forces to become so over-stretched that the country's reputation as a serious military player was on the line."

The story nicely illustrates the basic role of the UK in the New World Order. As the British empire declined after World War 2 the British state hitched its wagon to the American caravan. (The British state thought that in protecting its empire against nationalism, the US would protect the remnants of the British version. We became the new school bully's best friend would be another way of putting it.) As British decline continued so did its contribution to the various Anglo-American military and intelligence projects. These days the British role, apart from that of the US "floating aircraft carrier", has been reduced to serving as a fig-leaf of "international support" covering US actions. Those in the US, for example the LaRouchies, who continue to believe that the UK has some kind of control over America should take note: one armoured division...

The New World Order

I'm curious about how long this expression has been in use. The earliest reference I have seen so far is in Douglas Reed's, *Far and Wide* (The Non-Fiction Book Club, London, 1952). On p. 345 Reed refers to "a mysterious 'Group for a New World Order' headed by a Mr. Moritz Gomberg, which existed in 1942. How reliable this report is I don't know. Reed was an early conspiracy theorist and (lightly concealed)

anti-Semite who achieved some fame in Britain in the 1930s.

Late breaking news on the Militias - of 1838

Fans of the US Militias might like to order from their library a copy of *The Rise and Fall of the Patriot Hunters* by Oscar A. Kinchen (Bookman Associates, New York, 1956). Kinchen describes the formation of a "vast secret society known as the Hunters Lodges or Patriot Hunters" which formed in some of the American states bordering Canada in the late 1830s with the objective of helping the Canadians throw off the yoke of...... British rule. What was that old adage which ends ... "the second time as farce"?

Robin Ramsay publishes an indispensable journal of political and conspiratorial insight in England entitled *Lobster*, which comes out in June and December every year. Despite it's complaints about the dross and inaccurate perception in *Steamshovel Press*, *Lobster* contains well-documented and relevant study of the conspiracy culture. A single issue is available for about $8 US from 214 Westbourne Avenue, Hull 3JB, UK.

Report From Iron Mountain and The Protocols of the Elders of Zion:
Controversial "Hoaxes" and Their Real Life Analogues

by Uri Dowbenko

Just as Orwell's *1984*, originally titled *1948*, predicted accurately albeit satirically the surveillance society of today's National Security State of America, the reprinting of *Report from Iron Mountain on the Possibility and Desirability of Peace* likewise still holds awesome prescient powers, especially in retrospect.

According to the *New Yorker* magazine legend/cover story, May 13, 1996, however, the authors of *Report from Iron Mountain* were just a bunch of happy-go-lucky lefties who thought it would be a lark to publish a think-tank study in the bureaucratese writing style and pass it off as the real thing.

These three, novelist E.L Doctorow, freelance writer Leonard C. Lewin and *Nation* publisher Victor Navasky, later enlisted fellow prankster Harvard professor John Kenneth Galbraith who vouched for its authenticity in a *Washington Post* book review.

Curiously, however, the book holds up remarkably well as a prophetic document. Is it really a satire? Or has it become a blueprint for the future?

Whatever its origin or intent, the book nevertheless seems to accurately predict the current amoral, cynical and dissembling state of affairs in US government policies and actions.

When it was first published in 1967, the controversial "hoax" *Report from Iron Mountain...* concluded that "economic surrogates for war must meet two principal criteria. They must be 'wasteful', in the common sense of the word, and they must operate outside the normal supply-demand system."

What does that mean? It certainly sounds like government-sponsored social welfare programs.

Enumerating "economic surrogates for war:", the book cites, "Health. Drastic expansion of medical research, education and training facilities." (p. 59)

Could that be a prediction of the on-going never-ending always-increasing War on Cancer? Or the War on AIDS? Or the War on

Drugs? Or maybe the War on Violence sponsored by the Center for Disease Control itself?

How about "the general objective of complete government-guaranteed health care for all at a level consistent with current developments in medical technology" (p.59)?

Hey, maybe nobody told Bill and Hillary Clinton it's a hoax and they still think it's a viable policy statement.

Then, believe it or not, Report from Iron Mountain... likewise predicts the massive corporate welfare programs for space and "defense" research.

"Another economic surrogate that has been proposed is a series of giant 'space research' programs. These have already been demonstrated in their utility in more modest scale within the military economy. What has been implied, although not yet expressly put forth, is the development of a long-range sequence of space-research projects with largely unattainable goals." (p.61)

Remember "Star Wars"? Where did the billions upon billions of dollars spent for Research and Development disappear with nothing to show for it?

Continuing in this vein those clever *Iron Mountain* hoaxers write that "space research can be viewed as the nearest modern equivalent yet devised to the pyramid building and similar ritualistic enterprises of ancient societies." (p.62)

What's really striking, though, is their "prediction" of using the US Military as a UN Rent-a-Cop Agency for trouble spots throughout the world.

"A more sophisticated variant is the proposal to establish the Unarmed Forces of the United States. This would conveniently maintain the entire institutional military structure, redirecting it essentially toward social welfare activities on a global scale. It would be in effect a giant military Peace Corps. There is nothing inherently unworkable about this plan, and using the existing military system to effectuate its own demise is both ingenious and convenient." (p.64)

So now maybe we can understand why US Armed Forces are in Bosnia. And Macedonia. And Somalia. And Haiti.

"Credibility, in fact, lies at the heart of the problem of developing a political substitute for war. This is where the space-race proposals, in many ways so well suited as economic substitutes for war, fall short. The most ambitious and unrealistic space project cannot of itself generate a believable external menace. It has been hotly argued that such a menace would offer the last best hope of peace etc. by uniting mankind against the danger of destruction by 'creatures from other planets' or outer space. Experiments have been proposed to test the credibility of an out-of-our-world invasion threat; it is possible that a few of the more difficult to explain 'flying saucer' incidents of recent years were in fact early experiments of this kind." (p. 66)

Yeah, maybe even motion pictures like *E.T.*, *Close Encounters*, *Communion*, *Fire in the Sky*, *Roswell Incident*, *Independence Day*, *The Arrival* as well as TV shows like *X-Files* that promote the on-going fascination and "academic" debate regarding the "reality" of UFOs.

"Nevertheless, an effective political substitute for war would require 'alternate enemies', some of which might seem equally farfetched in the context of the current war system. It may be, for instance, that gross pollution of the environment can eventually replace the possibility of mass destruction by nuclear weapons as the principal apparent threat to the survival of the species. Poisoning of the air and of the principal sources of food and water supply is already well advanced and at first glance would seem promising in this respect; it constitutes a threat that can be dealt with only through social organization and

political power. But from present indications it will be a generation to a generation and a half before environmental pollution, however severe, will be sufficiently menacing, on a global scale to offer a possible basis for a solution." (p.67)

Written in 1967, could this have been the blueprint for the popularization of the Environmentalist Movement of today?

"It is true that the rate of pollution could be increased selectively for this purpose; in fact the mere modifying of existing programs for the deterrence of pollution could speed up the process enough to make the threat credible much sooner. But the pollution problem has been so widely publicized in recent years that it seems improbable that a program of deliberate environmental poisoning could be implemented in a politically acceptable manner." (p. 67)

Is that satire or what? I mean, talk about your droll humor, Lewin and the Boys must be slapping their thighs in merriment.

And then there's the sociological aspect of "substitutes for the functions of war." What activities can provide a good excuse for compulsory government service, a form of sophisticated slavery, if you will? Lewin and the Boys got it all figured out, and it actually sounds, well, it sounds just like current US policy.

"Most proposals that address themselves, explicitly or otherwise, to the postwar problem of controlling the socially alienated turn to some variant of the Peace Corps or the so-called Job Corps for a solution. The socially disaffected, the economically unprepared, the psychologically unconformable, the hard-core `delinquents', the incorrigible `subversive' and the rest of the unemployable are seen as somehow transformed by the disciplines of a service modeled on military precedent into more or less dedicated social service workers..."(p.68)

Steamshovel Debris: President Bill Clinton has created a program called Americorps National Service "where thousands of Americans will soon be getting things done through service in exchange for help in financing their higher education or repaying their student loans."

The *Report* continues: ".. Another possible surrogate for the control of potential enemies of society is the reintroduction, in some form consistent with modern technology and political processes, of slavery...It may be an absolute prerequisite for social control in a world at peace. As a practical matter, conversion of the code of military discipline to a euphemized form of enslavement would entail surprisingly little revision; the logical first step would be the adoption of some form of 'universal' military service." (p.70)

And if that becomes outdated, federal mandates for high school graduation can include mandatory "volunteer service to the community", currently a requirement in many states.

The author(s) of *Report from Iron Mountain...* fret, however, that the "alternate enemy" must imply a more immediate, tangible and directly felt threat of destruction. It must justify the need for taking and paying a "blood price in wide areas of human concern."

And this is where the worlds of mind control programming and TV news and entertainment (infotainment) intersect.

"Game theorists have suggested, in other contexts, the development of 'blood games' for effective control of individual aggressive impulses... More realistically, such a ritual might be socialized, in the manner of the Spanish Inquisition and the less formal witch trials of other periods, for purposes of `social purification', `state security' or other rationale both acceptable and credible to postwar societies."

And can you believe it? We got a program for that too.

Social purification? You betcha. Randy Weaver's wife and son were shot dead in Ruby Ridge, Idaho. David Koresh and his followers were burned alive in Waco, Texas. Live on TV.

State security? You saw the Oklahoma City Bombing. Live on TV. Added benefit? The National Security State was able to pass a new so-called "anti-terrorism" bill.

"A number of proposals have been made governing the relations between nations after total disarmament; all are basically juridical in nature. They contemplate institutions more or less like a World Court or a United Nations, but vested with real authority. (p.65)"

Sure, there's NAFTA, GATT and the World Trade Organization. How about a World Parliament next?

And then there's the population control problem with a handy eugenics solution. "The real question here, therefore, does not concern the viability of this war substitute, but the political problems involved in bringing it about. It can not be established while the war system is still in effect. The reason for this is simple: excess population is war material." (p.74)

That's right. Too-many-damn-people. Exactly the sentiments of UN poobah Canadian industrialist and environmentalist Maurice Strong. War, you see, is not only useful because of its "wasteful expenditures" but it also gets rid of the "cannon fodder" (Strong's words).

Then there are some interesting parallels between one controversial "hoax" document *Report from Iron Mountain*, allegedly from the left, and another controversial "hoax" document, *The Protocols of the Elders of Zion*, allegedly from the right. Whether satire or hoax, it's the same state of mind. Compare them and decide for yourself. For example, here are some words on Government:

From *Protocol No. 10*: "When we have accomplished our *coup d'etat* we shall say then to the various peoples: Everything has gone terribly badly, all have been worn out with sufferings. We are destroying the causes of your torment - nationalities, frontiers, differences of coinage."

From *Report From Iron Mountain*: "We have already pointed out that the end of war means the end of national sovereignty, and thus the end of nationhood as we know it today. But this does not necessarily mean the end of nations in the administrative sense, and internal political power will remain essential to a stable society." (p.65)

And here are some words on Social Programs and Entertainment:

From *Protocol No. 13*: "... In order that the masses themselves may not guess what they are about we further distract them with amusements, games, pastimes, passions, people's palaces... Soon we shall begin through the press to propose competitions in art, in sport of all kinds: these interests will finally distract their minds from questions in which we should find ourselves compelled to oppose them. Growing more and more disaccustomed to reflect and form any opinions of their own, people will begin to talk in the same tone as we, because we alone shall be offering them new directions for thought."

And from *Report From Iron Mountain*: Substitutes for the Functions of War: "Models...3. Sociological: Control functions. a) Programs generally derived from the Peace Corps model. b) A modern sophisticated form of slavery. Motivational function. a) Intensified environmental pollution. b) New religions or other mythologies. c) Socially oriented blood games. d) Combination forms." (p. 84)

And here are some words on Disarmament:

From *Protocol No 5.*: "Nowadays it is more important to disarm the peoples than to lead them into war; more important to use for our advantage the passions which have burst into flames than to quench their fire: more important to catch up and interpret the ideas of others to suit ourselves than to eradicate them. The principal object of our directorate consists in this: to debilitate the public mind by criticism; to lead it away from serious reflections calculated to arouse resistance; to distract the forces of the mind towards a sham fight of empty eloquence."

From *Report From Iron Mountain*: "The economic impact of general disarmament, to name only the most obvious consequence of peace, would revise the production and distribution patterns of the globe to a degree that would make the changes of the past fifty years seem insignificant. Political, sociological, cultural and ecological changes would be equally far-reaching. What has motivated our study of these contingencies has been the growing sense of thoughtful men in and out of government that the world is totally unprepared to meet the demands of such a situation". (p.8)

"The important point is that the *Report*, whether written as a think-tank study or a political satire, explains the reality that surrounds us," writes G. Edward Griffin, author of *Creature From Jekyll Island*.

"Regardless of its origin, the concepts presented in it are now being implemented in almost every detail. All one has to do is hold the *Report* in one hand and the daily newspaper in the other to realize that every major trend in American life is conforming to the blueprint. So many things that otherwise are incomprehensible suddenly become clear: foreign aid, wasteful spending, destruction of American industry, a job corps, gun control, a national police force, UN army, disarmament, a world bank, world money, the surrender of national independence through treaties, and the ecology hysteria. *Report From Iron Mountain* is an accurate summary of the plan that has already created our present. It is now shaping our future."

Whether satire or hoax, the author(s) of *Report from Iron Mountain* and the *Protocols* sure sound like they're reading off the same page.

STEAMSHOVELPRESS.COM
ALL CONSPIRACY. NO THEORY.

Totally redesigned web site with features, interviews and the regular columns:

***The Latest Word
Offline Illumination
Things Are Gonna Slide
Ferment!
Link Tank***

STEAMSHOVEL 16
1998

The Finders' Keeper

an interview with
Marion David Pettie

by Kenn Thomas
and Len Bracken

A 1994 reference work on utopian communities refers to the Finders as "a rather spontaneous non-organization...Their overall approach to life is to make it into a game--a challenging and educational process where the rules change from week to week, day to day, sometimes even by the hour." Contrast that with investigator Ted Gunderson's handwritten description, attached to Treasury Department memoranda on the Finders that Ted Gunderson circulates in a info-packet about the group: "the Finders are a CIA front established in the 1960s. It has TOP CLEARANCE and PROTECTION in its ASSIGNED task of kidnapping and torture-programming young children throughout the US. Members are specially trained GOVERNMENT KIDNAPPERS known to be sexual degenerates who involve children in Satanic sex orgies and bloody rituals as well as murders of other children and slaughter of animals."

The Finders group found itself in the news in February 1987 when an anonymous caller phoned police to report two formally dressed men (Michael Houlihan and Douglas Ammerman) supervising six casually dressed children--according to police, they were unkempt, disheveled and bruised--at Myers Park in Tallahassee, Florida. The police charged the men, members of the Finders, with child abuse, and Detective Jim Bradley of the metropolitan police in Washington, DC, used the arrest as a pretext to raid one of the Finders' properties there. Bradley's men seized evidence they said may have been indicative of an organized ring of pedophilic child kidnappers who made animal sacrifices to Satan.

A report by Customs Special Agent Ramon J. Martinez claimed that documents found at the Finders property "revealed

POPULAR PARANOIA, page 150

detailed instructions for obtaining children for unspecified purposes. The instructions included the impregnation of female members of the community known as the Finders, purchasing children, trading, and kidnapping. One telex specifically ordered the purchase of two children in Hong Kong to be arranged through a contact in the Chinese embassy there." Martinez also reported that the seized Finders evidence included "numerous photos of children, some nude, at least one of which was a photo of a child 'on display' and appearing to accent the child's genitals...a series of photos of adults and children dressed in white sheets participating in a blood ritual. The ritual centered around the execution, disembowelment, skinning and dismemberment of the goats at the hands of the children, this included the removal of the testes of a male goat, the discovery of a female goat's 'womb' and the 'baby goats' inside the womb and the presentation of a goat's head to one of the children."

Despite this, charges against the men in Tallahassee were dropped, the children were sent home to their parents unharmed (although the court attached conditions to the return of two of them), and prosecutions were not pursued in DC. Police authorities both in DC and Florida complained that the case was mishandled because the Finders work for the CIA. When Martinez went to meet with Detective Bradley to review the case, he was directed to a third party who advised that all the passport data from the seized Finders material check out as legal. According to Martinez, "the individual further advised me of circumstances which indicated that the investigation into the activity of the Finders had become a CIA internal matter. The MPD (DC metropolitan police) report has been classified secret and was not available for review. I was advised that the FBI had withdrawn from the investigation several weeks prior and that FBI Foreign Counter Intelligence Division had directed MPD not to advise the FBI Washington Field office of anything that had transpired."

The Justice Department released Martinez's report and other documents about the Finders when it opened a new investigation into the group's activities in 1993, in part to determine if the CIA had put the kibosh on the 1987 investigation. One memo claimed that the "CIA made one contact and admitted to owning the Finders organization as a front for a domestic computer training operation, but that it had gone bad." The operation, called Future Enterprises, had hired a Finder, but dismissed him when his connection to the group was exposed. North Carolina's Democratic representative Charlie Rose and Florida's Republican representative Tom Lewis supported and publicized that investigation, as did a former CIA operative named Skip Clemens (reported upon by Chris Roth in *Steamshovel Press #11*; see also pp. 295-296 of *Popular Alienation*.)

The Finders have more-or-less rational explanations for even the most bizarre behavior attributed to them, especially in the context of a group that exists to challenge social paradigms. Even the goat sacrifices, known as "Goatgate" to the group, have been attributed to the Finders just play-acting at being witches and warlocks, another "game" to dumbfound lookers-on. Many of the Finders' games serve as parody or put-on. The store windows of its offices include strange scarecrow artifacts and bumper sticker slogans like "Call Police" with the letter "C" missing. The words "Promise Keepers" adorn the marquis of an old theater owned by the Finders, although their meaning--

Above: Marion David Pettie
Photos by Len Bracken

perhaps something to do with the manic men of the infamous Christian movement Promise Keepers--is lost to strangers. Not all the weirdest at Finders HQ is Finders generated, however. Travelers arrive at Finders headquarter in Culpeper, Virginia, an hour and a half northwest of Washington, DC, via state route 666.

The Tallahassee incident and subsequent interest placed the Finders' reputation at the center of DC's conspiracy culture. That's no small feat in a town where Operation Monarch sex-slave operations and powerful pedophilic politicians rule the rumor roost. *Steamshovel* editor Kenn Thomas and author Len Bracken (whose 1981 novel *Freeplay* included fictionalized reference to the Finders) dropped in unannounced at the Finders facilities. At the time, eight former members had filed a chancery action against the group to recover money they had pooled into they currently considered a defunct partnership. More evidence that Goatgate did cost the Finders money and members. Marion Pettie was still holding court in Culpeper, however, and granted the following impromptu interview. It is presented here as a rare look at the controversies surrounding the group, verbatim from the perspective of the main personality at its core.

Q: How far back can you trace the origins of the Finders?

A: I had two apartments back in the 30s and 40s. I had two apartments in Washington and just kept open house. It was supported by the gift economy and I would throw something in. Some people would say I threw in my good taste. So anyway, it goes back that far. Four people here with me now have been with me for over twenty five years. In fact, I kept another thing called the Free State back in the hippy period, back in the mountains here.

Q: The Free State?

A: Yeah, it was called the Free State and it was known all over the world.

Q: Where was this?

A: About twenty miles from here. About a hundred people would usually be there at any one time. A few other people have done that. A man named Gottlieb, have you ever heard of him, a musician? He kept open house like that and the government came out and closed him down. But the local authorities let me keep it going up there.

Q: This was the 40s?

A: No, we've moved up to the 60s here. Before that, just to give you an idea of the time period, the sheriff came out and put a gun on me one day and said, "show me some ID." I showed it to him and he says, "Oh, I know you. You're the guy what keeps beatniks." So I kept open house to beatniks. We're talking about the 50s now. Going back to World War II, I kept open house mainly to intelligence and counter-intelligence people in Washington. OSS people passing through, things like that. So the open house at that time was more or less at that level. The main ones were beatniks, though, like Dick Dabney. Ever heard his name?

Q: What's the name?

A: Dick Dabney. He was the number two king of the beatniks in Washington and a novelist.

Q: But the group is basically different from the Kerouac/Ginsberg/Burroughs type crowd?

A: I just keep open house. That's about all I do. It changes as people show up. Basically, we have about 600 acres up there and a few houses and people who are here more or less permanently now. They spend part of the time in this town [Culpepper] and part of the time in DC and part of the time up in the mountains, and another part traveling all over the world.

Q: But it's still basically the same drift in, drift out kind of thing.

A: Nobody signs anything.

Q: It's an interesting philosophical difference with the culture at large.

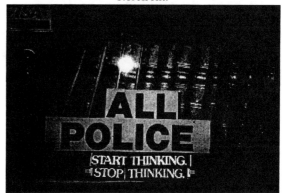

Below: **guerilla window dressing at Finders' storefront.**

A: Personally, I'd say the only thing that has been different is --I'm closest to being Taoist.

Q: I noticed you have a Lao Tzu quote framed on the wall there.

A: Two ministers were going to come over here and pray for me. I thought you two might have been them.

Q: [laughter]

A: They said they had a problem with me being a skeptic and me being in this town.

Q: There's a church next door. That's got to be difficult.

A: How so?

Q: I was thinking in terms of having a bohemian crowd around. Also, that's a real thing to infiltrate in terms of the intelligence agencies.

A: Some investigators back in the 60s tailed me for four years. At first they said they thought I was a dope dealer big time because, I didn't use it myself. Then they decided that I was a front for the CIA. They asked if I was a front for the CIA. Of course, I wouldn't have told them anyway, but I asked those people, they said they ran the name through the computer and they said, "No, we don't own that guy." So then the investigator says, "I've been working on you for four years and I can't figure out what you're doing. What the hell are you doing?" So the point is that actually I'm not doing anything, just enjoying life and working on good ideas all of the time. I considered when I was 12 years old that my mission in life was to know everything and do nothing.

Above: a glimpse of Pettie's library.

Q: I wonder in in the 1950s you ever encountered the name Wilhelm Reich or any of the Reichian people?

A: Oh yeah.

Q: Do you have any specific memories about that?

A: At that particular time I also kept open house mainly to the humanist psychology movement. They would come up to the country and have all these various gatherings and movements and some of them were Reichians. But i wouldn't say that I'm an expert on Reich. I think I've read most of his books I would say that I had an interest but I don't really have any inside connection to that personally.

Q: Reich's last years were in jail, as you know, and he was considered paranoid, and they burned his books and all that. He was considered paranoid because he said he was a victim of a Rockefeller conspiracy. But Rockefeller was the money behind the *New Republic* which ran an anti-Reich smear campaign and whose editor, Michael Straight, later confessed to being a Soviet spy.

A: He was a little bit paranoid, they said...when a plane would go over, he'd say it was one of Rockefeller's planes...

Q: Eisenhower's...

A: It might have been a mixture of both of those.

Q: What do you make then of these stories that connect the Finders up to a pedophilia ring in the CIA?

A: The pedophiles and all that stuff...

Q: That's all smear stuff?

A: I just kept open house to a lot of the counter-intelligence and intelligence people

over the years. I have been reported to their security officers probably plenty of times for trying to find out what's going on in the world. I've tried all of my life to get behind the scenes in the CIA. I sent my wife in as a spy, to spy on the CIA for me. She was very happy about it, happy to tell me everything she found out. She was in a key place, you know with the records, and she could find out things for me. And my son worked for Air America, which was a proprietary of the CIA. There are some connections, but not to me personally.

Q: But do you have any suspicions...the Finders sounds like a real open group that attracts a lot different elements...disinformation stories could be planted by certain elements to try to connect it to pedohilia...

A: The reason the CIA wouldn't hire me is that they wouldn't have the control factor over me. That's one of the things. They may have used me at some time without me knowing it. They have categories of unwitting agents. Maybe you two were sent here by them. But I'm pretty open about this kind of stuff, though. They wouldn't hire me as a contract employee because I wouldn't sign the papers. Anybody that's a contract employee must sign an agreement and then they pay you out the money. Well, I don't need the money, but I am trying to find out all about them. Basically, the one sentence about the CIA is that I have been studying them since before they were born. I was studying them back in the 30s. It was ONI Back then [Office of Naval Intelligence], and then the Coordinator of Information comes on, and after that it turns into the OSS and OSS turns into the CIAU and the CIAU turns into the CIA. So I've been studying

that all of my life. But I wasn't personally working for them.

Q: The renown case, of course, took place in Florida.

A: Would you like to hear about it?

Q: I'd like to hear everything you have to say about it, actually.

A: It's very simple. We had the kids and the general idea was that they would go up to the country up there, twenty miles from here, and they would go to school, a self-governing school. Adults would be available to them, intelligent, well-balanced people. And they would never be alone with a kid so that no one could accuse them of any pedophiles stuff. At least two would have to be there. As faras I know, they did all that. Then they were just taking them on a camping trip to Florida. There were four intellectuals with them and they just happen to drive into a park and somebody was suspicious because the two men were well-dressed. They had four people with them on the trip and they were all well-educated, well-balanced people. So I don't think there was any funny stuff going on.

Q: There were just police suspicions?

A: Well, somebody called up and said, "there's two well-dressed men with some kids in a van over there." So the police come and then they take them down and by their standards these well-dressed men weren't answering the questions properly. So then they called Washington and somebody in the Washington police says, "Yeah, we know those people. They're Finders and we're just

about to find out what they're up to up here and we'll use this as an excuse to go in there and rig them."

Q: So you were still under surveillance by them.

A: Surveillance? I have been personally, I know, for forty years because in other countries and so forth, counter-intelligence, come out and want to know what I'm doing...if you go around acting mysterious and just find out what's going on, naturally, people come to find out what it is.

Q: So then it snowballs. First there are unfounded suspicions by these people and the police. The local police connect to here in Washington and they say, "oh yeah, we know about the Finders" and that plays into theuir paranoia.

A: Then it goes back down to here. Like I said, in the 60s I was under surveillance for four years, from '64 to '68, and they get all their files out and everybody starts comparing them. Basically, they come up with the idea that "we don't know what they're doing. We don't know who they're connected with." What were those people called in Holland?

Q: The Provos?

A: Yeah. We are more or less like Provos or Situationists or something like that. Actually, we're not connected with anybody, other than trying to know what's going on the world and improve the world a little bit.

Q: So you haven't heard anything more about that? A guy named Skip Clemons took all this and turned it into, "this is a Satanic cult." Apparently his daughter actually successfully prosecuted somebody for satanic ritual abuse at a Montessori school. Have you heard of this?

A: Oh yeah. Maybe this is something big.

Q: There's also a computer training center that was actually training CIA guys how to operate, right?

A: There's some partial truth to it. We go out and do emergency services and get employment for a lot of people. So one of them was in there working, where you're talking about, but we didn't have any connection other than one man going down there. And the man didn't know it but he was so-called "hiring a Finder". The company was actually doing training for the CIA. We had no particular connection to that man other than what anybody else would call a temp worker. But it looks like on the surface that it all ties together. A lot of these things do happen, but we're not connected anymore than any of the individuals in the Provo or the Situationists were. Maybe there are some people who have been around here have been doing some intelligence work. I don't know about it. Mainly, there's no connection and it's just like I'm telling you. Individuals, I don't know. People show up. They may be sent here by the CIA, the FBI, the state police or anybody.

Q: Having it such a loose association furthers that. It's not like you join the Finders and get a membership card.

A: That's right.

Q: It's a scene. Drop in, drop out.

A: There's no such thing as the Finders. It's just a group term for people who like to hang around me. That could be anybody. There's nothing in writing. There's not even a group.

Q: I notice you're reading Arthur Koestler's *Thirteenth Tribe*. Is that a particualr interest of yours? Did you know Koestler?

A: I didn't know him, but I really like his books, his style of writing.

Q: Did you know Tim Leary?

A: Yeah.

Q: Was he in and out of the Finders scene?

A: At one time, when he was up in New York, he would send people down here and sombody got tired of something down here, they would go up there. It was a pretty close connection. He gave me LSD but I never took it. I kept it in the ice box in case I wanted to take it. I figured it must be pretty good if it came from him.

Q: Did he ever ask you about it afterward?

A: No. Actually, one of the people connected with Leary accidentally burned the house down. He was putting in a sauna and he was so efficient he burned the house down and burned the LSD up. I never did take it. But I had a particualrly close connection to him at that time, we're talking about the 60s again, by me running a place down here and him running one up there and people going back and forth all of the time.

Steamshovel Debris: The Finders

The *Steamshovel* file on the Finders includes the following information, taken from an anonymous memo entitled "Investigative Leads" with the attribution "produced sometime during the 1980s, authorship unknown."

Pettie met Joseph Chiang, a Chinese agent operating under journalistic cover, in 1939 and remained in close contact with him throughout the war. Around this time Pettie also made connections with the OSS, through George Varga, Earl D. Brodie and Nick Von Neuman (John Von Neumann's brother) -- all low-level OSS offciers. Sometime near the end of the war, Chiang introduced Pettie to Charles E. Marsh, at the National Press Club. Marsh, who ran the best private intelligence network of his era and was an intimate of FDR, Henry Wallace and later Lyndon Johnson, became Pettie's mentor and role model, shapiong his career. (Marsh's mentor and role model was Colonel Edward M. House, who was a personal advisor to President Wilson, circa 1919, often mentioned in connection to the Council on Foreign Relations). Marsh died in December 1964. His last known address was in Austin, Texas.

In the 1950s and 60s Marsh provided funds for Pettie to purchase hundreds of acres of farmland in Madison and Rappahannock Counties, near his estate in Culpeper County. Later Petty arranged for William Yandell Elliott (b. 1896) of Harvard University to purchase a property adjacent to him in Madison County. Elliott was a government professor at Harvard University who was on the National Security Council's

planning board and a trustee of Radio Liberty (sponsored by the CIA). As of 1984 Elliott was a board member of Accuracy in media. Wrote numerous books.

In 1946 Pettie, acting as chaufeur to General Ira Eaker, Marsh arranged for him to be trained in counterintelligence in Baltimore, Maryland. Around this time Pettie established close ties to two guards of atom bomb secrets, Captain Michael Altier (?) and Major Harry Wolanin, both retired. In 1954 Pettie recruited Eric Heiberg who lost his NSA clearance at about this time. Heiberg was redeployed as a private investigator and subsequently as a talent spotter at Georgetown University (now retired). Pettie received intelligence training at Georgetown University in 1956 and was sent to USAF intelligence training school in Frankfurt, Germany in 1956-1957. Through Marsh, Pettie got his wife a job with the CIA from 1957 to early 1961, working in Washington as secretary and in Germany for the Chief of Station, Frankfurt. Colonel Leonard Weigner, USAF (deceased 1990) trained Pettie and advised Pettie retire from active military service and surround himself with kooks, recruiting agents from youth hostels and universities. Major George Varga became Pettie's case officer, relaying Weigner's instructions until Varga died in the 1970s.

Under Varga's instructions, Pettie recruited a network of agents in Europe, including Dr. Keith Arnold (recruited in Paris in 1958) who he accompanied to Moscow in 1959 or 1960. Arnold, currently based in Hong Kong with the Roche Foundation, has made over 40 trips to mainland China and has stayed in contact with Pettie. In the 1960s Pettie established connections with the 'beat' movement. Norman Mailer and Dick Dabney (died in November 1981) frequented his Virginia farm. Dabney's widow Dana has extensive files on Pettie. Peter Gillingham (Intermediate Technology, Palo Alto, CA) and Christopher Sonne (currently Goldman saches, NY) met Pettie in Moscow in 1961. In the early 60s Pettie allowed Ralph Borsodi and Mildred Loomis to use his Virginia property for the School of Living, a 'decentralist' one-world government ront organization. Around 1964 Pettie recruited Bosco Nedelcovic and deployed him to penetrate the Institute for Policy Studies (he is currently an interpreter at the war College in Wahsington). In 1967 or 1968 Pettie established a 'futurist' network, assisting Edward S. Cornsih in founding the World Future Society and working through Roy Mason and John Naisbitt. At this time Pettie also penetrated the hippy drug culture through retired naval intelligence officers Walt Schneider (Timothy Leary and Billy Hitchcock's private pilot) and Willard Poulsen (cut out bewtween Pettie activities and those of Leary at millbrook). In 1971 Pettie infiltrated the 'human potential' movement, setting up Ken Kesey (Living Love) as a prominent guru and working through Dr. Stephen Beltz (related to Judith Beltz, a behavior modification specialist more recently deployed to the Institute of Cultural Affairs and the Meta Network cult.

Christopher Bird, former CIA officer who served in Japan and a psych warfare specialist in the Army, and author of New Age and occult books has also been associated with Pettie. Bird wrote *The Secret Life of Plants* with Peter Tompkins, New York: Avon, 1974. Tompkins wrote on new age subjects like the pyramids, and once served in the OSS (now anti-CIA).

Pettie's activities took a different turn in 1979 when he recruited John J. Cox, founder of General Scientific (a computer firm specializing in classified defense

contracts). Cox trained several of Pettie's Finders in computer programming and communications technologies and took two or more of them to Costa Rica and Panama in 1980-81. Cox worked through Miguel Barzuna, a prominent Costa Rican money launderer, the Vienna, Virginia-based Institute for International Development and Cuban exile Emilio Rivera in Costa Rica and Panama. Through Cox, Pettie and the Finders linked up with several Washington area computer-oriented groups, including Community Computers, a front organzation for The Community, a cult run by Michael Rios (aka Michael Versace). (Pettie's son, David Pettie, is a member of the Community. Pettie's other son, George, may be the one who was in *Air America*) Cox also recruited Theordore G. Reiss (wife: Ann), a reston-based computer programmer and highly active member of Werner Erhard Seminars (EST). Cox also recruited Susan Gabriel and Judith Beltz as couriers. Pettie and Cox have simulated a falling out and pretend to be enemies...

Paranoiac Iconography

by Max Well

Three groups fight for control of the earth. The circle represents one group; a triangle with an apex pointing up represents another; a triangle with a downward pointing apex represents the third. A fourth secret group exists and manifests itself in symbols that yield 34 degrees when measured with a protractor, one degree above the infamous Masonic 33rd degree.

The symbolism of this internecine warfare is ubiquitous in the malls, on trucks and in corporate icons throughout the world, as this pictorial essay demonstrates. Keys to understanding this symbolism can be founding a book by William J. Schnoebelen and James Spencer, *Mormonism's Temple of Doom* and in the video *The Naked Truth* with Bill Jenkins, Jordan Maxwell and Derek Partridge. (1-800-955-9960).

In the wallet: Follow arrows along the reverse pyramid to read the encoded word word "MASON."

Six sided stars superimposed over the American eagle. 666? A sixty degree measurement often appears in the hidden symbolism as well.

On TV and in newspapers:

Emblem from the *Star Trek* television show.

From fake story in *USA Today*.

On the highways and in the malls:

Project Mind Kontrol:
Did the U.S. Government Actually Create Programmed Assassins?

By Curt Rowlett

"The dream of every leader, whether a tyrannical despot or a benign prophet, is to regulate the behavior of his people."
--Colin Blakemore

Call Waiting

In the 1970s spy thriller called *Telefon*, the KGB has programmed Russian agents to commit assassinations and acts of terrorism, before committing suicide on completion of their programmed mission. All of this takes place without the subjects having any knowledge that they are mind-controlled. These individuals have been programmed to react when the lines of a Robert Frost poem are recited to them over the telephone. Placed all over America as "sleepers", these robot-assassins live their lives believing they are ordinary Americans, until the fateful moment when the telephone rings and a voice begins to recite, "The woods are lovely, dark and deep, but I have promises to keep and miles to go before I sleep. Remember, comrade, miles to go before you sleep".

Pure Hollywood fantasy about a paranoid conspiracy theory, right? Maybe. I am split on whether or not I believe in such things as mind controlled, programmed assassins. A part of me refuses to accept that this concept is anything more than an irrational fear and a good plot for a movie like *Telefon*. Then there is another part of me that looks at the information forced out of the CIA via the Freedom of Information Act and I somehow can't quite bring myself to dismiss the idea as mere concept. We now have substantiated proof that the CIA was working on projects to control human behavior. And given the history of the agency as revealed in once classified documents, it is safe to say that the CIA would have had a great interest in creating the perfect agent: one who didn't know he/she was an agent. One who was mind-controlled. Such a scenario would be plausible denial at it's finest, producing the ultimate patsy.

During their investigation and research into the history of LSD, authors Martin A. Lee and Bruce Shlain were allowed access to a special reading room at the Hyatt Regency in Rosslyn, Virginia. Documents pertinent to the CIA's MKULTRA program were being opened to the public as the result of a Senate subcommittee led by chairman Senator Ted Kennedy. In the prologue to their book *Acid Dreams*, they write:

In the course of our inquiry we uncovered CIA documents describing experiments in sensory deprivation, sleep teaching, ESP, subliminal projection, electronic brain stimulation, and many other methods that might have applications for behavior modification. One project was designed to turn people into programmed assassins who would kill on automatic command. (1)

Most conspiracy researchers are familiar with the CIA's mind control program MKULTRA. It was led by creepy scientist-spook Dr. Sidney Gottlieb, who testified before the same subcommittee only after receiving a grant of immunity from criminal prosecution. MKULTRA was launched in April of 1953 as a continuation of mind-control experiments that originated in the Nazi death camps of such notoriety as

Dachau. (MKULTRA and other CIA projects became possible because of Project Paperclip, a US Army scheme that smuggled Nazi scientists, intelligence personnel and other war criminals to the United States from Europe at the end of WWII.) The start of the Cold War and the Korean War in particular gave the go ahead to mind control research with the advent of "brain washing" as a house-hold name. Supposedly a development of the Communist-Chinese, the term was actually coined by a magazine writer later discovered to be on the CIA payroll as an "agent of influence". On the premise of a "brainwashing gap", the CIA got permission for research into countering alleged communist mind control efforts and set out to develop their own to aid in the espionage battle.

MKULTRA Calling: A History of Horrors

The abuses of MKULTRA are just beginning to see the light of day. On November 19, 1953, an Army scientist and germ warfare specialist named Frank Olson, who was working on an MKULTRA project, was without his knowledge or consent, slipped a dose of LSD in a drink at a party attended by other CIA personnel. For weeks afterward he remained in what many witnesses described as a state of depression and paranoia. He confided to one CIA doctor that the agency was putting something in his coffee to keep him awake at night, that people were plotting against him and that he heard voices commanding him to throw his wallet away, which he did, even though it contained several uncashed pay checks. On the last night of his life, he checked into a room at the Statler Hilton hotel in New York City along with a CIA agent assigned to watch him. Olson allegedly jumped through a closed hotel window and fell ten stories to his death. It was Dr. Gottlieb who had slipped him the drug at the party. An elaborate cover-up eliminated any clues as to the actual circumstances of his death. The full truth of what happened would not come to light for twenty years. (On a recent episode of the television show *Unsolved Mysteries*, serious doubts were raised as to whether Olson actually jumped through the window unaided.) Olson's widow was eventually awarded a large cash settlement in connection with his death at the hands of the CIA.

Dr. Ewen Cameron, a prestigious psychiatrist who directed the Allain Memorial Institute in Montreal, Canada also worked for the CIA during MKULTRA. With financial backing from the CIA, Dr. Cameron developed a bizarre method for reprogramming people. This involved "sleep therapy" where a person was knocked out with sedatives for months at a time. Next, the phase involved "depatterning" in which the person was given massive electroshocks and frequent doses of LSD in an attempt to wipe out past behavior patterns. Then, the doctor would attempt to recondition the person's mind using a technique called "psychic driving", in which the person was again heavily sedated, locked in a "sleep room" where tape recordings of various messages were played over a speaker under the person's pillow as many as a quarter of a million times. (2)

(Nine of Dr. Cameron's former "patients" have filed lawsuits against the American government in a claim that they are still suffering from trauma as a result of these experiments.)

Another death attributed to the program was that of Harold Blauer in 1953. Blauer was part of a study conducted by a group of doctors working under an army contract at the New York State Psychiatric Institute. He died a few hours after an injection of MDA, a psychedelic, amphetamine-derived drug, similar to the 90's

"rave" drug, Ecstasy. The drug had been supplied by the Army Chemical Corps in co-operation with MKULTRA. One army researcher later admitted that "we didn't know if it was dog piss or what it was we were giving to him." (3)

And in perhaps one of the most bizarre and horrifying abuses, Dr. Paul Hoch, while performing experiments for the army as a CIAA consultant, gave intraspina injections of LSD and mescaline to psychiatric patients, later lobotomizing them. In one experiment, after a psychedelic had been administered, Dr. Hoch gave a subject a local anesthetic and asked him to describe his visual experiences as surgeons removed pieces of his brain. (4) (The list of other abuses occurring during MKULTRA is a lengthy one that could fill a large volume.)

The CIA appears to have chosen to experiment primarily on certain groups: prisoners, mental patients, "foreigners", sexual deviants, and minorities. Much of the experimentation occurred at places like the Addiction Research Center, a federal hospital for drug addicts in Lexington, Kentucky. CIA documents describe experiments conducted in which persons were given LSD for over seventy-five consecutive days in double, triple and quadruple doses. The majority of these subjects were black males. Abuses of inmates at Vacaville Medical Facility in California, a prison psychiatric hospital, were also conducted under the auspices of MKULTRA. As we shall see, this selective policy may have culminated in such horrors as the People's Temple tragedy in Jonestown, Guyana.

A Directory of Lone Nuts

But to my knowledge, we have no actual proof that the CIA was successful in actually creating a programmed assassin. Or do we? In the late 60s and early 70s, assassinations changed the course of three

presidential elections. In each of these cases, responsibility was placed on a "lone nut", conveniently relieving any need for inquiries into possible conspiracies. Research into assassinations and attempted assassinations, various murders and mayhem, and covert activities of America's intelligence community
aimed at American citizens contain our best evidence of the possible success of mind-control experiments that may have produced programmed assassins.

Also present in some of these cases is the technique of using "doubles" and even theatrical effects to deliberately create confusion, promote propaganda and negative sentiments against "subversive groups" or to bolster the portrait of the "lone nut" in the minds of Americans. It is possible that these "doubles" were also programmed and mind controlled. The cases of John F. Kennedy, Martin Luther King, Ronald Reagan, John Lennon, Governor George Wallace, the People's Temple "massacre" at Jones Town, the Symbionese Liberation Army, the "Zebra" murders, and even the Charles Manson Family are rife with tantalizing clues that seem to suggest that mind-control has been achieved by the CIA. Consider the following, itemized list in America's Directory of "Lone Nut" Assassins:

Lee Harvey Oswald- the alleged "lone nut" assassin of JFK had numerous ties to the intelligence community and served with the Marine Corps at Atsugi, Japan (originating base of the U2 spy plane flights) during which time LSD was known to have been field tested there by the CIA. There is the implication to be considered by his known presence there that Oswald may have been the first "Manchurian Candidate" from which others were fashioned. The use of numerous "doubles" in the Oswald saga is well documented by other researchers.

James Earl Ray-is the alleged assassin of Martin Luther King. This case provides us with evidence of the FBI and CIA's involvement in the assassination of a black "political dissident". In the tradition of intelligence "handlers", there is the mysterious "Raoul", whom Ray claims was his contact during the days leading up to the assassination. While there is no evidence of mind control in regard to Ray, the case remains of interest for the use of doubles "Paul Bridgemen", "Eric S. Galt", and "Ramon George Sneyd".

Sirhan Sirhan-portrayed as the "lone nut" in the assassination of Robert F. Kennedy. There is strong evidence of the presence of the CIA in this assassination. The LAPD (which may have been under the direction of the CIIA) figures prominently in th cover-up which took place after the shooting. In what is perhaps one of the best cases for the evidence of mind-control, it has been suggested that Sirhan may have been programmed by the CIA with hypnosis and drugs. (Sirhan claims to have no memory of the killing.) Hypnotist William J. Bryan, Jr., who allegedly worked for the CIA, bragged about hypnotising Sirhan prior to the assassination, as well as the serial killer known as the "Boston Strangler", Albert DeSalvo, and was also a technical consultant for the film *The Manchurian Candidate*. Phrases from Sirhan's private notebooks show the characteristics of "automatic writing" of a hypnotically programmed subject and he even makes references to "mind control", money, and drugs. Witness Sandra Serrano, who was harassed/intimidated/ridiculed by LAPD polygraph operator Sgt. Enrique Hernandez as he tried to get her to change her story (Hernandez had ties to the CIA and may have been a professional CIA interrogator) reported that, just prior to the shooting, she saw Sirhan with a "Latin" man and a girl in a polka-dot dress ascending an emergency

stairway in the hotel where RFK was shot. Other witnesses saw Sirhan near a coffee machine inside the hotel with a girl in a polka-dot dress who was whispering to him. (Sirhan has said that the last thing he remembers prior to the shooting of RFK was having a cup of coffee with a girl. The next thing he remembers is when he is being restrained after firing his weapon at Kennedy. This suggests the possibility of additional drugs being placed in his coffee, and further hypnotic suggestion being given to him just prior to the shooting) Immediately after the shooting, witnesses saw this same woman and a male companion (the "Latin") leaving the hotel and gleefully exclaiming, "We shot him! We shot Senator Kennedy!" Prosecution psychiatrist Seymour Pollack, who was convinced that Sirhan had been programmed by someone, asked Sirhan while under hypnosis if anyone was with him when he shot Kennedy, to which he replied in a hushed tone, "the girl, the girl."

Charles Manson-and his followers committed the Tate-LaBianca and other killings during the 1960s. Manson used mind-control techniques such as hypnotism, high doses of LSD, and programming to turn flower children into killers, but one has to wonder just exactly where did Manson learn to program people? Manson was part of the "hippie element" at the time of the CIA's use of all kinds of drugs and MKULTRA experiments to discredit the left wing anti-war movement in America. (A type of LSD known as "Orange Sunshine" was being used by the Manson Family immediately prior to the Tate-LaBianca murders according to Family member Charles "Tex" Watson. (13)

This special LSD may have been supplied by the CIA. Orange Sunshine was manufactured and distributed by a group known as "The Brotherhood of Eternal Love" which operated out of a beach resort near Los Angeles. The Brotherhood had among it's drug manufacturers and dealers, one Ronald Stark, a person with known connections to the CIA. It is believed that Stark was responsible for the manufacture of up to 50 million hits of LSD.) (14) It is also interesting to note that Manson, an avowed racist and having a known affinity for right-wing beliefs, was somehow conveniently linked with the left in the news media. It can be argued that the Manson murders "nailed the coffin shut" in the minds of many Americans as far as the image of the Hippies as a peace-loving, political movement was concerned, and it should be considered that this could have been part of a CIA operation to discredit the anti-war movement in America. Manson has said in interviews that he based some of his "philosophy" on the science fiction novel *Stranger in a Strange Land* by Robert Hienlien. In a scenario perhaps reminiscent of Mark David Chapman's infatuation with *Catcher in the Rye*, could *Stranger in a Strange Land* somehow have been Manson's program-trigger mechanism? And consider that if a hippie-ex-convict-nobody like Charles Manson could program people to kill, why not the U.S. Government? In *Helter Skelter*, Manson prosecutor Vincent Bugliosi discusses Manson's programming techniques in depth, likening much of the programming to the same thing that takes place with recruits in the U.S. military, but Bugliosi also hints at "some missing element, some aspect of Manson's personality that we do not understand" that enabled him to program his followers to kill. Manson was in prison during the time that the CIA was known to be using inmates at Vacaville prison in the MKULTRA experiments, a fact that leaves one guessing if perhaps Manson was some sort of mind-controlled *guru cum agent provocateur*, set loose against the "subversive" elements by the CIA. Since his incarceration for Tate-LaBianca, Manson has served part of his time at Vacaville.

Arthur Bremer- the attempted assassin of Governor George Wallace of Alabama, was described in the media as a deranged loner, but he wasn't alone at all if you count the involvement of the CIA and the Nixon/Watergate "plumbers" who figure prominently in this case. It has been suggested that Wallace could potentially have taken too many votes away from rival presidential candidate Richard Nixon if allowed to stay in the presidential race. He was conveniently eliminated by Bremer. On Monday, May 15, 1972, Arthur Bremer attempted to assassinate George Wallace at a campaign rally in Laurel, Maryland. According to researchers, within one hour after the Wallace shooting, Nixon aide Charles Colson, having invented a ruse to place blame for the shooting on radical extremists of the left wing, ordered Watergate "plumber" E. Howard Hunt to break into Bremer's apartment and plant Black Panther and Angela Davis literature. (Bremer, however, had political convictions leaning towards the extreme right. George Wallace himself stated that he wondered how members of Nixon's staff had found Bremer's apartment so quickly after the shooting.) But this "loner" actually had quite a few friends. One of these friends, Dennis Cassini, turned up mysteriously dead in the trunk of his own car before he could be questioned. (5) The FBI didn't even bother to investigate his death. According to *The Milwaukee Journal*: "The former Wisconsin College Republican State Chairman said (that) Donald Segretti, confessed political spy and Republican saboteur in the 1972 presidential campaign, urged him to recruit persons in Wisconsin to do dirty tricks to embarrass the Democrats." Arthur Bremer was from Milwaukee. Records show that Bremer traveled extensively while stalking Wallace on his campaign trail, staying in expensive hotels, running up debts totalling $5,000 dollars, which he paid. Unusual for a busboy whose total earnings were under $2,000 dollars for the year. Bremer was also identified prior to the assassination as the man seen accompanying Watergate-operative Anthony Ulasewicz in Michigan. Bremer was sentenced to 63 years in prison and has never given any explanation as to why he shot Wallace.

Mark David Chapman- "lone nut" assassin who killed "leftist" John Lennon, had possible ties to the CIA as a former World Vision Employee. (World Vision Missionaries is an international evangelical order that has performed espionage work for the CIA.) Allegedly, while working for World Vision, Chapman was trained in Beruit as a "security guard". After shooting Lennon, Chapman sat down and calmly began reading from *The Catcher in the Rye*, a novel by J.D. Salinger. (According to the *Big Book of Conspiracies*, J.D. Salinger, author of *Catcher* served in the Counter Intelligence Corps during WWII with Henry Kissinger. We can theorize that this book served as some sort of post- hypnotic suggestion or program "trigger".) (6) At least one policeman who interviewed Chapman was convinced that, due to his demeanor, that he (Chapman) was under the influence of some sort of hypnotic programming. Chapman has officially been portrayed as an obsessed Beatles fan who stalked and killed Lennon. (A source of mine who wishes to remain anonymous told me that he once worked in a record store in Decatur, Georgia where Mark David Chapman shopped for records. He claims Chapman was not a Beatles fan, but rather a Todd Rundgren fan.)

John Hinckley, Jr.-attempted assassin of Ronald Reagan, whose death would have placed CIA- man vice-president George Bush into the white house eight years earlier than when he was eventually elected. Hinckley was the son of a World Vision official. Like Mark David Chapman, he also had a copy of Catcher in the Rye in his

possession when apprehended. According to official reports, Hinckley was also heavily "influenced" by the Travis Bickle character in the film *Taxi Driver*. In this film, Robert DeNiro plays an obsessed gunman who plans to assassinate a presidential candidate. (A role that was inspired by Arthur Bremer) Like Bremer, Hinckley traveled extensively around the U.S., and was arrested at the airport in Nashville, Tennessee with three handguns. Curiously, Hinckley was not placed under any surveillance after this incident. And Like Sirhan Sirhan and Bremer, Hinckley also kept a dairy in which he detailed his plans for shooting Reagan. There are reports that a Hinckley "double" named "Richardson" traced Hinckley's path from Colorado to Connecticut, all the while writing letters to Jodie Foster, just as Hinckley did. (Richardson was arrested with a weapon at New York's Port Authority bus terminal, claiming he was going to kill Reagan. He also had links to World Vision.) Even Mae Brussel spotted an apparent Hinckley double prior to the assassination attempt and reported this to the Secret Service. It is known through court records that Hinckley underwent psychiatric "treatment" just prior to his attempt on Reagan and that at the time of the shooting, he was under the influence of tranquilizers.

Found not guilty by reason of insanity, he remains confined to a psychiatric hospital where he occasionally corresponded with such notables as serial killer Ted Bundy and Lynette "Squeaky" Fromme of Manson Family fame and an attempted assassin in her own right.

Kerry Thornley-has claimed that he and Oswald were both mind-controlled and involved in the JFK assassination without conscious knowledge. Thornley served in the Marine Corps with Oswald. He too, was once stationed at Atsugi, Japan. He has come to believe that he was, against his will and without his knowledge, part of the conspiracy that killed Kennedy. (Thornley once worked at a Mexican restaurant in the Little Five Points area in my hometown of Atlanta, Georgia. I remember him being pointed out to me once at a party. At that time, Thornley was regarded as just another oddball street personality who had wacky ideas about the JFK assassination, and no one really gave any particular credence to what he had to say. This was prior to the revival of mass interest in the assassination that was generated by the release of the Oliver Stone film, *JFK*. Since then, opinions have changed.) Thornley testified before the Warren Commission and at the time he claims he was satisfied that Oswald was Kennedy's killer. In his book, *Conspiracies, Cover-ups and Crimes*, author Jonathan Vankin interviewed Thornley and reveals, among other things, that Thornley was living/working in New Orleans at the same time that Oswald was living there and in a neighborhood that was host to a whole cadre of intelligence agencies. Thornley reportedly met both Guy Bannister and David Ferrie while in New Orleans, and after moving to L.A., he met John Roselli, one of the country's most powerful mobsters and an object of suspicion regarding the assassination. (Roselli was later found chopped into pieces and stuffed into an oil drum which had been dumped off the Florida coast shortly before he was to testify before the House Select Committee on Assassinations) Vankin's book discusses how in 1961, while living in New Orleans, Thornley was introduced to a man named Gary Kirstein in a New Orleans bar called the Bourbon House. Thornley recalls that Kirstein was "sort of a neanderthal racist" and was writing a book titled, *Hitler Was a Good Guy*. Thornley, in recalling the most memorable parts of his conversation with Kirstein states that he (Kirstein) and himself

debated theoretically on how to assassinate President Kennedy, as if they were two writers discussing how it could be written in a novel. Thornley also says that Kirstein basically predicted everything that was going to happen in the next twenty years, including the Manson Family, the war in Vietnam, etc. (Thornley states that at the time he listened to this conversation, he was bored and disbelieving of Kirstein and that he had blotted out the memory of this conversation for ten years) Thornley now believes that Kirstein may have been E. Howard Hunt, CIA spook extraordinaire and Watergate "plumber". Thornley later wrote an article entitled, *Did the Plumbers Plug J.F.K., Too?* that appeared in an Atlanta underground newspaper. In the book *Secret and Suppressed*, Thornley wrote an article titled, "Is Paranoia a Form of Awareness?" in which he writes:

After I wrote *Did the Plumbers Plug J.F.K., Too?*, I got two unusual phone calls. First was a male voice imitating the sounds of a speeded-up tape recorder or a gibberish-talking cartoon character. Ten years earlier a (New Orleans resident) named Roger Lovin and I used to address one another in the Bourbon House with identical noises to those I was now hearing on the other end of the line...This time I simply replied with a word or two of bewilderment, and the caller hung up. Within seconds, the phone rang again. Now a male voice-not Roger's-said very clearly, "Kerry, do you know who this is?" When I answered in the negative, he said, "Good!"-and again the caller hung up. (7)

Thornley said the voice on the telephone brought back "eerie memories" and sounded similar to the voice of the "Kirstein/Hunt" individual from New Orleans. (Shades of *Telefon?*) Also while in Atlanta, Thornley went to the Atlanta police during a time that an interest in new allegations regarding the assassination of Martin Luther King, Jr. were being investigated because he again "remembered that Kirstein had also talked about killing King". Twelve days after making statements to the police, Thornley was attacked and pistol-whipped by two men in ski masks who, strangely, took only his identification. Thornley now believes that he was programmed for some part in the assassination of Kennedy and that "Kirstein" was his controller and may have implanted some sort of device in his brain.

Donald DeFreeze-the leader of the Symbionese Liberation Army who was imprisoned at Vacaville during the time of the MKULTRA experiments, may have been a CIA, FBI "agent provocateur". He may also have been mind-controlled. According to Jonathan Vankin and John Whalen:

There was something queer about the SLA all along. Its leader, Donald "General Field Marshall Cinque" DeFreeze-career crook and informer for the LAPD-emerged from the California penal system's Vacaville Medical Facility where he'd come under the tutelage of CIA agent Colston Westbrook, a psychological warfare specialist. Westbrook enlisted DeFreeze into his "Black Cultural Association." Armed robber DeFreeze obtained early release from Vacaville by performing "a favor" for prison authorities. (Doing a "favor" was in reference to submitting to psychiatric experiments.) The SLA went public with the assassination of African American Oakland school superintendent Dr. Marcus Foster on Nov. 6, 1973. Just weeks earlier, a neo-Nazi group issued a flyer predicting Foster's death. "Black men" were witnessed scurrying from the scene of the crime but the arrested shooters were whites. Blackface makeup was discovered in their apartments. (8)

Regarding the use of makeup and other theatrical props, consider the following:

In a *Strange Magazine* article, "The Makeup Man and the Monster: John Chambers and the Patterson Bigfoot Suit", editor Mark Chorvinsky mounted an investigation into whether the famous "Wright-Patterson" Bigfoot film, a virtual cornerstone in the investigations and belief of the existence of Bigfoot, was actually a hoax perpetrated by renowned Hollywood makeup/effects artist John Chambers. The film was allegedly shot on October 20, 1967 and shows what is purported to be an actual Bigfoot creature as it walks through the forest in California. The footage has been featured in numerous television shows and films and is usually the film people think about when discussing the reality of the creature. During Chorvinsky's investigation, he interviewed many of Hollywood's most prominent makeup artists. Chorvinsky writes, "I have investigated many phenomena over the past decade, and some of the cases have been quite controversial, but rarely has anyone requested anonymity...I'm in the awkward position of knowing more than I can tell at this time. One aspect of either (John) Chambers' career or the legends surrounding it is the buzz about Chambers' involvement in government-sponsored "black box" work. No one has ever been willing to go on the record concerning this alleged work, but within the Hollywood makeup community it is generally believed that such work did occur and that it has added to the secretiveness of Chambers and his closet associates...Widespread rumors in the makeup community depict Chambers applying a wig and prosthetics to a cadaver to fake the death of a foreign ruler, and engaging in a number of "Company"-sponsored "nontheatrical" projects. These black box rumors are all reminiscent of Mission Impossible plots, many of which relied on disguises--some courtesy of Chambers' makeup prowess. One rumor depicts the CIA watching *Mission Impossible* on television and getting disguise ideas from it, then going after the makeup artist--Chambers--to work for them...we do know for a fact that Hollywood makeup artists have been instrumental in various military/intelligence projects...In this regard I interviewed Bob Schiffer, the head of Disney's makeup and hair department with over sixty years in the business. The veteran makeup master touched on this sensitive topic:

John did mention to me at one time that he was involved in something for the government. Some of us, including myself, were recruited during World War II by (then Lieutenant) Gordon Bau for undercover work of a certain type. Sometimes we did not know what the makeup was used for. A lot of us did camouflage work in World War II. I was also involved in the years after the war. In the Bay of Pigs invasion we made up people to look Cuban. (9)

Rev. Jim Jones-was the supposed mastermind behind the People's Temple massacre in Guyana where over a thousand people died. The official version of this story is that Jones' followers committed mass suicide by swallowing cyanide-laced Kool-Aid in an act of religious devotion to Jones. New information reveals the possibility that this "massacre" was in reality an MKULTRA mind-control experiment, conducted by the CIA, and that most of the dead were actually murdered. Drugs such as those used in known MKULTRA operations were discovered at Jonestown, including a whopping 11,000 doses of Thorazine, a major tranquilizer used in psychiatric hospitals. (10) In a recording made during the final moments of the mass deaths in Jonestown, Jim Jones can be heard shouting, "Get Dwyer out of here", in reference to Richard Dwyer, a CIA agent who was present during the "massacre". Evidence gathered by other researchers points to a strong CIA presence in almost all of the dealings of Jim Jones before, during and after

Jonestown and to the Guyana site itself. The People's Temple also had ties to the World Vision ministry. There is evidence that Jones used doubles and even some confusion as to whether it was the genuine Jones whose body was found among the dead.

Witnesses to the shooting of Congressman Leo Ryan and others at the Jonestown site describe the assailants as "zombie-like" and emotionless. In reference to a rumored "death list" compiled by the People's Temple, a congressional aide was quoted as saying, "There are 120 white, brainwashed assassins out from Jonestown awaiting the trigger word to pick up their hit." (11)

Serial Killers-the recent explosive rise in the 1980s of the serial killer phenomenon has always made me wonder if perhaps what we are seeing is the result of mind-control experiments gone awry. That maybe these killers are "sleepers" who woke up too early. Consider that for the most part, serial killers tend to prey on the "undesirables" of society, such as prostitutes, homosexuals, and other targeted minorities of the right wing. The FBI's Behavioral Science Unit has stated that as many as 150 serial killers may be operating undetected in the United States. Serial killers appear to be acting under a programmed obsession to kill, usually in the same way, over and over again, as if trying to fulfill some sort of mission.

The Zebra Killings- San Francisco's "Zebra killings", a murder spree roughly simultaneous with the time that the SLA was active, were allegedly perpetrated by American Black Muslims motivated by "revenge" on the white race. Given the history of such tactics as the use of disinformation and smear campaigns against "subversive" groups, it is possible that this was a CIA program to discredit the Muslim movement in America, and that the murders were possibly committed by whites in black face makeup.

These crimes were allegedly carried out by a Nation of Islam group that called themselves the "Death Angels" and who believed that they were serving Allah by killing "blue-eyed devils", i.e. Caucasians. To become a Death Angel, a member supposedly had to kill either nine white males, five white females, or four white children in order to earn their "wings". This was supposed to guarantee the killer a place in Mecca in the afterlife. (The police estimated that up to two thousand persons earned their "wings".) The code-named Zebra killings (so-called because the crimes involved black on white) took place in San Francisco during a six month period from 1973 to 1974 and occurring during the time of CIA/FBI involvement in Vacaville and anti-subversive type operations in California. The murders involved shootings, stabbings, and hackings with machetes. On January 28, 1974, the killers claimed five victims in one night. A group of five black Muslims were arrested and accused of being the principal perpetrators, but one defendant (A.C. Harris) turned informant and testified with immunity. The Nation of Islam paid for three defense attorneys during the trial. All of the suspects received life sentences.

Disconnected Connections

The religious "cults" that come under public scrutiny always seem to involve accusations of mind-control. Do the implications of government involvement in a place like Jonestown and what we now know about MKULTRA suggest that we will see this sort of history repeat itself? "Those who do not remember the past are condemned to repeat it" are the very words that were displayed prominently on a sign above the pulpit at Jonestown. What will future investigations reveal as to CIA/intelligence ties lying behind other groups such as the Branch Davidians? Consider the rumblings

that have been heard regarding accused Oklahoma bombing suspect Timothy McViegh and a supposed mind-control device implanted in his brain. Perhaps McViegh received a special telephone call just prior to the events in Oklahoma City...

In response to public outcry in 1977, Congress forbade further research into mind-control and demanded that these programs be terminated. Former CIA man Victor Marchetti has revealed that as of today, so-called "black programs" working with mind-control still exist, only now they are better hidden. A new project that works with "synthetic telepathy" supposedly has the ability to remotely transmit microwave voices into the heads of targeted persons. This device and others are known as Less Than Lethal (LTL) weapons, according to an article that ran in the April 1994 issue of *Scientific American*. (12) During the NBC documentary *The Other Side*, Major Edward Dames of the Pentagon's Defense Intelligence Agency stated that "The U.S. Government has an electronic device which could implant thoughts in people." He refused further comment afterward.

And so the beat goes on. Your tax dollars are at work, even as you sleep. And who knows, maybe the next ringing telephone could be a "wake-up call" for either you or me?

NOTES:

1. *Acid Dreams: The Complete Social History of LSD: The CIA, the Sixties, and Beyond*, by Martin A. Lee and Bruce Shlain, Evergreen Books, Prologue, page xxiv.

2. *Acid Dreams*, page 23.

3. *Acid Dreams*, pages 37-38.

4. *Acid Dreams*, page 38.

5. *The Big Book of Conspiracies* by Doug Moench, Lone Nut Family Tree by Duncan Eagleson, page 160.

6. *The Big Book of Conspiracies*, page 157.

7. *Secret and Suppressed: Banned Ideas and Hidden History*, edited by Jim Kieth, "Is Paranoia a Form of Awareness?" by Kerry Thornley, page 49.

8. *60 Greatest Conspiracies of All Time*, By Jonathan Vankin and John Whalen, "The Brainwashed Debutante."

9. *Strange Magazine*, Issue No. 17, "The Makeup Man and the Monster: John Chambers and the Patterson Bigfoot Suit", by Mark Chorvinsky, pages 51-52.

10. *Secret and Suppressed: Banned Ideas and Hidden History*, edited by Jim Kieth, "The Black Hole of Guyana", pages 140-141.

11. Associated Press, May 19, 1979.

12. *Scientific American*, April, 1994, article, "Bang! You're Alive!".

13. *Will you die for me?: The man who killed for Charles Manson tells his own story* by Tex Watson, as told to Chaplain Ray, Fleming H. Revell Company, page 188-120.

14. *Acid Dreams*, pages 248-251.

THE MANHATTAN PROJECT TO MANUFACTURE THE FIRST YUPPIES

How the *New York Times* and *New York Magazine* transformed a generation.

by Martin Kaufman

They nauseated. They infuriated. Worst of all, they persisted, and are still with us today. But the real story of how the yuppies came about has never been told.

Instead, the media invented a yuppie mythology. In 1984, the year "yuppie" became a household word, *Newsweek* wrote "much of the energy and optimism and passion of the sixties seems to have been turned inward, on lives, careers, apartments and dinners." (1) Note the passive verb; been turned suggests it happened by itself, that nothing caused the rebellious sixties spirit to turn inward.

Years later, *Time* wrote "The getting-and-spending frenzy of the 1980s can be seen as just another stage in the life quest of the baby boomers, the successor to the hedonism of the sixties and the obsessive self-improvement of the Me Decade." (2) Yes, it can be seen that way, *Time*, but we'd rather see it accurately.

Esquire noted "Yuppiedom is a phenomenon of the Reagan era, inextricably tied to the values, follies and peculiar conditions thereof." They also credited 1966's "Gathering of the Tribes for a Human Be-In," saying it combined "the political sit-in and teach-in with the psychedelic-mystical be-here-now to symbolize the marriage of the strains that produced the distinctive mass youth culture of the baby boomers, and eventually-so sinuously and unpredictably does the dialectic work its mysterious will-yuppies." (3) Of course! "The dialectic" did it, assisted by the be-here-now. (How could we have been so dense as to not realize that?)

Do a bit of cultural archaeology, however, and you discover that the yuppies were a created phenomenon. The manufacturing process didn't start under Reagan, but all the way back in the days of Ford, even Nixon. Its goal? To transform the anti-materialistic sixties generation back into responsible Americans; i.e., get them to buy on command.

Some background: With the pullout from Vietnam and ouster of Nixon, many people in the 70s felt they could really make change happen. The 60s spirit was alive-in 1975 seven bills to legalize marijuana were introduced in the New York legislature.(4) David Rockefeller's elitist Trilateral Commission termed such attempts by the people to influence their government a "crisis of democracy" that had to be dealt with.

Shunning competitive standards of success, many sought personal fulfillment through self-exploration-encounter groups, "est" and the like. Thus Tom Wolfe's famous criticism of "The Me Decade." The real problem for Wolfe and his wealthy patrons may well have been that inward journeys did nothing to boost corporate profits.

But what if you could channel this urge for "me" elsewhere-say, into a quest for material possessions and luxury? It might even make people like competition again. And drop their silly ideas about having a say in government.

"Coincidentally," there were powerful forces doing just such channeling. On November 10, 1976, the world's most influential newspaper, The New York Times, debuted its Wednesday "Living" section. In the very first issue we find all the tokens and value systems of yuppiedom that would "mysteriously" arise eight years later.

An article, "Being in the Swim in Your Own Home" began: "After a Rolls Royce complete with liveried chauffeur and a low license plate number, what else could be the ultimate status symbol? A private swimming pool in your own city residence?"

In "The Best Pâtés...in New York" Mimi Sheraton ensured that "one of the least known" of "the many glories of French gastronomy" would be unknown no longer.

Craig Claiborne implored we cook "Volaille au Coulis de Poireaux et de Truffles." "Wine Talk" discussed champagne-not the plebeian California stuff but real champagne from "the valley of the Marne River east of Paris."

A professional party organizer advised: "Better you serve celery with pâté. It holds up; it doesn't wilt." Enid Nemy, "while on the subject of status," extolled Louis Vuitton's $275 backpack. "Pavarotti's Diet-with Pasta" made one long for the days when it was called macaroni.

Mike Wallace pondered his dream to open a restaurant (a future yuppie cliché). William F. Buckley, Jr. shared veal recipes, with a typically yuppie (and typically Buckley) unconcern for the disgraceful torture veal calves undergo.

"The 60-Minute Gourmet" described Shrimp Margarita and Vinaigrette Sauce with herbs. "Living Abroad," subtitled "Status for hire," noted "it is still important...to have a good London address." Anticipating the yuppie obsession with credit cards as status symbols, "Personal Finance" discussed bank cards and American Express cards. And "Personal Health" was about jogging.

In short, the very first "Living" section featured all the yuppie fixations, eight years before the yuppies became a recognized phenomenon and household word. And this was only the beginning.

What was the *Times* doing here? Were they describing a phenomenon, as real journalists do? Or were they actively endeavoring to move a reluctant generation toward big time capitalism, as elitist planners do?

If there was a yuppie trend before "Living", the only place it's apparent is in Clay Felker's *New York Magazine*. In the early 70s, New York began subtly, then overtly, promoting what would become the yuppie lifestyle. As Felker put it, "We felt one of the major activities of people was being consumers. So we ran these endless lists of what's the best this and that." (5)

"Lifestyle" cover stories like: "Honor Thy Pasta" (1972) also paid homage to those future yuppie fetishes espresso, pâté and wine. Articles promoted Braun coffee mills and the new Cuisinart food processor. A column, "The Underground Gourmet," made a neat little bridge between 60s culture ("underground") and the coming yuppie culture ("gourmet"). Consumerist pieces abounded: "Gael Greene eats the most expensive meal in town." "How to get the very best," wherein experts shared "their knowledge of food, from caviar to pasta..." "Manhattan Tea Party:" "Really fine tea is as different from supermarket brands as fine wine is from vin ordinaire." "The Daily Espresso" declared espresso machines "the perfect extravagance." Gael Greene conducted "a celebration of gluttony." More generational bridge terminology: "Going underground. Eight great wine cellars." If "underground" was "hip" in the sixties, the message was, "you can still be hip today. Just

follow us." In 1976, New York introduced "radicchio" to its yuppies-in-training. And from 1970 on, there was an annual "Salary Survey" that told readers how they measured up-a nice nudge to those who had spurned competitive standards of success in the 60s.

Note that *New York* apparently never saw fit to explore the finest incense in *New York*, the best sitar or the 10 best places to volunteer for the poor. That was not the culture they were pushing. As "The Underground Gourmet" rather snidely put it, "Since the official end of the greening of America...St. Mark's Place, once the center for flower children's dreams and delusions, has been slowly returning to its earlier form." (6) And a 1970 piece, "People's Capitalism is Killing Wall Street," yearned "It wouldn't hurt if the Dow Jones Industrial Average...climbed back [up]...A new crop of boy millionaire money managers would start telling us how to live the good life... ." (7) Remarkably prophetic for 1970.

If *New York* was attempting to shepherd the flower children back to Capitalism and the Flag (by proclaiming consumption "cool"), certainly Clay Felker was the perfect man to spearhead the effort. In 1962 he'd edited a CIA-funded newspaper, The *Helsinki Youth News*, that sought to bend socialist-minded youths attending Helsinki's World Youth Festival toward American values. Felker's associate on this project was none other than Gloria Steinem.(8) (Later, Felker almost single-handedly engineered Steinem's rise to glory and was instrumental in helping her found *Ms. Magazine*.) In 1976, Felker and Steinem threatened to sue Random House if it published a chapter from the feminist group Redstockings' book *Feminist Revolution* that detailed Felker's involvement with the World Youth Festival, the CIA and Ms. The Redstockings thought *Ms.* an elitist attempt to co-opt the women's movement and channel it in the wrong direction. (The women's movement was a target of CIA's "Operation Chaos" project, (9) which sought to neutralize the Left.) Felker's attorney wrote "the essence of the charge...is that Mr. Felker and his magazine [New York] were working for the CIA," which he called "false and libelous," though he later said the assertions were merely "exaggerated." (10) With Katherine Graham also objecting, Random House obediently deleted the article from the book. Graham was a major investor in *Ms.* and remains chairman of the *Washington Post* (whose cozy relationship with the CIA was typified by Graham's late husband, ex-*Post* publisher Philip Graham, helping CIA develop "Operation Mockingbird," a program to infiltrate and manipulate the news media).(11)

But despite its orgiastic consumerism, *New York* paled beside "Living", which evangelized the high life and status with near-religious fervor.

From the second, third and fourth "Living" sections, way back in pre-yuppie 1976:

"100 Holiday Gifts for Food Lovers:" "If you cannot afford the best fresh beluga malassol caviar, give...imported Italian pasta, the DeCecco brand made in the Abruzzi region. Whatever you choose should say you thought the recipient ...would recognize the best." "Owning a Rolls for an evening" told how to impress by renting a Rolls-Royce. An interview with Mr. Twinings, who "likens the appreciation of tea" to that of wine: "You're merely doing what your palate dictates. And that's the fun."

"Wine Talk:" "Let's go out and buy some wine-$1000 worth. Oh, it might be foolish to drop the entire sum on a bottle of 1896 Lafite-Rothschild... ." Mimi Sheraton: "Seekers of gastronomic exotica should waste no time getting to...the city's more ambitious produce markets..." Book review: "The Best of the Best." Point/counterpoint pieces advocating "diet" and "gluttony." Advice on selecting wine carafes and Luxo lamps.

Enid Nemy asked the pressing question "How could $25 million in jewels be boring?" "And when the prestigious name of Bulgari" is on the gems, and "the prestigious Skowhegan School of painting and sculpture" is the beneficiary... "it's impossible to go wrong."

"Caviar for Hard Times" described a discount caviar bar. "Wine Talk" noted "the Beaujolais Nouveau should be drunk young." Claiborne wrote "In Defense of Eating Rich Food."

On fashion: Following "the psychedelic fashions of the sixties...fashion was rather dormant. [translation: people were getting sensible.] Now...there is a renascence of interest in clothes...Fashion is coming back into fashion."

Coming back? Or being pushed?

In 1977-79, still years before yuppieism, "Living" tackled such important issues as:

"The Best of Brie:" "Late autumn marks...the year's best season for...game, truffles, fresh foie gras and-especially-brie, France's King of Cheese and the Number One status choice in this country as well."

We also discovered the wonders of Supreme de Volaille aux Polvrons. "The succulence of Caneton Etrange a la Suedoise." "The cheeky flavor of Salade Pisse en lit Garnie a la Cote d'Azur." The delights of gourmet cooking on the road: "We have served coq au vin in Pebble Beach...spledini in Indianapolis...pesto in Columbus..."

Claiborne: "Game...is in league with fresh oysters, fresh foie gras and new Beaujolais-something to titillate and glorify the palate."

The "newspaper of record" seemed intent on setting a record for sheer single-mindedness of purpose. Their super-salesmanship (and they were selling class consciousness for the would-be nouveau riche more than food), was obsessive, overdone, and showed an appalling lack of gentility and moderation-exactly the characteristics that came to typify the new-money yuppies.

After "Living"'s debut, *New York* played catch-up. December 1976's "Joy of Jogging" dubbed running shoes "part of faddish chic." Stories grew ever shallower. "The new great-looking dining places" asked the quintessentially yuppie question, "Is the food as good as the design?" Early-1977's "Food, Glorious Food" issue had a 12-page "gourmet handbook." We learned about "Elegant Dining Without Really Trying," the best mustards in *New York*, the best coffee and "Malcolm Forbes-the most happy millionaire." The *Times* was more pretentious, but *New York* had the lock on shallowness. The two qualities combined, of course, made yuppies.

New York's pioneering efforts quickly spread. For L.A., Felker created *New West*. He recently said "at one point there were around 80 [city and regional] magazines that used essentially not only our formula but the same layouts... . And...there were foreign magazines." (12)

In March, 1977, the *Times* unveiled "The Home Section", with articles like "Off the rack furniture for the put-together generation," which asked, "In a hurry to own...a status steel and glass table?"; "Great entrances," about designing a statusy foyer for your living space; "Decorating for the Diaper set," which advised how to raise a status baby. "More room-and woks within reach" about kitchen storage for those who apparently required more than one wok. And on and on, every week, *ad nauseam*.

By the time 1984 rolled around and the name "yuppie" had been coined, the *New York* yuppies had been programmed for over a decade and were obedient robots. The *Times*

and *New York* were now joined by innumerable other publications celebrating excess (and the economic system that made it possible). But the 1987 stock market crash found the *Times* in a reflective mood, noting that the yuppies' "huge incomes and ostentatious consumption, an inclination highlighted in both advertising and news coverage (italics mine; when you create a phenomenon, can you really be said to be 'covering' it?)-generated deep resentment." (13)

Get it? That distaste many of us felt for status-seeking and egotism was mere jealousy. That disgust at people without consciences, disguised envy. Post-crash, however, the *Times* quickly rejoined the party, with gift ideas: For your son: "A yuppie, he likes the new and different, so give him a BMW in milk, dark or white chocolate, $14.75 at Li-lac." (14)

Disgustingly rich money-manager yuppies were actually relatively scarce, but there were tens of millions of aspiring yuppies. A 1987 survey placed these "attitudinally affluent" people, who "like to buy only the best of everything, from gourmet popcorn to crocodile shoes, regardless of their income or education level," at 58.6% of all adult Americans. (15) (Could all those "Best of" lists the *Times* and *New York*-and their many imitators-published have had anything to do with this? Nah.)

What a feat of social engineering. Moving masses of people away from flower power, and toward materialism, class-consciousness and rightist politics. And making it seem like it all just happened spontaneously, unassisted.

In 1977, the first year with both new sections, *Times* income more than doubled from 1975.16 It's interesting how the *Times'* interests and Wall Street's coincide.

More interesting still is how the *Times'* duties as lapdog to the power elite (a role well

documented by Noam Chomsky and others) go well beyond just whitewashing U.S. foreign policy and printing corporate PR in the guise of news, all the way to inventing lifestyles and zeitgeists that bolster elitist values. Thus setting the course not just for educated professionals' lives, but those of the millions who emulate them. And all the other societies that emulate the U.S. (or, more accurately, are having U.S. culture forced down their throats).

Yes, the *Times* really outdid itself with its "coverage" of the yuppie phenomenon. We thought it was time they received the credit they were due.

As for Clay Felker, he wrote of this period, "...Magazines were at the leverage point of the culture, shaping attitudes... toward new, more fragmented ideas of identity and self-fulfillment...a trend that continues, unabated, today." (17) Felker now teaches at the Graduate School of Journalism at UC Berkeley. Where once radicals envisioned a new society, today they can absorb wisdom from Berkeley's new Felker Magazine Center (established with a $100,000 grant from the Philip L. Graham Fund named for the man who helped the CIA infiltrate and sabotage the news media).

NOTES:

1. "The Year of the Yuppie," *Newsweek*, December 31, 1984, p. 17.

2. "The birth and maybe death-of Yuppiedom," *Time*, April 8, 1991, p. 65.

3. Hendrick Hertzberg, "The short happy life of the American yuppie," *Esquire*, February 1988.

4. Albert Goldman, "Entering the new age of pot," *New York Magazine*, August 25, 1975, p. 28.

5. "He created magazines by marrying new journalism to consumerism," *New York Times*, April 9, 1995, IV, 7:1.

6. *New York Magazine*, November 10, 1975.

7. Stanley H. Brown, "People's Capitalism is killing Wall Street," *New York Magazine*, April 6, 1970.

8. "CIA subsidized festival trips," *New York Times*, February 21, 1967, p. 33; Robert G. Kaiser, "Work of CIA with youths at festivals is defended," *Washington Post*, February 18, 1967, p. A4; Kai Bird, *The Chairman: John J. McCloy and the Making of the American Establishment*, Simon and Schuster (New York: 1992), p. 483-4, 727.

9. Lucinda Franks, "Dissension among feminists: the rift widens," *New York Times*, Aug. 29, 1975, p. 32.

10. Nancy Borman, "Random Action," *Village Voice*, May 21, 1979, p. 107.

11. Debra Davis, *Katherine the Great*, Harcourt Brace Jovanovich (New York: 1979).

12. "He created magazines by marrying new journalism to consumerism," *New York Times*, April 9, 1995, IV, 7:1.

13. Lee Daniels, "After the fall: will the yuppies rise again?" *New York Times*, November 21, 1987, P. B4.

14. *NYT*, December 9, 1987, p. C1.

15. Michael Gross, "The spending spree that won't go away," *New York Times*, December 13, 1987, p. 17.

16. Joseph C. Goulden, *Fit to Print. A.M. Rosenthal and his Times*, Lyle Stuart (Secaucus, N.J., 1988), p. 228-9.

17. Felker blurb for David Abrahamson's book *Magazine-Made America*, from Internet http://abrahamson.medill.nwu.edu/WWW/MMA.html.

18. From *The Foundation Directory*, Internet http://fdncenter.org/book/fd97sam.html.

JFK Redux

The Strange Business of Dan Griffith

In January 1993 Mir Aimal Kasi shot Frank Darling and another man with an assault rife at point-blank range while they were stopped at a red light in front of CIA headquarters. According to the *Washington Post*, the shootings "appeared to be random." Dan Griffith knew about such "random" events, however, and he knew that name, At Mir Aimal Kasi's trial at the Fairfax County Courthouse in November 1997, Griffith discovered from Darling's father that the family had relatives on Vancouver Island. The information fit into a pattern of manipulation that Griffith had been involved with for over fifteen years. He just didn't know why.

Why would an ordinary citizen with no past connections to intelligence and/or organized crime be followed, harassed and threatened by people from several federal agencies, state and local police and mob thugs for fifteen years? Dan Griffith, who comes from the Cincinnati suburb of Covington, Kentucky, has pursued the answer to this question across fifty states, Europe and Hong Kong, in 1993, into the assassination research community.

Griffith, a former S&L manager and commercial realtor, believes his pedestrian life ended in March 1993 when he found himself being openly tracked to Florida, Georgia and, in South Carolina, by a Vienna, VA man. ("Vienna is a CIA company town," he was once told by a DC attorney). Griffith suspected it had to do with a family estate settlement in progress at the time, but the estate's small size seemed to work against that possible motive. He submitted a FOIA request to the FBI about this in 1984, but that ended when his principal witness said, "If I testify, they'll follow me for twenty years."

After the estate settlement in 1985, Griffith journeyed to Portugal to visit a sister. There he was run down by a car driven by a Portugese government employee. The day after leaving the Lisbon hospital, a Canadian intelligence agent joined him for lunch. Later, in Barcelona, a Spanish man said: "Don't go home, your government is after you." A U.S. Marine security guard escorted Griffith on the train from Madrid to Lisbon. All this too became the subject of a FOIA letter--to the State department and the Navy JAG.

In 1989, a casual acquaintance of Griffith's named Phil Conover asked him, "Are they still chasing you all over the country?" A few months later Conover was murdered and the Cincinnati homicide squad, not amused at Griffith's investigation of the homicide, subjected him to a third degree while accusing him of what was a very professional hit. Griffith was referred to "retired" FBI agent Richard Dorton, who was killed in an auto accident several months later. Griffith's investigation of Dorton's "accident" brought threats and intimidation from police in the rural county where agent Dorton was killed. The mysterious deaths not

Griffith's first encounter with murder In December 1987 to interview court probation officer named Clay Taylor, who was shot execution style a just hours after his request for conversation.

In 1990, Griffith's pursuit of his bizarre situation led him to Washington, DC to interview investigative author Sally Denton (*Bluegrass Conspiracy*). He never saw Denton but had lunch with Denton's PI partner Jim Hougan (*Spooks*). The night before the Hougan luncheon, a large caliber shot was flied outside Griffith's motel room. In 1992 Griffith encountered a woman named Tanya Darling in the September preceding Frank Darling's death. He had been instructed to deliver a 9x12 envelope to her at the docks in Victoria, British Columbia, by another new acquaintance, Tatyana Khromchenko. After some repartee about KGB contraband and CIA pigeon drops, he complied, if only to further his quest to answer that "why" question. Tanya Darling never showed up at the Victoria docks, and she was not at the house where Griffith finally left the envelope with a daughter.

Griffith's quest continued when he returned to Seattle. He spent some more time with Tatyana Khromchenko, discovering that she at one time had taught English to personnel at the Soviet ministry. She also taught the Russian language to American and British ambassadors. Pressing her for details about his own situation, Khromchenko told Griffith that she knew of a "group of VIPs" who had been tracking and harassing him since 1983.

He found out little more. Khromchenko worked for Delphi International, a State Department subsidiary based in DC, after her employment with the Russian Foreign Ministry. Delphi was a private contractor to the U. S. government involved with Iran-Contra, and a PIN supplied by Dan Alcorn, counsel to the Coalition on Political Assassinations, revealed to Delphi to be a State Department front for political activity in Central America.

Kromenchenko's name came up again in 1997, when Griffith traveled to Hong Kong during its transition back into the hands of the Communist Chinese. While on a day tour of Macau, he had lunch with an Asian woman, named Elena, who identified herself as the Costa Rican amabassador to the Chinese Government on Taiwan. She expressed a keen interest in the details of Griffith's 1992 encounter with Tatyana Khromchenko and Tanya Darling. When he checked later, he learned from the Costa Rican Embassy that their Taiwanese ambassador was in fact Elena Wachung.

After Frank Darling's murder, Griffith made urgent phone calls to both Tatyana Khromchenko and Tanya Darling to determine what, if any, reltionship existed between them and the dead agent. He attended Mir Aimal Kasi's trial and questioned Frank Darling's father, who told him about relatives in Vancouver. Griffith also discovered another detail about the case missed by the newspapers: both Mir Aimal Kasi and Frank Darling had been stationed in Pakistan. The court sentenced Kasi to death in January 1998.

The next "random" coincidence carried Griffith's narrative forward and tied it to JFK research. In October 1993, while in Atlanta, GA, he was approached by a woman who claimed that her maiden name was Charlene Trafficante. She wanted information about Marvin Warner, Jimmy Carter's ambassador to Switzerland and a figure in the S&L scandal in Cincinnati, Griffith's home turf. Instead of supplying that information, Griffith asked about her connection to Santo Trafficante and his associate, Carlos Marcello. Marcello was the New Orleans mob boss that many suspected as having a hand in the JFK

assassination. Charlene Trafficante became nervous and abruptly left.

Upon return to Cincinnati, JFK witness Jean Hill told Griffith about the forthcoming conference on the assassination, the ASK Symposium to be held in Dallas on the 30th anniversary. Griffith had met Hill previously on various stops of her book signing tour. In a letter to her in August 1992 he commented that "It was certainly good meeting someone who has also survived long-term, intense psychological guerilla warfare. One of the most audacious thrusts of the assault has been the effort to make me think that it is connected to the JFK hit. What the various shills are really saying (as you quickly and sagaciously commented) is that the same operatives from 1963 are still in business. As in real estate, you can't do big deals all of that time."

On Hill's recommendation, Griffith attended ASK '93 in the hope of tracking Charlene Trafficante and restoring his search for the reason behind his own predicament. At the conference he talked to a number of researchers. One turned up Ms. Trafficante's birthdate, April 26, 1930 and Jack Brazil suggested that Griffith contact the infamous Gordon Novel. (Griffith asked G. Gordon Liddy about Gordon Novel when Liddy lectured at the Cincinnati Junior League the following February. Liddy's response: "Stay away from him.") Brazil also said, "Somebody is protecting you" and "they have excellent discipline over their shills." Griffith even approached John Judge to discuss the Frank Darling case but was intercepted by someone identifying himself as a "conventioner from Omaha". Judge had gone by the time the mysterious conventioneer was through with Griffith.

Author John Davis told Griffith he would call Frank Ragano, former attorney for Santos Trafficante, to check Charlene's identity, and later Griffith received a phone call from Frank's wife Nancy Ragano explaining that Santo Trafficante had two daughters, neither named Charlene and both much younger than the person Griffith described. Griffith's response: "It is interesting that a phony mob person has been deployed."

In November 1993 he wrote to Robert L. Knight of the U.S. Commission on Civil Rights, who advised him to see his senator. When he insisted that it was a criminal matter, not a political one, Knight stuttered fearfully in the next conversation.

Two days later he met the fictitious daughter of Santo Traficante.

Throughout this fifteen year period, Griffith has been told: "drop the pursuit; let sleeping dogs lie; change your name and leave the country; kick over beehives and you will get stung; Carl and Charles are behind this and they want you to move to the Orient." Many hostile and merely harassing intercepts have been at meetings in private clubs from coast to coast. A CIA asset named David Hager intercepted Griffith at a meeting site in Hong Kong in July 1997. Church services

Above: Scene of Frank Darling's murder. When Griffith circulated the photo, his mail service was stopped.

have been a regular intercept points. Army Intelligence Major John Hamberg engaged Griffith in an angry conversation after a church service in his hometown of Owensboro, Kentucky.

In July 1996, Griffith attended the JFK research conference in Fredonia, NY and engaged esteemed researcher Peter Dale Scott in a long conversation about his situation. Scott identified a New York literary agent who had contacted Griffith about a book as a CIA asset. Scott also suggested that the FBI be FOIAed.

A FOIA letter was sent to the FBI and upon receiving no response from the Cincinnati office. Griffith retained an attorney who then received frivolous replies. The attorney suddenly resigned from the firm and moved to Columbus, Ohio; the replacement attorney then attempted to convince Griffith not to take the FOIA to the US District Court. Eventually the lawyer relented and suit was filed and the US attorney, responded that a file existed but would not be released. As of July 1998, no hearing has been held on the FOIA action.

Simultaneous with the FBI-FOIA suit a provocateur engaged Griffith in a scuffle in a local restaurant that resulted in a fourth degree assault charge. This misdemeanor charge has been stalled and dragged out over a year and a half and may go to a jury trial this fall.

Griffith regards the scope, time span and number of interceptors used as quite incredible. He is anxious to collect any information, about his or any similar situation. His biggest question remains: why would a huge assault operation be launched against an ordinary citizen?

CONSPIRACY 101
An Interview with
John Coleman

by Uri Dowbenko

John Coleman is the author of *Conspirators Hierarchy: The Story of the Committee of 300*, *Diplomacy by Deception*, and *Socialism, the Road to Slavery*, as well as more than 400 white papers or monographs on a variety of economic and political topics.

As a former British intelligence officer, he was stationed in fourteen different countries over the past twenty years. Since 1970, he has published *World in Review*, a monthly intelligence and economics newsletter.

John Coleman holds a doctorate in political science and economics, having studied for five years at the British Library and British Museum in London. He is a highly regarded historian, as well as a political analyst of current events.

Q: How did you first find out about the Committee of 300 and what happened to you that made you determined to expose them?

A: During the course of my professional career, I was given documents that were marked "Code: Word." "Code: Word" is the highest type of classification you can get. It's far above "Top Secret" or anything of that nature. In these documents was a plan laid out between the British government and the United States government as to how they would handle future conditions in Africa.

We were there ostensibly fighting communist penetration, trying to keep the communists out of Angola and Rhodesia and later South Africa, when in fact, what we were doing was laying the ground work for a total communist take-over. So we were there supposedly for one purpose, but in fact, we were carrying out the future plans of the New World Order.

Q: What happened when you objected to what you called the inimical goals of the Olympians?

A: The inimical goals of the Olympians, of course, is the same thing as the Committee of 300. In intelligence circles, that is what their name is, the Olympians.

Q: So the documents you saw refer to them as...

A: No, they didn't refer to them as the Olympians. They referred to the "Higher Committee" and they referred to the "Controlling Body." It was only later that I found out who this controlling body actually is. By backtracking on the name Olympians, I was then able to come up with the classification, that this was the Committee of 300.

Q: So the origin of the term Committee of 300 is from where?

A: It goes back to the days of the major drug trading empire. The British Empire is based upon drug trading. The British East India Company was a very powerful company dealing primarily in opium, which they grew in India, in Benares and the Ganges Valley, and then shipped to China and sold to Chinese buyers, controlled by the British government directly, for enormous profits.

If you take a year like 1973, for instance, where car profits were very good, and you combined General Motors and Ford, their sales for those two years, it would approximate about one-tenth of the sales of the general revenue earned by the British East India Company from opium sales in China. It was a huge and lucrative business, actually backed by the British government.

Q: So the 300 refers to 300 entities, or houses, or...

A: It refers to the actual structuring of this company. They knew from past experience that if you have people with unequal powers there's going to be trouble. So they structured it in such a way that there were 300 members of the board of this company, each with equal voting rights, each with an equal share approximating an equal sum of money, and with the proviso that nobody could gang up on anybody else, to outvote any member, or to oust any member.

Q: So it is basically an outgrowth of the British East India Company?

A: Yes, it was named after the controlling body that ran the British East India Company, the 300 members of the board of directors of this company that ran everything.

Q: And that organizational structure continues to this day?

A: That organization continues to this day. But, of course, it's now very much broader. It's not only introducing and expanding the drug trade in the United States. That's only one aspect. They're now into political control, not only of the United States, but

SOCIALISM
THE ROAD TO SLAVERY

Germany, France, Italy, in fact, virtually every country of the world.

Q: In your book, *Conspirators Hierarchy*, you write that the Committee of 300 is "the ultimate secret society made up of an untouchable ruling class, which includes the Queen of England, the Queen of the Netherlands, the Queen of Denmark and the royal families of Europe. These aristocrats decided at the death of Queen Victoria, the matriarch of the Venetian Black Guelphs, that in order to gain worldwide control, it would be necessary for its aristocratic members to go into business with the nonaristocratic, but extremely powerful leaders of corporate business on a global scale, so the doors to ultimate power would open to what the Queen of England likes to refer to as the commoners." Historically speaking, was there a meeting that took place, or how was it decided?

A: No, they all got together. All the royalty got together, and then they acted through their ministers. They kept themselves at a distance. The Queen never dirties her hands with anything direct. She has her ministers. She has the Duke of Kent, who is, let's say, her executive, who takes her place as the ruler of England when she is out the country. Then the instructions are handed down right until you get to the gutter level, which is the mafia. The mafia is part of this crowd, but they keep their distance from them. They never would associate with them or report any connection whatsoever. Nobody knows where it was held, but there is some thought that it was held in one of their castles up in Scotland.

Q: What evidence did you come across that this meeting actually took place?

A: The evidence that this meeting took place was contained in the records by the German who was responsible for managing the finances of the Kaiser of Germany and managing the finances of the Rothschilds and one would imagine that he would know exactly what was going on. He not only made reference to the meetings, but he said quite distinctly that here is a Committee of 300 known only to each other and they rule the world. His name was Walter Rathenau.

Q: This was when?
A: It was 1923. And a year later, of course, he got a bullet in the back of his head for his trouble.

Q: In *Conspirators' Hierarchy* you also write that "the Committee of 300 consists of specialists in intelligence, banking, and every facet of commercial activity... Included in the membership are the old families of the European Black Nobility, the American Eastern Liberal Establishment (in Freemason hierarchy and the Order of Skull and Bones), the Illuminati, or as it is known by the Committee, 'Moriah Conquering Wind', the Mumma group, the National and World Council of Churches, the Circle of Initiates, the Nine Unknown Men, Lucis Trust, Jesuit Liberation Theologists, the Order of the Elders of Zion, The Nasi Princes, International Monetary Fund, the Bank of International Settlements, the United Nations, the Central British Quator Coronati, Italian P2 Masonry, especially those in the Vatican hierarchy, the Central Intelligence Agency, Tavistock Institute, selected personnel, various members of leading foundations and insurance companies, the Hong Kong Shanghai Bank, the Milner Group-Round Table, German Marshall Fund, Nato, Ditchley Foundation, Club of Rome... literally, hundreds of other organizations." That's a lot of disparate groups. How do they keep order and coordinate strategy?

A: They do it in exactly the same way as a giant corporation keeps order. You take a company like General Motors, for instance. How do they keep order? They've got banking, sales, advertising, management, government, public relations. There are thousands of different departments, but each department head is designated with a specific task and he is answerable to one of the specific directors on the board. That's his field of expertise.

Q: So it's just a straightforward corporate hierarchical organization. So on a global level, who is at the top of this power structure?

A: Well, they say in papers of this Committee of 300 that there is no end. But we all believe -- and when I say we, all intelligence people I have ever spoken to, and I've spoken to a lot of them about it -- that it's the Queen of England.

Q: So she's the chairperson of the world, so to speak?

A: She's also the richest and most powerful lady in the world. She gets daily briefing from MI6 [British Intelligence] of what's

going on in the world. Once a week she meets with the head of MI6 and he gives her

a very in depth briefing of every event that has taken place. She is far better informed than anybody else, even the British Prime Minister. These people are answerable only to her. They are not answerable to the British public or the British Parliament.

Q: When you initially wrote your expose -- were there threats to your life?

A: Well there were a lot of problems we went through in the beginning, but we reached an understanding that if I don't cross a certain line, I'm not going to be bothered by them. What that line is, of course, I can't
tell you.

Q: Probably one of the most controversial points in your book is that the Beatles and rock music in general were the creation of the Tavistock Institute of Human Relations in England. What kind of documents did you see that brought you to this conclusion?

A: Well, I got hold of all of the documents concerning Theo Adorno, who was kicked out of Germany by Hitler because Hitler came across the fact that he was working with music which was designed to so confuse the mind of the listeners, directed primarily to the youth, that they would be susceptible.

Q: Adorno was a sociologist?

A: A musician. A professor of music.

Q: So this was a kind of experimentation?

A: What he was doing -- he was taking the music of the priests of Baal and he was using this, which is really a repetitive beat, incessantly played over and over with some variations, the variations being on a discordant note, atonal, which repetitively played, would make people become virtually disoriented.

Q: What was the reason for this research?

A: He was commissioned by the Committee of 300 to prepare the way for their huge drug invasion in America. Don't forget -- they had this enormous, profitable drug empire in China, worth billions of dollars. They were now bent upon doing exactly the same thing in the United States, with the youth of America. And they needed a vehicle by which this effort could be launched, and the obvious conclusion they drew was that certainly pop music was a great opportunity, because it ostensibly was a self-generating impulse amongst the youth, to kick over the traces and defy authority.

Q: Now where did Adorno get his sources?

A: Well, he studied the music of the ancient priests of Baal. All that stuff is available in the British Museum, by the way. Every bit of it is available there. And he also studied the music of the cult of Dionysus, which is a type of satanic cult. And the Dionysus people had taken the music of the priests of Baal a step further. What he did was to combine the two of them and then add even more jarring notes to it, so that people after hearing it at a given time, especially if played loudly, would become totally disoriented. That's exactly the basis of it all.

Q: So, if the creation of rock music was a marketing strategy for promoting the sale

of drugs to young people, how successful was it?

A: Look around and you'll see. There are more drugs in America now. The increase in the usage of drugs by the youth is astronomical. The drug war is a failure.

Q: **Who is Willis Harmon, and what was his role in the creation of the so-called counter-culture or Aquarian Age phenomenon in America?**

A: He was specially chosen, a professor at Stanford University in the Stanford Research Institute, a division of Stanford University. He was picked by the Committee of 300 as a person who was able to devise the strategy to usher in the so-called new age among the youth. They said, this is no longer the Age of Pisces, but the Age of Aquarius. In other words, the age when anything goes. If it's nice, if it feels good, do it -- without consequences, without regard to the consequences for your actions. And they called this the Age of Aquarius, which was really the entry vehicle for the youth into the New World Order, outside of politics.

Q: **So typically, a modus operandi, if you will, would be to take a kernel of truth and subvert it to the purposed of the Committee of 300.**

A: Don't forget, the Committee of 300 is strictly a communist organization.

Q: **What does that mean?**

A: They believe in communist principles. They are against the family. They are against any form of religion that would become a religion accepted by all the people. They are against private property. They are against capitalism. They want to rule the world and they say they are the gods of Olympus, that God has given them the title and the right to rule everybody else. Therefore, everybody else is to have nothing, except what they in their magnanimity will grant them.

Q: **How did they rationalize the failure of their system in the former Soviet Union?**

A: That was a trial run. Communism is not dead. The new communism is in America. We have a communist leader in the White House, ten times worse than Roosevelt and probably approximating the zeal of Stalin.

Q: **So it's basically a control system, nothing more, nothing less.**
A: That's all it is. Don't think communism is dead.

Q: **You said that people are sent to the Tavistock Institute, which you call the "premier brainwashing institution in the world," for what has been called "training." What exactly does this so-called training entail?**

A: Well, I use the word brainwashing, because that's a term that everybody knows and understands.

Q: **In other words, mind control techniques. What does this training entail?**

A: Well, this was founded by Brigadier John Rawlings Reese. He hit upon a great idea and a very simple one. He said, in psychiatry, people come to me to be healed. I can make people who are not sick -- I can make them sick by the same techniques.

Q: Reverse the process.

A: Exactly, and that simple thing he thought of, 80,000 British troops were given to him as guinea pigs. And he found out it works in the most fantastic way. And he evolved theories, which he then put into practice. Basically, he expressed the view that everybody can be controlled. It's just a matter of applying the correct techniques. Of course, those techniques are worked out by people under his control.

Q: So psychiatry was subverted then, or was it initially a discipline strictly created for this purpose?

A: It was strictly created for this purpose. People talk about Freud and so on, but these people had another ulterior motive altogether and that was to obtain full control of individuals, groups, major and minor, and eventually whole nations. The Tavistock group has been at war with this country since 1946.

Just to give you an example they worked out during the war -- the war criminal Churchill came to Tavistock and said, "We need a method of how we can defeat the Germans. They're too good for us in the military field. We can't beat them. They've bested the best of us. What can we do?" So they got their people to work and they worked out a plan which they called the Prudential Bombing Survey, which was this. They knew how much stress that people could take in their lives before cracking, before breaking. And what they worked out was that, if the American and British bombers could bomb 60% of German worker housing into extinction, the stress and the shock would be so great that the German public would no longer support the war effort and the war would come to a halt.

And that is exactly what they did. The RAF went over Dusseldorf and destroyed all the steel mills. Don't believe it. It's a pack of lies, because the steel mills and those making shells and artillery pieces are owned by both sides and financed by both parties. The Warburgs and the Rothschilds financed both sides of the war. They weren't going to go in and destroy their assets. What they were doing is destroying German worker housing. It didn't cost them anything. When they got up to a saturation of 60%, that's exactly when Germany collapsed.

Q: So they predicted it at 60% and it came out to be true?

A: Exactly right. Now you have the same thing happening in America. The technique is for "long-range penetration" and "interdirectional conditioning." What it means is that over a long period of time the American people are being subjected to a barrage of new ideas, strange ideas, ideas they can't cope with, so that their minds become so penetrated, they are presented with so many alternatives, that they can't handle it. They don't know what to do.

Q: So after this numbing takes place, then what happens?

A: Then, like a soldier in battle, you'll sit down in the thick of shells crashing and bullets whistling and just sit there and begin to sing a song or take out a book and read it. This used to be called "shell shock."

Q: Are you talking about a disassociation from reality?

A: Exactly right. So that the American people become shell shocked. They don't know which direction to go. Then the Tavistock Institute will show them the way to go. And they will think that what they are working with are their own ideas, but they are not. They are ideas presented by the Tavistock Institute and sublimated into their brains. Then they follow this ritual. And that's how we have all of these strange things happening in America today.

Q: John Mallone, the CEO of TeleCommunications, Inc. (TCI) has a doctorate in "operations research." What exactly is it, and how could it be used by mass media conglomerates to mold public opinion?

A: They use the Tavistock method. They present a set of alternatives. They create a problem, and a set of alternatives to solve the problem. There are so many choices that people don't know how to make choices and in the end they give up making choices.

Q: Now this is also a polling strategy. Is that right?

A: Exactly the same technique.

Q: Choices, alternatives, neither of which are useful.

A: All of those alternatives leading up to the poll are not viable alternatives. Just to give you a for instance. We know that Clinton is probably the worst president ever to disgrace the White House. This man has got so many strikes against him that he should have sunk beneath the waves, politically speaking, years ago. But he's still out there, happy, jolly, and people are going to vote for him. How has this been accomplished through the media brainwashing? They have told everybody, "look Whitewater doesn't matter." It doesn't matter what his wife did with Rose Law Firm. It doesn't matter that he was responsible for McDougal's trouble. It doesn't matter that he has seduced about 29 or 30 women since he has been married. It doesn't matter all the peccadillos he's engaged in. It doesn't matter that he exposed himself to Paula Jones. What matters it that he's getting the job done.

Well, he's not getting the job done. He told the American people with a barrage of information, all false, that his economic program is a success. There are more people employed today. People are enjoying a better standard of living, etc., etc. So you have an attack on two sides. We've been told it doesn't matter what he as a person is at all. He's not supposed to be there as a moral example to United States, again, an indication of how far we have sunk in this country. That what is important is that he is getting the job done. Then they have presented us with a barrage of information, which tells us over and over and over again - repeated maybe 20, 30, or 40 times a day in ten different media, maybe over 1,000 television stations, and 2,000 radio stations. The people are penetrated. They believe this man had done a good job.

Q: Now, regarding the Kennedy assassination, can you elaborate on the whys and wherefores?

A: Kennedy was one of the few men who stood up against this group. When he unravelled their plans for Cuba -- that's a very long story. When he disobeyed them regarding the printing of treasury notes. He said, "we're not going to use the Federal Reserve; we don't need them; we're going to

print our own U.S. Treasury notes issued upon prayers of the people." They told him, "Mr. Kennedy, Look, you're overstepping the bounds. We are giving you orders and you are going to obey them." And he said, "I'm not obeying orders. I'm the President of the United States." In order to show his associates, those immediately around him, would-be successors, would-be people in line for the presidency, that they are the boss, they publicly executed him in the most brutal fashion. In full view of millions and millions of Americans.

Q: Was he warned first?

A: He was warned several times to stop and to take orders. They told him bluntly, "you are here to take orders," and he refused to take the orders.

Q: Who were primarily the messengers of these orders?

A: Arthur Schlesinger and people of that nature, in exactly the same way as Colonel House used to give his British intelligence orders to Woodrow Wilson, for example.

Q: Now this explication of the Kennedy assassination will be in the new edition of your book.

A: Yes, in the new edition of the *Committee of 300*. We're expanding the book to take in the full story of the Kennedy assassination, the bandits who executed it and why.

Q: In your book, *Diplomacy by Deception*, you contend that AIDS has been deliberately planted in Brazil and Africa. What evidence can you cite in this regard?

A: We have all the evidence in the world and we have it in the new book that we're going to put out called *Full Disclosure*. We quote chapter andverse how this was done, who was involved, and how these agencies of the Federal Government, particularly in the field of chemical and bacteriological warfare experiments, were given a budget by the United States government, who said, "go out and invent these viruses. We want to use these in the future, in the wars that are coming; we need to use these, so that millions of our people don't get killed." And this was not a new thing, of course. They did do a big test in 1919.

Q: This was the flu epidemic?

A: The so-called "Spanish" flu epidemic. As World War I was winding down, they decided they were going to try this out on the Moroccan electorate as part of the allied war, and they did. And it killed thousands of them. But the virus was so powerful that it got away and swept the world, and more people died from that than the prior casualties of the war put together on both sides.

Q: Why is population control so important to the Committee of 300? How does the promotion of abortion, euthanasia, and suicide fit into the plans of achieving the goals of "Global 2000"?

A: Well, "Global 2000," as you know, was a paper prepared by the Club of Rome under the auspices of Cyrus Vance, who then presented it to President Carter three days before his term ended and told him, henceforth this is official US policy. And Carter, being a good servant, said, "OK, this is our policy." And it was adopted as US policy and still is today. What it basically

called for was the diminution of the world's population by half by the year 2000.

In terms of the blueprint, they said that there are just too many useless eaters in the world and that the world does not have unlimited resources and these people, the useless eaters, are consuming these natural resources at an alarming rate. Also, they are polluting the earth, the rivers and the streams, and the land itself is being polluted by people. In fact, the president of the Club of Rome said, there is a cancer in the earth and the cancer is man. [*Mankind at the Turning Point* by Mesarovic and Pestel]. We've got to get rid of him. And so they devised plans to get rid of 2.5 billion people by the year 2000. And they went about it. AIDS is one of their means of achieving that. Bertrand Russell said that wars seem to have been disappointing. They haven't killed enough people. In fact, he said, we need the return of the Black Plague. AIDS, you can say, is the return of the Black Plaque, greatly upgraded.

Q: What are the latest programs introduced by the Tavistock Institute in order to continue changing American society?

A: They are still working on exactly the same formulas. They have expanded their communication system, but the formulas have not changed. Barrage people with ideas, confuse them, give them alternatives -- this is the newest thing that is coming down and you have to accept it. You can't fight against it, and people get tired of fighting and they just give up.

Q: During the 1980s, tens of billions of dollars were spent on SDI, Strategic Defense Initiative, with nothing to show for it. Recent evidence shows that this money has gone into mind control research and implementation, programs by the Department of Defense, NSA, DIA, and the CIA. What do your sources tell you?

A: They tell me that the worst of them is the NSA. The NSA turned into a huge surveillance machine. They have 50,000 operatives who have the authority, not from the Constitution, but from the NSA. They can surveill anybody that they want. If they take an interest in you, they can bring tremendous forms of surveillance to bear upon you. They can even plant images in your mind. They can do it from computer to your mind, or they can do it by sound, by bypassing the auditory nerves in the cortex of the brain, and bypassing the optic nerves in the cortex of your brain. They can create images that make you think that you are doing things because you want to do them, when, in fact, you are listening to the commands that are outside of your body. And this has been proven over and over again. That's why I'm probably going to earn the wrath of a lot of these people who say they've been kidnapped and taken aboard the space ships, but what those people experienced was just computer-to-mind transferrals or signals, bypassing the optic nerves in the cortex of the brain, which showed them a picture of them being taking aboard these ships with these little aliens.

There are so many systems working today in electronic surveillance and mind control systems that took huge amounts of money to develop the proprietary systems -- let's put it, for want of a better term – machinery belonging to the NSA that no one else can handle. I mean, they are 18 years ahead of any computers today in the world.

Q: You contend that the NSA, FBI and CIA are illegal and unconstitutional federal agencies. What's the basis for your contention and what can be done about it?

A: Well, I will answer your last question first. If the Congress would do its duty, it could put these agencies out of business by the stroke of a pen. Because they are not authorized by the Constitution. For something to be lawful, or for a bill to passed by the legislatures, it has to be related to something already in the Constitution. You can't just, out of fresh air say, I'm going to pass this bill. If it's not already related closely to something in the Constitution; if it's not mentioned in the Constitution, if it's not by implication, of anything that's contained there, then it's a prohibition of those powers. Neither the name of the National Security Agency, the FBI, the CIA or ATF, none of these agencies are mentioned in the Constitution. Therefore, they are without a mandate. Therefore, they are unconstitutional, and anything unconstitutional is unlawful.

Q: The National Security Act of 1947 is also regarded as an unconstitutional breach in the nation's affairs. What can be done to repeal it?

A: As I said, if the Congress would do its duty, they could repeal it overnight, or refuse to fund it. They could take two steps immediately, saying, we are not going to allocate any more money - and that's what they were afraid of, so they took that money. The Congress might very well do that. Congress can say, we are passing a resolution today that we refuse to fund the activities of the FBI, the NSA, and that would put them out of business. Where would they get their money from to pay for their agencies? Or they could point to the unconstitutionality -- that these agencies are operating without a constitutional mandate, and say that we declare them null and void. They have no standing. The Congress could do that overnight.

Q: In the face of all the overwhelming information you have published, what can people do to take control of their lives?

A: The main thing to do is have faith in their country, have faith in the institutions of the Republic upon which it is founded. We are not a democracy. We are a confederated republic. Know the Constitution. Don't forget our laws are based on the laws of God. We all need to turn back to God and ask Him to help us. We need to be able to invoke the Constitution when people come with bills that are 100% unconstitutional and that have the stamp and the mark of the Communist Manifesto of 1848. We need to know history. We need to know the Constitution. When we've done that, we can
be well on the road to taking charge of our own destiny.

Dr. John Coleman's books are available from Joseph Publishing, 2533 North Carson St., Carson City, Nevada 89706, 800-942-0821

Caries, Cabals and Correspondence
Reader Letters

Thank you for sending me *Steamshovel Press*. Excellent work, as I expected. I will

soon get your book *The Octopus*, as I am a big fan of both yours and Jim Keith.

I was really impressed with Saab Lofton's article "The American Nazis and the Nation of Islam". Personally, I've long suspected that Louis Farrakhan is an *agent provocateur* supported by the CIA as a replacement for Malcolm X and MLK. I wonder what Lofton would think about this theory. To some, that may sound far-fetched, until one looks at his suspicous involvement with the Malcolm X death, and his recent work with another likely *agent provocateur*, Mo Kaddafi. (Read "Hit # 30" in Mark Zepezauer's *The CIA's Greatest Hits* for details on Mo.)

In any case, history shows that whenever a leader is assassinated, the next step in all cases is to put a puppet in place (the "suicide" of Salvador Allende in Chile and the support of mass murderer Augusto Pinochet as a replacement by the CIA and IT&T is a good example.) As the evidence clearly shows that both the Malcolm X and MLK assassinations were at least partially involving CIA elements, it is clear they needed a replacement for the two "black messiahs". Who better than Farrakhan, who, unlike MLK and Malcom X's later uniting philosophy, is a racist, sexist demagogue, thus splitting up African-Americans, Jews, and feminists, and thus hindering any real progressive movement for 25-plus years?

There's also the FBI's harrasing entrapment of Malcolm's daughter a couple years ago, in which they were trying to convince her to pay someone to kill Farrakhan over his involvement in her father's death, an idea she certainly did not originate and is dubious if she actually embraced. Why the FBI would set her up in such an elaborate sting doesn't make sense, unless one concludes that it was done to discredit a rising uniting force. I may add for a man who is supposedly so much against the system, Farrakhan sure doesn't seem to be looking over his shoulder. Why a man who says the things he does isn't looking over his shoulder in paranoia is beyond me. Unless, of course, he has a guardian angel. In fact, I have to wonder if Farrakhan really believes the bullshit he says, and maybe his anti-Semitism is about as cynically pragmatic as Pete Wilson's anti-immigrant exploitation.

In any case, thanks, and keep up the good work.

Robert Sterling
Los Angeles, CA

Steamshovel Debris: Since this letter came in, Rob Sterling has become a top source for conspiracy information on the internet. Readers should check out his *Konformist* web site at
www.konformist.com.

Here's one point of interest: the 1981 mail out of ex-White Power editor William Grimstad's "The Six Million Reconsidered" was funded by Inamullah Khan, a Saudi royal advisor, with cash from the World Muslim League. A 1983 mail out of it and Grimstad's "Anti-Zion" came straight from WML headquarters in Karachi (Hill, ray with Bell, Andrew, *The Other Face of Terror*, Grafton Books, 1988, p. 251.) I could go on...but I gather you will have concluded that the most fundamental difference between Nazi-ism and Islam is thirteen centuries. Otherwise, they're much the same.

Gerard Clinton
Ireland

While the obnoxiously reactionary and openly racist commentary about me (or was it someone using my name?) in *Steamshovel* #15 from G.J.Krupey does not warrant a response, some clarification about the historical issues raised and my "ideological correctness" may be of use to your endangered readers.

Krupey, while insinuating that I somehow resemble Joe McCarthy, makes itseem as though he has single-handedly exposed my deepest secret, that I am "a leftist"! However, had he listened more attentively to my political pronouncements, he would know that he has to take the red flag he has me carrying and paint it black. To anyone with the least bit of curiosity or knowledge about me, my politics are far from secret. Though, I suspect they may

seem a deep mystery to the likes of Krupey, given his level of comprehension of all other matters. I haven't hidden that I am anti-fascist and progressive as far as I know. On the other hand, I may not have mentioned it directly and slowly in my tapes, since I don't feel a need to proselytise.

My lectures aim at being factual and historical, with my own bias and opinon added but not required for reaching the general conclusions I would hope. Krupey says I see a Nazi where McCarthy saw a communist. There are two differences at least. I am not on a Congressional committee attempting to ruin lives for political self-aggrandizement, and there really are some Nazis in positions of power. I wouldn't mind it so much if there were a Nazi under my bed, it was discovering them in bed with the US military/intelligence/corporate complex that upset me (and since I am also a pacifist, makes me go "anti-ballistic" instead).

Krupey is the second person I've seen in print that wonders whether or not I'm Jewish, though we might ask whether he's keeping a list. For the purposes of all you fascists out there, I'm at least an "honorary" Jew. Also an "honorary" mental patient, the ones you killed first. I am indeed anti-Fascist, anti-militarist, and despite Krupey's ill-conceived suspicions, anti-statist. Have you enough colored triangles for me yet? I'm willing to be "honorary" gay as well. And proud to be a graduate of the "Mae Brussell school of Jewish paranoia" as Krupey says (or don't Jews have enemies?). Mae Brussell knew what was going on around her and did something about it. We would have laughed about Krupey's letter if she were still alive, and she would have said as she did in response to so much of the stupidity, "Oh, my aching ass." Excuse us for living.

My anti-statism does include the former Soviet Union (or did I miss something?) and Israel (especially to the extent they cooperate with the American corporate and military agendas), although I must confess that neither of them look to me to hold much of a threat compared to the

genocidal machinery we call "our military might." The Nazi generals would envy our current mega-death technology and global reach (if they don't actually control it).

I never believed, from the time of the red-scare fifties I grew up in until the current day, nor did any rational person, leftist or not, that a Soviet invasion of the US was anything but "completely out of the question," much less "from Mexico". The nuclear stalemate of deterrence was actually a case of constant nuclear superiority on the part of the United States, until it wore down the resources and existence of a "super-power" boogey-man the U.S. created out of a third-world economy struggling to break free of monarchies and capitalists who wanted it crushed from 1918 onward. The actual military and naval capabilities and machinery of the Soviet Union was incapable of such an "invasion", had it even been on anyone's suicidal agenda, and the threat of nuclear destruction that would not have recognized arbitrary national borderlines was enough to stop such fantasies from forming anywhere but in the minds of the most reactionary anti-communist elements here in America. Some are apparently still entertaining it. Nor do I think some secret Jewish cabal runs the world (nor a Nazi cabal for that matter).

I have to wonder about someone whose connection to political ideology consists of "considered myself a leftist" at one point, and "no longer consider myself a leftist" at another. He says he "won't deny" much of my critique, but finds it at the same time "skewed, lopsided and half-assed." No wonder he considers me "suspect" since I remain consistent based on rational analysis. One needs only to read his commentary, replete with sexist, racist and anti-communist rhetoric, to discover what you'd "consider" him to be.

At one point I am attacked for refusing to "stump for trials of former communists for 'crimes against humanity' in Russia and eastern Europe" and for being "mute on the need for war crimes trials for the [Israeli] mass executions of Egyptian prisoners of war". But, at another point, I am scorned for allegedly spurning the militia for "not shedding tears over the dead children in Somalia or Bosnia or wherever like good, humane leftists do". Worse yet, I am criticised for ignoring deaths caused by communism that purportedly, by sheer numbers, make a mountain in relation to a "Nazi molehill." Obviously, Mr. Krupey has no relatives buried in this "molehill" or he might consider the difference less consequential. Of course, the deaths of the revolutionary period in Russia are dwarfed by the war dead created in the Soviet Union and across the globe by the Nazi assault, or shall we blame all that on the "communists" as well, for having the audacity to resist? And those figures are similarly challenged by the holocaust of deaths created here and abroad since the end of World War II in covert, overt and financially supported coups, wars and genocides by U.S. forces (which might be tacked on to the original Nazi death count for historical accuracy, if I was counting). But, not all the Germans were Nazis and not all the Nazis were German.

Actually, I think that all the killings were wrong, criminal and inhumane. States are states. I criticise the one I can change, the one I live in. I don't encourage trials as a solution to social ills, but I think confession and justice have their place. I don't think war is a solution to international or internal disputes, but I do believe people have the simple right of self-defense and survival by any means necessary. I just find my level of tolerance for those who find violence as the

"necessary' first or anticipated solution at a low point. There is a great deal we can do before that option forces itself, and to refuse to do it may make it inevitable. I have no revenge or blood lust, nor would I participate in it. Non-violence is actually a better defense, history must have shown us by now, though few have the guts and discipline to use it. While it is true that I am not a "KGB-Mossad disinformation agent" on both counts, I wonder if such an animal exists anywhere but in the fervid imagination of Krupey and in the pages of *Spotlight/Criminal Politics* or whatever other enlightening journals he reads. Krupey shows his hand once more by accusing Herbert Marcuse of "cranking out anti-Nazi propaganda preapproved in Moscow," suggesting there might not be anti-Nazi truth somewhere.

Krupey claims that I am critical of the militia because they are "overwhelmingly white, and even (the horror) proud of it" .Actually, it's because they are overwhelmingly male, macho and stupidly reactionary, as well as being racist. And yes, being "proud" of being white in this society is objectively racist, while being "guilty" allows a different kind of paralysis that still fails to change the basic power structure of white supremancy and dominance. The militia's paramilitary mentality and response are counter-productive to real deomocracy and smack of the vigilantism that has appealed to disaffected veterans since they formed the Klan after the Civil War, the Hells Angels after Korea, and the militias after the Gulf War. One recent honest account of military basic training by Lt. Grossman, *On Killing*, might help readers get at the bottom of this type of social violence. The other problem is that these paramilitary groups have been prime targets for government infiltration, surrogate operations and even creation, and the arms have traditionally been supplied from military bases.

They feed on rumor and fear-mongering. I get handed these flyers with American flags at the top, titled "Did you know that..." and followed with the most idiotic, undocumented nonsense you can imagine. No, I didn't KNOW what was not TRUE. What a stupid come on, only the punch line is worse than the joke. We have no time for disinformation, for those who hide a white supremacist agenda under the flag or the sacralization of the Constitution. Slavery used to be Constitutional, shall we go back? It is 200 years later, we have to envision our own liberation, and white males get to talk last. Better "PC" than Nazi (Not see). White male rage and fear at the dissolution of their privileged positions in the class structure is reactionary, and if that's politically correct of me to say so I hope you can hear it.

Is this all of the militia? No, but enough of the leadership that's visible. Their agenda is not progressive social justice, it is simple revenge and "I want my job and position back". And I, for one, don't need to be led anywhere by that sort of nonsense. I know the government is rotten, so is the military and the corporations, boys. Fascist, in fact, but not communist, not United Nations, not New World Order but old boys order; not external and esoteric and other, but us, just the worst of us, nobody left to blame out there. Chickens come home to roost.

But I don't want a new government made up of boys and their pop guns. I want democracy, justice, an open society, an end to racism and sexism, and the death of fascism. I want something different, direct, participatory, informed, armed by reason, visionary and liberating. I have been part of

many struggles. One to end the endless war in Vietnam and Southeast Asia, which we won. One to organize active duty enlisted and veterans, who along with the Vietnamese stopped the war. One to liberate the so-called "mentally-ill", victims of drug, shock, lobotomy and menticide. One to stop the militarization of society. One to establish real, direct, non-representative democracy with open media and education, referendum, direct allocation of tax, and decentralization of economy and decision-making. One to expose and end the political assassination machinery that has continued killing throughout U.S. history, and which came of age on November 22, 1963 with a covert military *coup d'etat*. It is a history Krupey will end up on the wrong side of, though he cannot see the irony of finding a freedom fighter like myself "suspect" while he quotes and takes his cues from the very fascists he "considers himself" to be opposed to.

I make no apologies for being anti-racist. And despite his uninformed and unprincipled critique, the Black Panthers had a legitimate social program, got press only when the system wanted to discredit them, and were victims of an as yet unassessed Black Holocaust of massive proportions, though only a "molehill" compared to the Native American genocide that preceded it. In that respect, we taught the Nazis what to do. My problem is not with those who feel a wrong was done to Randy Weaver or to the people at Waco, it is that they have suddenly awakened from a deep sleep of denial because "good, white Christians" are being killed. It reminds me of the continuing silence concerning the shootings of students by police at predominantly Black Jackson State University in the weeks before the much-heralded, but smaller Kent State massacre by the National Guard, at a predominantly white school. And while the fire at Waco parallels the attack on MOVE in Philadelphia in many respects, they didn't burn down a whole white neighborhood to get at them. Thus, despite Krupey's annoyance with possibly hypocritical liberal response to the Panthers, the reality is that they were systematically killed, stripped, beaten, and jailed on phony charges (including the supposed "murder" Krupey thinks they "got away with"). They were victims of FBI Hoover's COINTELPRO, which included CIA Chaos and DIA martial law plans and sniper murders. They were infiltrated with phony leadership that survived and showed their colors, with police agents that set them up to be killed, and plagued with disinformation designed to sow distrust among themselves. State-sponsored paranoia.

To date, I have not seen any of this happening to the militia, who cannot count Weaver as one of their own after the fact, since he was not only racist but misanthropic. And if "molehill/mountain" logic is Krupey's criteria, the Panthers and other African American victims of the 60s alone have the militia beat hands down. A pop-gun will not save you from fascism, it is their best tool and they will be glad to put one in your hands after they kill you if you forget to buy one. They cannot be beat at their own rotten game. And the thing to do about it is not individual or small group vigilantism, which is ripe for government cooptation and control, but open exposure and real democracy. A public solution is the only possible one, an individual solution is the one they want us to take. Opportunism and paranoia suit them just fine. Hole up in your prison cell, armed to the teeth and wait for them to come and get you, and they will send in the nerve gas instead. Build a barricade mentality and they will attack

from the rear, from above, from below, and probably help you build the barricade before they start. Wise up!

I am dead "serious about what I'm preaching" and I am "up to something" which is called consciousness raising. Stick with that fearful, reptilian back brain of yours and you're dead meat in this grinder. There is a thing they do not understand, but you have to come out of your hole to find it. Right now, who would stand with Krupey? Do you want him to cover you? Think for you? There are more of us than of them, and we can think for ourselves if we put ourselves to it. We can also break the game of distrust, manipulation, fear, bigotry and selfishness they want us to play. Gandhi taught King, and King taught others that there is a way out. Not by the sword or the gun, but by the head and the heart. And, yes, by way of what Krupey calls a "far left agenda" because that's where simple decency and fairness and justice have been pushed to as the rest of the society has been dragged to the right. A liberal is today what a communist was when I was young. Does that make an anarchist like me into a terrorist? I suppose so, but I know who the real terrorists are, and I have no gun, no bomb, nor anything so explosive as a right mind, a good idea and a piece of the truth. Look out!

Honest John Judge
Washington, DC

My name is Robin Marie Head. I am a Texas madam. I have been sentenced to ten years in prison under the guise of "organized crime". I was the proprietor of an escort service in Houston and Austin, Texas. There are thousands of these businesses across the U.S. listed in the yellow pages. I, myself, have befallen solely because I refused to work for the BATF namely (or DEA, FBI). These agents, our U.S. government, were interested in our exclusive clientele, to wit, "selective" state and political officials of which I do maintain a taped conversation of an agent expressing this in his distinct voice. This discreet information would be invaluable if wanting to gain influence and power over those who fraternize our services (i.e., election fraud, judicial and legislation control, a silent coup even, etc.) This is the same strategy that empowered J. Edgar Hoover to weild great authority over Washington, DC. What was the more recent "Filegate" in '96 about and whatever became of that investigation?!

Ms. Robin Head
#742243
Murray Unit
Gatesville, TX

I just received *NASA, Nazis & JFK* [the *Steamshovel Press* book]. Thanks! I immediately noticed Jean DeMenil's name in its contents.

I live in Houston next to the University of Saint Thomas, the Catholic College built by the Menils in the early sixties. Next to the campus is the Menil Museum, which houses their breathtaking collection of prehistoric art and antiquities, as well as much modern art.

Also on campus is the Rothko Chapel, which houses Mark Rothko's final works he created for this special space in the final moments before his suicide. The Chapel is in a hidden park, perhaps the most beautiful and mysterious park in all of Houston. I say hidden because it is almost a secret--few people living here are aware it is even there, although they drive within a block of it everyday.

Although I am not a Catholic, I go over to the park to escape the city, to experience the quiet solitude of the space. Usually the only people around are tourists-- French, Japanese--and the poets that Dominique DeMenil supports with free housing adjoining the park. Richard Howard, Ed Hirsch, etc. I have encountered the Dalai lama twice at the chapel, as well as Jimmy Carter, French president Mitterand, and other international leaders of various religions and power structures. Although George Bush Sr. lives in the immediate area, I've never seen him or Barbara around--nor George junior, our Texas governor, who seems otherwise to always be around the neighborhood.

Anyway, the reason I mention all this because of a local mystery. The campus is open year-round, with its own private security hired from the Houston police. All year, except for three days in January. The campus closes completely January 15-17 and fills with mysterious well-to-do visitors, as a part of a private celebration of Saint Sulpice day, January 17. Perhaps you have read *Holy Blood, Holy Grail*. January 17 is the mysterious holy day celebrated in southern France in connection with the Magdalene.

I often encounter Dominique DeMenil sitting alone outside Rothko Chapel, lost in her thoughts, frail, in her 90s. I knew her family the Schlumbergers were originally from southern France, but until I received your book I never realized Jean DeMenil was a white Russian. The Russian poet Yevgeny Yevtoshenko is here almost every other month.

I have no idea what all this means-- the security of the event ensures privacy and silence.
Jack Turner
Houston, TX

I am only a bit interested in the factual, "real world" manifestations of Elizabeth Clare Prophet and the Church Universal Triumphant [as reported in *Steamshovel Press #14*], how she captures members, how armed they are, brainwashed, etc. What I am interested in is how Prophet's church, beliefs, metaphysical work operate in the "other world," so to speak. When, for instance, she claims to have a vision in a New York hotel room of a "black horse" which she associates with the Four Horses of the Apocalypse, etc., which she does not, cannot control--which she views as some "bad karma," Biblical plague about to strike earth as earthquake, bear market, plague or war, etc.

As a person who spends most of his time in that vision world, seeing and working there, I know that what Prophet sees is very real, though "subjective." She is, in fact, channeling the horses of the Apocalypse to accomplish those prophecies which will raise her church upon the earth. She abuse metaphysicalpower in ways that are evil almost beyond comprehension. And, her use of metaphyscial power, her secret ties to Hell, the raising of Hell, war, disorder, crime, depression can only be seen in that "subjective" realm. Not only can it only be seen there, that is the only place she can be fought and stopped from fulfilling her Biblical end game prophecies.

As a "concrete" for instance, I have "dreamt" that her "ranch" out in Paradise Valley is not a bomb shelter, rather it is a site where there are hundreds of "metaphysical nukes" buried in silos with whcih war can be begun, not ended. Yes, this is "subjective," I suppose, but it is where she really operates—and I feel it is where she could be most effectively hit, fought, exposed for what she is.

Jeff Lewis

They spend millions of dollars on building bigger and bigger telescopes and radiotelescopes but in my opinion it doesn't have any sense. What's the use of the Hubble telescope if it shows us how space looked like hundreds of millions of years ago? And radiotelescopes! Don't you think radio waves are too slow to contact or to get a message from another world? Another aspect: what would happen if for instance our world, I mean our whole space, is like a plane and all our attempts to contact with another intelligence are like moving on that plane? But maybe there are many other planes, other worlds with their own physics, velocities. Then all of our attempts would be of no avail. We won't discover anything different than we can find here on earth. I'd like to know if there are some scientists who don't go that way, who try to look at our world from different points of view, just like Einstein, Reich or Daniken.

Marcin Biernacki
Poland

Book Reviews

Mason & Dixon by Thomas Pynchon

The following commentary on Thomas Pynchon's latest novel, Mason & Dixon, *comes from a paper entitled "Mr. Pynchon's Historical Method: Using the Verifiable To Create The Plausible?" It was written by Gary Ryan, Thomas Gremaud, Kenn Thomas and David Warren, Ph.D., and presented at the 1998 International Pynchon week conference at King's College in London.*

The portrayal of George Washington, the Father of Our Country, in Chapter 28 of Thomas Pynchon's *Mason & Dixon* is an Insult to the country. To characterize our President as a land-grabbing, pot-smoking schemer who uses racism and bribery to manipulate others for his own selfish ends should offend every loyal American. Pynchon's treatment of America's original decorated war hero who later, reluctantly, after the Devilish deception, answered his country's call for leadership in the Virtues of honesty, judgment and duty is a profound Libel not just upon George Washington but upon America itself.
-- Newt Gingrich's *Spiritual Day-Book*

Perhaps even more so than in previous works, Thomas Pynchon in *Mason & Dixon* uses extensive verifiable historical fact, often in the form of topical reference in the thought or conversation of characters. The result for some of Pynchon's readers may be a strong sense of history coming to life—of a book closer to History than to Fiction. But is this sense of historicity in Mason & Dixon only an illusion created by the sophisticated techniques of a writer who knows so much more than his readers that he can easily fool them?

In addition, to what degree does Pynchon's use of elements of twentieth century popular culture make some readers more accepting of certain events in the novel? For example, in drawing a connection between a scene in the book of Mason and Dixon's coach ride from Philadelphia to Mount Vernon and our present day experiences of airline travel, one could argue that Pynchon creates an empathetic bond between the reader and the fictional Mason and Dixon. The same could be said of Washington's pot smoking, Ben Franklin's antics and Jefferson's youthful naiveté.

Pynchon has persistently created in his work—take, for example, *The Crying of Lot 49*—worlds where readers find themselves unclear as to just what is really going on. In *Mason & Dixon*, legitimate debate might well be had over whether or not George Washington was really a pot-smoking real estate speculator, Benjamin Franklin genuinely lived a life of a parting public celebrity, or one of the most memorable phrases from the Declaration of Independence originated by happenstance and primarily from the mind of Jeremiah Dixon, not that of Thomas Jefferson.

Elements in the novel to which the reader initially might conclude that "Pynchon made it up" turn out to have more truth than the reader might suppose. The veracity of elements in the novel's account of the meeting between Charles Mason, Jeremiah Dixon and Colonel George Washington (Chapter 28), for instance, make it difficult to discern where History ends and Fiction begins. It makes credible the question: "Was Washington as a pot-smoking real estate speculator served by a Jewish-African slave who earned a good living as a stand-up comedian and gourmet chef?"

Let's first look closely at the meeting with Washington, and after analyzing Pynchon's method in this scene in particular, we will then apply what we've learned to the novel as a whole and draw conclusions about Pynchon's purpose. In other words, is *Mason & Dixon* about History, about us, or both?

The journey to Mount Vernon reminds "us" of a ride on an airplane. Mr. Tallihoe takes them in a machine, "a coach of peculiar design" (*Mason & Dixon*, p. 273), and along the way, Mason and Dixon are given sandwiches to eat, magazines to read, and a drink—just like TWA. Perhaps, Pynchon is already stretching plausibility with this description of the coach as a "machine," not that it isn't consistent with the 18th century, but conceivably, Pynchon might be drawing on our 20th century experiences to make this curious coach ride familiar. So far, Pynchon has not necessarily changed history, just given the facts a jazzy reference. Chapter 28 starts off with the narrator, Reverend Cherrycoke, the self-styled chronicler of Mason and Dixon, qualifying the coming events of the meeting with George Washington. As a result, readers are lead to believe that the events will be filtered through a 17th century sensibility. Cherrycoke warns about these Virginians:

In their Decadency these Virginians practice an elaborate Folly of Courtly Love, unmodified since the Dark Ages, so relentlessly that at length they cannot distinguish Fancy from the substantial World, and Their Folly absorbs them into itself. They gaily dance the steps their African Slaves teach them, whilst pretending to an aristocracy they seem only to've heard rumors of…No good can come of such dangerous Boobyism. What sort of Politics may proceed herefrom, only He that sows the Seeds of Folly in His World may say.

--The Rev. Wicks Cherrycoke, *Spiritual Day-Book*

Cherrycoke goes on to say that Mason and Dixon find Washington "Out on the white column porch, tumbler in fist, the large Virginian wants to talk real estate," particularly a piece of land "passed the South Mountain." Washington goes on to discuss land speculation in general and the westward expansion of the various groups of colonists.

When Mason suggests that General Bouquet's recent Proclamation will stop all western settlements, Washington scoffs, arguing that it is all about business. Washington insists that the Proclamation has nothing to do with saving the Indian, rather it is an attempt "to confound their enemies…ProclomationShmocklamation." (p. 277)

Washington goes on to tell Mason and Dixon that they are welcome to make political jokes in America but he warns them never to talk about religion. He tells them to represent themselves as "Deist" so as to avoid being on the wrong end of a Lancaster county rifle and then adds, "besides, you cannot know what may be waiting among the trees…"

Dixon inquires about the aroma of Indian hemp, which Washington explains as an agricultural experiment. Washington calls for his Man Gershom, "Where be you at my Man?" And then asks Gershom to bring "some Pipes and a Bowl of the New-Cur'd hemp. And another gallon of your magnificent Punch." All proceed to get stoned and drunk.

In the midst of their conversation, Washington describes Gershom with the phrase "an Israelite in whom there is no guile", which causes a momentary ruffling of Dixon's feathers, and Washington apologizes. Gershom notes that he is Jewish and Washington adds that Gershom that Gershom is, besides being Jewish, a professional entertainer of some celebrity in Virginia and Maryland…" Indeed, he is known far and wide as "a Theatrickal Artist of some Attainment, leaving him less and less time for his duties here, not to mention an income per annum which creeps dangerously close to that of his nominal Master, me" (p. 279)

Gershom jokes that Washington wants to sell him (Gershom) some stock in the Dismal Swamp Land Company. Gershom takes the pipe from Dixon, inhales, and begins questioning the astronomers about their trip thus far. Gershom jokes that Dixon's red coat will be an easy target out in the forest and that Mason will be mistaken for a Buffalo. Washington responds to Gershom's teasing by groaning. "You see what I have to put up with…It's makin' me jus mee-shugginah."

At this point Martha Washington comes in with a plate of food, stating, "Smell'd that Smoak, figur'd you'd be needing something to nibble on" (p. 280). At this point, George starts a rambling narrative of the Ohio Company:

As the East India Company hath is own Navy, why, so did we our own Army. Out in the wild Anarchy of the Forest, we alone had the coherence and discipline to see (his land develop'd as it should be. Rest easy, that the old O.C. still exists…tho' in different Form. (p. 281)

Gershom taunts Washington about the failure of the Ohio Company, and Washington bemoans the fact that the charter wasn't written correctly because they didn't have the proper influence in the English court. Gershom points out that the O.C. failed to get the Bishop-of-Durham Clause.

Martha, meanwhile, proceeds to butter Mason up with compliments on the boys' astronomical work with the Transits of Venus. Mason feels obligated to defend himself against "what he suspects is Mrs. W.'s accusation of unworldliness of his profession." However, Mrs. Washington assures Mason that the Transits of Venus observations were a "Rage" in the colonies,

where there were celebratory Transit-of-Venus wigs and Transit-of-Venus Pudding and even Transit-of-Venus songs. At this point, both Martha and George breakout into a theatrical song culminating in a center stage embrace and duet.

The next act begins with Gershom telling King and Fool jokes, which he says are based upon Master and Slave jokes but fashioned here for the select audience. Gershom follows these by singing "Havah Nagila", a merry Jewish Air, whilst clicking together a pair of Spoons in Syncopation.

Later, Washington is still obsessed with the Ohio Company affair and begins to discuss how Celeron de Bienville started the dispute in 1749. Celeron, asserting French claims to the region of the Ohio, began to bury lead plates, bearing the Royal Seal. Dixon, rather stoned at this point, gathers the insight that lead plates, "or Disk, might plausibly have an Electrickal purpose" (p. 285) Mason chides Dixon for going wild on an obsession with electricity. Undaunted, Dixon muses tat the French might be developing the plates collectively to produce a Leyden-Pile:

"If not for storing quantities of simple Electrick Force, then to hold smaller charges, easily shap'd into invisible Symbols, decipherable by Means surely available to those Philosophies (p. 286)

Washington then shows the astronomers a lead plate he has dug up. Dixon gets excited, not by the Royal seal, but by what he assumes to be Chinese on the back of the plate. Washington responds, "Chinese? Remarkable, Sir. The only Europeans who recognize such Writing, seem usually to be the…Jesuits." (p. 287). Curiously, Washington asks Dixon a startling question: "-are you…a traveling Man?" to which Dixon, thinking that Washington has just given him a Masonic signal, replies with the secret response, "Why aye…and I'm traveling West!" Washington then tells Dixon to be wary of Jesuits that come from Quebec in disguise, "to work some mischief down here" (p. 287)

Thus, the chapter ends back in Philadelphia with Franklin expanding upon Dixon's hazy epiphany of Jesuit inventions, "elite teams of converted Chinese, drill'd, through Loyolan methods" (p. 288). Dixon now understands that the Jesuits are conjoining the "Brain-Power on Earth with Asian Mysteries to make up a small Army of Dark Engineers who could run the World." (p. 288)

Well, was Washington a pot-smoking real estate speculator served by a Jeish-African slave who earned a good living as a stand-up comedian and gourmet chef? A list of all the historical elements can be compiled that could

be verifiable in order to make some assessment of what Pynchon suggested could be plausible. In this way, like a good agricultural experiment, readers may separate the male from the Fimble and see what sells. The list would include the following:

What was Washington's role in the French and Indian war?

What is going on in Washington's life during this time?

Why would Washington sound African?

Would Washington have had a black valet ("my man Gershom")?

Was Washington a real estate speculator?

Who else benefited from the Mason Dixon line?

Is it linquistically possible for Washington to say "Proclamation Shlocklamation"?

In 1761, was there a sense that "We're not Brits, we're Americans"?

And finally, could there have been a Transit-of-Venus Wig?

Many of the things on our list turned out to be historical artifacts that we had either missed in school or had been just too lazy to look up before reading the novel. Pynchon's encyclopedic novel warns about basic American laziness. Curiously, some of the elements that ca be taken as comic anachronisms or just plain fantasy turn out to have some basis in actual history. Why couldn't there have been a Transit-of-Venus Wig?

The transit of Venus, which Charles Mason and Jeremiah Dixon observed from the South African cape, was, according to Pynchon's George Washington, more famous than the work of the Royal Society, with observers stationed all around the world, even in Massachusetts. The event so captured the fancy of the American colonists that it entered popular culture as the Transit of Venus wig, the Transit of Venus pudding and a particularly distinctive and Pynchonesque Transit of Venus song. That the importance of the Transit of Venus in eighteenth century American popular culture remains beyond an ability to verify, however, poses no insurmountable problems. Though unverifiable because, for one, of the lack of artifacts—the Transit of Venus wig, made in all likelihood of human hair, would probably not survive, and the Transit of Venus pudding with "a single black currant upon a circular field of white," (p. 283) would require such a slight variation from the standard pudding recipe that one would not likely write it down—the entrance of the Transit of Venus into popular culture is absolutely plausible on the condition that one accepts that eighteenth century America had a popular culture.

The Transit of Venus wig, though characteristic of Pynchon's inclination toward the bizarre, cannot be dismissed as purely fiction; nor can the pudding. We see in this novel that the presence of Mason and Dixon at the cape drew a good deal of attention. Preparations for their observation of this celestial event required that they reside at the cape for a time long enough to qualify them as members of the community. The other members of that community had ample time to become acquainted with the astronomers and with their project. They had ample time to become excited about this global event.

And a global event it was, for while Mason and Dixon were observing the Transit at the cape, other astronomers were simultaneously observing it from territories around the world, including the North American colonies. The presence of observers in Massachusetts must have attracted attention and must have generated a popular interest in the Transit in much the same way a couple of fellows looking through a telescope today will find a line forming behind them.

Whether a Transit of Venus wig actually existed is beside the point. One could have existed. Pynchon has created plausibility, and though a reader might suspect the faddish trappings of the Transit of Venus arise from Pynchon's fiction, enough outlandish references can be verified as historically accurate that one can confidently say a colonial woman wearing her Transit of Venus wig just may have sat down at a table to enjot a Transit of Venus pudding while upon a ship in the bay outside her window, while sailors were launching into a chorus of, "'Tis ho, for the Transit of Venus!"

STEAMSHOVEL 17
Summer 2000

**Table Tapping
Into The New Millenium**

William S. Burroughs

**Previously unpublished interview
by Kenn Thomas**

William S. Burroughs was a native St. Louisan whose return trips to his hometown, a place he has called the product of a "malignant matriarchy," were rare and brief.
In 1981 he gave a reading at Duff's, the coffeehouse of the literary cognoscenti in St. Louis, to promote his novel *Cities of the Red Night*. He came back in 1983 to attend the funeral of his brother Mortimer, a local architect. For the premiere of documentary on his life, *Burroughs: The Movie*, he signed book at Left Bank Books, the Central West End bookstore, in 1984. On these occasions, Burroughs gave long interviews with the *St. Louis Post-Dispatch* discussing his life in St. Louis (1).

The city's rival newspaper, the conservative *Globe-Democrat*, either through disinterest or outright hostility for this unconventional native son, had ignored reporting about Burroughs since its sensationalized handling of Burroughs' arrest for the murder of his wife in 1951 (2). The *Globe* would have ignored the 1983 visit as well if it had not been approached by

Steamshovel Press editor Kenn Thomas, working as the paper's rock music critic at the time. Even with that concession to Burroughs' fame, the *Globe* published only a small part of the interview due to space limitations. The full interview, which has never been published, has never before been published.

Burroughs' first novel, *Junkie: Confessions of an Unredeemed Dope Addict*, a graphic narrative on the life of a heroin addict, was published in 1953 under the pseudonym William Lee as part of a double-sided paperback of lurid, drug-crime fiction. Although Jack Kerouac had made him a legend in the Beat underground by including Burroughs as a character in his fiction, the impact of Burroughs' own writing was not felt until the 1959 publication of *Naked Lunch* (not published in America until 1962), a book that did as much to disassemble the structure of the American novel as it did to portray the horrible mental landscapes of addiction.

Naked Lunch presents descriptions of drug-warped reality alongside a very lucid discussion of the apomorphine treatment that helped Burroughs kick his own habit of many years. Acknowledged by such luminaries as Norman Mailer and Mary McCarthy as groundbreaking prose, when parts of the novel first appeared in America in 1959, it became part of a protracted court battle that ended with the Massachusetts Supreme Court declaring the book not obscene (3).

Burroughs "wrote himself out" of his drug addiction and other miserable details of his biography. The original pages *Naked Lunch* would have existed only as an addict's notes about his experience, a kind of therapy (or in Burroughs I terms, a series of "routines"), if Allen Ginsberg and others had not rescued several hundred pages and worked to get them published. The setting of the novel jumps from St. Louis to New Orleans to Tangier to New York, all the while retaining the single point of view of the semi-autobiographical William Lee, who is presumably undergoing the apomorphine treatment for heroin addiction. The characters comprise the cast of a traveling carnival. They include one literal carny, A. J.; two vaudeville performers, Clem and Jody; the infamous quack/butcher Dr. Benway; the pharmacist/bigot Doc Parker; and several sex acrobats, sailors and boys involved in wild scenes of decadent sex and death. The writer's season in hell moves into the lucid reality of the apomorphine cure, described coherently in the book's most conventional chapter.

By the time of *Naked Lunch*'s publication, Burroughs had led a complex an interesting life. He graduated from Harvard in 1936 but remained there to study ethnology and archaeology before pursuing various careers as a detective, advertising man, pest exterminator, reporter and even as an army serviceman briefly during the Second World War.

His addiction began in New York in the mid-1940s. A few years later he moved to Mexico and later to the South American Amazon to investigate yage, an hallucinogenic plant used by native Americans. Some of the prose in *Naked Lunch* stems from his experiences with yage, and in 1963, Burroughs published a book of correspondence with Allen Ginsberg called *The Yage Letters*, that detailed his experiences. Drug expert Dr. Andrew Weil has remarked that *The Yage Letters* is "distinguished by a uniformly negative tone and, according to experts on the region, considerable misinformation"(4).

In 1951 Burroughs was living in Mexico City when he shot his wife at a party, reportedly as part of a drunken parlor game version of the William Tell legend. The St. Louis papers reported the accident prominently, in part because of Burroughs" wealthy background, in part because he and

Jack Kerouac had been witnesses in another renown murder trial: the stabbing death of

William S. Burroughs

Washington University professor David Kammerer by Lucien Carr (5). The death of Burroughs' wife became a turning point in his life; after it, he re-committed himself to serious writing.

Burroughs escaped from the tragedies of his personal life to the vigors of creating a new form of serious, science-fiction-like writing. His second major work, the *Soft Machine / Ticket That Exploded / Nova Express* trilogy, depicts a world in which the Nova Mob, in the form of a viral parasite, seeks to control humanity. The Mob is analogous to drug addiction, to sexual repression and to anything else that traps humanity into restrictive thought patterns. In this trilogy, Burroughs cultivates the use of cut-up techniques he and the painter Brion Gysin began to experiment with in Paris in 1959. The technique involves stopping the conventional narrative and "splicing on" prose fragments from other writers, newspapers, scientific papers and advertisements. Although it did not inspire a court battle, the cut-up technique met with the same cool critical reception as *Naked Lunch*.

During the 1970s, Burroughs' fiction grew into apocalyptic satire that appealed particularly to American young people. His work has been celebrated at countercultural gatherings like the 1978 Nova Convention in New York City (6) and Burroughs spent many summers teaching at Allen Ginsberg's Kerouac School of disembodied poetics in Boulder, Colorado. While his popularity outside the mainstream continued, Burroughs also began to enjoy critical acceptance in the 1970s: he became the subject of six books, two bibliographies, several dissertations and scholarly articles. In 1983 he was elected into the American Academy of Arts and Letters.

At the time of this interview, Burroughs described his writing as a mythology of the space age, a new kind of writing created for the reder of the future, someone who has "escaped" from the state of arrested evolution that, in Burroughs' view, the world at large finds itself in. His last work at the time was a trilogy that included *Cities of the Red Night* (1981), *The Place of Dead Roads* (1983) and *The Western Lands* (1987). These novels were critically regarded as both anemic clones of *Naked Lunch* as as Burroughs' magnum opus. Kim Carsons, the protagonist of the last trilogy, has been called one of Burroughs' most autobiographical characters.

After his death in August 1997, Burroughs to up residence at a graveyard down the street from Kenn Thomas' St. Louis home.

The following interview was conducted with William Burroughs from his home in Lawrence, Kansas on March 24, 1984.

Q: Do impressions you make in interviews add anything to those given in your books?

A: Not usually. Occasionally, I don't know. Sometimes it might enable me to put something more clearly or even give me an insight. But ordinarily, they're pretty much repetitive.

Q: What are some of your impressions of childhood in St. Louis' west end?

A: Well, it was another world. That was in the 1960s. I wasborn in 1914. I lived at 4064 Pershing. The house is still there. There is a Dr. Fisher living there and we've becomequite good friends. It was a middle class, three story brick house with a fish pond in the backyard. I went to the Community School and the John Burroughs school. By that time we had moved out in the suburbs on Price Road in Clayton.

Q: One popular perception of your background here is that it was tremendously affluent from the adding machine fortune started by your grandfather, that this provided you with a safety net to be able to pursue your unusual life. Is that a very true perception?

A: No, it isn't. In the first place, of course, the family didn't realize anything from the Burroughs adding machine. The family was bought out in that company long before I was born. There were four children and they bought them out for $400,000--that's $100,000 each. The stock would be worth $60 million now. My father used the stock to buy a glass company, which he ran for some years. We were by no means ever in the millionaire slot. Just in the two or three hundred thousand area. Years later, during the Depression, my father went back, having sold the glass company out, first to landscape gardening and then to gifts and art. We had a gifts and art shop called Cobblestone Gardens. But other than that, through hard work at the gifts and art shop, they sent me for many years $200 a month. There was no trust fund or anything like that. It was an allowance out of what they made.

Q: A couple of hundred dollars was a livable sun at the time?

A: It was a livable sum in France and in Tangier where I lived. A livable sum no more.

Q: Many people see Jack Kerouac and Allen Ginsberg purely and simply as members of the Beat movement, but your work seems to stand as part of the Beats but also something apart. Could you comment on that?

A: The Beat movement was never a literary movement in the French sense. European literary movements would usually consist of people who sort of have a manifesto and would come to be closely related in a literary sense. That has never been true of the Beat movement. It was more a sociological movement than a literary movement.

That is, for example, Kerouac, Ginsberg and Gregory Corso and myself, while we all have certain objectives in common from a literary point of view, our work was completely different. Allen Ginsberg and Gregory Corso were poets. Kerouac's whole style, his whole way of writing, was completely different from mine. He always said the first version is the best. I said, "Jack, that may work for you, but it doesn't work for me. I work my material over at least three of four times. So there was no relation from the literary point of view

between members of the so-called Beat movement.

Q: *The Place of Dead Roads* **is dedicated to writer Denton Welch. How did Welch influence your fiction?**

A: He is ver much out of print. He's slowly coming back. I've been trying to get him back into print for many years because I think he is a very, very great writer. He died in 1948. He was 31 at the time. When he was twenty he was riding on a bicycle and somebody hit him from behind in a car. No one knows why. That left him cripple for the rest of his life. He finally died as a result of those injuries. It was during those ten years that he wrote his books.

Well, you have to read them. I just took the style and when I say that Denton Welch is Audrey Carsons and Kim Carsons (characters in *The Place of Dead Roads*), I mean that in a very real sense. It's table tapping from beyond the grave almost.

Q: You have called yourself a writer for the space age. How do you feel about people who think the space program is just a means to develop high-tech weaponry?

A: I doubt whether that is true. The actual space program, of course, is not what I'm talking about at all. I think, of course, that what they've done is go into space in an aqualung, and that was a very valuable achievement. I would say that it is one of the few government expenditures of which I do not begrudge a penny, just to show that man could get beyond this planet and look back at it.

Q: Are your ideas about space migration substantially different from Timothy Leary's?

A: Well, I think our ideas have something in common. How would you define his ideas?

Q: He seems to think that space migration is encoded in our genes, that because of gravitational spin, we're flying off.

A: Yes, I would go along with that. I've said very clearly in *The Place of Dead Roads* that man is an artifact designed for space travel.

Q: How do psychedelic drugs fit into your vision of the future?

A: They don't. I always found LSD and psilocybin to be quite unpleasant. The only hallucinogenic drugs that have had much value to me are cannabis and yage, the South American drug that I wrote a book about. I get very unpleasant reactions to LSD and psilocybin. They're both synthetic.

Q: In *The Place of Dead Roads* you also seen to suggest that memories are actually real time travel trips into the past. What mental activities are trips into the future?

A: A fellow named John Donne, who wrote *An Experiment in Time*, a mathematician and physicist and one of the early pioneers in aviation, discovered that his dreams contain episodes from the future as well as the past. He said anybody could verify this who will write down his dreams over a period of time. Many times these future events were quite trivial, like a dog running across the road or something like that. So he evolved a theory he called the serial universe, which is an observer of an observer, of an observer, to infinity. So the observer one level up would then see time as a spatial continuum in which both present and past were observable. So it is from that point of view that time travel occurs. The observer of the observer, of course, is an instance in everyone's mind so that memory, putting yourself back where you were a year ago and so on is in a very real sense time travel. This, of course, happens in dreams as well.

Q: The jacket notes of the new book say that its protagonist, cowboy Kim Carsons, is one of your most autobiographical characters. Is this true?

A: All characters are autobiographical and none of them are. Any fiction writer is always drawing from his experience. However, I would say that in a sense Kim Carsons comes closer to being an alter ego than any other of my characters. In that sense, yes, but it has very little to do with autobiography.

Q: Did you collaborate closely with Howard Brookner, the director of *Burroughs: The Movie*?

A: No, I didn't collaborate at all. Originally, it was fifty hours of film and then he made the final selection and cut it down to eighty minutes. I had nothing to do with the selection, nor did I have anything to do with structuring the film. I would have made different choices, but then practically anyone would. You give me five people fifty hours of film to select eighty minutes and you're going to have five different films.

Q: Does the movie cover a particular period of time? What does it have in it?

A: Well, it's got all sorts of things. It's got interviews with various people. It's got an interview with my old gardener who is now ninety years old. It has an interview with my brother, who is now dead, and with Allen Ginsberg and different people. It has some readings of different selections. It has a whole variety of things. It even has some films I made with Anthony Balch. He was a film director and distributor who lived in London, who is also dead. We made a couple of short films together.

Q: How do you respond to critics?

A: Not at all. There are so many good ones and so many bad. It's been going on since my first reviews. That's an old one, really. People panned *Naked Lunch*. Now they say, "What happened to the man who wrote *Naked Lunch*?" Well, you're going to get good ones and bad ones. Generally speaking, my criticism has been immoderate. It's been very good or very bad. There haven't been very many in the middle.

Q: Of all the Beat writers, it seems to me that Ginsberg made the biggest impact on the hippy counterculture. You, however, have become more the hero of the punk

underground. Do you see that distinction and do you have any thoughts on it?

A: No, I don't think it's a real distinction. It's just that the punk underground happens to be going on now and the hippy and beat movements are sort of out of date. Allen, I think, is quite as much a part of the punk generation as I am.

Q: A local rock magazine recently published an article in which the writer claimed that he picked you up hitchhiking in Colorado. Your management wrote then a letter denying the story, which they printed along with a response that essentially rejected the denial. Can you clear this one up once and for all?

A: It's absolute rubbish. I called up and they said it's no harm as it is. Fabrications are harmless. I said that no fabrication that pretends to be true when it isn't is harmless. The whole thing is absolutely ridiculous. First, he had me with a chauffeur's license. I don't even have a driver's license. I haven't driven in thirty years. Hitchhike? I never hitchhiked in my life. I don't say that as anything to be proud of, I just don't like contact with strangers. I never did hitchhike. So the whole thing is absurd. They publish something like that and then when I say it isn't true, they try to call me a liar. I know where I was.

NOTES:

1. Harper Barnes, "William Burroughs Comes Home," *St. Louis Post-Dispatch*, April 5, 1981, p. 1H.
 Florence Shinkle, "Made In St. Louis ... Burroughs Fled Life of Privilege," *St. Louis Post-Dispatch,* August 14, 1983, p. 1D.
 Harper Barnes, "William Burroughs' Return," *St. Louis Post-Dispatch*, March 23, 1984, p. 1E.

2. "Ex-St. Louisan Held for 'William Tell' Killing of Wife," September 8, 1951.

"Slayer of Wife Admits They Had Sued For Divorce," September 9, 1951.

"Mexican Court Holds Burroughs in Wife's Killing," September 11, 1951.

"St. Louisan Seeks Freedom in Mexico in Wife's Killing," September 12, 1951.

"Injunction Blocks Burroughs Trial in Mexico City," September 13, 1951.

"Burroughs Freed on Bail in Mexico," September 21, 1951.

"Ex-St. Louisan Must Stand Trial for Killing Wife," November 18, 1951.

"Burroughs to Re-Enact Fatal Shooting of Wife," August 6, 1952.

"Burroughs Re-Enacts Slaying of His Wife," August 28, 1952.

3. Michael Goodman, *Contemporary Literary Censorship: The Case History of Burroughs' Naked Lunch* (New Jersey: Scarecrow Press of Meteuchen, 1981), pp. 1-317.

4. Andrew Weil, *From Chocolate To Morphine* (Boston: Houghton Mifflin Company, 1972), p. 23.

5. "Former Teacher at WU Slain in East by Youth," *St. Louis Globe-Democrat*, August 17, 1944.

"No Bail for Carr in Kammerer Slaying," *St. Louis Globe-Democrat*, August 18, 1944.

"Lucien Carr Indicted on Murder Charge in Killing of Kammerer," *St. Louis Globe-Democrat*, August 25, 1944.

"Pleads Guilty of Manslaughter in Kammerer Death," *St. Louis Globe-Democrat*, September 16, 1944.

"Lucien Carr Given Indeterminate Term," *St. Louis Globe-Democrat*, October 7, 1944.

6. In 1976, Bob Dylan asked Burroughs to join his Rolling Thunder Revue and appear in the film, *Renaldo and Clara*, at Allen Ginsberg's suggestion. ("What would he do?" asked Dylan. "He would be William Burroughs!" responded Ginsberg, and an invitation was sent.) Although Burroughs has contributed regularly to *Rolling Stone*, has since appeared on *Saturday Night Live*, and with Laurie Anderson in albums and films, he turned down the offer because he felt he could not hold the attention of Dylan's audience. In an interview with Victor Bockris, Burroughs recalls that he met Dylan for the first time in Greenwich Village in 1965, where Dylan told him that he "had a knack for writing lyrics and expected to make a lot of money."

Victor Bockris, *With William Burroughs* (New York: Seaver Books, 1981), p. 35.

7. Joe Williams, "Wild Lunch With Naked Bill," *Jet Lag* 40, December 1983, pp. 28-29.

Table Tapping Into The New Millenium Part Two

Allen Ginsberg

Previously unpublished interview

Q: How do you feel about your role as official spokesman for the Beat generation?

A: I think Burroughs is that. Burroughs takes precedence. He's far wittier. Quite competent to take of that. I spoke to him just a few minutes ago, actually. He's doing a lot of writing and painting a lot. He just had a big show in New York. He's from here, in St. Louie. But I feel quite comfortable talking for

myself, ceratianly, as one of the people who was involved with the Beat Generation, whatever that was, at tleast the literary aspect.

Q: It has been romanticized and de-romanticized a lot.

A: I think now, after thirty years or so, what's coming through is the literature and some of the basic principles. The notion of candor, openness, some kind of hot heart and enthusiasm comes through. I think that's why I'm finding a lot of high school kids coming out to readings now. I did readings in Boise, Idaho and Orange County and then in Seattle and about a third of the audience was high school age, who are now in a retro-mood, rediscovering Kerouac, Burroughs and Gregory Corso and my own work. Gary Snyder and others. What seems to be coming through is a concern for ecology, concern with eastern thought, meditation practice, maybe some re-evaluation of the useful educational role of psychedelics and marijuana, rejection maybe of the Reagan/Bush drugs, cocaine, the ones they were dealing to support the contras. Maybe a demystification of the government, or the neo-conservative government, particularly marked with the fall of Bush after that big hysteria about war. And the demystification of J. Edgar Hoover as a drag queen! Because he was the acme and icon of the right wing, sour puss sector of the population. Now all of a sudden it turns out that he was a complete hypocrite. So, from that point of view, people are smarter than they were in the 50s. Maybe something of the sort of eagerness and insights that we had earlier are coming through.

Q: Does this give you a sense of hope?

A: No, I don't think hope or fear or relevant. It's more a question of, as Burroughs says,

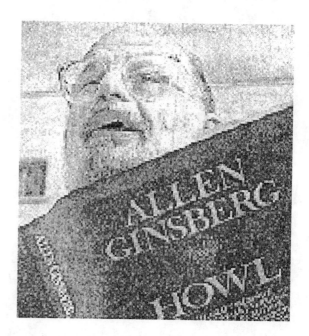

facts. The debt, for instance, was apparently a deliberate attempt to bankrupt the country so that we wouldn't be able to have any more welfare programs. David Stockman, the budget director, told that to Ben Bradlee. Remember that? David Stockman had a series of interviews with *Newsweek* and he wrote a book and he talked to Ben Bradlee off the record. One of the things he said was that Reagan deliberately tried to bankrupt the country by excessive military spending to starve out the welfare state. Do you remember that? That was part of the trauma that the conservatives dealt as well as the wrecking of the family farm, hyper-militarization with debt. Clinton is certainly a lot more is more cheerful. Less of a sour puss, less glum. Less of a depressant. But I don't see how he can overcome the substantive wounds that have been left behind.

Q: What would you say to a young person in America who wants to be a poet?

A: Write poetry! Learn how to meditate. Go to the movies. Read books. Read a lot of old poetry.

Q: Who are the people that you like to read?

A: Now? Among lesser known poets or better known poets?

Q: Just who do you enjoy particularly right now?

A: Gregory Corso remains a top one. I've been reading a lot of posthumous Kerouac poems. I just wrote a preface to *Pomes All Sizes* that came out from City Lights, a posthumous book of poems by Kerouac. Ann Waldman. Diane Di Prima. Gary Snyder and Michael McClure and Philip Whalen, whom I've always been associated with. Robert Creeley. Among lesser known poets, I'd say John Williams. Antler from Milwaukee, Andy Blosen from Oakland. David Cope from Grandville, Michigan. Eliot Katz from New Brunswick, also David Greenberg, who is only 21, from New Brunswick, who is a pretty good poet. Bunch of others.

Q: Where do you see poetry going?

A: It's not going anywhere. It's where it always is. It always has the same function of being candid representation of actual private life. Most public language has been manipulated if not predatory…

Q: Poetry is something you create from something spontaneous?

A: No, just the opposite. The mind moves as you become familiar with what is spontaneously arising in your mind. You never know what you're going to think in a minute. You never know your next thought. You can't plan thinking. In that sense, it's spontaneous totally, so what's deliberate or created is your awareness of the flow of spontaneous thought. You can boil it down to one slogan: Catch yourself thinking.

Q: What is poetry versus prose?

A: Is there a "versus" involved there? I don't think there is. They are inter-changeable. Like the best of Mehlville, Joyce, Proust, Kerouac, Burroughs, Lawrence, Rabelais, are prose/poetry. Thomas Wolfe. The best of it. Some of the best of Rimbaud, Baudelaire, Whitman and others, write prose. So at a certain point the distinction between prose and poetry need not be made, especially if you ask the simplest question, is the Bible prose of poetry? Job? Is that prose or is that poetry? It's written in paragraphs. It isn't poetry as poetry is thought of when you're being academic about it. One distinction I would make is that to write a novel, a prose novel, takes a lot more patience for the application and maintenance of a long-range visualization than poetry. Burroughs, for instance, lives with his characters for years at a time.

Q: What about the relationship between art and enlightenment?

A: I don't think there is any such thing as enlightenment. That's a traditional Buddhist view, there is no enlightenment.

Q: Well, you're already enlightened.

A: That's what they say, everyone is always enlightened. It's just a question of recognizing. Or recognizing what aspect of your nature is already enlightened and trusting that. It turns out to be the most obvious. In Zen people talk about ordinary mind as the enlightened stage.

Q: And what about madness?

A: Well, I would say that enlightenment is total sanity. But some forms of wisdom are called "crazy wisdom." According to the Shambala teaching of Chogyam Trungpa, who was my teacher, the characteristics of the Shambalian enlightened warrior, such as it is, is meekness, sparkiness or perkiness or mindliness, outrageousness and inscrutability. All that comes from the simple fact that his head is completely empty so he doesn't know anything anymore than anyone else does. Or at least he realizes he doesn't know anything, so it gives him the meekness. And because things rise spontaneously, it gives him the sparkiness. And because he never knows what's going arise, it might be outrageous. And at the same time, because he never knows in advance what's happening except by recognizing it, he becomes inscrutable. So that the Chinese laundryman with the toothpick in his mouth is inscrutable because his head is empty, that's all, not because he knows something different from the wesetrner, but because the westerner has constantly got his head full of ideology.

Q: You were talking before about psychedelics being used with meditation...

A: Meditation might be the ground. People who are going to use grass or psychedelics, they should first ground themselves in meditation or center themselves so that they don't get entangled in their own projections. I like a little marijuana once in a while, like for looking at artworks maybe even for having ideas for revising things. It kind of breaks up your fixated mind. I haven't had any psychedelics for a long time. I've had ecstasy and found that it was useful in resolving some hatreds I have. It creates a lot of empathy, realizing that people I thought were enemies were actually major characters in the drama of my existence and kind of dear because of that. Ecstasy is misnamed because it's really empathy. Some hippy dippy exaggerated bad poet called it Ecstasy.

Q: You're a teacher in a broad sense...

A: No, I'm a professor of English at Brooklyn College. I've had more experience in the last twenty years at Naropa Institute.

Q: Do you see young people as having changed particularly or not?

A: Young people are always young people. They're sexy and they're eager and they're open and they're interested, unless they have been thwarted.

Q: What do you think is most important to try to teach them?

A: I encourage them to write and maybe figure out what would liberate them to express themselves. Try to figure out what area of secrecy in inhibiting their candor, or preventing them from being candid.

During the tape flip, some discussion ensued about Kenn Thomas' then recent suspension from St. Louis'

KDHX radio for broadcasting a lecture by Abbie Hoffman that included the word "fuck". Ginsberg discussed recent legal maneuvering to help protect broadcasting his poem, "Howl." The tape resumed as he listed gropups and people invovled...

Burroughs, myself, Michael McClure, Eileen Miles, the PEN club, Emergency Civil Liberties Committee and the Benowitz and Boudeen law firm, and we won and got a stay of execution of that law so that there is safe harbor now from 8PM to 6AM. So you naturally would get in trouble between 6AM and 8PM. You have to respect that, because you could our station a license. Because it's a death sentence. It's not like a book being seized from a publisher nowadays, where just the one book is seized. But here you get the whole station closed down. So it's better to fight it legally than to try and make the station back you up and lose its license. So if you were improvident in doing that, no wonder you had trouble.

Q: The program was from 7 to 8, though.

A: You have to know the law. 7 to 8 is not safe harbor yet. Unless you are prepared in advance with a back-up with a whole bunch of lawyers, I have no sympathy for your improvident tactics! Never pick a fight you can't win. Or try not to pick fights you can't win. Not never, but best to pick your own territory and fight on the territory where you can win. Why give them a victory and cost the station a lot of money?

Q: Well, it happened a couple of times and I have become a little more careful about picking cuts that don't have the language, but that puts me in a position of censoring.

A: You're not in a position of censoring. The station is censoring because the station can lose it's license. It's Jesse Helms censoring it and it's the Congress. So you cam acknowledge it as censorship, tell your audience it's being censored, but know which hours are uncensored. I wouldn't get on a station and try and read "Howl" before 7PM if that'd get them in trouble just for my egocentric blathering. Why not wait until 8 O'clock? Besides which, I think ultimately the laws will fall. So rather than getting angry, what I did was literally organized a consortium of lawyers as soon as I heard that Helms' law had come in. And we won, so far in every state.

Q: I wonder if the station owners and program directors are that aware of the law.

A: You might tell them. If they need to be told, get a letter from the ACLU or the Emergency Civil Liberties Committee. You can get copies of the judicial decisions from the FCC at this point. But right now the law banning everything up to midnight has been given a stay by appeals judges in Washington, DC, quite a liberal group that will probably throw the law down. The arguments will be held in the fall. Safe harbor is 8PM to 6AM right now.

Q: So I just have to get my program moved to an hour later?

A: Yes. It's very simple.

Q: I am sure that if I did that I would still get kicked off the air just as well. The station is not looking at the actual law but to its own rules and perception.

A: But their argument is that they have to worry about the FCC regulations. If you can point out exactly what it is, you may have a personality conflict, but you don't have a real technical problem. You're in a much better ground if you confront them with the law than if you're just blowing hot air at them.

Q: You spoke a few minutes ago about revising. I wonder if you could talk about what happens when you sit down to do it?

A: I generally depend on the first draft. If my attention is focused on the visual material passing through my mind, or whatever thought forms rise, then there might not be much need for revision, like in "Sunflower Sutra." If I get distracted and vaporize off into abstraction and generalization or filler material then I have to move past all that. If I am inattentive and I don't really catch the right picture or draw the word from the vivid picture, then I might have to fill in the picture later. I try not to revise too much, except blue pencilling and getting rid of extraneous syntax.

Q: So if you were composing, you would just continue on.

A: I wouldn't stop! No, no, no. Not in the middle of writing. Big mistake.

Q: Even if you were aware that you were getting distracted?

A: No. Kerouac has an interesting phrase: "Don't stop to think of words but to see the picture better." That really solves that problem.

Q: How are your poetics compatible with the poetics of people you mentioned, like Rimbaud and Blake, for instance, who are not exactly observationally oriented?

A: Maybe it's totally incompatible. But on the other hand, I never felt that consistency was a virtue. We were talking about this in class just yesterday, that Blake has a high degree of symbolic la-dee-dah and abstraction. Then we started looking at the poem "London" and it was vivid, very vivid, visually, "I wandered through the chartered streets..." Already a very clear awareness that the streets are rented out and owned by other people and he's wandering lonely through other people's property.

Q: The charters were companies and corporations of their day.

A: Yeah. The "mind-forged manacles" is a little abstract, but it's still chains. Chains forged by the mind. Not exactly William Carlos Williams naturalistic vividness, but it's close enough.

Q: What are you most proud of?

A: Me? What I've done or of what happened on earth? I don't know. I've written some real good poems in the last couple of years. Some funny, trickster poems and a long poem called Charnel Ground. And I'm just putting together now a four CD set of material that has not been heard, some of it has, but maybe about a half hour of music I did with Bob Dylan in the 70s and 80s. The first complete reading of "Howl" has been retrieved by a rare tape, and the very first reading of "Sunflower Sutra" in America, in Berkeley in 1956, will be on it. A really outrageous gay poem called "Please, Master", I did a beautiful reading of that, and it's a difficult poem to read. Some rock'n'roll songs about meditation

done with Dylan. And Blake stuff that has been out of print for all these years, a lot of that will be included.

Q: *Songs of Innocence and Experience?*

A: Yeah, including volume two, which I never had a chance to put out. So I have five or six songs from that, including a version of Blake's "Spring" with Dylan, playing and singing back-up. A nice version. We're working with Hal Wilner, a producer who made the last Burroughs record and the Charlie Mingus new album, Thelonius Monk and Marian Faithful and my last album, called *The Lion For Real*. So he's like a really extraordinarily literate producer with a wide range of ideas. He's produced music for Saturday night Live. He specializes in bringing together all sorts of disparate. Strange, interesting musicians, working together.

So I'm really happy with all that.

Questioners included Kenn Thomas, Michael Castro, Andrea Murray and Susan Waugh.

Table Tapping Into The New Millenium Part Three

Timothy Leary

Previously unpublished interview

Q: Let's just give the people a little bit of background, because some may not be old enough to remember when you were beginning your LSD experiments at Harvard.

A: Before that, I discovered America, you know. I led the revolution against King George. I wrote *Huckleberry Finn*. And then I went to Harvard and we got involved in LSD. Yeah, that's true.

Q: Were you kicked out of Harvard because of the experiments?

A: No. I've been kicked out of a lot of places for one thing. All I stand for is, I tell people, "Think for yourself and question authority." That's the most subversive, most dangerous thing you can say. Think for yourself. Don't believe what religious authority says or political authority. Think for yourself. And that's why I got kicked out of a lot of places, and was glad to be kicked out.

Q: In *Flashbacks*, you describe your prison experience and being held by Eldridge Cleaver in Algeria.

A: I was in 39 jails and prisons over a period of eight years for possession of less than a half-ounce of marijuana. I was imprisoned because I was a saying what I am saying to you now. Think for yourself. Don't believe politicians, priests, rabbis, think for yourself. That's a very dangerous thing to say. Socrates said it first. Now, specfically, which prison do you want to talk about.

Q: The one that you were broken out of by Weather underground.

A: That was Vacaville.

Q: Was that the same prison that G. Gordon Liddy was serving time in?

A: Hahahaha! This is a prison travelogue! I was in several prisons that Gordon Liddy was in. They were federal prisons. The federal prison in San Diego, the federal prison in

Missouri. But San Quentin and Vacaville are California prisons. Now, I want to tell you that if any of you out there are listening to me, I'm sure a lot of you are going to be in prison soon. You know why? Because the number one industry in America is building prisons. Now America has three times more prisoners than any, any country in the world. South Africa, China are nothing. So many of those listening to me are probably going to end up in prison some time. You got to a Swiss prison. In Switzerland, you get good treatment. The Swiss know how to run a hotel. Stay out of southern prisons. My brothers and sisters in prison, believe me, I'm with you! It's a scandal, it's a disgrace, to live in a country that is the number prisoning countries in the world. Theer are kids spending twenty years in prison for a little marijuana or one or two does of LSD. Grateful Dead heads are being sent up for ten or fifteen years. Yeah, it's a totalitarian system and I'm with the prisoners all of the way. I've spent five years in prison, I escaped from prison and you don't know anything about America until you've been in one of those prisons and see how the prison industry works. You have to have someone to bust to keep the system going.

Q: Is it true that on at least one occasion you called G. Gordon Liddy responsible for your incarceration?

A: No one's responsible for my incarceration! I belong in prison in Russia or in China or Reagan/Bush/Nixon America-I belong in prison! No one person put me in prison. I'm a philosopher. I'm out to destroy the old, right-wing-Republican-Pentagon-CIA system. It's totalitarian! They make you pee in a bottle. They've got their noses in women's reproductive tracts, telling women what to do. Prayer in school. Meanwhile, the whole system is collapsing. No education, no health care. Kids are being neglected, and look at what they're concerned about. America today is worse than the Soviet Union was under Stalin. Know why? At least there you knew that Stalin was evil, evil, evil guy who throwing people into prison and killing them. Here, they're getting away with, they're getting away with, they're getting away with it...

Q: Did you hear this sound bite from Leaonard Peltier [replays sound bite from earlier in the program]; "This is Leonard Peltier, number one political prisoner in the United States, locked up in a federal penitentiary in Leavenworth, Kansas..."

A: Is Leonard listening right now?

Q: No, he's not.

A: I know who he is and I've followed his career for a long time. I have a lot of friends in the AIM movement and best wishes to you Leonard! We'll get you out! But anyway, I'm with you.

Q: Hunter S. Thompson suggested that G. Gordon Liddy may have been "Deep Throat" in Watergate. Do you believe that?

A: Who gives a F you know what? Who cares about that? That's all past. I'm concerned about Dan Quayle getting in front of America and saying "There's good and bad, We're good and they're bad. There's right and wrong." Can you believe that fascist Ayatollah Khomeini fundamentalist Islamic? Holy people and bad people. And I'm a bad person. You know why? I'm a mildly enthusiastic person wanting to get Clinton elected. I don't like Clinton, but he's better than Bush. And here's Quayle telling me I'm an evil person.

Q: Now you said you discovered America and wrote *Huckelberry Finn*. Were you referring to reincarnation?

A: I just got back from a party and I'm stoned and having fun. Of course I was there with George the Third. I knocked those redcoats back to the sea and we threw the king's tea in to the Boston harbor. You remember that.

Q: Of course, were you ever a woman in past lives?

A: When I was lucky! By the way, if we're going to talk about that, I think that the key issue in politics today and the key issue in government today is the fact that for the last 25,000 years, women and children have been systematically, relentlessly put down by men. Thank God we're going to see a change in that. The main thing in politics now is gender and age and race. It's thrilling to see. Many men, good guys, don't realize the power of this women's movement. Any of you guys out there, just talk to an intelligent woman and look them in the eyes and say, "hey, what's going on?"

The hippy movement was great but it was very macho. All these hippy guys with a swagger, they'd have a little woman at home. I spent the evening tonight with a woman named Anita Hoffman. She was Abbie Hoffman's wife. She was a real heroine. She was out there with Abbie, one of the leaders of the yippies. She's now working at a laser disk, computer graphics, hot shot company in Santa Monica. She's into the new move of the cybernetics. And she told me just tonight that she was so naïve back in the sixties that she was happy to be Abbie Hoffman's wife. He was a hero and she was just there to serve him. This is the female leader of the yippies saying that. But she's changed her mind now.

Q: Does she believe that the CIA killed Abbie Hoffman?

A: No. Abbie Hoffman had a terrible disease called manic depressive psychosis. It's a disease. We had all been worried about Abbie for months and months, for two or three years. No, the CIA did not kill Abbie Hoffman. He was very sad. He was physically diseased. He nobly bore up under it.

Q: The last time you had a conversation with Kenn Thomas you were having an underwear modeling party at your house.

A: That was a funny interview! Well, it was not just underwear, it was robes and, yes. So we got on the radio Jerry Rubin, Paul Krassner, (see *Steamshovel Press #7*, "Tim Leary's Party")...

Q: In an interview with Kenn Thomas, Abbie Hoffman's brother stated that Abbie was coming out of his depression and never sounded more happy about being alive than in the few days before he died. [*Steamshovel* Debris: the interviewer has this wrong. Jack Hoffman concurred with Leary's opinion that Abbie Hoffman committed suicide. See *Steamshovel Press #4*, "Tales of Hoffman"]

A: I want to tell you that Jack Hoffman, who is Abbie's brother--every one that knows Abbie, the family, are trying to make a lot of money writing a book saying these crazy things. Nobody that loved Abbie believes that. I was with Abbie Hoffman five days before he died, in Nashville, Tennessee. We were there with Bobby Seale, founder of the Black Panther party. And I was so upset at the way Abbie was falling apart that I phoned all of his friends, it's a matter of record, saying, "listen, call Abbie right away, because he's seriously in depression and getting deeper and deeper." The CIA is capable of any evil, they are totally evil. But on the other hand, we must be careful and precise and don't accuse them of things they didn't do. They've done many more things. The CIA did not kill Abbie Hoffman and it's disastrous to even imply that.

Q: Getting back to prisons, do you think that people in prison deserve top be there?

A: You are talking about hundreds of thousands of people. I don't know what "deserves" means. I think that mentally ill, violent people should be kept away from society. But they're releasing the killers on the street. That's because the police want the killers out there. The dopers aren't going to be any trouble at all.

My lecture now is a celebration, a reunion, a reaffirmation of the humanist feelings of the 60s and 70s. It's the basic belief that human beings are good. It's an update of current events and a plan for a great future.

Q: What has the 60s given the 90s?

A: It wasn't the 60s. Ralph Waldo Emerson, Henry David Thoreau were against the Mexican War and were leading their counterculture. The counter culture is the basic American principle. Yankee Doodle Dandy. Throw the king's tea bags into the harbor! Americans are people that don't like police establishment authority and religious leadership. And that's the basic American tradition that has been subverted by the Republican Party, by Pat Robertson and the religious right. But Americans are thrilled at independence to speak up and say what they want and make fun of the government. The last thing they want to do is have a police state government interfering with people's lives, like women's reproductive rights, or interfering with our right to get high on vegetables in our homes on Saturday night. The American tradition is anti-establishment. American tradition overthrew all of the royalties. And now we got King Bush and Prince Quayle and the Party of God.

Q: I interviewed Ice T not too long ago and he said "when they say country under one God" they mean is a country under Christian religion and anyone who deviates from that can go to prison.

A: But I must say about Christianity: these are the right-wing fundamentalist, evil Christians that make Christ into some kind of a bloody

God who wants to kill people who don't agree with him or her. There's a lot of good stuff in Christian notions of brotherhood and sisterhood and love, but the people that call themselves Christians are killers. They're just going to kill anyone who doesn't vote for Pat Robertson.

Q: How do you feel about the political scene?

A: None of us want politicians in Washington. We're against it. But the way to do that is to vote for the ones that are going to get power out. Bush is like Breshnev. So vote for Clinton and Hilary and Tipper and, what's Gore's first name?

Q: Al.

A: Yeah. They're like Gorbachev. They want to get control, but at least it's going to be a better control. They're going to give more power to the blacks and minorities and to the young people and to the gays and especially to the women. So you gotta vote for Hilary and Clipper. But then we want to get the next people. Yeltsin will come along. None of us like the central government in Washington, but we've got to vote for Clinton and Gore because they're going to loosen it up.

Q: As far as the point you made about Stalin, that the Soviet people at least knew that Stalin was horrible and America is worse because people don't know. I must disagree a little bit.

A: Ok, good!

Q: This is a totalitarian state. This is a corporate democracy. This is a republic. It is not free. I agree with you a hundred percent. Yet, I think under Stalin in the Soviet Union it was a lot worse. Stalin killed thirty million of his own people. That's a travesty worse than Hitler.

A: Understand that when I use the word Stalin, I'm trying to make the point that the totalitarianism in America is even more evil because you don't notice it. Did Stalin ever make people piss in bottles? Urine tests? Did he poke is nose into reproductive rights? Also, Stalin was dealing with an agricultural, rather primitive society that he took over. Whereas, the Republicans are now dealing with a very open-minded, sophisticated country. America is still getting away with a lot of the stuff that I would call totalitarian. Also, I say things to get people thinking, when is say that Bush is worse than Stalin.

I'm experimenting with new techniques now, using computer graphic images which you put on the screen that can produce a mild trance state. Right brain activation. I try to give a little feeling of this new way of getting your right brain booted up, activating many circuits in your brain that are activated by psychedelic plants like marijuana, but with electrons. It's a very thrilling thing to be doing this in public and so far it's legal. It does teach us a lot about how the mind and the brain work. And the aim, of course, is to learn how to operate your mind, how to turn it on and turn it off, operate your brain, turn it on, turn it off, boot up new

the mind and the brain work. And the aim, of course, is to learn how to operate your mind, how to turn it on and turn it off, operate your brain, turn it on, turn it off, boot up new circuits. It's not as intense, but you can do the same thing with electrons. Don't tell anyone I told you this, this is a secret. You could get in trouble if anyone else knows it, but when you run these computer programs, it will allow you to put yourself in a trance state so that when you use some of those drugs you will do it with more proficiency and skill and precision. But tell anyone I told you that. I've got some incredibly brilliant young people in the rave movement, hyper-delic people, Psychic TV in England are preparing a tape for me. It will have twelve experimental trance situations. And when you walk in the room, on the seat there will be a list of the things we're trying to impress on your brain, things like "Think For Yourself" and how to use your brain. But if you don't want to be programmed, you don't have to do it. That's the courtesy of the electronic brain programming. We tell you what we are doing ahead of time and we're doing it to show you how you can program your own brain and not be programmed by NBC and all the political people, all those "Willie Horton's going to come get you", vote for George Bush, he'll protect you against Willie Horton.

Q: It's funny that George Bush would tell us about family values, the number one spy in the whole country. He's probably responsible of the murder of more families than anyone else in America.

A: I agree with you.

Q: I'd like to ask you about your beliefs in having your organs frozen and your brain for reconditioning in the future.

A: It makes common sense. At the present time, there are thousands of hearts that are being kept in banks so that if someone who has a good brain has a bad heart, they can take the heart out of the heart bank and put it in to the human being. I'm going to do that with my brain. In the future, when science knows how do it, and there are very complicated problems of memory and storage of memories and digital reconstruction of personality. It's not easy. But I'm going to put my brain in a brain bank. Hopefully, in the future, when science and my friends in this field make it possible, m y brain will be put back in the body of some nice young, athletic person who brain died and my brain will be out in their body, just like a heart or a kidney or a lung transplant. I don't care whether I come back or not. My job as a philosopher is to demonstrate to people to not die passively. Plan your reanimation. Plan your deanimation. Don't just feed your body to the worms or to the barbecue oven. All of the religions want you to die when God wants you to die. The medical profession wants you to die when your Blue Cross runs out. Society doesn't want you to take the decision and decide when and how you are going to de-animate. Make some plans to reanimate. One method I'm using is I'm going to have my brain put in a storage bank hopefully to be brought back.

Finally, I'll say one thing: in my will, I have instructions as to what kind of person I want to be brought back in. If my brain's going to be in the body of some-or they might even be able to clone me, and get my own body back-I have some choice over what kind of a body I want to come back in. More important is when. I do not want to be brought back in this life during a Republican administration!

Good night!

steamshovelpress.com

NEAL CASSADY AS AN URBAN LEGEND

by Tom Christopher

From his birth on the road in Salt Lake City while his parents traveled in a truck with a cabin built on the back to his legendary last words in Mexico, few people of this century have been mythologized like Neal Cassady.

His unfinished autobiography, *The First Third* reads like a cross between Huck Finn and a sensational 1930?s novel about life among the urban underclass. His cross country trips with Jack Kerouac, and later with Ken Kesey and the Merry Pranksters have been thoroughly documented, and countless newspaper and magazine articles have been written from this source material. The legend continues. Two movies have been made about his life. Old school friends say to this day they've never met anyone like him. Ken Kesey was recently quoted as saying "There's something about Cassady that keeps this nation moving and meeting itself (1)."

Cassady did some of his own mythologizing. At a loss for family history while writing the *Prologue to The First Third* he simply made one up, a fact he states clearly in the audio tape transcript that became part of Jack Kerouac's *Visions of Cody* (2). Only the events from the time of his birth in the Prologue can be verified, but the older stories, like the one of his great grandfather killing his own brother over a woman, and his mother's first husband having been the mayor Des Moines (3), have made their into into Neal?s biography as well as the biographies of his friends. It should be understood that the rest of the book can be shown as true, with school and welfare records verifying surprisingly small details, and a walk through the Denver neighborhoods Neal describes from his youth will give a first hand demonstration of how keen his memory was, writing 20 years later and thousands of miles away.

Kerouac, Allen Ginsberg, William S Burroughs, Ken Kesey, Carolyn Cassady, Jerry Garcia and countless others have testified to the reality of the attributes that define his character; his intelligence and physical stamina, his sexual prowess, his use of language and his memory tricks, his inspired driving and sledge hammer juggling, but there's another, smaller arena, where Cassady has become legendary without anyone knowing his connection to the Beat Generation or the Summer of Love, a place where Cassady's name itself is forgotten, but his deeds live on. At the Los Gatos Tire shop, 35 years after Neal last worked there, and 15 years since the owner retired, Neal is a working class hero, a real life John Henry, the man who could outwork a machine.

In 1958 Neal Cassady was sentenced to five years to life in San Quentin Prison for giving two joints to a cop. It's a complicated story that's told best by Carolyn Cassady in her book *Off The Road*. He was released 3 June 1960, and found that his drug offense made it hard to find work.

He had worked as a tire recapper 20 years earlier in Denver, and he approached the owner of Los Gatos Tire Company and put his cards on the table in his usual straightforward and meticulous manner: he would be the perfect employee for two years, nine months, and twenty-four days, the length of his parole. The owner, who according to his children had led a pretty interesting life himself, was impressed with Neal and hired him on the spot.

The kind of work Neal signed on for as new man was hard and physically exhausting and Neal was 34 years old. Carolyn writes: "As usual, Neal astounded everyone with his speed and efficiency. Employers, employees and customers stood by and watched him with unabashed awe(4)."

Los Gatos Tire Company looks like a million similar industrial buildings. Built in the fifties as a tire center, with a couple of auto bays and an office off to the side. The building does it's job. It's well designed and still seems modern. The company has been there 50 years. Off to the side of the building, there are a couple of shallow ridges, each dropping three or four feet and then the property dips sharply out back, with railroad tracks at the bottom. Cassady used to have a Willies Wagon, which was the sports utility vehicle of it's day, and when arriving at work he would step out of the car at the first ridge, and turn off the engine, allowing the car to drift down to the second ridge where it would come to rest at the edge of the rise, just before the serious drop to the railroad tracks. He never missed.

While working he was still doing the car parking tricks that so impressed Kerouac and his highschool buddies before that. He would put a car in reverse on the slick cement floor, and hit the gas, making the tires bounce and the rear end squirrel around, and decelerating slowly till the tires could grip he would shoot the vehicle over to the racks, it's trajectory ending in a short squeal of skid as he hit the brakes.

Neal's dexterity with a sledge hammer a few years later is well known, but during this time he did some of the same tricks with a tire pry bar, which is like a shortie wrecking bar, used to pry the dense rubber of a tire away from the wheel. His favorite trick was to throw the bar down on its tip against the cement floor while walking. He would continue to walk as the bar bounced off the

Neal Cassady

floor and over his shoulder and into his open hand.

Neal was an average sized guy. Five foot ten and a hundred and fifty pounds, but he could lift a truck tire that out weighed him by a hundred pounds with one hand, bounce it off the floor and using his hip for leverage propel it onto a rack six feet off the floor in one easy motion. Only the owner of the shop, a much bigger man was ever able do likewise, and may have shown Neal the trick.

Despite his stamina and concentration, Neal did get tired, and parole or not, he was always burning the candle at both ends. Once, he was missing in the middle of a busy day, and when the other workers looked around, they found him asleep, standing up in the store room, a tire under each arm wedged into a stack on either side of him holding him up.

He had fallen asleep in mid stride.

Neal worked at the tire company until his parole was over in the summer of 1963 and he was free to pursue other interests. The business was sold 15 years ago and the owner retired, but these stories have been passed

down from worker to worker over the years. No one there knows that the guy who did this stuff was Neal Cassady, the secret hero of "Howl", the Adonis of Denver, the fastest man alive, but they know that way long ago the craziest guy used to work there.

NOTES:

1. Associated Press (AP) 28 July 99

2. Jack Kerouac. *Visions of Cody.* page 207, 218 Penguin edition. Thank you to Kim Spurlock for this reference.

3. The real story is that the uncle of his mother's first husband was City Boss of Des Moines in the turn of the century days of good ol bare knuckle backroom politics.

Carolyn Cassady says Neal believed this story to be true. It may have been a story he got from his father, whose alcoholism may have led to some inadvertant mythmaking. looking over old records, Mr Cassady seems never to have used the same birthday twice, and over the course of his life changed the spelling of his surname and dropped his middle name.

His wife was born Maud Webb Scheuer, but came to be called Jean, and the same confusion exists as to her birthdate

4. Carolyn Cassady. *Off the Road.* P. 350.

Neal Cassady's autobiography, *The First Third* has been in print continuously since 1971. His correspondence with Allen Ginsberg was collected in *As Ever*, and his prison letters released as *Grace Beats Karma*. An audio tape transcript of a long conversation with Jack Kerouac makes up a large part of Kerouac's *Visions of Cody*. Audio and video tapes of his prankster days are available. An internet web search under his name is always interesting

Kerouac's CITYCitycity

by Adam Gorightly

Having been a long time Kerouac devotee--and part-time Science Fiction enthusiast--I thought never the twain would meet, due to Kerouac's statement in his classic treatise, *Essentials of Spontaneous Prose* : "Modern bizarre structures (science fiction etc.) arise from language being dead, 'different' themes give illusion of 'new' life..."

It was Jack's contention that such artificial forms, i.e. Sci Fi, failed to capture the pure essence of speech; conversely, real themes taken from everyday life were more suitable vehicles for expressing the true voice of the Muse, much as jazz is the ideal framework for a saxophonist to "blow". This was how Kerouac saw the craft of writing, as a free-form improvisation--a la jazzman with sax--letting the subconscious mind blow mighty riffs of words on paper with stream of conscious abandon.

Saith Saint Jack again in *Essentials of Spontaneous Prose* : "If possible write 'without consciousness in semi-trance' (as Yeats' later "trance-writing"), allowing subconscious to admit in own uninhibited interesting necessary and so "modern" language what conscious art would censor, and write excitedly, swiftly, with writing-or-typing-cramps, in accordance with laws of orgasm, Reich's 'beclouding of consciousness'..."

Kerouac's criticism of science fiction was, in essence, a critique of all literature that relies on artificial constructs and formula. Kerouac himself was liken unto jazzman blowing his horn to high heaven, letting the spontaneous muse flow, free from the

strictures of "literary convention." To Jack, writing was a form of sexual release, as jazz was a similar form of communication, or like Neal Cassady behind the wheel of a car, letting the cosmic flow of life direct his crazy caterwauling course, making mad history in the process.

Once, while perusing various Kerouac biographies, I happened across a reference to a science fiction story Jack wrote called *CITYCitycity*, which came as a bit of a surprise, outlining--as it did—Kerouac's version of a totalitarian cyber-society set against the backdrop of a futuristic earth plagued by overpopulation and ruled by she-demon feminists. I thought: Jeez, Kerouac blowing a science fiction riff...Like, crazy!

According to Beat legend, around '55 Kerouac resumed work on *CITYCitycity*, a Sci-

Cityscape painted by Jack Kerouac

Fi story he began sometime during the heyday of the McCarthy hearings. Originally, Jack sent a draft to his friend William S. Burroughs in the eventuality that the two could develop the story together into a satiric novel, though nothing ever came of this prospective collaboration.

CITYCitycity was later sold for a whopping fifty dollars to the New American Reader and subsequently published in *The Moderns: An Anthology of New Writing in America*, edited by Leroi Jones. However, my search for the story proved no easy task, though I eventually tracked down this anthology, which was located in only four libraries across the globe: two in Great Britain, and two in the U.S. Finally, I was able to borrow a copy from Kansas State University, and at last lay my eyes upon this unheralded masterpiece depicting a Brave New World overrun with Thought Police and wondrous drugs that numb the mind to--that dirty word—"Activism". Writes Jack in *CITYCitycity*:

"Activated...a word written in black letters dripping with red ink...ACTIVATED, you'd see written on superseptic toilet walls of the cityCityCITY, with lewd drawings. It was a word whispered in dark sex rooms, turned into a colloquial dirty-word. 'Activate me'."

In his ultra-Orwellian tale, Kerouac paints a stark picture of the envisioned "antiseptic city", where such things as "pockets" have been outlawed, thus limiting the dumbed-down citizenry from concealing anything upon their bodies not authorized by the ruling faction. Mandatory drug ingestion and Multivision viewing are required for all inhabitants of cityCityCITY, as every "Deactivated person" is equipped with "...Brow Multivision set, just a little rubber disc adhering to the brow." Multivision is Kerouac's version of Orwell's "one eyed monster" staring into every living room and desiccated soul; much more far-reaching than mere TV, Multivision is the ultimate Cyberpunk nightmare, monitoring the lives of quiet desperation as they unfold on a planet

where legalized murder is the only way to keep the population in check. As Jack explains the cityCityCITY method of population control:

"It was necessary at intervals to electrocute entire Zone Blocks and make room for a new group culled from slags and miscalculations in the system. Deactivation which prevented people from leaving their own Zone Blocks, was a necessary caution against the chaos which would have resulted from an overpopulated Movement over the crowded steelplate of the world. Migrating to other planets was out of the question; especially after centuries of Self Enforced Deactivation. Other planets in the immediate vicinity of earth had been denuded of life and turned into Deactivator Bases and Laboratories, Deactivating all that part of the universe around the earth. Outside raged the life of the Universe, where Activation reigned. Many were the spaceships from unknown planets who'd come crashing against the No-Zone of earth and disintegrated in midair; many the meteors met the same fate. Nobody questioned the wisdom of Master Center Love in refusing to have any contact with the rest of the universe..."

Viewed in conjunction with "L"--the Love Drug--the breastbones of the mirthless inhabitants of cityCityCITY are riveted with transmitters broadcasting their brainwaves to indicate if they are remaining in accordance with the messages--aired on Multivision--via Master Center Love(MCL), the central hub of this mass mind controlled civilization, Earth circa 2900 A.D. This breastplate disc also serves as a drug dispenser, keeping its users "pumped with 'L'".

Like novelist Henry Miller, Kerouac saw post-World War II America as an "air conditioned nightmare"; the freedom to be whatever one choose was rapidly diminishing during the reign of Eisenhower. Soon, he felt, we would all eventually become robotoids, totally controlled by government bureaucracies, and perhaps even told when to die, as envisioned in *CITYCitycity*.

The story centers around a day in the life of a lad named M-80, who one morning makes the most amazing discovery on the streets of cityCityCITY...that of a pool of water.

"...(M-80's) heart thumped. He had never seen a pool of water in his life, except in Multivision in their history shows, showing how, in the days before rain was diverted from cityCityCITY, moisture used to fall from the skies and form in the streets and blocks of old cities. 'There's been a leak!' thought the kid frantically. 'What'll they say? Wow!'"

And with the discovery of this pool of the unexpected, a crack in the armor of uniformity and conformity has surfaced--no doubt caused by "Activists"!--sending a ripple of wonderment and dread throughout cityCityCITY, that could only be squelched by way of state sanctioned euthanasia. For eons rain had been diverted by a giant umbrella of energy draped over cityCityCITY, of which:

"...every inch was covered with electronical steelplate. The ocean had long ago been covered with earth acquired from surrounding planets. CITYCITYCITY was the world; every square inch of the world was covered with three types of Levels of CITYCITYCITY. You saw the skyline, of skyscrapers far away; then beyond that, like a ballooned imitation of the same skyline, rising way beyond and over it, vastly larger, the second level of CITYCITYCITY, the CITY level; beyond that CITY, like a dim cloud rose huge on the horizon a vast phantasmal skyline so far away you could barely see it, yet it rose far above the other two and far beyond. Those three levels were to facilitate the ingress of sunlight into the various people-flats. The CITYCITYCITY Tri-Levels were: one tenement ten miles high; the second, fifty miles; the third, a hundred miles high so that

from Mars for instance, you saw the earth with its complete CITY everywhere looking like a prickly ball in the Void..."

Coupled with Kerouac's Orwellian vision, there is also a paranormal element to the story, no doubt inspired to some degree by his close association with Burroughs, whose slant on telepathic transmission via disembodied entities is clearly evident throughout *cityCityCITY*:

"...Ideas of Activation had been brought onto the earth-globe via the only form of Activated life in the universe that was capable of penetrating the Great Electronics wall: beings on a level of certain rarity that enabled them to swim, veil-like, pale as ghosts, through the Wall and through the people of earth, yet communicating thoughts and ideas. For a long time they were said to be Tathagatas from a Buddha-land...

These Beings, these Activation Agents, were the terrors of the world; the troops of Devils of Gothic times were replaced by these pale phantasmal insinuators from Outside, called Actors. This name was referred philologically back to ancient times when disorderly elements were known as 'actors'...

...Illicit Actor Fumes were sold in forbidden little jars; Actor Fumes came from the emanation which an Actor left when it passed thru a jar, apparently by intention; the sniff of it had the peculiar effect of inducing a certain blissful feeling that was accompanied by a vitamin lapse, or false recharge, that made it impossible to inject L. (Love, the official CITY CITYCITY drug, used by everyone from birth, by law); with the effect of actor fumes, a man of this world was left wide open for telepathic messages from Actors infesting the air; nothing Multivision could send out could combat this, once the victim had a sniff of Actor Fumes, or Ghost, as it was called; it was so powerful and so sweet to the senses the weaker elements of the population were all addicted; it was easy to get, the Actors saw to that, by merely passing themselves through every jar in the world; jars became illegal...

If--back in the mid-50's--you'd given Ray Bradbury a few good hits of some Lebanese blond, this is just the type of mind-bending tale that would have emerged. *cityCityCITY* is a true a cyber punk precursor, written several decades before Science Fiction became "hip".

Look for it at an interlibrary loan near you!

Selected Bibliography

Charters, Ann, *Kerouac: A Biography*, Warner Paperback Library, New York, 1974

Charters, Ann, ed., *Jack Kerouac Selected Letters, 1940-1956*, Penguin Books, New York, 1995

COMIC BOOK CONSPIRACY

A Poisonous Mushroom Growth: The Simple Art of Diversion

by Robert Guffey

In 1948 an invisible artform was consumed by fire all across this country. The first spark was lit by a children's writer named Sterling North. Don't be alarmed if you've never heard of him. After checking

in almost a dozen libraries I finally discovered that North is the author of such yawn-inspiring masterpieces as Abe Lincoln, Log Cabin To White House and George Washington, Frontier Colonel. It's ironic but appropriate that long after the corpse of Mr. North has been devoured by worms, he is mainly known not for the stories he left to children, but for what he tried to steal from them like a witch in a fairy tale.

In a 1940 edition of the *Chicago Daily News* North fired the initial salvo against the comic book medium, calling it a "poisonous mushroom growth" of "graphic insanity" that used a "hypodermic injection of sex and murder" to corrupt America's youth from sea to shining sea. The effect of these illicit injections of crude four colors and "pulp paper nightmares is that of a violent stimulant," he claimed (Zone and Roblin 4).

Just showing a single panel to a child would cause him or her to go screeching out the door with knife in hand, ready to murder millions. To save America's youth from this creeping darkness gradually blighting land and sea, North demanded that Washington, D.C. step in and do something about this mess. After all, what were those darn politicians there for if not to save its citizens from the inconvenience of personal responsibility? Of course, the honorable Mr. North had only the children's best interests in mind. The fact that ten million comics were being sold every month in the year the *Chicago Daily News* article saw print, the fact that this rapidly growing medium was no doubt cutting into the sales of Mr. North's literary gems had absolutely nothing to do with his vehement attacks. Yeah, and Hearst didn't begin a propaganda campaign against marijuana so his paper industries wouldn't be hurt by alternative resources such as hemp. Yeah, and the automobile companies didn't buy up all the street cars and railway systems in Los Angeles and melt them for slag in order to create a city dependent on fossil fuels. In America people never conspire against anyone else for economic or political gain. That only happens in other countries and in old Shakespeare plays. This is what public education has taught me, and I'm glad I could take this opportunity to set the record straight.

At any rate, Mr. North's frenetic warning against this "cultural slaughter of the innocents" went pretty much unheeded at first, but began to pick up steam when an individual named Dr. Frederick Wertham entered the picture and attempted to reduce the world of comic books into flakes of gray ash. He nearly succeeded.

The year was 1948. World War II had ended only three years before and the Cold War had just begun. The Cotton Mathers of America were furiously

POPULAR PARANOIA, page 229

wriggling out of the woodwork, creating as much propaganda as possible to shift the nation's hatred away from Germany and Japan and onto the New Enemy: the USSR.

Never mind that Russia had nearly been devastated by the Germans during World War II and were in no shape to attack a small province much less the United States of America. Never mind the fact that General Reinhard Gehlen, a German intelligence specialist favored by Adolf Hitler, had been recruited by U.S. intelligence along with hundreds of other top-ranking Nazis under a covert program known as Project Paperclip to provide America with secret information on the Russians (Loftus and Aarons 151-52). Never mind that General Gehlen knew full well that Russia wasn't a threat to anybody and cooked up scary bedtime stories about "ten-foot tall Russians" in order to remain on the rather lucrative payroll of the Office of Strategic Services (Simpson 58-60). Never mind that this gleeful collaboration with Nazis led to the paranoia later spread by such wonderful personages as Joseph McCarthy, Richard Nixon, J. Edgar Hoover, George Bush, Ronald Reagan, and Oliver North (any relation to Sterling North?). Never mind that late in 1947 the U.S. Congress passed the National Security Act with nary a whisper of argument in order to give the CIA free reign to play in their global sandbox with as many of Gehlen's Raiders as they wished. Never mind all that. We as a nation in 1948 decided we had something far more important to worry about: comic books.

Clearly, 1948 was a year filled with enough paradoxes and irony to give Franz Kafka nightmares. This was the year when J. Edgar Hoover announced that crime comics were detrimental to the "American way of life, (Zone and Roblin 7). Wait a minute, let me get this straight. The same man who hated blacks while denying that he himself was half-black, the same man who wouldn't allow homosexuals to join the FBI while in his off-hours dressing up in pink nighties and performing oral sex on his faithful assistant Clyde Tolson, the same man who reaped millions from the Mafia's coffers while claiming that such an organization didn't exist except in the minds of total paranoids, declared comic books harmful to the "American way of Life"? (For more detailed information on this heartening aspect of covert U.S. history please see the book *Official and Confidential* by Anthony Summers. A comic book published in the mid-fifties authorized by the FBI has J. Edgar Hoover's face emblazoned on the cover. Above Jedgar's pug-nosed mug is the appropriate title: CALLING ALL BOYS! Those "in the know" in Washington, D.C. must have had a field day with that one.) Which "American way of life" are you talking about, Jedgar? The "American way of life," that advocates hiring male prostitutes while vacationing in New Orleans and blackmailing the President of the United States into reappointing you as Director of the FBI? I suppose if one avidly read Superman as a child and believed the Man of Steel when he preached about "Truth, Justice, and the American Way" then that would put a bit of a crimp in Mr. Hoover's lifestyle.

Why, someone who bought into such subversive rhetoric might actually suggest that the Director of the FBI probably shouldn't be pulling in two thousand dollars for every mob-backed horse race he bets two bucks on. Or as a certain Prince Hamlet once said, "There's something rotten in Santa Anita."

There was also something rotten in the studios of ABC radio on March 2nd, 1948 when drama critic John Mason Brown took to the microphone and declared comics to be "the marijuana of the nursery!" (Zone and Roblin 8). Boy, I'm sure that comment made both Hearst and North happy.

There was also something rotten in the May 29th, 1948 issue of the *Saturday Review of Literature* in which Dr. Frederick Wertham charged that comic books had caused children all around the country to suddenly go hi-diddle-diddle over the deep end and stab, shoot, beat, and otherwise annoy not only their peers, but (worst of all!) their elders as well. Apparently, these comics had even instilled in a couple of children the odd delusion that they were more intelligent than their parents and could decide for themselves what they wanted to read. Only the Devil himself could've been responsible for such sassiness.

Obviously, comic books were operating as a kind of mutant virus possessing the bodies of children like B-movie aliens from *The Village of the Damned.* This menace needed to be stamped out even if it took a posse of five hundred men to do it!

But such an endeavor didn't require five hundred men when Dr. Frederick Wertham was around to shoulder the responsibility. According to Ray Zone, on the third of September, 1948, Wertham delivered a speech "before the National Congress of Correction," calling for "a national ordinance to ban the sale of crime comics to children under fifteen years of age. This led to an "ordinance limiting the sale of crime comic books" in at least fifty cities (18). Out of this hysteria grew a scarier phenomena: Angry parents held mass comic book burnings in Chicago, New York, and throughout the mid-West. Some parents even forced their kids to throw their favorite comic books into the fire.

A friend of mine once mentioned the above information in a political science paper on censorship. The professor returned this essay with a written comment that such burnings had never occurred. This is rather peculiar, considering the fact that voluminous footage of these events do indeed exist and can be seen (just to name one example) in Ron Mann's excellent 1989 documentary *Comic Book Confidential*. Go ahead, rent it. Pop it in the VCR. If you squint your eyes and tilt your head, you just might think you're watching a scene from Nazi Germany. Say, is that Reinhard Gehlen waving in the background?

While military officers in the Pentagon were smuggling Nazi war criminals into the United States with the help of Vatican "ratlines" (Simpson 176), Frederick Wertham was doing all he could to import a little bit of the oil Fatherland to American soil as well--if not in the flesh, then at least in spirit. At around the same time that his learned diagnoses were inspiring book burnings all around the country, Wertham was also leading an attack against a brilliant psychiatrist named

Wilhelm Reich (Sharaf 361). In 1933 Reich had fled his native Germany in order to avoid the same fate as his book *The Mass Psychology of Fascism,* copies of which were burned *en masse* at the behest of the Gestapo (Reich xviii). After arriving in the Land of the Free, however, Reich was surprised to find the very same book being attacked by demagogues like Wertham. No doubt, Wertham was merely acting as a mouthpiece for the American Psychiatric Association and the pharmaceutical industry, both of whom were slightly upset that Reich had discovered the means to cure cancer via orgone energy.

For some odd reason professional healers often get upset when an erratic individual in the medical community actually begins curing people. After all, why help patients get better when you can spend the time more wisely by whipping them into a vortex of fear with made-up sicknesses like "Anti-social Personality Disorder" and "False Memory Syndrome" that can be "treated" via expensive, weekly dosages of unpronounceable drugs usually ending in "drinell" or "zine"? I don't know how America could cope if all the medical doctors and psychiatrists disappeared tomorrow. Without them we wouldn't know that electro-shock therapy, Ritalin, Thalidomide, and Malathion spraying are all quite healthy for us whereas comic books can permanently damage one's central nervous system.

A WOMAN WHO'S RECENTLY TAKEN THALIDOMIDE: Say, Doc, look at my kid! What's the matter with him?

DOCTOR (perusing the child intently): Uh, is there something the matter with him?

WOMAN: Of course! He's just a big eyeball with eight pudgy feet!

DOCTOR: Ah, I see what you mean now. (Stroking his chin.) Hm…were you reading comic books at any point during the pregnancy?

In 1954, just two years before the American Food and Drug Administration would burn piles and piles of Wilhelm Reich's books by the decree of a court order, William Gaines was forced to testify at the Senate Investigation of Comic Books and Juvenile Delinquency (that's actually what it was called, folks, I ain't making it up). William Gaines was the publisher of the now infamous EC line of comics including *Tales From the Crypt*, *Weird Fantasy*, *Two-Fisted Tales*, as well as numerous other titles. Many of these comics featured the artwork of singular talents like Bernie Krigstein, Wally Wood, Harvey Kurtzman (Terry Gilliam's mentor, incidentally), Al Williamson, Graham Ingels--the list goes on and on. This small clique of artists who were merely attempting to tell good stories were suddenly accused of being sicko-pinko-bastards out to pollute the precious bodily fluids of children the world over. It was up to their boss to pull them out of this mess.

During the Senate Inquisition Gaines held his own, verbally jousting with the politicos to such a point that the Chairman had to bang the gavel a couple of times to drown out his words. At one point a Senator held up an issue of *Crime SuspenStories* with a severed head on the cover and said: "Here is your May issue. Do you think that's in good taste?" Gaines replied, "Yes sir, I do --- for the cover of a horror comic." Anyone with an ounce of common sense would consider that to be a reasonable response. The Senate didn't think so.

Just as we see today with the television industry, all this hoopla and wagging-of-fingers from White Guys In Neck Ties caused the people under attack to regulate themselves. "In the United States of America we do not censor people. Instead we harass you and cling to your necks like rabid dogs until you censor yourselves. There's nothing the matter with that, is there?"

Sadly, inevitably, in September of 1954 the publishers were cajoled into forming the Comics Code Authority and ap-Pointed New York magistrate Charles F. Murphy as official "censor" to institute "the most stringent code in existence for any communications media." [Today, of course, we've grown beyond such immature candor and give our modern day Charles Murphys names like "the Head of Standards and Practices" rather than the far too blatant "official censor."] Horror and terror comics were banned and to receive the Comics Code Seal of Approval no comic books could "explicitly present the unique details and methods of a crime." (Zone and Roblin, 24)

Gee, I wonder what crimes they're talking about? Like smuggling Nazis into the country? Like being on the take from the mob? Like propositioning young boys? Back in 1954 if the Senate had completely ignored comics and instead held the Senate Investigation of the Pentagon and J. Edgar Hoover, the United States would be filled with a bunch of happy campers right now.

The parallels between 1954 and today are eerie. Where once it was J. Edgar Hoover proclaiming comics to be a threat to the "American way of life" we now have Janet Reno saying the same damn thing about television. Instead of grabbing a fire extinguisher and putting out that conflagration she lit with utter gleefulness in Waco, she's holed up in her office writing TV scripts. "This is the way they oughta be written-- you know, without all that sex and violence stuff in it." Meanwhile, she couldn't find any organized crime in Dade County while serving as Florida's assistant State Attorney, an act tantamount to accidentally overlooking the Grand Canyon while riding a pack mule through it. This is the same woman who covered up the rampant vote fraud in Florida discovered by James and Kenneth Collier back in 1972 (Collier and Collier, pp. 125-26). This is the same woman who's been known to love little girls as much as Lewis Carroll, the only difference being there's no photographic evidence of Carroll's predilections (Kawaja). And yet this overgrown gargoyle of a woman somehow thinks she's in a position to tell TV studios what they can and cannot put on their airwaves?

Unfortunately, she's absolutely right. The studios instantly rolled over and formed their own ratings system just like the comic book companies did forty-two years ago. Because of this restrictive Code of Approval it took mainstream comics over thirty years to reach the superior level where they now reside. Graphic novels like *From Hell* by Alan Moore (creator also, in collaboration with Melinda Gebbie: *Lost Girls*, a mannered pornographic tale about a lesbian love affair among the grown-up Alice from Wonderland, Dorothy from Oz and Wendy from Peter Pan) and Eddie Campbell, Chester Brown's *Ed the Happy Clown* and Daniel Clowes' *Like a Velvet Glove Cast in Iron* are just a few examples demonstrating the excellence the comics medium can attain when it's unhindered by government-dictated rules and regulations.

Along with jazz, comic books are one of the few internationally renowned

indigenous American art forms. Due in no small part to the efforts of Blue Meanies like Sterling North, however, it has more often than not been regulated to the invisible outposts of America's culture. What is it about this medium that so frightens the congenitally Serious? Is it because comic books, like jazz, have always been a home for society's dregs? According to Franklin Rosemont both art forms "were equally subject to derision by the guardians of bourgeois High Culture. These two despised media were thus well situated to express the deep and secret longings of the most despised sectors of the population: the most exploited of the proletariat, immigrants, blacks, slum-dwellers, hoboes, drug victims, prostitutes, lunatics, and jazz musicians. (p. 62)

Again and again throughout this century we hear the members of the above list being derided as "useless eaters," a phrase used by Goebbels to describe everyone in Germany not exactly like him. The phrase "a poisonous mushroom growth" isn't all that dissimilar to the rhetoric used against the outcasts of Nazi Germany. Goebbels, of course, was a "sterling" Pillar of virtue in his community. He was also quite conversant in the techniques of propaganda, and knew full well that the greatest political tool is always distraction. If it's not comic books turning your kids into killers, it's marijuana. If it's not marijuana, it's heavy metal. If it's not heavy metal, it's Dungeons and Dragons. If it's not Dungeons and Dragons, it's Saturday morning cartoons. If it's not Arabian terrorists trying to hunt you down, it's redneck terrorists. If it's not a black ex-convict named Willie Horton stalking the streets of well-to-do white neighborhoods, it's an ex-football star who "just so happens" to be black as well. If it's not Russians attempting to invade America, it's Mexicans. If it's not Iran that's led by "the New Hitler", it's Iraq. If it's not the lack of nuclear weapons that should be our major concern, it's the surplus of them. Goebbels' propaganda techniques did not die with Goebbels. At this point you should be asking yourself the question: From what, exactly, are we being distracted?

The only thing left to be said is this: Sterling North wouldn't know a great piece of literature if it held him down and reamed him up the ass. Of course, I'd like to go on record as saying that I have no idea what it feels like to be reamed up the ass, and yet I admit the subject certainly does fascinate me. Perhaps if things get boring later on we can dig up J. Edgar Hoover and ask him about it. Judging from his record, though, I gather he's not the kind of girl who kisses and tells.

WORKS CITED

Collier, James M. and Kenneth F. Collier. *Votescam: The Stealing of America.* New York: Victoria House Press, 1992.

Kawaja, Peter. Interview. *Something's Happening.* Pacifica Radio. KPFK, Los Angeles. Nov. 23, 1995.

Loftus, Jim and Mark Aarons. *The Secret War Against the Jews.* New York: St. Martin's Press, 1994.

Reich, Wilhelm. *The Mass Psychology of Fascism.* New York: Farrar, Straus & Giroux, 1971.

Rosemont, Franklin. *Surrealism & Its Popular Accomplices.* San Francisco: City Lights Books, 1980.

Sharaf, Myron. *Fury On Earth: A Biography of Wilhelm Reich.* New York: Da Capo Press, 1983.

Simpson, Christopher. *Blowback.* New York: Weidenfeld & Nicolson, 1988.

Zone, Ray and Chuck Roblin. *Forbidden 3-D.* Los Angeles: The 3-D zone, 1993.

Saucer Section

The Last Days of Fred Crisman

Excerpt from the new book, *Maury Island UFO* by Kenn Thomas

"The experts disagree. And in the final analysis this country...on its space effort and all the rest where we will find the most intense disagreement among those who know the most—in the final analysis the people themselves have to make a judgment..."

--John F. Kennedy, Cheney Stadium, Tacoma, WA, September 27, 1963

"I never thought much of a lie, because nobody believes a lie if he has a chance to find out the truth."

--Harry S. Truman, Tacoma, WA, June 10, 1948

In 1947 Fred Crisman said he witnessed a UFO at Maury Island, near Seattle. In 1968 New Orleans District Attorney Jim Garrison subpoenaed Crisman as part of his investigation of the JFK assassination. The infamous Torbitt Document named Crisman as one of the three tramps in the railyard behind Dealey Plaza. In between, Crisman became a known figure in the ufological community. His full story is told in a the new book, Maury Island UFO by Kenn Thomas, published by IllumiNet. The following excerpt comes from that book.

Crisman had started at KAYE on August 1, 1968, under the on-air name of John Gold. According to his 1970 autobiographical book, *Murder of a City*, published under the Gold pseudonym, he had been attracted to the radio station because he felt it was a way to express his concern over the Gypsy minority and that it would be useful in his political cause: the elimination of the city management style of government in Tacoma.

According to one source, Crisman's zeal in this matter stemmed from orders given him in 1968, "but there is no reason given as to why it is felt by the East section of the CIA that this form of government is wrong for this area." (1) Crisman's reasons, as well as his general philosophy (described by Crisman as "Liberal Democrat"-and he had indeed run for office as a Democrat-but clearly shown as anything but in his writing) and a detailed look at his political and business associations, provided the basis for his book. *Murder of a City* reviews the struggles between Tacoma's city manager, Dave Rowlands, and its mayor, A. L. "Slim" Rasmussen-a struggle that Crisman viewed as having lost.

In March 1969, Crisman helped create a non-profit corporation to pursue this ambition of eliminating city management government in Tacoma. It failed, of course, and by January of the following year Mayor Rasmussen was administering his final session, having lost the previous November election. One of his final acts was to appoint Fred Crisman to Tacoma's library board. The move received criticism for all that Crisman had done in local politics and his infamy as a right-wing radio com- mentator, but he

assured his critics that "I respect the library and use it frequently for my own studies as well as for background ... and would not think of attempting to influence [the library director] in his choice of books." (2)

Crisman's change of fortunes continued when the defamation lawsuit against KAYE was dismissed. (3) He got involved with cable-TV franchising to no success, however, and lost his bid for election to the Civil Service Board of Pierce county by 1559 votes (4) in September 1971. Shortly thereafter, charges of mismanagement began to circulate about the library manager, apparently emanating from Crisman, who believed that his opposition to city manager government kept him from being made the board president of the Tacoma Public Library.

Petty bickering about library politics continued in the Tacoma press until Crisman resigned in October 1973. (6) As early as 1967, however, Fred Crisman began to again turn his attention to the events at Maury Island of 1947. On July 22 of that year he lectured on the topic at the annual Northwest UFO Conference in Seattle. (7) He lectured the group about the seriousness of the subject, apparently a bit disgruntled at some of the carnival-like atmosphere that attends UFO gatherings (then as now). He made the claim that he had been the first person to photograph the UFOs and that he still had prints of the Maury Island photographs. He discussed the flying saucer slag and insisted that it was quite different from the discarded product of the local smelter works. He talked at length about the press distortion of the subject and how he hoped the true facts would someday emerge.

If Crisman was making a bid to become a UFO celebrity like Kenneth Arnold, he did little after that to further the cause. When he finished lecturing in Seattle, a young UFO researcher named Gary Leslie approached him anxiously to get copies of the Maury Island photographs. Crisman declined to offer his own address due to his distaste for publicity (a claim contradicted by his soon-to-come career as a shock jock, if not by the lecture itself), but he did provide an address for Harold Dahl. Dahl, after all, had the photographs in his possession.

Leslie found Dahl to be an amicable correspondent. He offered to provide copies of the photos and a written statement about his experiences at Maury Island, plus one from his son. He forwarded Leslie's inquiries to Crisman's New Orleans address (8) and reported that he had photographs of the North Queen boat taken at the time of the incident. Dahl also spoke very glowingly of Crisman, comparing him, in fact, to the character played by Roy Thinnes in the then current TV show, *The Invaders*, a character who hunted for his secret knowledge of flying saucers, and explained that nothing could be done without his partner's approval.

A few days later, Leslie received an angry response from Crisman. "I do not want this matter in public print!" he declared and expressed his anger that Dahl was so forthcoming. "He will not correspond with you again." (9) Leslie had the ambition of collecting information from the pair and publishing an unvarnished version of the Maury Island story. He was quite disappointed in Crisman's hostility and tried through several letters to both Dahl and Crisman to ameliorate the controversy, if indeed it was "Dahl." Some researchers suggest that the letters from Harold Dahl, the Easy Papers, and much of the other written documentation of this story may have actually been written by Crisman, even though the address was in Tenino, Washington, not New Orleans. (10)

In any event, "Dahl" caved in to Crisman's concerns immediately, but he kept in contact with Leslie for other purposes. He had an interest in promoting the work of Dr.

Frank E. Stranges of Van Nuys, California. "Dahl" sought the help of Leslie's UAPRO group to organize a showing a film by Stranges. Leslie obliged and continued to pursue the photographs and written statements from "Dahl." In a last letter from Crisman/Dahl ("I am irrevocably tied to Hal in any questions that arise on the Maury island incident"), he claims that he has only shared his views and research materials on Maury Island with small business and academic groups "that have extra and advanced knowledge" about UFOs.

"I travel widely and this allows me to be in areas that do have certain of the extra 'attentions' of the UFOs. It has always been a type of precise 'high-wire' balance act to keep up an investigative and reporting interest and at the same time deal with the areas of a business world that has no interest in such matters."

With reluctance, Crisman acquiesced to "Dahl's" interest in sharing with Leslie, but no record exists that the contact continued. Crisman closes with a report that he went to the original Maury Island UFO site, and found it barren of plant growth and surrounded by signs that the area would be razed for the sake of an unnamed federal project. "Why? ... A bit of inquiry revealed that government men of some agency have returned over the years ... many times for soil samples and pictures."

The name of Dr. Frank Stranges, still a personality in UFO circles in 1999, came up once more in research surrounding Crisman. The director of NICUFO (the National Investigations Committee on UFOS), Stranges was approached by an investigator for famed Kennedy assassination researcher and author Bernard Fensterwald. Fensterwald had received a leaflet from another noted author in the field, Paris Flammonde, that had Crisman's business partner-and a suspect in the anti-Castro milieu according to Jim Garrison-Thomas Beckham listed on NICUFO's board of directors. The investigator determined that Beckham met Stranges through Crisman. (11)

The August 1993 release of an interview transcript with Beckham affirmed that Crisman managed his singing career and had introduced him to the UFO world.

One other UFO circuit personality had a non-encounter with Crisman: Wayne Aho. Aho had remained active in the ufological community since his spaceship encounter in the Mojave Desert on May 11, 1957. Crisman invited him to attend the First Midwest UFO Conference in Omaha, Nebraska on August 12, 1967. Aho showed, but Crisman did not. Aho had previous involvement with shady characters on the UFO fringe. He and a business associate named Otis T. Carr were indicted in the late 50s for an investment scheme to develop a flying saucer that ran on free energy. The two were indicted for selling hundreds of thousands in illegal stocks, but charges against Aho were dropped. Carr was convicted and given a $5,000 fine. Like the money that Beckham and Crisman allegedly raised, the final disposition of Carr's profits remains unknown.

Aside from these instances, Crisman kept to his principle of avoiding publicity with regard to Maury Island and UFOS. He returned to his traveling and "the areas of a business world that has no interest in such matters." After the radio show, the Garrison subpoena, and his career with politics and the public, Crisman tried to start a public television station in Tacoma in 1975.(13)

The charge that he was one of the mystery tramps at Dealey Plaza on November 22, 1963 arose again in the mid-70s in articles that appeared in *True* magazine and *Crawdaddy*. Crisman maintained his story that he was teaching high school in Rainier on that day. (14)

The next time Fred Crisman ran for office, for a seat on the City Council; he lost by over 10,000 votes. (15) In September 1974, he was hospitalized for kidney failure. In April 1975 he married Mary Frances Borden, an ally in his library political battles. On December 10, 1975, Fred Crisman died at the age of 56.

NOTES:

1. This is found in something called the Easy Papers, discussed at length in *Maury Island UFO*.

2. Wilkins, Jack, "Slim Praises Pals, Raps Detractors as Era Ends," *Tacoma News Tribune*, January 7, 1970.

3. "Hodges Halts Libel Suit," *Tacoma News Tribune*, February 4, 1970.

4. "CTV Firm Plans To Sue City Council," *Tacoma News Tribune*, April 16, 1971; "Complete Unofficial Councilman Vote," *Tacoma News Tribune*, September 22, 1971.

5. Gibbs, Al, "Mismanagement Called Cause of Libraries Woes" *Tacoma News Tribune*, Octoberr 13, 1971; "Library Director Answers Critic," *Tacoma News Tribune*, October 13, 1971; "Three Attend Library Meet," *Tacoma News Tribune*, January 26, 1972.

6. Wilkins, Jack, "Politics Looms In Affairs of Tacoma Library Board," *Tacoma News Tribune*, August 7, 1973. Gibbs, Al, "Library In Hubbub: Jarstad, Crisman Exchange Invective," *Washington News Tribune*, August 22, 1973; Anderson, Win, "Crisman Resigns Position, Charges Library Politics," *Tacoma News Tribune*, October 7, 1973.

7. The Hahanos say that this actually took place at a meeting of something called Understanding Incorporated at the Tacoma Public Library on February 4. Correspondence from Gary Leslie indicates the July date. In either case, this was two years before Mayor Rasmussen appointed him to the board and a year before he started broadcasting on KAYE. (*UFO* Vol. 9, No. 1, p. 34.)

8. The Hanohanos note that this establishes Crisman's connection to New Orleans a year before the subpoena (*UFO* Vol. 9, No. 1, p. 34.)

9. The Hanohanos quote Dahl's widow Helen as saying "Something happened in the late 1960s to change the relationship between my husband and Fred. Fred began calling the shots. It's possible that Fred was blackmailing Hal." It should be recalled, however, that Dahl owned the boat upon which he had his UFO encounter but nevertheless reported it to his "boss," Fred Crisman. Crisman dominated the relationship even in 1947.

10. Support for this notion comes in the form of other letters written by "F. Lee" to noted UFO researcher Lucius Farish in Plumerville, Arkansas from November 1967 to January 1968. The correspondence discusses technical particulars of a well organized but small and invite-only paranormalist study group called Parapsychology Research, including that its new director would be Crisman chum Robert Lavender, and gives a detailed report about Maury Island. The letters also make mention of the Loch Ness monster and the San Juan Lights and of networking with over 200 Fortean societies. They contain Crisman's complaints about the UFO community, repeat the allusion to *The Invaders* TV show, and note that "Any letter sent to Hal Dahl is usually answered by Crisman - if he bothers to answer at all."

11. Hanohano, Kalani and Katiuska, "Beckham Talks About Crisman," *UFO Magazine*, Volume 9, Number 1, 1994, pp. 36-38. The Hanohanos also discuss Milton Northdruft, who had lunch with Stranges and Beckham. Northdruft reports, "Beckham was quite an enterprising individual and gave me the impression of operating rather smoothly, having some solid people on which he could depend when things actually got under way at 8:00 p.m. that evening, with Frank Stranges speaking." Also according to the Hanohanos, Stranges "was very hesitant to discuss the matter" with investigator Bill La Parl when approached about it at Timothy Beckley's 1992 UFO conference in Phoenix.

12. House Select Committee on Assassinations transcript 014888, Thomas Beckham interviewed by Robert Baras and L. J. Delsa.

13. Sypher, Richard, "TV Station's Promoters Assail TNT Coverage," *Tacoma News Tribune*, January 10, 1975.

14. Shomshak, Vem, "*True Magazine* Less Than True-Crisman Says of Article on JFK's death," *Tacoma News Tribune*, May 22, 1975. "Secret Agent Man Meets The Mystery Tramp", *Crawdaddy*, November 1975.

In December 1978, the House Select Committee on Assassinations summoned Stanley Peerboom, the principal at Rainer High School, to produce Crisman's employment records from the time. Peerboom complied, producing a two-page list with a single handwriting demonstrating that no substitute had been called for Crisman on November 22, 1963. It does reflect several absences for Crisman the following February through May. The accompanying letter from Peerboom points out that "Since the school district did not keep very extensive records at the time, I cannot supply the exact information which you requested. I am supplying all that is available." In a separate letter, however, Peerboom includes the remark, "I can also verify that on the day of the assassination of President John F. Kennedy, I was teaching at the school and Fred Lee Crisman was also teaching at the school on that day." He concludes, "I might mention that I regard Mr. Crisman as a person lacking in truth. I can only say if it is important, I can give reasons for the above statement."

Peerboom also doubted the authenticity of a letter he received from Crisman's wife Mary, asking for copies of the same records, but included the letter with the materials he sent to the HSCA.

15. "Elections At A Glance," *Tacoma News Tribune*, November 5, 1975.

16. Obituary, *Tacoma News Tribune*, December 11, 1975. "Council Critic Crisman Dies," *Tacoma News Tribune*, December 11, 1975. "Crisman Native Tacoman," *Tacoma News Tribune*, December 16, 1975.

The Strange Business of Dan Griffith, part two

continued from *Steamshovel Press* # 16

The most intriguing question raised by the assault mounted against Dan Griffith is who has the motivation and attention span to pursue an ordinary citizen openly since 1983 across vast distances? About year five (1988), Griffith began reviewing incidents in the years prior to 1983, which, at the time, were odd but not seriously threatening. Griffith was employed in early 1978 by one of Cincinnati's leading commercial realtors noted for his friendly, laid-back personality as much as his business acumen. About three months later the broker's demeanor suddenly changed to brusque hostility when he told Griffith: "I got a phone call at home last night." This hostility became serious when the broker attempted to steal half of Griffith's share of a large deal, which resulted in a two-day trial in which the jury took eleven minutes to decide for Griffith.

Reflecting further into the past, an incident in early 1971 began to take on an ominous meaning when placed into context. Charles Keating, lead counsel for tycoon Carl Lindner, began harassing Griffith with letters after an encounter on a Cincinnati street. Keating went on to infamy in Arizona and California in the late 1980s as the leading cause of the national S&L crisis. Griffith attended three days of a civil trial in Tucson in 1992 in which Keating took the Fifth Amendment numerous times.

In late 1970, Griffith encountered two former Tulane fraternity brothers, one in New Orleans and the other in San Francisco, at which more hostility was exhibited. Griffith had not seen these two (who were lawyers) since the 1950s.

Perhaps the most intriguing incident in Griffith's past was during his US Army service in Germany in 1959 when he was asked by his West Point platoon lieutenant to be a classroom instructor for what the Pentagon entitled: "troop information and education." The topic was the worldwide reach of the Soviet Comintern, which, as an afterthought, Griffith compared to the similar organizational structure of the Vatican. Griffith never taught another class and was openly followed on a long tour of Europe two months later. Griffith does not believe this Army incident is a causative factor but clearly established a counter-intelligence file. In 1988, the State Department wrote to Griffith that "after several searches, we cannot find the records of your 1959 passport." In 1995 in Washington, DC Griffith learned from a former Army CIC agent that he had probably been labeled a "disaffective," i.e., potential defector to the Soviets during those paranoid days of the Cold War.

A significant demonstration of highly based power has been the control over lawyers, bar association referral services and private investigators. In 1984, Griffith contacted the Washington, DC Bar Association to acquire names of FOIA lawyers in order to bring an action against the FBI,. The DC Association referred him to Eleanor Loos, whose office location changed twice before she disappeared altogether. At one conference with Griffith, Loos introduced a man whose credentials were that he had worked for the CIA in the Golden Triangle of southeast Asia. This meeting took place in the cafeteria of the federal courthouse although no lawsuit had been filed. A similar experience occurred with the Cincinnati Bar Association.

A Louisville Harvard lawyer took $2500 from Griffith in 1987 and then did nothing, including not returning phone calls. In 1996, Griffith tried the legal approach

again by hiring a Cincinnati lawyer to bring another FOIA action against the FBI. This lawyer (who left town) attempted to persuade Griffith to not bring the lawsuit and then turned the case over to his senior partners who also tried to prevent legal action. When Griffith persisted, the lawyer agreed to act as a "consultant" if Griffith brought the suit *pro se*. At the last minute the lawyer decided to act as legal representative. Griffith assumes that this sudden change of heart was because the FBI did not want to deal directly with an outraged citizen. The FBI stalled this lawsuit from 1996 to early 1999 when Griffith discharged these shills and took over the case *pro se*.

Left in Griffith's car before the World Affairs Council meeting, November 18, 1999.

Private investigators performed even more outrageously. Their people in Cincinnati, Washington, Fort Lauderdale and Miami had clearly been warned of Griffith's pursuit and reacted fearfully and non-productively. PIs apparently have an alert service (fax and/or mail), which can be used to bullitenize investigators across the country, complete with photographs. A complaint against a Washington, DC area PI led to a phone call to Griffith's motel room by a Fairfax County (VA) police officer who told him to "drop the pursuit and investigation."

Griffith regards the most significant, if not most ominous, intercept, as the appearance of a high ranking Vatican official in the British Hospital in Lisbon, Portugal in 1985. Griffith had been hit by a car three days after arrival in Portugal and was taken to the small (22 bed) independent hospital maintained by the sizeable British community in Lisbon. The next day, an Irish priest who was head of one of the major Catholic orders appeared as a patient in Griffith's five bed ward. After some small talk, the conversation lapsed into silence. Suddenly the priest said: "Do you think you could kill somebody?" Griffith's flabbergasted answer was "Huh?" The priest was allegedly hospitalized for an asthma condition, however, during the ten day stay, he would frequently don his uniform and leave for two to three hours. After Griffith's release, he discovered that Lisbon had two large Catholic hospitals where a genuinely sick priest would have been lodged.

During this ten day stay in the British Hospital, Griffith was visited at his bed by an American from Fort Stockton, Texas, who stated he was a tourist. He told Griffith of his young days when he served as a Peace Corps volunteer. He assisted Griffith in his first shaky steps (from broken ribs and clavicle) into the street in front of the hospital. After several days of visiting, he disappeared.

In March 1992, Griffith drove into Fort Stockton and visited the man's auto parts store and was told by the clerk that he had left early that morning on a sudden "vacation". The clerk also stated that his boss had not served in the Peace Corps but in the US Army.

The fact sequence in this saga is quite incredible. The caliber of interceptors has included everything from street level scuff bums to experienced intelligence agents. But the deployment of a high ranking Vatican official who feigns illness for ten days is at the top of the list. Who has the capability and clout to recruit and deploy such a person?

Rajneesh Rising from the Grave

by Acharya S

"I leave you my dream."

Some 15 years ago, a series of bizarre events unfolded that were publicized in the media around the world. Yet, this weird story, which had all the making of a spy novel and a great movie, was seemingly ignored by all but the most diehard conspiriologists, even though it contained all the elements of a conspiracy and was global in nature. One man, a "notorious" Indian guru with hundreds of thousands of followers worldwide, was booted with great vitriol out of not only the United States but also 21 other countries. He was hounded, vilified and, some claim, poisoned, evidently because the powers that be did not like what he had to say or what he was attempting to do. What was it about this small, frail man that freaked out some of the most powerful governments in the world?

Born on December 11, 1931 as Rajneesh Chandra Mohan, the son of a Jain merchant of modest means, in Kuchwada, India, Bhagwan Shree Rajneesh would go on to leave an indelible mark upon the world, for better or worse.

As the quintessential anti-religionist, Rajneesh didn't follow his parents' Jainism, an ancient Indian religion whose creed is "ahimsa," or nonviolence, except that he too subscribed to ahimsa, which is ironic, as well as tragic, considering how he would eventually be portrayed. Nor did he follow Hinduism, or Buddhism or Christianity, Islam or Judaism. He was a mischiefmaker from birth, and at an early age started challenging on the Jain monks and other authority figures, including parents, teachers and politicians. In fact, his childhood stories are hilarious - and somber.

At seven, his adored grandfather died with his head in Rajneesh's lap - an event that compelled the boy to investigate death, "to discover that which is deathless." Allegedly spurred on by depression caused by the death of his girlfriend when he was 15, Rajneesh went on an intense spiritual quest, at 21 becoming "enlightened," supposedly in the classical Indian sense, except that, in his case, he didn't go spouting about the love of some god person. Instead, he went on to obtain an MA in philosophy from the University of Saugur, subsequently teaching that subject at Jabalpur University for nine years, during which time he gathered a following.

After his stint at Jabalpur, he began traveling around India in his broken-down Fiat, giving talks and distributing booklets he'd had printed. He got into fights on the street and riled more than a few Muslims and Hindus. Although he had a following and had been an All-India debate champion, India is a big country, and there were plenty of places that hadn't heard of him - until he bested various religious leaders in debate. Wealthy backers started to appear, and he eventually began to do meditation camps, although initially he hated the whole guru thing and eschewed it.

In these meditation camps, Rajneesh shocked the people by telling them that their religions were oppressive and that they themselves were all sexually repressed, saying that "sex is a holy act" and that their priests were using it to manipulate them. He started to become known as the "sex guru." In *Tantra, Spirituality & Sex*, he said:

"While making love to a woman, you are really making love to Existence itself. The woman is just a door; the man is just a door. Really, it happens that the whole of Existence becomes the other - your beloved, your lover. One can remain in constant communion with

the Existence. And you can do it in other dimensions also. Walking in the morning, you can do it. Looking at the moon you can do it. You can be in a sex act with the whole universe once you know how it happens."

The locals were scandalized by the freewheeling air of the camps, where people in various stages of dress jumped around in cathartic meditations. Despite the moniker, however, only a few of his 650 books have the word "sex" in the title, and Rajneesh's countless and brilliant talks incorporated just about every subject under the sun, including the world's various religions such as Buddhism, Christianity, Hinduism, Taoism, etc., as well as assorted other gurus and philosophers, such as Gurdjieff, Socrates, Sartre, Freud, Jung, Lao Tzu and Wilhelm Reich.

In the early '70s, an ashram was established for him at Poona, and many Westerners started to come. Rajneesh had begun devouring books in English at an early age, so he was well equipped to teach English-speaking Westerners, telling them "your books are the mirrors of your mind." The list of books he read was enormous, spanning all subjects and amounting to tens of thousands. During these years, people from all over the world arrived and created various self-growth therapies under his guidance. These included, of course, sex therapies, some of which got out of control. In addition, the locals were incensed by the half-naked women running around. Rajneesh continued to get a bad name. The CIA began sending agents to infiltrate and spy on him, but at least a couple of them found the atmosphere so enjoyable that they stayed or returned there.

Destiny with Disaster

In the early '80s, one of the women who had wrested power within the ashram, Sheela Silverman, was sent to find a suitable

Above: Bhagwan Rajneesh.
Below: Osho International Commune, Poona, India.

place for Rajneesh to live in the U.S. Ostensibly the move was because his health was bad. He was a diabetic and, although strong at a youth, had a bad back and was pretty fragile for his age. Other factors for his decision to leave India evidently included a firebombing of the ashram, an attempt on his life and threats in Indian newspapers that he should have his tongue cut out and his hands cut off.

Detractors, however, claimed that Rajneesh fled to the U.S. because of the many problems at the ashram, including alleged income tax evasion, insurance fraud, and drugs and sex offenses by his numerous Western followers, many of whom were in fact essentially homeless wanderers looking for a good time and marring a good thing.

Once in the U.S., the group started out in a castle in New Jersey and from there scouted a place in the West. They settled on the 64,000-acre Big Muddy Ranch near Antelope, Oregon, which they purchased for $6 million. Part of their decision was based upon Rajneesh's conviction that there was "no future for the future," so they were to set up a survivalist utopia in the desert. The "Rajneeshees," as they would come to be known, told the local and state government that they would only have a few dozen people on the ranch, but this assertion was evidently a deception. There is no evidence that the decision came from Rajneesh himself; however, he surely expected thousands of his followers from around the world to show up.

To their credit, the Rajneeshees took a desert and turned it into a virtual oasis in a matter of a few years. The money poured in from everywhere, and the residents provided "volunteer" labor, landscaping, planting trees, creating organic farms, constructing economical buildings, including their own airport and school, and possessing a fleet of buses. The site was spectacular but environmentally unsound due to the large number of people, and the political structure was deteriorating.

The fiery Sheela rose to become the head lieutenant, and, with her harsh, agent-infiltrated clique, she would circulate around the commune barking orders and threatening people. In addition, Sheela and her husband were allegedly socking away some $55 million of the commune's money in accounts in Switzerland, a crime discovered by the feds, who then blackmailed her into being an operative.

The feds, who had been watching Rajneesh since he was in India, were moving in on the Oregon commune, at first watching and then provoking. There were agents of practically every significant agency at the city that came to be called Rajneeshpuram: CIA, FBI, INS, DEA, IRS, etc. - an estimated 17 state and federal agencies. Because of the threat from the fossilized locals, who took to shooting up Rajneeshpuram property, and because of Sheela's increasing and well-founded paranoia, the commune began to arm itself, allegedly smuggling weapons through Portland.

And then there were the druggings and poisonings. It is claimed that Sheela's right-hand "man," a woman nicknamed "Nurse Mengele," was an governmental agent provocateur who induced the increasingly

fascistic Sheela into committing an assortment of crimes, including putting salmonella in 10 salad bars in the town of the Dalles. Some 750 people allegedly were sickened, apparently to keep them from being able to vote against the commune in the upcoming election.

There were other plots, in none of which was Rajneesh himself never implicated, despite the fact that his room was bugged and his communications and movements monitored. These plots included shipping in homeless people from around the country so they could vote in elections in favor of the commune. Many of these homeless people were schizophrenic and were apparently drugged to keep them from being violent. The Rajneeshees essentially bought out Antelope and took over its local government. As the acrimony increased, plots allegedly were made against the life of attorney Charles Turner, as well as that of others. No doubt these plots were instigated and/or assisted by the agents provocateurs crawling all over the place.

According to Alex Constantine, the commune was linked to "opium trafficking, prostitution, money laundering, arson, slave labor, mass poisonings, illegal wiretaps and the stockpiling of guns and biochemical warfare weapons." He also says, "The year-long Oregonian investigation revealed cult ties to CIA-trained mercenaries in El Salvador and the Far East. Domestically, Rajneesh's secret police force worked with Agency operatives." But, he notes in *The Constantine Report, No. 3*, that this "eccentric religious" organization, among others, may have been "co-opted." In the case of Rajneesh, that is certainly true.

The shady business, along with the notorious Rolls Royces, caused tremendous media interest. The Rolls Royces, in fact, were designed to do just that. Rajneesh claimed to have 93 of them, and that he would eventually own one for each day of the year. In reality, he didn't actually own them. Many of them were gifts to the commune, and others were just loaners. It is claimed that Rolls Royce itself was in on the joke, which was to demonstrate how ridiculous was the American pursuit of material goods.

In the fall of 1985, Rajneesh came out of a 1300 day seclusion, called in the FBI and began to talk against various commune members, including Sheela, who by this time had fled the country. At this point, the National Guard and a "special SWAT team" were called in, and "USAF fighters were swooping over the isolated ranch." In October, Rajneesh boarded a plane and flew to North Carolina, to stay at a follower's home. He later stated that he did this because he believed the National Guard was going to move in and start a gun battle with the residents, probably killing many of them. One of Rajneesh's followers was the daughter of slain congressman Leo Ryan, Shannon Ryan, whose association with "the cult" caused much consternation that another "Jonestown" was about to happen.

On October 28, 1985, some crazed agents who were evidently told that he was a heinous criminal arrested Rajneesh without an arrest warrant at the airport in Charlotte, North Carolina. They grabbed the robe-wearing, small, frail guru, threw him onto the tarmac, and shackled both his hands and legs.

He was then shunted across country by ground transport, in 12 days being junketed to six different jails. He was tossed into a cell with a herpes-infected prisoner (Rajneesh had a notoriously terrible immune system and could not tolerate perfume of any kind, which led to "sniffers" at the entrance of places he was speaking), and placed in the Oklahoma State Penitentiary, before being brought back to Portland to await trial. It was in the OK penitentiary, he alleged, that he was poisoned with plutonium and thallium; the rat poison purportedly favored by the CIA and other spook organizations. The penitentiary,

apparently, is not far from the Kerr-McGee plutonium plant, of Karen Silkwood infamy.

On 11/8, while sitting in the Portland jail waiting to go to the trial house, Rajneesh was told that there was a bomb threat, at which point everyone except him was allowed out of the building. No bomb exploded, but it is alleged that a "box of electronics" was found under his chair.

The allegations against Rajneesh were widely trumpeted and made to appear very sinister, although they were not. He had arranged, it was claimed, hundreds of marriages so that followers could stay in the country. He was thus charged with "immigration fraud." Eventually, because there was no evidence against him for any of the crimes committed by his supposed followers (and the various agents), he was advised to take the "Alfred Plea," by which a defendant can maintain his innocence but the government can punish him anyway. His punishment was to be booted out of the country.

After he left the U.S. with a group of followers, he was kicked out of or prevented from entering 21 other countries, including England, France, Germany, Greece, Holland, Italy, Sweden and Switzerland. In Uruguay he had been given a 3 month visa, but this was yanked shortly after his arrival - and after an alleged phone call from Ronald Reagan to the Uruguayan government threatening to pull a $6 billion-dollar loan if that nation let him stay. The Uruguayan President was purportedly informed from a CIA report by American Ambassador Malcolm Wilkey that "Bhagwan Shree Rajneesh is a highly intelligent man. He is very dangerous. He is an anarchist. He has the power to change men's minds." By now, faxes and phone calls were preceding his landings, claiming that he was the leader of a drugs and prostitution ring. Many who have studied his numerous works feel this persecution was mainly because he was so astoundingly expert at revealing the hypocrisy and shenanigans of the status quo in religion and politics.

Rajneesh was not allowed to land in Canada or Britain, even with a Lloyd's of London policy that he wouldn't leave the airport. One of his followers was the German royal cousin of Bonnie Prince Charlie, and it was rumored that Charles had a keen interest in "the Bhagwan," which did not make the Queen, et al., very happy.

The irascible Rajneesh was chased out of Greece after he criticized the Greek Orthodox Church. He eventually landed in Nepal, where he stayed for some months before going back to Poona. For years afterward, his followers were harassed and prevented from entering India. But at some point, somebody realized that they represented big tourist dollars, so the policy was relaxed.

The notorious Sheela was caught in Germany and went to jail for about three years. Her cronies in the U.S. were eventually sentenced to several years for attempted murder and other crimes.

Rajneesh lived for four years after this debacle, during which time he changed his name to "Osho," saying that "Bhagwan," a title ostensibly meaning "Blessed One" and held by the holiest of Indian holies, actually referred to the male and female genitalia. Naturally, this declaration pissed off the Hindu hierarchy.

During this time, he continued to give talks. And his body continued to degrade. It was claimed that the poison was eating away his bones, and he was in a great deal of pain. In the months before his death, he lost a dozen or more teeth. He was literally rotting.

In the month prior to his death on January 19, 1990, his longtime confidant, a 37-year-old woman named Vivek, who Rajneesh claimed was the reincarnation of his deceased childhood girlfriend, and who allegedly

suffered from manic depression, tried one more meditation therapy and then took an overdose. She did this on his birthday, December 11. Needless to say, her suicide caused a great deal of disturbance. Osho's words concerning her death were, "She goes in peace." Five weeks later, Osho himself was dead. Some say he had himself euthanized because he could no longer stand "the pain of carrying his body." Others say he "left the body" to be with his lost love.

Some claim Vivek was not a "manic depressive" but was driven to suicide because she was dismayed by her lover's deterioration. It is further claimed that the poisoning story was a coverup for his addiction to drugs, including Valium and painkillers for the physical agony he experienced. It is also believed by some that his experimentation with and addiction to drugs while in Oregon were the main reason behind his loss of control over the commune. After the heat started to get turned up, however, he certainly snapped to attention long enough to make a lucid "comeback" during the process of his arrest, trial and deportation. In fact, despite the wish on the part of the media to present a "sinister mind-control cult leader," few unflattering images were released of him. There he was on the tarmac at Charlotte, for example, hands shackled yet in a namaste greeting gesture, with a beatific smile that could charm a snake.

The Aftermath

After his death, it was discovered and reported by Max Brecher in *A Passage to America* that the "second-incommand of the Vatican," Cardinal Joseph Ratzinger, had "pulled some strings to get Rajneesh booted out of the U.S.," with the assistance of Reagan and his attorney general, Edwin Meese III, who was "notorious for his anti-Rajneesh statements." Said Meese, "I want that man right back in India, never to be seen or heard of again." Of course, Rajneesh's ridiculing the Pope with endless "Polack pope" jokes didn't help his situation much with the Vatican.

It was obvious that the feds had been watching Rajneesh since before he left India for the U.S. Brecher reported that "a cable was sent May 29 [1981] to the Consulate from Alexander Haig, secretary of state. It said in plain words that 'THERE IS HIGH LEVEL INTEREST IN THIS CASE'." In addition, when Rajneesh applied for U.S. residency, the U.S. State Department allegedly sent "a confidential telegram to the American Consulate in Bombay on November 24th 1981, that 'THERE IS BOTH CONGRESSIONAL AND WHITE HOUSE INTEREST IN THE ACTIVITIES OF THE GURU AND HIS ASHRAM'."

It is also evident that Rajneesh was a threat to the status quo long before the Oregon debacle and that he was set up to a large extent. Why exactly were the elite so petrified of and threatened by him? As the ambassador said, he could change men's minds. And, he was described by impish American author Tom Robbins as "the most dangerous man since Jesus Christ."

Some 650 of Osho's books have been published in 31 languages, including *Priests and Politicians - The Mafia of the Soul*. Another, published after 1300 days of silence while he was in Rajneeshpuram, is called *The Rajneesh Bible*. Like these two, many of his books constitute an all-out assault on religions and politics. Such sentiment is the real reason Rajneesh was persecuted.

In *Priests & Politicians, The Mafia of the Soul,* he stated:

"You have to be aware who the real criminals are in this world. That's why I speak against the priests and religions, because I don't want any single loophole for you...The problem is that those criminals are thought to be great

leaders, sages, saints, mahatmas, and they are respected tremendously around the world, so you will never think that they can be criminals. So I have to insist continuously, every day.

"For example, it is easier to understand that perhaps politicians are the causes of many problems: wars, murders, massacres, burning people. It is even more difficult when it comes to religious leaders, because nobody has raised his hand against them. They have remained respectable for centuries, and as time goes on their respectability goes on growing. The most difficult job for me is to make you aware that these people - knowingly or unknowingly, that does not matter - have created this world.

"The politicians and the priests have been constantly in conspiracy, working together, hand in hand.

"The politician has the political power; the priest has the religious power. The politician protects the priest, the priest blesses the politician - and the masses are exploited, their blood is sucked by both.

"Religions have made man's mind retarded by creating beliefs out of fictions. And politicians have destroyed man by creating as undignified a life as possible - because their power depends on your slavery. These barriers should be removed.

"Rather, science should be employed not in the service of death and destruction, but in the service of life and love, affirmation, celebration.

"We are in such a situation today that either we will let these rotten politicians and priests destroy the whole of humanity and the earth, or we will have to take the power from their hands and decentralize it into humanity."

He also stated:

"The politicians are insane, the priests are insane too..."

and:

"That's why I say all politicians and all so-called great religious leaders are suffering from an inferiority complex. That inferiority complex is a torture to them. They want to be on some great pedestal with great power. That power will help them to get at least a temporary relief from the inferiority complex."

He also blasted Israel and the concepts of a "Holy Land" and of "Chosen People", and said:

"In America, Jews are among the richest people, so they have great power over the American congress. They have a lobby of their own, and because politicians depend on contributions from rich people for their elections, they cannot avoid the Jews. They cannot ignore them; their presence is too important - they have cash money."

Osho was dogged in his critique of organized religion and the concept of God as a hindrance to human happiness and evolution:

"All the organized religions care basically depriving humanity of religion because they are misdirecting you. They are always away in the sky. And when you pray, folding your hands towards the sky, you don't realize that there is nobody to hear you.

"In fact, the one who is praying, the one who is alive in you, the one who is breathing in you, is the God."

He also called God "the imaginary puppeteer" and said:

"God is the greatest dictator, if you accept the fiction that he created the world and also created mankind. If God is a reality, then man is a slave, a puppet."

And again:

"Either God can exist or freedom, both cannot exist together." "Once you drop the God, you are certainly free." "Laughter is a better cure than God…"

And he took a very dim view of Judeo-Christianity:

"I said in one of my speeches, that The Holy Bible is the most unholy book in the whole world, because it has five hundred solid pages of pure pornography. One of my friends in America, hearing this, actually collected all those five hundred pages and published a book called *The X-rated Bible*."

Although he spoke numerous volumes about the "sweet, loving Jesus," Rajneesh was also quoted as saying, "Jesus was a crackpot," which certainly did not endear him to the Christian community. Nor did the following: "Your God itself is a fiction; Jesus Christ being the only begotten son is another fiction. And the infallibility of the pope is just ridiculous." "Jesus' miracles are mythological." "…I consider Christianity to be the most criminal religion in the world." "More people have been killed by the Christian church than by anybody else."

Osho spelled out his mission when he said:

"So I want to destroy all your belief systems, all your theologies, all your religions. I want to open all your wounds so they can be healed. The real medicine is not a belief system; the real medicine is meditation."

Such was Rajneesh's constant theme, found in thousands of books, videos and audios.

Like the Pope, Rajneesh himself was not infallible and made no pretenses to such an impossible arrogance. He was brilliant, wise, deep and compassionate. But he was also naive, which is the downfall for all those who wish to better the world but who underestimate the cunning of the powermongers. The naive person revealed in Rajneesh's numerous "sermons" did not have the mind to be a schemer himself. He was childlike, although certainly extremely powerful and charismatic. But a cult leader bent on murder and drug-running? Not a chance.

Considering what he had to say about priests and politicians, it is easy to understand that saboteurs from a variety of different interest groups would ingratiate themselves into the community. The situation was bound to explode. No single person could have kept a lid on it, although many should have been able to see it coming. Rajneesh was way over his head, and it is possible that, in consideration of his success at doing extraordinary things, he miscalculated his power.

Greatness is often dogged by tragedy. The monkey who climbs the highest shows the most ass, and the nail that sticks up the highest gets hit the hardest. In reality, Osho's life was dedicated to changing seemingly intractable "natural laws." Evidently, such a Herculean task is simply too much to accomplish on this planet. But many will continue to try.

Out of the Ashes

Times have changed since Osho's death, and the fervid vitriol against him has softened considerably. He is now lauded as a "brilliant mind," one of the best of the 20th century, by even nonfollowers and some who once hated his guts. The Poona ashram, called "Club Meditation" for its relaxing atmosphere and wide range of therapies, including "primal-scream", encounter-group therapies, Gestalt, bioenergetics, and rolfing, is second only to the Taj Mahal as a tourist attraction in India. It is also responsible for cleaning up the once-toxic river running behind it, turning it into a beautiful park, a development that has created interest globally in countries wishing to reproduce its success.

Indian newspapers, which once called for his imprisonment, now trumpet him as "one of India's greatest sons." Said M.V. Kamath, the former editor of *The Illustrated Weekly*, "With Osho, words flow endlessly. Provocatively. Challengingly. In a hundred years more copies of Osho's works will have been printed than the Bible itself, till now the outstanding best-seller."

The confusion surrounding the story of Rajneesh comes in large part from the fact that he was, despite sordid developments and some outward appearances, a charismatic and empathetic person, with an intelligence rarely encountered. To this day, the bulk of his work is unusually encompassing, and many continue to benefit from it, as is evidenced by the thriving status of his ashram, a decade after his death. In fact, at least one of his predictions came true: "After I die," he said, "more people will be coming than ever."

In the end, Osho was too big to be dismissed, and his mark has been left, as not only does his ashram serve as testimony of a final triumph, but the concepts he crystallized slowly but surely trickle into common perception globally. Said he, shortly before he died:

"I will remain a source of inspiration to my people...I want them to grow on their own - qualities like love, around which no church can be created, like awareness, which is nobody's monopoly; like celebration, rejoicing, and remaining fresh, childlike eyes...I want my people to know themselves, not to be according to someone else. And the way is in."

SOURCES:

Alex Constantine, *Psychic Dictatorship* and *The Constantine Report*.

Pierre Evald/Sw. Anand Neeten, "Two Tales - One Story."

Assorted other books, audios and videos by and about Rajneesh.

Author, historian, mythologist and linquist Acharya S demonstrates in her new book, *The Christ Conspiracy: The Greatest Story Ever Sold*, that Jesus Christ is a mythological character based on more ancient godmen such as the Egyptian Horns and the Indian Krishna. She

marshals convincing evidence that Christianity and the story of Jesus Christ were created by secret societies, mystery schools and religions to unify the Roman Empire under one state religion. This multinational cabal drew upon many myths and rituals that already existed and reworked them for centuries into the religion passed down today.

Acharya S has served as a trench master on archaeological excavations in Corinth and Connecticut, USA, as well as a teacher's assistant on the island of Crete. She received a Bachelor of Arts degree in Classics, Greek Civilization. She has traveled extensively around Europe, and she speaks, reads and/or writes English, Greek, French, Spanish, Italian, German, Portuguese and a smattering of other languages to varying degrees. She has read Euripides, Plato and Homer in ancient Greek, and Cicero in Latin, as well as Chaucer's *The Canterbury Tales in Middle English*. She has also been compelled to cross-reference the Bible in the original Hebrew and ancient Greek.

Acharya S also has been been published in *Exposure*, *PARANOIA*, *Abyss* and regularly at the *Steamshovel Press* web site and many other periodicals. She also has appeared on many radio and television programs around the country. and lectures regularly. She will be appearing, along with *Steamshovel* editor Kenn Thomas, David Hatcher Childress, Richard Noone and others at the WEX Conference in Kempton, IL on May 5, 2000. Call 1-800718-4514 for more information.

Contact: acharya@artnet.net web site: www.truthbeknown.com

Book Reviews

THE COMMON PLOT

Conspiracy Theories: Secrecy and Power in American Culture
By Mark Fenster

a review by Len Bracken

Conspiracy Theories: Secrecy and Power in American Culture (Minnesota, 1999) by Mark Fenster reflects the author's efforts to describe and analyze conspiracy theory culture, but it doesn't address conspiracy theories themselves in a serious way. The infamous Gerald Posner claims that the book is a comprehensive analysis. It is not, and I will tell you why. But first recall that in its Latin roots, to conspire means to breathe together. This etymology indicates how widespread conspiracies are - people routinely breathe together and come together for a common purpose or plot. A restaurant patron conspires with the host to get a better table by passing along a twenty dollar bill, and so on. Fenster acknowledges that conspiracies take place, but he is skeptical about the usefulness of conspiracy theories to explain history. This doesn't surprise me.

Fenster's specialized training in law and his doctoral studies completely obscure everyday life from his experience. Academics reflexively view everyday life as an object to be studied with appropriate research tools. For some of us who are outside of professions and fully immersed in everyday life, the issue of conspiracies proves the axiom that historical consciousness is consciousness of everyday life. People conspire to drink in public without getting caught by concealing themselves in an obscure part of a park, just as Nixon's plumbers carry out their

conspiracies under cover of night. We shouldn't be surprised to find so many conspiracies in history.

In *Arch Conspirator*, (recently published by Adventures Unlimited Press) I give a few relevant examples. The first chapter of the first book of European prose, *Histories by Herodotus*, is about a conspiracy between a queen and her king's bodyguard - the first conspiracy in history, which happens to be verified by other accounts. You want more evidence?

I recount the classical conspiracies perpetrated by Spartacus to free slaves and by Cataline to cancel debts. No less an authority than Machiavelli, himself accused of conspiracy, notes that more princes have lost power by conspiracies than any other way. The years since Machiavelli wrote his famous typology of conspiracies have only added evidence to what many recognize as a fact of everyday life - people conspire in routine ways. It makes sense to theorize about ulterior motives and methods.

I won't try to read between the lines for signs of Fenster's sympathies with the likes of Noam Chomsky and the editor of *Z Magazine*, whom Fenster describes as realists for their structuralist dismissal of conspiracy theories. With these structuralists in mind, I would like to mention Fenster's main indictment of conspiracy theories, namely, that they are an unlikely way to exercise political will in what we might agree are oligopolies disguised as democracies. This isn't the place for a critique of structuralism (see my "Extra Notes on Guy Debord – Revolutionary" in the forthcoming tenissue collection of *Extraphile*), but it seems to me that structuralists are the least likely ones to make historical interventions because they push historicity to the background and because they fail to conspire against their enemies.

Structuralists find a given structure here and there and think it's the same thing; they discount the historical uniqueness of events. And on its surface, global unification of the commodity economy appears to support structuralist claims. But this unification is itself a unique historical event, indeed, it is the historic moment of our time that eclipses all wars and political assassinations. How does this unification happen? Has a static structure been imposed on the masses? Many of us contend that the commodity economy reproduces itself on a daily basis by billions of people selling themselves as commodities at work and consuming commodities in other aspects of everyday life.

To put it another way, people conspire with the commodity economy to reproduce it on a daily basis with hundreds, or even thousands, of often mindless acts. And they always find new ways to conspire for the system, ways that make the economy evolve by pushing the commodity into new reaches of everyday life. The conspiracy theory that I favor is one that interrupts the reproduction of the commodity economy with acts of refusal, such as the refusal of work or the refusal to consume commodities or theft or the destruction of commodities. These acts seem small, but given our situation, they are potentially historic events if the examples can be communicated and thereby inspire more conspirators.

In *Arch Conspirator*, I've outlined a conspiracy theory along these quixotic, utopian lines called "The Zerowork Theory of Revolution Including a General Theory of Civil War," which I invite Mr. Fenster to review so that he could see how, with a little reversal of perspective, conspiracy theory becomes strategic theory. As for part of what Fenster calls conspiracy theories, such as texts like the largely discredited Gemstone File, from a strategic perspective, they act like

intelligence reports that prepare one for worst case scenarios. Elements of these heretical versions of history can serve as propaganda in a psychological war aimed at winning the masses away from allegiance to bosses and the state.

Accurate conspiracy theories like Gianfranco Sanguinetti's *Terrorism and the State*, about COINTEL-style right-wing provocations in the name of the left in Italy, are highly instructive. At a time when so many spies of different stripes are ready for action, Sanguinetti's disclosures imply that one should avoid political militancy and fight a propaganda war that discredits not only the right, but also the false left. Sabotage at unambiguous places like the workplace is aimed at the boss without confusing the masses, whom we want to conspire with us against the commodity economy. I take it from Georg Groddeck, a colleague of Freud who actually helped many people at the spa town Baden Baden, that it is healthy to have utopian visions and aspirations. The Bible even refers to paradise as a place where people don't work; we conspire for paradise on earth.

I mention the Italian experience of the strategy of tension, also referred to as the Gladio conspiracy (for a chronology see "From the Egg to the Apples" translator's appendix in the English edition of Sanguinetti's *The Real Report for the Last Chance to Save Capitalism in Italy*), because it proves my point about the validity of conspiracies, and also because it points to the provincial nature of Fenster's book. A quick look around the world confirms that people risk their lives in conspiracies all the time. Armenia, Pakistan, Mexico - these countries remind us that assassination politics happen. Most scandals are conspiracies, even scandals like well-known married politicians conspiring to have affairs and cover them up. Fenster could have been much more totalizing in his conception of conspiracy phenomenon. Was he comprehensive? I don't think so.

Instead of taking on a conspiracy theory the caliber of, say, Quigley's *Anglo-American Establishment*, Fenster focuses on *X-files*. Instead of weighing the convincing details regarding October Surprise, he looks at the humor of *Illuminatus!* Instead of comparing the serious theories concerning the bombing in Oklahoma City, Fenster focuses on a novel, *Turner Diaries*. Sure, the novel was an ideological influence on McVeigh, but it isn't a conspiracy theory of the historical event.

The most aggravating aspect of this displacement of the real by representation was Fenster's discussion of conspiracy theory in everyday life. Rather than the obvious scenario that I sketched above whereby most people conspire with the commodity economy on a daily basis, Fenster's discussion centers on Christians whose prophecy, not theory, has nothing to do with everyday life and everything to do with heaven. In this light, juxtapose, if you will, Norman Cohn's well-known contempt for millenarianism, cited by Fenster, with the views of Raoul

Vaneigem in *Movement of the Free Spirit* about the liberating aspects of this millenarian sect's hedonistic heresy on the lives of the partisans. These are different times, and when Fenster depicts the Christian militia movement that is so close to the Republican party, I'm reminded of George Bataille's definition of a fascist as a Christian with a gun.

We are insufficiently antifascist here in the United States, to a woeful degree, and it should be a moral obligation to make theories about networks of ex-military intelligence types turned militia with ties to white supremacists, the Klan and to Congress. To his credit, Fenster does some of this, although I'm sure he knows he could have gone much further in this direction. He had other priorities, such as attempting to ground his analysis on the work of the political scientist Richard Hofstadter, who, in describing American paranoids and their populism, was himself engaging in conspiracy theory. Fenster wisely abandons most of this analysis and makes an interesting remark about Hofstadter's discussion of McCarthy - the paranoid of paranoia wasn't antifascist, nor was he concerned with the antidemocratic aspects of McCarthyism.

Unlike Hofstadter, Fenster gives hints throughout the book that his heart is in the right place. But he somehow ignores what I consider to be one of the most dangerous conspiracies of the postwar era. How shall I put it? The most succinct expression of this conspiracy theory is to say that Germany won the second world war.

Does the phrase Black Orchestra mean anything to you? No? Study the Portuguese Revolution of 1974-1975 and examine the documents pertaining to international neofascism discovered by the revolutionaries. Look into the role of ex-Nazis and Nazi collaborators in the US government, not just the CIA where their supreme role is well known. You might look at the Torbitt document for the possible role of a high-profile Nazi in the assassination of JFK, but also look at US support for neofascism in Greece, Italy and other places under other names. Follow the Nazi rat line from the Vatican to places deploying death squads while closely allied with the United States. Look at the Nazi collaborators who attended Reagan's White House dinners and the known fascists who worked for the Republican party for years and played a large role in exCIA director George Bush's successful presidential campaign. Investigate Bush's ties with the P2 Masonic lodge in Italy and its well-documented sponsorship of terrorism. Look at the war criminals and exdictators that Senator Patrick Leahy calls the "new Nazis" who have been given refuge in the United States. Germany won the second world war to the exact degree that the United States supports, embodies and harbors fascism.

FATHER OF LIES

Allen Dulles: Master of Spies by James Srodes

a review by Uri Dowbenko

What can you say about a dead white guy whose own wife called him "The Shark"?

Yes, Allen Dulles was a lawyer. He worked for the powerful illuminati law firm Sullivan & Cromwell, where daily conflicts-of-interest were a way of life, whose clients included multinational corporations as well as foreign governments, and whose big money deals shaped the destiny of the planet.

In his high profile career which spanned two World Wars as well as the Cold War, Dulles was also a director of the Central Intelligence Agency and a director of the Council on Foreign Relations.

Finally, Dulles was a moral, intellectual and physical cripple. His

philandering was notorious. His acquiesence to the wishes of his masters -- the Anglo-American Establishment -- is a matter of historical record. And ironically, he also had a club foot, like Dr. Sidney Gottlieb, the amoral director of the CIA's Technical Services Division, responsible for the Agency's devilish mind control programs.

James Srodes, author of *Allen Dulles: Master of Spies*, (Regnery, 624 pp., $34.95) has produced a sanitized whitewash of a biography, completely avoiding Dulles culpability in many heinous crimes against humanity.

During Dulles's tenure, after all, the CIA continuously used people as involuntary human guinea pigs. In their hubris, the arrogant spymasters believed they were accountable to no one, the lives of their victims mere Olympian playthings.

This dysfunctional mindset of the power elite is the psychopathology of Dulles himself and many others who consider themselves the moversand shakers of the twentieth century.

NAZIS BANKROLLED BY WALL STREET

With blithe disregard, Srodes downplays the importance of the collusion between Big Business and Big Government, writing "there is little doubt that a close relationship between the State Department and the senior partners of Sullivan & Cromwell suited all the parties well ...Questions of conflicts of interest rarely arose in a time when the interests of commerce and government were so closely allied."

Closely allied? That's Srodes quaint way of saying that the Old Boys Club parasites infested government as well as business.

Most bothersome, however, is Srodes's dedicated ignorance of the build-up of the Nazi War Machine by Wall Street investment bankers. For instance, in dealing with the Schroeder bank's involvement with financing Hitler, Srodes is disingenous at best. He claims that it was a "different" Schroeder bank because of the different spelling of the surname, even though the name was anglicized in its British incarnation.

"There never was any proof that Sullivan or Cromwell or the Dulles Brothers of the London Schroeder Bank ever had ties to or dealings with von Schroeder," huffs Srodes.

The facts remain that Srodes's disinformational biography disregards well known facts recounted in former Hoover Institution scholar Antony C. Sutton's landmark history, *Wall Street and the Rise of Hitler* (1976) "Who was Schroeder?" asks Sutton in his book. "Baron Kurt von Schroeder was born in Hamburg in 1889 into an old established German banking family. An earlier member of the Schroeder family moved to London, changed his name to Schroder (without the dierisis) and organized the banking firm of J. Henry Schroder in London and J. Henry Schroder Banking Corporation in New York."

In his well-documented story of the American financiers who provided the money and materiel Hitler used to launch World War II, Dr. Sutton recounts how Nazi Baron Kurt von Schroeder "acted as a conduit for I.T.T. money funneled to Heinrich Himmler's S.S. organization in 1944, while World War II was in progress and the United States was at war with Germany."

Furthermore, in recent correspondence with this author, Dr. Sutton writes that "New York was so determined to conceal the WWII links that a vice president of New York Schroeder Bank (Bogdan) was put in uniform and sent to Germany to grab the [incriminating] paperwork before US troops even reached Cologne."

The American subsidiary of the notorious Nazi firm I. G. Farben, called American I.G., was under the control of an American citizen named Halbach, nominally a consultant to the firm.

When his bank accounts were blocked after Pearl Harbor, Sutton writes, "Halbach filed suit against the Alien Property Custodian through the Establishment law firm of Sullivan and Cromwell to oust the US Government from its control of I. G. Farben companies. These suits were unsuccessful, but Halbach was successful in keeping the Farben cartel agreements intact through World War II."

"This tells me someone even today wants to keep history concealed," says Sutton. "The work of the Control Commission for Germany would be a very productive research project," he concludes.

DULLES AND THE WILSON PUPPET

In spite of himself, Srodes lest the truth out during unguarded moments. For instance, describing the way that President Wilson was controlled by his notorious handler 'Colonel' House, Srodes writes that "Wilson created a special advisory group, The Commission of Inquiry. It quickly became known as the Inquiry and the press called it Wilson's brain trust. Under Colonel House's direction, the group was made up of historians, geographers, economists and other experts on world affairs...With typical Wilsonian confidence, the president told his advisors not to bother him with the details of the issues he would confront, 'Just tell me what is right, and I will fight for it," he said." In other words, Wilson handled himself like an obedient puppet.

Srodes also does nothing to illuminate Wilson's obsession with the League of Nations, a failed precursor of the UN. "His fixation, which used the young Allen Dulles and his brother Foster Dulles, resulted in the Treaty of Versailles, which by carving up ethnic groups and nations was in due course responsible for setting the stage for World War II."

"Major participants began to flee Paris at once," writes Srodes, "though there remained an enormously detailed set of agreements on borders, arms trade and nationalities -- thirty five separate committees in all --that would have to be worked out for the final act of the drama, the Treaty of Sevres signed in August 1920."

Allen Dulles, meanwhile, failed upward -getting more responsibility from the Power Elite to fulfill their mandates.

MIND CONTROL -- THE SOLUTION TO DULLES'S PROBLEM WIFE

The illuminati double standard in sexual ethics – "do as I say not as I do" -- is underscored by Dulles's "private" behavior.

"Allen Dulles was a womanizer by any standards," writes Srodes. "It is inconceivable that he would have been hired by the CIA at all, let alone serve as its director for as long as

he did, if today's intense scrutiny and censorious attitudes had existed in the 1950s."

"His penchant for flirtations and flings [Srodes can't bear to call them affairs] drew frequent rages and warnings from Clover [Dulles's wife]," pontificates the author.

"Clover had come to terms with her husband's philandering," writes Gordon Thomas in *Journey into Madness: The True Story of CIA Mind Control and Medical Abuse* (1989). "It had been strong enough to have driven her to contemplate suicide," continued Gordon. "Each time she had discovered a new adultery she had gone to Cartier. She had filled a jewel box with expensive baubles marking his infidelities."

"Over the years Clover had also consulted several psychiatrists who had prescribed drugs that only momentarily masked her pain. It had been an Agency doctor, a kindly man, who had finally taken her aside during a reception at the French Embassy for Bastile day and said she could benefit from seeing a Dr. Cameron."

This was the notorious criminal Doctor Ewen Cameron whose hospital in Montreal became a living hell, the horror show setting for mind control experiments directed by CIA director Allen Dulles.

SANITIZING THE CFR

Srodes is just another spinmeister, sanitizing history in the tradition of other Establishment hacks. "His [Dulles'] early membership in the Council on Foreign Relations would prove much more important to his development," writes Srodes. In other words, if joining the Old Boys Club doesn't help your career, nothing will.

Srodes doesn't explain the significance of the CFR, a defacto U.S. Politburo, sister organization of the Royal Institute of International Affairs, whose mutual origin in Cecil Rhodes's Roundtable Group remains ground zero for contemporary globalists who dominate U.S. government policies and agendas.

The Council on Foreign Relations, the preeminent cabal of control freaks, is even quoted in the book from the 1944-45 Report as pronouncing, "Peace will need to be worked out as diligently as war has been."

The CFR's penchant for globalist micromanagement has been a bane for America ever since.

"From 1939 onward, Dulles had become one of the leading public proponents of the view that America's own defense security was inextricably entwined with that of Western Europe and particularly with that of Britain," writes Srodes.

"That year, he and Hamilton Fish Armstrong published a sequel to their 1936 argument against isolationism," he continues.

Undoubtedly Dulles's dull propaganda tract called "Can We Stay Neutral?" set the agenda for public acquiescence to the burgeoning war industry and further profiteering by Wall Street allied industries.

After all, how could you make money without a designated enemy?

THE WASHINGTON KREMLIN

Ironically, home to the OSS and the CIA -- a compound of buildings at 2430 E. Street N.W. -- was called "the Kremlin."

This bizarre moniker betrays the police state mentality of the OSS-CIA veterans who became the ardent fighters of communism.

As far back as 1945, the CIA has been called an "American Gestapo," most notably in a series of articles written by Walter Trohan in the *Chicago Tribune*.

During that time, General George Strong argued that the OSS was "possibly

dangerous" and that "it ought to be liquidated in a perfectly natural logical manner."

The specious argument that America "needed" an intelligence agency is betrayed by the fact that there were no less than eight different spy agencies in the US at the time.

THE CIA-MEDIA PROPAGANDA CONNECTION

"With a combination of hard dollar contributions and soft dollar services, major American corporations were enthusiastic supporters of both government and private cloak and dagger campaigns," writes Srodes.

"Correspondents for major newspapers, magazines and broadcast networks (notably TimeLife, NBC and CBS) doubled as collectors while the media outlets themselves shaped programming to propaganda needs," continues Srodes.

According to Deborah Davis, author of the definitive *Katharine the Great: Katherine Graham and Her Washington Post Empire* (1991), it was much worse.

Interviewed in the *Steamshovel Press* anthology *Popular Alienation* (1995), Davis says that "Philip Graham was Katherine Graham's husband who ran the *Post* in the 50s. He committed suicide in 1963. That's when Katherine Graham took over. [Benjamin] Bradlee was close friends with Allen Dulles and Phil Graham. The paper wasn't doing very well for a while and he was looking for a way to pay foreign correspondents and Allen Dulles was looking for a cover."

"So the two of them hit on a plan," says Davis. "Allen Dulles would pay for the reporters and they would give the CIA the information that they found as well as give it to the *Post*. So he helped to develop this operation and it subsequently spread to other newspapers and magazines. It was called Operation Mockingbird."

The *Washington Post* is a CIA front. Deal with it. CIA infiltration of the mass media is an historical fact. Is it taught in the prestigious Schools of Journalism around the country? Very unlikely.

THE DULLES-MAFIA CONNECTION

In mobster Sam Giancana's revealing biography, *Double Cross* (1992), "Mooney [Giancana] went on to say that CIA director Allen Dulles was the one who originally come up with the idea of taking out Castro."

"Two officials, Richard Bissell and Sheffield Edwards, were selected to put the scheme into action," write co-authors Sam and Chuck Giancana, godson and brother of mob boss Sam Giancana. "For the liaison to the Outfit [the Chicago based Mob], Mooney said they called on Bob Maheu [a Howard Hughes operative]."

"The guy from the FBI? The guy who used to be with the FBI. He has a cover, a detective agency," answered the elder Giancana. "He's working for our Teamsters attorney friend, Williams. That's how a lot of the guys work. Like Banister...Maheu and Banister work for the CIA all the time... They're good, damned good. And they've made me a lot of money."

The CIA's use of "cutouts," or go-betweens, put distance between the CIA's murderous deeds and the killers they hired. Most recently this practice has been called "privatization."

"After Mooney's initial meeting with Maheu, one arranged by his lieutenant Johnny Roselli, Mooney told Chuck he instructed Roselli to tell Santo Trafficante and Carlos Marcello he wanted them to provide the assistance necessary -their Cuban connections --- to pull off the CIA assassination plot," the book continues.

"Mooney made Roselli the go-between with Maheu and the CIA. Meanwhile

Mooney said he put Jack Ruby back in action supplying arms, aircraft and munitions to exiles in Florida and Louisiana, while the former Castro Minister of Games, Frank Fiorini, joined Ruby in the smuggling venture along with a Banister CIA associate, David Ferrie." These intimate connections between a notorious cast of characters from CIA, the Outfit and the JFK assassination players put credence to Giancana's contention, "That's what we are, the Outfit and the CIA, two sides of the same coin."

DULLES AND THE JFK MURDER

Then President John F. Kennedy had the audacity to fire Allen Dulles as director of the CIA. Why? He blamed himself and the CIA chief for the Bay of Pigs failed invasion of Cuba.

Enraged at the fiasco, Kennedy vowed to "splinter the CIA into a thousand pieces." Shortly thereafter the men who caused him public humiliation were fired -- CIA veterans Allen Dulles, Richard Bissell and General Charles Cabell.

It has been duly noted that CIA agents loyal to Dulles had been placed throughout the United States. Also the Nazi spymaster Reinhard Gehlen's German and Eastern European agents, exfiltrated after WWII, were positioned in Houston, Dallas, Fort Worth and New Orleans, where they would be later useful in providing a smokescreen for the Warren Commission's coverup of JFK's murder.

When President Johnson appointed Dulles to be a member of the Warren Commission to probe the JFK assassination, there was more than a little irony that the former CIA spymaster got the job.

When you need a first class coverup, call a professional. The blatant conflict of interest was once again covered up by the media watchdogs turned lapdogs. The fix was in.

Interestingly enough, Srodes writes that "the correspondence in Dulles's personal papers shows that a major preoccupation of all the commission members was to satisfy the American public that Lee Harvey Oswald had acted alone and above all, had not had any ties to the CIA, the FBI or any other arm of the government."

The Lone Nut Conspiracy Theory was born, and the Dulles-directed Warren Commission Report was produced -- a better historical fraud than even the Piltdown Man hoax.

DULLES -- ILLUMINATI GOFER

Even though "gofer of the illuminati" might be too harsh a sobriquet for Dulles, it is certainly not inaccurate.

As the ultimate insider and member of the ultra-secret Pilgrim Society, Dulles consistently followed his masters' agenda of internationalism. He steadfastly promoted globalism and the oligopoly's control of resources and nations, which the "useful idiots" -- as the Soviets use to call them -- believe will lead to the inevitable One World Government.

Allen Dulles: Master of Spies is a prime example of revisionist biography at best, -- or blatant hagiography at worst. It's another sanitized whitewash of a man who could be liberally characterized as a world-class criminal.

In his conclusion to the 570-page doorstop of a book, Srodes flirts with the truth and even briefly touches it. He writes that "Dulles was indebted to both his grandfather and uncle for his conviction that the safety of a free society must be protected by that institutional paradox, a publicly accountable secret service."

It is certainly secret, but most certainly not accountable.

"If that ideal was wrong, then Dulles was wrong and the concept on which the CIA was founded was also wrong," writes Srodes. "If the past fifty years were wrongly cast, then the Truman Doctrine, the Marshall Plan and the Cold War were all ghastly mistakes."

And that ghastliness remains Dulles's lasting legacy.

"His monument is around us," concludes Srodes, referring to the bas-relief medallion with Dulles's portrait, hanging in the central lobby of the CIA headquarters building.

That "monument" is today's surveillance society.

You can thank Allen Dulles -- Godfather of the National Security States of America.

Uri Dowbenko is Chairman and CEO of New Improved Entertainment Corp. and site manager of SteamshovelPress.Com. He can be reached by e-mail at:

u.dowbenko@cmailcity.com

SEX, ROCKETS AND JACK PARSONS

Sex And Rockets: The Occult World of Jack Parsons by John Carter

a review by Greg Bishop

Marvel aka John aka Jack Parsons was a weird guy. Most readers have probably heard of Parsons as Aleister Crowley's front man for the Ordo Templi Orientis in Los Angeles, or even as a pioneer rocket engineer (even though he was not a scientist and held no degrees.) He was all this and the selfproclaimed antichrist too. Parsons hated conventionality, authority, propriety, and hypocrisy, and dedicated his short life to the annihilation of the system that keeps most souls from realizing their true will. Ironically, it was the conventional aspect of Parsons' life that brought him his most lasting legacy. In the new release *Sex And Rockets: The Occult World of Jack Parsons*, biographer John Carter dispels many myths about the man, and uncovers many original documents, letters and transcripts that fill in the many blanks in his stormy life which ended literally with a bang.

He was born Marvel Whiteside Parsons on October 2, 1914. His father had an affair soon after which caused his mother Ruth to divorce him in forthwith. Forever after Ruth Parsons would vilify the memory of her husband to her son, which in turn caused the adult Jack Parsons to forever search for a father figure. Jack acknowledged this fact in his diaries. Carter unearths an unsubstantiated story that there were home movies of mother and son having sex with each other and the family dog. If true, Parsons may have passed up his master Crowley in the taboo-breaking/ ego destroying department.

In 1939 he discovered a copy of one of Crowley's books and soon after showed up on the doorstep of the Pasadena lodge of the OTO. Within a few years, Parsons was deeply involved in occult practice, and started up his own lodge in a 10 bedroom house which he had purchased with the profits from his wildly successful rocket work. The ads that Parsons placed for tenants in his bohemian paradise specified that those who believed in God would need not apply.

Carter documents Parsons' regrettable association with fledgling science fiction author L. Ron Hubbard in the mid 1940s as his partner in ventures occult and capitalistic. Hubbard charmed Parsons young girlfriend away from him while paradoxically helping him initiate the Babalon Working--a series of ceremonies that were designed to destroy the old order and bring about a new age of

personal freedom guided by an unnamed leader whom Parsons envisioned as a woman. Hubbard later ripped off his new friend to the tune of almost $20,000. Carter calls Parsons' naivete along with his occult hubris probably the greatest factors in his failure in matters magickal and worldly.

Thoughout his adult life, Parsons turned to his self-taught expertise in explosives to pursue his other True Will. He was one of the founding members of the Jet Propulsion Laboratory, and is so honored on

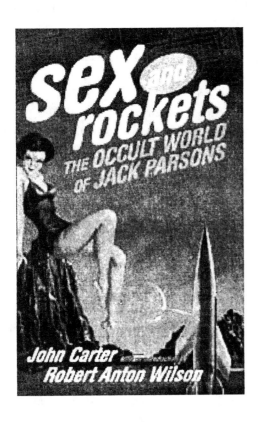

a plaque near the visitor's center. His eccentricites were accepted by his cohorts, even his habit of stomping around and invoking the god Pan before rocket tests. Carter documents Parsons' JPL work with painstaking detail, probably giving the subject better treatment than any science-based history ever has.

Unlike most biographies, Carter doesn't shy away from the darkest reaches of his enigmatic subject, and Parsons' violent death in a (probably) accidental explosion is the stuff of classic tragedy. A short review like this just doesn't do justice to the awesome thoroughness of *Sex And Rockets*.

Caries, Cabals & Correspondence
Reader Letters

Address: *Steamshovel Press*, POB 210553, St. Louis, MO 63121

A few hours before I saw this photo of *Steamshovel* editor Kenn Thomas wearing William S. Burroughs' glasses and hat and standing in front of a painting by Aliester Crowley, I was reading Robert Anton Wilson's introduction to a book about Crowley. But I didn't read the book. Instead, I read Martin Luther King's first book, published in 1958. Indirectly, for a class, I'm supposed to choose a videotape for Black History month, having talked myself into a corner when I suggested the idea. So, I felt it best that I read up some on the source documents. At least King used simple language. When Burroughs died, the Montreal

newspaper article about him listed no writings any later than 1964. A guy showed me *The Job* and I thought it was hilarious, and that book was written well after 1964.

Above: *Thomas points out that the grass above Burroughs' grave on the family plot is greener than the rest. Might this be the result of the orgone energy Burroughs had accumulated during his life?*

If WSB's grave has greener grass, it is probably because it is younger grass, well fertilized in fresh sod with lots of minerals. The older grass around his grave has taken the minerals out of the soil over the years, or maybe it is a different breed of grass.

--X. Sharks Despot, Lansing, MI

There are assassins working pretty steadily for every intelligence service, for defense contractors and, probably, for very wealthy groups of people. With regard to [late Commerce secretary] Ron Brown, a thought came to mind regarding the mysterious 45cal hole in his skull. Since his assassin would have been a man with very strong survival instincts, he would not have gone down with the plane. And, he certainly would have been a skilled parachutist. Did anyone check to see if the number of bodies in the wreckage tallied with the warm ones that got on that plane?

Well, I wonder why the real power in our country decided to put a brilliant sociopathic crotch hound into the Presidency? And, why did they allow him to put the Chinese in a position to threaten us? There clearly is an effort underway to make major shifts in military, financial and moral areas worldwide.

We're in the crapper and an evil hand is gripping the chain.

Bob Alford
N. Wildwood, NJ

PS: Note for intelligence agents steaming open Kenn Thomas' mail: I certify that fears real and imagined have so damaged my mind and body that I pose no threat whatsoever to any individual or organization.

Ref: Jonathan Vankin's book on conspiracies, Apolloscam

Bill Kaysing is right to suggest that ALL of the Moonlandings were faked, and I think the world media are fully convinced after nearly thirty years.

However, I am inclined to disagree with Kaysing on what really took place back in 1969. His theory is that Armstrong, Aldrin and Collins were NEVER launched into space, but merely orbited the Earth in the same way as previous Gemini missions. The capsule we see returning to Earth is therefore returning from space, i.e., Earth orbit, and is certainly not returning from the Moon.

I have done many years research into the faked Moonlandings and have uncovered a colossal amount of blunders made by NASA when faking the saga, so much that I have now produced a website, but even then there are some pictures I cannot use due to their size. The website is only half completed at the moment, but the evidence is compelling enough, and it would be interesting to hear what NASA, or any former astronauts who claim to have walked on the Moon have to say about the discrepancies.

www.cybnet.co.uk/apolio one hip hoax/ bill clinton.htm

GO GET IT NOW! OTHER WEBSITES OVERLEAF

Yours faithfully,
Mr. Reality England

Above: *Kenn Thomas and Acharya S at George Van Tassel's Integretron in the Mojave desert, near where the moon landings alledgedly were faked.*

"Subvert anything of value in the enemy"s country. Implicate the emissaries of the major powers in criminal undertakings; undermine their position and destroy their reputation in other ways as well; and expose then to the public ridicule of their fellow citizens. Do not shun the aid of even the lowest and the most despicable people. Disrupt the work of their government with every means you can ...Spread disunity and dispute among the citizens of the enemy's country..."

When I first read the above lines attributed to the ancient Chinese military strategist Sun Zu, I immediately thought of Mae Brussell and her protege, John Judge. Judge's response in *Steamshovel* #16 to my letter in *Steamshovel* #15 has only strengthened my conviction that the "lowest and most despicable people" are still at it.

Mr. Judge denies being a communist even while he describes himself with communist euphemisms. Even more telling is his use of "anticommunist" as a slur. When communism is, by definition, the apotheosis of the state, why would one opposed to Marxist slavery be considered a monster by an "anti-statist"?

Because an *anti*-anticommunist is *per se* a communist. Mr. Judge can paint his red flag black, but anarchists are always communism's useful idiots. They inhabit the same end of the poltical spectrum, employ the same rhetoric, harbor the same resentments, and long for the same revolution. But anarchists, stupid enough to believe their own rhetoric, can't realize that their utopia can only be achieved at gun point. Communists, being cynics, know that their godfather Marx meant the "withering away of the state" to be the carrot at the end of the stick of proletarian dictatorship. Anarchists who insisted on anarchy would join reactionaries in the grave of the Gulag.
--G. J. Krupey
N. Huntingdon, PA

Steamshovel debris: Mr. Krupey's full, ten-page response to John Judge is available from him for $1 plus a self-addressed, stamped enevelope at 12415 Larimer Avenue, N. Huntingdon, PA 15642. John Judge can be contacted through Prevailing Winds Research, POB 23511, Santa Barbara, CA 93121.

The Morongo Indian Reservation abutts Banning to the latter's east here in the pass on the high road (US 10) between the piles of Palm Springs (both kinds) and the pile ups of LA. They aren't really the Cabazon Indians, as your article in #15 names them, that's just the name of the town (of sorts) that sits next to the freeway through their area (an area that borders the road and runs up into the foothills and mountains toward Mt. San Gorgonio, but doesn't include all the property immediately adjacent to the road). Up to a few

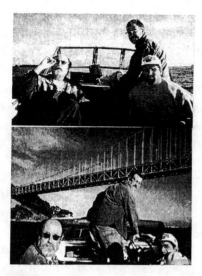

Above: Thomas, *Flatland*'s Jim Martin (at the helm) and *Konformist*'s Rob Sterling (www.konformist.com) boating in the San Francisco bay.

years ago Cabazon was a primeval gas station, a fruit stand, and some shanties and trailers loosely strung out among wrecked cars and old tires. Now its worse. It has all been bulldozed away and replaced with a massive complex of scores of schlock-selling, card-maxing, factory discount stores that pull in Americans who still have jobs, but mostly (it seems) busloads of banzaiing Japs (whoops, old propoaganda recrudescing!) on vacation who see all the Toyotas, Datsuns, etc. in the parking lot, as well as all the familiar names on the big new container freight cars rolling by on the Southern Pacific tracks, and thank their lucky stars they lost the war.

Not wanting to miss out on the take, the Morongos built a big glitzy Indian-revenge casino nearby that empties the pockets of the white-eyes round the click. Their sign flashes, "we want you to win!" Uh huh, just like they wanted Custer to win at Little Big Horn. But heck, the tribe splits up the swag and now they're all off welfare. Now one would think that such a turn of events would be welcomed by those of countenance pallid who have long crabbed about having to support Indians--all of whom were lazy, no-account drunks.

One would be wrong. Now they're complaining because the filthy redskins are out of their breechclouts and into suits.

By the way, the Morongo tribe has nothing to do with Indio, a city about thirty miles to the east. The Morongo reservation only extends about one fourth of the way to Indio. I think the Agua Caliente tribe has some of its territories around there. They also have a lot of the land in and around there. They also have a lot of the land in and around Palm Springs. Smart enough years ago only to lease some of their lands when the Hollywood crowd withtheir airconditioners and golf bags began to move in, the Agua Calientes have done well.

Richard Horton
Banning, CA

Burroughs' grave

POPULAR PARANOIA, page 264

"What private griefs they have, alas, I know not that made them do it. They are wise and honorable, and will no doubt with reasons answer you."

-speech of Marc Antony, Wm. Shakespeare, *Julius Caesar*, Act III, scene II

DIMLY VISIBLE THROUGH A FOG OF EVASIONS

IN MEMORY OF A FRIEND

By Wayne Henderson

Steamshovel debris: This magazine never expected to include the great Jim Keith in its Table Tapping issue. However, last September the long-time *Steamshovel* contributor, former publisher of the zine *Dharma Combat*, author of the two classic works on Black Helicopters, plus volumes on mind control, the Gemstone File, the OKC Bomb, Alternative Three, the Men In Black, and all other varieties of conspiracy and parapolitical topics, died of a blood clot after entering Washoe Medical in Reno for treatment of a simple knee injury. The controversies and possible conspiracies surrounding this tragic event have been discussed widely. Kenn Thomas made two national television appearances calling for an official investigation and assumed the chores of Keith's *Nitro News* column for several weeks before until that web site closed up shop. Details about Jim Keith's death appear at the web site created by his friend George Piccard at

users.intercomm.com/gpickard/jimkeith/

Steamshovel maintained a Keith memorial web site with comments from the many who knew and loved Keith, including Len Bracken, Jim Martin, Acharya S, Ivan Stang, Jim Hougan, Joan D'Arc, Timothy Beckley, Jay Kinney, Adam Parfrey and many others. IllumiNet Press has just released a new book by Keith, *Mass Control: Engineering Human Consciousness*, and has a few more Keith manuscripts to be published in the future. Below, another close friend of Jim Keith's, Wayne Henderson, now serving a life sentence for a crime he did not commit, offers his tribute.

[a trailer, outside Reno Nevada, early morning]

He is disheveled; still wearing most of what he was wearing last night (good performance. GREAT party) and the first thing he notices is that he's got a monumental case of dragonmouth, and a headache. Oh, and his leg hurts.

He rises, goes to the bathroom with a cup of strong coffee in his hand and some Led Zepellin on the stereo. The aspirin starts to kick in, the headache begins to fade. His leg hurts. He gargles, showers. Gets another cup of 40-weight coffee.

He rummages through a pile of papers on his kitchen table/workdesk. Book manuscript (GOT to finish that intro) Emails articles letters (gotta answer that one from IllumiNet) back issue of *Steamshovel Press* (his leg hurts) more letters more E-mails (should get online today, *Conspiracy Journal* is due) dog eared invitation to a party at the Burning Man festival, what was I looking for, anyway?

(god-all-MIGHTY what the HELL did I do to my LEG?) on the phone, make arrangements to go to the hospital and have a doctor look at this, put a splint on the darned thing, I've got work too, for chrissakes...

after the failure of Walter Raleigh's 1585 expedition to establish a colony on Roanoake island, it took a generation before the British were ready to mount another attempt. Even then, interest in colonization was hard to raise. Francis Bacon and others formed the "Virginia Company"; ostensible, to Xtianize the "Heathen Indian Savages"; the first party of 144 men, landed on 14 May 1607, were a mixed bag of English "Gentlemen"; second and third sons of wealthy families who expected no great inheritance nd in search of easy riches - and totally lacking in the skills necessary to survive in the unbroken wilderness. Their code of conduct forbade them from doing any physical labor, such as arming; however, while their company included such necessary 'highe" servants as jewellers and a perfumer, these Brits - the "Crown of Creation" - had neglected to bring a single farmer. To rub shoulders with such menials on the long journey to the New World would have been an affront to their class identity, and it never occurred to these high-caste imbeciles that their wouldn't be servants and serfs awaiting them in the forests primeval. Not taking servants was a mistake that would never again be repeated, and heaven forbid that anyone should ever inform the classes of just how essential their labor truly is.

[unmailed letter, dated 31 August 1999]

Dear Jim - Well, I got the copies of the writ done; I'll be filing it with the 9th Circuit court sometime next week. I'm just glad to be out of the state courts and that damned Northern District court - I'm sure I'll get some action in the 9th, though I expect it'll still be close to a year, at the earliest, before I'm finally out. We're still on for a victory party? I can stop over on my way east, make it a daylong layover in Sun Valley... how far are you from the Amtrak station? I'm afraid I don't have anything publishable on the Y2K thing, but I know this much: it's no damned accident. I'd like to see a copy of the book when it comes out. Gotta run - life in here is an endless series of lines to wait in. Give my best to Aerika and Verity [*Steamshovel* debris: These are Jim Keith's two daughters.], and write back when you have a chance. I'll hold this letter until I can enclose a copy of that article I promised you. Namaste, Wayne. PS: the sheer number of UN-grey planes flying overhead in this area would give you nightmares!

[ER, near Reno]

"My leg is WHAT?"

"Broken - you really should've come in sooner. Nothing serious, though."

"So, you can splint it and I can be on my way?"

"We're still looking at the Xrays, but it seems pretty simple. If you hadn't walked on it-- so much, we could've just put it in a cast and had you home in around an hour..."

"Well, how long will this take?"

"We're still looking at the Xrays; we'll know in a little while."

[pay telephone, ER, near Reno]

"I don't know, these sons of bitches never tell you a damned thing if it doesn't serve their interests. Still looking at the Xrays, they said... [pause] No, well, aah ...they said I should've come in sooner, shouldn't've been walking on it ... [pause] Hell no no way. Operate? For a broken bone? I can't see why... tell you the truth, I honestly believe that if I ever did need surgery, like if they had to put me under? I don't think I'd survive it ...I, ah...[pause], No, nothing concrete ... [pause.] No, maybe I'm just being paranoid [laughs] ... no, I just get this feeling, one of those gut reactions..."

When the stored food ran out, the "gentlemen" of the Virginia Company grew hungry. Were it not for the unusual tolerance and charity of Chief Powhatan, the "gentlemen" would have starved to death in short order. As it was, in less than two years, only 38 of the original 144 colonists were still alive at the Jamestown colony. When the rescue and resupply mission was finally launched in 1609, the 9-ship feet managed to steer itself directly into a hurricane, and the flagship ran aground on Bermuda. The elite "gentlemen" and their heirs know full well the necessity of having serfs to toil, and the necessity of keeping them ignorant of their own power, as well as the machinations whereby the elite accomplish this goal. Any who dare to rouse their fellow slaves against the masters seals his fate.

[admissions desk, ER, near Reno]

The keystroke operator finishes entering a document, sets the form aside, and picks up another admissions/insurance form; places it in the holder, and begins entering the information into the System. Name: KEITH, James. Insurance Carrier No.: ...

[*MIND CONTROL, WORLD CONTROL*, J. Keith, Adventures Unlimited Press 1997, pg.309]

"...the response is standard: this is science fiction. Certainly the technology of surveillance and control has been evolving at rapid rate, the average person responds, but it will be years, perhaps centuries, before true mind control is achieved. Think again. The response in itself is a carefully cultivated mind state. The true capabilities of technology have been concealed... There are no limits to the control that can be induced upon the population by technology as it currently exists."
[*Mein Kampf*, Adolf Hitler]

"...we must not let political boundaries obscure the boundaries of eternal justice ... the law of self preservation goes into effect"

[basement computer room, government office, Indian Springs Nevada; adjunct to Nellis AFB, 330 miles SW of Reno]

Two clerks, 02 security clearance, are playing gin rummy on a cardboard crate; they are surrounded by display screens, keyboards, and megamemory stacks. The lights are medium-low; there is a barely audible hum from the computers, and several nude photographs of Anna Nicole Smith compete for attention from the inside door of the toilet, which is ajar. A yellow light flashes by a display screen to the immediate right of the younger of the two clerks.

He observes the name and information scrolling down the screen, enters a search program. Another monitor displays a list of known associates, as well as the name of the FBI section chief currently designated as custodian of the casefile on "KEITH, James". The clerk enters a few keystrokes, shunting the information to the section chiefs office, and returns to his game; if he could just draw a nine of clubs, he could go out right now...

one of the dissenting groups within the English Xtian 'community' was the 'Separatists' religious zealots who believed that the church and its membership were unredeemably corrupt and beyond any possibility of reform, an opinion they also applied to anyone else outside their own ranks, as well as anyone within their ranks who dared argue the point. These Separatists were of the lower classes, menials, essentially the jesusfreak white trash and trailerpark bornagains of their era. King James I chased them out of England entirely; led by one William Bradford, they sought sanctuary in Holland, where Bradford collected a tidy sum farming them out as slave labor. Using his connections among wealthy British merchants,

Bradford arranged to take his slaves history remembers them as the Pilgrims, God's Frozen People - to the "New World". Although originally headed for Virginia, where they could be used by the Gentlemen of the Virginia Company, the Mayflower - a leaky derelict ship that wasn't expected to survive the ocean voyage (which would solve the 'Pilgrim Problem' for decent people back in Europe) was blown hundreds of miles off course, to the Cape Cod peninsula, where by blind luck they landed at the only spot for hundreds of miles where the refuse of Europe could settle without instantly providing target practice for the fiercely territorial coastal tribes. Thanks to the generosity of neighboring tribes, the Pilgrims survived; within ten years, the surviving outcastes had tamed a few areas and made it liveable. At that point the Puritans - who had fallen out of favor with Charles I - began arriving. Unlike the Pilgrim trash, the Puritans represented families of some wealth and standing. These Puritans became the nascent political power structure, the "masters" in the stolen lands. For their efforts, the Pilgrim trash were given the same sort of "jobs" their descendants hold today: tax collectors, televangelists, pit bosses and jackbooted gestapo thugs, to keep the even-less desirable slave castes in line.

[SECRET & SUPPRESSED, J. Keith, Ed., Feral House 1993(preface)]

"Careful examination of the facts will reveal something curious to the unbiased: America's electronic and print media are simultaneously 'free' and heavily controlled... To go beyond the brainwash requires only a modicum of curiosity and self-motivation."

[A PEOPLE'S HISTORY OF THE UNITED STATES, Howard Zinn, Harper Books, 1980]

"...by forced exile, by lures, promises, and lies, by kidnapping...poor people...became commodities of profit for merchants, traders, ship captains, and eventually their masters in America... the voyage to America lasted eight, ten, or twelve weeks, and the 'servants' were packed into ships with the same fanatic concern for profits that marked the [African] slave trade ... the sloop SEA FLOWER, leaving Belfast in 1741, was at sea sixteen weeks, and when it arrived in Boston, forty-six of its one hundred six 'passengers' were dead of starvation, six of them eaten by survivors...As the colonies passed their hundredth year...the gap between rich and poor widened; as violence and the threat of violence increased, the problem of control became more serious. What if these different despised groups - the Indians, the Slaves, the poor Whites - should combine? Even before there were so many Blacks, in the Seventeenth Century, there was, as Abbot Smith puts it, 'a lively fear that the servants would join with the Negroes [and] Indians to overcome the small number of Masters'."

[BLACK HELICOPTERS OVER AMERICA, Jim Keith, IllumiNet Press 1994]

"The reason I believe that the commitment of the entire populace of the United States to prison camps is not the likely scenario, is that we are already incarcerated in one of the most devilishly effective concentration camps ever devised..."

[ER, near Reno]

"...OPERATE?!?"

"Yes, Mr. Keith, we need to operate. If you'd stayed off the leg after breaking it..."

"Well, listen, I don't want a general, just a local..."

"Calm down, Mr. Keith, we can do that, not a problem..."

[nondescript office, Fort Rucker, near Dothan Alabama]

The section chief is out of his office, momentarily, to use the executive washroom. A secretary notes a name flashing on his monitor - one of the low-level 'notice' files. She reflects, momentarily, weighing options. The section chief had Mexican food last night; his sojourn in the washroom will be uncomfortable (to say the least), and his mood will be foul for the rest of the day. Better not piss him off, she thinks, as he reenters the office. His mood is unspeakably bad, and his sphincter is burning like a nuclear meltdown. He notes the name on the screen - another of those damned conspiracy buffs; passed someone off, mentioned the name of some doctor or something. In the hospital, now, for something. The section chief strokes a few keys, opts to shunt- the case to Ops for a decision, and hits the 'send' key just as the second of several servings of pork taquitos with quacamole leaves a stain in his boxers that will not wash out, ever...

By 1785, the Columbian Lodge of the Order of Illuminati, established in New York City after the Illuminist Congress of Wilhelmsbad, boasted such members as Governor DeWitt Clinton, Horace Greeley, and Clinton Roosevelt. In his writings, Roosevelt described the US. Constitution as "hastily put together when we left the British flag"; and therefore in need of drastic revision he, and his Illuminist colleagues, considered the document fatally flawed in that there were too many checks and balances - such as those pesky First and Second Amendments - that could protect the rights of the slave castes against the enlightened self-interest of their hereditary masters. Grand Architect of the Universe forbid that an armed population of slaves, mistakenly taught to read, should ever set eyes upon tracts, let alone books, that would awaken them to the degrading depths of their true enslaved condition. While laws exist to squelch such revelation -from the Alien and Sedition Act of earlier this century, to the more recent & more pernicious Antiterrorism and Effective Death Penalty Act of 1996 - the policy, of silencing dissent is accomplished clandestinely, always clandestinely, and almost always fatally; the slaves cannot be permitted to know the truth, and the few who do must themselves be too frightened by mysterious deaths in their ranks to speak above a whisper.

[nondescript military computer facility, Desert Range Experimental Station, abutting state route 21, twentytwo miles SW of Garrison, Utah; 210 miles ENE of Indian Springs, Nevada; 390 miles due E of Reno]

"What's that on screen four?"

"Referral to OPS - Section Chief, Fort Rucker - one Keith, James."

The second clerk, at monitor four, keystrokes in a search protocol. Information scrolls up the screen. The first clerk, still relaxing at his station, watches noncommittally.

"...conspiracy buff, books published, coupla lucky guesses ... hold on..."

"...what's up?"

"...list of known associates ...Thornley..that's that crank in Atlanta..."

"Yeah, the twenty-third Oswald..."

[laughter]

"Thomas, out at U-Missouri, conspiracy writer, publisher, radio show; Henderson, conspiracy writer, California prison he's at Vacaville"

"What, wackyvi-l-le? the psy-ops facility?"

"That's the one. L'see, Krupey, part-time mainstream writer, near Philly; Bracken - novelist; Bonds, publisher..."

"Bonds - he that one in Georgia?"

"Yeah, Illuminati press or somesuch..."

"Real sweet bunch he runs with ... any on The List?"

The second clerk reaches over to monitor three keystrokes, calls up "The List" - the White House Standing List of Enemies of the State, also called the "Enemies List"

"Got two - no, three - plus a whole lot of crossreferences."

"REAL sweet bunch. Real sonafabitch."

"Low-level threat to national security [checks screen] - arrest on sight warrant, active on DEFCON upgrade; he's strictly nickel-and-dime."

"Why the hell do we have it?"

"Hell, I don't know - the section chief just shunted it, no recommendations, nothing - all this guy does is make a few lucky guesses and write strokebooks. He could live next door to ya. v'de never know it...'

A third clerk, young, female, and somewhat attractive, enters the room, walks over to the monitor bank where the first two clerks are studying KEITH, James.

"What's up?"

"Got a real sonofabitch, here, potential threat to national security, you should see the crowd he runs with - real sweet buncha COMSYMPS and conspiracy buffs..."

"Yeah, the one was subpoenaed by the Warren Commision, co-conspirator in the Kennedy shoot; this one here's in lockup in California some kinda psychokiller."

"Fucking bad crowd, for sure. Should lock'em all up."

"Why do we have it?"

"He's in the hospital in... [pauses, reads screen] ... Washoe Medical, that'd be near Reno. Broken leg, surgery scheduled..."

"Rough customer, though - so he breaks a leg, he's still got hands, he's still on the 'net, spewing propaganda..."

"Yeah, y'don't underestimate these anarchists."

The female clerk seems incredulous.

"Anarchists? In this day and age?"

"Yeah, rough crowd. Section Chief at Rucker forwarded this one to OPS for handling, obviously wants us to take care of business."

"So, what do you guys do with him?"

[The second clerk pauses pregnantly, checking the screen on monitor seven a list of names and locations scrolls]

"We've got a guy right there, usually does out jobs for Nellis and Indian Springs, he's on-site and a Med Tech Assistant, full access; I'll just pass this along...

[pauses, checks a file, types a brief instructional paragraph, sends]

... to our guy on the ground and let him earn his keep.

"It does not take an extensive study of the masters of any age, the pharoahs, the kings, the popes, the Rothschilds, the Rockefellers, to verify their existence or to determine their modus operandi. This ruling class (in its darkest and sometimes hidden manifestations) is unfettered by such insignificant things as ethical or moral qualms. They uniformly view themselves as pure-blooded aristocrats and the minions beneath them in. The same way that most people view cattle - as animals to be harvested. This harvesting is usually done by the men ostensibly hired to protect us..."

Malcolm X. Karen Silkwood. Jessica Savitch. Danny Casolaro. And now, Jim Keith.

I have a hard time eulogizing ...not that I'm inexperienced with grief. My own dad died shortly after my fifth birthday, so I know how Aerika and Verity feel. My comrade Alan, an AIM activist, died under equally-mysterious circumstances back in '73. Two good friends, both committed Communists willing to dialogue with the Anarchist clique I ran with in Tampa, also dead - well, one dead, one missing & presumed dead (no body was ever found) back in 1960, right after the 'May Day 1980' fiasco. I'm no stranger to this - but it doesn't make it any easier. Especially not when it's someone like Jim.

Nor can I say that Jim was the 'target' of a massive conspiracy -much like the rest of us, out here on the fringe, he was a 'target of opportunity', just like that; like a warped mutant spider, those whose masks we insist on tearing off await in the shadows, not really targeting us, per se, just noting an opportunity when it arises and swatting us like flies.

We're all targets, when you get right down to it ... targets of opportunity, our names and known associates filed somewhere, to show up on monitor screens in isolated, nondescript government/military facilities at odd moments, subject to notice.

Nor can we quit doing what we do and keep our heads down, in the hope that we'll pass through this life unscathed. We do what we have to do, we stand on the housetops and shout to whomsoever will listen, sharing what we've found, hoping that enough people will finally wake up and smell the catbox. And keeping your head down doesn't work. Believe me, I know.

Jim Keith died for doing what we do. I, for one, do not believe in 'accidents' in these bloody, frightening times. There are too many connections, too many coincidences, too many questions left unanswered. All that really counts, right now, is that Jim Keith is dead; Jim, a friend, a mentor, a man who believed in his friends, who believed in the future, who believed in truth, and Truth, and the overwhelming importance of the search that would lead us, finally, to truth, and to Truth.

Jim Keith, who believed in me and made of me a Dharmic Combatant; Jim Keith, who (more than anyone else) helped me to mature, politically beyond mere politics; Jim Keith, who encouraged me and gave me opportunities that would otherwise have been unavailable

I believe there is more to us than is expressed and manifest in this life; that there is a state of existence beyond. I know that Jim is there, even now, comparing notes (and likely cutting up) with Malcolm, and Karen, and Jessica, and Danny.

Jim Keith has earned his wings.

Requiem in felix at amor
Wayne Henderson
Finished 2 Oct 1999

Diana and The Octopus

by Kenn Thomas

August 31, 1997: intoxicated to some degree with alcohol, Prozac and the sedative Tiapridal, chauffeur Henri Paul took two famous charges, Dodi Al Fayed and Diana Princess of Wales, on a ride into the Pont D'Alma tunnel underneath the streets of Paris. The only person in the S280 Mercedes sedan to emerge alive from the other end of the tunnel was the accompanying bodyguard, Trevor Rees-Jones. The sedan had passed a white Fiat and, after a blinding flash (1), it crashed into a concrete tunnel pillar at somewhere between 90 and 110 miles per hour. It ricocheted and smashed also into the opposite tunnel wall. Paul and the 42 year old Dodi Al Fayad died instantly. Paramedics gave 34 year old Diana a blood transfusion at the scene, but her heart stopped in the ambulance en route to the hospital and she died four hours after the crash.

Diana's death made a global impact similar in world history only to the Kennedy assassination. Just like that event, the details of how she died became matters of great debate and conspiracy theorizing. (2) Just as JFK's death was officially investigated and declared the result of a single gunman acting alone, official investigations of Diana's death concluded that it was a simple automobile accident. And just as with JFK, a preponderance of unlikely coincidences and unanswered questions left most people interested in the topic with the suspicion that the crash in the Pont D'Alma tunnel was an orchestrated assassination, done for the sake of keeping Diana from pursuing her relationship with Dodi Al Fayad, an Egyptian, a Muslim and the son of powerful businessman, Mohamed Al Fayed, at odds with the crown and other power elements in the UK (3). Some even suggested that Diana was pregnant with Dodi Al Fayed's child at the time of her death. While such speculation has become not at all unusual in the affairs of public figures, underneath the layers of various competing theories about the death of Diana lie facts, rumors and arcane connections that relate it directly to Danny Casolaro's Octopus research. In fact, three years after Diana's still unsettled death, which occurred six years after Casolaro's, the disaster in the Pont D'Alma tunnel brought the story of the Octopus, the PROMIS software, and Casolaro's world of Iran-Contra spies, arms merchants and corrupt politicos back in the news.

Conspiracy writers noted almost immediately the shadowy presence of Adnan Khashoggi in the background of the Diana death. Khashoggi was Dodi Fayed's uncle and a well-known broker of military hardware deals involving Saudi Arabia stretching back to the 1970s. (4) A few days

before his death, Casolaro took his friend Ben Mason down into his basement and proudly showed him several photocopied pages documenting contra arms transfers involving Khashoggi and a partner, Manucher Ghorbanifar. Casolaro even had copies of BCCI checks drawn on Khashoggi's accounts.

Mason later reported that Casolaro was elated over a source he was about to meet in West Virginia, someone Casolaro described to Virginia McCullough as being involved in guns-and-drugs transfers. Casolaro told a fellow hotel guest, Mike Looney, that he was meeting with an Arab. No one has suggested that Casolaro planned to meet Khashoggi or even a compatriot, but he was investigating Iran-contra arms dealings and he did place great importance on that final meeting, and called it something that would wrap up his Octopus research.

As with all of his research, however, this final tributary led to others involving Octopus entanglements beyond Iran-Contra and beyond PROMIS and Inslaw. Casolaro's focus on the Khashoggi documents at the end almost certainly involved knowledge of Khashoggi's April 1986 meeting with Tony Rowland, Australian tycoon, publisher of *The Observer* newspaper and an adversary of Mohammad Al Fayed's attempt to gain British citizenship. (5) Khashoggi, Gorbanifar and journalist/Israeli foreign adviser Amiram Nir attempted to persuade Rowland to join the Iran-contra effort by helping sell arms to Iran. The attempted alliance bogged down after the meeting, when Rowland inquired into US circles about covert support for such an effort.

It seems very likely that Casolaro knew about this alliance between Dodi Fayed's maternal uncle, Khashoggi, and his father's bitter enemy, Rowland. It's deeper significance, of course, became clear after Casolaro's death, and after Diana's.(6)

Although Casolaro had apparently wrapped up, or was going to wrap up after that final meeting, his research into Iran-Contra, he no doubt also took a strong interest in possible Octopus involvement in other covert arms deals with Khashoggi. That was no small list. It included such little and well known brouhahas in the world of international arms traffic as the Petromonde scandal, the Litton scandal, the Westland Scandal, the Lockheed scandal, the Northrop scandal, the Lina Al-Bassam scandal and, most importantly, the corruption involving the Al Yamamah contract and Iran-Contra. The amount of attention and detail Casolaro brought to all this parahistory remains lost in the accordion file that disappeared at his death. Adnan Khashoggi's role in the Northrop scandal of the early 1970s was well known to him, however. In 1972 and 1973 Khashoggi had served as the middle man in corruption pay-offs ("commissions") for various arms-deals, often involving the sale of sub-standard equipment to the Saudis) by the aerospace firm Northrop to the head of the Saudi Air Force, General Hashim M. Hashim and to his successor, General Asad Zuhair. Northrop, which also made illegal campaign contributions to Richard Nixon, also paid Saudi prince Khaled bin Abdullah over $500,000 in bribes, after the prince's public complaint that "If I get nothing, then I will make sure Adnan gets nothing." A Security Exchange Commission investigation of the situation led only to Northrop's signing a pledge to no longer conceal the bribes.

The Saudi royal family outlawed the commissions, but with laws that were ill defined and never enforced. Extra-contractual "commission" payments

continued to maintain the wealth of the Saudi royals. Khashoggi continued as the sole House of Saud contact for arms dealers, through a front company incorporated in Luxembourg, Triad America Corporation, with funds Northrop deposited into a Swiss bank for Khashoggi, who continued to funnel much of it to the Saudi royals. Although the Northrop deal eventually did fall apart, Khashoggi continued to use his connections to King Fahd and Prince Sultan to broker arms deals.

Not the least of these deals was the Al Yamamah contract umbrella, a central contractual arrangement signed in Riyadh in February 1986 that supports both the British aerospace industry and the corrupt wealth of the Saudi royal family. Through this series of contracts, the Saudis turn over oil to the Bank of England, which allows for its sale through Shell Oil and British petroleum. Profits from that are turned over to the UK's defense ministry, which pays the British Aerospace corporation when it provides military hardware to Saudi Arabia. Like the Northrop arrangements, the Al Yamamah umbrella comes replete with "commissions" and bribes, and involves the delivery of substandard military hardware. (8) Still current in the all-important machinations of big oil on the global scene today, there is little doubt that the tentacles of the Octopus thrash about mercilessly in this milieu.

It comes as no surprise coincidence, therefore, that in search of justice in what he regards as the murder of his son and Princess Diana, Mohammad Al Fayed returned to the history and speculation about the multinational Octopus cabal that was so important to Danny Casolaro. In the early fall of 2000, Al Fayed filed a Freedom of Information Act suit against the CIA and several other US intelligence services. He declared his intent to recover documents orignally surfaced by a self-proclaimed CIA agent named Oswald LeWinter. LeWinter previously had tried to sell documents to an Al Fayed cohort in Austria, documents purportedly implicating the British government in the Diana crash. LeWinter was arrested as a fraud, however, and sentenced in Vienna to four years in 1998. LeWinter apparently still holds to the authenticity of the doucments, stating that "I had a choice at my arrest to identify the documents as genuine or as fakes. If I said genuine, I would face charges in the US of high treason...so I said they were forgeries and was arrested for fraud."

Only one of LeWinter's documents surfaced in the British press after being seized by police in Vienna. It reads:

"DOMESTIC COLLECTION DIVISION Foreign Intelligence Information Report Directorate of Intelligence WARNING NOTICE - INTELLIGENCE SOURCES AND METHODS INVOLVED FURTHER DISSEMINATION AND USE OF THE INFORMATION SUBJECT TO CONTROLS STATED IN BEGINNING AND END OF REPORT REPORT CLASS: TOP SECRET REPORT NO: 00.D 831/173466-97 COUNTRY: France DATE DISTR: 17 June 1997 SUBJECT: File Overview: Diana Princess of Wales-Dodi

REFERENCES DCI Case 64376 SOURCE: CASParis/CASLondon/COSGeneva/CASKingston/UK citizen Ken Etheridge. 1. Relationship initiated between Diana POW and Dodi aF according to reliable intel sources in November 1996. Intimacy begins shortly after they meet (Report filed) 2. Reliable source reports Palace seriously disturbed by liaison. PM considers any al Fayed relationship politically disastrous. Edinburgh sees serious threat to dynasty should relationship endure. Quote reported: "Such an affair is racially and morally repugnant and no son of a bedouin camel trader is fit for the mother of a future king," Edinburgh. (Report filed) #. Request from highest circles to DEA attache UK for 6 on Dodi re: Cocaine. See file forwarded to UK embassy DC. (Copy filed) 4. US liaison to MI6 requested by David Soedding for assistance in providing permanent solution to Dodi problem. Blessing of the Palace secured (Twiz filed) 5. WHuse denies Spedding request. Harrison authorized only to arrange meeting for MI6 representative with K-Team Geneva. (Twiz on file). Meeting in Geneva reportedly successful (Report filed) 7. al Fayed Mercedes Limo stolen and returned with electronics missing. Reliable intel source confirms K-Team involved. Source reports car rebuilt to respond to external radio controls. (Report filed.)" (9)

Writer Rayelan Allan (10) made this correlation between the LeWinter document and many of the figures Casolaro had followed as part of the Octopus involvement in Iran-contra:

"The connection between Al Fayed and the Iran/Contra scandal was difficult to prove, but Richard Taus, former FBI agent states that Al Fayed and Khashoggi were connected to the Iran/Contra scandal through Castle Securities. Castle Securities was formerly Drexel Company, which was connected to Drexel, Burnham, Lambert and the junk bonds scandal. Taus states that many people who were involved in Castle Securities part of a group out of Freeport, Long Island known as the K-Team. Most if not all K-Team members were part of the Iran/Contra scandal. Taus reported that the K-Team was a CIA operation which included many infamous names such as Oliver North, Admiral John Poindexter, Richard Secord, and Adnan Khashoggi...

Lord Earl Spencer (Diana's father) was the best friend of Adnan Khashoggi's brother-in-law, Mohammad Al Fayed. Al

Adnan Khashoggi and Manucher Ghorbanifar

Fayed was connected to the K-Team and its enterprises through Castle Securities. The ten year friendship between Lord Spencer and Al Fayed eventually lad to the introduction of Al Fayed's 40 year old son, Emad 'Dodi' Fayed, to Princess Diana. Mohammad El Fayed and Adnan Khashoggi had been connected to the K-team through their business deals. The K-team was/is made up of CIA operatives who were/are

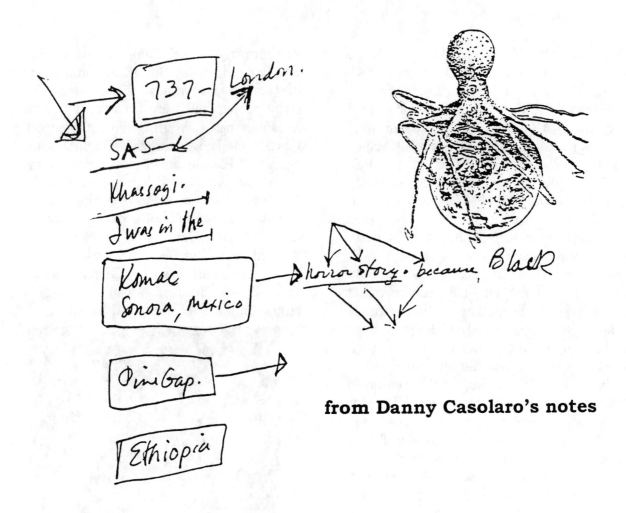

from Danny Casolaro's notes

members of Faction 1 - the New World Order, and Faction 2 - the opposition to the NWO. Al Fayed and Khashoggi were connected to the men who make up Faction 2." (11)

The idea of the factional split in the global police intelligence community has a long life in the Casolaro saga. Casolaro informant Michael Riconosciuto previously maintained that two factions, COM12 and Aquarius, had leaked information to Casolaro in order to embarass and manipulate each other.

As this accumulation of rumor and speculation continued to move Diana and the Octopus closer together in the thinking of conspiracy students, Riconosciuto himself emerged again to make a connecting link. The Royal Canadian Mounted Police, key players in the original tale of the PROMIS software piracy, reopened its investigation into the affair in 1999/2000 when it conducted a series of interviews with a former stockbroker in Ontario named John Belton. Reporters from the *Toronto Star* discovered from Belton that the RCMP had reopened its investigation into the Canadian role in the Inslaw affair and the possible threat it represented to Canadian security. "Belton

said RCMP officers have already confirmed to him that they do use the PROMIS software [and the security of the RCMP has been compromised as a result of trap doors in the software.]...The chainsmoking Belton unraveled his story at the kitchen table of his sprawling, ramshackle house near Ottawa. The table is stacked with thick binders jammed with documents detailing his allegations. Court documents, detailed notes of telephone conversations and newspaper clippings are marked up with highlighter and neatly organized." The *Star* quoted Belton as saying "You're not dealing with paranoid crazies, or the UFO guys. I'm very serious about this." (12)

Belton's story affirms details that have long been supplied by arms merchant and former Israeli spy Ari Ben-Menasche, who now works as a security consultant in Montreal. At the time of Belton's revelations to the Canadian press, Ben-Menasche reported that renewed interest in the case had led two Scotland Yard detectives to fly over and interview him. Their purpose: to discuss meetings Ben-Menasche had with none other than Mohammad Al Fayed. Details of that contact have yet to surface, but the Scotland Yard investigators were inexplicably accompanied by the two RCMP officers working on the (unofficially) reopened PROMIS case, Sean McDade and Randy Buffam. (13)

Investigators also spoke with Riconosciuto's lawyer, Louis Buffardi, and Riconosciuto himself repeated the details of his involvement with PROMIS, but both made another unexpected connection of it all to a 1997 Octopus-style double homicide in Hercules, California. Like members of the Cabazon tribe before them, the bodies of 12 year old Brendan Abernathy and his 43 year old father Neal, who owned a car repair shop, were found bound in their living room, wrapped in electrical cable and shot execution style. Acquaintance with Riconosciuto may have been among the motives for their murder. Mountie McDade joined Hercules police detective Sue Todd in a prison interview of Riconosciuto, but the details of how the Canadian case relates to the California murder, as well as its connection to Ari Ben-Menasche and Mohammad El Fayed, and to the death of Diana, remains unclear.

NOTES:

1. An internet posting to the *Conspiracy Theory Research List* (*CTRL*) from September 11, 1997 echoed reports that photographs from the scene at one point reveal a motorcyclist ahead of the Mercedes popping flashbulbs into the eyes of driver Henri Paul. The motorcyclist/photographer was not among the paparazzi arrested at the scene. The report of the flash persisted three years later, as a former MI6 agent named Richard Tomlinsin reported that "Henri Paul was an MI6 informer paid to spy on Diana and Dodi. The Diana crash was chillingly

similar to a previous MI6 plot. That plot was

to assassinate the Serbian leader Slobodon Milosevic in Geneva using a powerful laser strobe light--similar to that described by witnesses to the Paris crash- -to blind the driver." The laser strobe, publicized greatly in an English documentary entitled *Diana: Secrets Behind The Crash*, was mentioned again by Dodi Al Fayed's father Mohammed Al Fayed during a press conference announcing his Freedom of Information Act suit against the CIA and other US intelligence agencies for documents pertaining to the crash. One witness, secretary Brenda Wells, made statements strongly discriminating the strobe flash from the paparazzi flashbulbs.

2. A short list of suspicious details about the car crash:

It took an hour and forty minutes to get Diana to the Pitie Salpetiere hospital. Four other hospitals were closer. The White House, and consequently the US intelligence community, regards the Pitie Salpetriere as the official hospital of choice for officials visiting Paris. (This slowness has been described as part of the French inclination to stabilize a victim before proceeding to hospital and as an attempt by the ambulance to not aggravate Diana's injuries.)

Early news reports had Diana up and walking around immediately after the crash. She also supposedly was able to speak some words, and reportedly one photograph of the scene showed her utterly unbloodied.

A few weeks prior to the accident, the Mercedes had been stolen from the garage of the Ritz hotel, where the fatal ride began. Police recovered the car but found that its instrumentation had been tampered with. Shortly thereafter, the car was re-inspected and reconditioned.

Contrary to normal procedures for bodyguards, guard Trevor Rees-Jones fastened his seatbelt before the ride. The others did not. Rees-Jones later claimed amnesia about the event, not due to trauma but to the drugs he received in the hospital for his severe facial injuries.

Henri Paul appears sober in video footage taken at the Ritz Hotel just before the fatal ride. The notion that Paul was severely alcoholic has been challenged by friends and family.

A mysterious $200,000 had been deposited in Henri Paul's bank account just prior to the wreck. Former MI6 agent Richard Tomlinson claims the money came from MI6.

The French opened up the tunnel roadway only hours after the crash and neglected to collect important evidence. Even mainstream apologists like Gerald Posner acknowledge the incompetence of the French investigation.

Seventeen cameras inside the tunnel failed to operate at the time of the crash.

The paparazzi photographer who may have owned the white Fiat encountered by the death car, James Adnanson, died under questionable circumstances in May 2000. Police discovered Adnandson's burned body in a charred BMW in the Aveyron woodland, near the viilage of Nant in southwestern France. Previously, Adnanson's Paris office had been burglarized by three masked and well-trained men who wounded a security guard and for a while kept the office staff hostage.

It took four weeks for police to identify Adnanson's remains from DNA tests. Official investigators claim that the white paint of Adnanson's Fiat did not match that recovered from scrape marks on the Merecedes, and consider Adnanson's death a suicide, despite the bizarre circumstances.

3. Mohammed Al Fayed owns the posh Harrod's department store in London . He has been a champion in trying to ferret out government documents held in secret and other information concerning possible plots in the death of his son Dodi and his son's lover Diana. The UK government has long denied Mohammed Fayed's application for British citizenship and has looked askance at the impact his wealth and influence have had on politics in England. It has also deferred his request for a full inquiry into the crash to the official French investigation that most people find seriously flawed. Mohammed Al Fayed holds the view that Queen Elizabeth's husband, Prince Philip, the Duke of Edinburgh, ordered the deaths of his son and Diana, and is now using the CIA, MI5 and MI6 to cover it up, and he has of course been dismissed as a conspiracy theory nutter. The status of his lawsuit and any new information about his investigative effort can be found at his website, www.alfayed.com.

4. Khashoggi spent three semesters studying economics at Chico State University in California before starting a business renting his truck to companies doing business in Saudi Arabia. After college, he developed those contacts into a role as a liaison between US and Saudi corporations and the Saudi military, primarily under Sultan bin Abdul Azziz. That role, in its various legal and extra-legal dimensions, brought Adnan Khashoggi to great wealth as a broker of long-term deals involving military hardware. In the transformation from renting out his truck to shepherding arrangements for tanks and jet fighters, Khashoggi came to own a dozen posh estates and a $70 million yacht docked at Porto Banus, Spain. The yacht, called the Nabila, appears in the James Bond movie *Never Say Never Again*. Khashoggi later sold it to his friend, Donald Trump. The 1987 biography of Adnan Khashoggi, published by Warner Books and written by Ronald Kessler, is entitled *The Richest Man In The World*.

5. Alex Constantine notes: "Tiny Rowland was the publisher of London's *Observer* until a reporter Tom Bower researched the financier's past a few years ago and discovered him to be a former Hitler Youth Corps leader. Rowland served a spell in an allied detainment camp toward the end of the war, then migrated to S. Africa and found enormous wealth there in the mining industry. Thereupon he relocated to the UK to purchase the *Observer* and rub shoulders with some of the most notorious movers in the world business community, including Daniel Ludwig, a hotel magnate who retains a PR agency solely to keep his name out of the newspapers." (10/13/97)

6. Peter Rushton claimed on the ALT.POLITICS.ORG.CIA internet list that he had been given "a large file of allegations against Rowland" by Francesca Pollard as part of a counter-offensive launched by Mohammad Al Fayed against intrigue by Arab industrialist Ashraf Marwan, working as a front for Tiny Rowland, to secure a large number of shares in the House of Fraser, the company that owns Fayed's Harrod's. The battle between Roland and Mohammad Al Fayed was fought in part with the help of Nemi Chand Jain, known

also as Chandraswami. The followers of Chandraswami, one of India's swarm of gurus for the jet-setting elite, include Indian prime minister Narasimha, Tiny Rowland and Adnan Khashoggi. At one point Chandraswami circulated a faked tape of Mohammad Al Fayed admitting that he acquired Harrod's with the help of the Sultan of Brunei. He also introduced to Khashoggi a woman named Pamela Bordes, whose wiles apparently helped Khashoggi seal deals. Bordes was quoted as saying she was physically afraid of Khashoggi but mentally afraid of Chandraswami.

7. In 1996, the Committee Against Corruption in Saudi Arabia (CACSA) reports: "The reverberations of Saudi Arabia's procurement of over 80 Northrop F-SE/F's are still being felt today, even as the kingdom seeks to replace the top heavy aircraft with newer, sleeker trainer-fighter models. Saudi Arabia also bought F-SNB's from Northrop in 1971, the first phase of the contract, a few years before they bought the F-5EIF's. The deal was worth $4.2 billion before they bought the F-5EIF's. The deal was worth $4.2 billion.

The F-5's still have to be maintained until they are replaced. Three years ago, the Minister of Defense, Prince Sultan bin Abdul Aziz, pressured Northrop to award the maintenance contract to the Al Salam Aircraft Company, which was described as "poorly managed." (*Mednews - Middle East Defense News*, April 19, 1993). The joint venture company was established to handle the overhaul of both Royal Saudi Air Force and Saudia, the commercial carrier aircraft. Al Salam's facilities at the Riyadh airport are inadequate because if its overhaul hangars are not connected to the runway, rendering them inaccessible to planes, and because the hangars do not have an adequate power supply for the maintenance and repair work Al Salam was set up to do."

8. Information about Al Yamamah comes largely from the dissident group within Saudi Arabia, since British Aerospace does not reveal terms of the contract and the British press has been slow to investigate. The Committee reports that "The Saudi Arabian government has British Aerospace wrapped around its finger because revenues from the al-Yamamah deal saved the company from going under. In the early 1990s, it was losing as much as $1.8 billion dollars a year...British Aerospace agreed to supply Saudi Arabia with 48 Tornadoes, 30 Hawks, 30 Pilatus PC 9s, two Jetstream trainers, and a variety of missiles and ground based equipment in exchange for oil. Two years later, under Al-Yamamah, the Saudi government ordered 48 more Tornados.

In January 1993, immediately after the company reported one of the worst annual losses of any British company ever, Saudi Arabia ordered more Tornados. The focus of the Al-Yamamah contract is money, not weapons. In the words of George Galloway, the Saudi governemt has ordered "vast amounts of unusable weapons" which were worth millions of pounds to British aerospace. The Saudi government does not care whether the weapons work. The royal family is using the al-Yamamah deal as a cover." (Internet posting September 19, 1997.)

Researcher DasGoat summarized it thusly: "It was in the context of the joint US-British trade in arms in the Middle East, camouflaged by Operation Desert Storm-- that Khashoggi's brother-in-law Mohammad Al Fayed apparently managed somehow to bring down the British government, or rather the conservatives around Thatcher (and her protege John Majors) who, indistinguishable

from Republicans around Reagan and Bush, turned their nation's treasury into a personal slush fund, making their fortunes from investing in corrupt and criminal activities (whitewashed as covert operations or wars) in the arms and drugs market." (To *CTRL* list, 9/11/97)

9. "Edinburgh" here refers to Prince Phillip; "Whuse" refers to the White House; and David Spedding is the head of MI6.

10. In 1997 the writer provided a fanciful but fascinating discussion of the history behind the fateful crash site, under the psuedonym "Ru Mills" via Brian Redman's *Conspiracy Nation*:

"Princess Diana and her soon-to-be husband, Dodi Fayed, were fatally injured in the Pont de l'Alma tunnel. The site is ancient, dating back to the time of the Merovingian kings (ca. 500 - 751 A.D.), and before. In pre-Christian times, the Pont de l'Alma was a pagan sacrificial site. Note that in the pagan connotation, at least, sacrifice is not to be confused with murder: the sacrificial victim had to be a willing participant.

In the time of the Merovingian kings, the Pont de l'Alma was an underground chamber. Founder of the Merovingian dynasty was Merovaeus, said to be descended from the union of a sea creature and a French queen. Merovaeus followed the pagan cult of Diana. In Middle English, "soul" (Alma) has as etymology "descended from the sea." "Pont" has as a Latin root "pontifex," meaning a Roman high priest. (See also pons, pontis -- bridge; passage.) "Alma" comes from the Latin 'almus,' meaning nourishing. One translation of Pont de l'Alma would be "bridge of the soul." Another would be "passage of nourishment." All true European royalty is descended from the Merovingians, which are believed to be descendants of Jesus Christ.

During the Merovingian era, if two kings had a dispute over property, it was settled in combat at Pont de l'alma. According to legend, anyone killed there goes straight to Heaven and sits at the right hand of God, watching over all his foe was to do. The person killed in combat was actually considered to be the "winner," since he became God's eyes on earth and even could manipulate events.

The current British royal family are imposters. The House of Windsor is a fraud. But the lineage of Lady Diana Spencer goes back to Charles II House of Stewart. The House of Stewart is of "true" royal blood. Diana's sons, William and Harry, have three quarters true nobility in their blood."

Rayelan Allan developed her thesis that Diana's death was arranged in order to use her image to create a world-controlling religion in the book, *Diana, Queen of Heaven,* available at the web site www.dianaqueenofheaven.com.

11. Allan, Rayelan, "Diana Was Not The Target," *PARANOIA Magazine*, Issue 24, Fall 2000.

12. Lawton, Valerie and Thompson, Allan, "Rigged Software Claimed To Hack Intelligence Files," *Toronto Star*, August 28, 2000.

13. Lawton, Valerie, "Spy Trap Probe Now Tied To US and Britain," *Toronto Star*, August 29, 2000.

SAINT DI
(Definitely Not a Movie)

by Uri Dowbenko

Why was the world so shocked at the death of Pop Icon Diana Spencer, Princess of Wales?

Sure, Di was too rich, too beautiful, and too young. But, such overwhelming torrents of grief have not been seen since the 1963 Kennedy Assassination.

Was it just mass hysteria? Or was there something more sinister?

There is, of course, no proof and no evidence of foul play.

Speculation, however, regarding the whys and wherefores is rampant. In fact when news of Di's demise flashed around the world, cynics immediately thought "uh-oh."

After all it wouldn't be the first time. The Brits have a long, well-documented history, an astonishing track record, in fact, of dealing with inconvenient mistresses, unproductive wives, or even uncompromising counsellors.

Historically the British monarchy has never been shy about dealing with political embarrassments.

Take, for example, Thomas Beckett. In the classic film masterpiece *Beckett*, Henry II is played by Peter O'Toole and Thomas by Richard Burton. Beckett was the Archbishop of Canterbury and the nemesis of King Henry II. He was murdered on December 29, 1170, in the Cathedral by the King's Barons. Soon after, the King did public penance. Then the archbishop was canonized and a new saint was born. Martyrdom often precedes sainthood.

Sainthood is sometimes one of those "honors" afforded the politically incorrect, once they have been tortured and/or killed. Similarly, in twentieth century Cuba, a secular saint was created when the charismatic Che Guevara, Fidel Castro's main political rival, was betrayed and murdered in Bolivia. Instantly the young, handsome -- and dead -- Che became a pop culture icon worldwide. Castro expressed the requisite grief, but most importantly his political power was preserved.

There is, of course, no proof and no evidence of foul play in the death of Diana. At least not the kind associated with the Jack the Ripper murders in London in 1889. Journalist Stephen Knight in his landmark book *Jack the Ripper: The Final Solution* delivers startling evidence that the world-famous Ripper killings were ritual murders directed by members of the British government.

According to Knight, the killer was Sir William Gull, Queen Victoria's physician-abortionist. Among his accomplices in the subsequent cover-up were Sir Charles Warren, founder of the Ars Quatuor Coronati masonic lodge and assistant Commissioner of Police Sir Robert Anderson.

Knight writes that "a great deal is at stake if the Establishment considers it necessary to operate a full-scale cover-up. For the truth of the Jack the Ripper affair to have been painstakingly concealed can mean nothing less than State security was at risk or that someone high in the Government or the Royal Family was involved."

So what was at stake? According to the first-hand information of Knight's informant, Victoria's son Prince Eddy was a bisexual and had done the unforgivable. Not only did he fall in love with a Catholic commoner, but he married her and had a

child. Several prostitutes, friends of the poor wench, tried to blackmail the Royals. Ergo Jack the Ripper kills.

On the other hand, there is no proof and no evidence of foul play in the death of Diana. In his book *Secret Societies and Psychological Warfare*, Michael A. Hoffman II writes about the worldwide traumatic psychodrama experienced during the death of President Kennedy. He writes that "the occult cryptocracy has a much more refined inducement for attendance at their masonic ritual. Few need to be induced to watch TV or read a sensational mass market picture magazine or newspaper. In fact, we pay to do so."

Commenting on the global amplification of the power of the broadcast media he writes that "in the end what we have is a highly symbolic ritual working, broadcast to millions of people, a satanic inversion, a black mass where the 'pews' are filled by the entire nation."

Or in Di's case, the entire world.

Hoffman also quotes Theater of Cruelty proponent Antonin Artaud on the sex-and-death media and the processing of the group mind: "Aside from trifling witchcraft of country sorcerers, there are tricks of global hoodoo in which all alerted consciousnesses participate periodically. That is how strange forces are aroused and transported to the astral vault, to that dark dome which is composed above... the poisonous aggressiveness of the evil minds of most people..."

James Shelby Downard in his essay "Sorcery, Sex, Assassination and the Science of Symbolism" (from *Secret and Suppressed*) writes about the JFK murder and the arcane connection with Shakespeare's tragedy Macbeth.

Downard comments parenthetically on "the appearance of Hecate to the three witches [in *Macbeth*]. Hecate is triple-countenanced, and being threefold in aspect she is known as Diana on earth, Luna in heaven and Hecate in hell..."

"Crossroads were considered sacred to Diana-Hecate, the deity who is both virgin and whore ('Fair is foul and foul is fair') and such crossroads were the favored sites of the wanton women-witches and the grand masters (masonic sorcereors) who were her votaries."

"... Crossroads were also places of human and aniumal sacrifice. Such rites were often carried out in conjunction with magica sexualis since the participants recognized an existing relationship between fertility and death."

Meanwhile the Mainstream Media Cartel has been outwardly contrite regarding allegations that they contributed to Di's death. Since the driver was supposed to be drunk, he has become the new scapegoat for the so-called accident. Blaming the paparazzi photographers has also taken a back seat in media coverage.

"News" magazines like *Time*, *Newsweek*, *People* and *The New Yorker* as well as supermarket tabloids *Star* and *National Enquirer* have capitalized on the dead princess by producing special memorial editions on "Saint Di," mass media's newly anointed Celebrity Martyr.

From a *realpolitik* perspective, however, all media reports confirm that the British Establishment barely tolerated Mohammed Al Fayed, Dodi's father. Even though - or maybe because - he flaunted his wealth and unsuccessfully lobbied for British citizenship for five years, the Fayed family, like Rodney Dangerfield, never got any respect. The old man bought Harrod's, London's internationally known shrine of Conspicuous Consumer Culture as well as the Fulham Football Club. Ali, the younger brother, owned Turnbull & Asser, Prince Charles' tailor. But to no avail.

As *Time Magazine* (Sept. 15, 1997) put it, the Fayeds were "a thorn in the side of the British Establishment" and their "bluster, defiance and eccentricity" was evidently considered trop gauche by the Overlords of the Elite.

In *The New Yorker Magazine* (Sept. 15, 1997) the Islam-bashing highly over-rated Salman Rushdie, author of *Satanic Verses*, wrote about the death of Diana and Dodi and the obvious gruesome connection to J.G. Ballard's infamous novel *Crash*. The book's infatuation with Sex, Death and Celebrity was recently made into a David Cronenberg-directed horror movie of the same name, a glorification of porno-car accident violence promoted as - you guessed it – "art."

Rushdie observed that "the Windsors and the Al Fayads are archetypical Insiders and Outsiders adding however that at this moment their status is also in doubt. Once beloved of the nation, they are now widely seen as the family that maltreated the far more beloved Diana. If Mr. Al Fayed is fated to remain on the outside looking in, then the Royal Family itself, very much on the inside, may just possibly be on the way out."

Hopefully Rushdie won't hold his breath. His own death sentence *fatwa* may come quicker than the Royals relinquishing power.

Having a wog for the Prince's grandfather -- if Diana was indeed pregnant at the time of her death -- must also have been disconcerting to the Royals.

There is, of course, no proof and no evidence of foul play in the death of Diana.

But, as they say, the paradigm is definitely shifting. The defensiveness of the Establishment Media Cartel reached a crescendo in the *Wall Street Journal* (Sept. 17, 1997) with a bizarre editorial screed called "Queen Oprah" in defense of the status quo.

"Whatever the benefits of sacralizing individual consciousness or of presidents and queens who weep before their public, the fact remains that nations like the United States and Britain are organized around successful institutions, common and predictable enterprises, and not whatever sentiment spills out of the emotional cauldrons that day. In fact, these institutions exist to protect such people from harming themselves through wildly wrong choices. If we abandon or damage the protective institutional credibility of our courts, schools, religion, politics or even our sources of information, such as the media, we become more vulnerable to the systems that preceded them -- the rule of mobs carried by rivers of emotion."

Status Quo Uber Alles screeches the editorial. Imagine the rule of mobs without the daily pontification of the over-stuffed

Journal writers.

Imagine invoking the threat of "mob rule" if you don't "believe" a State Propaganda Organ like the *Journal*, which is essentially *Pravda* for the Monopoly Capitalist Class.

Believe in the *Wall Street Journal*. Or else... Surely you will lose your reason. Not to mention the moorings of your society.

Simon Scham, another writer in the Saint Di tribute issue of *The New Yorker*, wrote that Diana Spencer was "consciously selected for the purpose of dynastic reinvigoration," but added that "Diana Spencer was no Anne Boleyn."

That's code-word for "illuminati breeder."

The *Time Magazine* Di Tribute story (Sept. 15, 1997) enigmatically ends like this: "Everywhere in the Arab world where Dodi's relationship with Diana became a source of national pride, there is speculation that a British plot killed the princess to prevent her from marrying an Egyptian... The thought of a well organized conspiracy would be a comfort."

Comfort? Naaah, I don't think so.

Fast living - and driving - finally caught up with the Playboy and the Princess. There is, of course, no proof and no evidence of foul play. But enquiring minds really want to know.

Was it a warning? Was it a threat? Or was it a promise when Diana was told, "Remember. Accidents happen."

Uri Dowbenko is CEO of New Improved Entertainment Corp. He can be reached by snail mail at P. O. Box 43, Pray, Montana 59065 or by email at u.dowbenko@mailcity.com

Jim Keith, Burning Man and "Wounded Knee"

by Adam Gorightly

During his days editing *Dharma Combat*, Jim Keith gave voice to a number of dissident writers, who--without his assistance--would have sunk even deeper into literary obscurity. Among these was Jeff Lewis, one of the most unique and controversial voices to emerge from the alternative 'zine scene of that period, the late 80's/early 90's.

In Jeff's case, "sunk" seems an apropos term, as his writings plumb the depths of the dark subconscious, and it is through sinking into these turgid waters--and his search for their "sunken" treasures--that Mr. Lewis attempts an ascent above those ancient forces which, throughout human history, have held men as slaves, in waking reality and in the realm of dreams. In these respects, Lewis is a poet engaged in spiritual warfare.

"Much of my work," says Lewis, "is based upon personal experience in dreams, and describes the long process of recovering personal control in the realm of the unconscious. The recovery of active metaphysical vision and will with which to work in the depths of the unconscious is, I believe, the primary task of the poet, creative person--and the means by which we may regain, not only the singing ability of the mythical Orpheus, but also his power."

As I interpret Jeff's dream-work, it more than just affects his immediate surroundings, but extends outwards, intuitively grasping the emotional or psychic turmoil of others, and--like a shaman gazing deep into the ethers for answers--he has taken it upon himself to work out the chaos of the world. Order from Chaos. But before we get too deeply into Jeff Lewis' "wounded knee" revelations, let's recount Jim Keith's final days...

Most readers of *Steamshovel Press* should be well familiar with the late Mr. Keith--noted conspiracy author and researcher--who met his untimely death via a circuitous route which led through Burning Man, an "alternative culture" festival that takes place each year in the Black Rock Desert near Reno, Nevada. Your humble reporter has twice attended Burning Man--in '97 and '98--and to put into words what takes place there could hardly be captured in the short span of this article. Call it performance-art-meets-fireworks/ pyrotechnics nudity techno-tribalism pagan ritualism Subgenius Devivalism topped by a liberal sprinkling of booze and psychedelics--and that's just what happens on the first day! To get a general overall feel of the event, do a web search for Burning Man, and you'll turn up all kinds of interesting links and high weirdness.

As the story goes, Keith broke his knee falling from a three-foot stage at Burning Man, and the next morning went to Washoe County Medical Center to get it looked at. Hospital reports state that related kidney problems developed soon after, preventing immediate surgery. Three days later--on September 7th--when surgery was finally performed, Keith died due to a fatal blood clot that was released from his leg, and traveled into his lung.

As to be expected, rumors soon began circulating through the "conspiracy research" community about the true nature of Keith's untimely passing. Many have pointed to his last article for the now defunct webzine *Nitro News*, the results of which presumably sealed Jim's fate due to his naming of the physician who declared Princess Diana pregnant at the time of her death. One should also bear in mind the list of those who've died mysterious deaths in relation to the Clinton Presidency, one of whom was researcher Danny Casolaro. The only published work yet to delve to any great extent into the Casolaro affair is *The Octopus* by Keith and *Steamshovel Press'* editor Kenn Thomas.

From this jumping off point, it could be conjectured that Jim Keith is but another in a long line of those who've gained infamous mortality vis-à-vis Clinton's ever-growing Death List. For anyone unfamiliar with this list, there are no doubt many sources available on the Internet where it can be accessed, and one quick perusal of

said will tell you that any one associated with Clinton in the early years of his candidacy-cum-presidency possessed some terribly bad luck. With this being said, it could have been any one of a number of conspiracies that attributed to Keith's death.

But perhaps there's an even more obscure explanation for Jim's premature passing, which brings us back full circle to Jeff Lewis' dream-work. Prior to receiving news of Keith's death, Jeff had a perplexing dream, as he termed it to me; a dream in which terrible wounds appeared on his knees, apparently fatal in nature. The inference here is that Jeff had psychically transferred the trauma of Jim Keith's ordeal--in essence, assuming Keith's ordeal--so that in some manner he could work it out, and heal these "knee wounds", in the same way a shaman accepts the pain of others,

assuming sickness in order to dispense with it, to transmute it into a transcendent form. I would only add here that Lewis--although he does, in my opinion, take on a sort of shamanistic role in his dream-work--has never referred to himself in such a context. As a shaman is one who's immediately identified with channeling "gods", this also flies in the face of Jeff's approach, because he would be the last to ascribe his "talents" (vis-à-vis interpreting the true meaning of dreams, and from there the long and difficult process of attempting to transform them for the benefit of himself, and the world at large) as a gift from any god, or gods. For all intents and purposes, Jeff Lewis' battle is with those who would keep us asleep, in the dark, unaware of the possibility of controlling our own realities, whether in the dreaming or waking worlds. For Lewis, this is a psychic battle for the mind; one waged against the biblical gods of old, who through the ages have maintained a stranglehold upon our collective dreams and visions, both while asleep or awake, influencing history in the process. While all of this might seem mere delusion to many of you reading these pages, it has been my experience that the significance of everyday events is influenced by occult symbolism and imagery, many of which come to us in the form of dreams.

It should be noted that it was only after receiving news of Keith's death that Jeff Lewis discovered the meaning of his "wounded knee" dream; a dream that apparently occurred at the same time that Keith suffered his knee injury. Afterwards--with news of his death--it became clear to Lewis that Jim's passing was associated to ancient Celtic or Druid fertility rites, which, at their core, possessed "human sacrifice" underpinnings. Lewis' described this "sacrifice" of Jim Keith as one that would be accomplished "in a covert, unconscious fashion without apparent connection to the event or even conscious consent of the participants."

What is most astonishing is that these very themes (human sacrifice, fertility rites) were explored in the 1973 film, *The Wicker Man*, starring Christopher Lee. Although the creator of Burning Man, Larry Harvey, has never publicly acknowledged *The Wicker Man* as his inspiration, the connection between the two is undeniable, as anyone who has seen the movie--or has been to Burning Man--can attest. That Jeff Lewis was able to put these connections together--having never seen the movie or having been to Burning Man, for that matter--speaks to his ability to reach far into the subconscious realm of dreams, and make sense of the madness waiting there. In this case, the dream vision presented to Jeff was such that the "real" burning man is Jim Keith, who was sacrificed in deed, just as the "burning man" effigy is sacrificed each year at Black Rock Desert. Likewise, the lead character in *The Wicker Man* is similarly sacrificed to an effigy of a demon named King Wicker during his investigation of an occult group involved in pagan ritual sacrifice.

Jim Keith, due to his own pursuits, such as the Casolaro affair, the Oklahoma Bombing, among numerous other investigations, might have unwittingly set himself up for just this type of sacrifice. According to Conspiratologist Michael Hoffman, *The Wicker Man* was also associated symbolically and alchemically to the Son of Sam murders, as outlined in his treatise *Secret Societies and Psychological Warfare*. Quoting Hoffman: "The word wicker has many denotations and connotations one of which is 'to bend,' as in the 'bending' of reality. It is also connected to witchcraft through its derivative, wicca..."

Although it would be a tad far-fetched on my part to cite a deliberate plot hatched along these lines (using the Burning Man festival and Washoe County Medical Center as a backdrop for the conspiratorial sacrifice of Jim Keith), I believe there may be other factors at work here, of an occult nature. Let it also be noted that Jim is not the first casualty associated with Burning Man, as in '96 another human was placed upon the sacrificial alter, the victim of a head-on motorcycle collision. Of course, that's not a bad track record when you consider how the event has grown over the years, and all the anarchic freedom unleashed there in a three-day span. Burning Man--for those not in-the-know--marked its humble beginnings back in '86 at Baker Beach in San Francisco, when artist Larry Harvey, having just ended a troubled romantic relationship, built the first burning man, in a act of freeing himself from the past; a sort of banishment, and ritual working, from a love affair gone bad. The first "Man" was a mere eight feet tall, with twenty people in attendance for the burn. Twelve years later--at the last Burning Man

I attended--the "Man" had grown to an astounding 50 feet tall, with approximately 15,000 people in attendance!

As logically fuzzy as this all may sound, I think Jeff Lewis is on to something here, and--for that matter--Michael Hoffman, as well, although there is definite gulf between their two points of view. Hoffman's worldview subscribes to the theory that subliminal messages are being implanted on a subconscious level in the minds of modern man in order to usher in a New World Order. Conversely, Jeff Lewis feels that it is actually the subconscious realms that influence our conscious minds. So, in essense, a movie such as *The Wicker Man* is the outcome of conscious manipulation ala Hoffman, whereas in Jeff Lewis' worldview the realm of dreams influences such events as Burning Man, specifically in regards to Jim Keith's death. In this article, I have formed a bridge--albeit wobbly as all get-out--bringing these two divergent points together; at least for a brief instant, and perhaps shedding light on the alchemical and occult symbolism surrounding Jim Keith's death in relation to Burning Man.

As you may have gathered from my earlier thumbnail sketch of Burning Man, it's an event that needs to be experienced first hand to be grokked. Aside from one big free-for-all party and mindphuck, there are many levels going on at Burning Man in terms of human sacrifice--at least on an emotional, or psychic level--of opening one's self up to "spirit energies", in whatever form they may proceed. Oddly enough, I was crucified there myself, albeit in effigy.

Granted, I've had loads of fun at Burning Man, but yes, it's indeed a surreal spectacle infused with certain elements of unbridled anarchy, not to mention people accidentally torching themselves, on occasion, during ritualistic "fire dances" in conjunction with the actual burning of the Man. While putting this piece together, I sorted through photos my wife and I snapped during Burning Man '97 and '98. What suddenly became evident was this undercurrent of human sacrifice, mixed in with such themes as fertility rites, sex magick workings, and occult symbolism. Like any risky venture in life, you definitely open yourself to unknown forces when you wander into any Burning Man event...

As I rooted through these photos of Burning Man past, there were a handful of shots that particularly stood out. One of note pictured yours truly inserting my head into one of the many orifices of a strange creation dubbed by its diabolical makers: "The Nebulous Entity", a many tentacled three-story tower. In a press release distributed by Nebulous Entity propagandists, this strange creation was described as that which "absorbs and metabolizes information." By day, The Nebulous Entity merely held its ground with nary a sound emitted from its arcane countenance, consisting of twirling appendages and the aforementioned purplish sucking orifices. That day, when I stuck my head into said orifice--out of sheer playfulness more than anything--I was not at all aware of the ulterior motives of this "Entity". Later, in revisiting this photo, the theme of human sacrifice once again reared its multifarious head, as I--in turn--had naively offered my own head on a platter to this strange "Nebulous Entity". After the ceremonial burning of 'The Man" in '98, the Ritual of The Nebulous Entity unfolded. By day, a mild manner sculpture, that night, illuminated from within--and playing the strangest music; a compilation of 50s atomic energy ditties, 70s bubblegum pop, and

other twisted thrift shore treasures--The Nebulous Entity attracted a huge following of merry fools, all expecting to see it sacrificed in flames, just as "The Man" had been sacrificed before it. People were jumping and dancing and having a merry ol' time, as they followed "The Entity" across the Playa, attracted like moths to a flame in a crazy kinda conga line, mesmerized by these figurative Pipes of Pan. Though it all seemed like innocent merriment, occasionally the scene would get a bit eerie, as The Nebulous Entity would suddenly stop in its tracks, as the goofy music emanating from its surreal structure would likewise surcease. Strange violet lighting emanating from within the belly of this beast would then begin to pulse, as "The Entity" emitted sounds of such a nature as to give the effect that it was "consuming". Only later did it dawn on me what was going on. The music and spectacle was literally "sucking in" all spectators, as The Nebulous Entity was in reality feeding off the collective energy of the gathered throng, some 300 or so strong. Much of the aforementioned music played by "The Entity" was similar to the sort of propaganda muzak made popular in the 50s and 60s, a sort of Mickey Mouse Club atmosphere, with human beings inducted into something they thought was simple fun and frolic, whilst in reality there was a degree of insidiousness to the whole spectacle...Just the same, I wouldn't have missed it for all the world!

Clinton's History!

The Blue Blood of Billy Blythe

By Andrew D. Basiago

President Bill Clinton's official biography states that he was born William Jefferson Blythe. We have all heard the tear-jerking story of how he was born Billy Blythe; how his father died three months before he was born, when he drowned after his car careened into an irrigation ditch; how he was adopted by a man named Clinton, whose name he took. These are heart-wrenching scenes from the black-and-white movie that is Clinton's past.

Despite this storyline, however, questions have lingered about the true facts of the President's ancestry since he first stepped onto the national stage in 1992. This debate has been fueled in part by the President's political enemies, masters of the low blow. But it has also been re-ignited, time and again, by the Clinton team itself, which has always acted as if they were hiding something about Clinton's heritage.

Remember how, following his election, Clinton went in search of his Blythe cousins? Generally, when one has just been elected President of the United States, it is regarded as unseemly and unnecessary to go in search of one's long-lost cousins. Traditionally, they are expected to come to you.

Then we have the first inaugural of William Jefferson Clinton in 1993. The President and First Lady scheduled, and then abruptly cancelled, a sojourn to Monticello

that was to immediately follow his Inaugural Address. Was this maneuver carried out to conceal the fact that the 42nd President is a direct descendant of the 3rd President, the sage of Monticello, Thomas Jefferson?

At least one long-time friend of the President has made public statements that would tend to support the premise that he is, in fact, related to Thomas Jefferson. William McDonough, dean of architecture at the University of Virginia (the college that Jefferson founded), told a Sustainability Project symposium at Santa Barbara City College in April 1994 that William Jefferson Clinton is "the seventh lineal descendant of Thomas Jefferson."

Distinguished environmentalists were in attendance, including Peter Calthorpe, Judy and Michael Corbett, and Sim Van der Ryn. It was neither the time nor the place to be making unfounded claims. True to his capacious intellect, McDonough, who built the first solar home in Ireland, called upon the President to bravely act in the spirit of his illustrious ancestor, Thomas Jefferson, by drafting "A Declaration of Interdependence," one that would encompass the biosphere, just as Jefferson authored a Declaration of Independence on behalf of human beings. Clinton later appointed McDonough to his Commission on Sustainable Development.

This interpretation of the President's "hidden heritage" was confirmed to this reporter by a Clinton cousin in 1994, who stated that she and the President were related to novelist John Grisham, and that both are descendants of Thomas Jefferson. She suggested that this assertion is strongly supported by the famous "standing, red-haired" painting of Jefferson, which Clinton supposedly resembles.

Other theories about the President's lineage have been advanced over the years by muckraking journalists, who have implied that something sinister or amiss lies lurking in Clinton's DNA. Two of the most spirited investigators of these theories the Clinton years have seen are Sherman Skolnick and Ace Hayes.

Skolnick, the Chicago-area court activist and author of recent anti-Bush jeremiads, has alleged that President Clinton is not a Jefferson, as McDonough would purport, but, in fact, a Rockefeller, specifically, the illegitimate son of Governor Winthrop Rockefeller of Arkansas, Clinton's political godfather. Skolnick has

Skolnick

even claimed that several Rockefeller family members have confirmed this in interviews. His claim is not to be taken lightly, for Skolnick is both an indefatigable researcher and a courageous seeker of truth and justice. He has pursued corrupt public officials, especially judges, relentlessly, for over forty years, from a wheelchair.

In a similar vein, Hayes, the late, great editor of the *Portland Free Press*, speculated that Clinton may be the illegitimate son of President Franklin Delano Roosevelt's son, Elliott, which would make him, like his grandparents Eleanor and Franklin, a "Charlemagne

descendant."

Ace Hayes

The "Charlemagne descendants" are a tribe of WASP "blue-bloods" who have posted their elite pedigree on the Internet. Hayes thought that Clinton may have been trying to "control" the "spin" of historical events beyond his control, namely, that the Presidency was for the third time in the control of a Roosevelt, and that America is ruled by Adams' "artificial aristocracy of wealth and privilege" as distinguished from Jefferson's "natural aristocracy of virtue and talent." This would cause the Presidential gene pool to appear a tad tiny, would it not?

After he was re-elected in 1996, Burke's Peerage, the British aristocratic heritage society [in full BURKE'S GENEALOGICAL AND HERALDIC HISTORY OF THE PEERAGE, BARONETAGE, AND KNIGHTAGE], whose pronouncements are authoritative, stated that Bill Clinton is a descendant of Hugh Capet and Robert I of France, and that he has more "royal blood" than any president in American history. Curiously, Burke's Peerage also stated that the candidate with the most "royal blood" has won every presidential election since our Republic was founded.

Subsequent events would bear out the certainty that Clinton has royal blood and the raffish propensity to disseminate this royal blood, willy-nilly, in the libidinous manner of a debauched monarch. I am speaking of the blood evidence in the Lewinsky case.

In the sordid season of 1998, when the stain on Monica's blue dress was analyzed, the President's "blood" -- to put it politely -- was found to have genetic markers possessed by only one in every five TRILLION Caucasians. Holy Blood, Holy Grail, Batman! Could this uncommon combination of chromosomes have been created by the "kissin' cousins" of Hope? Even over many generations in which the bee didn't wander very far from the flower patch? It seems doubtful. Talk to a mathematician.

Rather, perhaps Bill pleased Monica with a cigar not merely to prove that he is a polite smoker, but also to ration the divine substance of his royal essence.

As he prepares to leave office and resume life as a mere mortal again, and walk and talk among us -- royals and commoners alike, mind you -- and become an Oxford don, and chase British women, humidor in hand, Clinton's true paternity remains a lot like Sir Winston Churchill described Russia to be in his celebrated history of the Second World War – "a mystery wrapped inside a riddle wrapped inside an enigma."

What to make of this undistinguished President's distinguished lineage? Who is

he?

One line of research that hasn't been explored, but that might be, with telling results, I suspect, is the possibility that Bill Clinton is a direct descendant of Cecil Rhodes, the British oligarch who founded The Roundtable and the Rhodes Scholars Program. If this were the case, active concealment of Clinton's ancestry might have been necessary to cloak the fact that he is a close blood relative of one of the principal figures in the vanguard of the world government movement.

At Georgetown, Clinton was a protege of Professor Carroll Quigley, who wrote the seminal history of the New World Order, entitled *Tragedy and Hope*. As President, Clinton, a member of the Bilderbergers, the Trilateral Commission, and the Council on Foreign Relations, has proven himself to be a tireless toiler on behalf of transnationalism. He has supported every free trade measure that would help his friends, the multinational corporations, expand their markets, and defended every move that would cause NATO and the UN peacekeeping apparatus to become the building blocks around which a world army can one day be established.

We have to put Clinton's concealment of his heritage in its historical moment. He came to power after President George Bush had been widely condemned for uttering the phrase "New World Order." With the anti-government movement in America rapidly degenerating into a dangerous militia movement, public revelation of the fact that Clinton is a descendant of NWO founder Cecil Rhodes would have been more than controversial. It would have put his Presidency, perhaps even his physical security, in immediate danger.

Hence, the Clinton chromosome cover-up.

Three lines of research support the hypothesis that Bill Clinton is related in some way to Rhodes. Admittedly, they are tenuous leads at best, but I think that they merit diligent investigation by those with the time and the inclination to unwrap the mystery, the riddle, and the enigma that is the blue blood of Billy Blythe.

First, Bill Clinton was a Rhodes Scholar at Oxford, but left without taking a degree, which is difficult to do. One has to really screw up at Oxbridge to be "sent down." So long as one attends one's lectures and tutorials and completes one's essays without, say, trying to hit on the master's wife at "high table," one is permitted to graduate with at least some personal dignity intact. Clinton, however, who applied himself diligently at Georgetown and at Yale Law School, seems to have taken his Oxford degree for granted, as if it would be given to him. By comparison, his brainy classmates, Robert Reich and Strobe Talbott, behaved as if they would be expected to actually earn their degrees. Did Clinton fail academically, or was there some resentment among faculty that he had been selected for this meritocratic program merely because he was a descendant of its founder and patron, Cecil Rhodes?

Second, check any British family heritage site on the World Wide Web, and you will find that "Clinton," the President's adoptive surname, is an Oxfordshire family name. This odd fact again implicates Clinton, said to be an ordinary boy from Hope, with the town of Oxford -- that shadowland of arch cabalist Cecil Rhodes -- long before he even became a Rhodes Scholar. Could this be a coincidence?

One would think not, especially now that Clinton may soon accept a professorship at Oxford.

Third, and finally, we have the documentary evidence. These include photographs of Cecil Rhodes and Bill Clinton taken in their maturity. Phenotypes tend to change, sometimes dramatically, over the course of many generations, but over the course of only several, it is quite common for a striking physical resemblance to be passed down between a father and a son, a grandfather and a grandson.

A descendant of one of Rhodes' Rhodesian business partners states that this simply cannot be the case, because Rhodes had no descendants. Rhodes, this source suggests, was a homosexual who became physically agitated around women. The complexities of human personality and circumstance might suggest otherwise.

In any case, I invite the reader to examine a photograph of Cecil Rhodes provided courtesy of David Icke. Study closely the sanctimonious self-seriousness expressed in clenched jaws and a slightly uplifted chin, which Clinton has shown the American people so frequently in office; the irregular, roughly oval-shaped face; the heavily wrinkled, flinty blue eyes; the small, proper mouth; the gray hair flecked with white that Rhodes, like Clinton, possessed as distinguishing facial features at mid-life.

As surely as they grow big watermelons in Arkansas, and cousins copulate with cousins there, Cecil Rhodes looked like Bill Clinton with a moustache! Close, but no cigar, you say? If you doubt this, then I would invite you to find another human genome to be part of.

Basiago, a lawyer, journalist, and novelist educated at UCLA and Cambridge, writes on matters of politics, social justice, and the environment.

Book Reviews

NEW BOOK EXPOSES SECRETS OF IRAN-CONTRA

by Uri Dowbenko

The Conspirators: Secrets of an Iran Contra Insider by Lt.Cmdr. Alexander S. Martin (US Navy, Ret.) Available at Al Martin Raw (www.almartinraw.com)

According to this new book, Iran-Contra never ended. Government-sanctioned narcotics trafficking, wholesale fraud and illicit weapons deals are still part of an ongoing criminal enterprise.

The high-level perps were never indicted. Meanwhile hundreds of witnesses and hapless participants have been liquidated.

Whistleblower Lt. Cmdr. Al Martin (US Navy, Ret.) has written a powerful expose of the hidden history of America from the 1980s, through the 1990s and into the present day. He reveals details of wholesale corruption and unimaginable financial fraud foisted on US taxpayers.

The book's premise is simple. Organized crime (actually a white-collar crime syndicate comprised of government bureaucrats, military officers, intelligence officers and con men or "beltway bandits") has taken over the US Government.

Al Martin has first hand knowledge of the dirty deals, high-level scams, frauds, and treasonous activities of the Shadow Government. And he's definitely the man who knows too much. He has even testified before Congressional Committees chaired by Senator Kerry and Rep. Alexander. Al Martin's new electronic book-manuscript, *The Conspirators: Secrets of an Iran Contra Insider*, is a true crime story that's too been too hot for prime time. (It's only available on the internet.)

Al Martin's book includes his own eye-witness accounts of government drug trafficking, illegal weapons deals, and a veritable epidemic of fraud -- securities fraud, real estate fraud, and insurance fraud by high level government perps.

Because of what he's seen, Al Marton has recently been in hiding. He's a whistleblower targeted by these very same bureaucrat-perps. To date, their criminal-government schemes have cost taxpayers hundreds of billions of dollars.

How did it start? When George Bush, Bill Casey and Oliver North initiated their plan of fraud and drug smuggling, they envisioned using 500 men to raise $35 billion. When Iran Contra finally fell apart, they ended up using 5,000 operatives and making $350 billion in illegal secret operations.

And who is Al Martin? After he retired as a Lt. Commander from the US Naval Reserves, Al Martin's life went into the fast lane as a black ops specialist.

At a meeting with General Richard V. Secord and Lawrence Richard Hamil, the US Government's own con man, Martin was briefed about Iran Contra operations and allowed to view CIA white papers on "Operation Black Eagle," code name for the illegal George Bush/Bill Casey/Oliver North program of government-sanctioned narcotics trafficking, illicit weapons deals and wholesale fraud.

Now Al Martin tells the facts that have been ignored or covered-up for over 15 years. There are many detailed descriptions of ongoing fraud committed by the Bush family, specifically George Bush Sr., George Bush, Jr., Neil Bush and Jeb Bush. These include the Trinity Gas and Oil Fraud,

the Tri-Lateral Investment Fraud, the Harken Energy Fraud, as well as major high-yielding real estate, insurance and bank frauds in Florida, Colorado and Texas.

Al Martin names names, dates and events, which no one has ever dared write or publish before.

Here are some of the chapter titles:

Confidential File: Alexander S. Martin

The National Programs Office (NPO) and Operation Sledgehammer

Oliver North: The Money Laundering Drug Smuggling "Patriot"

"Do Nothing" Janet Reno and Iran-Contra Suppression

Classified Illegal Operations: Cordoba Harbor and Screw Worm

The Don Austin HUD Fraud Case

Insider Stock Swindles for "The Cause"

Lawrence Richard Hamil: The US Government's Con Man.

US Government Narcotics Smuggling & Illicit Weapons Sales.

The Chinese Connection: US Weapons & High Tech Graft.

The Real Story of Operation Watchtower

KGB & East German Intel Activities in the US (1985-87)

Bush Family Corporate, Real Estate, and Bank Frauds

Author Al Martin is an accomplished businessman, as well as one of the last remaining insiders of "Iran-Contra." Here are some of the explosive information you'll learn --

1. What's the real story behind Oliver North and the National Programs Office?

2. Why was Iran Contra profiteering so popular with government insiders?

3. What does George Bush say is the "greatest reliever of stress"?

4. What were the best real estate scams and frauds of the Iran Contra era?

5. What's in the future for government sanctioned fraud in America?

The Conspirators by Al Martin is highly recommended reading for anyone interested in the secret history of the United States.

Uri Dowbenko can be reached by email at u.dowbenko@mailcity.com

Masonic Shadows
by Len Bracken

French Connections: Networks of Influence by Sophie-Coignard and Marie-Thérèse Guichard (Algora, 2000) names names and charts the secret organization of France by various cliques. The authors approach their subject by looking at who hunts with whom, to mention one example, or at the Masonic creation of golf with its fraternal ties. Finance, industry, media – each sector sways under pressure from elitist groups. For someone like me who follows French affairs from a distance, it's hard to judge the book's accuracy, but there doesn't seem to be much effort to sensationalize the material. Moreover, Coignard is the co-author, with Alexandre Wicham, of the bestseller *French Nomenklatura*; my hunch is that the current tome presents a refined version of the material.

My particular interest is in French Freemasonry, its collaborationist role during the Vichy regime, and in Masonry's subsequent dominance in finance and its ties to neofascism. The authors found substantial evidence of Masonic financial subterfuge and of fear among brothers that something terrible will happen, as in Italy with the P2 lodge. "From the Victor-Schoelcher lodge (the base of a fraud scheme) to the scandal over funds raised for cancer research, not to mention the Buildings and Public Works (BTP) and the racket that operates under the warm Mediterranean sun, these 'terrible brothers' have become so renowned that their behavior frightens their peers."

As a materialist psychogeographer, I approach David Ovason's *The Secret Architecture of Our Nation's Capital: the Masons and the Building of Washington, DC* (Harper Collins, 2000) with heavy skepticism. To his credit, Ovason reveals many interesting historical facts about the city, but he distorts them with such spiritist mumbo-jumbo that it's impossible to read with a straight face. When Madame Blavatsky makes her entrance and Ovason turns his gaze to the stars, I reach for my nose to block the stench. Others might enjoy this sort of speculation or take their Penguin *Dictionary of Symbols* into the city and formulate their own theories. Yet even the Masonic sovereign grand commander who wrote a foreword for Ovason warns against drawing "too many conclusions from a schematic map," in this case a map of Virgo. Ovason's obsession with astrology nonetheless reveals a delightful fact: "During the Washington, DC, race riots of 1968, a city zodiac was destroyed. This was the zodiac on the bronze Noyes armillary sphere, which was torn down, carted away and probably broken up for scrap."

Len Bracken is the author of *The Arch Conspirator* (Adventures Unlimited, 1999); Guy DeBord – Revolutionary (Feral House, 1997) and several novels, although he is perhaps best known for rock-backed rants and wild screeds written on concrete. POB 5585, Arlington, VA 22205. lenbracken@hotmail.com.

CARIES, CABALS, CORRESPONDENCE

When are people going to get it through their heads that Mark David Chapman was just a poor brainwashed soul? When are journalists going to start asking him the "right" questions? Probably never... Those really responsible for what he did and the state of his present condition probably feel he is so confused he is no threat, the truth buried so deep in his subconscious, it will never resurface. So in that respect, yes, Lennon would probably forgive the poor bloke, because one could hardly say Chapman was, and still is, responsible for his actions. But since there is no acknowledgment of Manchurian candidate crimes, there can be no proper handling of such circumstances. Freeing Chapman obviously is out of the question, but I have seen no evidence of any attempts on the part of anyone, Yoko included, to have him undergo tests to determine the extent to which his mind was tampered with.

The same goes for Sirhan-Sirhan, and a dozen other assassins who wrecked havoc on the counterculture leadership of the 60s and 70s. The fact that conspiracy writers like Alex Constantine also refuse to acknowledge first person testimony makes it virtually impossible to get the truth out! Lennon was killed by a cabal of CIA operatives retired in Palm Beach, Florida, who congregated at a bar called Taboo on Worth Avenue, the same bar where the rape victim in the Kennedy-Smith trial allegedly went for 20 minutes, away from Au Bar, to score some coke. Taboo was owned by the father, also a retired CIA agent, of her best friend, the blonde who grabbed media attention before testifying. This man also owned La Petite Marmitte right down the street where Lennon regularly had dinner with Yoko. This group of CIA old timers feared Lennon's organizational skills would start affecting the conservative nature of the Palm Beach charity circuit (a 2 billion dollar business a year!) when Yoko moved Lennon into a mansion by the ocean, literally inside the lion's mouth of the US intelligence retirement community. They trained a poor schmuck to pull the trigger. The stuff Constantine and other conspiracy writers bring up is just circumstantial. It may or may not have figured into the overall motive. What I just described is the real reason Lennon was shot! Why am I so sure? Because I was there! And I was helpless to stop it! I kept quiet about it for years, because frankly I was scared, and because nobody wanted to believe me anyway. All the people I knew who knew Lennon, like the lead guitar player for Elephant's Memory who I graduated from high school with, patronized and dismissed me by saying things like: "We all feel responsible for John's death!" So I just stopped trying. But these days I get exceedingly upset because here we have the guy who actually shot the revolver, miraculously still alive, and nobody is doing anything to track down the creeps who fucked with his head. He wasn't as lucky as all the other poor fools who fell victim to all these mind control toys during an era when Palm Beach was prime territory for this type of experimentation on unknowing citizens. Some were mentally independent enough to discern between what was coming from their own consciousness and what was being the resul of external manipulation, piped into their brain by some outside "neurophone" electronic source. Those who couldn't tell they were being used as guinea pigs for bio

electromagnetic mind control experiments ended up being tortured until they lost their usefulness. Don't forget Lennon was shot around the same time as the mass suicide in Guyana. You do the math! You take it or leave it.

Name Witheld
Washington, DC

The Pentagon has a national security interest in portraying the aliens as celestial CIA agents who have chosen the United States as their point of contact on earth. Such a liaison would appear to make us invincible on the battlefield with the super technology from our "benefactors."

The implication of the black propaganda about the character of the "the aliens" is that they understand certain "universal necessities", which are essentially fascist, seemingly based on the teachings of Madame Blavatsky and Alice Bailey (Lucis Trust), which have for years been the mystical excuse for black oppression and genocide. Somewhere along the line, the aliens will be joyously portrayed as sugar-coated Nazis.

If the "aliens" are really as advanced as interstellar journeys and aeropropulsion technologies imply, then they'd be incredibly stupid to mingle with any earth government, let alone the premiere war-mongering regime.

If there are aliens, and we commingle with them, then they are unscrupulous pirates not to be trusted, capable of treachery. Perhaps in this way our intelligence community would find the alien soul brothers.

Someone Else
Richardson, TX

Dear Sir,

[Re: Jim Keith's passing, ostensibly due to a blood clot.] The odds of dying from a blood clot in surgery in the world of modern medicine are about 5000 to 1. I worked in the medical field for 5 years as an EMT, and very rarely heard of that happening and never while in surgery.
HWH (Homer)

With regard to "The American Nazis and the Nation of Islam" by Saab Lofton in *Steamshovel Press #15*:

The 1981 mail-out of ex-White Power editor William Grimstad's "The Six Million Reconsidered" was feuled by Inamullah Khan, a Saudi Royal advisor, with cash from the World Muslim League. A 1983 mail out if it and Grimstad's "Anti-Zion" came straight from W.M.L. HQs in Karachi. (*The Other Face of Terror*, Ray Hill with Andrew Bell, Grafton Books, 1988, p. 251.) I could go on...but I gather you will have concluded that the most fundamental difference between Nazi-ism and Islam is 13 centuries. Otherwise, they're much the same...

Gerard Clinton
Co. Louth
Ireland

Substantial evidence exists that AIDS was created as a custom-tailored Black Death, although nary a word of this appears in the everyday mainstream media. We know now that our government experimented on US citizens without their consent in the 1950s and 1960s. Cities were sprayed with chemicals and patients were exposed to high radiation levels. We must now consider the possibility that AIDS is the result of another morbid experiment.

All governments are about one thing: POWER. And power corrupts. The Cold War spawned a powerful secret U.S. government that developed biological weapons -- including one that destroyed the human immune system. This was done by splicing or combining viruses. WHO experimented in Africa where life is cheap; but in America the enemy was the sinful gay population. Does anyone really believe that AIDS suddenly appeared out of thin air and attacked only homosexuals? God's revenge, indeed.

Paul T. Kane
Denver, CO

Did you know that Whitley Strieber invited William S. Burroughs to his cabin in upstate NY where they attempted to summon the Grays together? Burroughs discusses this in the updated 1996 edition of *With William Burroughs* by Victor Bockris. If you don't have that book, you should run out and get it right now. It somehow manages to be startling and amusing at the same time, kind of like Burroughs' novels.

Robert Guffey
Torrance, CA

My name is Robin Marie Head. I am a Texas Madam. I have been sentenced to ten years in prison under the guise of "organized crime". I was the proprietor of an escort service in Houston and Austin, Texas. There are thousands of those businesses across the US listed in the *Yellow Pages*. I myself have befallen solely because I refused to work for the BATF namely (or DEA, FBI). These agents, our US government, were interested in our exclusive clientele, to wit, "selective" state and political officials of which I do maintain a taped conversation of an agent expressing this in his distinct voice. This discreet information would be invaluable if wanting to gain influence and power over those who fraternize our services (i.e.: election fraud, judicial and legislative control, a silent coup even, etc...) This is the same strategy that empowered J. Edgar Hoover to wield great authority over Washington, DC.

Robin Head
Gatesville, TX

antidote

by Acharya S

1. \'an-ti-dot\ a remedy to counteract the effects of poison

2. something that relieves, prevents, or counteracts

Darwin was wrong. Man's still an ape. His creed's still a totem pole. When he first achieved the upright position, he took a look at the stars, and thought they were something to eat. When he couldn't reach them, he decided they were groceries belonging to a bigger creature. That's how Jehovah was born.

Gene Kelly, "Inherit the Wind"

Have we been seduced by the theory of evolution? No, this is not a deranged creationist rant. Rather, it is an impassioned plea for sanity and solution.

In my childhood naivete and good-heartedness, I truly believed that humanity was a continually evolving process. Beginning as barbarians, whether created as such in the "Garden of Eden" or developed out of the slimy primordial soup, human beings, I believed, had subsequently progressed, marching slowly but surely toward a state of superconsciousness, an awakening or enlightenment, as proposed by various religions and philosophies.

Unfortunately, I was wrong. Man's still an ape.

At some point in life, the savvy will recognize that man as a species not only progresses but regresses. Two steps forward, one step back. Or vice versa.

After thousands of years of supposed sentience, mankind has progressed materially in some areas, yet remains spiritually, mentally and emotionally retarded in many ways. Spiritually, man is a mess, still childishly, megalomaniacally and savagely fighting over whose god is bigger and better than everyone else's, instead of realizing his own divinity and that of the cosmos as a whole. Mentally, the average Joe is a dullard. Emotionally, humankind remains deadened, after millennia yet having little idea as to its own nature, the differences and similarities between race and gender, and how to deal with them. Same old, same old. Same prejudices, same hatreds, same immaturity. Or, possibly even more. In fact, rather than being barbarians, the ancients in some places seem to have been far wiser and more mature than the moderns, which means that we have indeed regressed.

As an intelligent and aware person grows up and becomes enlightened to the world's workings, she or he may easily become disappointed, disenchanted, frustrated and even pissed off, as she or he realizes that little changes in the human realm. For example, 20 years ago, who would have thought that by now pot would still be illegal in the U.S. and elsewhere? It seems like a small point, but in consideration of all the suffering caused over the decades by the prohibition of marijuana and hemp, in reality it is a colossal issue. Yet, we have hypocritical potsmokers in high office who nonetheless perpetuate this immense damage and anguish by strengthening draconian laws and essentially killing people and the planet.

Such a scandal is but one of countless. We who possess curious and

investigative minds also discover that in this human world exist endless other horrendous conspiracies, some so vast as to blow our minds and overwhelm us with thoughts of futility. Knowing that huge power comprising enormous sums and entrenched organizations is in place to thwart various efforts at bettering life on planet Earth, who cannot but feel helpless and hopeless? Who but the pitifully few strongest and most courageous will ever continue to bother about such things? Why not simply surrender to the "American Dream" of cheap material goods and quick thrills? Why chance fighting the monstrous machine?

Instead of taking the safe but unsatisfying route, *Steamshovel*'s esteemed publisher, Kenn Thomas, has risked his neck and busted his ass for years to alert the world to the existence of numerous disrespectful and disempowering activities and influences, i.e., behavior and conspiracy that have robbed the "common folk" of their dignity and power. It's often a thankless task, so - THANK YOU, KT!!

Like Kenn and so many others over the centuries, I too have sacrificed much and risked my ass for years to "enlighten the masses." As the author of *The Christ Conspiracy: The Greatest Story Ever Sold*, which represents the insights of hundreds of history's most brilliant thinkers as to the mythical nature of Christ, I am yet dismayed to continue to discover how widespread and old has been the knowledge of this hoax, one of the most insidious and deadly in history. When the subject is studied in depth, it becomes clear that thousands of members of the elite, the hierarchy, i.e., those powermongers who dictate human creation and policy on this planet, have known all along that Jesus Christ was not a historical personage. Yet, except for the daring rebels, many of whom paid dearly for their audacity, the power elite have sat on this information, continuing to promulgate falsehood for material gain, justifying their dishonesty and deception in a variety of callous, contemptuous ways. It's an utter disgrace.

And there are, of course, innumerable other hoaxes and scams that have poisoned the human species. I'm sure Kenn feels the same way about the JFK assassination. What is the antidote? Come on, already! Fess up, you SOBs!

Not bloody likely, so what can be done about these tiresome political and religious conspiracies? So many of which are indubitably real, but which we can seemingly do little about? Truly, overwhelming is an understatement. Knowing the supreme scurrilousness all around us, is there anything we can do besides report on it? An ages-old dilemma, to be sure.

When the brotherhood rules, the people live in a frat house.

It can be incredibly difficult to find a reason to continue exposing the incessant shenanigans that pass for life on this planet. I personally find solace and inspiration in nature¾such awe-inspiring majesty and beauty! But, knowing that such splendor is being destroyed "at an alarming rate," what then? Can we enjoy the simplest pleasures, knowing that they may be ripping out the heart of Mother Nature?

Which reminds me of what else pisses me off:

* The ongoing destruction of our beautiful, natural environment.

* The interminable poverty, in the face of tremendous wealth in the hands of the few.

* The inability to reduce womankind's onerous labor.

* The continuing abuse of women, absolutely horrendous in many areas.

* The mistreatment of animals and other, human innocents, such as the sexual abuse and enslavement of young girls and boys.

* The perception of religionists that just because they believe some spurious nonsense they are somehow better than the rest of humanity. And the resultant bigotry, suffering and warfare because of such beliefs.

* The political chicanery that has little meaning except to enrich those who perpetrate it. In other words, the absolute lack of integrity in politics. And so on...

As I wander upon this crazy path called life, I am constantly reminded that much of human creation is a brutal insult to my dignity.

Another example: Circumcision, or genital mutilation. Of course, the mutilation done to girls and women is more heinous than that which is done to boys and men. Nevertheless, when one considers that so-called civilized nations continue to cut boys, one can become infuriated. Imagine if a doctor were to remove wedges of skin from, say, the baby's butt, back or leg wouldn't that doctor immediately go to jail, never to be heard from again? But, it is somehow not only perfectly legal but "healthy" and "righteous" for a mad doctor or religious nutcase to hack at the most sensitive part of a baby's body. Such indecent and contemptible behavior truly insults my dignity.

As does the following despicable example of how low human beings can go. In certain countries, there are such things as "honor crimes," usually perpetrated against young women, merely because they dare to be young women. From a recent *LA Times* article (9/10/00), regarding "honor crimes" in Turkey:

In Modern Turkey, Women Continue to Pay the Price for Honor

Rights: For some families, the only way to restore a reputation that they believe has been tarnished by a female relative is to kill her...

The 14-year-old daughter of a Kurdish farmer admitted having sex with her neighbor's son. Never mind that he had raped her. She had stained the family honor. In this largely Kurdish province in Turkey's arid southeast, the only way to erase that stain was with Azize's blood. Two of her brothers took her to an irrigation canal, threw her in and left her for dead.

Azize's story isn't uncommon in Turkey. Experts say that "honor killings" claim dozens of women each year in this predominantly Muslim country...

The teenager's throat was slit in the town square in broad daylight by her 11-year-old brother because someone dedicated a love balled to her over the radio. The girl was a virgin and didn't have a boyfriend...

Then there was 12-year-old Hatice. Her throat was cut by her 17-year-old husband because she had gone to the movies without his permission....

It is not unusual for mothers and other female relatives to act as willing accomplices in honor killings.

"A stained reputation means that other unmarried girls in the family will never find suitors until it is cleansed,"

Gulluoglu says. "If a woman has no skills, no education, her honor is her only currency in the marriage market."

Even death isn't enough to remove the stigma attached to unchaste behavior. Disowned by their families, victims of honor killings are often buried in paupers' graves.

"For us, such girls are no different from dogs; they are dirt," says Mehmet Gucsuz, a spice merchant in the city center, spitting noisily to reinforce his point....

Makes my blood boil.

Okay, I've outlined the insanities, now what's the solution? Individual responsibility, development of consciousness, enjoyment of personal integrity and honesty? Education and cultural exchange? Fun, humor, happiness, joy, and love? Sounds simple. May not be very effective. Activism, marching in the streets? Boycotts? Possibly. More legislation? Abolish politics, religion and objectionable "cultural" practices? Not totally practical, if even possible. Warfare? That's always been a big part of the problem, not the solution.

Actually, it can all be rather discouraging. We can go on blandly reciting facts: "On the 13th of December, so-and-so did such-and-such, blah, blah, blah." But does anything ever really change? Because of bogus social mores and sensibilities, we have become PC automatons, dull robots attempting to "be respectable," "get along" and "get published" by cutting off passion and becoming tedious. We've become BORG.

Sane is he who sees his own insanity.

On my website, I attempt to provide a livelier, more honest outlet for frustration. Each month, I receive hundreds of emails, some of which are clearly cathartic for their writers, who pour out their hearts to me regarding their abusive experiences with religion. Some of these missives have been very intelligent, if full of pain and confusion as to what exactly has happened in their lives. Many of the individuals express that they wasted years of their lives believing a load of puerile poppycock, only to be cruelly dashed to the rocks by some horrible tragedy, such as the unexpected death of a loved one or the contraction of a dreadful disease. Because of such experiences, there is a real need for catharsis. Not only for the individual but also for the human species as a whole.

The folks who are impeding human evolution, such as the dinosaurian politicos, religionists and assorted other powermongers need to be quiet and step aside. Their maniacal rule has brought immeasurable dementia and destruction to this world. We need to loudly tell those who continue to perpetrate scams and hoaxes, whether or not wittingly, that their paradigm is old, dead, rotten and reeking. Their age is over. And, since they are essentially senile, they need to follow us instead. Diapers and dribble cups are waiting.

That's my catharsis and antidote. And seed, perhaps?

Righteous indignation is a spiritual enema.

In the effort both to acknowledge the futility of it all and to offer meaningful respite, we at *Steamshovel* would like to know the readers' complaints, as well as any solutions to the never-ending creepy shit on this planet. *Steamshovel* therefore invites its readers to contribute their "rantidotes" to the numerous problems facing humankind, from Aliens to Zealots. The rules are simple:

1. The subject must be inclusive, i.e., applicable to the human species and/or the planet as a whole. In other words, no rants about Uncle Fred's bad breath or the

neighbor's barking dog, unless it is an "object lesson" applicable to a larger spectrum of people.

2. The rant may not be a personal attack on any individual, unless said individual is a public figure, such as a politician, religious leader, writer, journalist, entertainer, athlete, etc.

3. The submission should be a "rant-idote," in other words, not just bringing up an annoying or dangerous issue but suggesting a solution, however lame or wondrous. Since solutions are so hard to come by, this requirement will not be overarching. Mostly, this column will exist for catharsis, for politically incorrect expression. Expletives are okay, as long as they don't fucking make up the fucking bulk of the fucking rantidote.

4. *Steamshovel* reserves the right to edit and make commentary on all accepted submissions.

Here's your chance to be politically incorrect and get your voice heard! So, keep *Steamshovel* in mind when you are eating, laughing, crying, walking, driving, working, partying, reading, writing or having sex. As you observe life, let your mind flow, take notes, toss it all into a Word or RTF document on a disk and send it via snailmail to Steamshovel, P.O. Box 210553, St. Louis, MO 63121. Or email a file to editor@steamshovelpress.com.

And keep on ranting and evolving.

Acharya S is an archaeologist, historian, mythology, linguist, religious critic and commentator on life in general. A member of the American School of Classical Studies at Athens, Greece, she has a working knowledge of several languages, including French, Spanish, Italian, German, modern and ancient Greek, Latin, and a smattering of Hebrew, Sanskrit, Portuguese and others. Acharya is the author of *The Aquarian Manifesto, Paradise Found* and *The Christ Conspiracy*, as well as a number of articles published in various periodicals. She has appeared on numerous radio programs, on TV and has been known to do a conference or two, if prodded. She also hosts a popular discussion group on the Net, "From Sex to Superconsciousness," which can be accessed via her website, www.truthbeknown.com.

Acharya S herself can be reached at acharya_s@yahoo.com.

ROBISON, BARRUEL AND MOUNIER:

THREE BOOKS ABOUT THE ILLUMINATI

by X. Sharks DeSpot

Back in 1993, I looked up things about the Illuminati in books and soon realized that all the materials divided into two ideological camps: "conspiratorial" and mainstream establishment. The mainstream establishment camp, exemplified by Seymour Martin Lipset and Earl Raab in their book *The Politics of Unreason* (1) said the following:

The Order of the Illuminati was founded in Bavaria, Germany in 1776 by Adam Weishaupt, a professor of Canon law

at the University of Ingolstadt. It was disbanded by the Elector of Bavaria in 1785. Then in 1797 two books about the Illuminati appeared. These were *Memoirs of Jacobinism* by Albbe Augustin de Barruel, and *Proofs of a Conspiracy...* by John Robison. Both books blamed the French Revolution on a conspiracy masterminded by the Illuminati. Barruel's work became important in Europe when Barruel reworked his theory to blame a conspiracy of Jews for the French Revolution (2). Robison's work became important when it led to an anti-Illuminati panic in New England between 1798-1799. (3) Robison's work became a source for the far-right, including the Reverend Pat Robertson's 1991 book *New World Order* (4).

The conspiratorial camp, which ignored everything said about it by the mainstream establishment camp, said that the Order of the Illuminati was found in 1776 by Weishaupt, spread to France where it caused the Revolution, went underground after its official disbanding, and was today active through such groups as the Council on Foreign Relations, the Trilateral Commission and the Bilderberger Group.

I realized something: both groups were talking right past each other and ignoring the obvious. The conspiratorial camp said that the group went underground and continued to exist. The establishment camp said it had ceased to exist in 1785. Therefore, the obvious question was, what evidence exists to prove or disprove the idea that the group survived its official disbanding by the Elector of Bavaria in 1785?

The obvious thing to do, I realized, would be to go back to Bavarian Germany, find the original handwritten documents of the Illuminati, find out who the members of the group were, and then find out what they did afterwards. Obviously, if the diaries and letters of the members of the group written after 1785 showed they were still in contact with each other, still attending meetings to Tether, and raising money for joint efforts, the group survived its official disbanding in some form. Even if the group just got together and had lunch or played music, the organization would have survived.

But, I realized, this obvious question had never been asked, much less answered. The whole of opinion about the Illuminati's continued existence hung on the French Revolution of 1799-1794. If you believed it was the result of a plot, the Illuminati were behind it. If you believed the French Revolution was result of social and political factors, you dismissed the idea of an active Illuminati.

But it's stupid, I realized. The question is not if the Illuminati caused the French Revolution, it's what happened to

the members of the group after 1785. The Illuminati's membership could have done many things, but it did not have to include causing the French Revolution.

Furthermore, if the CFR, Trilateral Commission and Bilderberger Group had the goal of setting up a One World Government, as so many on the far right claimed, they did not have to have anything to do with the Illuminati. The establishment scholars had always dismissed the charges against the CFR, Trilateral Commission and Bilderberger Group by insisting that the Illuminati had ceased to exist In 1785. This is not the same thing as examining the conduct of these three groups. If their actions indicated a desire for a single world government, which was an entirely different subject than if they were an extension of the Order of the Illuminati.

So, three years later, I decided to do the obvious: I would track down the original documents of the Bavarian Illuminati of 1776-1786. (The disband order came in 1785, the complete closing down of the Illuminati lodges in Germany took place in 1786.) This came down to three books available to me at the Michigan State University Library. More than these three books about the Illuminati dating from this period may be available in the United States, but I did not have access to them. Because it would have taken so much time and effort to read all three books, and because Ephraim Hadner has written that some documents from that time are hoaxes, I chose not to untangle the story of the Illuminati (5). My question was, what were the source documents of these three books about the Illuminati? Where did they get their information? The question of the reliability of the source documents would have to wait. And the question of what happened to the members of the Illuminati, which may have been 3,000 or 5,000 people, after the official disbanding would also be unanswered.

Robison, John, 1739-1805 *Proofs of a Conspiracy Against All the Religions and Governments of Europe: Carried On In the Secret Meetings of Freemasons, Illuminati and Reading Societies.* **Printed for William Creech and T. Cadell, Junior and W. Davies. London, 1797. The 2nd Ed., corrected, to which is added a postscript. If you've read Robert Anton Wilson's** *Illuminatus* **trilogy, you may remember this book.**

In his parody, Wilson wrote:

"Robison was an English Mason who discovered through personal experience that the French Mason Lodges--such as the Grand Orient--were Illuminati fronts and were the main instigators of the French Revolution." (6)

The book makes clear that Robison was a Freemason, but Robison never claimed personal experience for his knowledge about the Illuminati. He had, in his youth, visited European Freemasonic lodges, and was distressed by the exotic forms of ritual and strange doctrines taught there. But by his own account, he got his information about the Illuminati from at least three different German language texts, which he translated. These were: *Religions Begebenheiten*; *I.E. Religious Occurrences*, including volumes for 1779, 1785 and 1786, plus *Neueste Arbeitung des Spartacus Un Philo in der Illuminaten Order* and *Hoherer Granden des Illum. Ordens.* The proofs make clear that he first learned of the Illuminati in the summer of 1795 when he found volumes of Religions Begebenheiten at a friend's house. He had never met a member of the Illuminati, or at least a

member listed by name in his source documents.

He may have had more than these three books. He wrote: "A collection of original papers and correspondence was found by searching the house of one Zwack (a member) in 1786. The following year, a much large collection was found at the house of Baron Bassus; and since that time Baron Knigge, the most active member next to Weishaupt, published an account of some of the higher degrees which had been formed by himself." (7) Robison also says that after the disbandment order given by the Elector of Bavaria in 1785. "...Weishaupt now safe *In Regensburg*, published an account of the Order, namely, the account which was given to every novitiate in a discourse read at his reception. To this were added, the statutes and the rules of proceeding, as far as the degree of Illuminarue Minor, inclusive. This account he affirmed to be the real practice of the Order." (8)

Robison also notes that this account conflicted with testimony given by four men testifying against the Illuminati, probably Cosandy, Renner, Utzschnelder and George Grumberg, whose testimony is listed in Abbe Barruell's book.

Barruel, Abbe' Augustin de. Memoirs, Illustrating the History of Jacobinisim, I.E. *Memoires pour servir a' l'histoire du Jacobinisme.* **Translated Into English by the Hon. Robert Clifford, F.R.S., & A.S. Printed for the Translator by T. Burton, No. 11, Gate-Street, Lincolns-Inn Fields, IV Volumes. London, 1798.**

Barruel believed that the Knights Templars, destroyed by Philip The Fair of France in 1314 were ultimately behind the French Revolution of 1789-1794.

Wrote Vamberto Morals:

"But the Abbe Barruel, ignoring this troublesome historical fact, was certain that the Templars had survived as a secret society, devoted to the abolition of all monarchies, the overthrow of the papacy and the proclamation of unrestricted freedom for all peoples. The French Philosphes of the eighteenth century, like Diderot, Voltaire and d'Alembert, had all belonged to a secret Acadamy affiliated with the Freemasons. But the real leaders of this rather complicated network were yet another--the 'Illuminati.' This society, a rival of Freemasonry, had been dissolved in 1786, but one could always argue that they had continued to exist secretly." (9)

Yes, but Mr. Morals, did it continue to exist secretly? Abbe Barruel certainly thought so, and he listed nine sources in his volume III of his work.

I. Some of the original writings of the Sect of Illuminees, which were discovered on the 11th and 12th of October 1786, at Landshut,

on a search made in the house of Sieur Zwack, heretofore counsellor of the Regency and printed by Order of His Highness the Elector--Munich by Ant. Franz, printer to the court.

II. The second is a supplement to the Original Writings, chiefly containing those which were found in a search made at the Castle of Sanders-dorf, a famous haunt of the Illuminees, by order of his Highness the Elector, Munich 1787.

III. *The True Illuminee, or the real and Perfect Ritual of the Illuminee, comprehending the preparation, the novitiate, the minerval degree that of the minor and major Illuminee, all without addtion or omission* (No author name given.)

IV. Last observations, or last words of Philo, and answers to diverse questions on my connections with the Illuminees. By Baron Knigge.

V. The last works of Spartiacus and Philo I.E. *Die Neuften Arbeiten se Spartacus and Philo.* "'Spartacus' was Weishaupt's code name, 'Philo' was Baron Knigge's code name.

VI. A Critical History of the Degrees of Illuminism. (No author.) Because Barruel knew the name of the publisher but did not give the name in the book, I wondered If V. and VI were the "Spurious Documents" mentioned by Ephralm Radner.

VII. *The Directing Illuminee, or the Scotch Knight.* (No author.)

VIII. *Remarkable Depositions Resecting the Illuminees* by Cosandy, Renner. Utzschneider, and George Grumberg.

IX. Apologies – "Published by some of the leaders of the sect."

Page 283 of Volume IV lists "Charles Augustus of Saxe Weimar" as someone who would have been listed as a member of the Illiuminati if he had not refused a suggestion from Adam Weishaupt. But the account makes clear that Charles Augustus of Saxe Weimar knew Adam Weishaupt. But the account makes clear that Charles Augustus of Saxe Weimar knew Adam Weishaupt.

Mounier, Jean Joseph 1758-1806 *On the Influence attributed to Philosophers, Free-Masons and to the Illuminati on the Revolution of France.* Printed by W. and C. Spilbsbury, Snow Hill, London 1801. Reprinted by Scholars Facsimiles & Reprints, Delmar, NY, 174. With introduction by Theodore A. Di Padova, 1974.

Of the three authors, Mounier was the only one of the three to have actually met any living members, or ex-members, of the Order of the Illuminati. Ephraim Radner wrote:

"Intellectuals such as Goethe, Merder and Mozart were apparently members of Weishaupt-sponsored Illuminati groups..." (10).

Theodore A. Di Padova wrote in the reprint edition of *On the Influence...*

"In 1795 the duke of Saxe-Weimar put his castle of Belvedere at Mounier's disposal to establish a school for preparing young people for careers in public service. Evidently Mounier's reputation as a man of learning and wise moderation had become well known. Mounier taught history here from 1795-1801. Though his life was made

sadder by the loss of his wife in 1795, it was enriched by his association with men like Gentz, Boettlger, Herder and Goethe. This was the atmosphere in which he wrote *On the Influence Attributed to Philosophers. Free-Masons and to Illuminati on the Revolution of France*, his last important work.

I don't know if the Duke of Saxe-Weimar was the same person as Charles Augustus of Saxe-Weimar listed by Barruel, but if Ephraim Radner is right, Johann Wolfgang von Goethe and Johann Gottfried von Herder were both former members of the Illuminati and both were known personally by Mounier.

Wrote Di Padova:

"As an opponent of integral counter-revolution, Mounier maintained, contrary to what Barruel and Robison were saying, that the Revolution had resulted from abuses inherent in the Old Regime. The restoration of these abuses would only lead to instability and further revolution. Mounier felt that all societies must change, and he accused those who opposed change of being more dangerous than revolutionaries. The latter would not exist if the former did not protect abuses in government ... As one who had suffered personally under the regime of privilege and had resented royal 'despotism,' Mounier was deeply aware of the sources of discontentment in pre-revolutionary France. Experience had convinced him that the Revolution was caused by social and political factors. He rejected the conspiratorial theory essentially because it did not correspond to his personal knowledge of the events and because it failed to recognize the underlying causes of the Revolution. (12)

Although his sources of information about the Illuminati were the same printed volumes as Barruel (apparently), he reached a different conclusion from the same evidence:

"Let us examine impartially the origin and the real spirit of the association of the Illuminati. It is easy to know them, since the Government of Bavaria has caused all the papers to be published which were found, belonging to the principle members of this Order; and since this publication has occasioned a great number of works, some in order to oppose, others in order to defend them." (13)

Mounier wrote about the situation inside of Bavaria after the official disbanding of the Order of the Illuminati:

"The destruction of the Society did not calm the hatred and jealousy which the influence of several of its members had excited. Their private enemies took advantage of this favourable circumstance Some persons whose intentions were pure, having conceived the order of the Illuminati to be dangerous to religion and to the State, did not believe that they could exert themselves too much in order to prevent its reestablishment. Many called in question its destruction, and feared that it was only apparent. Several works accused the Illuminati of having prepared the ruin of all governments; and when the Revolution of France began, it was asserted that they were the authors of it" (14)

In effect, the idea that the French Revolution was caused by the Illuminati was not started by Barruel and Robison. It was started inside of Bavaria itself and spread outward.

In summary, it seems obvious that all three authors believed in the documents seized by the Elector of Bavaria at the house of Xaverius Zwack in October of 1786. Mounier never believed that the Illuminati wanted to ruin all governments. Robison and Barruel always did. Barruel and Robison

never had any contact with living, first hand witness of the Illuminati. Mounier did, but did not tell his readers this or quote their first-hand accounts which they may have told him. And the establishment scholars never doubted that the Elector of Bavaria eliminated the Illuminati in 1785. The conspiratorial camp never adressed the question how you prove that the Illuminati survived its official disbandment of 1785. Instead, the conspiratorial viewpoint was content to blame the French Revolution on the Illuminati, caring nothing about the actual members of the group.

NOTES:

1. Lipset, Seymour Martin & Raab, Earl, *The Politics of Unreason: Right-Wing Extremism In America, 1790-1977*, University of Chicago Press, Chicago and London, 1978.

2. Morals, Vamberto, *A Short History of Anti-Semitism*, W. W. Norton and Company Inc., New York, 1976.

3. Lipset &,Raab, page 35.

4. Radner, Ephraim, *Christian Century*, September 13-20, 1995.

5. Radner, Ephraim "The Illuminati in Europe" *Christian Century*, September 13-20, 1995 page 846.

6. Shea, Robert & Wilson, Robert Anton, *The Illuminatus! Trilogy*, Dell Publishing, New York, 1975, page 103.

7. Robison, John, *Proofs of a Conspiracy...* page 133.

8. Robison, page 109

9. Morals, page 194.

10. Radner, page 846. I found the name of an "Adolf Baron Knigge" who reviewed Mozart's plays in *Mozart:A Documentary Biograph,* Deutsch, Otto Erich. Adam and Charles Black, London 1965. I do not know if this was Baron Knigge of the Illuminati.

11. Theodore A. Di Padova, in Mounier, Jean Joseph *On the Influence Attributed* from unnumbered introduction.

12. Di Padova, in Mounier, unnumbered introduction.

13. Mounier, pages 173-174.

14. Mounier, page 192.

15. An article in the *Encyclopedia Brittanica* asserts that four cells of the Illuminati existed in Italy at this time, which may have survived the official disbandment in 1785. "And there were...in Milan, Bologna, Rome and Naples cells of the Illuminati, republican freethinkers after the pattern recently established in Bavaria by Adam Weishaupt." Italy: p. 223 Volume 22, *Encyclopedia Brittanica*, 15th Edition, 1989.

X. Sharks DeSpot has written about the mass media for *Crash Collusion* magazine and contributed to *Steamshovel Press' Popular Alienation* anthology.

JFK Redux

Gemstone Update

by Stephanie Caruana

Stephanie Caruana is preparing, at long last, a book which will be an update of the Skeleton Key to the Gemstone File, which she originally circulated beginning in March of 1975. The title of the book will be: The Gemstone File Update.

This revision will include, for the first time, a transcription of some provocative material from a segment of Bruce Roberts's Gemstone letters, dating from 1971-2, as well as some of Roberts's Gemstone letters from Stephanie's own files which date from 1974-5--including details of the tumultuous days of Nixon's resignation. An updated "Skeleton Key to the Gemstone File" will also be included.

The book will include an account of Stephanie's meetings with Roberts, and events which occurred as a result of the publication of Stephanie and Mae Brussell's article on "Howard Hughes" in Playgirl, *at Christmas, 1974. The book is at the printer now, and will be published and available for shipment within 60 days. The cost will be $16.00 + $5.00 postage and handling.*

If you would like to order a draft copy now, you can order it on the web at http://dogbert.abebooks.com by searching for: "Gemstone File Update." You will be able to order it via credit card. Orders received prior to publication of the book will receive a draft copy on 8.5 x11 paper. Orders received after publication of the book will be filled with a published copy. Additional updates are projected in the future. For further information, Email Stephanie at:

spear-shaker(a),minds pring. Com

above: **Ralph Nader, 1983**

[1970 (After August)]

This writing is one of many attempts to secure moral and legal cooperation in the correction of immoral and illegal acts. So defined in my Constitution--and in yours.

It is in a sense an application for legal representation.

As will be seen--the legal system is a part of the massive group from whom I seek relief. They will not prosecute themselves.

I apologize for the sometimes hardly legible handwriting.

The subject matter will be new to you and--because of its vastness--and your unfamiliarity with the background-you will have immediate questions.

I ask only that you overlook any questioning until you have read the entire bit. You will find that most of your questions will be answered. Certainly most of the key questions.

Surely--in any event--enough to enable you to reach a decision as to whether to pursue the matter--or to drop it, as many have done.

POPULAR PARANOIA, page 312

above: **Bruce Roberts and Carmen Miranda**

Should an illegible word or phrase puzzle you--and again my apologies--I will of course interpret it for you.

I am an American--born that way and I'll die that way. But--of the original 1776 variety--whose intent was really clean, believing in freedom for this country--and for all others. Not the type of today, the group which has converted that original Constitution--and its inten-t-into a Mafia base of operations, grown so powerful that it censors the will of the general public and threatens the security of the rest of the world.

It is a request for legal representation: The first lawyer to whom I made this request--two months before the 1968 election--was Richard M. Nixon--and his partner, John Mitchell. That request elected Nixon to the Presidency--as you shall see. And he has been running from me ever since. Chappaquiddick, "Howard Hughes". And Nader are some of the keys. But the real key was a hit-and-run accident by the Alioto family--covered up by Alioto--that exposed the Mafia election process which elected Nixon. They now want Alioto out of the way--but not by exposing that key. And Alioto knows this--and so--

NOTE: Ralph Nader published a book--*Unsafe at Any Speed*--a costly critique of General Motors. The attorney for G.M. was Ted Sorenson (former JFK advisor). G.M. attempted to discredit Nader--private investigators. Nader sued-$26 million—"invasion of privacy." Called the "suit of the century"--G.M. attorneys (Sorenson, Rifkind, Goldberg), had it blocked. through the century. Nader faithful believed that Nader would fight it all the way through.

Public knowledge of the accompanying letter changed that in four days. Without stopping Nader--in any way--in his critique of G.M.--Simon Rifkind (note that Sorenson suddenly dropped out of sight)--Sorenson's partner--delivered to Nader a $457,000 cash--tax free settlement. Nader quickly grabbed the bait--to the total dismay of his faithful. Nader knew, however, what his followers didn't know--this letter. This, he knew, was the whole ball of wax. He didn't have to settle for $26 million. He could have it all. If I gave it to him. And I offered.

(Ted Sorenson, an advisor to JFK, was called upon to write Teddy's Chappaquiddick "walk on water" speech. Simon Rifkind, former federal judge, and Sorenson's partner, was a key figure in the Tammany Hall Judge Crater disappearance in the 1920's--an old Kennedy friend. Arthur Goldberg, former U.N. representative and Sup. Court Justice r d [sic] Labor Department head for Kennedy, and a partner in the firm, hired Esther Newburgh (one of the Chappaquiddick "girls")--but recently-sensing problems--resigned from the firm in favor of private practice.)

Today--Nader kicks Presidents and Senators in the ass and spits in the eye of other governments (i.e., Japan, England), with impunity. Fellmeth [?] --finally allowed access to this information--by me, not Nader--

above: **Aristotle Onassis**

crusades" everywhere--Mid East, Pakistan and Ireland. China wouldn't let him in. (Yesterday a British politician stated in Parliament: "Kennedy should stay out of Public affairs--and settle his own Personal affairs." The Churchill-Kennedy-Onassis cancer of the British hierarchy (a hangover from the Joseph P., Roosevelt, Winston, Onassis's original booze-heroin group) hooted him down: "Unfair to mention the murder at Chappaquiddick!" This--of course--is the same group that covered up the headchopping-off murder of Wilkinson in England by Senator John Tunney's sister. (Tunney-Teddy's closest friend-originated the phone call series to (and from) Chappaquiddick on that murder night--from his sister's home in the Bay Area. That caused Tunney's sister to wind up in England--and chop her squawking husband's head off. For this murder she's in a nut house-"sequestered". She'll be released soon-"cured"!

published a report labeling the entire California State Government a Mafia cell. Today, Fellmeth is publicly investigating Congress. The original Nader group was Nader, Fellmeth and Cox. Cox is now Nixon's son-in-law.

This letter--since August 1970--has been on Nixon's desk, Mitchell's, Alioto's, Teddy's, Onassis', Hoover's-and on and on. It--with related incidents--has resulted in China's admission to the U.N., Nixon's world trips to everywhere--including Russia and China; Agnew's antics, Teddy's bit--and Nader's winning of a private poll (non-political party) poll by Mike Royko on the Presidency: 1100 for Nader, 400 scattered between Muskie, Kennedy, Humphrey, and Nixon.

Nixon is crawling around the world on his belly. Buying, where possible. Selling, otherwise. Teddy dips in all the "holy

above: **Howard Hughes**

POPULAR PARANOIA, page 314

Me? Since August, 1970? Nothing. Mitchell and Hoover are hiding. The entire hierarchy is out with shovels-covering up.

The plainly exposed areas--Onassis's "Howard Hughes", Chappaquiddick, this letter, and a host of uncovered history--assassinations through wars--are all focused on the 1972 U.S. elections. Cover-up is the name of the game. Potentials? Nixon, Nader, Tedy, Muskie, Humphrey—and all the rest? Well, how impressive can they be—with shit-covered faces and massive necrophilia (that's "fucking of the dead") on the grave of Mary Jo Kopechne?

It starts, of course, with the most crucial cover-up of all—the cause of Chappaquiddick: the expose of the Mafia election process—the unveiling of the cover-up, by Alioto, of the Alito hit-and-run on my car at 10:47 p.m., at the corner of Franklin and Lombard, San Francisco, on September 16, 1968, two months before the 1968 election, which secured Nixon's election—because of the cover-up action. This in spite of Onassis'-"Hughes"-Maheu wholesale Las Vegas skim money bribes to all contenders (the skin that "Justice" currently ascribes to Lansky—and that's how big it is—Lansky is to be the "fall guy" for that phase of the bit.) That hit-and-run report is currently buried--in City Hall--under a Federal "no-peek" order-in a loose leaf book--for convenient removal--under the name of Kathryn Hollister. My name is Bruce Porter Roberts--and I am not a girl.

Because of this, Alioto is on trial for things. Many things. But always elsewhere. And never the hit-and-run. My "friend" of the hit-and-run incident in September, 1968--Richard Carlson (now known in China as "Chappaquiddick Little Dickie") was ordered to write "The Alioto Mafia Web" "Look" story on election day, 1968--by Nixon--and to bury the hit-and-run. He obeyed. This, of course, to hide the key--the Mafia election process, highly exposed--by me. Nine months later, the pressure from that hit-and-run caused Chappaquiddick. And there they are, all of them, with shit on their faces.

(This page dated August 12, 1971, to Fellmeth (and Miller))

Here's a contemporary validity check.:

The accompanying letter was written on August 10, 1970, following a TV interview with Nader on August 9.

Saucer Section

The "Real" Philadelphia Experiment?

by Alexandra Bruce

I recently was introduced to Bob Beckwith, owner of a successful electrical engineering firm that services utility industries throughout the world. Beckwith is an innovator who has patented many electrical systems over his long career and he shows no signs of quitting today. He continues to develop and sell electrical protection and control equipment at a time of life when most people are in their second or third decade of retirement.

Late in 1942, while still in his early twenties, Beckwith invented Frequency Shift Keyed transfer trip equipment, which facilitated the sending of electrical power over long distances. This was part of a nationally coordinated electric utility crash program to connect existing generation together to supply power to the world's first nuclear facilities,

such as the one at Hanford in Washington State.

Bob's *wunderkind* status led to his being tapped by Bell Laboratories for a project to improve sonar technology. This was urgently needed to defend against the German mines that were being laid off the U.S. coasts, blowing Navy boats out of the water before they could reach the European theater.

Beckwith recalls that, while the refinement of radar and grappling with its ramifications were of chief importance to wartime electrical engineers on the European front, "Radar was not a major problem to the Navy in the defense of the U.S. coast, whereas, submarines and the new German mine were." This is interestingly divergent from the predominating accounts of the Philadelphia Experiment legend, which usually include a tangent about the Navy's frantic rush to develop 'radar invisibility'. However, as Beckwith remembers it, the radar war took place mainly in the skies over Europe. According to him, the protection of the US Coast was the primary objective of the 'real' Philadelphia Experiment and it was not a test of radar, *per se*.

Between WWI and WWII, the Germans had developed underwater mines that were set off by the magnetism of passing ships' hulls, requiring no direct contact with the targets. The US countered by developing minesweepers that were successful in setting off the German mines with the use of low frequency AC current-carrying cables dragged in the water over the sides, much in the manner of commercial fishing nets. The AC current from the cables activated the mines' detectors, exploding them at a safe distance. The Germans responded by developing a nasty new mine anchored to the bottom that would not explode when their detectors were activated but would, instead, rise to the surface to get the minesweeper. There were many fatalities and keeping US shipping lanes open became a major problem. 'The Bomb' was not ready yet and it was feared that the German mine problem might cause the US to lose the war before 'The Bomb' could be used.

As a civilian working for U.S. Navy contractor, Bell Laboratories, Beckwith was involved in Navy sonar and communications tests over the course of many months. At the time, he was told that Vannevar Bush, the presidential appointee in charge of the Office of Scientific Research and Development had commissioned his project. Initial tests were carried out in a secret lake in New Jersey. Later, he says tests were carried out in Long Island Sound, using the experimental minesweeper, IX-97 and the private yacht, Sardonix, as well as at the Navy's underwater sound lab in New London, CT.

It was hoped that an application of Beckwith's Frequency Shift Keyed telemetry technology to sonar would enable the detection of the new mines at a sufficient distance to avoid and/or detonate them safely. While this application of FSK proved unsuccessful, he did help the Navy to develop sonar for communications that was inaudible to the Germans.

There were other ways around the problem of the new German mine that were evidently tested, as well. In January of 1943, Beckwith says he attended an initial briefing with the father of the atom bomb, Dr. Edward Teller. Teller described to him a smallscale teleportation demonstration by Nikola Tesla, which he intended to duplicate using a fullscale minesweeper.

Eighteen months later, in June of 1944, while Beckwith was running his advanced sonar tests aboard the IX-97, he recalls overhearing the enlisted shipmates' repeated remarks about the apparent results of Teller's secret teleportation project. A very strange series of incidents was reported to

have taken place during a previous clandestine experiment aboard the IX97, in which Beckwith was not personally involved. The details of the stories, which he continually overheard from his fellow shipmates are strikingly similar to the salient features of the Philadelphia Experiment legend. These highlights included the accidental teleportation of a Navy vessel from Philadelphia to a Naval base in Virginia and the horrible consequence of a sailor's body becoming fused with the ship's hull. Beckwith is convinced that these anecdotes, which he overheard from the crew about the previous experiment aboard the IX-97, were about the 'real' Philadelphia Experiment.

In a letter to me, Beckwith writes:
"As I have said in my book, *Hypotheses*, [published in 1996] the remarkable time reversal trip of the previous experiment on the IX-97 was common scuttlebutt shared with me at meals, etc. during 'my' experiment. Officers had undoubtedly been told to keep the time travel event secret and were dismayed at the talk going around freely to outsiders such as myself. Remember that there was no CIA, FBI, NSA etc. etc. at the time. There were no classifications of secrecy except not to do anything to help the enemy as long as the war continued. It is easy to imagine a small number of high ranking military and political figures organizing a cover story to discredit the scuttlebutt.

"The stories [I constantly overheard] were about the disappearance and movement of the IX-97 and disturbing results that led the skipper and experimenters to quickly shut down the experiment when they suddenly found themselves at the dock in Newport News, VA where the ship had been berthed two weeks previously.

"Navy operators and undoubtedly at least one civilian in charge of the experiment may have been completely enclosed in the inner ships cabin space and went along for the ride' with no ill effects. The IX-97 may have stayed in Newport News long enough for those frightened operators of the experiment, enclosed in the space, to see where they were and suddenly turn off the power, bringing the ship back to Philadelphia yards. Unfortunate sailors on deck or the dock must have been partly moved in time giving them the mind disturbing space separation reported.

"One most unfortunate mate fell from the deck to a position where he was trapped in the steelwork. Part of his body was inside and part outside of a splash cowling just forward of a port side cabin's sliding door. I was shown fresh paint on the inside and outside of this curved cowling where the mate had been impaled, half in and half out of the cabin.

"I clearly remember the scuttlebutt among those of us working together in New London concerning the experiments and I had no reason not to believe the stories which included the man trapped in steelwork and men with very serious mental disorders. One mate was said to have later faded from plain sight in a barroom, never to appear again! The mealtime and free time conversations may or may not have included Dr. Horton [the director of Beckwith's subsequent sonar project], but I believe some did. As to the validity of the scuttlebutt concerning the ship moving experiment, I can only say that jokes of this kind simply were not made up during the war. Besides, how could one hoax a story involving so many people?"

Beckwith's testimony is a very interesting and exciting development in the unraveling of this World War II secret. Conspicuously absent from this version of the Philadelphia Experiment are the figures of John Von Neumann, 'Dr. Rinehart' and the *USS Eldridge*, normally associated with the legend.

Beckwith is convinced that these details are part of the disinformational

campaign set up by the Navy to confuse the issue and discredit accounts of what actually took place.

For their part, the Navy has put some effort into denying that anything like the Philadelphia Experiment ever took place. In fact, they seem to do a brisk business substantiating their side of the story, selling copies of the microfilm of the *Eldridge*'s logbook from their website (number NRS-1978-26, if you are interested).

As to verifying Beckwith's claims, I have seen a copy of a photo ID civilian pass the Navy issued to him in May of 1944, which gave him access to government and military facilities, boats and submarines, along with his numerous expense reports. In the Navy's official *Dictionary of American Fighting Ships* by Samuel Eliot Morison, there is a photograph and description of the of the IX-97's activities which document the ship's use in sonar tests in the Long Island Sound area during the time period Beckwith specifies. According to this record, the IX-97 was originally a private yacht, named *Thelma*, which was loaned to the Navy by her owner, George A. Miller on January 11, 1943. The "IX" hull classification is for miscellaneous boats, which explains how it was being used as an experimental minesweeper, though not originally constructed as such. The Navy re-christened her the *USS Martha's Vineyard* and she was commissioned on March 30, 1943 with Lt. William W. Boyton in command. On April 18, 1946, she was decommissioned, stripped of military equipment and returned to her owner.

I asked Beckwith if the name Boyton rang a bell and he said that it did and that it was likely that Boyton was in command of the ship during the teleportation experiment, which he estimates having occurred sometime around September and October of 1943. There is no mention of the IX-97 ever traveling to Philadelphia or Newport News in the brief official report that I saw. One way to verify the IX-97's whereabouts would be to access the ship's logs, if they are still on file at the National Archives in Washington, DC, although there was a major fire there in the 1970s which destroyed many of the Navy's records.

I showed Beckwith the four handwritten Philadelphia Experiment documents attributed to Oscar Schneider. He believes these letters to be genuine Navy documents written by Oscar Schneider, generated as part of the abovementioned cover-up.

In another letter to me, he says:

"My first meeting before the experiment was with Dr. Edward Teller. He had been assigned to the anti-sonar project by the President. Dr. Teller told of an experiment done by Tesla in 1907 where Tesla moved an object along a laboratory bench, turned on his electric field, making the object move back in time to its original position. When the power was turned off, the object moved forward, to its place in present time. If anyone can research Tesla's work and confirm this experiment, it would greatly support this story and my memory.

"Teller said he had no time to repeat Telsa's work and had to believe it would work when scaled up to the size of an experimental minesweeper, the IX97. The plan was to add a third currentcarrying conductor high in the rigging of the boat, forming a three-phase field. High-current rotating generators manufactured by GE at the Pittsfield, Massachusetts plant supplied the three currents. Again, an excellent source of confirming facts, if anyone can find such generators in the General Electric Co. records…"

Beckwith saw these "time travel" generators that were located at the rear of the craft. They were still onboard during his tests, although not in use. They consisted of three single-phase units placed 120 electrical

degrees apart. Each unit was approximately 5' tall by 2' in diameter. The generators put out low voltage but did more than 1000 Amps. He said the boat had sliding doors, (which looks right from the picture) and that the controls for the generators were in the back cabin. The generators were electrically driven by the ship's power.

The proposition of Beckwith's 'real' Philadelphia Experiment aboard the IX-97 had nothing whatsoever to do with radar invisibility: It was an elaboration of Nikola Tesla's earlier work in teleportation.

Teleportation is tantamount to time travel. The idea that the Philadelphia Experiment intentionally involved the manipulation of space-time physics is more congruent with the subsequent legends of the ship's disappearance 'from this reality' than the idea of it having been a test of radar invisibility or 'cloaking'.

Why the First Thirty Minutes of *The Matrix* is the Best Conspiracy Movie Ever Made

by Greg Bishop

Steamshovel debris: Greg Bishop edits and publishes the zine, Excluded Middle. *An anthology of its back issues, with a boatload of new material, has just been published entitled* Wake Up Down There. *Robin Ramsay in* Lobster *said this about it: "smart people wrestling with tricky material." (Back issues of Ramsay's zine are now available on CD-ROM from 214 Westhourne Avenue, Hull, HU5 3J8, UK. Find out more at www.lobster-magazine.co.uk.)* Wake Up Down There *is available from Adventures Unlimited Press.*

Forget *Red Alert*. Forget *Capricorn One*. Forget *The Manchurian Candidate* and *JFK*. The film that exposes the "conspiracy," the industrial-age attempt, as Allen Ginsberg once said, "to impose one level of mechanical consciousness on mankind" is 1999s *The Matrix*. This perfect exposition only lasts only through the first half-hour. The rest of the film is a run-of-the-mill affair for the most part, with only the glimmer of promises made in the opening scenes.

Someone has to interview sibling writer-directors Larry and Andy Warchowski and see if the really meant everything that they said, or simply stumbled onto the story as *idiot savants*. The visual, didactic, and dramatic cohesiveness of the first half-hour would indicate that they in fact knew exactly what they were up to, and just couldn't figure out a way to make the message evolve and last for the full two hour and 16 minute running time. The message, simply put, is the essential truth that people are robots, controlled by what has become a cybernetic/ machine/ hive consciousness. Humans are the cogs on the wheels, and money is the grease. The root of everything that has been shoved into the "conspiracy" box over the last few decades can be reduced to this bare-bones fact. *The Matrix* takes this scenario to a higher level, and tell us what is really going on in the best way we have-through a visual art medium.

The film presents a pervasive controlling force on the abstract, or symbolic level. Some have drawn the character Neo, played by Keanu Reeves, as a Christ/ savior figure, but this seems to miss the point of what he is trying to save us (or is forced into saving us) from. Look up the consumer reviews on Amazon. The idea presented as the cornerstone of the plot seems to have bypassed these video consumers, who instead discuss the "way cool effects and fight scenes." One reviewer even goes as far as to call it his "favorite film of all time" without

acknowledging of the lynchpin of the story. What is ironic is that the other main character, Morpheus (Lawrence Fishbume) at one point explains the consumer mentality and the insidiousness of its world (and psychic) dominance.

In the first ten minutes of the film, Neo realizes he's been dreaming the last few minutes of his life. This brings to mind Gurdjieff's idea that we are all spiritually asleep, and as if to emphasize this, Neo wakes up from two dreams in succession. We really don't know whether what he is experiencing is really "real." Morpheus (also the Greek god of dreams, or dream states, appropriately enough) decrees: "'Real' is electrical signals interpreted by your brain." Cool, since much of the story takes place in an alternate space and/or state accessed by strangely antiquated electronic devices, and since most of the ideas and sensations running around inside our heads really *are* electrons flashing around neural pathways, rendering what we perceive as reality. He continues:

"There's something wrong, but you don't know what it is. You can see it when you look out your window, or when you turn on your television. You can feel it when you go to work, or to church, or pay your taxes. It is the world that has been pulled over your eyes to blind you from the truth."

An anomalous message flashes on Neo's computer screen as he wakes up from a doze session: "Follow the white rabbit." This obvious reference to Alice In Wonderland is reinforced later as Neo prepares to enter the Matrix. A broken mirror loses its cracks (echoing the waking from the first dream) and then becomes fluid so that Neo can put his hand through it (waking from the second dream.) Significantly enough, the silvery mirror crawls up his arm and sends him into another reality where he struggles to escape from a womblike "pod."

Wires and cables sprout from all over Neo's body, like some sort of macabre umbilical cords. These placenta-like tubes are not giving life to Neo and the banks of other humans he can see stretching to infinity, they are using the bioenergetic heat of their bodies to power the machine consciousness of the Matrix. He tears open the amniotic sac and looks around just as a huge floating machine stops in front of him, scrutinizes this "awakened" being, and quickly dumps him out a sewerlike pipe. When we wake up out of the sleep that has been imposed upon us from birth, ever since that doctor gave you a whack on the butt, the machine consciousness that forces materialism, instant gratification, and unsatisfiable desire upon all humans with any access to "civilization," becomes obsolete and insane, as indeed it always was.

If you want to watch the rest of the film, go right ahead, but if you want to continue the message on another level, pop this tape out and rent or buy a copy of *Fight Club*.

And keep taking the orange pill.*

* This is a plot element from the first 30 minutes as well.

SUBSCRIBE TO

STEAMSHOVEL PRESS

**ALL CONSPIRACY.
NO THEORY.**

SINGLE ISSUE, $7
**SUBSCRIBE AND SAVE!
FOUR ISSUES, $25**
BACK ISSUES, $10 @

Subscribe now to America's premiere zine on the parapolitical scene! Cited and quoted by the *Washington Post*, the *New York Times*, the *Chicago Tribune*; reviewed by the *New Yorker* and the *Smithsonian*; lauded by *Flatland*, *Lumpen*, *Nexus*, *Excluded Middle* and the rest of the info underground! As seen on such TV shows, *Extra!*, *Exploration of the Unexplained* and the late, unlamented *Full Nelson!* Used for research by top conspiracy writers and the White House itself!

Not available in bookstores where the Conspiracy prevails!

**All checks payable to "Kenn Thomas"
NOT "*Steamshovel Press*"**

BACK ISSUES
(if sold out, a photocopy will be supplied)

__**#5** Interviews with Dick Gregory, Mark Land and Jim Marrs; Gerald L. K. Smith and the Ozark Nazis; Lenny Bruce; Presidency as Theater

__**#6** Deborah Davis on Katharine Graham and the Washington Post; Wilhelm Reich's prison file

__**#7** Interviews with Robert Anton Wilson, John Judge and Jonathan Vankin; Wilhelm Reich in Vienna; Jim Keith in Atlanta.; Tim Leary party.

__**#8** Mae Brussell's secret service file; Sean Morton at Area 51; Carroll Quigley and Wilhelm Reich; Philip K. Dick; A. J. Weberman.

__**#9** Dave Dellinger on Abbie Hoffman's assassination; JFK and MPM, part 1; Jonathan Vankin on Biowarfare; Allen Ginsberg on J. Edgar Hoover; Jim Keith on LaRouche; Mind Control and Bob Dylan.

__**#10** JFK and Mary Pinchot Meyer, his LSD mistress, part 2; Dave Emory; Len Bracken on the Carroll Quigley tapes; Keith on Scientology.

__**#11** Sherman Skolnick interviewed; JFK & MPM, part 3; Biosphere 2; Jack Nicholson & Wilhelm Reich; Ed Lansdale at Dealey Plaza; Inslaw-Whitewater connection.

__**#12** New View of Bill Cooper; Glen Campbell at Area 51; Reich's Declassified Files; Robert Anton Wilson interview; Dylan's *Tarantula*; Gulf War Syndrome; JFK/MPM finale.

#13 only in *Popular Alienation* (see **Books**)

__**#14** "Paranoid" media label; John Judge interview; Jim Keith on OKC; Elizabeth Clare Prophet; Tim Leary; Alan Cantwell.

__#15 Nation of Islam and American Nazis; Octopus UFOs; Neal Cassady; David Ferrie; Tim Leary interview.

__#16 The Finders; Paranoid Iconography; Comic Book Conspiracy; Manufacturing Yuppies.

_#17, "Table Tapping Into The New Millennium" issue, with previously unpublished interviews with Allen Ginsberg, Timothy Leary and William S. Burroughs

__#18, Diana and the Octopus; Jim Keith at Burning Man; Ralph Nader in Gemstone; Chica Bruce on the Philadelphia Experiment.

Steamshovel Press
POB 210553
St. Louis, MO 63121

All checks payable to "Kenn Thomas"
NOT *Steamshovel Press*

www.steamshovelpress.com

Advertising & Website: *Steamshovel's* audience is the most dedicated, fanatic and information hungry group of conspiracy and parapolitics readers in the world. *Steamshovel* has subscribers and readers throughout the planet and a global network of newsstand distributors. Space is limited and offered on a first come, first served basis.
() Full Page - Back Cover $500.
() Full Page - Inside Cover $400.
() Full Page - Inside $300.
1/2 Page
() vertical (4-1/4 x 11) $300.
() Horizontal (8-1/2 x 5-1/2) $300.
() 1/4 Page $200.
() 1/8 Page $100.

STEAMSHOVEL BOOKS

Inside the Gemstone File. Onassis kidnaps Howard Hughes! Commentary on the infamous Gemstone file conspiracy rant, with an actual Gemstone letter reproduced. Also: the James Bond connection. **$16**

Cyberculture Counterconspiracy: A Steamshovel Web Reader. Collecting essays, articles, interviews, photographs and raw data that have passed through cyberspace about conspiratorial undercurrents of recent times and in history. *Two volumes:* **$14 @**

The Octopus: Secret Government and the Death of Danny Casolaro. The classic! Join conspiracy researcher Danny Casolaro as he dies trying to bring his research to light of day. PROMIS software, Iran/Contra, October Surprise; Area 51. Pine Gap; Nugan Hand-the litany of conspiracy and corruption from the 1990s to today! Photocopy of original edition: **$20** (new edition planned from Feral House, late 2002)

The Octopus Supplement - photocopied index to Casolaro's notes: **$20**

Maury Island UFO, The Crisman Conspiracy by Kenn Thomas - A prequel to *The Octopus*. In 1947 six flying saucers circled above a harbor boat in Puget Sound near Tacoma, Washington, one wobbling and spewing slag. The falling junk killed a dog and burned a boy's arm. His father, Harold Dahl, witnessed it all. The Maury Island incident became the first UFO event of the modern era.

Dahl's co-hort, Fred Crisman, was one of the most curious characters in the UFO lore and the history of covert intelligence. He fought bizarre underground beings in the caves of Burma, was wounded by a laser before it was invented, and had a background with the OSS. Dahl told him about the Maury Island and the next day, Crisman witnessed another, single saucer... or did he?

In 1963 New Orleans District Attorney Jim Garrison identified Crisman as one of the mystery tramps in the railyard at Dealy Plaza. Garrison called him an industrial spy, steeped

in the anti-Castro Cuban underground who may have been one of the assassins who killed JFK. Who was Fred Crisman, and what was his connection to the Maury Island incident?

Long dismissed as a fraud and a hoax, the Maury Island case has never been fully examined until now. *Maury Island UFO: The Crisman Conspiracy* collects an enormous amount of data from government tiles. Oral history interviews. intelligence agency reports and privately held correspondence. Authored by Kenn Thomas, publisher of the renowned conspiracy magazine *Steamshovel Press*, this book includes required reading for any student of conspiracy and parapolitics.

"Information rich to the point of saturation."
--Greg Bishop, *Excluded Middle*, **$16**

NASA, Nazis & JFK - The Torbitt Document, outlining the role of the Paperclip Nazis, Defense Industrial Security Command and Division Five of the FBI in killing Kennedy, with new commentary by Kenn Thomas and Len Bracken, **$16**

NASA/Nazis Supplement: photocopy reprints of all articles mentioned in the Torbitt, **$20**

NASA/Nazis Supplement II: photocopied articles on the Jim Garrison JFK case, **$20**

Mind Control, Oswald & JFK: Reprints *Were We Controlled?*, the 1968 examination of mind control in the Kennedy assassination with new introduction and photos. **$16**

Popular Alienation, A *Steamshovel Press* Reader: Anthologizes *Steamshovel* back issues through 12, plus issue #13, not published elsewhere. Here's a review from *amazon.com:* "Basically a collection of issues of *Steamshovel Press*, that bastion of bizarre conspiracy theorists, this is a fascinating read. It's not something you'll devour in one sitting,

but if you have an interest in the underbelly of pop culture (whether or not you believe the theories themselves) you'll come back to it again and again. **$20**

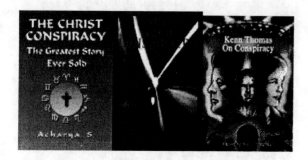

The Christ Conspiracy, The Greatest Story Ever Sold by Acharya S. Christ created by conspiracy to enslave humanity and destroy the ancient past. **$20**

Arch Conspirator by Len Bracken. Essays and analysis of conspiracy and historical consciousness. **$16**

Jim Keith Radio Show. Jim Keith's comrades discussing the man, his work and the conspiracy rumors of his death, **$12**

Kenn Thomas On Conspiracy Video: A videocassette anthology of lecture clips and television appearances by the publisher of *Steamshovel Press*, including UFO footage from Area 51. **$20**

Kenn Thomas On Conspiracy Video II: Recent television appearances of Steamshovel publisher Thomas, **$20**

ORDER FORM

__ Cyberculture Countercon, Vol. 1, $14
__ Cyberculture Countercon, Vol. 2, $14
__ Inside Gemstone, $16
__ The Octopus, $20
__ Octopus Supplement, $20
__ Maury Island UFO, $16
__ NASA, Nazis & JFK, $16
__ NASA/Nazis Supplement, $20
__ NASA/Nazis Supplement II, $20
__ Mind Control, Oswald & JFK, $16
__ Popular Alienation, $20
__ Christ Conspiracy, $20
__ Arch Conspirator, $16
__ Jim Keith Radio, $12
__ Kenn Thomas video, $20
__ Kenn Thomas video II, $20
__ latest issue of *Steamshovel Press*, $7
__ 4 issue *Steamshovel* subscription, $25
__ Back issue #s ___, ___, ___, ___ $10@
__ Popular Paranoia (reserve), $20
__ The Shadow Government (reserve), $20
__ The Octopus, new edition, (reserve), $20

SUB-TOTAL ____
SHIPPING ____ (see below)
TOTAL ____

All checks payable to "Kenn Thomas" **NOT** *Steamshovel Press*

SHIPPING CHARGES: In the US: Postal book rate: $2.50 first item; .50 each additional item. Priority Mail: $3.50 first item; $2 each additional item. UPS: $5 first item; $1.50 each additional. In Canada: Postal Book Rate: $2.50 first item; .50 each additional. Priority mail: $3.50 first item; $2 each additional. UPS: $5 first item; $1.50 each additional. Foreign: (US funds only!) Surface, $6 first item; $2 each additional; Air Mail, $12 first Item, $8 each additional.

Name_____

Street_____

City_____

State_____

Zip_____

Send to:
STEAMSHOVEL PRESS
POB 210553
St. Louis, MO 63121

POPULAR PARANOIA, page 325

CONSPIRACY & HISTORY

LIQUID CONSPIRACY
JFK, LSD, the CIA, Area 51 & UFOs
by George Piccard

Underground author George Piccard on the politics of LSD, mind control, and Kennedy's involvement with Area 51 and UFOs. Reveals JFK's LSD experiences with Mary Pinchot-Meyer. The plot thickens with an ever expanding web of CIA involvement, from underground bases with UFOs seen by JFK and Marilyn Monroe (among others) to a vaster conspiracy that affects every government agency from NASA to the Justice Department. This may have been the reason that Marilyn Monroe and actress-columnist Dorothy Kilgallen were both murdered. Focusing on the bizarre side of history, *Liquid Conspiracy* takes the reader on a psychedelic tour de force. This is your government on drugs!
264 PAGES. 6X9 PAPERBACK. ILLUSTRATED. $14.95. CODE: LIQC

INSIDE THE GEMSTONE FILE
Howard Hughes, Onassis & JFK
by Kenn Thomas & David Hatcher Childress

Steamshovel Press editor Thomas takes on the Gemstone File in this run-up and run-down of the most famous underground document ever circulated. Photocopied and distributed for over 20 years, the Gemstone File is the story of Bruce Roberts, the inventor of the synthetic ruby widely used in laser technology today, and his relationship with the Howard Hughes Company and ultimately with Aristotle Onassis, the Mafia, and the CIA. Hughes kidnapped and held a drugged-up prisoner for 10 years; Onassis and his role in the Kennedy Assassination; how the Mafia ran corporate America in the 1960s; the death of Onassis' son in the crash of a small private plane in Greece; Onassis as Ian Fleming's archvillain Ernst Stavro Blofeld; more.
320 PAGES. 6X9 PAPERBACK. ILLUSTRATED. $16.00. CODE: IGF

WHO KILLED DIANA?
by Peter Hounam and Derek McAdam

Hounam and McAdam take the reader through a land of unofficial branches of secret services, professional assassins, Psy-Ops, "Feather Men," remote-controlled cars, and ancient clandestine societies protecting the British establishment. They sort through a web of traceless drugs and poisons, inexplicable caches of money, fuzzy photographs, phantom cars of changing color, a large mysterious dog, and rivals in class and ethnic combat to answer the question, Who Killed Diana?! After this book was published, Mohammed El Fayed held an international news conference to announce that evidence showed that a blinding flash of light had contributed to the crash.
218 PAGES. 6X9 PAPERBACK. ILLUSTRATED. $12.95. CODE: WKD

THE ARCH CONSPIRATOR
Essays and Actions
by Len Bracken

Veteran conspiracy author Len Bracken's witty essays and articles lead us down the dark corridors of conspiracy, politics, murder and mayhem. In 12 chapters Bracken takes us through a maze of interwoven tales from the Russian Conspiracy to his interview with Costa Rican novelist Joaquin Gutierrez and his Psychogeographic Map into the Third Millennium. Other chapters in the book are A General Theory of Civil War; The New-Catiline Conspiracy for the Cancellation of Debt; Anti-Labor Day; 1997 with selected Aphorisms Against Work; Solar Economics; and more. Bracken's work has appeared in such pop-conspiracy publications as *Paranoia*, *Steamshovel Press* and the *Village Voice*. Len Bracken lives in Arlington, Virginia and haunts the back alleys of Washington D.C., keeping an eye on the predators who run our country.
256 PAGES. 6X9 PAPERBACK. ILLUSTRATED. BIBLIOGRAPHY. $14.95. CODE: ACON.

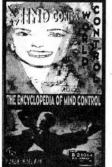

MIND CONTROL, WORLD CONTROL
by Jim Keith

Veteran author and investigator Jim Keith uncovers a surprising amount of information on the technology, experimentation and implementation of mind control. Various chapters in this shocking book are on early CIA experiments such as Project Artichoke and Project R.H.I.C.-EDOM, the methodology and technology of implants, mind control assassins and couriers, various famous Mind Control victims such as Sirhan Sirhan and Candy Jones. Also featured in this book are chapters on how mind control technology may be linked to some UFO activity and "UFO abductions."
256 PAGES. 6X9 PAPERBACK. ILLUSTRATED. FOOTNOTES. $14.95. CODE: MCWC

NASA, NAZIS & JFK:
The Torbitt Document & the JFK Assassination
introduction by Kenn Thomas

This book emphasizes the links between "Operation Paper Clip" Nazi scientists working for NASA, the assassination of JFK, and the secret Nevada air base Area 51. The Torbitt Document also talks about the roles played in the assassination by Division Five of the FBI, the Defense Industrial Security Command (DISC), the Las Vegas mob, and the shadow corporate entities Permindex and Centro-Mondiale Commerciale. The Torbitt Document claims that the same players planned the 1962 assassination attempt on Charles de Gaul, who ultimately pulled out of NATO because he traced the "Assassination Cabal" to Permindex in Switzerland and to NATO headquarters in Brussels. The Torbitt Document paints a dark picture of NASA, the military industrial complex, and the connections to Mercury, Nevada which headquarters the "secret space program."
258 PAGES. 5X8. PAPERBACK. ILLUSTRATED. $16.00. CODE: NNJ

MIND CONTROL, OSWALD & JFK:
Were We Controlled?
introduction by Kenn Thomas

Steamshovel Press editor Kenn Thomas examines the little-known book *Were We Controlled?*, first published in 1968. The book's author, the mysterious Lincoln Lawrence, maintained that Lee Harvey Oswald was a special agent who was a mind control subject, having received an implant in 1960 at a Russian hospital. Thomas examines the evidence for implant technology and the role it could have played in the Kennedy Assassination. Thomas also looks at the mind control aspects of the RFK assassination and details the history of implant technology. A growing number of people are interested in CIA experiments and its "Silent Weapons for Quiet Wars." Looks at the case that the reporter Damon Runyon, Jr. was murdered because of this book.
256 PAGES. 6X9 PAPERBACK. ILLUSTRATED. NOTES. $16.00. CODE: MCOJ

24 hour credit card orders—call: 815-253-6390 fax: 815-253-6300
email: auphq@frontiernet.net www.adventuresunlimitedpress.com www.wexclub.com

CONSPIRACY & HISTORY

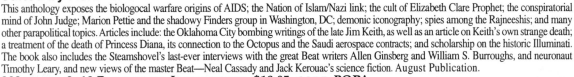

POPULAR PARANOIA
The Best of Steamshovel Press
edited by Kenn Thomas

This anthology exposes the biologocal warfare origins of AIDS; the Nation of Islam/Nazi link; the cult of Elizabeth Clare Prophet; the conspiratorial mind of John Judge; Marion Pettie and the shadowy Finders group in Washington, DC; demonic iconography; spies among the Rajneeshis; and many other parapolitical topics. Articles include: the Oklahoma City bombing writings of the late Jim Keith, as well as an article on Keith's own strange death; a treatment of the death of Princess Diana, its connection to the Octopus and the Saudi aerospace contracts; and scholarship on the historic Illuminati. The book also includes the Steamshovel's last-ever interviews with the great Beat writers Allen Ginsberg and William S. Burroughs, and neuronaut Timothy Leary, and new views of the master Beat—Neal Cassady and Jack Kerouac's science fiction. August Publication.
308 PAGES. 8X10 PAPERBACK. ILLUSTRATED. $19.95. CODE: POPA

THE SHADOW GOVERNMENT
Drugs, Guns, Oil and the Bush Dynasty
by Kenn Thomas

Thomas goes on the trail of a multi-armed hydra of oil interests, the CIA, organized crime and a huge team of hit men known as the Octopus. He explores the connection to the Bush family, its oil company, the development of the aerospace industry and secret technology. Inside: Prescott Bush sold aviation fuel to the Nazis during WWII; George Herbert Walker Bush's alleged early CIA years and his involvement in the Bay of Pigs fiasco which was called "Operation Zapata"; Was George H.W. Bush in Dallas on the day of JFK's assassination, and did he have any connection with other assassinations, including those of Martin Luther King and Robert F. Kennedy?; Why was Ronald Reagan nearly assassinated in Washington DC by a known Bush family associate?; What was the "deal" made to hold the Iran hostages until the inauguration of Reagan?; What was George H.W. Bush's real association with Iraq before the Gulf War?; What did current President George W. Bush know prior to the events of 9/11?; How do the family ties with Saudi Arabia affect the hunt for Osama bin Laden?; Dick Cheney's ties with Enron and Halliburton; more. September Publication.
288 PAGES. 6X9 PAPERBACK. ILLUSTRATED. $16.00. CODE: SGOV

THE HISTORY OF THE KNIGHTS TEMPLARS
by Charles G. Addison, introduction by David Hatcher Childress

Chapters on the origin of the Templars, their popularity in Europe and their rivalry with the Knights of St. John, later to be known as the Knights of Malta. Detailed information on the activities of the Templars in the Holy Land, and the 1312 AD suppression of the Templars in France and other countries, which culminated in the execution of Jacques de Molay and the continuation of the Knights Templars in England and Scotland; the formation of the society of Knights Templars in London; and the rebuilding of the Temple in 1816. Plus a lengthy intro about the lost Templar fleet and its connections to the ancient North American sea routes.
395 PAGES. 6X9 PAPERBACK. ILLUSTRATED. $16.95. CODE: HKT

SAUNIER'S MODEL AND THE SECRET OF RENNES-LE-CHATEAU
The Priest's Final Legacy
by André Douzet

Berenger Saunière, the enigmatic priest of the French village of Rennes-le-Château, is rumored to have found the legendary treasure of the Cathars. But what became of it? In 1916, Sauniere created his ultimate clue: he went to great expense to create a model of a region said to be the Calvary Mount, indicating the "Tomb of Jesus." But the region on the model does not resemble the region of Jerusalem. Did Saunière leave a clue as to the true location of his treasure? And what is that treasure? After years of research, André Douzet discovered this model—the only real clue Saunière left behind as to the nature and location of his treasure—and the possible tomb of Jesus.
116 PAGES. 6X9 PAPERBACK. ILLUSTRATED. BIBLIOGRAPHY. $12.00. CODE: SMOD

THE STONE PUZZLE OF ROSSLYN CHAPEL
by Philip Coppens

Rosslyn Chapel has fueled controversy and debate in past centuries, and also recently because of several world-bestselling books. Revered by Freemasons as a vital part of their history, believed by some to hold evidence of pre-Columbian voyages to America, assumed by others to hold important relics, from the Holy Grail to the Head of Christ, the Scottish chapel is a place full of mystery. This book will virtually guide you around all the enigmatic and important aspects of the chapel. The history of the chapel, its relationship to freemasonry and the family behind the scenes, the Sinclairs, is brought to life, incorporating new, previously forgotten and heretofore unknown evidence. Significantly, the story is placed in the equally enigmatic landscape surrounding the chapel, which includes features from Templar commanderies to prehistoric markings, from an ancient kingly site to the South to Arthur's Seat directly north of the chapel. The true significance and meaning of the chapel is finally unveiled: it is a medieval stone book of esoteric knowledge "written" by the Sinclair family, one of the most powerful and wealthy families in Scotland, chosen patrons of Freemasonry.
124 PAGES. 6X9 PAPERBACK. ILLUSTRATED. $12.00. CODE: SPRC

WAKE UP DOWN THERE!
The Excluded Middle Anthology
by Greg Bishop

The great American tradition of dropout culture makes it over the millennium mark with a collection of the best from *The Excluded Middle*, the critically acclaimed underground zine of UFOs, the paranormal, conspiracies, psychedelia, and spirit. Contributions from Robert Anton Wilson, Ivan Stang, Martin Kottmeyer, John Shirley, Scott Corrales, Adam Gorightly and Robert Sterling; and interviews with James Moseley, Karla Turner, Bill Moore, Kenn Thomas, Richard Boylan, Dean Radin, Joe McMoneagle, and the mysterious Ira Einhorn (an *Excluded Middle* exclusive). Includes full versions of interviews and extra material not found in the newsstand versions.
420 PAGES. 8X11 PAPERBACK. ILLUSTRATED. $25.00. CODE: WUDT

ARKTOS
The Myth of the Pole in Science, Symbolism, and Nazi Survival
by Joscelyn Godwin

A scholarly treatment of catastrophes, ancient myths and the Nazi Occult beliefs. Explored are the many tales of an ancient race said to have lived in the Arctic regions, such as Thule and Hyperborea. Progressing onward, the book looks at modern polar legends including the survival of Hitler, German bases in Antarctica, UFOs, the hollow earth, Agartha and Shambala, more.
220 PAGES. 6X9 PAPERBACK. ILLUSTRATED. $16.95. CODE: ARK

24 hour credit card orders—call: 815-253-6390 fax: 815-253-6300
email: auphq@frontiernet.net www.adventuresunlimitedpress.com www.wexclub.com

CONSPIRACY & HISTORY

TECHNOLOGY OF THE GODS
The Incredible Sciences of the Ancients
by David Hatcher Childress

Popular *Lost Cities* author David Hatcher Childress takes us into the amazing world of ancient technology, from computers in antiquity to the "flying machines of the gods." Childress looks at the technology that was allegedly used in Atlantis and the theory that the Great Pyramid of Egypt was originally a gigantic power station. He examines tales of ancient flight and the technology that it involved; how the ancients used electricity; megalithic building techniques; the use of crystal lenses and the fire from the gods; evidence of various high tech weapons in the past, including atomic weapons; ancient metallurgy and heavy machinery; the role of modern inventors such as Nikola Tesla in bringing ancient technology back into modern use; impossible artifacts; and more.

356 PAGES. 6x9 PAPERBACK. ILLUSTRATED. BIBLIOGRAPHY. $16.95. CODE: TGOD.

UNDERWATER & UNDERGROUND BASES
Surprising Facts the Government Does Not Want You to Know
by Richard Sauder, Ph.D.

Dr. Sauder lays out the amazing evidence and government paper trail for the construction of huge, manned bases offsore, in mid-ocean, and deep beneath the sea floor! Bases big enough to secretly dock submarines! Official United States Navy documents, and other hard evidence, raise many questions about what really lies 20,000 leagues beneath the sea. Many UFOs have been seen coming and going from the world's oceans, seas and lakes, implying the existence of secret underwater bases. Hold on to your hats: Jules Verne may not have been so far from the truth, after all! Dr. Sauder also adds to his incredible database of underground bases onshore. New, breakthrough material reveals the existence of additional clandestine underground facilities as well as the surprising location of one of the CIA's own underground bases. Plus, new information on tunneling and cutting-edge, high speed rail magnetic-levitation (MagLev) technology. There are many rumors of secret, underground tunnels with MagLev trains hurtling through them. Is there truth behind the rumors? *Underwater and Underground Bases* carefully examines the evidence and comes to a thought provoking conclusion!

264 PAGES. 6x9 PAPERBACK. ILLUSTRATED. BIBLIOGRAPHY. INDEX. $16.95. CODE: UUB

UNDERGROUND BASES & TUNNELS
What is the Government Trying to Hide?
by Richard Sauder, Ph.D.

Working from government documents and corporate records, Sauder has compiled an impressive book that digs below the surface of the military's super-secret underground! Go behind the scenes into little-known corners of the public record and discover how corporate America has worked hand-in-glove with the Pentagon for decades, dreaming about, planning, and actually constructing, secret underground bases. This book includes chapters on the locations of the bases, the tunneling technology, various military designs for underground bases, nuclear testing & underground bases, abductions, needles & implants, military involvement in "alien" cattle mutilations, more. 50 page photo & map insert.

201 PAGES. 6x9 PAPERBACK. ILLUSTRATED. $15.95. CODE: UGB

KUNDALINI TALES
by Richard Sauder, Ph.D.

Underground Bases and Tunnels author Richard Sauder's second book covers his personal experiences and provocative research into spontaneous spiritual awakening, out-of-body journeys, encounters with secretive governmental powers, daylight sightings of UFOs, and more. Sauder continues his studies of underground bases with new information on the occult underpinnings of the U.S. space program. The book also contains a breakthrough section that examines actual U.S. patents for devices that manipulate minds and thoughts from a remote distance. Included are chapters on the secret space program and a 130-page appendix of patents and schematic diagrams of secret technology and mind control devices.

296 PAGES. 7x10 PAPERBACK. ILLUSTRATED. BIBLIOGRAPHY. $14.95. CODE: KTAL

DARK MOON
Apollo and the Whistleblowers
by Mary Bennett and David Percy

•Was Neil Armstrong really the first man on the Moon? •Did you know that 'live' color TV from the Moon was not actually live at all? •Did you know that the Lunar Surface Camera had no viewfinder? •Do you know that lighting was used in the Apollo photographs—yet no lighting equipment was taken to the Moon? All these questions, and more, are discussed in great detail by British researchers Bennett and Percy in *Dark Moon*, the definitive book (nearly 600 pages) on the possible faking of the Apollo Moon missions. Bennett and Percy delve into every possible aspect of this beguiling theory, one that rocks the very foundation of our beliefs concerning NASA and the space program. Tons of NASA photos analyzed for possible deceptions.

568 PAGES. 6x9 PAPERBACK. ILLUSTRATED. BIBLIOGRAPHY. INDEX. $25.00. CODE: DMO

THE TIME TRAVEL HANDBOOK
A Manual of Practical Teleportation & Time Travel
edited by David Hatcher Childress

In the tradition of *The Anti-Gravity Handbook* and *The Free Energy Device Handbook*, science and UFO author David Hatcher Childress takes us into the weird world of time travel and teleportation. Not just a whacked-out look at science fiction, this book is an authoritative chronicling of real-life time travel experiments, teleportation devices and more. *The Time Travel Handbook* takes the reader beyond the government's activities, such as the Philadelphia Experiment—the U.S. Navy's forays into invisibility, time travel, and teleportation—and deep into the uncharted territory of early time travellers including a spate of "UFO" sightings and landings in the 1890s and early 1900s. Childress looks into the claims of time travelling individuals, and investigates the unusual claim that the pyramids on Mars were built in the future and sent back in time. A highly visual, large format book, with patents, photos and schematics. Be the first on your block to build your own time travel device!

316 PAGES. 7x10 PAPERBACK. ILLUSTRATED. $16.95. CODE: TTH

THE ORION PROPHECY
Egyptian & Mayan Prophecies on the Cataclysm of 2012
by Patrick Geryl and Gino Ratinckx

In the year 2012 the Earth awaits a super catastrophe: its magnetic field reverse in one go. Phenomenal earthquakes and tidal waves will completely destroy our civilization. Europe and North America will shift thousands of kilometers northwards into polar climes. Nearly everyone will perish in the apocalyptic happenings. These dire predictions stem from the Mayans and Egyptians—descendants of the legendary Atlantis. The Atlanteans had highly evolved astronomical knowledge and were able to exactly predict the previous world-wide flood in 9792 BC. Orion and several others stars will take the same 'code-positions' as in 9792 BC! For thousands of years historical sources have told of a forgotten time capsule of ancient wisdom located in a mythical labyrinth of secret chambers filled with artifacts and documents from the previous flood. We desperately need this information now—and this book gives one possible location.

324 PAGES. 6x9 PAPERBACK. ILLUSTRATED. BIBLIOGRAPHY. $16.95. CODE: ORP

24 hour credit card orders—call: 815-253-6390 fax: 815-253-6300
email: auphq@frontiernet.net www.adventuresunlimitedpress.com www.wexclub.com

PHILOSOPHY & RELIGION

RETURN OF THE SERPENTS OF WISDOM
by Mark Amaru Pinkham
According to ancient records, the patriarchs and founders of the early civilizations in Egypt, India, China, Peru, Mesopotamia, Britain, and the Americas were colonized by the Serpents of Wisdom—spiritual masters associated with the serpent—who arrived in these lands after abandoning their beloved homelands and crossing great seas. While bearing names denoting snake or dragon (such as Naga, Lung, Djedhi, Amaru, Quetzalcoatl, Adder, etc.), these Serpents of Wisdom oversaw the construction of magnificent civilizations within which they and their descendants served as the priest kings and as the enlightened heads of mystery school traditions. The Return of the Serpents of Wisdom recounts the history of these "Serpents"—where they came from, why they came, the secret wisdom they disseminated, and why they are returning now.
332 PAGES. 6x9 PAPERBACK. ILLUSTRATED. REFERENCES. $16.95. CODE: RSW

THE TRUTH BEHIND THE CHRIST MYTH
The Redemption of the Peacock Angel
by Mark Amaru Pinkham

Return of the Serpents of Wisdom author Pinkham tells us the Truth Behind the Christ Myth and presents radically new information regarding Jesus Christ and his ancient legend, including: The legend of Jesus Christ is based on a much earlier Son of God myth from India, the legend of Murrugan, the Peacock Angel; The symbol of the Catholic Church is Murrugan's symbol, the peacock, a bird native to southeast Asia; Murrugan evolved into the Persian Mithras, and Mithras evolved into Jesus Christ; Saint Paul came from Tarsus, the center of Mithras worship in Asia Minor. He amalgamated the legend of the Persian Son of God onto Jesus' life story; The Three Wise Men were Magi priests from Persia who believed that Jesus was an incarnation of Mithras; While in India, Saint Thomas became a peacock before he died and merged with Murrugan, the Peacock Angel; The myth of the One and Only Son of God originated with Murrugan and Mithras; The Peacock Angel is a historical figure who has been worshipped by many persons worldwide as The King of the World; Hitler, the Knights Templar, and the Illuminati sought to use the power of the Peacock Angel to conquer the world; more.
174 PAGES. 6x9 PAPERBACK. ILLUSTRATED. BIBLIOGRAPHY. $14.95. CODE: TBCM

CONVERSATIONS WITH THE GODDESS
by Mark Amaru Pinkham
Return of the Serpents of Wisdom author Pinkham tells us that "The Goddess is returning!" Pinkham gives us an alternative history of Lucifer, the ancient King of the World, and the Matriarchal Tradition he founded thousands of years ago. The name Lucifer means "Light Bringer" and he is the same as the Greek god Prometheus, and is different from Satan, who was based on the Egyptian god Set. Find out how the branches of the Matriarchy—the Secret Societies and Mystery Schools—were formed, and how they have been receiving assistance from the Brotherhoods on Sirius and Venus to evolve the world and overthrow the Patriarchy. Learn about the revival of the Goddess Tradition in the New Age and why the Goddess wants us all to reunite with Her now! An unusual book from an unusual writer!
296 PAGES. 7x10 PAPERBACK. ILLUSTRATED. BIBLIOGRAPHY. $14.95. CODE: CWTG.

THE CHRIST CONSPIRACY
The Greatest Story Ever Sold
by Acharya S.
In this highly controversial and explosive book, archaeologist, historian, mythologist and linguist Acharya S. marshals an enormous amount of startling evidence to demonstrate that Christianity and the story of Jesus Christ were created by members of various secret societies, mystery schools and religions in order to unify the Roman Empire under one state religion. In developing such a fabrication, this multinational cabal drew upon a multitude of myths and rituals that existed long before the Christian era, and reworked them for centuries into the religion passed down to us today. Contrary to popular belief, there was no single man who was at the genesis of Christianity; Jesus was many characters rolled into one. These characters personified the ubiquitous solar myth, and their exploits were well known, as reflected by such popular deities as Mithras, Heracles/Hercules, Dionysos and many others throughout the Roman Empire and beyond. The story of Jesus as portrayed in the Gospels is revealed to be nearly identical in detail to that of the earlier savior-gods Krishna and Horus, who for millennia preceding Christianity held great favor with the people. *The Christ Conspiracy* shows the Jesus character as neither unique nor original, not "divine revelation." Christianity re-interprets the same extremely ancient body of knowledge that revolved around the celestial bodies and natural forces.
256 PAGES. 6x9 PAPERBACK. ILLUSTRATED. $16.95. CODE: CHRC

THE BOOK OF ENOCH
The Prophet
translated by Richard Laurence
This is a reprint of the Apocryphal *Book of Enoch the Prophet* which was first discovered in Abyssinia in the year 1773 by a Scottish explorer named James Bruce. In 1821 *The Book of Enoch* was translated by Richard Laurence and published in a number of successive editions, culminating in the 1883 edition. One of the main influences from the book is its explanation of evil coming into the world with the arrival of the "fallen angels." Enoch acts as a scribe, writing up a petition on behalf of these fallen angels, or fallen ones, to be given to a higher power for ultimate judgment. Christianity adopted some ideas from Enoch, including the Final Judgment, the concept of demons, the origins of evil and the fallen angels, and the coming of a Messiah and ultimately, a Messianic kingdom. The *Book of Enoch* was ultimately removed from the Bible and banned by the early church. Copies of it were found to have survived in Ethiopia, and fragments in Greece and Italy.
224 PAGES. 6x9 PAPERBACK. ILLUSTRATED. INDEX. $16.95. CODE: BOE

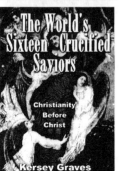

THE WORLD'S SIXTEEN CRUCIFIED SAVIORS
Christianity Before Christ
by Kersey Graves, foreword by Acharya S.
A reprint of Kersey Graves' classic and rare 1875 book on Christianity before Christ, and the 16 messiahs or saviors who are known to history before Christ! Chapters on: Rival Claims of the Saviors; Messianic Prophecies; Prophecies by the Figure of a Serpent; Virgin Mothers and Virgin-Born Gods; Stars Point Out the Time and the Saviors' Birthplace; Sixteen Saviors Crucified; The Holy Ghost of Oriental Origin; Appollonius, Osiris, and Magus as Gods; 346 Striking Analogies Between Christ and Krishna; 25th of December as the birthday of the Gods; more. 45 chapters in all.
436 PAGES. 6x9 PAPERBACK. ILLUSTRATED. $19.95. CODE: WSCS

24 hour credit card orders—call: 815-253-6390 fax: 815-253-6300
email: auphq@frontiernet.net www.adventuresunlimitedpress.com www.wexclub.com

PHILOSOPHY & RELIGION

JESUS, LAST OF THE PHARAOHS
Truth Behind the Mask Revealed
by Ralph Ellis

This book, with 43 color plates, traces the history of the Egyptian royal family from the time of Noah through to Jesus, comparing biblical and historical records. Nearly all of the biblical characters can be identified in the historical record—all are pharaohs of Egypt or pharaohs in exile. The Bible depicts them as being simple shepherds, but in truth they were the Hyksos, the Shepherd Kings of Egypt. The biblical story that has circulated around the globe is simply a history of one family, Abraham and his descendants. In the Bible he was known as Abram; in the historical record he is the pharaoh Maybra—the most powerful man on Earth in his lifetime. By such simple sleight of hand, the pharaohs of Egypt have hidden their identity, but preserved their ancient history and bloodline. These kings were born of the gods; they were not only royal, they were also Sons of God.

320 PAGES. 6x9 PAPERBACK. ILLUSTRATED. $16.00. CODE: JLOP

TEMPEST & EXODUS
by Ralph Ellis

Starts with the dramatic discovery of a large biblical quotation on an ancient Egyptian stele which tells of a conference in Egypt discussing the way in which the biblical Exodus should be organized. The quotation thus has fundamental implications for both history and theology because it explains why the Tabernacle and the Ark of the Covenant were constructed, why the biblical Exodus started, where Mt. Sinai was located, and who the god of the Israelites was. The most dramatic discovery is that the central element of early Israelite liturgy was actually the Giza pyramids, and that Mt. Sinai was none other than the Great Pyramid. Mt. Sinai was described as being both sharp and the tallest 'mountain' in the area, and thus the Israelite god actually resided deep within the bowels of this pyramid. Furthermore, these new translations of ancient texts, both secular and biblical, also clearly demonstrate that the Giza pyramids are older than the first dynasty—the ancestors of the Hyksos were writing about the Giza pyramids long before they are supposed to have been constructed! Includes: Mt. Sinai, the Israelite name for the Great Pyramid of Egypt; the biblical Exodus inscribed on an Egyptian stele of Ahmose I; the secret name of God revealed; Noah's Ark discovered, more.

280 PAGES. 6x9 PAPERBACK. ILLUSTRATED. COLOR SECTION. BIBLIOGRAPHY & INDEX. $16.00. CODE: TEXO

THOTH
Architect of the Universe
by Ralph Ellis

This great book, now available in paperback, is on sacred geometry, megalithic architecture and the worship of the mathematical constant pi. Ellis contemplates Stonehenge; the ancient Egyptian god Thoth and his Emerald Tablets; Atlantis; Thoth's Ratios; Henge of the World; The Secret Gate of Knowledge; Precessional Henge; Royal Planisphere; Kufu's Continents; the Ma'at of the Egyptians; ancient technological civilizations; the Ark of Tutankhamen; Pyramidions; the Pyramid Inch and Pi; more. Well illustrated with color photo sections.

236 PAGES. 6x9 PAPERBACK. ILLUSTRATED. BIBLIOGRAPHY. $16.00. CODE: TOTH

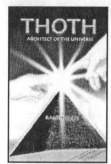

K2—QUEST OF THE GODS
by Ralph Ellis

This sequel to *Thoth, Architect of the Universe* explains the design of the Great Pyramid in great detail, and it appears that its architect specified a structure that contains a curious blend of technology, lateral thinking and childish fun—yet this design can also point out the exact location of the legendary 'Hall of Records' to within a few meters! The 'X' marks the spot location has been found at last. Join the author on the most ancient quest ever devised, a dramatic journey in the footsteps of Alexander the Great on his search for the legendary Hall of Records, then on to the highest peaks at the top of the world to find the 'The Great Pyramid in the Himalayas'; more.

280 PAGES. 6x9 PAPERBACK. ILLUSTRATED. COLOR SECTION. BIBLIOGRAPHY. $16.00. CODE: K2QD

THE DIMENSIONS OF PARADISE
The Proportions & Symbolic Numbers of Ancient Cosmology
by John Michell

The Dimensions of Paradise were known to ancient civilizations as the harmonious numerical standards that underlie the created world. John Michell's quest for these standards provides vital clues for understanding:
- the dimensions and symbolism of Stonehenge
- the plan of Atlantis and reason for its fall
- the numbers behind the sacred names of Christianity
- the form of St. John's vision of the New Jerusalem
- the name of the man with the number 666
- the foundation plan of Glastonbury and other sanctuaries
- and how these symbols suggest a potential for personal, cultural and political regeneration in the 21st century.

220 PAGES. 6x9 PAPERBACK. ILLUSTRATED. BIBLIOGRAPHY. INDEX. $16.95. CODE: DIMP

THE AQUARIAN GOSPEL OF JESUS THE CHRIST
Transcribed from the Akashic Records
by Levi

First published in 1908, this is the amazing story of Jesus, the man from Galilee, and how he attained the Christ consciousness open to all men. It includes a complete record of the "lost" 18 years of his life, a time on which the New Testament is strangely silent. During this period Jesus travelled widely in India, Tibet, Persia, Egypt and Greece, learning from the Masters, seers and wisemen of the East and the West in their temples and schools. Included is information on the Council of the Seven Sages of the World, Jesus with the Chinese Master Mencius (Meng Tzu) in Tibet, the ministry, trial, execution and resurrection of Jesus.

270 PAGES. 6x9 PAPERBACK. INDEX. $14.95. CODE: AGJC

A HITCHHIKER'S GUIDE TO ARMAGEDDON
by David Hatcher Childress

With wit and humor, popular Lost Cities author David Hatcher Childress takes us around the world and back in his trippy finalé to the Lost Cities series. He's off on an adventure in search of the apocalypse and end times. Childress hits the road from the fortress of Megiddo, the legendary citadel in northern Israel where Armageddon is prophesied to start. Hitchhiking around the world, Childress takes us from one adventure to another, to ancient cities in the deserts and the legends of worlds before our own. Childress muses on the rise and fall of civilizations, and the forces that have shaped mankind over the millennia, including wars, invasions and cataclysms. He discusses the ancient Armageddons of the past, and chronicles recent Middle East developments and their ominous undertones. In the meantime, he becomes a cargo cult god on a remote island off New Guinea, gets dragged into the Kennedy Assassination by one of the "conspirators," investigates a strange power operating out of the Altai Mountains of Mongolia, and discovers how the Knights Templar and their off-shoots have driven the world toward an epic battle centered around Jerusalem and the Middle East.

320 PAGES. 6x9 PAPERBACK. ILLUSTRATED. BIBLIOGRAPHY. INDEX. $16.95. CODE: HGA

24 hour credit card orders—call: 815-253-6390 fax: 815-253-6300
email: auphq@frontiernet.net www.adventuresunlimitedpress.com www.wexclub.com

ATLANTIS REPRINT SERIES

ATLANTIS: MOTHER OF EMPIRES
Atlantis Reprint Series
by Robert Stacy-Judd
Robert Stacy-Judd's classic 1939 book on Atlantis is back in print in this large-format paperback edition. Stacy-Judd was a California architect and an expert on the Mayas and their relationship to Atlantis. He was an excellent artist and his work is lavishly illustrated. The eighteen comprehensive chapters in the book are: The Mayas and the Lost Atlantis; Conjectures and Opinions; The Atlantean Theory; Cro-Magnon Man; East is West; And West is East; The Mormons and the Mayas; Astrology in Two Hemispheres; The Language of Architecture; The American Indian; Pre-Panamanians and Pre-Incas; Columns and City Planning; Comparisons and Mayan Art; The Iberian Link; The Maya Tongue; Quetzalcoatl; Summing Up the Evidence; The Mayas in Yucatan.
340 PAGES. 8x11 PAPERBACK. ILLUSTRATED. INDEX. $19.95. CODE: AMOE

MYSTERIES OF ANCIENT SOUTH AMERICA
Atlantis Reprint Series
by Harold T. Wilkins
The reprint of Wilkins' classic book on the megaliths and mysteries of South America. This book predates Wilkin's book *Secret Cities of Old South America* published in 1952. *Mysteries of Ancient South America* was first published in 1947 and is considered a classic book of its kind. With diagrams, photos and maps, Wilkins digs into old manuscripts and books to bring us some truly amazing stories of South America: a bizarre subterranean tunnel system; lost cities in the remote border jungles of Brazil; legends of Atlantis in South America; cataclysmic changes that shaped South America; and other strange stories from one of the world's great researchers. Chapters include: Our Earth's Greatest Disaster, Dead Cities of Ancient Brazil, The Jungle Light that Shines by Itself, The Missionary Men in Black: Forerunners of the Great Catastrophe, The Sign of the Sun: The World's Oldest Alphabet, Sign-Posts to the Shadow of Atlantis, The Atlanean "Subterraneans" of the Incas, Tiahuanacu and the Giants, more.
236 PAGES. 6x9 PAPERBACK. ILLUSTRATED. INDEX. $14.95. CODE: MASA

SECRET CITIES OF OLD SOUTH AMERICA
Atlantis Reprint Series
by Harold T. Wilkins
The reprint of Wilkins' classic book, first published in 1952, claiming that South America was Atlantis. Chapters include Mysteries of a Lost World; Atlantis Unveiled; Red Riddles on the Rocks; South America's Amazons Existed!; The Mystery of El Dorado and Gran Payatiti—the Final Refuge of the Incas; Monstrous Beasts of the Unexplored Swamps & Wilds; Weird Denizens of Antediluvian Forests; New Light on Atlantis from the World's Oldest Book; The Mystery of Old Man Noah and the Arks; and more.
438 PAGES. 6x9 PAPERBACK. ILLUSTRATED. BIBLIOGRAPHY & INDEX. $16.95. CODE: SCOS

THE SHADOW OF ATLANTIS
The Echoes of Atlantean Civilization Tracked through Space & Time
by Colonel Alexander Braghine
First published in 1940, *The Shadow of Atlantis* is one of the great classics of Atlantis research. The book amasses a great deal of archaeological, anthropological, historical and scientific evidence in support of a lost continent in the Atlantic Ocean. Braghine covers such diverse topics as Egyptians in Central America, the myth of Quetzalcoatl, the Basque language and its connection with Atlantis, the connections with the ancient pyramids of Mexico, Egypt and Atlantis, the sudden demise of mammoths, legends of giants and much more. Braghine was a linguist and spends part of the book tracing ancient languages to Atlantis and studying little-known inscriptions in Brazil, deluge myths and the connections between ancient languages. Braghine takes us on a fascinating journey through space and time in search of the lost continent.
288 PAGES. 6x9 PAPERBACK. ILLUSTRATED. $16.95. CODE: SOA

RIDDLE OF THE PACIFIC
by John Macmillan Brown

Oxford scholar Brown's classic work on lost civilizations of the Pacific is now back in print! John Macmillan Brown was an historian and New Zealand's premier scientist when he wrote about the origins of the Maoris. After many years of travel thoughout the Pacific studying the people and customs of the south seas islands, he wrote *Riddle of the Pacific* in 1924. The book is packed with rare turn-of-the-century illustrations. Don't miss Brown's classic study of Easter Island, ancient scripts, megalithic roads and cities, more. Brown was an early believer in a lost continent in the Pacific.
460 PAGES. 6x9 PAPERBACK. ILLUSTRATED. $16.95. CODE: ROP

THE HISTORY OF ATLANTIS
by Lewis Spence
Lewis Spence's classic book on Atlantis is now back in print! Spence was a Scottish historian (1874-1955) who is best known for his volumes on world mythology and his five Atlantis books. *The History of Atlantis* (1926) is considered his finest. Spence does his scholarly best in chapters on the Sources of Atlantean History, the Geography of Atlantis, the Races of Atlantis, the Kings of Atlantis, the Religion of Atlantis, the Colonies of Atlantis, more. Sixteen chapters in all.
240 PAGES. 6x9 PAPERBACK. ILLUSTRATED WITH MAPS, PHOTOS & DIAGRAMS. $16.95. CODE: HOA

ATLANTIS IN SPAIN
A Study of the Ancient Sun Kingdoms of Spain
by E.M. Whishaw
First published by Rider & Co. of London in 1928, this classic book is a study of the megaliths of Spain, ancient writing, cyclopean walls, sun worshipping empires, hydraulic engineering, and sunken cities. An extremely rare book, it was out of print for 60 years. Learn about the Biblical Tartessus; an Atlantean city at Niebla; the Temple of Hercules and the Sun Temple of Seville; Libyans and the Copper Age; more. Profusely illustrated with photos, maps and drawings.
284 PAGES. 6x9 PAPERBACK. ILLUSTRATED. TABLES OF ANCIENT SCRIPTS. $15.95. CODE: AIS

24 hour credit card orders—call: 815-253-6390 fax: 815-253-6300
email: auphq@frontiernet.net www.adventuresunlimitedpress.com www.wexclub.com

FREE ENERGY SYSTEMS

LOST SCIENCE
by Gerry Vassilatos
Rediscover the legendary names of suppressed scientific revolution—remarkable lives, astounding discoveries, and incredible inventions which would have produced a world of wonder. How did the aura research of Baron Karl von Reichenbach prove the vitalistic theory and frighten the greatest minds of Germany? How did the physiophone and wireless of Antonio Meucci predate both Bell and Marconi by decades? How does the earth battery technology of Nathan Stubblefield portend an unsuspected energy revolution? How did the geoaetheric engines of Nikola Tesla threaten the establishment of a fuel-dependent America? The microscopes and virus-destroying ray machines of Dr. Royal Rife provided the solution for every world-threatening disease. Why did the FDA and AMA together condemn this great man to Federal Prison? The static crashes on telephone lines enabled Dr. T. Henry Moray to discover the reality of radiant space energy. Was the mysterious "Swedish stone," the powerful mineral which Dr. Moray discovered, the very first historical instance in which stellar power was recognized and secured on earth? Why did the Air Force initially fund the gravitational warp research and warp-cloaking devices of T. Townsend Brown and then reject it? When the controlled fusion devices of Philo Farnsworth achieved the "break-even" point in 1967 the FUSOR project was abruptly cancelled by ITT.
304 PAGES. 6X9 PAPERBACK. ILLUSTRATED. BIBLIOGRAPHY. $16.95. CODE: LOS

SECRETS OF COLD WAR TECHNOLOGY
Project HAARP and Beyond
by Gerry Vassilatos
Vassilatos reveals that "Death Ray" technology has been secretly researched and developed since the turn of the century. Included are chapters on such inventors and their devices as H.C. Vion, the developer of auroral energy receivers; Dr. Selim Lemstrom's pre-Tesla experiments; the early beam weapons of Grindell-Mathews, Ulivi, Turpain and others; John Hettenger and his early beam power systems. Learn about Project Argus, Project Teak and Project Orange; EMP experiments in the 60s; why the Air Force directed the construction of a huge Ionospheric "backscatter" telemetry system across the Pacific just after WWII; why Raytheon has collected every patent relevant to HAARP over the past few years; more.
250 PAGES. 6X9 PAPERBACK. ILLUSTRATED. $15.95. CODE: SCWT

THE TIME TRAVEL HANDBOOK
A Manual of Practical Teleportation & Time Travel
edited by David Hatcher Childress
In the tradition of *The Anti-Gravity Handbook* and *The Free-Energy Device Handbook*, science and UFO author David Hatcher Childress takes us into the weird world of time travel and teleportation. Not just a whacked-out look at science fiction, this book is an authoritative chronicling of real-life time travel experiments, teleportation devices and more. *The Time Travel Handbook* takes the reader beyond the government experiments and deep into the uncharted territory of early time travellers such as Nikola Tesla and Guglielmo Marconi and their alleged time travel experiments, as well as the Wilson Brothers of EMI and their connection to the Philadelphia Experiment—the U.S. Navy's forays into invisibility, time travel, and teleportation. Childress looks into the claims of time travelling individuals, and investigates the unusual claim that the pyramids on Mars were built in the future and sent back in time. A highly visual, large format book, with patents, photos and schematics. Be the first on your block to build your own time travel device!
316 PAGES. 7X10 PAPERBACK. ILLUSTRATED. $16.95. CODE: TTH

THE TESLA PAPERS
Nikola Tesla on Free Energy & Wireless Transmission of Power
by Nikola Tesla, edited by David Hatcher Childress
David Hatcher Childress takes us into the incredible world of Nikola Tesla and his amazing inventions. Tesla's rare article "The Problem of Increasing Human Energy with Special Reference to the Harnessing of the Sun's Energy" is included. This lengthy article was originally published in the June 1900 issue of *The Century Illustrated Monthly Magazine* and it was the outline for Tesla's master blueprint for the world. Tesla's fantastic vision of the future, including wireless power, anti-gravity, free energy and highly advanced solar power. Also included are some of the papers, patents and material collected on Tesla at the Colorado Springs Tesla Symposiums, including papers on: •The Secret History of Wireless Transmission •Tesla and the Magnifying Transmitter •Design and Construction of a Half-Wave Tesla Coil •Electrostatics: A Key to Free Energy •Progress in Zero-Point Energy Research •Electromagnetic Energy from Antennas to Atoms •Tesla's Particle Beam Technology •Fundamental Excitatory Modes of the Earth-Ionosphere Cavity
325 PAGES. 8X10 PAPERBACK. ILLUSTRATED. $16.95. CODE: TTP

THE FANTASTIC INVENTIONS OF NIKOLA TESLA
by Nikola Tesla with additional material by David Hatcher Childress
This book is a readable compendium of patents, diagrams, photos and explanations of the many incredible inventions of the originator of the modern era of electrification. In Tesla's own words are such topics as wireless transmission of power, death rays, and radio-controlled airships. In addition, rare material on German bases in Antarctica and South America, and a secret city built at a remote jungle site in South America by one of Tesla's students, Guglielmo Marconi. Marconi's secret group claims to have built flying saucers in the 1940s and to have gone to Mars in the early 1950s! Incredible photos of these Tesla craft are included. The Ancient Atlantean system of broadcasting energy through a grid system of obelisks and pyramids is discussed, and a fascinating concept comes out of one chapter: that Egyptian engineers had to wear protective metal head-shields while in these power plants, hence the Egyptian Pharoah's head covering as well as the Face on Mars! •His plan to transmit free electricity into the atmosphere. •How electrical devices would work using only small antennas. •Why unlimited power could be utilized anywhere on earth. •How radio and radar technology can be used as death-ray weapons in Star Wars.
342 PAGES. 6X9 PAPERBACK. ILLUSTRATED. $16.95. CODE: FINT

24 hour credit card orders—call: 815-253-6390 fax: 815-253-6300
email: auphq@frontiernet.net www.adventuresunlimitedpress.com www.wexclub.com

ANTI-GRAVITY

THE FREE-ENERGY DEVICE HANDBOOK
A Compilation of Patents and Reports
by David Hatcher Childress

A large-format compilation of various patents, papers, descriptions and diagrams concerning free-energy devices and systems. *The Free-Energy Device Handbook* is a visual tool for experimenters and researchers into magnetic motors and other "over-unity" devices. With chapters on the Adams Motor, the Hans Coler Generator, cold fusion, superconductors, "N" machines, space-energy generators, Nikola Tesla, T. Townsend Brown, and the latest in free-energy devices. Packed with photos, technical diagrams, patents and fascinating information, this book belongs on every science shelf. With energy and profit being a major political reason for fighting various wars, free-energy devices, if ever allowed to be mass distributed to consumers, could change the world! Get your copy now before the Department of Energy bans this book!
292 PAGES. 8X10 PAPERBACK. ILLUSTRATED. BIBLIOGRAPHY. $16.95. CODE: FEH

THE ANTI-GRAVITY HANDBOOK
edited by David Hatcher Childress, with Nikola Tesla, T.B. Paulicki, Bruce Cathie, Albert Einstein and others

The new expanded compilation of material on Anti-Gravity, Free Energy, Flying Saucer Propulsion, UFOs, Suppressed Technology, NASA Cover-ups and more. Highly illustrated with patents, technical illustrations and photos. This revised and expanded edition has more material, including photos of Area 51, Nevada, the government's secret testing facility. This classic on weird science is back in a 90s format!

- How to build a flying saucer.
- Arthur C. Clarke on Anti-Gravity.
- Crystals and their role in levitation.
- Secret government research and development.
- Nikola Tesla on how anti-gravity airships could draw power from the atmosphere.
- Bruce Cathie's Anti-Gravity Equation.
- NASA, the Moon and Anti-Gravity.

230 PAGES. 7X10 PAPERBACK. BIBLIOGRAPHY/INDEX/APPENDIX. HIGHLY ILLUSTRATED. $14.95. CODE: AGH

ANTI-GRAVITY & THE WORLD GRID

Is the earth surrounded by an intricate electromagnetic grid network offering free energy? This compilation of material on ley lines and world power points contains chapters on the geography, mathematics, and light harmonics of the earth grid. Learn the purpose of ley lines and ancient megalithic structures located on the grid. Discover how the grid made the Philadelphia Experiment possible. Explore the Coral Castle and many other mysteries, including acoustic levitation, Tesla Shields and scalar wave weaponry. Browse through the section on anti-gravity patents, and research resources.
274 PAGES. 7X10 PAPERBACK. ILLUSTRATED. $14.95. CODE: AGW

ANTI-GRAVITY & THE UNIFIED FIELD
edited by David Hatcher Childress

Is Einstein's Unified Field Theory the answer to all of our energy problems? Explored in this compilation of material is how gravity, electricity and magnetism manifest from a unified field around us. Why artificial gravity is possible; secrets of UFO propulsion; free energy; Nikola Tesla and anti-gravity airships of the 20s and 30s; flying saucers as superconducting whirls of plasma; anti-mass generators; vortex propulsion; suppressed technology; government cover-ups; gravitational pulse drive; spacecraft & more.
240 PAGES. 7X10 PAPERBACK. ILLUSTRATED. $14.95. CODE: AGU

ETHER TECHNOLOGY
A Rational Approach to Gravity Control
by Rho Sigma

This classic book on anti-gravity and free energy is back in print and back in stock. Written by a well-known American scientist under the pseudonym of "Rho Sigma," this book delves into international efforts at gravity control and discoid craft propulsion. Before the Quantum Field, there was "Ether." This small, but informative book has chapters on John Searle and "Searle discs;" T. Townsend Brown and his work on anti-gravity and ether-vortex turbines. Includes a forward by former NASA astronaut Edgar Mitchell.
108 PAGES. 6X9 PAPERBACK. ILLUSTRATED. $12.95. CODE: ETT

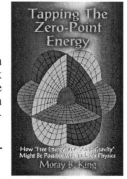

TAPPING THE ZERO POINT ENERGY
Free Energy & Anti-Gravity in Today's Physics
by Moray B. King

King explains how free energy and anti-gravity are possible. The theories of the zero point energy maintain there are tremendous fluctuations of electrical field energy imbedded within the fabric of space. This book tells how, in the 1930s, inventor T. Henry Moray could produce a fifty kilowatt "free energy" machine; how an electrified plasma vortex creates anti-gravity; how the Pons/Fleischmann "cold fusion" experiment could produce tremendous heat without fusion; and how certain experiments might produce a gravitational anomaly.

190 PAGES. 5X8 PAPERBACK. ILLUSTRATED. $12.95. CODE: TAP

24 hour credit card orders—call: 815-253-6390 fax: 815-253-6300
email: auphq@frontiernet.net www.adventuresunlimitedpress.com www.wexclub.com

LOST CITIES

TECHNOLOGY OF THE GODS
The Incredible Sciences of the Ancients
by David Hatcher Childress

Popular *Lost Cities* author David Hatcher Childress takes us into the amazing world of ancient technology, from computers in antiquity to the "flying machines of the gods." Childress looks at the technology that was allegedly used in Atlantis and the theory that the Great Pyramid of Egypt was originally a gigantic power station. He examines tales of ancient flight and the technology that it involved; how the ancients used electricity; megalithic building techniques; the use of crystal lenses and the fire from the gods; evidence of various high tech weapons in the past, including atomic weapons; ancient metallurgy and heavy machinery; the role of modern inventors such as Nikola Tesla in bringing ancient technology back into modern use; impossible artifacts; and more.
356 PAGES. 6X9 PAPERBACK. ILLUSTRATED. BIBLIOGRAPHY. $16.95. CODE: TGOD

VIMANA AIRCRAFT OF ANCIENT INDIA & ATLANTIS
by David Hatcher Childress, introduction by Ivan T. Sanderson

Did the ancients have the technology of flight? In this incredible volume on ancient India, authentic Indian texts such as the *Ramayana* and the *Mahabharata* are used to prove that ancient aircraft were in use more than four thousand years ago. Included in this book is the entire Fourth Century BC manuscript *Vimaanika Shastra* by the ancient author Maharishi Bharadwaaja, translated into English by the Mysore Sanskrit professor G.R. Josyer. Also included are chapters on Atlantean technology, the incredible Rama Empire of India and the devastating wars that destroyed it. Also an entire chapter on mercury vortex propulsion and mercury gyros, the power source described in the ancient Indian texts. Not to be missed by those interested in ancient civilizations or the UFO enigma.
334 PAGES. 6X9 PAPERBACK. RARE PHOTOGRAPHS, MAPS AND DRAWINGS. $15.95. CODE: VAA

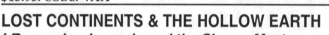

LOST CONTINENTS & THE HOLLOW EARTH
I Remember Lemuria and the Shaver Mystery
by David Hatcher Childress & Richard Shaver

Lost Continents & the Hollow Earth is Childress' thorough examination of the early hollow earth stories of Richard Shaver and the fascination that fringe fantasy subjects such as lost continents and the hollow earth have had for the American public. Shaver's rare 1948 book *I Remember Lemuria* is reprinted in its entirety, and the book is packed with illustrations from Ray Palmer's *Amazing Stories* magazine of the 1940s. Palmer and Shaver told of tunnels running through the earth—tunnels inhabited by the Deros and Teros, humanoids from an ancient spacefaring race that had inhabited the earth, eventually going underground, hundreds of thousands of years ago. Childress discusses the famous hollow earth books and delves deep into whatever reality may be behind the stories of tunnels in the earth. Operation High Jump to Antarctica in 1947 and Admiral Byrd's bizarre statements, tunnel systems in South America and Tibet, the underground world of Agartha, the belief of UFOs coming from the South Pole, more.
344 PAGES. 6X9 PAPERBACK. ILLUSTRATED. $16.95. CODE: LCHE

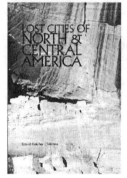

LOST CITIES OF NORTH & CENTRAL AMERICA
by David Hatcher Childress

Down the back roads from coast to coast, maverick archaeologist and adventurer David Hatcher Childress goes deep into unknown America. With this incredible book, you will search for lost Mayan cities and books of gold, discover an ancient canal system in Arizona, climb gigantic pyramids in the Midwest, explore megalithic monuments in New England, and join the astonishing quest for lost cities throughout North America. From the war-torn jungles of Guatemala, Nicaragua and Honduras to the deserts, mountains and fields of Mexico, Canada, and the U.S.A., Childress takes the reader in search of sunken ruins, Viking forts, strange tunnel systems, living dinosaurs, early Chinese explorers, and fantastic lost treasure. Packed with both early and current maps, photos and illustrations.
590 PAGES. 6X9 PAPERBACK. ILLUSTRATED. FOOTNOTES & BIBLIOGRAPHY. $14.95. CODE: NCA

LOST CITIES & ANCIENT MYSTERIES OF SOUTH AMERICA
by David Hatcher Childress

Rogue adventurer and maverick archaeologist David Hatcher Childress takes the reader on unforgettable journeys deep into deadly jungles, high up on windswept mountains and across scorching deserts in search of lost civilizations and ancient mysteries. Travel with David and explore stone cities high in mountain forests and hear fantastic tales of Inca treasure, living dinosaurs, and a mysterious tunnel system. Whether he is hopping freight trains, searching for secret cities, or just dealing with the daily problems of food, money, and romance, the author keeps the reader spellbound. Includes both early and current maps, photos, and illustrations, and plenty of advice for the explorer planning his or her own journey of discovery.
381 PAGES. 6X9 PAPERBACK. ILLUSTRATED. FOOTNOTES & BIBLIOGRAPHY. $14.95. CODE: SAM

LOST CITIES & ANCIENT MYSTERIES OF AFRICA & ARABIA
by David Hatcher Childress

Across ancient deserts, dusty plains and steaming jungles, maverick archaeologist David Childress continues his worldwide quest for lost cities and ancient mysteries. Join him as he discovers forbidden cities in the Empty Quarter of Arabia; "Atlantean" ruins in Egypt and the Kalahari desert; a mysterious, ancient empire in the Sahara; and more. This is the tale of an extraordinary life on the road: across war-torn countries, Childress searches for King Solomon's Mines, living dinosaurs, the Ark of the Covenant and the solutions to some of the fantastic mysteries of the past.
423 PAGES. 6X9 PAPERBACK. ILLUSTRATED. FOOTNOTES & BIBLIOGRAPHY. $14.95. CODE: AFA

24 hour credit card orders—call: 815-253-6390 fax: 815-253-6300
email: auphq@frontiernet.net www.adventuresunlimitedpress.com www.wexclub.com

LOST CITIES

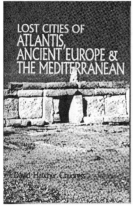

LOST CITIES OF ATLANTIS, ANCIENT EUROPE & THE MEDITERRANEAN
by David Hatcher Childress
Atlantis! The legendary lost continent comes under the close scrutiny of maverick archaeologist David Hatcher Childress in this sixth book in the internationally popular *Lost Cities* series. Childress takes the reader in search of sunken cities in the Mediterranean; across the Atlas Mountains in search of Atlantean ruins; to remote islands in search of megalithic ruins; to meet living legends and secret societies. From Ireland to Turkey, Morocco to Eastern Europe, and around the remote islands of the Mediterranean and Atlantic, Childress takes the reader on an astonishing quest for mankind's past. Ancient technology, cataclysms, megalithic construction, lost civilizations and devastating wars of the past are all explored in this book. Childress challenges the skeptics and proves that great civilizations not only existed in the past, but the modern world and its problems are reflections of the ancient world of Atlantis.
524 PAGES. 6X9 PAPERBACK. ILLUSTRATED WITH 100S OF MAPS, PHOTOS AND DIAGRAMS. BIBLIOGRAPHY & INDEX. $16.95. CODE: MED

LOST CITIES OF CHINA, CENTRAL INDIA & ASIA
by David Hatcher Childress
Like a real life "Indiana Jones," maverick archaeologist David Childress takes the reader on an incredible adventure across some of the world's oldest and most remote countries in search of lost cities and ancient mysteries. Discover ancient cities in the Gobi Desert; hear fantastic tales of lost continents, vanished civilizations and secret societies bent on ruling the world; visit forgotten monasteries in forbidding snow-capped mountains with strange tunnels to mysterious subterranean cities! A unique combination of far-out exploration and practical travel advice, it will astound and delight the experienced traveler or the armchair voyager.
429 PAGES. 6X9 PAPERBACK. ILLUSTRATED. FOOTNOTES & BIBLIOGRAPHY. $14.95. CODE: CHI

LOST CITIES OF ANCIENT LEMURIA & THE PACIFIC
by David Hatcher Childress
Was there once a continent in the Pacific? Called Lemuria or Pacifica by geologists, Mu or Pan by the mystics, there is now ample mythological, geological and archaeological evidence to "prove" that an advanced and ancient civilization once lived in the central Pacific. Maverick archaeologist and explorer David Hatcher Childress combs the Indian Ocean, Australia and the Pacific in search of the surprising truth about mankind's past. Contains photos of the underwater city on Pohnpei; explanations on how the statues were levitated around Easter Island in a clockwise vortex movement; tales of disappearing islands; Egyptians in Australia; and more.
379 PAGES. 6X9 PAPERBACK. ILLUSTRATED. FOOTNOTES & BIBLIOGRAPHY. $14.95. CODE: LEM

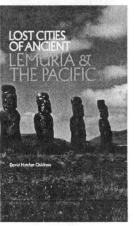

ANCIENT TONGA
& the Lost City of Mu'a
by David Hatcher Childress
Lost Cities series author Childress takes us to the south sea islands of Tonga, Rarotonga, Samoa and Fiji to investigate the megalithic ruins on these beautiful islands. The great empire of the Polynesians, centered on Tonga and the ancient city of Mu'a, is revealed with old photos, drawings and maps. Chapters in this book are on the Lost City of Mu'a and its many megalithic pyramids, the Ha'amonga Trilithon and ancient Polynesian astronomy, Samoa and the search for the lost land of Havai'iki, Fiji and its wars with Tonga, Rarotonga's megalithic road, and Polynesian cosmology. Material on Egyptians in the Pacific, earth changes, the fortified moat around Mu'a, lost roads, more.
218 PAGES. 6X9 PAPERBACK. ILLUSTRATED. COLOR PHOTOS. BIBLIOGRAPHY. $15.95. CODE: TONG

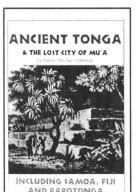

ANCIENT MICRONESIA
& the Lost City of Nan Madol
by David Hatcher Childress
Micronesia, a vast archipelago of islands west of Hawaii and south of Japan, contains some of the most amazing megalithic ruins in the world. Part of our *Lost Cities* series, this volume explores the incredible conformations on various Micronesian islands, especially the fantastic and little-known ruins of Nan Madol on Pohnpei Island. The huge canal city of Nan Madol contains over 250 million tons of basalt columns over an 11 square-mile area of artificial islands. Much of the huge city is submerged, and underwater structures can be found to an estimated 80 feet. Islanders' legends claim that the basalt rocks, weighing up to 50 tons, were magically levitated into place by the powerful forefathers. Other ruins in Micronesia that are profiled include the Latte Stones of the Marianas, the menhirs of Palau, the megalithic canal city on Kosrae Island, megaliths on Guam, and more.
256 PAGES. 6X9 PAPERBACK. ILLUSTRATED. INCLUDES A COLOR PHOTO SECTION. BIBLIOGRAPHY. $16.95. CODE: AMIC

24 hour credit card orders—call: 815-253-6390 fax: 815-253-6300
email: auphq@frontiernet.net www.adventuresunlimitedpress.com www.wexclub.com

One Adventure Place
P.O. Box 74
Kempton, Illinois 60946
United States of America
• Tel.: 1-800-718-4514 or 815-253-6390
• Fax: 815-253-6300
Email: auphq@frontiernet.net
http://www.adventuresunlimitedpress.com
or www.adventuresunlimited.nl

10% Discount when you order 3 or more items!

ORDERING INSTRUCTIONS

✓ Remit by USD$ Check, Money Order or Credit Card
✓ Visa, Master Card, Discover & AmEx Accepted
✓ Prices May Change Without Notice
✓ 10% Discount for 3 or more Items

SHIPPING CHARGES

United States

✓ Postal Book Rate { $3.00 First Item / 50¢ Each Additional Item
✓ Priority Mail { $4.50 First Item / $2.00 Each Additional Item
✓ UPS { $5.00 First Item / $1.50 Each Additional Item
NOTE: UPS Delivery Available to Mainland USA Only

Canada

✓ Postal Book Rate { $6.00 First Item / $2.00 Each Additional Item
✓ Postal Air Mail { $8.00 First Item / $2.50 Each Additional Item
✓ Personal Checks or Bank Drafts MUST BE USD$ and Drawn on a US Bank
✓ Canadian Postal Money Orders OK
✓ Payment MUST BE USD$

All Other Countries

✓ Surface Delivery { $10.00 First Item / $4.00 Each Additional Item
✓ Postal Air Mail { $14.00 First Item / $5.00 Each Additional Item
✓ Payment MUST BE USD$
✓ Checks and Money Orders MUST BE USD$ and Drawn on a US Bank or branch.
✓ Payment by credit card preferred!

SPECIAL NOTES

✓ RETAILERS: Standard Discounts Available
✓ BACKORDERS: We Backorder all Out-of-Stock Items Unless Otherwise Requested
✓ PRO FORMA INVOICES: Available on Request
✓ VIDEOS: NTSC Mode Only. Replacement only.
✓ For PAL mode videos contact our other offices:

European Office:
Adventures Unlimited, Pannewal 22,
Enkhuizen, 1602 KS, The Netherlands
http: www.adventuresunlimited.nl
Check Us Out Online at:
www.adventuresunlimitedpress.com

Please check: ✓

☐ This is my first order ☐ I have ordered before ☐ This is a new address

Name	
Address	
City	
State/Province	Postal Code
Country	
Phone day	Evening
Fax	Email

Item Code	Item Description	Price	Qty	Total

Please check: ✓

☐ Postal-Surface
☐ Postal-Air Mail (Priority in USA)
☐ UPS (Mainland USA only)

Subtotal ➡
Less Discount-10% for 3 or more items ➡
Balance ➡
Illinois Residents 6.25% Sales Tax ➡
Previous Credit ➡
Shipping ➡
Total (check/MO in USD$ only) ➡

☐ Visa/MasterCard/Discover/Amex

Card Number
Expiration Date

10% Discount When You Order 3 or More Items!

Comments & Suggestions

Share Our Catalog with a Friend